American Paintings

in the
Detroit Institute
of Arts

*The
Collections of the
Detroit Institute
of Arts*

Introduction by Nancy Rivard Shaw

*Essays by Mary Black, Gerald Carr,
Dorinda Evans, William H. Gerdts,
William T. Oedel, Richard H. Saunders,
Allen Staley, and J. Gray Sweeney*

American Paintings

*in the
Detroit Institute
of Arts*

VOLUME I

**WORKS BY ARTISTS BORN
BEFORE 1816**

Hudson Hills Press • New York
In Association with the Founders Society
Detroit Institute of Arts

First Edition

©1991 by the Founders Society
Detroit Institute of Arts

For Hudson Hills Press

Editor and Publisher: Paul Anbinder

Copy Editor: Judy Spear

Proofreader: Lydia Edwards

Indexer: Karla J. Knight

Designer: Binns & Lubin/David Skolkin

Composition: U.S. Lithograph

Manufactured in Japan by Toppan Printing
Company

**For the Founders Society
Detroit Institute of Arts**

Director of Publications: Julia Henshaw

Associate Director of Publications: Cynthia
Newman Helms

Assistant Editor: Cynthia Fogliatti

Library of Congress Cataloguing-in-
Publication Data

Detroit Institute of Arts.
 American paintings in the Detroit Institute
of Arts / introduction by Nancy Rivard Shaw ;
essays by Mary Black . . . [et al.].—1st ed.
 p. cm.—(The collections of the Detroit
Institute of Arts)
 "In association with the Founders Society
Detroit Institute of Arts."
 Includes bibliographical references and
index.
 Contents: v. 1. Works by artists born before
1816.
 ISBN 1-55595-045-0 (pbk. : alk. paper)
 1. Painting, American—Catalogues.
2. Painting—Michigan—Detroit—Catalogues.
3. Detroit Institute of Arts—Catalogues. I.
Shaw, Nancy Rivard, 1945– . II. Black,
Mary (Mary C.) III. Founders Society. IV.
Title. V. Series: Detroit Institute of Arts.
Collections of the Detroit Institute of Arts.
ND205.D298 1991
759.13'074'77434—dc20 90-85027
 CIP

Cover illustration: Benjamin West, *Death on the
Pale Horse* (detail), ca. 1796

*Support for this publication was provided by
the Henry Luce Foundation, Inc., as well as the
state of Michigan, the city of Detroit, and
the Founders Society Detroit Institute of Arts.*

Contents

Color Plates

Any collection of art consciously formed by an institution must inevitably reflect the special tastes and interests of the local community. The interests of Detroit collectors, as represented in the Detroit "Art Loan Exhibition" of 1883, were centered upon contemporary art in the United States and France. Thus the first activities undertaken by the new Detroit Museum of Art when it opened on Jefferson Avenue in 1888 were exhibitions of contemporary art and the establishment of an art school.

In the early years of the museum's history, however, the trustees and a number of the museum's staunchest supporters held opposing views on the mission of the institution. A controversy developed regarding the direction its collections should take. A significant amount of space had been devoted already to plaster casts of classical sculpture and to a large collection of artifacts accumulated by Frederick Stearns, the head of a Detroit pharmaceutical company, who traveled widely and whose interests lay primarily with ethnic arts and the natural sciences. James E. Scripps, editor and publisher of the *Evening News*, was a man of literary tastes who felt the museum should eschew "artifacts" and instead follow the examples of the finest European museums, which held large, broadly based collections of European art. To that end, he decided to undertake the selection of a series of old-master paintings as a foundation for the museum's collections that would also serve as examples for the art-school students.

In 1919 the Jefferson Avenue museum building—together with the art collections that had already outgrown it—was given to the city of Detroit, and plans for the present museum on Woodward Avenue were implemented. The new, municipally owned Detroit Institute of Arts was dedicated on October 7, 1927, as the booming economy of the 1920s neared its crest. With the new building and organization came an expanded philosophy of collecting. Under the directorship of William R. Valentiner, the museum initiated an acquisitions program designed to shape the collection as a comprehensive survey of the history of art. Subsumed within this broader aim was the belief that it was important for an American museum to exhibit a representative collection of the nation's cultural heritage.

The idea found the ready support of the Detroit seed merchant Dexter M. Ferry, Jr., who, in addition to acting as president (1920–48) of the museum's main fund-raising auxiliary, the Founders Society, undertook to build up the museum's collection of American paintings, contributing one or more works nearly every year from 1924 until his death in 1959.

Acquired through the generosity of patrons and careful purchasing by the museum's directors and curators, the cumulative holdings now offer an outstanding survey of the nation's achievements in the visual arts: the development of portrait painting from the close of the seventeenth through the early twentieth century; the development of figure painting beginning with an early-eighteenth-century Gustavus Hesselius; and a variety of landscape and genre paintings shown in select series. The primary requisite for inclusion in the collection has always been the quality of an individual work, regardless of the current reputation of the artist, within the limits of availability and financial resources.

The importance of the collection of American paintings prompted the museum, under the directorship of Frederick J. Cummings, to prepare a scholarly catalogue devoted to it. Nancy Rivard Shaw has directed the project with tremendous energy and devotion, organizing a three-volume series that, like the one produced by the Metropolitan Museum of Art in New York, will incorporate all American painters represented in the collection who were born before 1875. The museum received two generous grants in 1982 and 1984 from the Luce Fund for Scholarship in American Art to publish this first volume of the series, which catalogues the work of artists born before 1816. Herewithin we show distinguished achievements by some of our preeminent artists, including Washington Allston, George Caleb Bingham, Thomas Cole, John Singleton Copley, Thomas Doughty, Asher B. Durand, William Sidney Mount, Charles Willson Peale and most of the members of his extraordinary family, Gilbert Stuart, Thomas Sully, and Benjamin West, together with some remarkable works by lesser-known painters who have enriched our cultural history, such as Mather Brown, William Dunlap, Robert Feke, John F. Francis, John Greenwood, Francis Guy, Reuben Moulthrop, John Mix Stanley, and John Wilkie.

The second volume, which is also supported by a grant from the Luce Fund for Scholarship in American Art, will consist of paintings by artists born between 1816 and 1845. The third volume, paintings by artists born between 1846 and 1875, will be prepared at a later date. Paintings by American artists born after 1875 are presently in the care of the Department of Twentieth-Century Art.

We are extremely grateful to the Henry Luce Foundation, and specifically to its Fund for Scholarship in American Art, for the generous support that has made this long-awaited publication a reality.

Samuel Sachs II
Director

This catalogue of American paintings by artists born before 1816 is the first in a series of three volumes on the American paintings in the collection of the Detroit Institute of Arts. It is appropriate that such a major publication should be devoted to American paintings, since the development of the collection is closely linked to the history of this institution. Francis D. Millet's classically inspired *Reading the Story of Oenone*, purchased with the proceeds of the Detroit "Art Loan Exhibition" of 1883, was the first acquisition of the museum, and contemporary (that is, late-nineteenth- and early-twentieth-century) American art was the subject of the first consistent series of temporary exhibitions.

Despite Detroit's early interest in American art, the formation of the collection was at first gradual and haphazard. Until the first decade of the twentieth century, its growth was almost entirely dependent upon gifts and bequests. During the years since, although attributions have in some cases been changed and a few fakes relegated to storage, the acquisitions have been of consistently high quality, and today the American paintings in Detroit constitute one of the finest and most representative museum collections of eighteenth-, nineteenth-, and early-twentieth-century American art. In addition to an impressive number of masterpieces, there are major examples of the work of recently rediscovered painters and important pictures by well-known Michigan artists.

The foundation of the collection was laid in the first thirty years of this century under the guidance of Clyde H. Burroughs, a Monroe County, Michigan, schoolteacher who came to the museum in 1901 as assistant to Armand H. Griffith, who was then director. Burroughs later served in a variety of capacities, including director of the museum (1917–24), secretary to the Arts Commission (1919–46),

and curator of the American collection (1924–46), in a career that spanned forty-five years. Burroughs's primary areas of interest were the artists who formed the progressive movement in American art at that time, such as Robert Henri and Maurice Prendergast, and American Impressionist painting.

From 1903 to 1931 Burroughs staged yearly spring exhibitions of paintings by contemporary American artists, including the annual "Michigan Artists Exhibition" that he instituted in 1911. During these years Burroughs also arranged one-artist and group shows, such as "Paintings by Ten American Artists" in 1904 and "Paintings by Eight American Artists Resident in New York and Boston" in 1908. These exhibitions provided a way in which American pictures could be seen and purchased locally; well-known artists such as William Merritt Chase and Childe Hassam, as well as Detroit artists such as Gari Melchers and Julius Rolshoven, exhibited their works for sale. Many of the most important late-nineteenth- and early-twentieth-century paintings in the museum's collection came from the above-named exhibitions, including George Bellows's splendid *Day in June*, purchased with funds established in 1910 by Lizzie Merrill Palmer, widow of Senator Thomas W. Palmer, for the acquisition of works by artists of American citizenship, both living and deceased. Several significant works in the collection, such as Willard Leroy Metcalf's *White Veil* and George Luks's *Woman with Macaws*, were first acquired by their donors-to-be from one or another of the early exhibitions.

The Detroit museum's American Impressionist and Tonalist paintings were acquired primarily during this period as well. Most of the examples in the collection, including works by Frank Weston Benson, Hassam, Theodore Robinson, and others, were purchased soon after their completion, in several instances directly from the artist. An important impetus to the acquisition of works in these

styles was the establishment of the Picture Fund, which existed from 1906 until 1916 and which enabled the museum to purchase one painting per year by an American artist. It also served to encourage private collectors to give other works. Notable among such patrons was Charles Lang Freer, who headed the fund's selection committee and who presented the museum with *The Pool* by John Twachtman in 1908. Freer's taste is evident in three of the fund's other selections: Dwight Tryon's *Before Sunrise, June*, acquired in 1906; *The Recitation* by Thomas Dewing, purchased in 1908; and Metcalf's *Unfolding Buds*, purchased in 1910. Mary Cassatt's *Women Admiring a Child*, given by Edward Chandler Walker in 1908, was also acquired in response to the interest generated by this fund.

The Picture Fund attracted the attention of other important patrons and collectors as well, among them Isabella Stewart Gardner of Boston who, in 1907, gave the museum eight American paintings, the most significant of which is *The Ball Players* by William Morris Hunt. Two years later the museum learned that it was to benefit from a fund established by a former Detroiter, Grace Whitney Hoff, at the time she served as honorary president of the International Art Union of Paris. The Whitney Hoff Museum Purchase would assist American women artists and, at the same time, cultivate a taste for art in the United States. The painting selected for Detroit by Mrs. Hoff at the May 1909 exhibition of the Art Union was Elizabeth Nourse's *Happy Days*.

A few years later, with plans in the air for a new and expanded museum building, a variety of new acquisition programs were proposed by the staff. One of them called for a gallery of self-portraits by American artists similar to the one devoted to European counterparts in the Galleria degli Uffizi in Florence. The plan was still only vaguely conceived when

William Merritt Chase visited Detroit during the course of the spring exhibition. With characteristic generosity, Chase presented the museum with one of his paintings in the exhibition, a self-portrait that had been executed two years earlier. The following year J. Carroll Beckwith gave his self-portrait to the same project. Although the gallery of self-portraits as such was never formally created, the collection is especially rich in the self-images of esteemed American artists, including Rembrandt Peale (cat. no. 71), William Page (cat. no. 63), and James McNeill Whistler. Several paintings purchased as self-portraits but now thought to be by other artists, such as the unattributed *Portrait of an Artist* (cat. no. A40), were also acquired expressly for this purpose.

Detroiters were given their first view of the work of American masters of the Colonial and Federal periods in a traveling exhibition in 1915. Comprising fifteen examples loaned by the Boston dealer Robert C. Vose, the show was supplemented in Detroit with eight examples from the collection of Lendall Pitts, a local artist, and two paintings by Benjamin West from the museum's permanent collection. In 1921 the "Pilgrim Tercentenary Exhibition" focused on the same periods, with 317 examples of American painting and decorative arts. The exhibition was composed chiefly of objects, but thirty-eight paintings, including works by Joseph Badger, Joseph Blackburn, John Singleton Copley, John Smibert, Gilbert Stuart, Thomas Sully, and John Trumbull were also presented, eleven of them since purchased by the museum.

The excitement generated by the exhibition and by the new building being raised on Woodward Avenue in the early 1920s stimulated many Detroit families to respond with gifts. The strength of the current collection owes much to the donors and trustees who helped the Institute both in their own time and through permanent endowment funds established specifically for the purchase of American works that have continued to support the department's purchases after their deaths. One of the first and most devoted patrons was the Detroit seed merchant Dexter M. Ferry, Jr., president of the museum from 1913 to 1917 and of the Founders Society from 1920 to 1948. Working with Clyde Burroughs during the 1920s, he laid the foundation of the collection of early American portraiture. Donor by direct gift, fund, or bequest of nearly a quarter of the paintings in the collection, Ferry remains the department's largest single benefactor. His appreciation of the early masters may be explained by a regard for American literature that he acquired at Columbia University, where he received a Bachelor of Arts degree in 1898. At Columbia, Ferry joined a literary guild devoted to the study of American writing, an interest he maintained throughout his lifetime.

Except for owning a few late-nineteenth-century canvases—by George de Forest Brush, Ralph Blakelock, and the Detroit artist Myron Barlow—Ferry was not himself a collector. His involvement with historical American art was limited to his museum interests, which began to take form in the early 1920s following the appointment of William R. Valentiner as adviser to the museum. Under Valentiner's leadership as director from 1924 to 1945, the museum initiated an acquisitions program designed to make the collections a comprehensive survey of the history of art; America's cultural heritage was a major component of this scheme. In 1922 Ferry set up an endowment fund for the purchase of American paintings and, in 1927, the year the new museum opened to the public, presented the collection with four eighteenth-century portraits. These gifts, which included John Hesselius's *William Allen* and *Mrs. William Allen* (cat. nos. 52 and 53) and Chester Harding's *Dr. Samuel A. Bemis* (cat. no. 46), signaled the beginning of a plan to develop the collection of American art in a serious, complete, and systematic way. Portraits by John Neagle and Samuel F. B. Morse (the latter now attributed to Harding; see cat. no. 48) followed in 1929, and in the early 1930s Ferry presented two examples by Thomas Eakins.

Other outstanding acquisitions include Sully's *Dr. Edward Hudson* and *Mrs. Edward Hudson* (cat. nos. 97 and 98) and John Greenwood's *John Adams* (cat. no. 42), all purchased in 1926; Arthur Davies's *Dances*, given by Ralph Harman Booth in 1927; and *Promenade* by Prendergast, purchased that same year. Also in 1927 the museum received two paintings by Tryon and one by Dewing that together comprise *The Seasons Triptych* commissioned by Colonel Frank J. Hecker, a friend and associate of Freer's, for his Detroit home, and Copley's beautiful portrait of Mrs. Clark Gayton (cat. no. 24), the gift of D. J. Healy. Another important contributor to the collection that year was Mrs. Eugene B. Gibbs, who left the Gibbs-Williams Fund (so named to honor her sister, Mrs. Williams) for the development of a collection of early American paintings and decorative arts. Major paintings acquired with this fund during more recent years include Thomas Doughty's *In Nature's Wonderland* (cat. no. 28); Copley's *Jonathan Mountfort, John Gray, John Montresor,* and *Head of a Negro* (cat. nos. 18, 20, 22, and 23, respectively); Smibert's *Mrs. James Pitts* and *Mrs. John Pitts* (cat. nos. 78 and 79); Badger's *James Bowdoin* and *James Pitts* (cat. nos. 5 and 6); Blackburn's *James Pitts* (cat. no. 12); Melchers's *Thomas Pitts* and *Mrs. Samuel Mountfort Pitts*; and *Master Charles William Park* (cat. no. 14) by Mather Brown.

In 1930, with the appointment of Edgar P. Richardson as educational secretary, the Institute gained an expert in American art. Richardson, then twenty-eight years old, had studied painting at the University of Pennsylvania (1920–21) before attend-

ing Williams College, from which he was graduated summa cum laude in 1925 (later receiving the school's honorary degree of Doctor of Humane Letters in 1947). With the intention of pursuing a career as an artist, Richardson entered the Pennsylvania Academy of the Fine Arts, where he remained until 1928. Realizing a short time later that he had "more of a scholar's mind" (Museum Archives, Richardson Papers), Richardson turned his attention to museum work—a timely decision for Detroit.

Richardson belonged to the generation that rediscovered the Hudson River school, the early genre painters, and the mid-nineteenth-century portraitists. During his lengthy tenure as an assistant director in charge of curatorial and exhibition activities from 1934 to 1945 and as director from 1945 to 1962, he expanded the collection from one chiefly concerned with turn-of-the-century examples to one that illustrates the development of American painting from the close of the seventeenth century to the early twentieth.

Richardson began to acquire major nineteenth-century landscape and genre paintings in the late 1930s while continuing to expand the eighteenth-century portraiture collection, buying at bargain prices works that are invaluable today. In 1938, again through Ferry's beneficence, William Sidney Mount's *Banjo Player* (cat. no. 61) and Asher B. Durand's *Monument Mountain, Berkshires* (cat. no. 32) joined the collection. The same year, through the William H. Murphy Fund, Richardson bought seventeen oil sketches (cat. nos. A11–A27), eighteen sketchbooks, and five hundred loose sheet drawings executed by Thomas Cole from Florence Cole Vincent, the artist's granddaughter. Winslow Homer's *Girl and Laurel* was a Ferry gift in 1940, and in 1941 the Ferry Fund was used to purchase Ralph Earl's *Lucy Bradley* (cat. no. 34).

Other important acquisitions made during Richardson's tenure through Ferry's re-markable munificence include Whistler's *Nocturne in Black and Gold: The Falling Rocket*; *The Checker Players* and *The Trappers' Return* by George Caleb Bingham (cat. nos. 9 and 11); Richard Caton Woodville's *Card Players*; Homer's small Civil War scene *Defiance: Inviting a Shot before Petersburg, Virginia*; Washington Allston's *Italian Shepherd Boy* and *Italian Landscape* (cat. nos. 3 and 4); Robert Feke's *Mrs. John Banister* (cat. no. 39); Copley's *Watson and the Shark* (cat. no. 26); Gustavus Hesselius's *Bacchus and Ariadne* (cat. no. 51); Charles Willson Peale's *James Peale* (The Lamplight Portrait) (cat. no. 67); Rembrandt Peale's *Self-Portrait* (cat. no. 71); and Albert Pinkham Ryder's *Tempest*. There are many other distinguished works that testify to this unique collaboration.

Richardson's publications while at the Detroit Institute of Arts paralleled his collecting activities. His first book, *The Way of American Art*, appeared in 1939 and was followed by *American Romantic Painting* in 1944, the same year that saw the first of four paintings by Allston enter the collection. In 1948 Richardson's definitive biography of Allston established the major role of this enigmatic artist. *Painting in America: The Story of 450 Years*, the first general history of American painting to be published in nearly half a century, appeared in 1956 and became the standard work on the subject. Six months later, Richardson mounted a major exhibition based on this book. There were 183 paintings in all, ranging from works by Gilbert Stuart to the Abstract Expressionist painters of the 1950s. Perhaps his most important contribution to scholarship, however, was the founding in 1954 of the Archives of American Art, now a branch of the Smithsonian Institution in Washington, D.C.

Although not directly advised by Richardson, other collectors filled gaps in the museum's holdings. One of the most outstanding was Robert H. Tannahill, who served the museum as trustee (1931–69), commissioner (1932–62), and honorary curator of American art (1927–69), and contributed significantly in many other ways. Because of his generosity to the museum, the galleries housing the American collections were named the Robert H. Tannahill Wing of American Art in 1969. William Harnett's *American Exchange* and John Frederick Peto's *After Night's Study* were gifts from Tannahill in the late 1940s; Homer's *Four-Leaf Clover* was included in the Tannahill bequest to the museum in 1970. The Tannahill Foundation Fund has since provided the monies for several important American works, including West's *Lot Fleeing from Sodom* (cat. no. 112) and *Death on the Pale Horse* (cat. no. 109) and Cassatt's *Alexander J. Cassatt*.

In the decade following Richardson's departure from Detroit to accept the directorship of the Winterthur Museum in Delaware in 1962, subsequent curators—Charles Elam, Graham Hood, and Larry Curry—under the guidance of two directors—Willis F. Woods and then Frederick J. Cummings—significantly strengthened the collection. Copley's *Hannah Loring* (cat. no. 19), given by Mrs. Edsel B. Ford in memory of her cousin Robert H. Tannahill, came to the museum in this period, as did the first major example by John Singer Sargent, the elegant *Madame Paul Poirson*. Two other events also served to enrich the collection. In 1967 Beatrice Rogers made the museum the major beneficiary of her estate, with the stipulation that the money be used for the acquisition of traditional American art. The same year, under Hood's leadership, an important auxiliary of the Founders Society—called the

Associates of the American Wing—was formed to ensure continuing interest in America's cultural heritage. Notable among individual members' contributions to the collection are Dewing's *Classical Figures*, a folding screen presented by Mr. and Mrs. James O. Keene in memory of their daughter Sandra Mae Long; Charles Willson Peale's *Belfield Farm* (cat. no. 66) from Dr. and Mrs. Irving Levitt; Chase's portrait of his wife, the gift of Raymond C. Smith; William Rimmer's *Civil War Scene*, given by Dr. and Mrs. Sheldon Stern; Thomas Anshutz's *Aunt Hannah* and Samuel Lovett Waldo's *Portrait of a Man* (cat. no. 104) from Mr. and Mrs. Lawrence A. Fleischman; Thomas Hovenden's *In Hoc Signo Vinces*, given by Mr. and Mrs. Harold Love; and Copley's *Colonel George Lewis* (cat. no. 27) from Mr. and Mrs. Richard A. Manoogian. The Manoogians have also made generous contributions to several recent acquisitions and have placed important examples from

their collection on long-term loan to the Detroit Institute of Arts.

Although the art market for American pictures has changed dramatically during the curatorship of this author (1975 to the present), efforts to combat deficiencies in the collection have resulted in some outstanding successes. Luck played a major role in the acquisition in 1977 of *Cotopaxi*, one of Frederic Edwin Church's finest achievements, purchased through a New York dealer from the heirs of James Lenox, who commissioned the work in 1862. Representation of West was significantly enhanced with the addition of two religious subjects, the aforementioned *Death on the Pale Horse* and the monumental *Last Supper* (cat. no. 106). John White Alexander's *Panel for Music Room* and H. Siddons Mowbray's *Calenders* were each the first examples by these important late-nineteenth-century painters to enter the collection. Most recently, in 1986, the museum acquired Cassatt's 1880 portrait of her brother Alexander J. Cassatt, one of the artist's rare depictions of an adult male and, to modern eyes, perhaps the most successful.

As the museum enters its second century of collecting American paintings, much remains to be done. The Hudson River school is represented by a well-developed series at this date, but there is no major example by Cole, nor is there a classic luminist landscape. While the collection includes four charming early works by Homer, there is no heroic seascape by him, nor a major Eakins portrait. Given the museum's dwindling buying power, the shrinking art market, and the increasingly high prices commanded by such works, these gaps may well be permanent in the Detroit collection. It is hoped that the future will bring new and innovative collecting strategies with which to meet the challenge.

Nancy Rivard Shaw
Curator of American Art
1990

I would not have dared to conceive, much less undertake, this project without the assured financial support of the Henry Luce Foundation, Inc., through its Fund for Scholarship in American Art. I am deeply grateful to Henry Luce III, chairman and CEO; Robert E. Armstrong, president; and Mary Jane Crook, Program Director for Arts, Theology, and Public Affairs, for their assistance and encouragement over the several years this catalogue has been in preparation.

My appreciation goes to the catalogue authors—Mary Black, Gerald Carr, Dorinda Evans, William Gerdts, William Oedel, Richard Saunders, Allen Staley, and J. Gray Sweeney—for their foresight and scholarship. It is especially gratifying to have several long-standing questions of authenticity and attribution herein resolved. Many thanks go also to Rena Coen, John Dillenberger, Elizabeth Ellis, Ellen Miles, and Christine Schloss, who read portions of the manuscript and contributed valuable suggestions.

Several members of the museum staff have been particularly helpful, and I am indebted to them all. In the early stages of research, Robert Payne and Kyra Curtis assisted the Department of American Art in compiling information on the collection and its formation. During the editing of the manuscript, James W. Tottis capably helped tie up loose ends. Throughout the whole of this project, Anita Calvert coordinated numerous internal details with good humor and patience.

The Publications Department shares much of the credit for the catalogue. Cynthia Newman Helms deserves the highest regard for her perceptive and respectful editing of the eight contributors' manuscripts; her painstaking attention to detail and her commitment to the project can never be adequately acknowledged. Special thanks are given to Cynthia Fogliatti, who took over the manuscript as it approached the galley stage and guided it skillfully through completion. Julia Henshaw, Director of Publications, provided good counsel at crucial moments. I am also grateful to Opal Suddeth-Hodge, who cheerfully typed and retyped the manuscript over the course of several years.

Particular recognition is due Barbara Heller and her conservation staff, who performed such treatment of the collection as was necessary for photography and provided the authors with detailed condition reports and technical analyses of questionable paintings. Dirk Bakker produced the superb photographs with the assistance of Robert Hensleigh, Marianne Letasi, and Timothy Thayer.

A number of scholars and institutions across the country aided this effort in various ways. Most of them are credited in the catalogue entries, however, the authors give further acknowledgment to the following: Linda Ayres, Wadsworth Atheneum, Hartford; Marisol Borrero, New York Public Library; the staff of the Burton Historical Collection, The Detroit Public Library; Donald Fangboner, Lake George Historical Association, New York; Karl Kilinski II, Southern Methodist University, Dallas; Leah Lipton, Framingham State College, Framingham, Massachusetts; Ellen Miles, National Portrait Gallery, Washington, D.C.; Barbara Millstein, Brooklyn Museum, New York; Ellwood C. Parry III, University of Arizona, Tucson; David Rosand, Columbia University, New York; Paul J. Staiti, Mount Holyoke College, South Hadley, Massachusetts; the staff of the Winterthur Library, The Henry Francis du Pont Winterthur Museum, Winterthur, Delaware; and Christopher Young, The Flint Institute of Arts, Flint, Michigan.

Finally, I would like to acknowledge the expertise of Paul Anbinder, president of Hudson Hills Press, the careful editing by Judy Spear, and the skill of the catalogue designers, Betty Binns and David Skolkin.

Nancy Rivard Shaw
Curator of American Art
Detroit, August 1990

As noted in the Foreword, this first volume of the *American Paintings* series focuses on the work of artists born before 1816. Volume two will cover paintings by artists born between 1816 and 1845, and volume three those born between 1846 and 1875. Paintings by American artists born after 1875 are in the keeping of the Department of Twentieth-Century Art. Pastels and all works on paper come under the care of the Department of Graphic Arts.

Sequence

This catalogue is arranged alphabetically by the artist's surname, except for the unknown artists, whose works have been placed last. Minor paintings have been grouped in the Appendix following the main catalogue.

Attribution

Works either signed or considered to be autograph are designated by the artist's name. If a reasonable doubt exists concerning the authorship of a work, the term "attributed to" has been used. The following terms are defined to clarify an artist's contribution to works not believed to be autograph:

"Style of": the painting is similar stylistically to the work of the master, but direct influence may be lacking; this phrase implies a distance in time and/or place from the master.

"Copy after": the painting is a copy, by an unidentified artist, of a known or suspected original by the master but not produced in his studio; a copy may range in date from a work contemporary with the original to a modern version.

"Imitator of": the painting is the work of an unidentified artist who deliberately intended that it pass as an original by the master; the forgery may be contemporary with works by the master or may be of later invention.

Date

If a work is securely dated, that date is given. The term "circa" indicates that a work is dated on stylistic or other grounds. If a work was produced over a documented period of time, a range of dates is given with a dash, such as 1817–43; if the period is undocumented, as ca. 1817–43. If a work was produced within a specific, documented time period, the range of dates is separated by a slash, such as 1750/54; if the period is undocumented, as ca. 1750/54. Uncertainty about part of a date is expressed with a question mark and parentheses, as in 182(3?) or 1788/(91?).

Medium and Dimensions

Both medium and support are identified for all works. Dimensions are given in both the metric and the United States Customary systems with height preceding width. Measurements were taken at the time each painting was examined by conservators in the Detroit Institute of Arts' Conservation Services Laboratory.

Condition

Originally, condition reports were to be included for each work. Due to staff and time limitations, however, it was not possible to do so. Information on specific paintings in the collection is available through the Department of American Art or the Conservation Services Laboratory; please submit a written request.

Provenance

The history of each painting has been traced as completely as possible. Dealers have been so designated to distinguish them from collectors, although in some cases the two categories overlap and it was not possible to determine whether a work was in a dealer's private collection. In the case of sales, the owner's name, if known, precedes the place and date of the sale.

Exhibitions and References

All known exhibition and bibliographical information has been included, with the exception of references to illustrations that convey no information about a work (such as in annual reports, picture books, and so forth, published by the Detroit Institute of Arts and others).

Within the entries, exhibition and bibliographical references are indicated by a short form consisting of the city and date of exhibition for the former and the author's name and date of publication of the work for the latter. Complete citations may be found in the Bibliography for all but recurring exhibitions (for example, those at the Royal Academy in London and the American Art-Union shows), for which only the city, institution, and date are given in the pertinent Exhibition listing. Information on such recurring shows is available in Cowdrey 1953 and Graves 1905. Listings of exhibitions without catalogues are followed by "[no cat.]"; if the title of the exhibition is unknown, the listing is followed by "[Exhibition; no cat.]."

American Paintings

in the
Detroit Institute
of Arts

Washington Allston

1779 NEAR CHARLESTON, SOUTH CAROLINA—
CAMBRIDGEPORT, MASSACHUSETTS 1843

After spending his early years on the family plantation northeast of Charleston, South Carolina, Washington Allston was sent to school in Newport, Rhode Island, in the spring of 1787. There he formed friendships with the future Unitarian preacher William Ellery Channing and with Edward Greene Malbone, later to become America's finest miniature painter. He also received some instruction from a local artist, Samuel King (1748/49–1819). In 1796 Allston matriculated at Harvard College; his earliest known paintings, primarily landscapes, date from his Harvard years. After his graduation in 1800, he announced his intention to devote his career to art, and in May of 1801 Allston and Malbone departed for London.

Shortly after arriving in England, Allston met with the American expatriate Benjamin West (q.v.), then president of the Royal Academy and the leading historical painter in Great Britain. In the autumn of 1801 Allston was admitted to the Royal Academy schools. The following year three of his works were exhibited at the academy's annual exhibition. In 1803 Allston met a fellow American, John Vanderlyn (q.v.), and in October the two left London, traveling first to the Low Countries and then to Paris, where Allston painted his earliest surviving masterwork, *Rising of a Thunderstorm at Sea* (1804; Museum of Fine Arts, Boston). Allston left Paris in August of 1804, and early in 1805, after traveling through the Swiss Alps and visiting Florence and Siena, he settled in Rome, where Vanderlyn joined him at the end of the year. There Allston formed enduring friendships with Washington Irving and Samuel Taylor Coleridge and established a close relationship with the community of German artists living in Rome. He adopted the glazing techniques developed by Venetian painters during the Renaissance, and his Roman paintings earned him the designation "the American Titian."

Allston returned to America in 1808 and settled in Boston, painting primarily portraits for a time (although he would become the first American painter whose livelihood was not dependent upon portraiture). In July 1811, with his wife and his pupil Samuel F. B. Morse, Allston went again to London. He spent the next seven years abroad and during this period established himself as a historical painter of great repute. Inspired by West's success with large pictures on scriptural subjects, Allston produced major works concerned with inspiration and miracle, such as *Dead Man Restored to Life by Touching the Bones of the Prophet Elisha* (1811–14; Pennsylvania Academy of the Fine Arts, Philadelphia). In 1817 he began his most ambitious work, also in this genre: *Belshazzar's Feast* (see cat. no. 1). In September of that year Allston traveled to Paris, where he remained for six weeks, studying contemporary French art and copying old masters in the Louvre.

Allston left England in August 1818 and returned to Boston. His first major works painted back in America continued to draw upon religious sources, specifically the Old Testament, for inspiration. But increasingly in this long, last period of his career, the artist turned away from dramatic epics to concentrate on paintings of lyrical and poetic landscapes and depictions of single figures—lovely women or adolescent youths. These were the works most admired by later generations. In 1830 Allston married for a second time, his first wife having died during his stay in England, and went to live in Cambridgeport, across the Charles River from Boston. During his later years, more and more recognized as the principal artist in America, he was visited and consulted by nearly all his younger colleagues. In 1839 a much-heralded and reviewed exhibition of almost fifty of Allston's pictures was held at the studio gallery of Chester Harding (q.v.) in Boston.

In addition to painting, Allston designed sculpture and architecture. He also published a novel, *Monaldi* (1842), and a volume of poetry, *The Sylph of the Seasons, with Other Poems* (1813). His *Lectures on Art and Poems,* a volume primarily on the theory of art, was published posthumously in 1850, and a folio volume titled *Outlines and Sketches by Washington Allston,* engraved and lithographed by the Boston printmakers John and Seth Cheney, also appeared that year. Allston's influence remained particularly strong in Boston, influencing younger artists for a considerable time after his death.

W. G.

Bibliography Ware 1852. Tuckerman 1867, 136–157. Sweetser 1879. Flagg 1892. Richardson 1948a. Boston and Philadelphia 1979.

1

Belshazzar's Feast, 1817–43

Oil on canvas
366 × 488 cm (144⅛ × 192⅛ in.)
Gift of the Allston Trust (55.515)

Although it remained unfinished, *Belshazzar's Feast* was not only Allston's most famous painting, it has also long been recognized as the most important and most monumental example of romanticism in the grand manner in American art. The artist's inability to complete it has been seen as symbolic of the frustrations attendant on attempts to establish high culture on the hostile, or at least indifferent, shores of an America concerned only with mercantilist, utilitarian pursuits. The story of Allston's masterwork is not nearly that simple. His failure to complete *Belshazzar* also reflects an increasing estrangement from the cultural source that prompted its beginning. While neither the work's categorical identification as history painting nor its traditional grand-manner theme would necessarily have undermined its meaningfulness to Ameri-

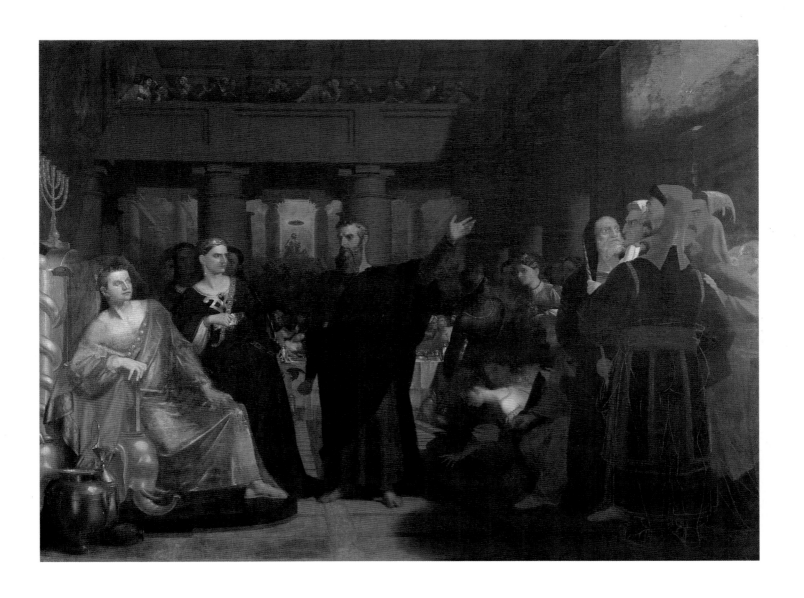

cans (as proven by the popular success of Daniel Huntington's *Mercy's Dream* of 1841 [Pennsylvania Academy of the Fine Arts, Philadelphia], drawn from the works of John Bunyan), the Old Testament flavor of its theme of prophetic doom and a vengeful God was at odds with the optimistic spirit of the growing new nation that saw America as being at one with God and Nature.

In 1816, while living in London, Allston had expressed his desire to paint a major scriptural subject, and the following year he began his great canvas, perhaps conscious of the fact that his native government had just awarded its first major commission for a pictorial series to John Trumbull (q.v.) for four historical subjects in the rotunda of the Capitol in Washington, D.C. (*Belshazzar's Feast* is almost identical to those works in dimensions.) Important to Allston's choice of subject and conception, too, was the *Belshazzar* undertaken at the time by a colleague and good friend, the English painter John Martin.

In 1818 Allston decided, rather hurriedly, to leave London. He returned to America, with his unfinished *Belshazzar*, believing that it would require only six to eight months more work to finish it. Initially, he delayed getting back to the great canvas for a variety of reasons—the task of locating a studio, the possibility of other major commissions, and the necessity of painting smaller canvases, the sales of which would allow him to continue with his purely speculative *Belshazzar*. Allston finally unrolled the work in September 1820, but a visit by his major Boston colleague, the portraitist Gilbert Stuart (q.v.), who is supposed to have criticized the perspective of the picture, appears to have led Allston to begin a reworking of the design (a task that was never completed). Even the fact that a group of well-meaning Boston and Charleston philanthropists and patrons subscribed a fund of ten thousand dollars to enable Allston to work on *Belshazzar*

unhindered appears actually to have imposed on him a burden of moral responsibility that was more oppressive over the following decades than his pecuniary embarrassments.

In the winter of 1828/29, Allston's Boston studio was sold, and although he established a new studio across the river in Cambridgeport, he does not seem to have unrolled the monumental *Belshazzar* again until 1839, after which he appeared to have remained engaged with the painting until his death in 1843. In fact, on the evening of his death on July 9, he had been working on the soothsayers to the right of the central figure of Daniel.

Subsequent examination of the painting revealed it to be in a distressing condition, with elements of both Allston's original design and his later reworking, as well as the figure of Belshazzar himself, completely covered with a layer of solid paint. The task of restoration was given to a little-known Boston artist, Darius Chase (active 1840s–50s), who removed the paint to reveal the figure of the king, although with some resultant loss of the chalk outlines that had indicated Allston's intended changes. The work was then seen extensively—first by artists who journeyed to examine the picture and then in public exhibition—in 1844 at the Corinthian Gallery in Boston and subsequently at the Boston Athenaeum (1845–72). The picture's impact upon the course of American art, and particularly upon painting in Boston, is difficult to determine, but there was certainly during the 1840s a great increase in the number of major Old Testament subjects painted and exhibited by American artists. Also, the "Great Exhibition of Religious Painting," held at the Pennsylvania Academy of the Fine Arts in 1844, was undoubtedly inspired, at least in part, by the renown of Allston's great work. (The subscriber-trustees would not allow *Belshazzar* to travel, and the work was sorely missed in Philadelphia.) Not unexpectedly, however, critical opinion of Allston's masterwork gradually shifted from the rapturous reception it received when it was first publicly un-

veiled to the disapproval of later writers, who preferred Allston's more intimate and poetic landscapes and figure pieces.
W. G.

Provenance The Allston Trust. Acquired in 1955.

On deposit With the Dana Family, Boston, 1862. Museum of Fine Arts, Boston, 1878–1941. Fogg Art Museum, Harvard University, 1941–55.

Exhibitions Boston 1844. Boston 1845–72. Boston 1863, no. 141. Boston 1876, no. 201. Boston 1881, no. 201.

References (*Belshazzar's Feast* figures in almost every discussion of the history of American art; therefore, only the major examinations of the picture are listed here). Dunlap 1834, 2: 181, 184–185. A. Dearborn 1844, 205–217. Hunt 1844, 49–57. Jameson 1844, 39–40. Spear 1844. Ware 1852, 109–142. Sweetser 1879, 119–130. Dana 1889, 637–642. Flagg 1892, passim. Wright 1937, 620–634. Richardson 1948a, 122–129, 152–155. Barker 1950, 347–348. Gerdts 1973, 59–66. Gerdts 1973a, 58–65. Los Angeles 1974, 11, fig. 2. Johns 1977, 7. Meservey 1978, 81. A. Davidson 1978, 15–17. Boston and Philadelphia 1979, 134–156. Johns 1979, 5. Kasson 1982, 70–73. Dillenberger 1984, 136–138, no. 5. Lloyd 1984, 151. Bjelajac 1988.

2

The Flight of Florimell, 1819

Oil on canvas
91.4 × 71.1 cm (36 × 28 in.)
City of Detroit Purchase (44.165)

The Flight of Florimell, the subject of which is taken from Edmund Spenser's *Faerie Queene*, is probably Allston's finest painting derived from a literary source. Spenser's work had interested Allston earlier in his career—the Harvard College Archives record that Allston borrowed *The Faerie Queene* during his col-

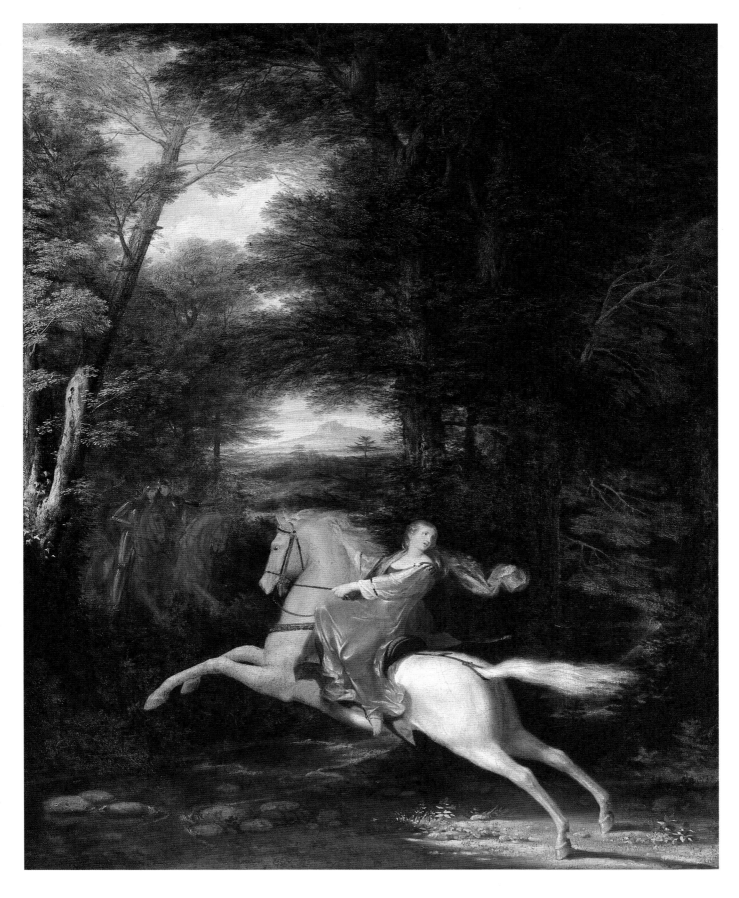

The Flight of Florimell

lege years —and while he undoubtedly consulted the poem later to refresh his memory and to provide inspiration anew for his picture, it was typical of the artist that he allowed his literary source to filter down through years of memory. Allston would return to Spenser's great opus again as inspiration for several depictions of Una (Lowe Art Gallery, Coral Gables, Fla.; others unlocated), which, however, the artist never completed.

Una had been, in fact, the subject of a major literary painting by Benjamin West (q.v.), Allston's mentor in London, who painted *Una in the Woods* in 1772. West had also derived from *The Faerie Queene* his *Fidelia and Speranza*, painted in the 1770s—a work that offered a prototype for the frequent paired-female images that figure importantly in Allston's oeuvre.

Many other Anglo-American artists, including John Singleton Copley (q.v.) and West, frequently sought their imagery in Spenser's writing, as did a host of British artists, notably John Opie and Henry Fuseli, who painted Spenserian subjects for Thomas Macklin's Poet's Gallery in London. The works in the Poet's Gallery proliferated extensively through engravings. Thus, for an artist such as Allston, working within the conventions of grand-manner pictorialization, *The Faerie Queene* would have been an obvious source of inspiration, particularly given his early familiarity with the book. In turn, Allston's success with *Florimell* must have offered inspiration for his most able pupil and follower, Samuel F. B. Morse, to undertake his own Spenserian subject, *Una and the Dwarf Relating the Capture of the Redcross Knight to Prince Arthur and His Squire* (1827; Toledo Museum of Art). Morse's painting was, in fact, part of a series by various American artists created for James Stevens's Hudson River steamboat, *Albany*, and thus brought Spenserian pictorialization to a wide audience.

Morse's painting may be read as an anti-Catholic presentation, with Una, representing Truth, and Sir Arthur, representing Protestantism, seeking to rescue the Redcross Knight from the castle of the giant Orgoglio (Catholicism); an interpretation totally consistent with Morse's strong anti-Popery stance. Allston's painting is an embodiment of the spirit of medieval chivalry and romance that so fascinated the artist and his contemporaries; it is also indicative of the aesthetic rekindling of the Venetian Renaissance. Indeed, Florimell, symbolic of female virtue and chastity, is the most Titianesque of Allston's figures, not only in figural type but also in the treatment of her shimmering drapery and golden tresses. The resonance and luminosity of the figure and her garments carry over to the landscape as well—a soft, feathery setting quite different from the solid clarity of the artist's previous neoclassical interpretations of nature—and look forward to the soft romanticism of his later landscapes and settings. Allston's portrayal of the horse's anatomy in *Florimell* is surprisingly effective for a painter with little experience in either the depiction of horses or the rendering of violent movement.

Capturing the essence of anxiety and mystery inherent in Spenser's verses, Allston's *Florimell* follows closely the poet's description of his heroine:

All suddenly out of the thickest brush
Upon a milk-white palfrey all alone
A goodly lady did foreby them rush
Whose face did seem as clear as christall stone
And eke, thru fear, as white as whale's bone.
Her garments all were wrought of beaten gold
And all her steed with tinsel trappings shone
Which fled so fast that nothing might him hold
And scarce them leisure gave her passing to
 behold.

Still, as she fled her eye she backward threw
As fearing evil that pursued her fast
And her fair yellow locks behind her flew....

Spenser's *Faerie Queene*, published in 1590, is roughly contemporary with the art of Titian and Veronese, whose paintings Allston cherished and emulated. Perhaps it was for such a reason that Allston found Spenser to be an inexhaustible source of subject matter. *Florimell* was acquired by Loammi Baldwin, one of Allston's principal patrons and a subscriber to the fund established to allow him to continue and complete *Belshazzar's Feast*. w. g.

Provenance Loammi Baldwin, 1827; James F. Baldwin, 1839; Mrs. George R. Baldwin, 1876. M. Knoedler Co., New York, 1944. Acquired in 1944.

Exhibitions Boston 1827, no. 18. Boston 1839, no. 5. Boston 1876, no. 71. Boston 1881, no. 223. Detroit 1944, no. 27. Chicago and New York 1945, no. 5. Detroit and Boston 1947, no. 27. Denver 1948, no. 17. Pittsburgh et al. 1957, no. 4. Newark 1963, no. 220. Chapel Hill 1968, no. 45. Boston and Philadelphia 1979, 133–134, no. 52.

References Letters from Allston to Gulian Verplanck, April 19, 1819; from Allston to Charles Leslie, November 15, 1819; from Leslie to Allston, March 3, 1820; from Allston to William Collins, May 18, 1821 (Dana Family Papers, Massachusetts Historical Society). Peabody 1839, 13–16. S. Clarke 1865, 131, 136. Sweetser 1879, 111, 190. Downes 1888, 260. Flagg 1892, 162. Richardson 1944, 4. Born 1945, 274. Richardson 1945, 21. Dame 1947, 13. Richardson 1947b, 218. Richardson 1948a, 139–141. Canaday 1958, 75. Comstock 1958, 66. Dorra 1960, 21. Canaday 1969, no. 233. Novak 1969, 56. Cummings and Elam 1971, 136. Johns 1977, 8. Rivard 1978, 1047. Johns 1979, 6.

3

Italian Shepherd Boy
(possibly *Edwin*), 1819

Oil on canvas
53.3 × 43.2 cm (21 × 17 in.)
Gift of Dexter M. Ferry, Jr. (44.166)

One of the first works painted by Allston after his return from London in 1818, *Italian Shepherd Boy* foretold the emphasis upon idyllic figure painting that would be

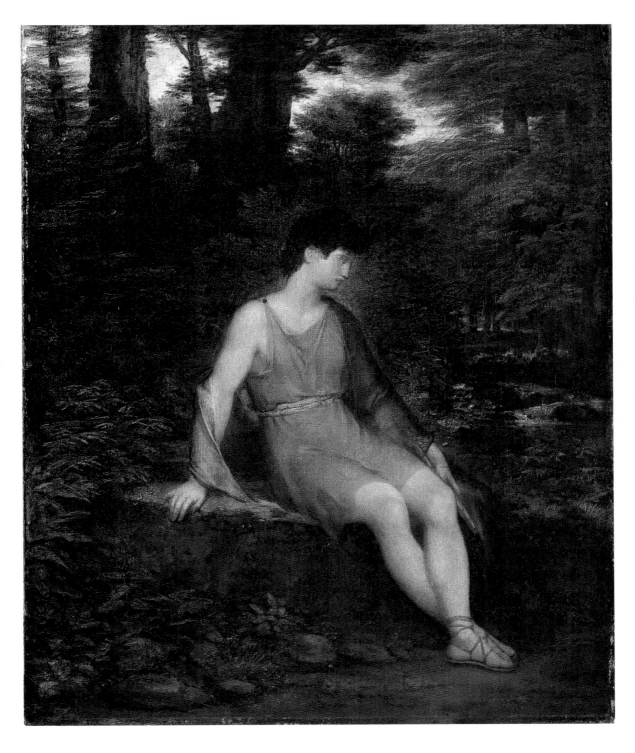

Italian Shepherd Boy

a major concern of the artist during the next several decades. The youthful shepherd's figure is posed in a contemplative, poetic moment, and the tranquil, lush landscape in which he is set underscores the mood of reverie. The landscape is closed rather than open and cushions the figure gently. Like the pure landscapes Allston produced during the next two decades, this painting is a product of imagination and memory rather than a transcript of observed nature.

In a sense, the figure, likewise, is a memory image; it is based on a life drawing (Fogg Art Museum, Harvard University, Cambridge, Mass.) done over a decade earlier on Allston's first trip to Europe. In returning to this drawing and the memory of the experience that inspired it, Allston infused the image with the romantic, reflective spirit that was developing in his work in these later years. The romantic aura first emerged in Allston's work in *The Valentine* of 1809–11 (private collection), painted in Boston after his first trip abroad, and it surfaced sporadically while he was back in London, above all in *Contemplation* of about 1817–18 (Petworth House, Sussex, England). The figure in that work, like the Italian shepherd boy, is a poetic image set in a gentle, enfolding landscape.

The Detroit picture is one of two contemporaneous paintings by Allston that depict an adolescent male in the woods; the other is in the collection of the Brooklyn Museum, and it, too, is based upon one of Allston's early European drawings. The Brooklyn figure is larger in scale and younger in age than the youth in the Detroit work, and the landscape setting is wilder and rockier. Embodying an exaltation of the pastoral life, these images suggest the primacy both of the arcadian, precivilization stage of cultural development and of youthful innocence and its oneness with nature. Among those who wrote of the sweetness and beauty of Allston's image of the shepherd boy were Elizabeth Peabody and Margaret Fuller.

The Detroit picture may be something more than just an image of an Italian shepherd, however. While the Brooklyn picture has a secure history, having been acquired by the Hooper family of Boston during the artist's lifetime, the Detroit painting's provenance is far less certain. Documents do record the fact that in 1819 Allston painted the protagonist (Edwin) from the Scottish poet James Beattie's once-famous poem *The Minstrel* (1771–74). (The image of Edwin had been a popular one with British artists, notably Joseph Wright of Derby, who painted this subject in 1777–78 [private collection].) It can be argued that Detroit's *Italian Shepherd Boy* may indeed be this previously unlocated work.

The mien of the figure is pastoral, even rustic, thus corresponding closely to Beattie's "shepherd-swain, a man of low degree," who was meant to embody the birth of poetical genius. Likewise, Beattie's *Minstrel* was a flutist, and Allston's shepherd holds a flute in his hand. Furthermore, Elizabeth Ellis (forthcoming Ph.D. diss.) has located a sketch made of Allston's *Edwin* (letter from Allston to William Collins, May 18, 1821 [Dana Family Papers, Massachusetts Historical Society, Boston]) by the Charleston artist John S. Cogdell when he visited Nathaniel Amory's home in New England, where the picture was hanging in September of 1825; the sketch depicts the figure in a pose similar to that of Detroit's Italian shepherd boy.

Allston's *Edwin* was exhibited at the Pennsylvania Academy of the Fine Arts, Philadelphia, in 1826, and by 1834 it was in the collection of Robert Gilmor of Baltimore, one of the greatest collectors in the United States in the early nineteenth century.
w. g.

Inscriptions On the back, *W. Allston/1819*

Provenance Possibly Nathaniel Amory, by September 1825. Possibly Robert Gilmor, Baltimore, before 1839 (as *Beattie's Minstrel*). William Gibson Borland family,

Concord, Massachusetts, 1944. Victor Spark (dealer), New York, 1944. Acquired in 1944.

Exhibitions Philadelphia 1826, no. 151 (as *The Minstrel*, from Beattie, possibly this picture). Boston 1839, no. 9 (as *Edwin*, possibly this picture). Detroit 1944, no. 28. Detroit and Boston 1947, no. 29. Boston and Philadelphia 1979, no. 50.

References Letter from Allston to William Collins, May 18, 1821 (Dana Family Papers, Massachusetts Historical Society). Dunlap 1834, 2: 461. Peabody 1839, 7. Fuller 1840, 79. Sweetser 1879, 190. Richardson 1944, 5. Richardson 1948a, 139, 141, 148, 207, pl. 48. Johns 1977, 12. Johns 1979, 122. Crean 1983, 61. Wolf 1982, 74. Ellis forthcoming, chap. 3.

4
Italian Landscape, 1828/30

Oil on canvas
76.8 × 64.1 cm (30¼ × 25¼ in.)
Founders Society Purchase, Dexter M. Ferry, Jr., Fund (43.31)

Allston's production of Italianate landscapes extends over a period of twenty-five years, from 1805 to around 1830, during which he produced a number of works known by the title *Italian Landscape*. The Detroit work is the last of this "series" and almost the last pure landscape known to have been painted by Allston. Like all of the artist's landscapes, it is a work of the imagination, based in part upon his earlier experiences in nature and in part upon his familiarity with the work of other artists, both old masters and his contemporaries. While Allston had not been in Italy for at least twenty years when this work was painted, it nevertheless recalls his experiences there. The source of inspiration is evident not only in the character of the landscape, the architectural forms, and the costumes of the peasants but also in the quality of the

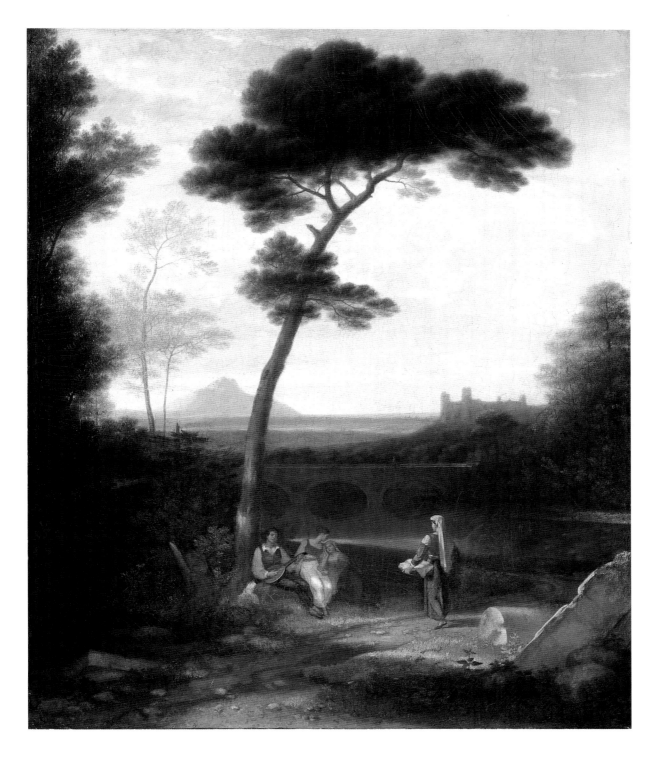

Italian Landscape

light and haze, which is essentially "Italianate." An aura of gentle romance and soft pleasure suggests his own earlier experiences in Italy, which by the late 1820s would have acquired a "golden glow" in the evocation of his youth.

The picture contains some of the standard props of romantic landscapes of this kind: peasant figures as a symbol of timelessness and ruins as a recollection of antiquity. Appearing in a number of Allston's figural works, the music-making lute player attracts his companions and so, empathetically, involves the viewer in the totality of the scene. The lute itself, associated with the medieval world of romance, is not only a gentle instrument of music making commensurate with the mood of Allston's picture but also draws the viewer back in time.

Detroit's *Italian Landscape* is Allston's only known vertical landscape. As such it displays its derivation from the Italianate landscape conception first defined by Claude Lorrain in the seventeenth century, with specific reference to an example of great prominence by the old master that Allston would undoubtedly have known and studied. During Allston's final sojourn in London in 1811, Claude's *Landscape with Hagar and the Angel* (1646; National Gallery, London) was in the collection of one of the greatest of Allston's patrons, Sir George Beaumont. (In 1823 Beaumont donated the Claude to the newly founded National Gallery in London, which took possession of the picture in 1828, after Sir George's death in the previous year.) The planar recession, as well as the placement of figures and foliage, and the bridge in the middle distance in Allston's work all conform to the Claudian model, but they conform equally well to the most famous contemporary English work of Allston's time, which itself derives from *Landscape with Hagar and the Angel:* J. M. W. Turner's *Crossing the Brook* (1814–15; Tate Gallery, London). Allston would certainly have seen this work when it was on exhibition at the Royal Academy in 1815.

The Detroit *Italian Landscape* was not dated by the artist, but the time of its creation can be placed sometime between November 1828, when the painting was commissioned by Samuel A. Eliot—a leading Boston collector and one of Allston's more important patrons—and the fall of 1830, when it was shown in the annual exhibition at the Boston Athenaeum. This was one of the works that John La Farge recommended to the New York dealer Samuel P. Avery when Avery visited Boston in July of 1869. The picture is the subject of a poem by the American Unitarian clergyman and reformer James Freeman Clarke, which was published in the *Dial* in October 1840.

W. G.

Provenance Samuel A. Eliot; the family of Mrs. S. A. Eliot, 1876. Mrs. Henry W. Foote, Boston, 1881; Mrs. Roger B. Merriman (dealer), Boston, 1943. Acquired in 1943.

Exhibitions Boston 1830, no. 146. Boston 1831, no. 22. Boston 1839, no. 11. Boston 1857, no. 221. Boston 1863, no. 177. Boston 1871, no. 154. Philadelphia 1876, no. 60. Boston 1881, no. 231. Detroit 1944, no. 62. Detroit and Boston 1947, no. 32. Detroit and Toledo 1951, no. 3. Coral Gables 1975, no. 22. Boston and Philadelphia 1979, no. 62.

References Peabody 1839, 23. J. Clarke 1840, 173–175. Ware 1852, 36. Stillman 1855, 155. S. Clarke 1865, 130. Sweetser 1879, 70. *Brooklyn Museum Quarterly* 1915, 283. Richardson 1944, 5. Richardson 1944a, 55, fig. 10. Richardson 1947, 14. Richardson 1948a, 146–148. Ourusoff 1962, 13. Crean 1983, 59. Ellis 1986, 72, n. 38, fig. 3. Ellis forthcoming, chaps. 3 and 4.

Badger was the son of Stephen Badger, a Charlestown tailor. While he spent his youth in the town of his birth, he moved across the river to Boston in 1733, two years after his marriage to Katherine Felch (1715–?). There he raised a family, attended the Brattle Square Church, and sought work. Little is known of his activities in the 1730s, aside from a trip to Dedham in 1737 to paint a house. By about 1740, however, Badger was active as a portrait painter. He may well have purchased supplies from the "colour shop" owned by John Smibert (q.v.), as he lived nearby, and he undoubtedly became familiar with the elder artist's work.

Despite the opportunities created for him when Smibert stopped painting around 1746, Badger's success as a portrait painter was modest. Almost entirely self-trained, he was painfully conservative in style and was either unwilling or unable to develop a varied palette or to employ more contemporary poses. Although his career spanned more than twenty years and included periods when he was the sole portrait painter in Boston, he was only moderately productive. Approximately 150 of his portraits survive, the best of them dating from the late 1740s and early 1750s. Although he numbered among his sitters some of Boston's most prominent citizens, they were for the most part from his own or earlier generations. Younger patrons seem to have preferred more stylish artists like Robert Feke (q.v.), John Greenwood (q.v.), and Joseph Blackburn (q.v.).

Like other colonial artists, Badger needed all the ingenuity he could muster to survive in an environment that did not place a premium on the arts. Consequently, to supplement his portrait income he painted houses, glazed windows, and is said also to have painted signs, hatchments, and other heraldic devices. By the late 1750s Badger and his fellow portrait painters in Boston had all been eclipsed by John Singleton Copley (q.v.). When Badger died intestate during the summer of 1765, his estate was insolvent.

R. S.

Bibliography Park 1917, 158–201. Nylander 1972. P. Warren 1980, 1044–1045.

5
James Bowdoin, ca. 1746/47

Oil on canvas
129.9 × 101.9 cm (51⅛ × 40⅛ in.)
Founders Society Purchase, Gibbs-Williams Fund (58.354)

Badger painted two virtually identical portraits of James Bowdoin: this picture and another now at Bowdoin College (Brunswick, Maine). Neither is signed, as it was not Badger's custom to do so. It is likely that the Detroit painting, in light of its greater subtlety, is the original portrait and the Bowdoin College version a replica (Belknap 1959).

It is somewhat surprising that Bowdoin selected Badger to paint his portrait. Bowdoin (1686–1747) made a fortune as a shipping merchant and was said to have been New England's wealthiest citizen at the time. In 1735 he ordered from John Smibert (q.v.) a portrait of his nine-year-old son and namesake. It was most likely Smibert's retirement eleven years later that persuaded Bowdoin to turn by default to a lesser artist like Badger.

One authority (Belknap 1959) has suggested that this is a posthumous likeness, but the only evidence for the theory—the fact of Bowdoin's death in 1747—is circumstantial. Although it is conceivable that Badger painted the portrait from memory or based it on an undiscovered prototype, it seems more likely that the portrait was painted at the end of the sitter's life. Badger seems to have summoned all his abilities to paint Bowdoin, and seldom in succeeding years did he match this effort. Here he painted with a sense of space, a sureness of brush, and an attention to detail that usually eluded him. The pose, although unimaginative, was one long favored by colonial artists. It derives ultimately from a mezzotint, *Sir Isaac Newton,* by John Faber after a painting by John Vanderbank (Sadik 1966; for the mezzotint, see Sellers 1957, pl. 14). Badger, who might have known the pose from Smibert's use of it in the 1730s, had also employed it for his earlier portrait of Thomas Cushing (Essex Institute, Salem, Mass.) and chose it again in 1750 for that of Cornelius Waldo (Worcester Art Museum, Mass.).

Bowdoin's attire is decidedly old-fashioned for the mid-1740s. His dark-colored, heavy frock coat and matching waistcoat were still acceptable for members of his generation but had been discarded by younger sitters, who preferred brighter colors and elaborately patterned waistcoats. The background contains the stock motifs of a merchant portrait: an inkstand, a letter, and a sailing vessel. These were used by numerous eighteenth-century artists as reminders of the sitter's profession. In short, this portrait possesses the virtues respected by most colonial art patrons, who were primarily concerned with acceptable likenesses and whose conservative tastes led them to prefer consistency over innovation.

R. S.

Provenance The sitter's daughter, Elizabeth Bowdoin [Mrs. James Pitts], Boston; her great-great-great-grandson, S. Lendall Pitts, Detroit; Mrs. S. Lendall Pitts, Norfolk, Virginia. Acquired in 1958.

Exhibitions Detroit 1921, no. 1. Detroit 1930, no. 70. Richardson 1934. Detroit 1959, 20, 21. Boston 1975, no. 33.

References Goodwin 1886, 3–4, 7–11, 15. Park 1917, 165. Park 1918, 9–10. Richardson 1934, 11–12. Sellers 1957, 425, 427. Belknap 1959, 290, pls. 14E, 18. Payne 1960, 88. Sadik 1966, 22, 24.

James Bowdoin

6
James Pitts, ca. 1750/54

Oil on canvas
90.2 × 70.5 cm (35½ × 27¾ in.)
Founders Society Purchase, Gibbs-Williams
Fund (58.355)

When this portrait was acquired by the Detroit Institute of Arts in 1958, it was identified as James Pitts (1710–1776), a prominent Boston merchant. The museum staff, however, decided that the sitter could not be the same as the individual in Joseph Blackburn's *James Pitts* (cat. no. 12) and consequently identified the Badger portrait as James's father, John (1668–1731). The reason given was that the features of the two men are different. At the time, one authority noted that the features "of our so-called John appear to be considerably coarser and heavier; the bony structure seems far more slender in the head of the portrait by Blackburn" (letter from Elizabeth Payne to Robert C. Vose, Jr., December 1, 1959, curatorial files, DIA). This same line of reasoning led to the conclusion that the Badger portrait was probably painted after a lost portrait by John Smibert (q.v.), since John Pitts died in 1731 and Badger was not then painting portraits.

As ingenious as this theory is, it is not confirmed by the evidence. In the first place, the figure in the portrait by Badger does resemble Blackburn's *James Pitts,* therefore it seems that the two portraits are of the same man. Allowing for the difference in ability of the two artists, and for the fact that the Badger portrait depicts a slightly younger man, the facial features are remarkably similar. Second, Smibert's *Notebook* (Massachusetts 1969), which documents the majority of his portrait commissions, does not include a portrait of John Pitts. Third, the Pitts family identified the portrait as James Pitts, and it was published that way on several occasions (Park 1918, Richardson 1934). Pitts probably had his portrait painted by Badger sometime prior to the arrival of

Blackburn in Boston in 1754. This, together with the age of the sitter, who appears to be around forty, suggests that the portrait was painted around 1750 but before 1754. At the time, Pitts was an influential Boston merchant, a graduate of Harvard (1731), who later served on the King's Council (1766–76). Apparently, Pitts later decided that Blackburn would be better able to create a more majestic likeness of him, which would explain the 1757 portrait by the new arrival.

This portrait is quite typical of Badger's work and illustrates how closely, on occasion, he imitated Smibert's compositions, although his painting technique was considerably different. Where Smibert used glazes to create shading and color effects,

Badger frequently mixed pigments to lower their overall intensity. Consequently, elements of his paintings, such as the face and wig here, have a pastel-like quality.
R. S.

Provenance The sitter, James Pitts, Boston, 1776; his son, John Pitts, Tyngsborough, Massachussetts; his great-grandnephew, Thomas Pitts, Detroit; Mrs. Thomas Pitts, Detroit; her son, S. Lendall Pitts, Detroit; Mrs. S. Lendall Pitts, Norfolk, Virginia. Acquired in 1958.

Exhibitions Richardson 1934. Detroit 1959, 18, 19.

References Goodwin 1886, 15–16. Park 1917, 187. Park 1918, 32. Richardson 1934, 12. Payne 1960, 88.

James Pitts

Orlando Hand Bears lived in Sag Harbor, New York, for most of his life and painted a number of family portraits there and in other Long Island towns. In the mid- to late 1830s he worked in Connecticut, specifically in New London in 1835 and 1836, and in the early to mid-1840s in New York City and in Brooklyn. M. B.

Bibliography Storrs 1973, 165.

7

Attributed to Orlando Hand Bears
Miss Tweedy of Brooklyn, ca. 1845

Oil on canvas
104.1 × 83.8 cm (41 × 33 in.)
Gift of Edith Gregor Halpert (53.107)

The attribution of *Miss Tweedy of Brooklyn* to Orlando Hand Bears was first suggested by Stuart P. Feld in a 1970 letter (curatorial files, DIA) that also assigned to Bears two 1837 portraits of members of the Bird family of New York City, one of Maria R. Bird and her infant daughter and another of an older daughter, Mary Louisa Bird (see New York 1970a, nos. 57 and 58). The attribution of the Bird portraits to Bears is confirmed by their resemblance to two double portraits of members of the Miner family of Connecticut, painted by Bears about 1838 (see Storrs 1973, nos. 99 and 100).

Likewise, a comparison of *Miss Tweedy* to *Mary Louisa Bird* shows dramatic similarities. The girls are dressed in nearly identical costumes (even their pantalettes are edged in similar lace), and both are posed with river landscapes in the background. Mary Louisa Bird is seated in the open before a river view, while Miss Tweedy is posed in an interior setting with a similar vista shown through a window. The portrait of Miss Tweedy is remarkable for its exuberant use of floral motifs. A basket of flowers appears on a two-drawer chest with blossom-shaped glass pulls similar to ones made in the mid-1840s by Thomas Meeks in New York, a vase of flowers fills the space at the far left, and a few posies are strewn in the open top drawer of the chest.

Although city directories trace the family name Tweedy in the borough of Brooklyn late in the nineteenth century, no association can be drawn between these references and the charming young lady illustrated in this painting.

In 1985 Barbara Heller (Conservation Services Laboratory, DIA) removed the overpainting in the area of the figure's right hand, which was cramped and claw-like, revealing its original configuration. M. B.

Provenance The Tweedy family, Brooklyn. Edith Gregor Halpert (dealer), New York. Acquired in 1953.

Exhibitions New York 1941b. Santa Barbara 1941. Wellesley 1950. Akron 1951. New York 1967. New York 1967a.

References Ford 1949, 88 (illus. before restoration). Denver 1956.

Miss Tweedy of Brooklyn

Zedekiah Belknap

1781 AUBURN, MASSACHUSETTS—
WEATHERSFIELD, VERMONT 1858

Zedekiah Belknap was the son of Zedekiah and Elizabeth Wait Belknap. As a boy of thirteen, he moved with his parents to Weathersfield, Vermont, where his father made his living as a farmer. Belknap received ministerial training at Dartmouth College, graduating in 1807 at the fairly advanced age of twenty-six. In 1812 he married Sophia Sherwin in Waterville, Maine, but the union was brief. According to family tradition, he served as chaplain in the War of 1812, but there is no record of his having been ordained or of any other service as a minister.

Belknap's actual occupation, documented by dated paintings between 1810 and 1848, was as an itinerant portrait painter in Vermont, New Hampshire, and Massachusetts. That he had some training in his profession may be assumed from his education, which was far superior to that of most folk artists. Like other painters employed by rural patrons, Belknap quickly adopted a stylistic shorthand. His formula was a distinctive and highly personal one, making identification of his work comparatively easy. Very often he painted on wood panels roweled diagonally to provide a scored surface that held paint easily. He occasionally used a twill canvas, the diagonal weave of which, when viewed in a raking light, appears similar in texture to the prepared panels. His subjects are shown in strong light, and their faces display Belknap's distinctive flesh pink shadows—with a darker shade used for the delineation of features: noses, ears, and mouths. He was highly proficient in painting crisp linen, sheer lawn and lace, military paraphernalia, and the dolls, baskets of fruit, and music books that enliven his many appealing portraits of children.

Apparently, he worked quickly. Three portraits of the Warren family of Townsend, Massachusetts, have inscriptions that describe Belknap only as a "strolling Artist, name unknown" but note that he completed the portrait of the two-year-old son of the family in just two weeks (see Richmond 1977, 10–13, 62–65).

In his late sixties Belknap retired to the family farm. In poor health, with no family of his own, and deprived of his vocation as the camera came into common use, he lived the last year of his life at the Chester Poor Farm in Weathersfield.
M. B.

Bibliography Mankin 1976.

8

Seated Girl, ca. 1835

Oil on canvas
72.4 × 62.6 cm (28½ × 24⅝ in.)
Gift of the Estates of Edgar William and Bernice Chrysler Garbisch (81.831)

This charming likeness of an unidentified young girl holding a doll (dressed as she is in the fashion of the mid-1830s) and wearing a miniature of a woman on a red ribbon around her neck is typical of many of Belknap's paintings of children. The rosewood, or mahogany, frame sofa, upholstered with black horsehair and outlined in prominent brass tacks, appears in almost exactly this form in several portraits. Similar to the features of the sitter are those of a young girl holding a music book in another portrait of about the same date (see Mankin 1976, fig. 17). The resemblances are undoubtedly the result of Belknap's use of a formula for quickly developing an attractive portrait: full lips, soft chin, and piercing eyes turned directly toward the viewer, combined with flesh-toned to deep pink modeling.
M. B.

Provenance Hillary Underwood (dealer), 1963. Edgar William and Bernice Chrysler Garbisch, New York. Acquired in 1981.

References Mankin 1976, 1069 (as *Girl Holding Doll and Wearing Miniature*).

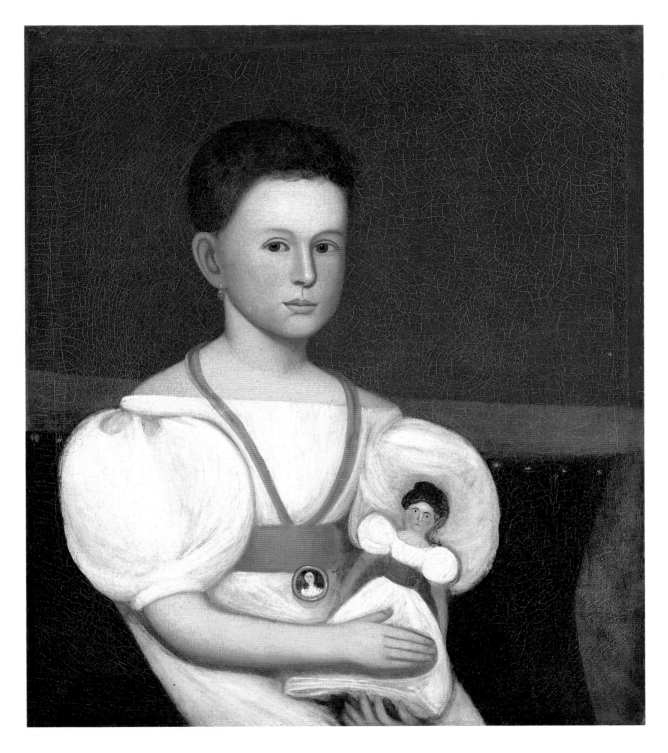

Seated Girl

George Caleb Bingham

1811 AUGUSTA COUNTY, VIRGINIA—
KANSAS CITY, MISSOURI 1879

Born on a plantation in Virginia, George Caleb Bingham moved with his parents to Franklin, Missouri, at age eight. Within a few years he was apprenticed to a cabinetmaker and had dabbled in sign painting. Around 1830 he undertook his first serious artistic efforts, inspired by an encounter several years earlier in Franklin with the portrait painter Chester Harding (q.v.) and more recently by an itinerant portraitist whose name has escaped detection. By 1833 Bingham had formally begun practice as a portraitist. For the next five years he was frequently on the move in central Missouri, painting portraits and attempting to establish a reputation. Toward the end of the decade, he embarked on an extended sequence of journeys to major cities on the East Coast—Philadelphia, New York, and Washington, D.C.—to further his education and strengthen his professional standing.

On his first visit to Philadelphia in 1838, Bingham may have studied briefly at the Pennsylvania Academy of the Fine Arts, and he certainly purchased (in his words) "a lot of drawings and engravings, and also a lot of casts from antique sculpture" (quoted in Bloch 1967, 37–38). On another visit to that city in 1843, he viewed the academy's annual exhibition and secured portrait commissions. Meanwhile, in 1838 he had introduced himself to the New York art world through the exhibition of *Western Boatmen Ashore* (unlocated), his first recorded picture of a genre subject, at the Apollo Gallery. (This gallery was the predecessor of the American Art-Union, the organization through which he later sold—or attempted to sell—many of his most important works.) Two years later, he sent six canvases of various subjects to the annual exhibition of the National Academy of Design in New York. The last major showing of Bingham's work in New York during his lifetime took place in 1852 at Goupil's Gallery. During the 1850s he was again frequently on the move, traveling across the southern Midwest, up and down the East Coast, and between 1856 and 1859 making two separate visits to Europe, where he spent most of his time in Düsseldorf and Paris. For the last thirty years of his life, he resettled in the Midwest, journeying occasionally to the East Coast, and combining an on-again, off-again political career with work as a portraitist and, less frequently, as a painter of historical and genre scenes.

Throughout his adult life Bingham's admiration for America's founding fathers and small-town democratic electoral processes informed both his own political activities and his art. His first sojourn in Düsseldorf, undertaken to fulfill commissions from the state of Missouri for full-length portraits of Washington and Jefferson, must have been motivated in part by the magnetic presence of Emanuel Leutze, creator of the most famous modern image of the first president, *Washington Crossing the Delaware* (1851; first version, destroyed; second version, Metropolitan Museum of Art, New York); Bingham himself had commenced a painting of the same subject early in 1856 (completed in 1872; Chrysler Museum of Art, Norfolk, Va.). Soon after his unsuccessful bid in 1846 to become a member of the Missouri state legislature, he began to paint scenes of rural politicking that were premised ultimately on Hogarth's "Election" series (Sir John Soane's Museum, London). In the largest composition of this type, *The Verdict of the People* (1854–55; National Boatmen's Bank of St. Louis), Bingham packed more than one hundred figures into a five-and-one-half-foot-wide canvas.

Bingham's fame today rests on nationalistic images of another sort: more sparsely populated, generally smaller scenes of life on the Missouri River, most of them painted during a brief period of his career between 1845 and 1852. His mature genre pictures combine allusions to earlier art culled from prints and casts and observed vignettes of everyday life, all informed by an instinctive sensitivity to "classicism" as well as color handling and brushwork that are at once simplified and precise. In the best of these paintings, familiar episodes of life on the frontiers of an emerging nation are enshrined in poetic, sculpturesque compositions that contain references to "classical" art from many historical periods. The most pertinent parallels are to be found in Bingham's own era, notably in the works of numerous mid-nineteenth-century European artists who were influenced by John Flaxman, Jean-Auguste-Dominique Ingres, and the Nazarenes.

G. C.

Bibliography McDermott 1959. Bloch 1967. Bloch 1986. St. Louis and Washington 1990.

9

The Checker Players, 1850

Oil on canvas
63.5 × 76.2 cm (25 × 30 in.)
Gift of Dexter M. Ferry, Jr. (52.27)

Bingham's genre scenes involving just a few figures are characteristically set alongside or in the middle of a wide midwestern river and illuminated by full daylight; in a handful of instances, however, he experimented with nocturnal outdoor and indoor settings. In the present painting, the artist positioned three figures so near the picture plane that the legs of the two seated players are cut off at mid-calf by the bottom edge of the composition, and the tavern setting is reduced to two pieces of furniture, a bar, and two walls covered with shelves that recede into dimly illuminated space at the right. Except for the barely perceptible beverage vessels on the shelves, still-life elements are similarly restricted to a glass on a tray, a metal cup, and the checkers and checkerboard. Ornamental details are likewise kept to a minimum, and the palette is subdued.

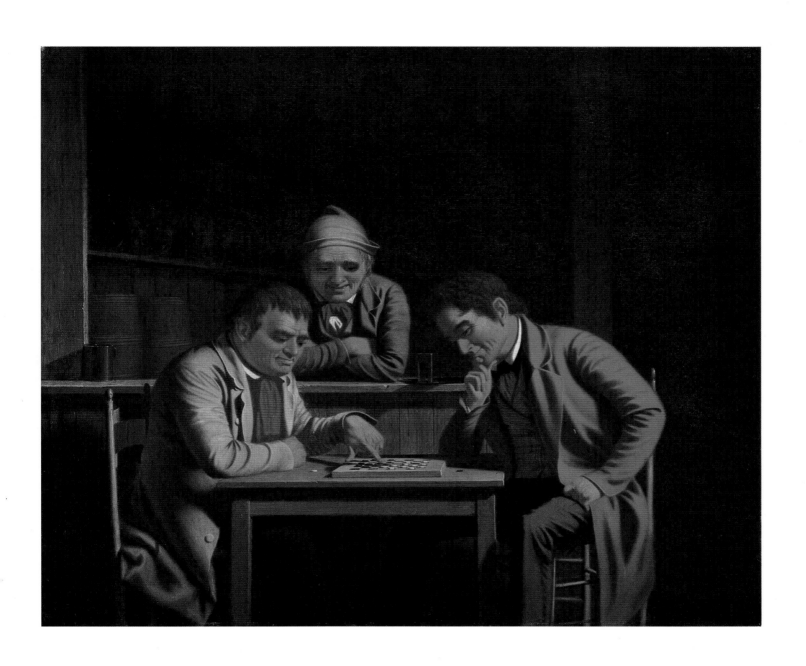

The Checker Players

The purpose of this compositional stringency is to focus the viewer's attention on the intellectual, as well as the congenial, character of the activity. Bingham's *Raftsmen Playing Cards* of 1847 (St. Louis Art Museum) is in some respects a related predecessor, but the picturesque informality of that outdoor shipboard game of chance is supplanted here by a close-up, close-knit quietude and a strict rectilinear design appropriate to the theme of mental calculation. Neither the rowdyism that frequently pervades seventeenth- and eighteenth-century depictions of card games, nor the allusions to *vanitas* or love that often underlie earlier scenes of chess matches, is to be found here. The comparative reticence reflects the rules of the game of checkers accepted in America during the mid-nineteenth century, which emphasized intellectual strategies and strict rules of conduct (see Elizabeth Johns in St. Louis and Washington 1990, pp. 128–130).

Around 1850 Bingham painted several other scenes of rivermen in which the central group consists of three figures (and in one instance, two men and a dog [*The Squatters*, 1850; private collection]), indicating the extent of his interest in pyramidal figure groupings at that point in his career. Among Bingham's extant works, the closest compositional counterpart to the Detroit picture is another canvas of nearly identical dimensions: *Canvassing for a Vote* (1851–52; Nelson-Atkins Museum of Art, Kansas City, Mo.) displays a similarly compact arrangement of five figures and a dog, strong chiaroscuro, a dark palette highlighted by greens and browns, and a setting on terra firma. The more insistent diagonals, the greater number of details, and the placement of figures within a fully realized landscape, however, differentiate the Kansas City picture from *The Checker Players*, underscoring the unusual compositional character of the latter.

The Checker Players was painted in St. Louis toward the end of 1850. A St. Louis newspaper reporter (*Missouri Republican*, October 11, 1850, 2; cited by Bloch 1967a, 76) who saw the work in progress described the picture as depicting "a game of 'drafts' or 'checkers' in a country tavern." The writer continued:

In this [work] the force and power of the artist, in catching and portraying the position and expression, is finely developed. This, when completed will by itself be a lasting evidence of his [Bingham's] talents.

Early in 1851 the artist submitted the picture to the American Art-Union for two hundred dollars unframed, but the offer was declined. For several years thereafter *The Checker Players* languished in Bingham's possession until it was acquired by N. J. Eaton of St. Louis.

The reasons behind the American Art-Union's rejection are not difficult to guess. For one thing, Bingham's asking price was high, seventy-five dollars more, in fact, than he requested for the larger *Trappers' Return* (cat. no. 11) a short time later. (On previous occasions when faced with a refusal from the American Art-Union, he had responded by lowering his price, but there is no record of his having made a reapplication for *The Checker Players*.) For another, the ungainly proportions of the three figures, their unprecedented (for Bingham) closeness to the picture surface, and the restricted interior setting doubtless conjured comparisons in the minds of Art-Union officials between *The Checker Players* and works by the European-trained genre specialist Richard Caton Woodville (1825–1856). Then at the height of his popularity, Woodville had attracted legions of admirers at the American Art-Union in 1847 and 1849, respectively, for his fastidious style and incisive characterizations in paintings such as *Card Players* (1846; Detroit Institute of Arts) and *War News from Mexico* (1848; National Academy of Design, New York). In late 1850 Woodville's work was again conspicuous as the proprietors of the Art-Union issued an engraving of *Card Players* and purchased his *Game of Chess* (private collection) for the organization's exhibition-sale of 1851–52.

Bingham must have been well aware of his competitor before that time; we know for certain that he was disenchanted with the American Art-Union. On March 31, 1851, he wrote from New York to his friend James S. Rollins in St. Louis and complained of "gross favoritism" by Art-Union officials "in the purchase of their pictures" (quoted in Rollins 1937, 21). In fact, he had already begun to seek alternative outlets for his work. In the same letter, Bingham noted that Goupil and Company, the New York dealer-publisher, was about to engrave (i.e., lithograph) "one of my recent pictures" (*Raftsmen Playing Cards*), and that he would soon paint a new work (*Canvassing for a Vote*), also to be reproduced by them. Goupil owned the so-called International Art-Union, an arch rival of the American Art-Union, and their major agent in New York, William Schaus, with whom Bingham no doubt had contact, also acted on behalf of William Sidney Mount (q.v.). Maurice Bloch (1967) hypothesized that Bingham's *Checker Players* is based in part on Mount's *Raffling for a Goose* (1837; Metropolitan Museum of Art, New York). While the supposition is difficult to prove, a relationship between the present work and Mount's interior scenes becomes more plausible in light of Bingham's affiliation with Mount's agent at that time.

In any event, Bingham probably came to believe within a few months that his break with the American Art-Union, precipitated in part by the rejection of *The Checker Players*, had been the correct decision. In the summer of 1852, within days of the judicial verdict declaring the Art-Union illegal, and several months before the closing Art-Union sale, his *Canvassing for a Vote* and the four-foot-wide *County Election* (1851–52; St. Louis Art Museum) were shown at Goupil's Gallery in an exhibition organized by William Schaus.
G. C.

Provenance N. J. Eaton, St. Louis, by 1864. John J. Herrick, Tarrytown, New York; George T. Herrick, Tarrytown, New York. John B. Ingham, Pittsburgh. The Old Print Shop, New York, 1952. Acquired in 1952.

Exhibitions St. Louis 1850. St. Louis 1859, no. 34 (as *Game of Draughts*). St. Louis 1864, no. 192 (as *Chequer Players*). Cincinnati 1955, no. 2. Taggart 1961, no. 12. Washington et al. 1967, 46–47, no. 16. Leningrad 1976, 11. Paris 1976, pl. 33. Cody et al. 1987, pl. 24. St. Louis and Washington 1990, pl. 31.

References American Art-Union n.d., no. 2711. American Art-Union 1851 (as *Chequer Players*). Letter from Bingham to James S. Rollins, March 30, 1851 (State Historical Society of Missouri, Columbia). *Bulletin of the AAU* 1851, 151. Rusk 1917, 54, 122. Christ-Janer 1940, 57. Richardson 1952, 251–256. McDermott 1959, 78–79, pl. 31. Bloch 1967, 116–117, pl. 33. Bloch 1967a, no. 193. Constant 1974, 103–104. Bloch 1986, 189. Cody et al. 1987, 42. St. Louis and Washington 1990, 128–130.

10

John Quincy Adams, 1850

Oil on wood panel
25.4 × 20 cm (10 × 7⅞ in.)
Gift of Mrs. Walter O. Briggs (53.153)

The large majority of Bingham's paintings are portraits. By painting portraits he launched his career, sustained it, and concluded it. Even the Western genre paintings of 1844 to 1855, for which he is most remembered, derive much of their enduring meaning from his ability to describe character—a talent he developed by taking likenesses.

Ambition inevitably led Bingham the portrait painter to Washington, D.C., where, except for visits to Petersburg,

Virginia, and Philadelphia, he spent four years, from late 1840 to mid-1844. His purpose was to portray politicians, to gain a name, and to impress potential patrons in Missouri. He had a studio in the Capitol, on one of the lower floors, and he kept busy, but, judging from the small number of documented portraits from this period, he was not in demand. In 1844 he did paint the portraits of two luminaries: Daniel Webster (1782–1852) and John Quincy Adams (1767–1848). Adams sat to Bingham first on May 14 and then for an hour each day on May 21, 23, 24, 27, and 28. By May 29 the portrait was finished. On each occasion Bingham shared a studio, presumably his own, with John Cranch (1807–1891), whose father was Adams's cousin. (The Cranch portrait is unlocated, but a photograph of it is reproduced in Washington 1970, no. 32.) Cranch probably invited Bingham to join the sittings in exchange for the use of his studio; Bingham's opportunity to portray Adams, then, arose by chance, not by solicitation or commission. Adams, a veteran at facing the easel, confided to his diary after the second sitting that neither artist was "likely to make out either a strong likeness or a fine picture" (quoted in Bloch 1967, 58).

Three portraits of Adams by Bingham are known, only one deriving from the sitting of 1844 (had another life sitting taken place, Adams would have recorded it). Recent authorities have argued that the single life portrait is the cabinet picture that descended in the family of Bingham's friend and patron Major James S. Rollins (1849, oil on wood panel, 25.4 × 19.7 cm; private collection, Columbia, Mo.; see Washington 1970, no. 31). The Detroit painting is virtually identical, differing mainly in the blank background, a heightened contrast of light and shade, and a lessened degree of detail. The third version, which also descended in the Rollins family (ca. 1844/50, oil on canvas, 74.3 × 62.2 cm; National Portrait Gallery, Washington, D.C.; see

Oliver 1970a, fig. 100), is the least successful of the three portraits, manifesting, according to Maurice Bloch (1967, 69), the lassitude in expression and broadness in handling that one would expect in an enlarged and revised copy.

Confounding this account, however, is the testimony of C. B. Rollins, Major Rollins's son, that Bingham gave to the major "a small copy" of his portrait of Adams, "painted on a walnut board, . . . and it is still in the family" (Rollins 1926, 471). Rollins's recollections are unreliable, but the possibility exists that the Rollins family cabinet picture is itself a copy. Fern Helen Rusk (1917, 29) offered a similar explanation, identifying the cabinet picture as a "finished portrait" derived from a much larger, "rudely done" study. In this scheme the only known painting that could be the life portrait is the likeness at the National Portrait Gallery, which is conventional in size, pose, and format. Such may be the case, since that painting compares more closely than the two panels to another of Bingham's few oil portraits of public figures painted in Washington in 1844: the *Daniel Webster* (Thomas Gilcrease Institute of American History and Art, Tulsa, Okla.). If it were the case that the canvas preceded the panels, the latter would have to be described as adaptations, not replications, for in them Adams is seen more frontally, gazing almost directly at the viewer, and his head is less ovoid. The panels also show Adams as a more vigorous man, with an active brow and without the sagging jaw, distended lips, and prominent circles under the eyes seen in the large painting.

As for the theory that a print or photograph was the source for Bingham's two panel paintings, the possibility, once considered, must be ruled out. We know that Bingham was interested in acquiring a portrait print of Adams as early as February 21, 1841, when he wrote from Washington to Major Rollins: "I shall

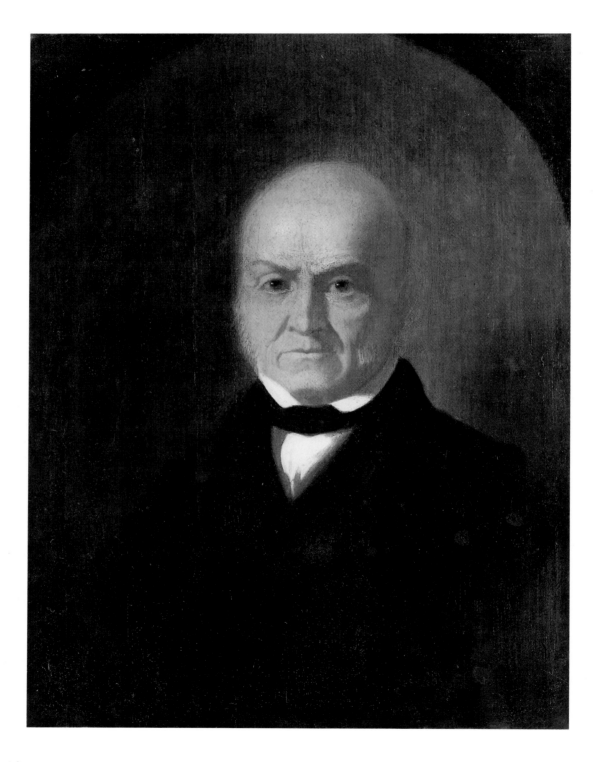

John Quincy Adams

attend to your request with regard to the portraits as soon as I see a safe opportunity of sending them to you. There is no lithograph of J. Q. Adams, the others can be obtained without difficulty" (quoted in Rollins 1937, 12). By "no lithograph," Bingham probably meant that portrait prints of Adams were not then available in the shops, for he could not have been ignorant of the many lithographs and engravings of Adams published in the late 1820s and 1830s. Even so, the panel paintings do not derive from any of these earlier prints, just as they do not relate to other oil portraits of Adams. Their salient feature—their frontality—is practically unique in the Adams portraiture, occurring otherwise only in a daguerreotype by Albert S. Southworth and the lithograph made after it in 1843 by Philip Haas (see Oliver 1970a, 282–287). Bingham may have revised his large life portrait of 1844/50 by reference to the lithograph; the result may have been the small panel that descended in the Rollins family. The Detroit portrait could then be a copy of the Rollins panel with even further revisions. The possibility also exists that the large canvas at the National Portrait Gallery derives from a daguerreotype or print; in that case, the "rudely done" life study remains unlocated.

The garbled inscriptions on the back of the Detroit panel present further confusion: they suggest that Adams's eighty-first year was 1850, but it was actually 1848, the year in which he died. The inscribed date of August 4, 1850, however, is too precise to be an error of miscalculation and most likely represents the actual completion date of the portrait. On that date Bingham was in either St. Louis or Columbia, Missouri; in either case he was in a position to have borrowed the Rollins panel for copying and to present the copy to the Reverend Jeremiah Twitchell of New Orleans.

Even if the Detroit panel is a hybrid, it is an effective likeness of this distinguished public servant, man of letters, and renowned speaker. Bingham, who was active in regional politics and was himself an accomplished orator, would have admired Adams, the more so since his own views on the American system of government and the abolition of slavery paralleled those of the man hailed by his friends as "Defender of the Rights of Man." Adams was known for his serenity, gentility, dignity, vigilance, and his black, piercing eyes. He enjoyed even the most disagreeable confrontations in the service of a just cause; he did not, it was said, wear a smile well. In Emerson's words, he was a man "who cannot live on slops, but must have sulphuric acid in his tea" (quoted in Oliver 1970a, 199). Adams complained that most of his portraitists saw his grim facade but not his heart. The complaint would pertain to Bingham's portrayal—a stern, almost forbidding presence. Here and elsewhere Bingham did not flatter or interpret his sitter beyond the facts of appearance: a portrait, in his view, was "a true delineation of the form and features of his subject, with all the lines of his face which mark his individuality" (quoted in McDermott 1959, 175).

w. t. o.

Annotations On the back in ink, *Born 1767 / Adams / taken [in his 81st year] *[indecipherable] (aetat 8) *[indecipherable] / taken [by] Bingham of Washington / presented to Rev. Jeremiah Tw[it]ch[e]ll of / New Orleans / La.;* on the back in pencil, *Portrait of J. Q. Adams / Taken in his 81st year / By Bingham / of Missouri / Aug. 4 1850 / & presented to Rev. Jer [indecipherable] T [wit] chell / of N [ew] O [rleans]*

Provenance Oliver R. Barrett, Chicago; his son, Roger W. Barrett. Parke-Bernet Galleries, New York, 1953. William Macbeth (dealer), New York, 1953. Mrs. Walter O. Briggs, Detroit, 1953. Acquired in 1953.

*Previously recorded, now illegible

References Antiques 1953, 310. McDermott 1956, 412–414. McDermott 1959, 43–45, 427, pl. 15. Bloch 1967, 57–60, pl. 35. Bloch 1967a, no. 211. Oliver 1970, 753. Oliver 1970a, 231–235, fig. 99.

11

The Trappers' Return, 1851

Oil on canvas
66.7 × 92.1 cm (26¼ × 36¼ in.)
Gift of Dexter M. Ferry, Jr. (50.138)

One of six Bingham canvases auctioned during the dispersal sale of the American Art-Union from December 15 to 17, 1852, *The Trappers' Return* was painted during Bingham's six-month stay in New York in 1850–51. On May 8, 1851, under the title *Dug-Out* (i.e., dugout canoe), it was received by the American Art-Union manager and, a week later, was accepted at the offered price of $125, unframed. The work was described in the Art-Union *Minutebook* in 1851 as depicting "two figures [who] are descending the river in a dug-out, at the bows [sic] of which is a bear chained." Nineteen months later the picture was purchased for $155, reportedly by "H. Reed" (who obtained nothing else at the sale). A picture by Bingham also titled *The Trappers' Return* (possibly the Detroit work) was sold at the American Art-Union building on December 30, 1852 (by which time the AAU itself had ceased to exist).

The Detroit *Trappers' Return* is a slightly smaller variant of *Fur Traders Descending the Missouri* of 1845 (originally titled *French Trader and Half-Breed Son;* Metropolitan Museum of Art, New York), regarded today as Bingham's finest work. Bingham's oeuvre includes variant replicas of several of his genre works, notably *In a Quandary* of 1851 (Harry E. Huntington Collection, San Marino, Calif.), a smaller, simplified reprise of *Raftsmen Playing Cards* (1847;

St. Louis Art Museum). Bingham painted *In a Quandary* presumably to enable Goupil and Company of New York to reproduce the composition in a lithograph (dated 1852), and it is tempting to think that the artist's objectives for the present work lay along similar lines. Because *Fur Traders Descending the Missouri* and its three companion works had generated no published commentary when distributed by the Art-Union in 1845, Bingham may have hoped, six years later, that an altered presentation of the subject would remedy the deficiency. If that was his purpose, he was surely disappointed by the virtual neglect by New York critics of his paintings at the American Art-Union. In any event, *The Trappers' Return* was the only one of his six contributions to the Art-Union in 1851 and 1852 that invoked the characteristic theme of frontier boatmen adrift on one of the nation's inland waterways.

An attractive composition in its own right, *The Trappers' Return* is nevertheless not as compelling a work as its predecessor, as Maurice Bloch (1967) has noted. For example, in an effort to position the bear cub in a convincing three-dimensional stance consistent with the more sculpturesque figures in the newer painting, Bingham devised a smaller, less mysterious, and ultimately less interesting animal than that in *Fur Traders Descending the Missouri*. Details such as fabric colors and decorations, still-life elements, and snags and rocks in the water are either simplified, reduced in quantity, or omitted altogether. Riding higher in the water, positioned nearer the picture plane, and given a fuller three-dimensional appearance, the

dugout canoe has been redesigned, displaying cleaner workmanship and a more elegant prow. The water surface, too, has been calmed, the background shoreline reorganized and regularized, and the misty atmosphere clarified. Thus, whereas in the earlier work neither the boat nor the figures are visually linked to any land area, and by implication the oarsman is obliged to be alert for obstacles in the water (and perhaps for Indians on the shore), the boatmen in the Detroit painting float easily within a few dozen yards of a well-defined riverbank, on which they might alight without difficulty or threat. Everything considered, *Fur Traders Descending the Missouri* is a more effective evocation of flux, process, and apparently endless movement, of a transient way of life momentarily emergent from the mists; that is, it conveys just the right balance of wilderness and the westward movement of people and commerce to appeal to Americans in the mid-1840s.

During the ensuing half-dozen years, as Bingham's artistic aims became more sophisticated, and as the Midwest in general became more civilized, the painter evidently felt the need to assert greater control over his pictorial environments. Thus, *The Trappers' Return* was, appropriately, one of his last "classical" genre paintings. At nearly the same moment, he was turning to scenes of much greater thematic ambition, formal complexity, and compositional integration, most notably *The Election* (1851–52; St. Louis Art Museum), itself part of a three-painting series that occupied the artist through 1855.

G. C.

Inscriptions At lower right, on side of canoe, *G. C. Bingham / 1851.*

Provenance H. Reed, 1851. John J. Herrick, Tarrytown, New York; George T. Herrick, Tarrytown, New York. John B. Ingham, Pittsburgh. The Old Print Shop, New York, 1950. Acquired in 1950.

Exhibitions New York, American Art-Union, 1851, no. 173 (as *Dug-Out*). New York, American Art-Union, 1852, no. 194 (as *Trappers' Return*). New York, American Art-Union, artists' sale, 1852, no. 108 (possibly this work). Detroit 1951, 87, no. 205. Madison 1952. Frankfurt et al. 1953, no. 6. New York 1954, no. 35. Rome and Milan 1954, no. 33. Pittsburgh et al. 1957, no. 24. Taggart 1961, no. 15. Los Angeles et al. 1972, 187, no. 39. Buffalo et al. 1976, no. 17. Minneapolis 1976, 31. Evanston 1981, 16–17, no. 18. New Orleans 1984, 58.

References American Art-Union 1851a (as *Dug-Out*). American Art-Union n.d., no. 2971 (as *Dug-Out*). Rusk 1917, 51, 122. Christ-Janer 1940, 55, 57. Richardson 1950–51a, 81–84. McDermott 1959, 82–83, 416–417, pl. 34. Bloch 1967, 83–84, pl. 48. Bloch 1967a, 86, no. 222. Cummings and Elam 1971, 141. Gilbert 1973, 66–67. Constant 1974, 119. Bloch 1975, 19, 175–177. Christ-Janer 1975, 49, pl. 54. Pike 1975, 38. Wight 1976, 240. Rivard 1978, 1048. Bloch 1986, 13, 196–197. St. Louis and Washington 1990, 168–169.

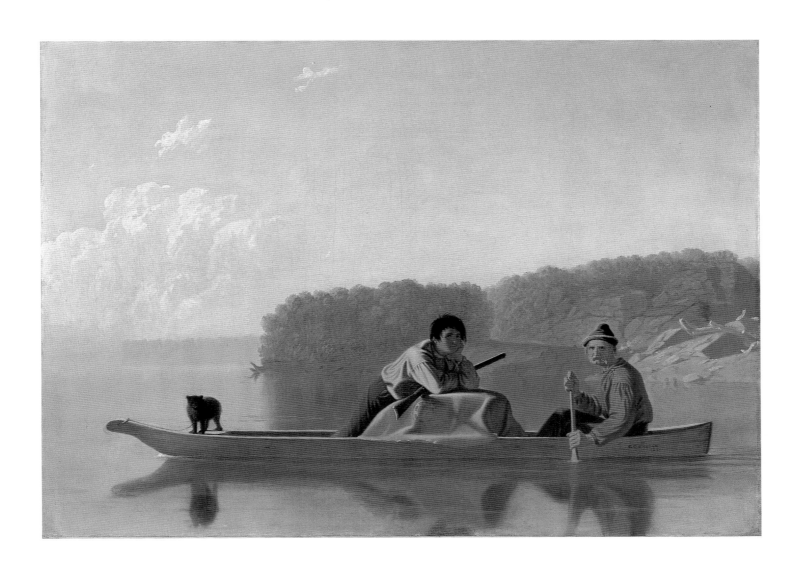

The earliest evidences of the career of Joseph Blackburn are the portraits he painted in Bermuda during 1752. Where he came from is unknown. Most scholars have concluded that he must have been trained in England, but several have speculated that he might be of American origin. Once Blackburn left Bermuda for America, his whereabouts are well documented, since he signed and dated over half of the more than one hundred surviving portraits by his hand. He apparently arrived in Newport, Rhode Island, in 1754, then spent the next few years in the greater Boston area. He brought with him to Boston at least one letter that introduced

the bearer Mr. Blackburne to your favor & friendship, he is late from the Island of Bermuda a Limner by profession & is allow'd to excell in that science, has now spent some months in this place, & behav'd in all respects as becomes a Gentleman, being possess'd with the agreeable qualities of great modesty, good sence & genteel behaviour (Stevens 1967, 101).

Blackburn must have been delighted with the modest level of competition he found in Boston. John Smibert (q.v.) had died in 1751, Robert Feke (q.v.) had ceased working in the area by 1752, and John Greenwood (q.v.) had gone to Surinam. Only three artists remained: Joseph Badger (q.v.) and two tyros, Nathaniel Smibert (1735–1756) and John Singleton Copley (q.v.). Little wonder the Boston oligarchy of Olivers, Pittses, Winslows, and Bowdoins embraced Blackburn.

Blackburn's style relies on the same light, pastel colors favored by Feke, but his poses are more fanciful and his modeling skills more adept. In fact, Blackburn's costumes are so meticulously painted that some scholars have speculated that he was trained as a drapery painter. Whatever the case, Bostonians reacted positively to his confections. But unfortunately for Blackburn, Copley was a fast learner and quickly took heed of the more experienced painter's success. By 1758 Copley was,

figuratively at least, stalking Blackburn step by step, and this potential threat to his position may have influenced Blackburn's removal to Portsmouth, New Hampshire, in that year. After five years there, during which he made occasional trips to Exeter and Newburyport, Blackburn went to England, perhaps because he was unable to sustain himself on the level of patronage he found in and around Portsmouth. In any event, this somewhat elusive painter of beguiling images continued his career at least until 1778, when signed and dated examples of his work cease.

R. S.

Bibliography Baker 1945, 33–42.

12

James Pitts, 1757

Oil on canvas
127.3 × 101.6 cm (50⅛ × 40 in.)
Founders Society Purchase, Gibbs-Williams Fund (58.357)

Blackburn had been painting in Boston for approximately three years when James Pitts commissioned portraits of himself and his wife, Elizabeth Bowdoin Pitts (see cat. no. 13). Although Pitts's portrait had been painted earlier by Joseph Badger (q.v.), and his wife's had been painted by John Smibert (q.v.), the couple apparently could not resist having their likenesses made in the current fashion. Like so many other Blackburn sitters, the Pittses belonged to one of Boston's influential families and thus were part of a group that preferred grandiose three-quarter-length canvases to the less expensive, and less imposing, bust lengths. In contrast to his attire in the earlier portrait by Badger, Pitts is dressed here in a more up-to-date fashion: a silvery white frockcoat. In general, Blackburn's male sitters were more summarily treated than their female counterparts. Even the background in a Blackburn portrait of a man rarely re-

ceives much attention; here, in particular, it seems curiously incomplete. Behind Pitts is a sunset scene, but the painting's present darkened state makes this element even less effective than it probably was originally.

R. S.

Inscription At lower right, *J. Blackburn Pinxt 1757*

Provenance The sitter, James Pitts, Boston, to 1776; his son, John Pitts, Tyngsborough, Massachusetts; his great-grandnephew, Thomas Pitts, Detroit; Mrs. Thomas Pitts, Detroit; her son, S. Lendall Pitts, Detroit; Mrs. S. Lendall Pitts, Norfolk, Virginia. Acquired in 1958.

Exhibitions Detroit 1921, no. 3. Detroit 1930, no. 72. Richardson 1934. Detroit 1959, 22–24.

References Goodwin 1886, 14–16, 25–59. Park 1922, 275, 311. Richardson 1934, 12. Baker 1945, 34, 41. Payne 1960, 88. Stevens 1967, 105–106.

13

Mrs. James Pitts, 1757

Oil on canvas
127.3 × 101.6 cm (50⅛ × 40 in.)
Founders Society Purchase, Gibbs-Williams Fund (58.356)

Blackburn's appeal to American sitters is readily apparent in this picture, which is among his finest works. Where his predecessors had difficulty satisfying their patrons' desires for portraits that enhanced their appearance, Blackburn accommodated their every wish. One finds in his portraits not probings of character, but rather artful gestures and exquisite trappings. It was this concern for detail—such as meticulously rendered lace, diaphanous shawls, and delicate pink bows—that, in addition to attractive likenesses, enchanted his female sitters. One patron, marveling at his abilities, exclaimed to a friend "Tel

Mr. Blackburn that Miss Lucy is in love with his Picktures wonders what business he has to make such extreem fine lace and satten, besides taking so exact a likeness" (Morgan and Foote 1936, 81).

Blackburn's female figures are characterized by chalky white flesh tones set off by hot pink highlights, diminutive doll-like hands, and poses suggesting graceful movement. In this instance, the pose is derived from the mezzotint *The Celebrated Mrs. Sally Salisbury* by John Smith after Sir Godfrey Kneller (see Sellers 1957, pl. 27). Blackburn had already, two years earlier, used a variant of this pose for *Mrs. Andrew Oliver, Jr.* (private collection).
R. S.

Inscriptions At lower right, *J. Blackburn Pinxit 1757*

Provenance James Pitts, Boston, to 1776; his son, John Pitts, Tyngsborough, Massachusetts; his great-grandnephew, Thomas Pitts, Detroit; Mrs. Thomas Pitts, Detroit; her son, S. Lendall Pitts, Detroit; Mrs. S. Lendall Pitts, Norfolk, Virginia. Acquired in 1958.

Exhibitions Detroit 1921, no. 2 (as *Elizabeth Bowdoin*). Detroit 1930, no. 71. Richardson 1934. Detroit 1957, no. 28. Detroit 1959, 26–27. Los Angeles and Washington 1981, 90–92.

References Goodwin 1886, 10–11. Park 1922, 311–312. *Art Digest* 1930, 8. Bolton and Binsse 1930, 53. Richardson 1934, 11. Baker 1945, 41. Sellers 1957, 441, pl. 27a. Belknap 1959, 301, no. 27a, pl. 28. Payne 1960, 88. Stevens 1967, 97–99. Cummings and Elam 1971, 131.

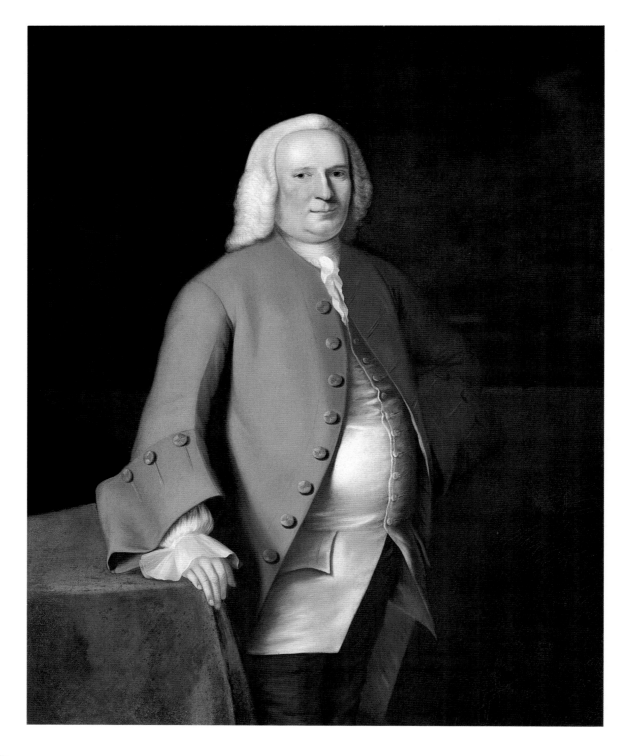

James Pitts

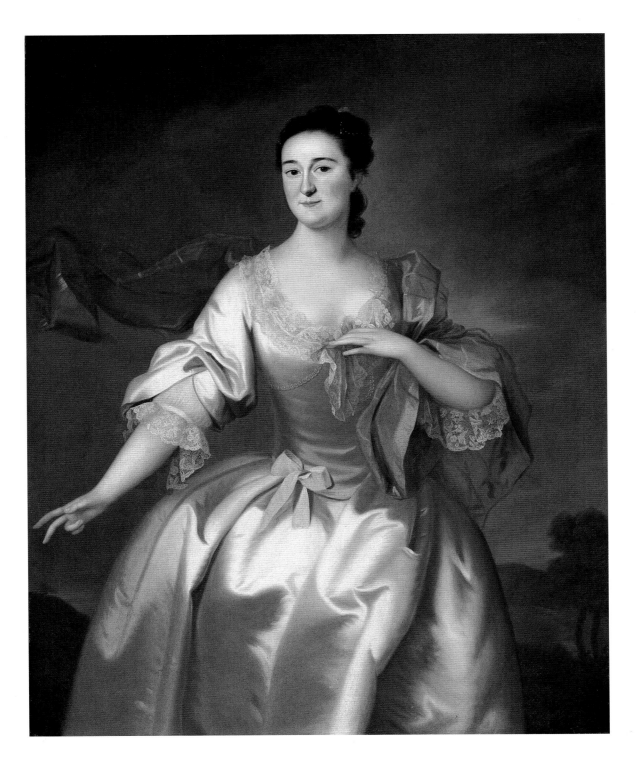

Mrs. James Pitts

The son of a clockmaker, Mather Brown was related through his mother to the famous New England clergymen Cotton and Increase Mather. He received his first lessons in drawing from Gilbert Stuart (q.v.), when the latter lived temporarily in Boston in 1774–75. At the age of nineteen, after earning sufficient travel funds as an itinerant painter of portrait miniatures, Brown journeyed to England via France in pursuit of self-improvement as an artist. Arriving in London in 1781, he studied at the Royal Academy and with Benjamin West (q.v.). Soon he established himself as a portrait painter whose sitters included distinguished American visitors and many of the English nobility, among them Thomas Jefferson, John Adams, and the Prince of Wales. In 1788 he received a royal appointment—the only American artist other than West to be so favored—as official portrait painter to King George III's favorite son, the Duke of York. The honor was augmented within two years, when he became portrait painter as well to another son, the Duke of Clarence.

Brown's reputation reached a peak during the early 1790s, when he exhibited popular history pictures, to be engraved on subscription, at a commercial London gallery. Although the most successful of these concerned current events, such as the British military victories in India, Brown also enjoyed painting medieval scenes. He contributed, on invitation, a picture titled *Richard II Resigning His Crown to Bolingbroke* (present location unknown) to John Boydell's Shakespeare Gallery, an unusually successful commercial venture in which exhibited pictures, based on scenes from Shakespeare's plays, were engraved for profit. Despite this auspicious beginning, he was repeatedly rejected for membership in the governing organization of the Royal Academy. The last rejection in 1795 coincided with a wartime depression that sent Brown into a

financial decline from which he never recovered. From 1808 to 1824 he painted in provincial cities, particularly Liverpool and Manchester. Finally he returned to London and died in relative poverty.

Brown's portrait style when he was in his prime, from about 1785 to 1800, came closest to that of Gilbert Stuart, but his heads were always more defined and substantial, with more opaque coloring.

D. E.

Bibliography D. Evans 1982.

14

Master Charles William Park, probably late 1780s

Oil on canvas
127 × 101.6 cm (50 × 40 in.)
Founders Society Purchase, Gibbs-Williams Fund (70.616)

The boy in this portrait is shown in a fashionably romantic pose, seated under a tree, supporting his head with one hand in a somewhat melancholy attitude. A discarded book on the ground and the quill pen in his other hand suggest scholarly ambitions that are temporarily forgotten. Evidently lost in thought, he even neglects the devoted spaniel who approaches him from the right. The portrait is one of a type, consistent with British precedent, in which these conventions are intended to imply a desirable sensitivity on the part of the sitter.

The portrait is a prime example of Brown's love of viscous paint texture, rich coloring, and visible brushwork—as in the wildly applied zigzag strokes that define the surrounding landscape. Such paintings, in accordance with English taste, were calculated to give the impression of having been produced spontaneously. This picture would have been admired in its day not only for the truth of the likeness, for which Brown was known, but also for the audacious technique.

D. E.

Inscriptions At lower right, *M. Brown. p.ᵗ / Cha.ˢ Will.ᵐ Pa[r?]k / Aged 13 17[?]*

Provenance Dealer, Redhill, Surrey, England. Leger Galleries, London, 1967–70. Acquired in 1970.

References Hood et al. 1977, 79–80. D. Evans 1982, 54–55, no. 138.

15

George Augustus Eliott, Baron Heathfield, 1788/(91?)

Oil on canvas
76.2 × 63.5 cm (30 × 25 in.)
City of Detroit Purchase (70.953)

Modeled carefully but with the effect of having been painted spontaneously, particularly in the long curls of the wig, this portrait is a first version. It descended in the sitter's family with a full-length second version (East Sussex County Council, England) showing Eliott standing amid the flames of the battle of Gibraltar.

George Augustus Eliott (1717–1790) capped a brilliant military career with a heroic defense of the British garrison on Gibraltar. He was able repeatedly to repulse the allied forces of the Spanish and the French for three years (1779–82) with a reduced force at constant risk of starvation. Finally, when Eliott could not have held out much longer, Rear Admiral Lord Howe broke through the allied blockade and rescued the beleaguered garrison with reinforcements. For his remarkable defense, Eliott was made a knight of the Bath (as his badge shows) and in 1787 was elevated to the peerage as Baron Heathfield.

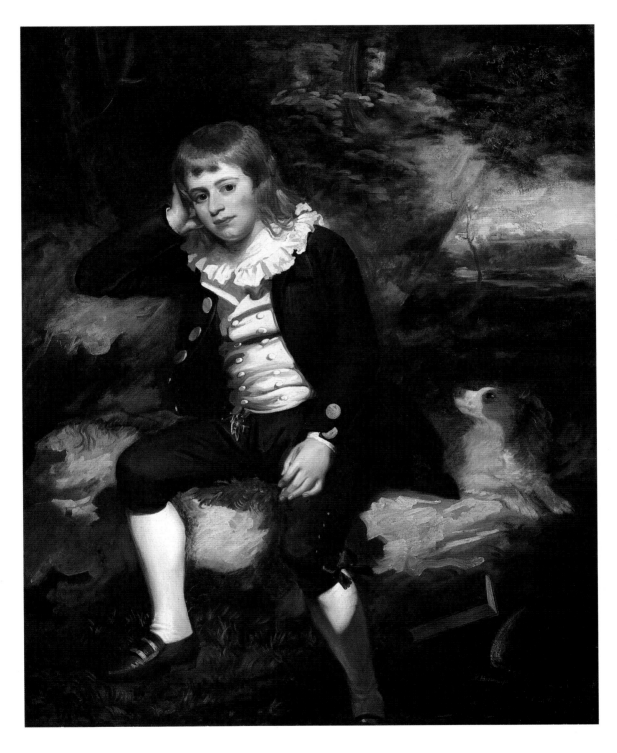

Master Charles William Park

From a London newspaper account of Lord Heathfield visiting Brown's studio, we know that the artist worked on a portrait of Eliott in 1788 (*World*, September 9, 1788), but the first version was not exhibited until 1791. The full-length work (see Evans 1982, fig. 64), evidently commissioned later by Lord Heathfield for his estate and entered in the Royal Academy exhibition of 1792, was praised in a review as "a strong likeness" ("Press Cuttings," vol. 1, p. 118, Courtauld Institute of Art, London). Yet compared with the Detroit portrait, upon which it is based, the larger one is somewhat generalized and more removed from the sitter. D. E.

Provenance Augustus Eliott Fuller, descendant, Rose Hill Park, Sussex, by 1846. Decended indirectly in the sitter's family to Sir George Eliott Meyrick Tapps-Gervis, Bt., Hinton Admiral, Hampshire, ca. 1876; his great-grandson, Sir George D. Eliott Tapps-Gervis-Meyrick, Bt., 1970. Sale, Christie's, London, May 15, 1970, no. 99. Leger Galleries, London, 1970. Acquired in 1970.

Exhibitions London, Royal Academy, 1791, no. 241 (as *Portrait of a Nobleman*).

References Hood et al. 1977, 80–82. Evans 1982, 82, 92, no. 84.

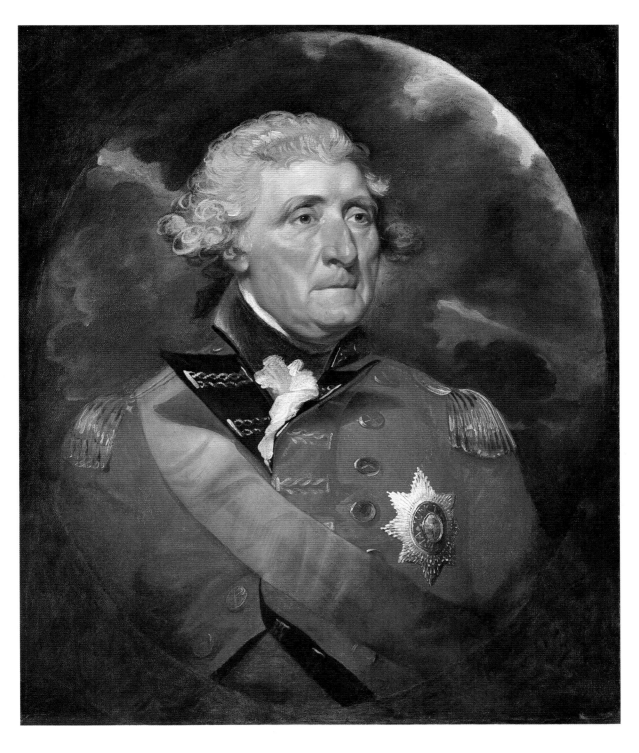

George Augustus Eliott, Baron Heathfield

The preeminent member of the founding generation of Hudson River school landscape painters, Thomas Cole was born in England, one of eight children of a woolens manufacturer. After receiving some early training as an engraver and fabric designer, he emigrated with his parents and siblings to America in 1818. His efforts to chart a career during the following eight years were inconclusive. Often remaining in a locale for a period after his itinerant father and the rest of his family had moved on, Cole ventured into engraving, fabric design, portrait painting, landscape painting, and prose and poetry writing. Success came at last in late 1825, when, in an episode that quickly became a near-legend in the retelling, John Trumbull (q.v.), William Dunlap (q.v.), and Asher B. Durand (q.v.) each purchased one of three paintings of Hudson River Valley scenery that Cole had placed in the window of a picture dealer's shop in New York City.

From that time until his death, Cole ranked as one of America's leading artists. Increasing self-confidence and financial stability enabled him to undertake regular summertime sketching trips to upstate New York and New England, and eventually to live (as a tenant, not an owner) in Catskill, New York, from 1834 onward. In that year, he met Maria Bartow of Catskill; two years later the couple were married. The support of generous but sometimes mercurial patrons enabled him to return to England for two years, to travel extensively on the Continent between 1829 and 1832, and to tour Europe again in 1841 and 1842. Partly out of economic necessity, he began in 1844 to accept pupils, of whom the first, Frederic Edwin Church, was easily the most illustrious. Cole died suddenly following a brief illness in February 1848, a few days after his forty-seventh birthday.

Even the most serene of Cole's topographical landscapes quiver with an undercurrent of agitation, as though traces of the artist's deeply religious, poetic, restive, and alternately exultant and melancholic personality had spilled onto his canvases. Instinctively attracted to sublime natural prospects and occurrences, he leaned, for precedents for his own art, toward Salvator Rosa among the old masters and toward J. M. W. Turner and John Martin among contemporary painters. But Cole's protoexpressionist tendencies should not be allowed to obscure his intellectual side. A thoughtful reader, diarist, and correspondent, he also presented public lectures and authored essays, aspired to be a practicing architect in the mid-1830s, and kept company with enlightened connoisseurs, poets, and scientists, as well as colleagues in his own profession. Nor did he lack awareness of the practical aspects of his calling: from the early 1830s onward, he plotted the public display of his pictures with all the deliberateness of an experienced showman.

Beneath the theorizing and the calculated cultivation of his reputation, he was convinced that the fine arts had a high moral and didactic mission. His first paired historical paintings, *The Garden of Eden* (1828; Amon Carter Museum, Fort Worth, Tex.) and *The Expulsion* (1828; Museum of Fine Arts, Boston), were succeeded by several series of large-scale works, notably "The Course of Empire" (1833–36, New-York Historical Society) and "The Voyage of Life" (1840; Munson-Williams-Proctor Institute, Utica, N.Y. Second version, 1842; National Gallery of Art, Washington, D.C.), as well as a number of individual epic compositions. At the end of his life he was at work on another monumental series of five paintings, "The Cross and the World," of which only the first three canvases (unlocated) were completed.

Posthumous tributes by his many friends, an extensive retrospective exhibition in New York in 1848, and frequent reappearances of his works in exhibitions, at auction sales, and in reproduction helped to perpetuate Cole's influence on American landscape painting for a generation. The bulk of his drawings and a considerable number of his manuscripts, donated by the artist's descendants, belong to the Detroit Institute of Arts.
G. C.

Bibliography Parry 1988.

16

From the Top of Kaaterskill Falls, 1826

Oil on canvas
79.1 × 104.5 cm (31⅛ × 41⅛ in.)
Founders Society Purchase, Dexter M. Ferry, Jr., Fund (46.134)

During the nineteenth century, Kaaterskill Falls was regarded as one of the scenic wonders of the northeastern United States. Situated approximately one and one-half miles southwest of its source in North Lake in the eastern range of the Catskills, the tall, twin-tiered cascade tumbles a total of two hundred sixty feet into Catskill Clove, soon joining Catskill Creek, which in turn eventually winds to the Hudson River fifteen miles to the east. A narrow, level surface at the rear of a vast rock semidome beneath the upper fall offers the intrepid hiker an expansive semicircular promenade and a spectacular view to the west through the column of water, as though from just inside the mouth of a huge cavern.

When Cole undertook the first of his many journeys to the locale in mid-1825, the Catskill Mountain House, a nearby resort hotel, was a year old, and the region as a whole was acquiring national recognition for its natural beauty. But the twenty-four-year-old Cole seems to have been the first painter of note to be capti-

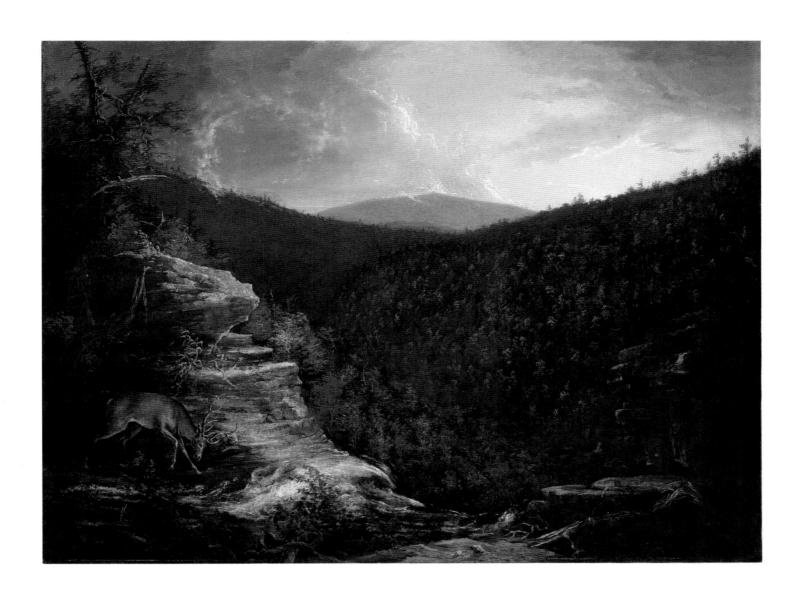

From the Top of Kaaterskill Falls

vated by this portion of the Catskills and by Kaaterskill Falls in particular. Eighteen years later, after a wintertime excursion to the falls, he wrote that "the savage and silent grandeur" was compelling in any season (Noble 1853, 258–260). In the meantime, Cole had parlayed his youthful fascination with Kaaterskill into professional success. A painting of the upper fall seen from beneath the rock semidome (unlocated) was instrumental in Cole's sudden rise to fame. Purchased by John Trumbull (q.v.), president of the American Academy of Fine Arts, in late 1825, this work attracted attention at the Academy's exhibition of 1825–26 (no. 89, titled *Catterskill Upper Fall, Catskill Mountain*), inducing Daniel Wadsworth to order a replica version (Wadsworth Atheneum, Hartford, Conn.) from Cole in 1826. Probably influenced by Cole's painting, William Guy Wall (1792–after 1864) portrayed much the same scene (Honolulu Academy of Arts) in 1827. Cole also contributed a view of the falls "from below," titled *Landscape, Catterskill Fall, Catskill Mountains*, to the American Academy display of 1826 (no. 84, unlocated) and in 1827 painted at least four more canvases on the subject.

For nearly a quarter-century after Cole's death, his canvases of Kaaterskill Falls were presented in exhibitions in the eastern United States. Among these was a showing, in the Cole memorial exhibition of 1848 (no. 73, wrongly dated 1824), of the picture originally bought by Trumbull in 1825. By then that work was owned by Philip Hone, a New York merchant and diarist who served as mayor of the city in 1825. Hone also owned Cole's scene of North Lake titled *Lake with Dead Trees* (1825; Allen Memorial Art Museum, Oberlin College, Oberlin, Ohio). Hone had both a brother and a son named John, and in 1826 Cole noted in a written list (owned by the Detroit Institute of Arts, acc. no. 39.680.1-.2) he kept of

works sold that one J. Hone had purchased a work titled *View from the top of the fall of Kaaterskill;* the painting referred to is probably the Detroit picture.

Five undated drawings by Cole in the collection of the Detroit Institute of Arts (39.496a and b, 39.198a and b, and 39.261a) are closely related to the present painting. In each of the drawings, made on the site either in 1825 or 1826, Cole explored aspects of the view from the top of the falls. The most elaborate of the five, and the only one executed primarily in ink (39.496a), served as the model for the painting. Except for the immediate foreground (the rock ledge, the falls themselves, and the deer at the left), the drawing is composed of all the essential elements of the painted composition, including the storm at the upper left. Among Cole's characteristically extensive notations on the sheet, one sequence—"It must be at sunset / the sun in sight / contrasted through / the trees on the rig[ht]"—indicates his plan, as he sat before the scene, to employ that particular sketch as the basis for a studio work. In the painting, he positioned the sun just setting behind the hill at the right, its bright rays contrasting with the deep shadows below and the darkness of the storm at the left.

The Detroit painting is stylistically consonant with *Lake with Dead Trees* and (as we may judge from Daniel Wadsworth's replica version of it) the view of the falls once owned by Trumbull and later by Hone. All three works display shaggy, rather stiff brushwork, strong contrasts, an electric atmosphere, expressively distorted trees, and autumnal coloring. The stag gingerly bending to drink at the edge of the abyss in the Detroit work is akin to the pair of rigid creatures Cole inserted in the foreground of the Oberlin picture: as their highlighted antlers echo the angular shapes of the dead trees, the antlers of the single stag mimic the gnarled sprig clinging to the rocks just overhead.

When Cole painted a distant view of both falls set in an autumnal atmosphere a few months later for the New York merchant William Gracie (1826; Warner Collection of the Gulf States Paper Corporation, Tuscaloosa, Ala.), he had in effect completed a trilogy, presenting the natural monument from all three characteristic vantage points—that is, from beneath the upper fall, from the top of the upper fall, and from a few dozen yards west, looking toward both falls.
G. C.

Inscriptions At lower center, *T. Cole.*; on the back (visible before relining), *From the top of Kaaterskill Falls 1826.*

Provenance Probably John Hone, New York, 1826. Old Print Shop, New York, 1946. Acquired in 1946.

Exhibitions Possibly New York 1827, no. 120. Yonkers et al. 1988, 45, pl. 19.

References Van Zandt 1966, 135–137, fig. 31. Parry 1988, 43–44, 51, fig. 20.

17
American Lake Scene, 1844

Oil on canvas
46.4 × 62.2 cm (18¼ × 24½ in.)
Gift of Douglas F. Roby (56.31)

This unprepossessing late work of modest size by Cole is important from two standpoints. First, there seems no reason to doubt the traditional assumption that the painting was shown at the American Art-Union in 1844 under the title *American Lake Scene* (no. 7). If the supposition is correct, then the work was one of just two paintings to represent Cole at the annual displays of America's two foremost art organizations that year. The other picture, laconically titled *Landscape*, shown at the National Academy of Design (no. 211,

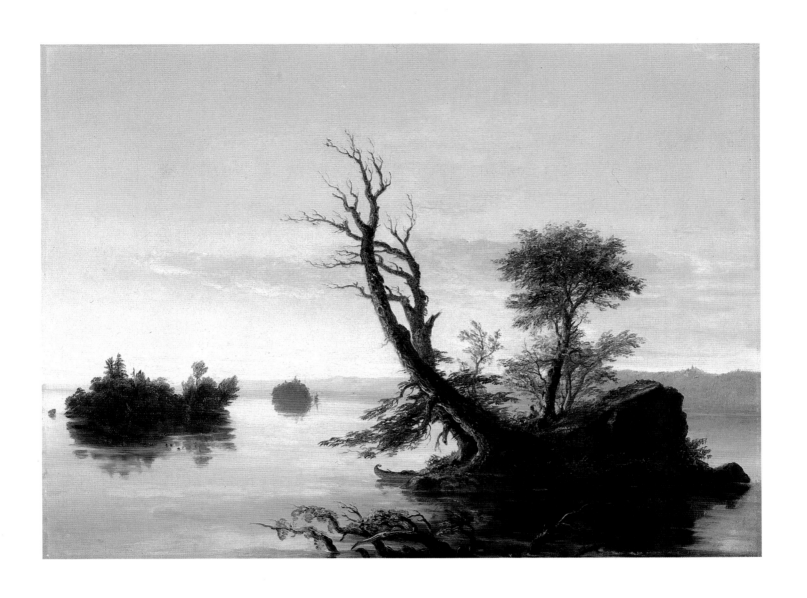

as owned by A. M. Cozzens; unlocated), evidently depicted a similarly unpretentious North American subject. Second, in contrast to Cole's earlier lake or river compositions, *American Lake Scene* casts the viewer adrift far from shore, to float amid surface reflections extending endlessly toward distant low hills, a low horizon, and an almost clear blue sky.

The fact that Cole chose to offer so few new paintings in the major New York group exhibitions in 1844, as well as the unusual character of the Detroit composition, doubtless reflected the period of personal and professional reassessment through which the artist was passing at the time. During the previous year and a half, both his creative endeavors and his public presentations had been dominated by references to a recently concluded eleven-month European journey (from which he had returned in July 1842) and by his continuing interest in history painting. All but one of the half-dozen works he sent to the National Academy of Design's annual exhibition in 1843 were devoted to European subjects. Of the twelve pictures he selected for a solo exhibition at the academy during the winter of 1843–44, seven were large historical works (including the second "Voyage of Life" series [1842], which Cole also displayed in Boston and Philadelphia in 1843–44), and three depicted Italian subjects. An article on "Sicilian Scenery and Antiquities," published in the New York *Knickerbocker* in February and March of 1844, underlined his preoccupation with the Old World at the time. In 1845 and 1846, however, his publicly exhibited works were divided about equally between North American and European themes, while in his single new historical composition of those years, *Elijah at the Mouth of the Cave,* shown at the National Academy of Design in 1845 (no. 97; unlocated), he reverted to a theme he had painted in London in 1830. Thus, during 1845 and 1846 Cole

often made an implicit contrast between the Old World and the New. The contrast was made explicit by his presentation of paired paintings titled *The Old World* and *The New World* at the American Art-Union in mid-1845 (see *Broadway Journal,* April 12, 1845, 238).

Seen in light of these developments, *American Lake Scene,* another medium-size picture of early 1844 titled *The Old Mill at Sunset* (Collection of Jo Ann and Julian Ganz, Jr., Los Angeles), and perhaps the Cozzens *Landscape* signaled the artist's return to more familiar North American themes. Yet the Detroit composition is serene and effortlessly expansive compared with Cole's earlier inland water scenes such as *Lake with Dead Trees* (1825; Allen Memorial Art Museum, Oberlin College, Oberlin, Ohio), *Autumn Twilight, View of Corway* [sic] *Peak, New Hampshire* (1834; New-York Historical Society), or even *View on the Arno* (1838; Shelburne Museum, Vt.). Granted, a number of traditional hallmarks of Cole's style are present—the dead tree imbedded in the rocky island, the nearly submerged tree in the immediate foreground, the solitary Indian, and the vigorous brushwork and strong contrasts— but these do not fundamentally alter the uncrowded, reflective mood. Particularly pertinent details in this regard are the mirrored images of the artist's signature and of the date at the base of the rocky island.

It is tempting to interpret the composition in part as a revision and updating of two of Cole's earlier allegorical works, *The Subsiding of the Waters of the Deluge* (1829; National Museum of American Art, Washington, D.C.) and the final scene from the "Voyage of Life" series (1840 and 1842; see p. 48). Especially in its resemblance to both a boat and a ruin, the rocky island at the right echoes those pictures and, to an extent, Cole's scenes

of the Roman campagna. In turn, the imagery as a whole is strikingly akin to that of George Caleb Bingham's *Fur Traders Descending the Missouri* (1845; Metropolitan Museum of Art, New York), shown at the American Art-Union at the end of 1845.

Cole probably intended to evoke the solemn stillness of North American lakes in general rather than a particular body of water or a topographically specific view. J. Gray Sweeney (Muskegon 1983, 38) has judiciously linked the Detroit picture to Cole's remarks in his "Lecture on American Scenery" (1841) concerning "the unrippled lake, which mirrors all surrounding objects, [in which] we have the expression of tranquility and peace.... In this great element of scenery what land is so rich [as America]? I would not speak of the Great Lakes, which are, in fact, inland seas—possessing some of the attributes of the ocean without its sublimity." Sweeney's suggestion that the painting depicts the Thousand Islands area in Lake Ontario is implausible, however, in view of Cole's slighting reference to the Great Lakes, and because Cole evidently had not visited that locale in many years. That *The Old Mill at Sunset,* also dating from early 1844, clearly does not reproduce an actual scene underscores the conclusion that Detroit's *American Lake Scene* is a "composition."

The *Broadway Journal* in New York was the only publication to review the American Art-Union exhibition of 1844. The journal's writer was perceptive and sympathetic toward Cole's purposes. Although he did not mention the Indian and canoe, his description of *American Lake Scene* is otherwise consistent with the contents of the Detroit work:

Cole loves the solemn stillness of our forests and prairies and he has selected the foot of the Catskill mountains for his studio. There was only one of his pictures in the [recent] distribu-

tion, and though small and unpretending, it possessed much of his character. A still lake, a clear sky without a cloud, the ruins of a majestic tree stretching out its scathed but giant branches; and hoary old rocks; it is the very poetry of solitude, and you hold your breath lest the echo of your voice should frighten you. There's nothing living in sight—indeed, nothing could live there, for there's not a particle of atmosphere. It looks like the earth, before God breathed on it. (*Broadway Journal*, January 4, 1845, 12–13)

G. C.

Inscriptions At right, lower center of the island, *T Cole 1844*

Provenance Young Men's Mercantile Library Association, Cincinnati, 1844. T. L. Ogden, New York; descendants of Ogden. John J. Bowden, Long Island, New York. Douglas F. Roby, Ypsilanti, Michigan. Acquired in 1956.

Exhibitions New York, American Art-Union, 1844, no. 7. San Francisco 1957, no. 81. Montreal 1967, no. 318. Ann Arbor 1972, 34, no. 39, pl. 69. Muskegon 1983, 38–39.

References Grigaut 1955–56, 88–90. Detroit 1965, 26. Cummings and Elam 1971, 139.

John Singleton Copley, alone among colonial-born painters, exhibited brilliance even before traveling abroad. The stepson of Peter Pelham, a Boston engraver, Copley grew up surrounded by tools of the artist's trade. By age fifteen, he had scraped a mezzotint. This was followed by other exercises, such as painting mythological compositions derived from prints, copying an English portrait, and creating a book of anatomical drawings. Copley's professional career began in 1753, and his first portraits show him grappling with a variety of influences. By 1761 Copley had shed the mantle of his predecessors and contemporaries. At this point, several virtuoso performances such as *Epes Sargent* (1759–61; National Gallery of Art, Washington, D.C.) established new levels of distinction in American portraiture. His portraits in these early years, although marked by linearity, strong value contrasts, and intense colors, were becoming increasingly sophisticated. They remained, however, much more rugged than portraits by his contemporary Joseph Blackburn (q.v.).

In the 1760s Copley painted unchallenged in Boston. His work was much in demand, and he developed a skill in painting pastels and miniatures as well as oil portraits. Copley made his only lengthy American painting trip outside of Boston in 1771, when he spent the second half of the year in New York and painted over thirty-five portraits. These were years of considerable personal growth and professional stability, but Copley agonized over his predicament. While his career to this point had been financially rewarding, he could not hope to obtain the international acclaim for which he longed if he remained in America. He had tested the waters in 1766 by exhibiting the striking portrait of his half-brother Henry Pelham, better known as *Boy with a Squirrel* (Museum of Fine Arts, Boston), at the Society of Artists in London. Despite its positive reception, Copley chose to remain in America. In 1774, however, his sentiments changed as a result of the

heated political climate in Boston, and he sailed for England. After a brief visit there, he spent the next year in Italy, traveling to Venice, Florence, Rome, and Naples. Copley then returned to London and shortly thereafter moved to a large house in Leicester Square.

As in America, his main source of income continued to be portraits, but he aspired to success as a painter of historical subjects. In 1778 he painted *Watson and the Shark* (National Gallery of Art, Washington, D.C.), his first large-scale history painting and a provocative subject that captivated audiences (see cat. no. 26). This was followed by his admission to the Royal Academy and the creation of *The Death of the Earl of Chatham* (Tate Gallery). Copley worked on the painting for over two years, and during the six weeks it was on exhibition, it was seen by twenty thousand people. In 1783 Copley reached the zenith of his career with *The Death of Major Pierson* (Tate Gallery), arguably the most powerful subject from contemporary history painted in the eighteenth century. It is generally agreed that Copley's skills diminished from this point on, his work increasingly overshadowed by that of younger artists. Although he continued to paint virtually until his death at age seventy-seven and his paintings were still frequently noteworthy—for example, *The Siege of Gibraltar* (finished 1791; Guildhall Museum, London)—his achievement after 1800 is flawed as a result of the increasing infirmities of age.
R. S.

Bibliography Prown 1966.

18

Jonathan Mountfort, ca. 1753

Oil on canvas
74.3 × 62.2 cm (29¼ × 24½ in.)
Founders Society Purchase, Gibbs-Williams Fund (58.360)

This picture is among the first portraits painted by Copley. When recorded in

Frank Bayley's catalogue of the artist's work (1915), the painting was identified as being signed with the date 1753. This differs from the present appearance of the inscription, which is clearly readable as *John S. Copley / nx*. The misreading of the inscription was repeated by Barbara N. Parker and A. B. Wheeler (1938), and it was not until Jules Prown's Copley catalogue (1966) that it was realized that what had been read as a date was actually part of the term *pinxit*, Latin for "he painted [this]." It is conceivable, however, that the painting was dated originally, as Copley did date other portraits in 1753. The inscription abuts the edge of the painting, and the date may have been cut off accidentally in an early lining and restretching of the canvas.

Although there is no date on the portrait, it is reasonable to conclude that it was painted at the outset of Copley's career. At that point, Copley was deriving many of his ideas from other Boston artists, such as John Greenwood (q.v.) and Joseph Badger (q.v.). Here, in particular, Copley's technique of painting thinly, allowing the darkened ground to show through in flesh areas, echoes the style of Badger (and of John Smibert [q.v.]), whose work he could see all around him in Boston. In this instance, Badger's style was a logical model for Copley since the older artist had probably painted more portraits of children than any other colonial painter (Warren 1980). But Copley's figure is more sharply defined, and his selection of colors more varied, than was Badger's practice. Copley did not seek inspiration from Badger again.

The 1753 dating of the painting is consistent with the age of the sitter, Jonathan Mountfort of Boston (1746–1785), who appears to be about seven. Mountfort's family was less illustrious than Copley's later patrons. The young boy became an apothecary, married Mary Bowles of Medford, Massachusetts, and died at age thirty-eight.

The device of showing a child holding flowers was well established by the time

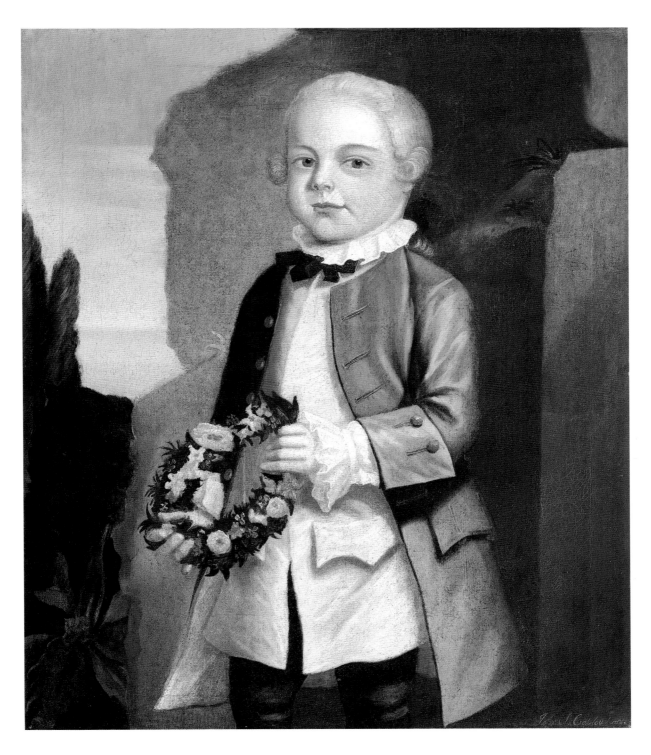

Jonathan Mountfort

Copley employed it. It is another mark of the tentative nature of his early work that Copley felt compelled to borrow from existing models rather than break new ground. Very shortly, however, he would dispense with these hackneyed gestures and rely more fully on his own invention. R. S.

Inscriptions At lower right, *John S. Copley / nx.*

Provenance The sitter, Jonathan Mountfort, Boston, ca. 1753–85; his daughter, Mrs. Thomas Pitts [Elizabeth Mountfort], Boston(?); her daughter, Sarah Pitts Farlin, Detroit, by 1883; her great-nephew, S. Lendall Pitts, Detroit, by 1938; Mrs. S. Lendall Pitts, Norfolk, Virginia. Acquired in 1958.

Exhibitions Detroit 1883, no. 147. Brooklyn 1917, no. 16. Boston 1938, 25, no. 54. Detroit 1959, 34–35.

References Perkins 1873, 13, 52. Goodwin 1886, 4, 73. Bayley 1915, 95. Parker and Wheeler 1938, 136, pl. 4. A. Burroughs 1943a, 161–162. Payne 1960, 89. Prown 1966, 14, 20, 22, 27, 32, 34, 41, 223–224, fig. 26.

19
Hannah Loring, 1763

Oil on canvas
126.4 × 99.7 cm (49¾ × 39¼ in.)
Gift of Mrs. Edsel B. Ford in memory of Robert H. Tannahill (70.900)

By 1763 Copley was the only portrait painter in Boston, and he was beginning a decade of unparalleled success. Patrons from as far away as Halifax and Quebec pleaded with him to visit, assuring him of great reward. The reason for Copley's popularity is quite evident in the Detroit portrait of Hannah Loring (1742–1785). American patrons could appreciate the air of gentility and propriety conveyed by portraits such as this. It is signed boldly, as was Copley's usual practice.

In the first ten years of his career, Copley had become increasingly adept at creating refined and opulent likenesses. Most effective is the addition of pink and blue color accents to a silver gown that shimmers in the light. Here, in contrast to Blackburn's work of the same era, which this painting recalls superficially, the lace trim has volume and texture. Copley's concern for detail extended to the point of dangling a richly painted bonnet from the sitter's right hand. He also took the long-popular woodland-glade setting and, through the manipulation of rich, cool tones, gave it a new sensuousness.

The portrait may well have been commissioned to celebrate Hannah Loring's wedding to Joshua Winslow on December 26, 1763. Her husband was a Loyalist and one of the consignees of the tea tossed into Boston harbor in 1773. By 1775 she was a widow and, being a Loyalist, left Boston with her family when the British evacuated the city. After the war she wished to return to Boston, but did not do so, as her family's property had been confiscated. She died in Canada, where her portrait remained until the 1890s.

Although Copley painted similar portraits during the early 1760s, such as *Mrs. James Warren* (Museum of Fine Arts, Boston), he was careful never to repeat exactly the same composition. This obvious but time-consuming policy, which no other colonial artist had pursued, made each portrait distinctive and undoubtedly endeared him to his sitters.

Copley also executed pastels of Hannah Loring, her husband, and one of their sons sometime around 1769 (New York 1970, figs. 3–5). R. S.

Inscriptions At center left, *J. S. Copley Pinx 1763*

Provenance The sitter, Hannah Loring, 1763–85; her daughter, Hannah Winslow de Paiba; her daughter, Mrs. L. G. M. Temple, Toronto; L. G. M. Temple, Toronto. Bought by William

Caleb Loring, Boston, 1893; his nephew, Augustus P. Loring, Jr., Boston, 1938; his son, William C. Loring, Prides Crossing, Massachusetts. Kennedy Galleries, New York, 1970. Acquired in 1970.

Exhibitions Boston 1930, 98.

References Bayley 1915, 167–168. Bayley 1929, 291. Bolton and Binsse 1930a, 118. Parker and Wheeler 1938, 125–126, pl. 37. Prown 1966, 38, 222, fig. 122. New York 1970, figs. 4–5. Butler 1971, 289. Cummings and Elam 1971, 132. Winchester 1971, 695. Hood et al. 1977, 65, 69–70. Detroit 1985, 180.

20
John Gray, 1766

Oil on canvas
125.6 × 99.9 cm (49⁷⁄₁₆ × 39⁵⁄₁₆ in.)
Founders Society Purchase, Gibbs-Williams Fund (43.30)

Just as Copley had the ability to charm female sitters, he was also innately aware of how to please men. In portraits such as this one of John Gray (1713–1782), he took a much-used composition—a figure set against drapery and leaning on a column base—and still extracted vitality from it. The ability attests to Copley's versatility. While most of his memorable pictures are those in which his own invention exceeds his borrowing from established models, here he made a virtue out of a vice. The portrait succeeds because the figure is one of substance—a man with a seriousness of purpose who gazes intently at the viewer. Both the sobriety of the palette and the absence of compositional devices, such as pens and documents, contribute to the work's unflinching directness and make the image all the more accessible and real.

By the year of the portrait, Copley was hitting his stride as a painter. He had recently been notified that his *Boy with a Squirrel* was being well received in

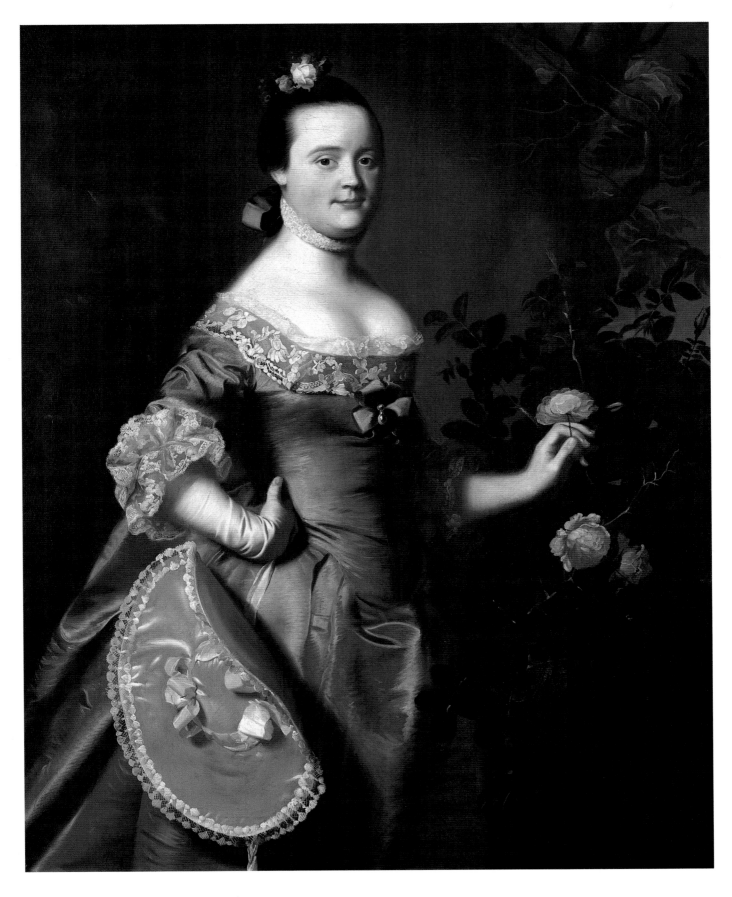

Hannah Loring

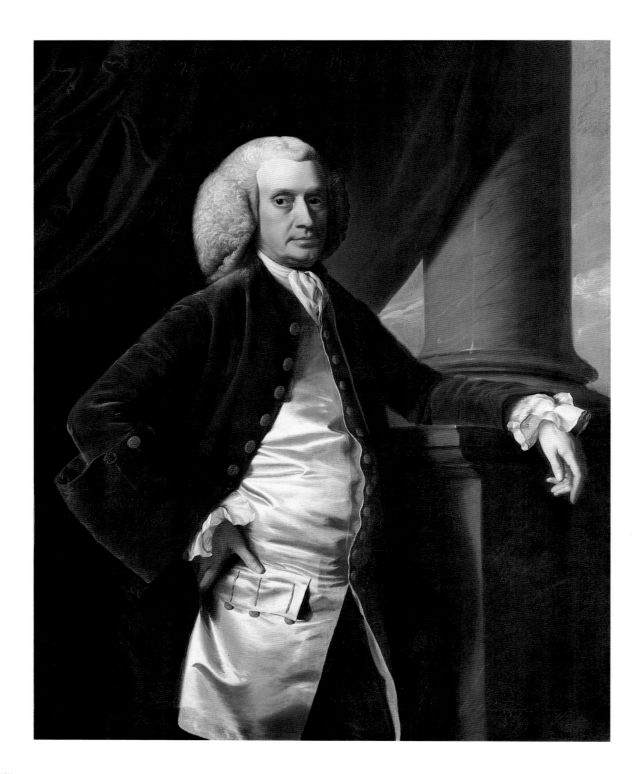

John Gray

London and had been advised of his admission to the Society of Artists there. In portrait after portrait in the late 1760s he maintained a high level of consistency in his work; rarely did he falter.

Copley had done several portraits for the Gray family by 1770, among them *Mrs. John Gray* (ca. 1763; Massachusetts Historical Society, Boston), the pendant to the Detroit picture, and a portrait of Harrison Gray (private collection), John Gray's older brother. Like many of Copley's other sitters, the Grays were Loyalists, and John Gray, who was deputy collector of taxes, fled Boston with the British in 1776 (Mrs. Gray having died in 1763). He later settled in India and is credited with starting there the first factory for the commercial production of indigo. Gray died on his East Indian plantation, where he is said to have been poisoned by the natives.
R. S.

Inscriptions At lower right, on plinth, *J. S. Copley pinxt 1776*

Provenance The sitter, John Gray, 1766–82; a descendant, Judge John Gray Otis, Boston, by 1873. Judge John Gray Rodgers, Boston, by 1899. The Misses Rogers, by 1908. Mrs. W. Arthur Dupee, 1928–43. M. Knoedler Co., New York, 1943. Acquired in 1943.

On deposit Boston Museum of Fine Arts, 1908.

Exhibitions New York 1921, no. 1. New York 1936, no. 17. Leningrad 1976, 11. Paris 1976, pl. 20.

References Perkins 1873, 68. Bayley 1910, 123. Bayley 1915, 213. Bayley 1929, pl. 213. Bolton and Binsse 1930a, 116. Parker and Wheeler 1938, 88–89, pl. 76. Detroit 1957, 72. Prown 1966, 38–39, 53, 216, fig. 171.

21

Mrs. Benjamin Hallowell, ca. 1766/67

Oil on canvas
119.4 × 95.3 cm (47 × 37½ in.)
Founders Society Purchase, Gibbs-Williams Fund, Dexter M. Ferry, Jr., Fund, Robert H. Tannahill Foundation Fund, and Beatrice W. Rogers Bequest Fund (71.168)

As Boston was not a large city in the eighteenth century, many of Copley's patrons inevitably came from a small circle of families. Among the most prominent were the Boylstons, numbering Mrs. Benjamin Hallowell (1722–?), born Mary Boylston, as a member. Her staunchly Loyalist family had vast holdings in Boston, and her husband, whom she married on June 13, 1746, was appointed comptroller of the Port of Boston in 1764. In a span of three years (1765–67), Copley painted seven portraits for them and their immediate relatives.

The Detroit picture is one of a type that Copley favored for middle-aged women, whom he often depicted seated in amply proportioned upholstered armchairs. He used this format as early as 1766 for Mary Boylston's mother, *Mrs. Thomas Boylston* (Harvard University), and painted in the 1760s over half a dozen portraits that resemble it in composition. Here, however, he added one mildly distracting detail: the bird perched on the sitter's hand. By virtue of its size and placement, it appears more like a falcon than the dove Copley no doubt intended. Like the squirrels and dogs that populate other colonial portraits, the dove is supposed to indicate domesticity and playfulness. This was a motif Copley had inserted to keep pace with contemporary London portraitists. He borrowed the idea from Sir Joshua Reynolds, who had used it for *The Ladies Amabel and Mary Jemima Yorke* (1761; Cleveland Museum of Art)—a painting Copley must have known from a print

after it, since such engravings were widely circulated in the Colonies. The Boston artist used it again for his portrait *Elizabeth Ross* (Museum of Fine Arts, Boston), painted about the same time.

Copley's intention was to surround Mrs. Hallowell with rich fabrics of contrasting colors: a red-damask-covered chair, a pumpkin-colored gown, and a deep blue shawl. In so doing, however, he lost the understated subtlety that is an essential ingredient of his best portraits. In spite of all Copley's diversions, the face of Mrs. Hallowell shines through, as though she is good-naturedly enduring the fuss the artist is making over her. It is her thoughtful, piercing gaze that enables the portrait to succeed despite Copley's theatrics.
R. S.

Provenance The sitter, Mary Boylston Hallowell; her daughter, Mary Hallowell Elmsley; her daughter, Mary Elmsley Bond; her daughter, Elizabeth Bond Coke; her son, George Elmsley Coke; his son, Basil Elmsley Coke; his daughter, Cassandra Coke Wise; her son, Adam Nugent Wise, 1971. Leger Galleries, Ltd., London, 1971. Acquired in 1971.

References Prown 1966, 54–56, 108, 124, 140, 142, 217, fig. 190. Hood et al. 1977, 70–72.

22

John Montresor, ca. 1771

Oil on canvas
76.2 × 63.5 cm (30 × 25 in.)
Founders Society Purchase, Gibbs-Williams Fund (41.37)

After 1768 Copley found that his sitters increasingly favored the thirty-by-twenty-five-inch (76.1 × 63.5-centimeter) bust-length format, and two-thirds of his

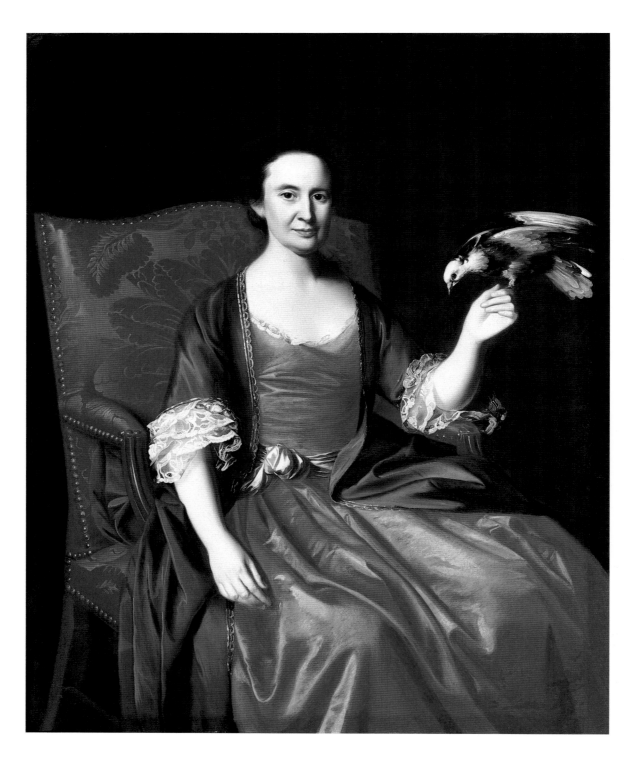

Mrs. Benjamin Hallowell

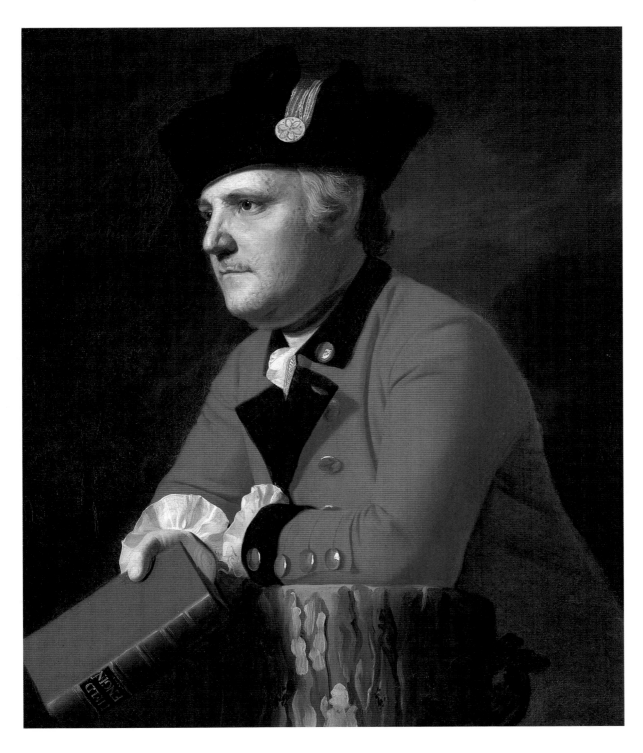

John Montresor

portraits of this size were painted during his last six years in the Colonies (Prown 1966, 83). Smaller canvases meant a reduction in income, and by 1771 Copley was ready to travel outside Boston to counter this loss. Copley was assured by Stephen Kemble, an acquaintance in New York, that he would have at least fifteen commissions awaiting him upon his arrival in that city. It was most likely during his seven-month visit that Copley painted this picture of John Montresor (1736–1799), engineer extraordinary and captain lieutenant in the British army, since Kemble's "List of Subscribers" included bust-lengths of "Captain and Mrs. Montresor" (G. Jones 1914, 114). The portrait of Montresor's wife, *Frances (Tucker) Montresor* (private collection), whom he married in 1765, seems, however, because of its profile format and exuberant costume, to have been painted around 1778 after Copley relocated in London.

The portrait of Montresor is of startling intensity. The officer leans on the stump of a tree, which is emblematic of the felling of trees that preceded construction of military fortifications. His pockmarked face and graying hair are thrown into a cascade of light that effectively silhouettes him against the dark sky. His uniform seems to be a simplified version of that of the British corps of engineers: red with black facing, gold braid, and regularly set buttons. Also exhibited here is Copley's prowess as a painter of reflective surfaces: the brass buttons gleam, and the brilliant red of Montresor's uniform is echoed in the lower lobe of his ear. In his hand, Montresor holds a book stamped on the spine with "FIELD ENGINR," which is probably the 1773 English translation of Louis André de Clairne's celebrated book on military engineering, *L'Ingénieur de campagne, ou traité de la fortification passagère* (1750).

Montresor had followed his father's profession and become a distinguished engineer for the British army. He served

successively as ensign, 1755; lieutenant, 1755; lieutenant and subengineer, 1761; engineer extraordinary and captain lieutenant, 1765; captain, 1771; chief engineer of America, 1775; sometime aide-de-camp to General Howe and colonel, after 1778. He had arrived in America with his father in 1755 and participated that year in the Braddock Expedition and the siege of Quebec (1759). As an engineer, he was responsible for constructing fortifications, which he did at Niagara (1764) and elsewhere. His activities in 1763 are of particular interest to Detroit as he was sent there from New York carrying dispatches to major Henry Gladwin, commandant of Detroit, who was then besieged by Chief Pontiac. After considerable difficulty, he reached the fort at Detroit on October 3. During his stay, he helped improve defenses, made sketches, and skirmished with the Indians. It was most likely during this visit that Montresor drew his *Plan of Detroit with Its Environs* (William L. Clements Library, Ann Arbor), although his *Journals* (New-York Historical Society) reveal that he visited Detroit at least one more time. Eight years later, Copley painted Montresor, and it appears that the two men were good friends. Montresor carried a letter from Copley to his half-brother Henry Pelham in Boston; in a subsequent letter, Copley, who was renovating a newly acquired residence in Boston, discussed advice he had received from Montresor about constructing a piazza.

During the course of the Revolution, Montresor surveyed American positions at Bunker Hill, was present at the Battle of Long Island, constructed the defenses of Philadelphia, and in 1778 accompanied the British army to New York. The following year, he retired from service and returned to England.

For a number of years, the Detroit portrait was thought to have been painted in England, and, consequently, it does not appear in Barbara N. Parker and A. B. Wheeler's 1938 catalogue. There is a copy of the portrait in the New Brunswick

Museum (Saint John, N.B.), and either this or another copy was painted about 1934 by Algernon Talmage, R. A., for Mrs. L. Joan [Montresor] Read.
R. S.

Inscriptions On the back in paint, *John Montresor b. 1736–1799 pinxt Copley*

Provenance The sitter, John Montresor, Belmont, Faversham, Kent, to 1799; his son, Sir H. T. Montresor, Dene Hill, Kent, 1799–1837; Lt. Col. H. E. Montresor; his brother, Charles M. Montresor, Stoneley Grange, to 1898; his son, Lt. Col. E. H. Montresor, 1898–1914; his daughter, Mrs. L. Joan Read, to 1934. Feragil Galleries, New York, 1941. Acquired in 1941.

Exhibitions Detroit 1957, no. 30. Hamilton 1961, no. 13. Richmond 1961, 93. Detroit 1963, no. 37. Boston 1975, no. 185.

References Jones 1914, 114. Bayley 1915, 22. Detroit 1957, 73, fig. 26. R. Davidson 1957, 364. Prown 1966, 223, 295, fig. 295.

23
Head of a Negro, ca. 1777/78

Oil on canvas
53.3 × 41.3 cm (21 × 16¼ in.)
Founders Society Purchase, Gibbs-Williams Fund (52.118)

The vast majority of Copley's surviving works are finished paintings or preliminary drawings. Less common are portrait studies in oil, particularly of the caliber of the *Head of a Negro*. This portrait has long been linked to the black member of the rescue party in *Watson and the Shark* (cat. no. 26). The Detroit picture is thought to be the painting identified in the 1864 Lyndhurst sale as "HEAD OF A FAVOURITE NEGRO. Very fine. Introduced in the picture of 'The Boy saved from the Shark.'" It sold for eleven pounds and eleven shillings (Prown 1966, 402).

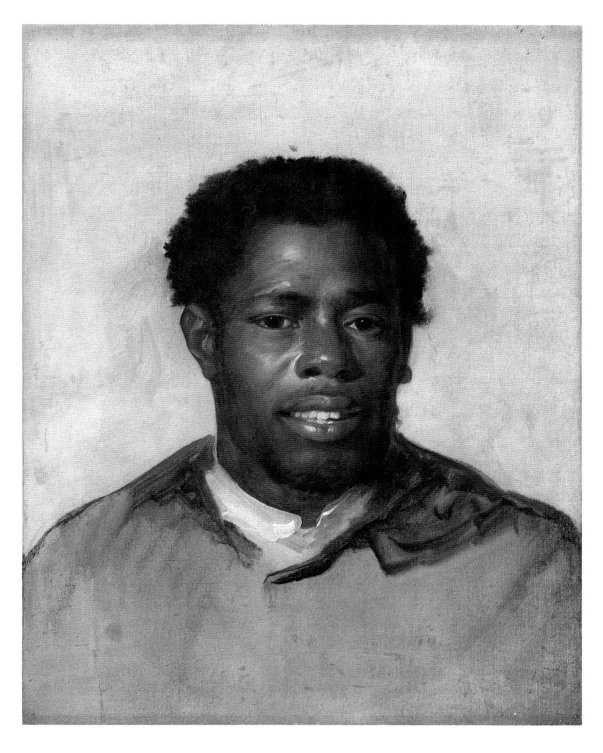

Head of a Negro

The Detroit study was probably painted in the months preceding the 1778 exhibition of Copley's finished picture at the Royal Academy. Jules Prown observed that the study bears little resemblance to the sober-looking black man in *Watson and the Shark*. His plausible explanation for the difference is that Copley may have desired to keep attention focused on the harpoonist who epitomized the rescue operation. The warm, animated, Rubenesque quality of the Detroit portrait makes evident that Copley knew this man well. It is therefore entirely believable, as stated by Perkins (1873), that the figure was a favorite servant of the Copley family. A sparkling, natural portrait, quickly painted, and exhibiting great freedom of brushwork, it possesses the clarity of observation of Copley's American portraits and the increasing fluidity of his London work. It is also totally unpretentious, with no colors added for effect. The freshness of this sketch, so highly prized by modern eyes, was a characteristic that the conventions of the day precluded in most of Copley's finished works. An uninhibited spontaneity confirms, however, the breadth of the artist's talent in the early years of his London career.

The head appears within a slightly darkened oval, suggesting that the painting was at one time set behind an oval mat.
R. S.

Provenance The artist, London, to 1815; his wife, London, 1815; their son, John Singleton Copley, Jr., Lord Lyndhurst, 1836–63. Lyndhurst sale, Christie's, London, March 5, 1864, lot 69, bought by Isaac J. W. Burnett, Rock Hall, Alnwick, Northumberland, England, to 1928. J. W. Burnett sale, Christie's, London, May 23–24, 1928, lot 217, bought by Mann. Sale, Christie's, London, February 24, 1951, lot 102, bought by Mason. M. Knoedler Co., New York, 1951. Acquired in 1952.

Exhibitions Washington et al. 1965, 95, no. 69, fig. 69.

References Perkins 1873, 132. Bayley 1929, 184. *Art Digest* 1952, 7. Richardson 1952a, 35. Richardson 1952–53, 68–70. Prown 1966, 274, 402, 433, fig. 381. Frankenstein 1970, 149.

24
Mrs. Clark Gayton, 1779

Oil on canvas
127 × 101.6 cm (50 × 40 in.)
Gift of Mr. D. J. Healy (27.556)

During 1779 Copley was preoccupied with an ambitious historical picture, *The Death of the Earl of Chatham*. He did, however, take time to paint a few individual portraits, among them the Detroit picture of Mrs. Clark Gayton (ca. 1748–1809). The portrait is among the most fluidly painted of Copley's works to this date, and the pose is considerably less rigid than those found in his American work of five years earlier. The most noticeable contrasts to Copley's American works are the overall lighter palette, a wider range of colors, and less pronounced value contrasts. Here Copley also made more active use of the background, calling attention to it by placing a pot of vividly painted geraniums on the windowsill. While the pose is decidedly more animated than in most of the portraits of his American female sitters, it does bring to mind his 1771 portrait *Mrs. Thomas Gage* (Timken Art Gallery, San Diego) in reverse. Mrs. Gayton holds a brush or pen in her right hand; a stack of folios is at her side. These motifs suggest a cosmopolitan air appropriate to London, but out of place in Boston.

The Detroit portrait was intended as the pendant for *Admiral Clark Gayton* (National Maritime Museum, Greenwich, England), painted in the same year. Admiral Gayton was thirty years his wife's senior and died in about 1787.

His wife, who was the daughter of Captain Edward Legge, married twice more: to a Mr. Newnham of Aldershott Lodge, Hertfordshire, and—on December 10, 1801—to the Reverend James Pigott, vicar of Wigston, County Leicester.
R. S.

Inscriptions At center right, *J S Copley. fec. 1779*

Provenance The sitter, Mrs. Clark Gayton, 1779–1809; her husband, the Reverend James Pigott, 1809–22; his daughter, Lydia Pigott [Mrs. William Thresher], Fareham, Hampshire, England. Captain W. Thresher, R.N., Avenue End, Fareham, Hampshire; his niece, Lucy Mabel Thresher. O'Hagan sale, Christie's, London, November 24, 1922, lot 106. M. Knoedler Co., London. Woolworth sale, American Art Association, January 5–6, 1927, lot 87. Metropolitan Galleries, New York, 1927. Acquired in 1927.

Exhibitions Richardson 1934. Grand Rapids 1943.

References C. Burroughs 1928, 69–70. Bolton and Binsse 1930a, 116. Heil and Burroughs 1930, no. 285. Richardson 1934, 11. Prown 1966, 275, 420, fig. 384.

25
George Boone Roupell, ca. 1779/80

Oil on canvas
213 × 137 cm (84 1/16 × 54 in.)
Founders Society Purchase, Robert H. Tannahill Foundation Fund (1983.23)

Although several hundred portraits by Copley survive, relatively few are full length. Predictably, he had greater occasion to paint the latter in London, where more of his sitters were accustomed to such expense. One of those who turned to Copley for a full-length portrait was

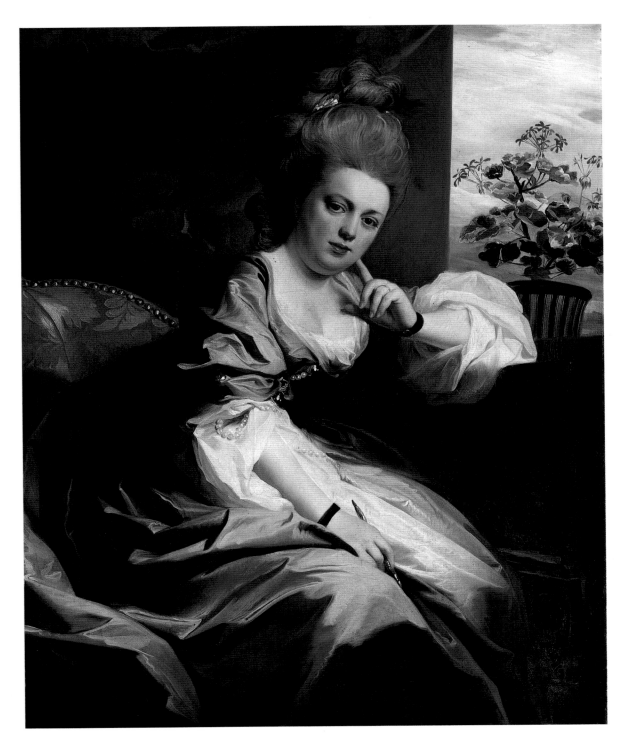

Mrs. Clark Gayton

George Boone Roupell (1762–1838), a native of South Carolina and a member of the Loyalist refugee community in London. Roupell was born in Charleston, where his father was a merchant and served the customs office as a "searcher" for incoming cargoes on which tax had not been paid. Young Roupell went to London, studied law, and was called to the bar at the Middle Temple on June 4, 1790, eventually to be appointed Master in Chancery (1831). He died at his seat, Chartham Park, near East Grinstead, on January 19, 1838. Like many other Loyalist refugees in London with a common bond of dislocation, Roupell sought out Copley when he decided to have his portrait done. The work was left in the painter's hands, however, since Roupell's South Carolina estate was confiscated at the very time his picture was commissioned; it came to him only later as a gift from his friend and fellow lawyer, Copley's son, Lord Lyndhurst.

Like the picture of Mrs. Clark Gayton (cat. no. 24), *George Boone Roupell* was painted at a time when Copley was preoccupied primarily with his historical picture *The Death of the Earl of Chatham* (see p. 64). It is unclear why he took time out to paint the Detroit portrait and a few other works thought to have been done at that time. Copley may have felt that his new status as a full member of the Royal Academy required him to make an imposing presentation at the first opportunity. The imperative was all the more pressing, since Copley had not exhibited any works at the academy in 1779. In particular, he may have felt the need to impress Sir Joshua Reynolds, the president of the academy. These circumstances may help to explain why *George Boone Roupell* bears a resemblance to Reynolds's work of the time.

William Whitley (1928) reported that Copley exhibited the Roupell portrait at the Royal Academy in 1780, the year it is thought to have been painted. He identified the painting as "a fine whole-length

of Mr. Roupell, native of South Carolina. He stands in a graceful, easy attitude and the whole is well painted." Jules Prown (1966, 275) also dated the painting to this year, based on its exhibition, although it could conceivably have been painted in 1779. At the 1780 exhibition Copley also presented another full-length portrait that has been identified as *Major Hugh Montgomerie* (unlocated; copy at the National Portrait Gallery of Scotland), as well as a portrait of a second American sitter, Joshua Loring of Boston.

The Detroit portrait illuminates the strengths and weaknesses of Copley's style at this point. His color sense is superb. Roupell's scarlet jacket provides an appealing color chord for the painting, and with his natty vest, walking stick, and gold-trimmed hat, the subject cuts a dapper figure. Copley seems to have encountered some difficulty, however, in bringing the painting to a point where he was satisfied with it. This is suggested by the numerous pentimenti, as well as by areas that have been extensively retouched, overpainted, or overglazed. To our knowledge, Copley had painted few full-lengths of single figures since his arrival in London—a fact that may have contributed to his struggle with the Roupell portrait.

Certain elements suggest Copley's vulnerability to Reynolds's influence. Prior to the late 1770s, Copley rarely used the open landscape setting, but Reynolds used it frequently. Since this area of the picture contains the most pentimenti, it is here that Copley seems to have had the greatest degree of indecision. Roupell rests his outstretched right arm on a masonry plinth, before him a somewhat unconvincing cascade of water. It is as though Copley could not decide whether to place Roupell in a woodland glade, to which the rivulet is appropriate, or stand him on a formal terrace beside a balustrade or plinth. The result is a somewhat half-hearted attempt to do both. Copley may have asked himself, consciously or unconsciously, how Reynolds would have handled the background. Reynolds had exhibited

at least three full-length portraits at the Royal Academy (in 1776 and 1777) that provided Copley with ready models. Each of the pictures—*Lady Georgiana Spencer, Duchess of Devonshire* (Huntington Library, San Marino, Calif.), *George John, Viscount Althorp* (Earl Spencer, Althorp, Northampton, England), and *Catherine Moore, Wife of Sir John Bamfylde* (National Gallery, London)—includes plinths, rivulets, or both. More effective is Copley's fluid handling of the cloud-filled sky and the gray birches in fall splendor, which provide an appropriate backdrop for Roupell's figure. These, too, are elements found in contemporary works by Reynolds. The Roupell portrait can thus be seen as a partially successful experiment on Copley's part to emulate both the form and bravura of Reynolds's style.

It is hard to believe that a demanding artist like Copley could have been entirely satisfied with this portrait in its present state. While his sense of color and anatomy are as vigorous as ever, other elements of the painting seem unresolved. In any event, the portrait is a clear example of Copley's ever-present desire to learn from his colleagues and to surpass levels of workmanship that would have satisfied lesser painters.

R. S.

Provenance The artist, London, ca. 1779/80–1815; his wife, London; their son, John Singleton Copley, Jr., Lord Lyndhurst, London. Gift to George Boone Roupell, Chartham Park, near East Grinstead, England; Brigadier George R. P. Roupell, Little Chartham, Shalford, Surrey, England. Sale, Sotheby's, London, November 21, 1979, lot 120. H. Schickman Gallery, New York. Acquired in 1983.

Exhibitions London, Royal Academy, 1790, no. 195 (as *Portrait of a Gentleman*).

References Graves 1905, 2: 159. Whitley 1928, 2: 376. Rutledge 1958, 269–270. Prown 1966, 266, 387, 439, fig. 388. Van Braam 1979, 129. *Apollo* 1980, 268.

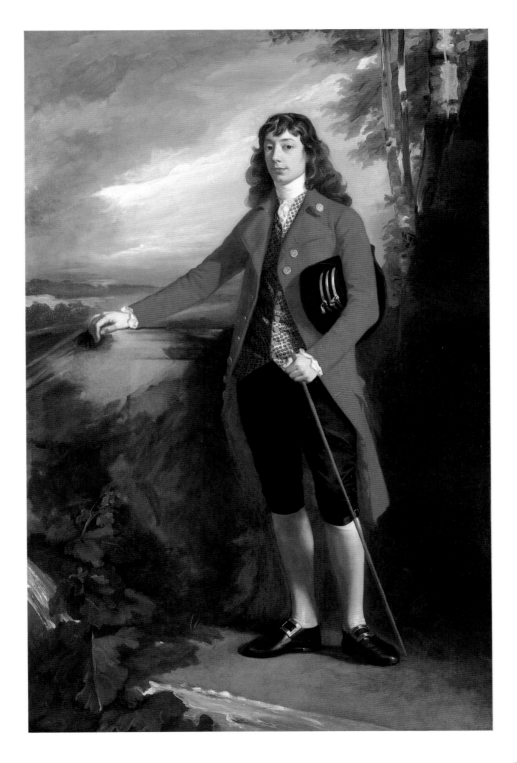

George Boone Roupell

26

Watson and the Shark, 1782

Oil on canvas
91.4 × 77.5 cm (36 × 30½ in.)
Founders Society Purchase, Dexter M. Ferry, Jr., Fund (46.310)

Of all Copley's paintings, *Watson and the Shark*, as it is now known, has stirred the most debate. The subject is the well-known story of Brook Watson, who, as a boy of fourteen, took an ill-fated swim in Havana harbor. Attacked by a shark, he lost his right leg before his friends could rescue him. The subject was painted by Copley to establish his capability to execute historical painting on a grand scale in the style of Benjamin West (q.v.). Copley had been painting portraits in London for over two years, but he longed to be recognized as a painter of historical subjects as well. In this instance, as has been recounted by Jules Prown (1966, 267–274), he deliberately selected a subject that was guaranteed to shock the public and apprise them of his talents. Although the event was of little historical importance and had taken place almost thirty years earlier, it still had currency, as the victim was then a leading London merchant.

The original painting, which Copley titled *A Boy Attacked by a Shark*, was exhibited at the Royal Academy in 1778. Its positive reception must have satisfied the artist's expectations. The *London Morning Post* (April 25, 1778) reported that "the softness of the colouring, the animation which is displayed in the countenances of the sailors, the effort of the drowning boy, and the frightened appearance of the man assaulting the shark constitute altogether a degree of excellence that reflect the highest honour on the composer," and the general reaction helped pave the way for Copley's admission to the Royal Academy in the following year. Shortly after the picture was completed,

Valentine Green produced and exhibited an engraving after it, titled *A Youth Rescued from a Shark,* also adding to Copley's prestige and to his purse.

The enthusiastic reception of the painting led to a succession of replicas and copies. The most thorough discussion of these, as well as of the historical aspects of the painting, are presented by Prown. The facts are as follows: Copley apparently painted a large version of the subject (National Gallery of Art, Washington, D.C.) for purposes of exhibition at the Royal Academy. This version is dated 1778, and most scholars have reasoned that it was probably commissioned by Brook Watson himself, since it was in his possession the following year, when engraved by Green. It was then bequeathed by Watson to Christ's Hospital in Horsham. Shortly after completing the original painting, Copley painted another large-scale version (Museum of Fine Arts, Boston), equal in size to the first and differing in only the slightest details. It is also signed and dated 1778. Why and for whom Copley painted this version is unknown. While Prown and others have listed it as being in the sale of paintings owned by Copley's son (Lord Lyndhurst), the record is incorrect. It seems more likely that the work was given by Lord Lyndhurst to a relative living near Boston (Amory 1882, 74). Four years later, Copley painted a third version. This is the painting now in Detroit, which is signed and dated with Copley's characteristic signature.

The present version differs from its two predecessors in several ways. Not only is it considerably smaller, but Copley replaced the horizontal format with a vertical one. A likely explanation (in Detroit and Philadelphia 1968, no. 44) for this is Frederick Cummings's suggestion that Copley considered the vertical format an improvement since it creates a visually compact interlocking pyramid of figures. At least one scholar (McCoubrey 1963) has viewed the third version as more pat and conventional but, even so,

the psychological drama of the moment depicted is intensified. While the specifics of the Detroit picture are virtually identical to the two large versions, the focus is sharpened, the contrasts strengthened, and details, such as the shark, emboldened. In addition to these autograph versions, there is a small horizontal canvas (Bayou Bend Collection, Museum of Fine Arts, Houston) so abraded in condition as to make it difficult to determine whether it is a copy by another hand or a replica by the artist.

Seven copies of the painting are also identified by Prown. Of these, a version at the Metropolitan Museum of Art was long thought to be the original sketch by Copley (as it appears to be the painting sold at the Lyndhurst sale), but recent opinion assigns it to another hand. Prown suggested, on circumstantial evidence, that it might be the work of Copley's half-brother Henry Pelham. A copy in ink and sepia wash (The Art Museum, Princeton University) is also thought to be by another contemporary hand.

Copley's selection of the subject is a good indication of the process by which he worked. It has been pointed out that Copley may have heard of Watson's mishap from the victim himself, or from Jonathan Clarke, Copley's brother-in-law, who sailed to Canada with Watson in 1776. In painting the subject, Copley also reasoned correctly that the ingredients of an exotic setting in the West Indies and a dreaded but little-known sea creature would attract a fair amount of attention.

Despite much discussion of the subject, there is still considerable disagreement as to its significance. On the surface, it seems obvious enough, and most scholars have agreed on the event depicted, but a number of prickly questions remain, and several different interpretations have been proposed as to its ultimate meaning. Prown summarized the traditional view that the painting was simply a re-creation of an unfortunate incident that had maimed a

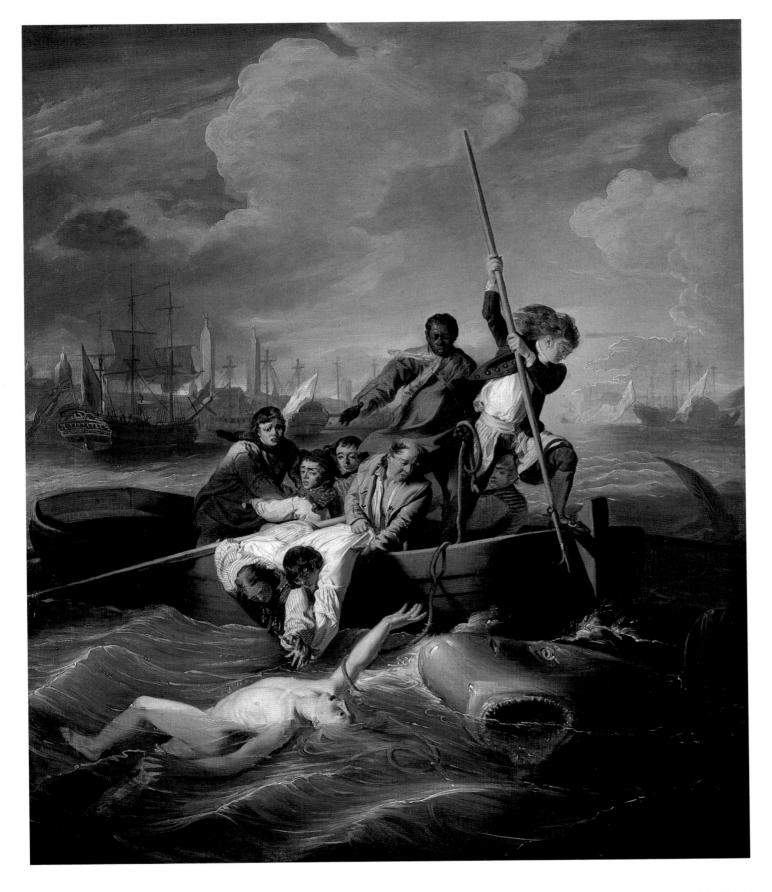

Watson and the Shark

London merchant. More recently, however, this viewpoint has been challenged by Roger Stein (1976), Irma Jaffe (1977), and Ann Abrams (1979). Jaffe argues that, far from being a simple narrative of a beastly accident, the painting contains a complex series of theoretical and aesthetic references. She suggests a religious symbolism for the work and cites association with Raphael's and Rubens's versions of *The Miraculous Draught of Fishes*. The painting is thus an expression of the Scriptures, with Watson as naked innocence receiving salvation in the Church.

Stein likewise sees Copley as borrowing from Raphael but chooses to interpret the painting as a new type of seascape resulting from a fusion of neoclassical aesthetics and inherited Puritan tradition. Perhaps the most complex and intriguing of recent interpretations is that of Abrams, who finds political sentiments expressed in the picture. She links the painting to a long tradition of English political cartoons as well as to Copley's reliance on prints for inspiration. Among the sources she points out as being at Copley's disposal is a print called *The Deplorable State of America* (Library Company of Philadelphia)—which bears the inscription *The Original print done in Boston by J°S Copley*, the satirical message of which is Liberty's demise at the hands of unscrupulous European powers. Its themes of death and danger indicate that Copley had experimented with those subjects before. Stein's conclusion is that Watson can be seen as a symbol of virtue, individual freedom, and the positive elements of British commerce and prosperity. To Abrams, Watson's severed leg is America, lost in the irresponsible political maneuvering that led to the Revolution and, ultimately, Britain's dismemberment.

Whether any of these complex levels of meaning would have been grasped by Copley's audience is unclear. In the search for meaning it should not be overlooked that the painting's impact is not dependent upon intricate webs of philosophical intent. Copley well understood that the success of a historical painting results not so much from allegory and symbol, useful though they may be, but rather from the graphic portrayal of an event to which the viewer has an immediate emotional response. It is this quality that sets *Watson and the Shark* apart from the paintings by many of Copley's contemporaries.
R. S.

Inscriptions At lower left, *Painted by J. S. Copley R.A. London/1782*

Provenance Noel Desanfans, before 1786. Sale, Christie's, London, April 8, 1786, lot 396. W. Goddard, by 1791. Sale, Christie's, February 5, 1791, lot 73, sold to Green. G. P. Anderson, London. W. P. Hunter, London, ca. 1850. M. Knoedler Co., London, 1946. Acquired in 1946.

Exhibitions Brooklyn 1949a, 15, no. 33. Colorado Springs 1949, 19. Detroit and Philadelphia 1968, no. 44. Los Angeles 1974, 31, no. 4. Kansas City 1977, no. 28.

References Richardson 1947a, 213–218. Newberry 1949, fig. 1. Detroit 1957, 94, fig. 40. McCoubrey 1963, 20, pl. 14. Mastai 1965, 67. Gardner and Feld 1965, 50. Prown 1966, 460, fig. 373. Boston 1969, 81. Cummings and Elam 1971, 153. Williams 1973, 27, fig. 8. Stein 1976, 88–89. Bush 1977, 299–301. Rivard 1978, 1044–1045, pl. 1.

27
Colonel George Lewis, 1794

Oil on canvas
76.5 × 63.5 cm (30⅛ × 25 in.)
Founders Society Purchase with funds from Mr. and Mrs. Richard Manoogian (70.560)

For eight long years, Copley worked continually on his painting *The Siege of Gibraltar* (finished 1791; Guildhall Museum, London). The composition celebrated one of the great British military victories of the 1770s, when England's forces withstood a massive assult by floating batteries directed at them by the French and the Spanish. After completing the mammoth painting, which measures twenty-five feet in length, Copley once again had time to devote to painting portraits. One of the Gibraltar participants, whose relatives commissioned a portrait of him shortly thereafter, was Colonel George Lewis (?–1791). At the time of the siege, Lewis was a captain in command of the artillery. He is prominently depicted in the first row of Copley's large-scale painting.

The Detroit portrait is not included in the Copley literature, since it was unknown until it appeared at auction in London in 1969. When sold, it was accompanied by its original bill of sale, written in Copley's hand, which reads:

Feby 1794— / Receit from J. S. Copley Esqr. For a Portrait done by him from His / Picture of The Siege of Gibraltar, / placed in the Chamber of London in ye Year / 1792 / of Colo George Lewis

Portrait	£31.10 –
Frame	3.3.
Case ditto	.8.
	£35.1. –

Lewis is depicted in the exact pose Copley selected for him in his large history picture. Since the likeness is a posthumous one, the reason for this is self-explanatory. His somewhat strained turn of the head is

a result of the angle at which he peers out over the British south bastion to view the floating batteries exploding in the distance. In the background of the Detroit portrait, Copley included a single burning wreck to remind the viewer of the event.

Colonel Lewis had a distinguished military career. On the basis of his performance at Gibraltar, he rose in rank from captain to major. By 1790 he had been promoted to colonel, the rank he held at the time of his death. The black uniform with scarlet lapels is that of an artillery officer, and according to the military historian Major R. G. Bartelot, it was a uniform that Lewis had had for some time; parts of it were out of date by 1780 (letter from Bartelot to Elizabeth Gaidos, October 6, 1970, curatorial files, DIA). For example, his black cocked hat, if up-to-date, would have been trimmed with gold braid. The single epaulet denoted a junior officer and is correct for the captain's rank Lewis held at Gibraltar.

Copley did have to make one minor adjustment when translating Lewis's portrait to the smaller format. In the large picture, the Colonel's right hand rests on his sword hilt, as though it were a cane. The smaller proportions of the Detroit picture prevented this placement, so Copley turned the hand inward and tucked the sword hilt under it. Here, as in other late Copley portraits, the technique is loose, the flesh tones are bright pink, and fussy detail is absent. The portrait marks the last decade during which Copley was a figure of consequence. By 1800 he was no longer capable of such forcefulness.
R. S.

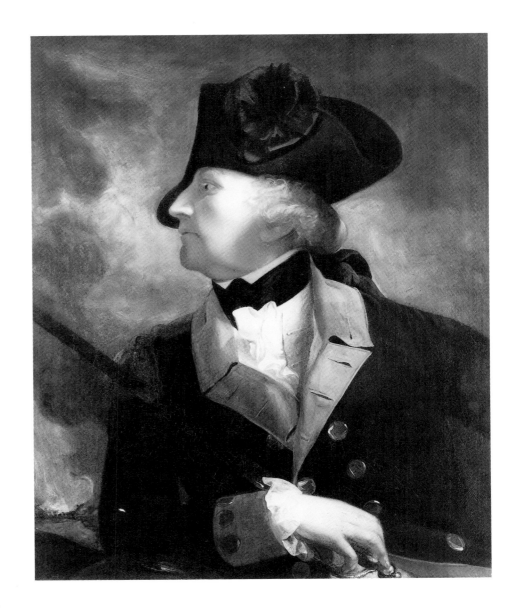

Provenance By descent in the sitter's family. Sale, Sotheby's, London, November 19, 1969, lot 42. Leger Galleries, Ltd., London, 1969. Acquired in 1970.

References Prown 1966, 489, 495–499. Hood et al. 1977, 73–75.

Colonel George Lewis

The first major American artist to devote himself primarily to landscape painting, Thomas Doughty can be considered both a progenitor and a transitional figure who emerged from an indigenous craft tradition. For the most part he was self-taught and, evidently, self-motivated, since, except for his eldest brother, William (b. ca. 1763), who practiced as a naval draftsman, the Doughty family was without background in the fine arts. As a young man, Doughty was apprenticed to and for a time worked in partnership with another older brother, Samuel, as a leather currier. In 1816 he attempted to break from that profession by becoming a painter, at first with mixed results, then in 1820 with a firm resolve and ascendant achievement. Within four years he had become a cultural fixture in Philadelphia, obtaining full membership in the Pennsylvania Academy of the Fine Arts, numbering Thomas Sully (q.v.) and Chester Harding (q.v.) among his close friends and frequent sketching companions, and attracting praise from the writer John Neal, who declared that Doughty was one of just three noteworthy American landscape painters of the day.

Doughty was soon seeking new career horizons, however. Between 1828 and 1830 he moved to Boston, intent on establishing himself in what he hoped would prove a still more congenial artistic environment. When these expectations were not fully realized, he returned to Philadelphia to work with another brother, John, on a monthly publication titled *The Cabinet of Natural History and Rural Sports*, for which Thomas provided illustrations of animals and birds. Shortly before that venture closed in 1832, he moved again to Boston, this time with notably greater success. In late 1837 and early 1838, he traveled to England for a brief stay, afterward settling in New York City for much of the remainder of his life. Another, more prolonged European sojourn from 1845 to 1847 was spent in London, Paris, and—perhaps—Italy.

Despite bouts of ill health, disagreements with critics, bitterness toward what he regarded as neglect by his colleagues, and a patronizing evaluation of his work in 1834 by William Dunlap (q.v.), the first systematic chronicler of American art, Doughty's professional success reached its zenith during his second Boston residence. The 1840s and early 1850s were marked by considerable public interest in his creativity and respect for his professional eminence, as well as by difficulties. In 1845 and 1847 his contributions to the Royal Academy exhibition in London and the Paris Salon, respectively, attracted praise from foreign and American commentators, and a lecture on landscape painting he presented in March 1849 in New York City was well received. During the spring of 1851, the editor of the New York *Home Journal* published two extended accounts of his activities. When the *New York Herald* aired his lengthy denunciation of the American Art-Union on November 27 of the same year, many other American artists, as well as the *Herald* itself, were voicing strong dissatisfaction with that organization. In the end, however, sympathy proved an inadequate substitute for patronage and financial solvency, and just prior to his death he was reported to be destitute.

G. C.

Bibliography Philadelphia et al. 1973.

28

In Nature's Wonderland, 1835

Oil on canvas

62.2 × 76.2 cm (24½ × 30 in.)

Founders Society Purchase, Gibbs-Williams Fund (35.119)

Doughty's best-known work and one of the most renowned paintings from the first generation of the Hudson River school, *In Nature's Wonderland* is nevertheless thinly documented in almost every essential respect—title, exhibition history (if any) in the nineteenth century, subject matter, the relationship between artist and initial owner, and provenance. The title, apt as it is considering the sentiment of the composition, is a modern one coined by the Boston dealer Robert Vose when he acquired the work from a local private collection around 1935. The original title has been lost and with it, perhaps, access to clues about public awareness of the work during the artist's lifetime. A search of nineteenth-century American exhibition records yields no conclusive result when a spectrum of possible old titles is taken into account.

Twentieth-century scholars have sometimes assumed that the scene is set in the Adirondacks, but the artist's wide-ranging sketching trips through New England and upstate New York during the mid-1830s permit a broader range of possibilities for the locale—if, indeed, Doughty intended to represent a topographically explicit theme. No firm information survives pertaining to the circumstances in which John Dix Fisher (1797–1850) commissioned the picture. One may assume that the patronage of this eminent Boston physician and educator of the blind is traceable to his elder brother, Alvan Fisher (1792–1863), a Boston painter with whom Doughty became a close friend during Doughty's second residence in that city between 1832 and 1837; but more than that cannot, at present, be said. While the painting appears to have remained in the Boston area during the first century of its existence, its whereabouts after John Fisher's death are unclear.

These uncertainties aside, the painting itself, in combination with statements made by the artist in 1849 about his profession, provides the most useful insights into his purposes. The subject and style of the picture suggest that, at the midpoint of his career, Doughty perceived the aesthetic

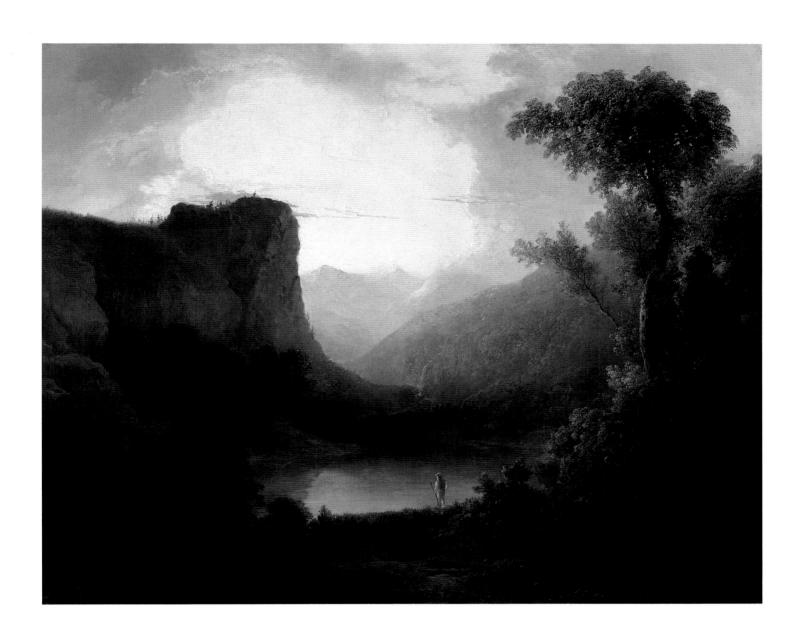

character of the northeastern United States landscape in terms of a balance between sublimity and arcadian reverie. Holding a flintlock rifle at his side, a lone male figure stands at the lower middle of the composition, looking across a lake with a barely quivering surface toward shadowy precipices at the left, light-resplendent mountains in the central distance, and a delicate halo of sunset (or possibly sunrise) clouds above. These elements, in conjunction with the framing trees at the near right, direct the viewer's attention to the glowing patch of clear sky at the upper left. Despite the composition's swirling movement and its strong visual pull into the distance, the pace of nature has been slowed, in general, almost to a standstill. Doughty's figure, and in turn the spectator, gaze into a rugged, ethereal wilderness from which the element of time virtually has been removed. The strong contrasts of dark against light, of rugged rocks against soft foliage, as well as the curving, funnel-like spatial organization, are reminiscent of the early works of Thomas Cole (q.v.), some of which Doughty could have seen in Boston in the early 1830s or in Philadelphia at a previous date. The handling of light, edges, and paint—noticeably softer than that of Cole—recalls the landscapes of Washington Allston (q.v.), examples of which Doughty surely knew in Boston, as well as the portraiture of Doughty's Philadelphia friend Thomas Sully (q.v.).

At the outset of his career, Doughty's enthusiasm for nature study was carried over into his easel paintings, but in maturity his studio productions became what his contemporaries and modern critics alike have regarded as formulaic and conventional. Doughty himself, however, seems to have remained unrepentant. In a lecture presented at Astor House in New York City in March 1849, he argued that "every artist was at liberty to exercise his own taste, and indulge in either the free or the finical, the cool or the warm styles of manipulation of color" (*New York Evening Post*, March 13, 1849, 2). As his remarks in other portions of the lecture make clear, this advocacy of laissez-faire creativity arose in part from Doughty's disenchantment with art critics, many of whom were by then not favorably disposed toward his work. But still other sections of his disquisition, some of which are applicable to *In Nature's Wonderland*, stand as statements of disinterested theorizing. Among these is the general observation that "the true criterion of a work of art is in its capacity to awaken emotions of delight, and to repeat them." More specific is what amounts to a justification for the idealized, atmospheric character of many of his mature and late paintings:

When we look at nature, our eyes invariably seek the most interesting point within the scope of vision, consequently the obtrusion on the mind of a particular form ... would be a discord. It is the whole, and not the part of the picture, we look at. . . . The practice of high finish is held in abomination by the best masters of the English and American school; and for one, we should deprecate a taste which aims to subvert an authority so great. What becomes of the *finish* of a picture when hung on the walls of our houses and seen at the proper distance? There is but one palliative for exquisite finish—i.e., the purchaser gets *work* enough for his money.

G. C.

Inscriptions At lower center, T. DOUGHTY / *1835*; on the back (visible before relining), *Painted by Tho's Doughty for John D. Fisher M.D. 1835*

Provenance John D. Fisher, Boston, 1835. Mrs. Samuel Hammond, Boston. Vose Galleries, Boston, 1935. Acquired in 1935.

Exhibitions Detroit 1944, 29, no. 42. Chicago and New York 1945, 37, no. 82. New York 1949, no. 3. Washington 1959, no. 19. Philadelphia et al. 1973, 17, 27, no. 32. Rome 1980, 3.

References C. Burroughs 1936, 86–87. Detroit 1957, 157. Washington 1959, 38. McCoubrey 1963, 37, pl. 23. Detroit 1965, 35. Callow 1967, 122, pl. opp. 114. Wilmerding 1967, 39, 91. Wilmerding 1970, 5–6, 31, pl. 13. Cummings and Elam 1971, 138. Brown et al. 1979, 193–194. Thistlewaite 1979, no. 47.

William Dunlap

1766 PERTH AMBOY, NEW JERSEY—
NEW YORK 1839

Despite a desultory formal education, William Dunlap developed an early interest in books and pictures that was to be of great value to him. In 1762, after a few art lessons in New York, he began to draw portraits in pastels and, through a friend, obtained the coveted opportunity to do a life portrait of George Washington (United States Capitol) in 1783. A year later he visited England to study with Benjamin West (q.v.).

As an only child who had accidentally been blinded in one eye, Dunlap had always been indulged by his parents. Away from them in London, he found the self-discipline necessary for an artistic career particularly difficult. As a result, Dunlap returned home in 1787, having made little improvement as an artist but having spent a great deal of time in London theaters. He apparently enjoyed the experience so much that, about six years later, he abandoned portrait painting temporarily (except for the occasional miniature) to write plays and to manage a New York theater. Lacking success in this area, he finally became an itinerant painter of small portraits in about 1812. During the 1820s he created his most challenging pictures, a series of large canvases based upon the life of Christ and intended to be the attraction of admission-charging road shows. Only one painting from the series survives, and it is so closely imitative of a work by West that it is generally considered to be inferior to Dunlap's small portraits and his few known "conversation pieces." Yet this painting, *Christ Rejected* (1821–22; Princeton University), attracted crowds and was relatively successful as an exhibition picture.

Dunlap helped to found the National Academy of Design in New York in 1826, but he is best known today as an author. His most important works are *History of the American Theater* (1832) and *History of the Rise and Progress of the Arts of Design in the United States* (1834). The latter is without equal as a major source of information on early American artists.

D. E.

Bibliography Dunlap 1834.

29
Adjutant General David Van Horne, 1793/1801

Oil on canvas
76.8 × 61.6 cm (30¼ × 24¼ in.)
Gift of Dexter M. Ferry, Jr. (54.233)

The identity of the sitter in this portrait was lost for over sixty years. When the painting surfaced on the New York art market in 1954, it was mistakenly called a portrait of General Anthony Wayne (1754–1796). Then a dealer discovered that it was reproduced with the Van Horne identification in Clarence Bowen's 1892 *History of the Centennial Celebration of the Inauguration of George Washington*.

David Van Horne (d. 1807) served in the Continental Army, resigning his commission in 1779. In 1786 he was made a major in the New York City Brigade of the New York State Militia. He rose to lieutenant colonel in 1789 and acted as adjutant general from 1793 to 1801. The years of his promotions are an important means of dating this picture since Dunlap shows him in uniform. According to Colonel Frederick P. Todd, formerly director of the West Point Museum, the soldiers can be identified as the German Grenadiers, a New York City corps who marched, as did Van Horne, in George Washington's inaugural procession in 1789; thus the picture may commemorate that event (letter from Todd, April 7, 1954, curatorial files, DIA). Donald Kloster, curator of armed-forces history at the National Museum of American History, more recently placed the painting later, however, since Van Horne appears to be represented as an adjutant general in the militia's artillery division. He holds a form labeled "Inspection Return" as he reviews the line of grenadiers (not necessarily German Grenadiers) at the lower right (letter from Kloster, May 9, 1985, curatorial files, DIA). This would support a date of sometime between 1793 and 1801, although more probably 1793, when the sitter might have wanted to commemorate a promotion and when Dunlap was less involved in the New York theatrical world.

The Detroit portrait, despite its size, shows all the signs of being the work of a miniaturist. It is done with a keen sense of decorative color and great delicacy of handling. The artist paid careful attention to such minor details as the articulate highlighting of the braided epaulets, watch fob, sword hilt, and medal of the Society of the Cincinnati. Even the pencil in Van Horne's hand casts a meticulously observed shadow from below one finger to above another. The portrait is also the work of an artist who conceived of painting chiefly in terms of coloring between outlines, again perhaps a legacy of miniature painting.

D. E.

Provenance Charles Isham, New York, 1892. Augustus Van Horne Stuyvesant, New York, by 1917; his son, A. Van Horne Stuyvesant, Jr. Victor D. Spark (dealer), New York, 1954. Acquired in 1954.

Exhibitions Chapel Hill 1968, 27.

References C. Bowen 1892, 537 (as probably by William Dunlap). Coad 1917, 302, no. 19. *BDIA* 1954–55, 14.

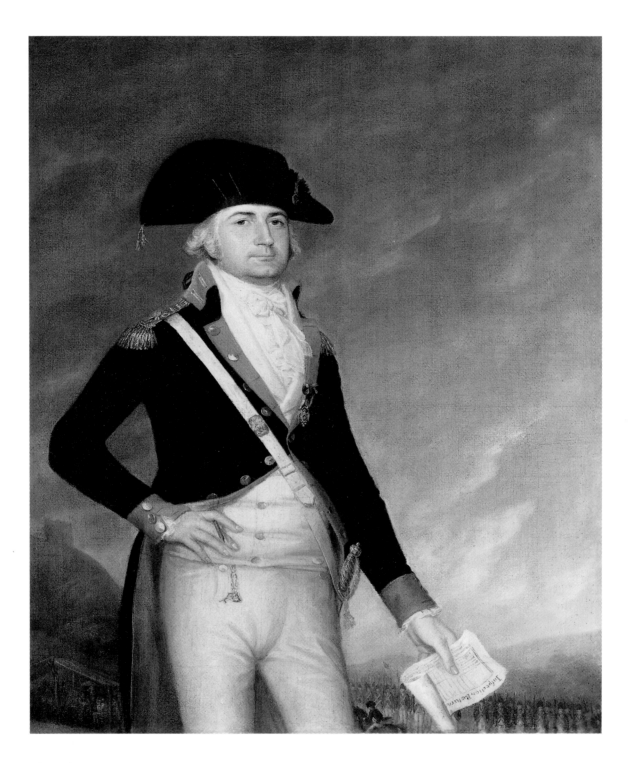

Adjutant General David Van Horne

Asher Brown Durand

1796 JEFFERSON VILLAGE (MAPLEWOOD),
NEW JERSEY 1886

Asher B. Durand's artistic career of more than sixty years' duration can be divided into three partially overlapping chronological phases and as many professions. His earliest occupation, in which several members of his family participated during the first half of the nineteenth century, was that of engraving. Following an apprenticeship with the Newark (New Jersey) engraver Peter Maverick (1780–1831) between 1812 and 1817, Durand at first entered into partnership with his former master; in 1823 he co-founded with his brother Cyrus Durand (1787–1868) a New York engraving firm, which continued in business until 1831. Asher Durand's individual talents as a pictorial engraver, meanwhile, prompted John Trumbull (q.v.) to commission an engraving of his own *Declaration of Independence* from the young printmaker in 1820. Durand concluded his printmaking activities in 1835 with a renowned engraving after *Ariadne Asleep on the Island of Naxos* by John Vanderlyn (q.v.), a painting purchased by Durand himself in 1830.

In the 1820s Durand also began developing his own capabilities as a painter, at first primarily through portraiture, then increasingly in landscape. As a portraitist, he was especially successful in the 1830s, exhibiting twenty-six portraits at the National Academy of Design between 1833 and 1838, contributing to a sumptuous

four-volume publication, *The National Portrait Gallery of Distinguished Americans* (1834–36), and obtaining several commissions from Luman Reed (1705–1836), who had funded Durand's engraving of Vanderlyn's *Ariadne*.

Eight landscape paintings displayed at the National Academy of Design in 1838 signaled Durand's commitment to that branch of art to which, with only a few digressions, he remained devoted for the balance of his career. His earliest landscapes are constructed in broad, simplified planes broken by clusters of detail, a tendency doubtless derived from his practices as an engraver. In the early 1830s and more frequently after 1844, however, he established a precedent in the history of American art when he began to paint exacting outdoor oil studies, a practice that soon imparted a characteristic specificity and freshness to his studio works. In the most representative of these studies, and in the easel paintings developed from them, groups of trees in the foreground lean slightly toward an atmospheric view into the distance on the opposite side.

Although in the late 1830s and 1840s he painted several single and sequential allegorical compositions inspired by the work of his friend Thomas Cole (q.v.), Durand eschewed ambitious historical content and potent romantic flavorings, for the most part, in favor of pastoral poetry and serene spiritual sentiments. His views on the subject were articulated in five "Letters on Landscape Painting" published in *The Crayon* during 1855, when the periodical was edited by his son John Durand (1822–1908).

While Durand's art was often criticized as repetitious and old-fashioned after 1860, he remained a respected figure for his role in the formation of the American art profession as a whole and for his pioneering efforts in landscape painting. One of the founders of the National Academy of Design in the mid-1820s, he had risen through various academy offices to become its president between 1845 and 1861. He was also an ardent advocate of the American Art-Union, prior to that institution's demise in 1852, and had helped to organize the Sketch Club in New York in 1826. He traveled in Europe only once, for eighteen months in 1840 and 1841. Otherwise he remained mostly in the vicinity of New York City, frequently sketching in upstate New York during the summers.

G. C.

Bibliography Lawall 1977.

30
View of Rutland, Vermont,
ca. 1839–40

Oil on canvas
74 × 107 cm (29⅛ × 42⅛ in.)
Gift of Dexter M. Ferry, Jr. (42.59)

This painting first came to light in 1942. On April 7 of that year, the New York dealer Victor Spark wrote a letter (curatorial files, DIA) to Clyde H. Burroughs, curator of paintings at the Detroit Institute of Arts, explaining that the scene, "painted between 1840 and 1850 . . . represents the property of Luman Reed in Rutland, Vermont, and was purchased [by Spark] from a direct descendant. Mr. Reed was Durand's patron. It has never before this year been out of the possession of the Reed family." To date, Spark's letter is the only known document pertaining to the provenance of the picture.

While Luman Reed himself, a lifelong New Yorker who died in 1836, cannot have been personally associated with a Vermont landscape painted around 1840, his daughter Mary, who in 1831 married a Rutland resident, Dudley B. Fuller, could have remained on friendly terms after 1836 with one of her father's favorite artists. David Lawall (Montclair 1971; Lawall 1977) has related the Detroit work to a letter to Durand (Durand Papers, New York Public Library), dated Rutland, Vermont, June 27, 1839, from Horace Fuller, Dudley Fuller's brother:

My brother is determined that you shall paint a picture for him of this village. . . . The point from which the picture is to be taken is about 1 mile west. I have been there today with my friend Mrs. Geo. J. Hodges & we have settled that the subject is without doubt the finest in creation, to say nothing of the additional interest of its being our native place. . . . I beg of you not to omit seeing Mrs. Hodges & taking a sketch so that you can finish at your leisure.

In a letter to his wife (Durand Papers, New York Public Library) written in Boston three days later, Durand announced his intention to return to New York "by way of Rutland."

Except for some minor adjustments, most of them in the foreground, the Detroit painting closely follows the prescription outlined by Horace Fuller. From a location about one mile west of Rutland, the viewer looks across Otter Creek and green pastures toward the town, which stretches in a north-south direction along Main Street at the foot of East Mountain in the left distance. The steepled buildings are presumably intended to represent, from left to right, the Congregational Church, the courthouse, and the Baptist Church. A few of the more substantial summits of the Green Mountains, among them Killington Peak (which projects above East Mountain at the left) and Shrewsbury Mountain (the tallest peak at the right), rise in the far distance. The foreground is enlivened by a pair of elegantly dressed couples relaxing beneath the tall trees at the left; a picturesque clutter of vegetation, rocks, and tree stumps stretching across the near middle; and a wooden truss bridge of unusual design spanning the creek at the right.

Lawall's assumption that Durand exhibited the present work at the National Academy of Design in 1840 as *Landscape, View of Rutland* (no. 174) can be verified through a lengthy critique of a picture of that title written by a New York reporter at the time:

Here is another striking proof of the versatility of talent possessed by Durand. This is really a very pleasing picture, although it is altogether too tame, too flat, and too grassy green. It also wants gradation, and is destitute of effect. The clouds are by no means so good as they might be, or as this artist can paint. The foreground is entirely too weak. The bridge is dingy and snuffy, the aerial perspective is not near as good as that of his large pictures in the other room. The long low hill in the foreground, and the distant mountains appear all on the same plane. It is a pretty picture but not truthy [*sic*]. There was a fine chance for skillful touches on the low broad slope of the hill which has not been taken advantage of. The light is not well managed, and the whole picture looks too unfinished to please us; still it is a great relief among a lot of unmeaning daubed up portraits (*New York Weekly Herald*, June 27, 1840, 230).

The "large pictures in the other room" praised by the reviewer were *Landscape, Composition, Evening,* and *Landscape, Composition, Morning* (both dated 1840; National Academy of Design, New York), the major works Durand exhibited in 1840. These paired allegorical compositions, which in their derivation from Thomas Cole's historical paintings strike a note distinctly different from the topographically explicit *View of Rutland*, nevertheless share many formal characteristics with the latter, particularly the broad, relatively flat surfaces and generalized detailing that distressed the *Herald's* critic. Within a few years, Durand developed a more realistic, atmospheric, and firmly painted style to which he adhered self-confidently for the rest of his career.
G. C.

Provenance Dudley B. Fuller, Rutland, Vermont, 1840; descendants of Fuller. Victor Spark (dealer), New York, 1942. Acquired in 1942.

Exhibitions Detroit 1944, 38, no. 57. Chicago and New York 1945, 47, no. 103. Washington 1949, no. 5. Columbus 1952, no. 13. Montclair 1971, 54, no. 43. Buffalo et al. 1976, no. 9.

References *New York Weekly Herald,* June 27, 1840: 230. Detroit 1944a, 41. Richardson 1944, 31. Detroit 1965, 36 (dated ca. 1840–50). Lawall 1977, 232–233 (dated ca. 1840). Lawall 1978, 32, no. 64.

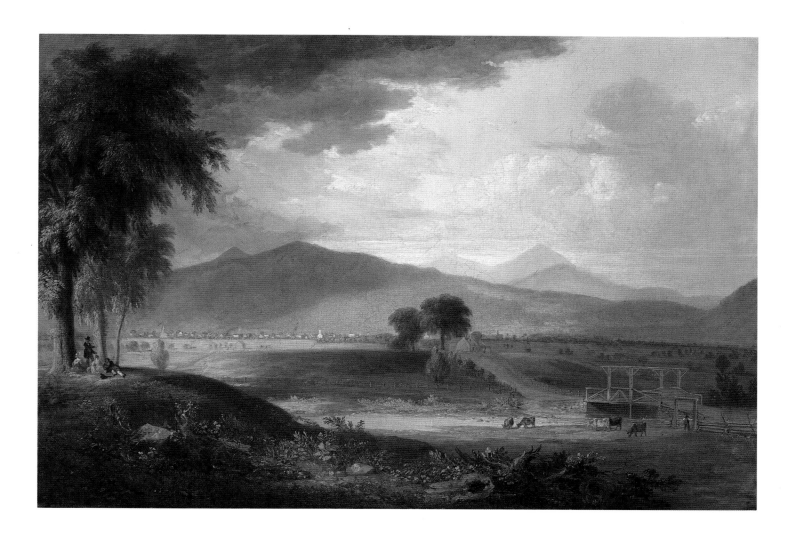

View of Rutland, Vermont

31

Forest Scene in the Catskills,
ca. 1855–60

Oil on canvas
38.1×61 cm (15×24 in.)
Gift of Mr. and Mrs. Harold O. Love (77.93)

Oil studies such as the Detroit work played a major role in Durand's artistic practice. Beginning in 1844, he allocated much of his outdoor sketching to the painting of detailed, close-up woodland scenes, the majority of which focused on groups of a few trees or a single tree. Presumably most of these studies were carried considerably forward, as well as commenced, *en plein air.*

From the first, Durand regarded these works as more than private exercises to be consulted during the preparation of his easel paintings. Already in 1844, and more often by the late 1840s, the boundaries between his outdoor and indoor productivity blurred as he exhibited and offered for sale some of his "studies," and as numbers of his easel pictures assumed the compositional character of enlarged "studies." During the following decade, collectors occasionally sought out his on-the-spot sketches. Within another ten years, the demand—and the artist's readiness to meet it—induced Durand to place on sale one hundred oil "studies from nature" at the New York auction house of Leeds and Miner on December 5, 1867. A posthumous sale of eighty such sketches was held at the Ortgies Gallery in New York nearly twenty years later, on April 14, 1887. Judging by the titles of many of the works listed in the two sale catalogues (see Lawall 1977, 196–208), Durand was conscious of the individual character of his subjects; that is, he approached the task of recording nature's vignettes, which he might conceivably have encountered anywhere in the Northeast, with the topographical exactitude usually reserved for scenes of larger scope. Unfortunately, the catalogues' compilers failed to publish a date for any item on sale in either year, probably because the artist himself did

not date most of his works, and dimensions of the works are listed only in the 1887 catalogue.

Like most of Durand's oils that fall into the category of "nature studies," the Detroit example is undated, bears a somewhat crude initialed signature, and carries a modern title of unknown origin that can be linked only by inference to titles recoverable from the nineteenth century. Also characteristic of known examples of these works is the fifteen-by-twenty-four-inch format (several studies in the 1887 sale are recorded at approximately that size); the even lighting, overall green tonality, and careful differentiation of textures and tonal gradations in the scene itself; the slightly crusty, unadventurous paint handling is likewise a recurrent feature of such studies.

The specific, atypical aspects of the Detroit picture provide a few clues to its place in Durand's oeuvre, however. By far the most noteworthy feature of the work is its subject, an immense tree trunk fallen across the viewer's path, acting as an apparently insurmountable barrier to the forested wilderness beyond. From time to time during his career, Durand accentuated the monumental and the sublime—for example, in *Study of a Wood Interior,* usually dated to the mid-1850s (Addison Gallery of American Art, Phillips Academy, Andover, Mass.), a giant, moss-covered boulder that clogs the center of the composition in a manner analogous to that of the fallen tree in the present work. Several titles in the 1867 and 1887 sale catalogues that refer to "fallen tree[s]" demonstrate this recurrent interest in similar themes. More specifically, *Decayed Log, Catskill* (1867 cat., no. 31) and *Fallen Trunk, East Kill, Catskill* (1887 cat., no. 290, just under fifteen by twenty-four inches) confirm that Durand discovered in the Catskills subjects related to that of the Detroit study. That the present work is stylistically consonant with his easel paintings and oil studies securely dated be-

tween the mid-1850s and early 1860s and that Durand paid several summertime visits to the Catskills during those years tends to affirm the accuracy of the current title and to indicate a date of execution in that period.

G. C.

Inscriptions At lower right, *ABD*

Provenance Kennedy Galleries, New York, 1960. Harold O. Love, Grosse Pointe Woods, Michigan. Acquired in 1977.

References *Kennedy Quarterly* 1959, no. 5. Cornell 1983, no. 407.

32

Monument Mountain, Berkshires,
ca. 1855–60

Oil on canvas
71.1×106.7 cm (28×42 in.)
Founders Society Purchase, Dexter M. Ferry, Jr., Fund (39.6)

Both the subject matter and the probable date of this fine specimen of Durand's mature work are difficult to pin down. One problem is the title by which the work has been known since its acquisition by the Detroit Institute of Arts in 1939. Assuming that the title is accurate and that it originated in Durand's time, the spectator's position is presumed to be along the Housatonic River looking northeast toward Monument Mountain, a peak in the Berkshires located just southwest of Stockbridge, Massachusetts. But in fact, the feature shown in the distance of the painting bears only general resemblance to that particular peak as seen from that vicinity. Furthermore, the vantage point itself is curious, considering that the most distinctive aspect of the mountain is its rocky eastern summit. A more characteristic prospect of the mountain is seen from accessible viewpoints looking southwest from nearer Stockbridge, as Frederic E. Church, for example, recognized in three drawings he made in 1847 (Olana State Historic Site, Hudson, N.Y.).

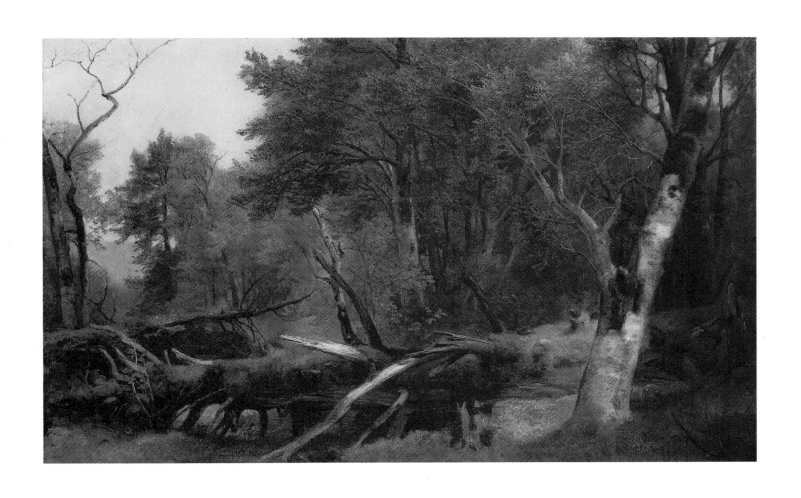

Forest Scene in the Catskills

Another difficulty is the unusual omission of a date on a canvas of this size in Durand's mature work. It is possible that the precisely lettered signature was originally paired with a date, although recent examination of the lower left corner of the picture has yielded no firm conclusions on the question. At most, it can be said that there has been some damage and subsequent retouching in this area, as well as substantial repair to the middle left side of the canvas in general.

Adding to the uncertainty is the fact that, while he did not frequently use this compositional type, Durand did revert to similar formal arrangements on several occasions throughout his career. As Lawall (1978) pointed out, the closest counterpart, a twenty-one-by-thirty-two-inch canvas titled *The Sketcher* (1870; Randolph-Macon Woman's College, Lynchburg, Va.), was the artist's sole contribution to the National Academy of Design exhibition of 1870 (no. 403). The close compositional correspondence between *The Sketcher* and the Detroit work induced Lawall to date the latter around 1869 and to associate it with Durand's summertime travels of that year, undertaken in part so that the artist could fulfill a commission from Walter Wright of Chicago for a two-by-three-foot painting depicting "the scenery of Berkshire County, Mass." (Lawall 1978, 149). Durand had received Wright's request at the end of May 1869.

Durand's movements in 1869 are meagerly recorded. A single newspaper report (*New York Evening Post*, October 4, 1869, 2) that he had "just returned from a sketching tour of the Adirondack region" places him, indirectly, not far from Stockbridge, Massachusetts. His subsequent studio activities, by contrast, are documented extensively. To the lengthy references to Wright's painting (destroyed in 1871; a replica painted by Durand for Wright is now in the New Jersey State Museum, Trenton) assembled by Lawall (1978, 150–158) may be added a mention of the work in progress in the same

Evening Post report, and an extended appreciation of the completed composition by the same paper two months later (reprinted in the *New York Albion*, December 4, 1869, 739). At almost the same moment, Durand was working on a picture, slightly over fourteen by twenty-four-inches, now known as *Landscape, a Peaceful Day, Sunset* (1870; Washington University, St. Louis; see Lawall 1978, 151–153). Previous to its sale in mid-1870 to Samuel A. Coale, Jr., of St. Louis, that painting was exhibited at Goupil's Gallery in New York under the title *New England Landscape* (*New York Evening Post,* January 3, 1870, 1). To the spring 1870 exhibition of the Brooklyn Art Association Durand sent a *New England Hillside* (no. 36, unlocated), presumably a work of small size. And while it did not attract much attention at the National Academy of Design, *The Sketcher* was accorded a complimentary mention in London's *Anglo-American Times* (June 25, 1870, 14) and a lengthier, equivocal notice in the *New York Evening Mail* (April 27, 1870, 1).

Of the aforementioned paintings identifiable today, two that are dated as well as signed are smaller than the Detroit work. That the replica version of Wright's picture, which is likewise of smaller size than the Detroit painting, is both signed and dated (1872) suggests that it was the artist's practice to provide full inscriptions at that time. Furthermore, all three extant compositions contain figures, and two—*Landscape, a Peaceful Day, Sunset* and the replica of Wright's canvas—are idyllic, atmospheric, and picturesque, a mood that Durand often evoked in his late pictures. The painting that appears to have signaled his turn to this nostalgic mode, *A Summer Afternoon* of 1865 (Metropolitan Museum of Art, New York), was also unveiled at Goupil's Gallery (*New York Evening Post,* March 3, 1865, 2). In addition, although Durand's handling of paint tended to vary within narrow limits from work to work—rather than undergoing a pronounced evolution once he had attained artistic maturity in the late 1840s—the crispness of the 1850s softened, on

the whole, during the 1860s as his thematic preferences drifted in an analogous direction. Even the monumental reprise of his woodland studies of the 1850s, *The Edge of the Forest,* painted in 1871 (Corcoran Gallery of Art, Washington, D.C.), partakes of a less sharply focused aesthetic, as does *The Sketcher* of 1870.

Given the lack of documentation from 1869 to 1870 for a picture of the size, ambition, and clarity of the Detroit work, as well as the distinctly different characteristics of several Durand paintings that can be dated to those years, it is tempting to postulate for it a date in an earlier period, say 1855–60. To this writer, the subject matter of the present work—a wilderness scene betraying no evidence of man—and the firm handling most evident (and best preserved) in the trees at the right indicate a date nearer that of *In the Woods* (Metropolitan Museum of Art, New York) and *The First Harvest* (Brooklyn Museum), both of 1855, than that of *The Sketcher.* The twenty-eight-by-forty-two-inch format may offer an additional clue. Although Durand frequently turned to canvases of similar dimensions from the late 1840s through the late 1860s, he evidently employed canvases of precisely this size in only two other instances: *Sunday Morning* (New Britain Museum of American Art, Conn.) and *Genesee Oaks, Genesee Valley* (Memorial Art Gallery of the University of Rochester, N.Y.), both of which were painted in 1860.

G. C.

Inscriptions In lower left corner, on the rock, *A B Durand*

Provenance Dalzell Hatfield (dealer), Los Angeles, 1938. Acquired in 1939.

Exhibitions Chicago and New York 1945, 47, no. 98. Athens 1954, no. 9. New York 1954, 28–29, no. 159. Norfolk 1961, no. 11.

References C. Burroughs 1940, 5–7. Detroit 1944a, 41. Huntington 1966, 24–25, fig. 5 (dated ca. 1851). Lawall 1978, 149, no. 287 (dated ca. 1869).

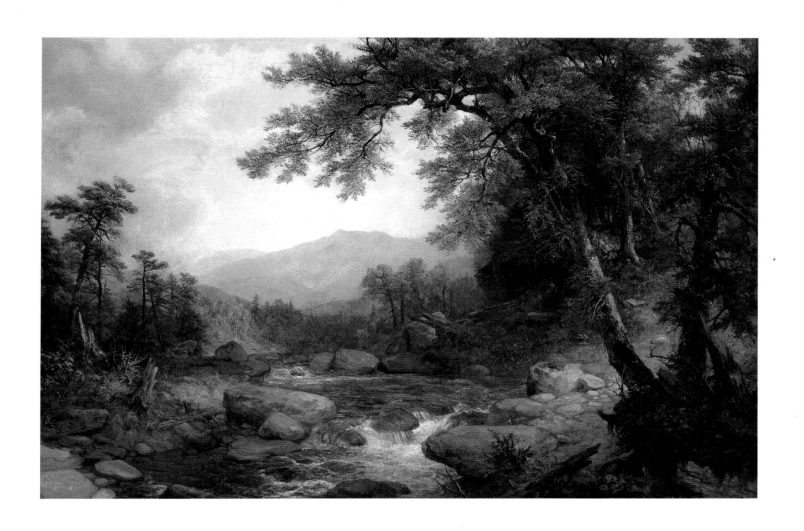

Monument Mountain, Berkshires

The younger brother of the artist Ralph Earl (q.v.), James Earl is thought to have received his first instruction in portrait painting from his older sibling, possibly in 1785 after Ralph returned from a seven-year period as an artist in England. In any case, James followed the example of his brother in seeking further instruction abroad, for it is known that he exhibited two portraits in 1787 in London at the Royal Academy's spring exhibition.

Although we know less about James than about his brother, he was apparently the more ambitious of the two. In 1789 he enrolled to study at the Royal Academy. He painted and exhibited a number of portraits in England that have, until recently, been attributed to other artists. In 1794 Earl left his wife and children behind in England while he traveled to Charleston, South Carolina, on what was to be a temporary painting expedition. He died there two years later during a yellow-fever epidemic.
D. E.

Bibliography Stewart 1988.

33

Formerly attributed to Gilbert Stuart

A Gentleman, ca. 1790

Oil on canvas
76.2 × 63.5 cm (30 × 25 in.)
Gift of Andrew Wineman in memory of his wife (53.3)

This half-length portrait has been attributed to Gilbert Stuart (q.v.), but the flesh color is much too pale and opaque for Stuart and the long brushstroke is quite unlike Stuart's work.

Because of recent research that has helped to identify more of James Earl's missing pictures, a strong case can be presented for adding this portrait to his oeuvre. Most characteristic of Earl are the dry brushstrokes in the hair, the drawing and modeling of the face, the loosely painted white jabot and metal buttons, the composition, the sitter's posture, and the inclusion of a shield-back chair and a glove. A close parallel can be found in the James Earl painting of the American Loyalist Robert Carey Michell, which appeared at Sotheby's in London in April 1973. Stylistically the Michell portrait recalls this work and, like it, was once attributed to Stuart (Stewart 1988, fig. 19).

From the costume and hairstyle, it is possible to date the painting about 1790, which would coincide with Earl's period in England. That his *Gentleman* was painted there may be inferred also from its greater similarity to Earl's few known English pictures. It is modeled to a lesser extent than nearly all of the work he is known to have done in America. The relatively thick paint on the face and visible brushwork in this area are not typical of Earl but are not sufficiently different to cause doubt about the attribution to him.

An x-radiograph of the Detroit picture shows that it is essentially unchanged. Under ultraviolet light, recent repainting is found only in minor areas.
D. E.

Provenance Andrew Wineman, Detroit, 1953. Acquired in 1953.

References BDIA 1953–54, 50 (as by Gilbert Stuart).

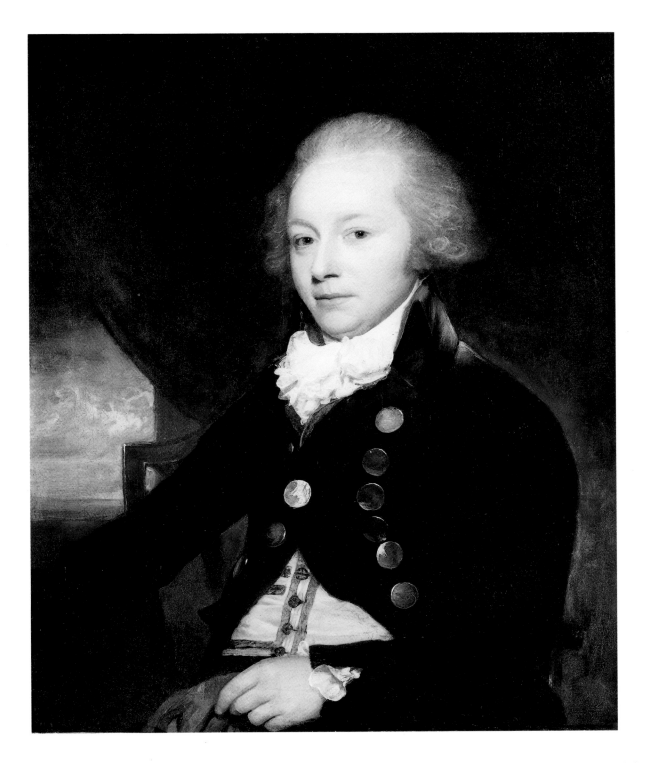

A Gentleman

Very little is known about Ralph Earl's early training. Probably self-taught, he had a portrait studio by 1774 in New Haven, Connecticut, which he left the next year to visit Boston. From there, he traveled to Concord and Lexington, where he painted four scenes representing the recent battles in those locales (engraved for sale by Amos Doolittle [1754–1832]). The series seems to reflect Earl's Loyalist sympathies, a point of view that eventually led to his being expelled from Connecticut. In 1778 he escaped to England to avoid imprisonment as a Loyalist spy.

In England Earl painted portraits consistent with his earlier American manner: strong, simple characterizations that reveal an admiration for the work of John Singleton Copley (q.v.) despite their lack of sophistication. Gradually, under the influence of English painting, Earl's modeling became more subtle, his brushwork freer, and his poses more relaxed. At the same time, he learned to rely less on his sitter's appearance and more on his own imagination. In about 1783, Earl apparently went to Benjamin West (q.v.) for advice and became part of West's circle. While in London, he also exhibited four portraits at the Royal Academy. Then in 1785, perhaps discouraged by the competition as well as by the English taste for flattery in portraiture, he returned to America. As an itinerant painter, he sought commissions in New York, Connecticut, Rhode Island, Massachusetts, and Vermont. At the end of the 1790s, his ability began to decline, purportedly because of an increasing addiction to alco-

hol. "Intemperance," a contemporary noted, caused his death at age fifty (Goodrich 1967, 11).

D. E.

Bibliography Goodrich 1967.

34
Lucy Bradley, 1794

Oil on canvas
112.1 × 79.5 cm (44⅛ × 31⁵⁄₁₆ in.)
Founders Society Purchase, Dexter M. Ferry, Jr., Fund (41.4)

This portrait of Lucy Bradley (1768–1823) is one of a pair, the companion piece being an image of her younger sister Huldah (1794; Museum of Fine Arts, Boston). Each young woman is seated outdoors in the tradition of many contemporary English portraits, but the two pictures are unusual in that they are intended to be seen as part of a single scene (see New Haven 1935, no. 5). Their background landscapes afford a pleasing, continuous view from Greenfield Hill, Connecticut, toward the rolling coastline and across Long Island Sound to the opposite shore. A distant sunset echoes the rose pink in the identical dresses of both sitters.

The sense of the two works as a harmonious whole is conveyed not only by the repeated rosy color and the continuity of their compositions but also by the delightful curvilinear rhythms created in the ribboned border of each woman's fichu. This lively pattern is "rhymed" with the curling hair of both sisters and with the spiral design on the ivory fan that Lucy holds.

Earl may have expressed a refined sensibility in his enjoyment of pattern, but he was also in a number of ways naïve. For instance, while he worked over the trompe l'oeil effect of Huldah's parasol projecting into the viewer's space, the sheen on Lucy's dress fabric, and the roundness of her arms, he painted Lucy's cummerbund inconsistently as a flat, angular shape. At times Earl's painting is crude and uneven, but his great charm lies in his simple directness, his use of accessories and sometimes elaborate backgrounds, and, in his best portraits, the suggestion of distinct character in his sitters.

Earl painted the Bradley family of Greenfield Hill twice. In 1788 he completed portraits not only of Lucy's parents—the merchant Samuel Bradley and his wife, Sarah—but of her brother and sister-in-law and their child (letter from Louis E. Morehouse, March 7, 1941, curatorial files, DIA). A 1794 date inscribed on the Detroit portrait and on its Boston mate is proof of the sitters' satisfaction and of Earl's return as an artist in demand.

D. E.

Inscriptions At lower left, *R. Earl Pinx.ᵗ / 1794*

Provenance The sitter's grandnephew, William Bradley, Greenfield Hill, Fairfield, Connecticut, 1918; his daughter, Mrs. E. B. Morehouse, Greenfield Hill; her son, Louis E. Morehouse, Westport, Connecticut, 1941. Acquired in 1941.

Exhibitions New Haven 1935, 9, no. 6.

References C. Burroughs 1941, 2–3.

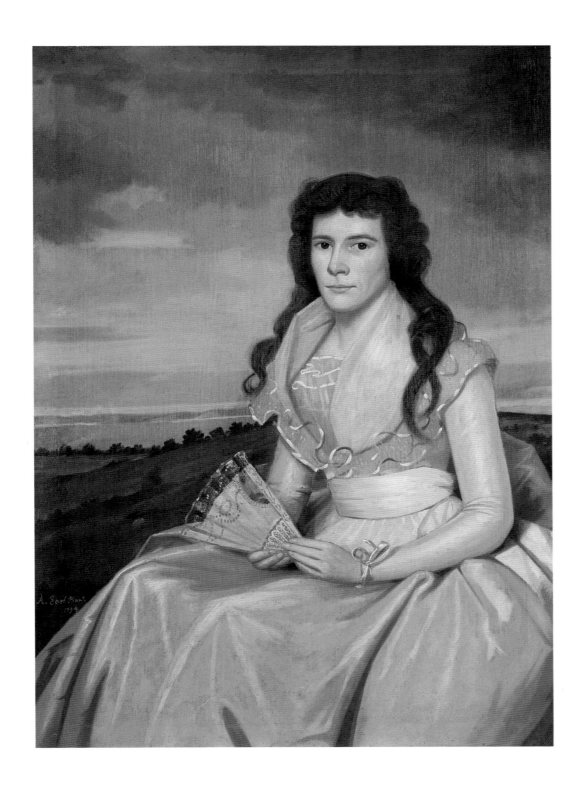

Lucy Bradley

Jacob Eichholtz began his career as a copper- and tinsmith. Having had some experience in painting signs, he turned to painting portraits, and by 1811, after brief encounters with James Peale, Thomas Sully (q.v.), and Gilbert Stuart (q.v.), he became a professional artist. Riding a circuit that encompassed Lancaster, Harrisburg, Baltimore, and Philadelphia, he was known as " the celebrated self-taught limner" and acquired a reputation for "good, hard likenesses" (Beal 1969, xxvii). Eichholtz worked in Philadelphia from 1823 to 1832 and then in Lancaster until his death. He was an industrious and prolific craftsman, a servant of the middle ranks of society who kept his fees low.
W. T. O.

Bibliography Beal 1969.

35
Attributed to Jacob Eichholtz
Isabella Hodgkiss Norvell, ca. 1823

Oil on canvas
91.4 × 72.4 cm (36 × 28½ in.)
Bequest of Henry Lyster Walker and Elizabeth Gray Walker (56.263)

According to family tradition, Thomas Sully (q.v.) painted this portrait in Philadelphia in May 1823, six months after Isabella Hodgkiss Freeman (1805–1873) married John Norvell (1789–1850). She was the adopted daughter of Mr. and Mrs. Henry Freeman of Philadelphia; he was the son of a Revolutionary officer from Virginia. In 1832 the Norvells moved to Detroit, where John—a journalist, lawyer, and supporter of Andrew Jackson—was postmaster of the city, a leading organizer of the state constitutional convention in 1835, one of Michigan's first senators, and a district attorney. The Norvells resided in Hamtramck.

Sully did not paint the portrait. It is not listed in his "Account of Pictures" (Dreer Collection, Historical Society of Pennsylvania, Philadelphia), and it does not attest to his proficiency in any respect—in drawing, control of the brush, handling of light and shade, color, or characterization. The work does, however, belong to an artist who emulated Sully's style and who, as is indicated by the stencil on the back of the canvas, acquired material in Philadelphia. While several artists—including John Neagle (q.v.) and at times even Bass Otis and Rembrandt Peale (q.v.)—fit such a description, the author of this portrait is Jacob Eichholtz. Indeed, Norvell family documents consulted in 1990 record Eichholtz as the painter of this portrait and a portrait of John Norvell (possibly that in the Detroit Historical Museum).

The portrait of Isabella Hodgkiss Norvell is typical of Eichholtz's work of the early 1820s (see Beal 1969, 319–327).

It aspires to the style of Sully in the broad handling and generalized modeling, the pomp of the color scheme, and the self-conscious prettiness. Although probably conveying an accurate likeness, the painting is purely decorative; an arabesque wrapped in white, enframed by red, accented by brown, green, and blue, it is an elegant parlor ornament. Eichholtz's mastery of linear abstraction—obvious here in the hard-edged outline of the figure and the relationship of that outline to the various props—is perhaps to be expected from a painter trained in the shaping and conjoining of sheets of tin. In this portrait, as in most of his works, Eichholtz successfully synthesized his innate regionalism with the cosmopolitanism of Sully.
W. T. O.

Annotations Stencil on the back at lower center, *SAM^L* [indecipherable] *AM*[indecipherable]*T / Philad^a*

Provenance The Henry Freeman family, Philadelphia; the sitter's daughter, Emily Norvell Walker, and her husband, Henry Nelson Walker, Detroit, 1872 to at least 1912; their children, Elizabeth Gray Walker and Henry Lyster Walker, Detroit, 1956. Acquired in 1956.

References Beal 1969, 183–184.

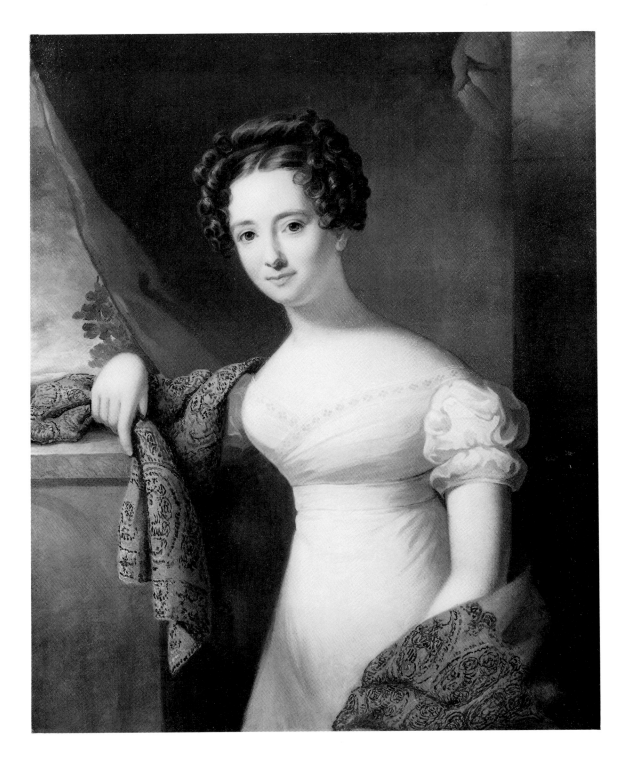

Isabella Hodgkiss Norvell

Upon the untimely death of Henry Inman (q.v.) in 1845, Charles Loring Elliott assumed his role as the premier portraitist in New York City, just as Inman had succeeded John Wesley Jarvis (q.v.). Elliott's early work was similar in its Stuart-derived style to the portraits of Inman as well as to those of Samuel Waldo (q.v.) and William Jewett, but by the mid-1840s he had taken a new direction toward a more prosaic, objective naturalism. In his art, factualism and a deliberately affected painterliness that could be described as bourgeois combined to supersede the aristocratic ideal that had characterized American portraiture since the early eighteenth century. Elliott enjoyed great success: in 1867 he was called "our first portrait painter" (Bolton 1942, 76).

His father had reared him to become an architect, but when Elliott arrived in New York City from upstate in 1829, he pursued an interest in painting. He probably studied briefly in the studios of both John Trumbull (q.v.) and John Quidor (q.v.) and then, disgusted with city life, left for central New York, where he was an itinerant portraitist for the next ten years. In the course of his wanderings he acquired a portrait by Gilbert Stuart (q.v.) that became the inspiration for his early art. Elliott returned to the city about 1839; by 1846 he was exhibiting his portraits to high praise and had become a full member of the National Academy. Settled comfortably—eventually in Hoboken, New Jersey—he traveled little and, arguing that the grand tour had not served American painters, did not visit Europe; nonetheless, he cultivated a cosmopolitan air and ease that gained him favored status among both artists and patrons.

Elliott painted a few landscapes and figural compositions but did not aspire to anything beyond portraiture, producing about seven hundred portraits in his career. "After all," he said, "there is nothing in all nature like a fine *human face*. Portrait painting is a big thing when it *is*

portrait painting" (Lester 1868, 47). Like Stuart, he developed a formulaic facility in bust-length portraiture; although he also painted several important full-length portraits, he was commonly out of his element in essaying complex compositions. His primary interests lay in physiognomy, in discovering the individual, and, of course, in success. He could capture a living, often unrelenting likeness in scarcely a lunch hour, a winning talent in the estimation of busy, newly rich professional men, who were his usual patrons. A spokesman for Ruskinian naturalism and moral rectitude, he came to use photographs as sources for his art, often achieving, by the height of his career in the years before the Civil War, a forceful immediacy and realism that left little to the imagination and were far removed from his early romantic manner.
w. t. o.

Bibliography Bolton 1942.

36
Charles Edwards Lester,
1846 or 1847/48

Oil on canvas
61 × 50.8 cm (24 × 20 in.)
Bequest of Charles P. Larned (55.178)

Charles Edwards Lester (1815–1890) was a diplomat, a prolific writer, and a man of enormous energy. Born in Connecticut, he studied law in Mississippi and theology in New York and became a Presbyterian minister. Although a confirmed Democrat, he opposed slavery, publishing *Chains and Freedom* in 1839 and attending the World Anti-Slavery Convention in London in 1840. He also wrote two books on the hardships of British workers in factories and mines. From 1842 to 1847, during Polk's administration, he was consul in Genoa. At that time, as he came into

contact with American sculptors working in Italy—particularly Hiram Powers and Thomas Crawford—he became a champion of the American artist, endeavoring through his writing and personal proselytizing to heighten public appreciation for the contributions that artists made to national culture. Of his many writings on art the most important was *Artists of America* (1846), which, after Dunlap's work of 1834 (q.v.), was only the second published history of American art. In all he wrote twenty-seven works, some in collaboration. He died in Detroit while visiting his daughter, Ellen Salisbury Larned.

Elliott portrayed many Knickerbocker writers of international stature, including Nathaniel Parker Willis, William Cullen Bryant, James Fenimore Cooper, George P. Morris, Rufus W. Griswold, and Washington Irving. Of the group, however, Lester probably became Elliott's closest friend, and upon the artist's death he published a eulogistic biography.

Since Elliott portrayed Lester in consular dress of dark blue coat with brass buttons, the portrait must date from either 1846, when Lester briefly visited New York, or 1847/48, when he was retired from the service. In either case, the painting pertains to his productive career in Italy as diplomat, writer, and friend of the arts. The daguerreotype-like oval format, popular in the baroque decades of the 1840s and 1850s, is the ideal medium for such an artist as Elliott, whose passion was for painting heads and conjuring up heroes. As a framing device, the oval is the classic complement to the head and a forceful means of focus; no props, possessions, or space detract from the direct perception of the man himself. Lester's noble bearing, offset gaze, and ruddy features define the Byronic ideal of the man of sensitivity and action. The portrait is "like all his best portraits," as Henry T. Tuckerman (1867, 301) described them: "remarkable for the certain manly simplicity; the head and expres-

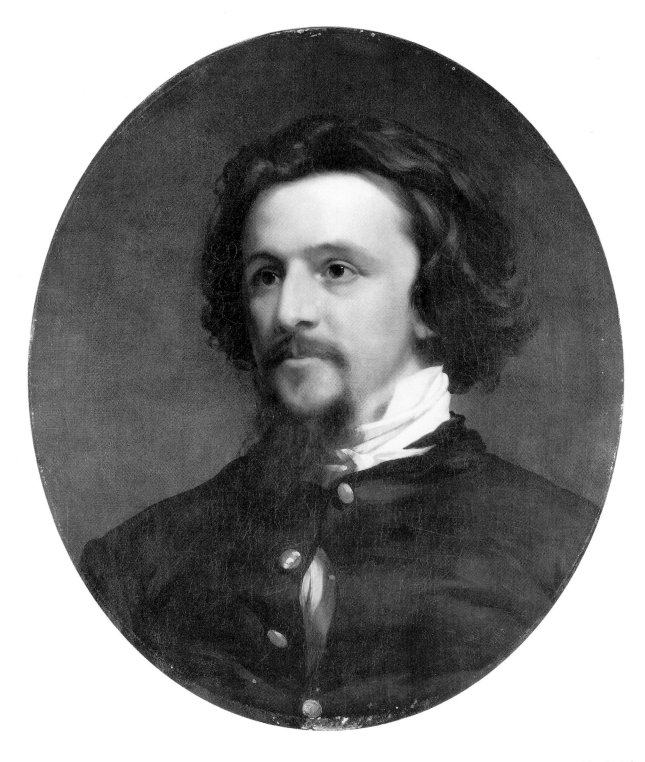

Charles Edwards Lester

sion are full of character; the likeness is excellent, the effect lifelike."

This portrait reflects Elliott's indebtedness to Stuart's fluid, aggrandizing style and Inman's romantic sentimentality, as well as his own pursuit of fact. Despite the broad handling, the surface is smooth; the face is similarly smoothly modeled and highly finished, except for a striking, light-generating highlight of heavy impasto on the forehead. William Sidney Mount (q.v.) described Elliott's usual technique in detail. He took three sittings. Painting "on a ground of pure white," he first "touched on the highest light (on the forehead) with pure white" and then added the secondary highlights on the nose, upper lip, and chin, and finally the principal shadows. Having gained "a broad effect of the head," he corrected the drawing in the second sitting and strengthened the lights and shadows. In the last sitting he darkened the hair and glazed the face by rubbing in "transparent colors" with his brush or fingers. "The beauty of Elliott's coloring," Mount concluded, "depends on his glazing, during the last sitting—allowing the previous painting to appear more or less underneath" ("Diary," November 23, 1848, and January 18, 1850, quoted in Frankenstein 1975, 188, 238).
W. T. O.

Provenance Probably Charles Edwards Lester, New York; probably his daughter, Ellen Salisbury Larned, Detroit; Charles P. Larned, Detroit, to 1952. Acquired in 1955.

Exhibitions BDIA 1938.

References Richardson 1937, 16–18. Bolton 1942, 91, no. 74. Payne 1954–55, 82, 84.

37
John Frederick Kensett, 1854

Oil on canvas
76.8 × 63.5 cm (30¼ × 25 in.)
Gift of Dexter M. Ferry, Jr. (43.32)

One measure of Elliott's success was that his fellow artists liked both him and his art. He painted portraits of many of them, including Mathew Brady (ca. 1823–1896), Frederic E. Church, Jasper F. Cropsey (1823–1900), Asher B. Durand (q.v.), William Sidney Mount (q.v.), Sanford Thayer (1820–1880), Erastus Dow Palmer, and Daniel Huntington (1816–1906). John Frederick Kensett (1816–1876) was an eminent member of this group of friends; he was one of the most highly regarded American painters of the third quarter of the nineteenth century.

Having begun his career as an engraver, Kensett took up landscape painting in 1840. By 1850 he had already become quite successful and much in demand in elite social circles. His measured luminist visions, remarkable in retrospect for both their escapism and their exciting spirit of rediscovery, appealed greatly to an increasingly technological, urban, and suburban society. Kensett had a studio in New York City but spent more than half of the year touring, usually in the mountains and along the coasts of the Northeast. In 1854, the year Elliott painted the Detroit portrait, he made summer excursions to the Mississippi River, the Genesee Valley of New York, and Newport, Rhode Island. Although he logged years swatting flies on his long hikes, Kensett was as urbane as he was rugged. He was an activist in the cause of art, a fund raiser for the National Academy, a founder and president of the Artists' Fund Society in New York, a member of the United States Capitol Art Commission, the chairman of

the Art Committee of the Sanitary Fair in 1865, and a founder and trustee of the Metropolitan Museum of Art.

By about 1850 Elliott had hit upon a consciously limited, objective conception of portraiture, moving his art away from its earlier reliance on Henry Inman's (q.v.) conventional, romantic vision to a new realist mode. As Henry T. Tuckerman (1867, 300) pointed out, he was "a man of will rather than of sensibility, one who grasps keenly his subject, rather than is magnetized thereby: his touch is bold and free; he seizes the genuine and pierces the conventional; he has a natural and robust feeling for color; he is more vigorous than delicate."

The development is illustrated in contrasting Elliott's portrait of Lester with that of Kensett. While the sense of three-dimensional volume is the same, the head in the latter portrait is more vigorously modeled and the likeness more patently individualized. Kensett's gaze is directed; his image is immediate and unrelated to any conceptual notion other than the ideal of the particular, the real, and the present. Elliott's handling has likewise been transformed; it is, in the words of James Jackson Jarves (1864, 189), "less refined, heavier and darker in color, [and] more materialistic in technical treatment," characteristics that also describe American culture in the 1850s and 1860s. Jarves noted further Elliott's "Salvatoresque touch of brush," a reference to the separated, stringlike, and zigzag strokes that often, as in the forehead and nose of the *Kensett,* resolve themselves into patterns. This is self-conscious artistry, since such intrusive evidence of the artist's own presence and energy seems at odds with realist objectivity. The enlivening technique does in part

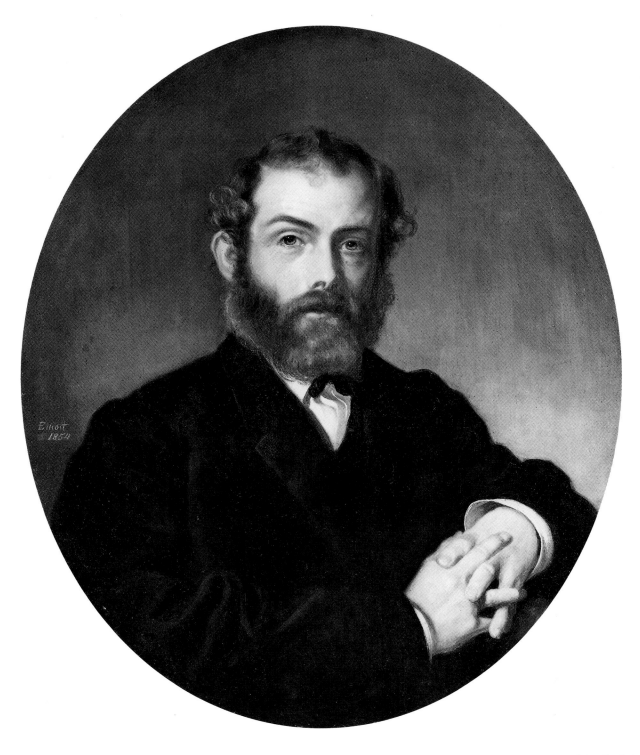

John Frederick Kensett

compensate for Elliott's generally unexciting composition making.

W. T. O.

Inscriptions At center left, *Elliott / 1854*

Annotations On stretcher, *JF Kensett From Life*; stenciled on back, *From / N. Schaus / print Seller & Artists Colorman, / [303?] Broadway / New York*

Provenance August F. DeForest, New York, 1922. Arnold Seligmann (dealer), Rey & Co., Inc., New York, 1943. Acquired in 1943.

Exhibitions New York 1922, no. 57. Brooklyn 1960, no. 188.

38
Self-Portrait, 1860

Oil on canvas
28.3 × 23.2 cm (11⅛ × 9⅛ in.)
Founders Society Purchase, Merrill Fund (65.27)

Elliott painted at least eight self-portraits between about 1846 and 1860. Among them were two cabinet portraits, one of which is the present work. The noted collector and dealer Samuel P. Avery owned one of these two pictures, and in 1867, when part of his collection was sold at auction, it was purchased for the then-unheard-of sum of eight hundred dollars. For some time it has been assumed that the earlier of Elliott's two cabinet-sized self-portraits (ca. 1850, oil on canvas, 30 × 25.4 cm; Collection of Jo Ann and Julian Ganz, Jr., Los Angeles) is the work once owned by Avery (Washington et al. 1981, 128–129). That work is a sketchy affair in which the artist wears a goatee and affects a Shakespearean attitude; it is interesting in that it documents the belief of Elliott's contemporaries that he was strikingly similar in appearance to Shakespeare, whose alleged likeness was known in New York at that time through an oil copy and an engraving after the famous Chandos portrait in the National Portrait Gallery in London.

There is, however, no conclusive evidence that the cabinet picture in the Ganz collection came from the Avery sale. On the contrary, there is better reason to believe that the Detroit portrait was originally owned by Samuel P. Avery. A sketch of the portrait in an annotated catalogue of the 1867 sale shows Elliott facing right, as in the Detroit painting—not left, as in the Ganz painting (Archives of American Art, microfilm roll NMM 20, 109–121). Since the dimensions cited—ten by seven inches—do not correspond precisely to either the Detroit or the Ganz canvas, the Avery painting may still be unlocated. The latter picture disappeared from the record until 1947, when Newhouse Galleries claimed to own it (this was the same painting later bought by the Ganzes). However, in 1956 two authorities wrote that the Avery portrait was not yet located (King and Ross 1956, 5, no. 19), and in 1965 spokespersons for Kennedy Galleries maintained that their portrait, which they then sold to the Detroit Institute of Arts, descended from the Avery collection.

Apparently the case for the Ganz portrait hinges upon the interest that contemporaries took in Elliott's Shakespearean physiognomy. Without question, however, the more popular self-portrait was the 1860 painting, for the image recurs in two other versions: one at the Heckscher Art Museum (oil on canvas, 68.6 × 55.9 cm; Huntington, N.Y.), the second at the Walters Art Gallery (oil on canvas, 68.6 × 55.9 cm; Baltimore). The latter portrait Elliott presented in 1860 to W. T. Walters, his friend and patron, who owned other paintings by him. Apparently, then, the 1860 self-portrait was the accepted likeness of Elliott at the height of his career. It is therefore reasonable to suggest that the Detroit painting was the cabinet picture that brought eight hundred dollars at the Avery sale in 1867.

The painting is a lively characterization. In expression and handling it is

more vigorous than either the Heckscher or the Walters version. As he had in the *Self-Portrait* from about 1850, Elliott affected an "old-master" pose. In this case, as in much of his art, he identified himself with both Rubens and Rembrandt, donning a black, broad-brimmed "Rubens" hat and emphasizing the kind of extreme effects of light and shade for which he especially admired Rembrandt. The boldness of the brushwork, the interplay of the dark silhouette and the reddish brown ground, the contrast between the raking shadow across the forehead and the brightly lit face, the brilliant accents of the white collar and the red cloth are all unmistakable references to northern baroque portraiture. There are parallels also to be found in the work of Gilbert Stuart (q.v.), who struck a Rubenesque pose in the self-portrait that he painted in London in 1778 (Redwood Library and Athenaeum, Newport, R.I.).

Despite the evident affectation in this portrait, it accurately represents the painter in 1860. Elliott was a spokesperson of his age. "Often," as Henry T. Tuckerman (1867, 30) noted, "his portrait is the man himself, and, at the same time, a perfect illustration of American life—with hat, coat, and cane—firm on his feet, confident, and going *somewhere*—the epitome of a progressive locomotive race, born for office and action."

W. T. O.

Inscriptions At lower right, *Elliott / 1860*

Provenance Possibly Samuel P. Avery, New York, 1861–67. Possibly Marshall Owen Roberts, New York, 1867–97. Kennedy Galleries, New York 1965. Acquired in 1965.

Exhibitions Brooklyn 1863, no. 33 (possibly this work).

References Tuckerman 1867, 303 (possibly this work). Bolton 1942, 87, 88, no. 35 (possibly this work). *Kennedy Quarterly* 1965, 100–101, no. 96.

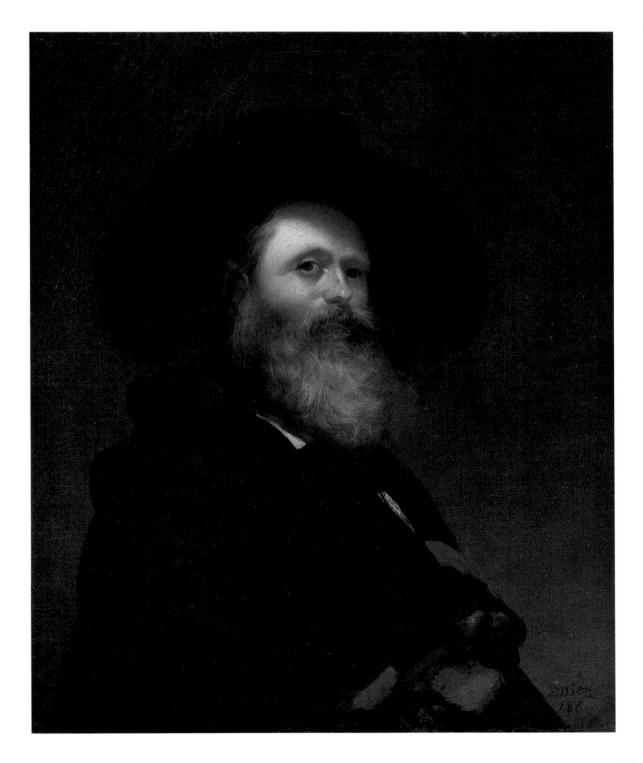

Self-Portrait

Robert Feke

CA. 1706/07 OYSTER BAY, LONG ISLAND,
NEW YORK (?)—BARBADOS CA. 1752 (?)

Of all the careers of major colonial painters, that of Robert Feke is among the most enigmatic. Even a 1744 description of him by a visitor to his studio suggests on air of mystery:

In the afternoon Dr. Moffat, an old acquaintance and schoolfellow of mine, led me a course thro' the town. He carried me to see one Feykes, a painter, the most extraordinary genius I ever knew, for he does pictures tollerably well by the force of genius, having never had any teaching. I saw a large table of the Judgement of Hercules, copied by him from the frontispiece of the Earl of Shaftesburry's, which I thought very well done. This man had exactly the phizz of a painter, having a long pale face, sharp nose, large eyes with which he looked upon you stedfastly, long curled black hair, a delicate white hand, and long fingers (Bridenbaugh 1948, 102).

Feke's early biography was the subject of much speculation, but the most substantial evidence suggests that he was raised on Long Island. One of the few irrefutable facts about his career is that he painted in 1741 a large and imposing group portrait, *Isaac Royall and His Family* (Harvard Law Art Collection), which he proudly signed and dated. Feke is next heard from in 1742, when he married Eleanor Cozzens (1718–1804) in Newport, Rhode Island. Paintings by him survive from Newport (1745), Philadelphia (1746 and 1749), and Boston (1748). Like the trips of other colonial artists, his travels can be explained by the lack of large numbers of patrons in any given location. At least one scholar has suggested that between 1746 and 1748 he might have been in England or Europe gaining exposure to contemporary tastes in painting (Sadik 1966, 37). His finest work was done in 1748 in Boston, where he painted a spate of portraits that included such striking displays as *James Bowdoin II* (Bowdoin College, Brunswick, Me.). Feke is last

known to have been in Newport in 1751. It has been argued that he had either died or left Newport by January 1752 (Mooz 1971, 181) and that he may have traveled to Barbados for his health.

Many questions regarding his training and his relationship with other painters remain. The most we know is that in a relatively short span of time (1745–49), Feke produced a remarkable group of images in several colonial cities. But almost as quickly as he rose to prominence, he once again disappeared, leaving behind approximately fifty-five portraits, upon which his reputation rests. To the younger generation of sitters that made up the large share of his patrons, Feke must have arrived like a breath of fresh air. Even if he did not possess the sophisticated modeling techniques of a London-trained painter, his portraits undoubtedly dazzled colonial eyes. Families tired of the somber-toned palette of John Smibert (q.v.) must have found attractive Feke's preference for silver and pastel shades of blue, pink, and yellow. Although Feke's presence was fleeting, his impact on the development of colonial painting was substantial, and his work set a new, up-to-date standard by which the work of the next generation of aspiring artists was judged.

R. S.

Bibliography Belknap 1959.

39
Mrs. John Banister, 1748

Oil on canvas
128.3 × 102.9 cm (50½ × 40½ in.)
Gift of Dexter M. Ferry, Jr. (44.283)

When acquired, this portrait was misidentified as Mrs. Josiah Martin. In 1970 Peter Mooz discovered that John Banister's account book for December 22, 1748,

recorded payment to Feke for portraits of himself and his wife. Mooz then speculated, knowing the Banister and Martin families to have intermarried, that the Detroit picture, along with its pendant, *John Banister* (Toledo Museum of Art), might be portraits of John and Hermione Pelham Banister of Newport, Rhode Island. Susan Strickler confirmed Mooz's suspicions when she learned that the will of John Banister, Jr. left "portraits of his parents to his brother Thomas, then living on Long Island, and who had married Rachel Martin, daughter of Josiah Martin, about 1792" (Strickler 1979, 48). This fact explains how the subjects of the portraits were subsequently misidentified as the Martins. Mrs. Banister, who was thirty in 1748, was born Hermione Pelham (1718–before 1767), a granddaughter of Governor Benedict Arnold of Rhode Island. Her husband, whom she married on November 14, 1737, was a wealthy landowner, merchant, and shipbuilder who imported finished goods into Newport.

The Detroit picture was painted when Robert Feke was at the pinnacle of his career. In 1748 he painted portraits of a number of New England's leading citizens, including *Charles Apthorp* (Cleveland Museum of Art), *Isaac Winslow* (Museum of Fine Arts, Boston), and *General Samuel Waldo* (Bowdoin College, Brunswick, Me.), the last his only full-length work. The recently discovered *Mrs. James Boutineau* (Nova Scotia Museum; see Elwood 1979, 1150) may date from 1748 as well, since its format is virtually identical to *Mrs. John Banister*. For the Detroit picture, Feke chose a subdued and harmonious palette in which the sitter's silvery white gown is highlighted by a red rose held in her lap. Feke seems to have encountered difficulty in painting Mrs. Banister's hands, which are pudgy and

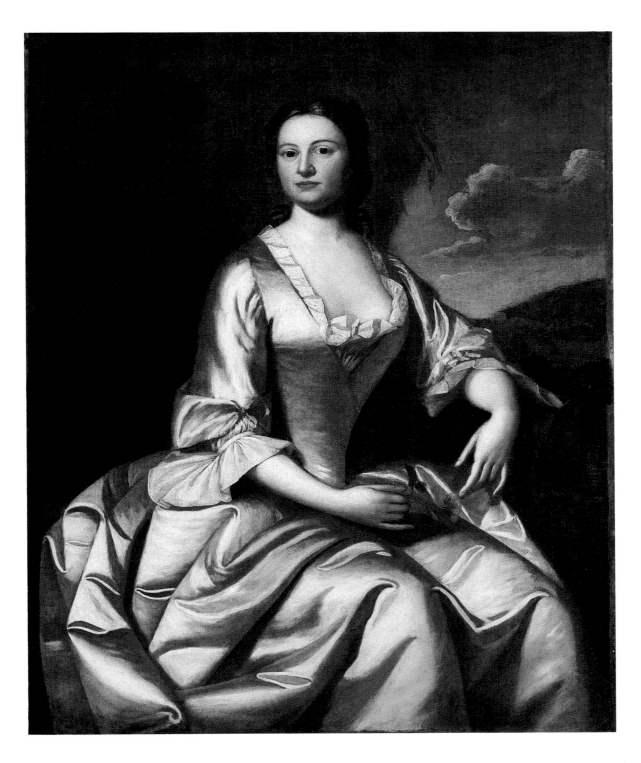

Mrs. John Banister

indelicate. Also, her gown billows out exceedingly far, and the portrait is less impressive than other works of the time by Feke. In its palette, brushwork, and composition, however, the portrait is characteristic of the artist's abilities and makes evident why, within a short period of time, his work was so well received.
R. S.

Provenance John Banister, Newport, Rhode Island, 1748–67; his son, John Banister II, Newport, ca. 1767–1803; his brother, Thomas Banister, Lawrence, New York, 1803–15; his daughter, Alice Hermione Pelham Banister McNeil, Lawrence, 1815–23. Thomas Hewlett, Lawrence, 1823– 41; Mary Hewlett, Lawrence, 1841(?)–1870(?); James Hewlett, Lawrence, 1870–90; Mary Sanderson Hewlett, Lawrence, 1890–1917; George Hewlett, Brooklyn, 1917 to at least 1931. Stephen C. Clark, New York, to ca. 1944. William MacBeth, Inc., New York, 1944. Acquired in 1944.

Exhibitions New York et al. 1946, no. 18.

References Banister 1746–49, 369. (All succeeding references cite the work as *Mrs. Josiah Martin* unless otherwise stated.) Bolton and Binsse 1930b, 37, 74, 82. Foote 1930, 66, 164–165. *Art Digest* 1945, 12. C. Burroughs 1945, 64–65. *Toledo Museum News* 1945, unpaginated. *Antiques* 1946, 398. Parker 1946, 6–7. Flexner 1947, 143, 261, 304, 348. Flexner 1947a, 36. Sellers 1957, 433, 437, pl. 20B. Novak 1969, 16, 18. Mooz 1970, 146, 147, 161, 213, 229, 230 (as *Mrs. John Banister*). Baigell 1971, 39, 42.

John F. Francis

1808 PHILADELPHIA—
JEFFERSONVILLE, PENNSYLVANIA 1886

The career of John F. Francis can be divided neatly into two chronological and thematic segments, both spent primarily in rural Pennsylvania. Until about 1850 Francis was a portraitist, working as an itinerant throughout his home state as well as in Ohio and Tennessee. In 1840 he was listed as a resident of Philadelphia and exhibited there at the Artists' Fund Society and at the Pennsylvania Academy of the Fine Arts in the years between 1840 and 1858. Later in his career, his work was occasionally lent to exhibitions in distant cities by the gallery of J. S. Earle and Sons of Philadelphia. His portrait work suggests a stylistic derivation from the manner of the finest and most famous of contemporary Philadelphia portrait specialists, Thomas Sully (q.v.).

A number of Francis portraits of young women include the traditional attribute of a vase of flowers as a symbol of beauty. Perhaps it was his clients' positive response to such accessories—always skillfully placed—that prompted Francis, rather abruptly, it seems, to abandon portraiture around 1850 for still-life painting. He may also have been attracted by the more sedentary life available to the still-life specialist as opposed to that of the traveling rural portrait painter, for by 1856 he had settled in Jeffersonville, where he stayed for the remainder of his life. In any case, Francis's latest known portrait dates from 1852, and his earliest known dated still life was painted in 1850.

Despite the artist's proficiency at painting the floral arrangements included in his portraits, his pure still lifes consist almost exclusively of edibles plus the necessary containers and utensils for their consumption. Only one floral still life is known. Francis's stylistic development is difficult to discern, since he tended to replicate his compositions, sometimes with minor variations, over a long period of time; thus, almost any dated painting may, in fact, reflect a composition and an interpretation first realized much earlier. In general, however, the earlier works are a good deal simpler in arrangement, setting, and formal concentration than those dated later. The 1850s and 1860s appear to be the decades when Francis developed major themes and created their finest realizations; there are no known examples of his work dated after 1879.

Francis painted many small canvases depicting only a few objects, but he expressed himself most fully in large pictures containing many varied objects, and these fall into three basic types. The first group has been christened "luncheon" paintings—arrangements consisting of fruits, nuts, cheeses, and crackers; they include glasses and wine bottles of various sizes, shapes, and contents. The arrangements are placed on a table covered with a white cloth and are set against a neutral interior background. The second group, known as "dessert" paintings, specifically emphasizes the end of a meal and contains fruit and other sweets and, usually, an abundance of glasswork, crockery, and metalwork. These objects are again placed on Francis's ubiquitous white cloth, often with a bit of brightly colored landscape showing in the background through a window, door, or unspecified opening. The third compositional choice, for more elaborate arrangements, centers around a basket heaped with fruit, sometimes a single kind, sometimes a great variety. There may be either a neutral or a partial landscape background. It is possible that Francis was the originator of the "luncheon" and "dessert" still life in America; he was certainly its finest practitioner at mid-century. In all of his major modes, Francis conforms to the predominant sentiment of American still-life painting during this period, reflecting the optimism and sense of the "good life" prevalent in the country's nationalistic thinking. Although the nature of the theme precludes human content, Francis's still lifes nevertheless suggest the presence of a family gathered around the bountiful board.
w. g.

Bibliography Frankenstein 1951. Lewisburg 1958. Gerdts and Burke 1971, 59–61. Gerdts 1981, 89–93. Lewisburg 1986. New York 1990.

40
Still Life with Yellow Apples, 1858

Oil on canvas
64.1 × 76.8 cm (25¼ × 30¼ in.)
Founders Society Purchase, Gibbs-Williams Fund (75.58)

This still life was painted at what may be the high point of Francis's creativity, the period about 1855–60, and represents the finest form of his single-fruit, centralized basket compositions. Here the artist achieved a sense of solidity in the painting of the fruit, a richness of color that is uniquely his, and a dramatic chiaroscuro in the brightly illuminated still life set in relief against a dark background, with the starkness of the composition mitigated by the carefully rendered decorative pattern of the Victorian pitcher at the left.

A fascinating development can be traced in Francis's exploration of this arrangement over the period 1856–59 in his extant works (there well may be both earlier and later examples still unlocated —for example, *Apples and Chestnuts* was exhibited by the Art-Union of Philadelphia as early as 1851). The first known example is *Still Life: Yellow Apples and Chestnuts Spilling from a Basket* of 1856 (Collection of Jo Ann and Julian Ganz, Jr., Los Angeles; see Frankenstein 1951). This is the simplest, starkest version of the composition, featuring only the arrangement of apples with a counterpoint of small chestnuts on the white tablecloth, the yellow of the apples offering the dom-

inant hue. In *Basket of Fruit* (Cincinnati Art Museum), painted the following year, the three apples formerly at the left have been replaced by a blue-and-white pitcher and two glasses, presumably filled with cider. By adding glass and ceramics Francis was elaborating the conception with greater decorativeness in shapes, in colors, and in varying textures.

In the Detroit painting of 1858 Francis reached the culmination of his invention. Here the single apple in the lower right has been replaced with a shallow dish in which sits an apple with a quarter removed, that quarter and several seeds also lying in the dish. To the left of the dish is a knife, which is often found hanging over the table edge in other fruit compositions by the artist; the chestnuts in this area have thus been rearranged and their number increased. The altered grouping on the right provides a balance for the pitcher-and-glassware arrangement previously introduced and also embodies several corollary themes that appealed to Francis. These include a slight suggestion of trompe l'oeil (a still-life device never emphasized by Francis) in the overhanging knife, and especially the exploration of specific forms—for example, accentuation of the "appleness" of the apple by displaying both its outside and its inside.

Immediately behind this grouping is another apple, a very red one, contrasting with the wealth of yellow apples and creating an additional color note, thus asserting Francis's preference for a full display of the primary colors. Furthermore, the two apples in the rear, immediately to the right of the basket in the 1856 and 1857 versions, have been moved apart to reveal each more clearly—one of them liberally colored red, providing a stronger balance for the vivid blue note at the left. One of these three paintings was very likely the work exhibited and offered for sale by Francis in 1858 at the Pennsylvania Academy of the Fine Arts as *Apples, Chestnuts, and Cider*.

Color is the key distinction between the Detroit picture and a version of 1859, *Still Life with Apples and Chestnuts* (Museum of Fine Arts, Boston). With the latter work Francis seems to have ended his compositional variations, carrying the coloristic variety further by increasing the counterpoint of red accents in many of the yellow apples. Otherwise the arrangements are substantially identical, with only a few slight changes in the pattern of chestnuts, notably the addition of a pair of nuts to the left of the knife blade. The version of 1859 is arguably less effective in several respects: the structural tensions displayed in earlier examples of the composition have been relaxed; the contrast of light and dark is less dramatic; and some of the drawing is less crisp, notably the pattern of the wicker basket and that on the blue Victorian pitcher.

w. g.

Inscriptions At lower left, *J. F. Francis, Pinxit, 1858.*

Provenance Vose Galleries, Boston. Acquired in 1975.

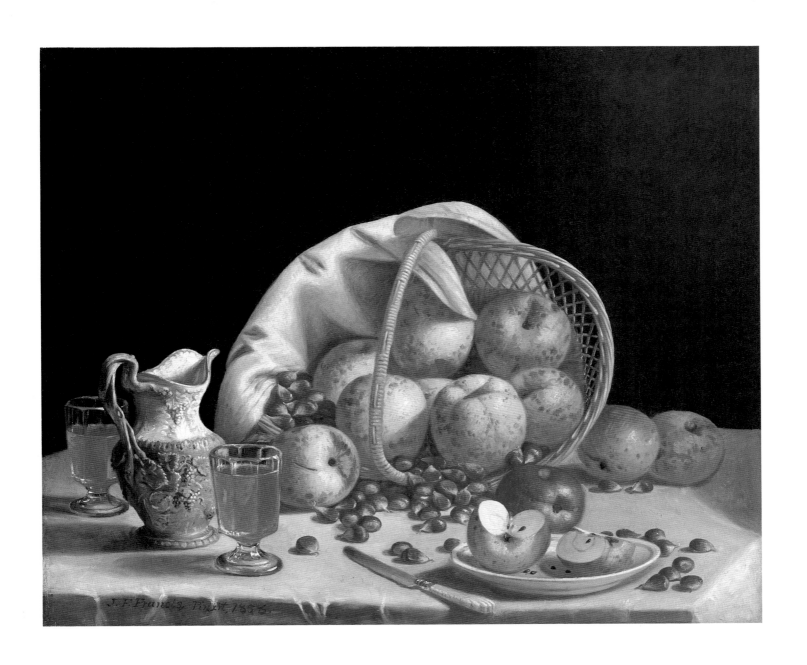

Still Life with Yellow Apples

James Frothingham's artistic career began with the colorful decorations he painted as a boy on the carriages he and his father made in Charlestown. He was self-taught and worked with a crude, homemade palette that consisted of a board with holes in it containing thimbles of oil colors. Eventually he drifted from supplying ornamentation for carriages to limning portraits, which were successful enough to win the praise of his friends and neighbors.

The chief source of information on Frothingham is William Dunlap (q.v.), who knew the artist and included a biography of him in his 1834 *History of the Rise and Progress of the Arts of Design in the United States*. According to Dunlap, Frothingham first received instruction in portrait painting in Lancaster, Massachusetts, from a Mr. [Fabius] Whiting (1792–1842), who in turn had been taught by Gilbert Stuart (q.v.). Later, at about the age of twenty, Frothingham himself went to Stuart for advice and criticism of his portraits. Since Stuart, then living near Boston in Roxbury, was unusually cooperative, Frothingham returned to him again and again for suggestions. He last visited Stuart for a critique in 1810, at which time Stuart pronounced him second only to himself as a portrait painter. Of all Stuart's pupils, Frothingham is the most imitative. He is an uneven painter—often weak—but his best work shares Stuart's spontaneous, dabbing stroke and fresh skin coloring.

After moving to New York City in 1826, Frothingham was elected an associate of the National Academy of Design in 1828 and an academician in 1831. He exhibited widely, showing his work at the Boston Athenaeum and the Pennsylvania Academy of the Fine Arts, Philadelphia, as well as the American Academy of the Fine Arts, the National Academy of Design, and the Apollo Association in New York.

D. E.

Bibliography Dunlap 1834.

41
Mary Bellows Kinsley Gardner, 1825

Oil on canvas
69.2 × 56.2 cm (27¼ × 22⅛ in.)
Bequest of Emma J. Farwell (53.78)

This portrait has been repainted extensively since 1898, the year Thomas Bellows Peck reproduced it in his *Bellows Genealogy* (opp. p. 182) with the information that it was painted by Frothingham and belonged to a descendant of the sitter. Sometime after 1898—undoubtedly after the painting left the sitter's family—the image was modified to make her more conventionally attractive. It may have been at that time that the attribution was changed to Gilbert Stuart, perhaps in order to sell the picture for greater profit.

An x-radiograph reveals that the Detroit portrait originally conformed to the illustration in Peck's book, and there is no apparent reason to think that the two portraits are not the same. Before

"restoration" the sitter appeared more distinctive than she does now, the jaw being somewhat wider with almost a straight-line mouth, the nose not turned up, the long spit-curl absent, and the breasts not as prominent. As in Peck's illustration, her shawl was once fringed and positioned, for modesty, to cover her shoulders and arms. The portrait's appearance as revealed by the x-radiograph is consistent with Frothingham's style, lending weight to the family tradition that attributes the work to him. Paradoxically, the portrait as it appears in Peck's illustration is less convincing as a work by Frothingham, but even at that date it probably had undergone some repainting.

Mary Bellows Kinsley (1801–1839) married Samuel Gardner, a lawyer in Roxbury, Massachusetts, in 1820, only a few years before being painted. Peck described her as "bright and cultivated . . . remarkable for her loveliness of person, her amiability of character, and her . . . fortitude with which she bore her long illness, consumption" (Peck 1898, 182).

D. E.

Inscriptions On back of canvas, *Mary Bellows Kinsley Gardner / July 1825 / Aged 24 years*

Provenance Descended in the sitter's family until after 1898. Emma J. Farwell, Detroit, 1931 (as by Gilbert Stuart); her estate, 1953. Acquired in 1953.

Exhibitions Richardson 1934.

References T. Peck 1898, 182 (as by Frothingham). Richardson 1934, 13 (as by Gilbert Stuart).

Mary Bellows Kinsley Gardner

Although overshadowed by portrait painters who preceded and followed him, John Greenwood led a varied and rewarding career. The son of Samuel Greenwood, a Harvard graduate, he might also have attended school in Cambridge had that not been precluded by financial difficulties. Upon his father's death in 1742, Greenwood was apprenticed to the Boston engraver Thomas Johnston (1708–1767). Engraving was a safe trade but it held little promise of wealth, and within three years he had abandoned it in favor of painting.

Greenwood was ambitious and adventuresome. He was determined not to follow in the footsteps of Joseph Badger (q.v.) or Nathaniel Smibert (1734–1756) and live out his career as a minor portrait painter in the backwater of the British colonies. In 1752, after five years of painting in Boston and its environs, Greenwood set sail for what he must have hoped was more fertile territory. He traveled to Dutch Guiana (Surinam), where, in a space of five years, he is said to have painted one hundred fifteen portraits. As none of them is located, one might dismiss the claim as fabrication were it not for his son's 1797 statement that Greenwood made over three thousand guineas during his South American stay. It was during this trip that he painted his best-known work, the tavern scene *Sea Captains Carousing in Surinam* (St. Louis Art Museum).

The peripatetic Greenwood then proceeded to Amsterdam, where he helped to reopen the art academy and returned to engraving, producing numerous mezzotints. By 1763, he had made his way to London via Paris. With the exception of an occasional trip to the Continent, he remained in England until his death in 1792. He continued on occasion to paint and make engravings but became far better known for his talents as an art dealer and auctioneer.

From his seven-year career as a painter in America, fewer than fifty paintings survive. They range from an ambitious group portrait of his own family, *The Greenwood-Lee Family* (Museum of Fine Arts, Boston), to humble copies of portraits by other artists. Many of his sitters came from the north-shore town of Salem, the home of his mother's and wife's families. Greenwood possessed considerably more natural ability than Badger, and his color sense was delightfully fresh. Although his American portraits are frequently rather wooden, they suggest a potential that to some degree went unfulfilled in his exploration of other pursuits.
R. S.

Bibliography A. Burroughs 1943.

42
John Adams, ca. 1748–52

Oil on canvas
90.8 × 68.9 cm (35¾ × 27⅛ in.)
Founders Society Purchase, General Membership Fund (26.386)

Considerable discussion has been devoted to the authorship of this painting. Prior to 1917 it was attributed to John Singleton Copley (q.v.), but in that year it was published in a list of paintings assigned to Joseph Badger (q.v.) (Park 1917). For a number of years afterward, scholars continued to be convinced that the portrait was the work of Badger—some undoubtedly confused by the presence of a face that is consistent with Greenwood's work, but a right hand resting on the hip, with the first two fingers outstretched and separated, that superficially recalls similar treatments by Badger.

As more was learned about the two artists, it was noted that the portrait was "considerably above Badger's usual work" in quality (Lee 1929); another authority observed that it was "very close to Greenwood's signed work" (A. Burroughs 1936). In recent years it has become apparent that the portrait is entirely consistent with others by Greenwood. In particular, it resembles his signed and dated *Judge*

Robert Brown (1748; private collection) and his unsigned and undated *Robert Jenkins* (Rhode Island Historical Society, Providence). The elaborate waistcoat brings to mind his signed and dated *William Phillips* (1750; private collection). Rarely, if ever, did Badger utilize the sharp value contrasts seen here, which give Greenwood's style its distinctive character. Nor is Badger, who was extremely conservative and *retardataire* in his choice of fashion, likely to have been comfortable painting a multicolored brocade waistcoat, which appears nowhere else in the older artist's work.

Quite simply, Greenwood, even with his limited experience as a painter, was more proficient than Badger. His grasp of modeling was sounder, and his portraits have a freshness and clarity that Badger never achieved. Also, a recent removal of overpainting has made clear that the modeling of the sitter's right hand is somewhat sharper than was previously apparent.

In the extensive discussion about its attribution, the subject of the portrait has been, for the most part, overlooked. John Adams (1718–?) was a Boston merchant about whom little is known. The son of the Reverend Hugh Adams and Sarah Winborn Adams of Oyster River (now Durham), New Hampshire, he married Savannah Parker on December 24, 1741.
R. S.

Provenance George B. Dorr, Somerset Club, Boston. Robert C. Vose (dealer), Boston, 1926. Acquired in 1926.

Exhibitions (All references cite the work as by Badger unless otherwise stated.) Richardson 1934. Pittsburgh 1940, no. 21.

References Park 1917, 163. C. Burroughs 1927a, 73, 74. Bayley 1929, 7. C. Burroughs 1929a, 261. Lee 1929, 196. Detroit 1930, no. 257. Richardson 1934, 11. A. Burroughs 1936, 52 (as attributed to Badger). A. Burroughs 1943, 60, no. 23.

John Adams

Despite industrious, pioneering scholarship by Jacob Hall Pleasants in the 1930s and 1940s, a detailed investigation of the artist's life and art by Stiles Tuttle Colwill in 1981, and recent rediscoveries of a few major examples of his work, both the biography and oeuvre of Francis Guy remain thinly charted. Part of the difficulty is traceable to dependence on documentary materials that are either fragmentary or heavily biased both for and against the painter. Another part stems from the fact that Guy turned his full-time efforts to painting only around the time of his fortieth birthday, in 1800, some five years after he had emigrated from England to America. According to Guy himself (in a lost manuscript autobiography, recounted in Stiles 1869, vol. 2), his innate artistic talents were first manifested in boyhood sketches of scenery in the English Lake District, not far from his birthplace. But for much of the ensuing three decades, he worked in other professions, namely tailoring and silk dyeing. After moving to London in 1788, he soon obtained royal patronage in the latter business, and he continued to engage in it after 1795 in New York, Philadelphia, and Baltimore. As a painter, he evidently developed substantial skills only after settling in Baltimore in 1797, principally by copying works in local collections. Of his experiences relating to the fine arts while he lived in England, no firm information has as yet come to light.

The destruction by fire of the artist's Baltimore dyeing premises in 1799 (the date has been established by Colwill) was, as Guy tells us, a blessing in disguise, since he was able thereafter to devote his energies to his "darling pursuit"— landscape painting (Pleasants 1942, 241). By all accounts, he was soon successful, depicting the city from various vantage points, memorializing gentlemen's estates in the vicinity, and engaging in occasional heated debates with rivals and detractors.

One of the more important products of his Baltimore years was a large picture (unlocated) of the new Catholic cathedral, painted in consultation with the architect Benjamin Henry Latrobe.

Probably in early 1817, for reasons that are unclear, Guy moved back to Brooklyn, where he had lived briefly in the late 1790s. There he spent the last three years of his life, painting two versions of his most famous work, *Snow Scene in Brooklyn* (Brooklyn Museum; private collection), a compendium of architectural details and genre incidents as seen from his second-floor studio window. Throughout his later years, even as his dependence on alcohol reportedly increased, his artistic productivity and his readiness to place his work before the public showed no signs of diminishing. Early in 1819 he offered over a hundred paintings to Baltimore audiences, presumably the same paintings he put on display in New York during the summer of that year. In May 1820 he exhibited eighty-one works in New York, and during 1821 and 1822 his heirs mounted a showing of one hundred twelve of his pictures. At least four canvases in the later two displays were of large size, measuring six by ten feet.

G. C.

Bibliography Baltimore 1981.

43
Carter's Tavern at the Head of Lake George, 1817–18

Oil on canvas
101 × 168.3 cm (39¾ × 66¼ in.)
Founders Society Purchase, Gibbs-Williams, Merrill, Robert H. Tannahill Funds (68.39)

This painting is a useful aid in clarifying the nebulously documented final three years of Guy's life. Writing in 1869, Henry Stiles, the historian of Brooklyn, relying primarily on information given him by one of the artist's former Brooklyn neighbors, singled out *Snow Scene in Brooklyn* (ca. 1819; versions in the Brooklyn Museum and a private collection) as the preeminent work of the concluding phase of Guy's career. But when the Detroit picture is considered together with titles of six additional Guy paintings (unlocated) exhibited in New York in 1820 and 1821–22 and with commentaries on those and other examples of the artist's work written by a well-informed critic calling himself "Candor," published in the *New York Evening Post* between October 1821 and April 1822, a different impression of Guy's late artistic activities emerges. The seven canvases were shown under the titles *View on the Hudson River* (New York 1821, no. 33, described as a view of Stony Point and Haverstraw Bay), *View on the Hudson River near Hyde Park* (New York 1820, no. 23; New York 1821, no. 67), *New Burgh, with the River Banks to Butterhill* (New York 1820, no. 62; New York 1821, no. 4), *Rhinebeck Landing, Hudson River* (New York 1820, no. 2; New York 1821, no. 61), *Glenn's [sic] Falls, Hudson River* (New York 1821, no. 35), *Lake George, State of New York* (New York 1820, no. 71; New York 1821, no. 11), and *Carter's Tavern at the Head of Lake George* (the Detroit work; New York 1820, no. 12; New York 1821, no. 74). In toto, they constituted a panoramic anthology of the Hudson River Valley.

Neither the dates of the journeys Guy must have undertaken along the length of the river in preparation for the sequence nor those of the paintings themselves are recorded, but presumably the former took place in 1817 or 1818, and the pictures were then executed between 1817 and 1819. The project was an ambitious one. Two canvases in the series, *New Burgh* and *Lake George*, were listed in the exhibition catalogues as measuring six by ten feet; four others, *View on the Hudson River, Hyde Park, Rhinebeck Landing,* and the Detroit work, were said by Candor to

Carter's Tavern at the Head of Lake George

be of "large" dimensions; and the remaining painting, *Glenn's Falls*, was described by the critic as "of large cabinet size." Hence, on a considerably grander scale and at a slightly earlier date, Guy's compositions encompassed the Hudson Valley in a spirit similar to that of the works in the *Hudson River Portfolio* by William Guy Wall (1792–after 1864), the initial portions of which were published in 1821.

It is noteworthy that all of the larger paintings prominently portrayed towns or villages in the valley, that in addition to the natural feature, several manmade structures comprised *Glenn's Falls*, and especially that three constituents of the group—*Lake George, Carter's Tavern,* and *Glenn's Falls*—focused on the northern end of the valley (two on Lake George itself). Already the center of a flourishing lumber trade, the lake was rapidly becoming popular as a fashionable summer resort in the early nineteenth century. The village of Caldwell (today known as Lake George), which appears in the lower center of the Detroit picture—and which, again according to Candor, could be seen in the distance of Guy's larger painting of the lake—was founded only in 1813, the same year that the Presbyterian church, the earliest ecclesiastical building in the town, was begun. Four years later, the inauguration of steamboat service on the lake facilitated travel in the entire region.

Guy's *Carter's Tavern at the Head of Lake George,* therefore, depicts the lake and its surroundings at the moment of burgeoning domestication. As the viewer looks southward toward the end of the lake, the newly constructed two-storied inn and tavern, identified by a detached signpost and emphasized by clusters of nearby figures, stands on a rise in the right middle ground, its balconied construction affording an open prospect to the lake in the opposite direction. Farther into the scene, just past a dip in the road, a log building with a puffing chimney (identified by Candor as a blacksmith's shop) stands as testimony to the local lumbering industry. In the middle distance, the village is marked by the wooden spire of the church, while the neighboring peaks extend into hazy atmosphere beyond. Two sailing vessels and a rowboat carrying four persons ply across the lake at the left. Guy's larger painting of Lake George depicted approximately the same scene from the opposite shore, looking southward from the ruins of Fort George toward Caldwell and Diamond Island. Again, according to Candor, the most conspicuous feature of the "charming little village" was "the handsome church and spire" (*New York Evening Post,* October 26, 1821, 2).

As a whole, the Detroit work is refined, explicit, and descriptive, rather than rustic, dramatic, or imaginative, although the titles and Candor's description of other specimens of Guy's art shown in 1821 and 1822—for example, *Conflagration of a Church at Night; Flash of Lightning at Night;* and *English Cottage, Sun Set, Style of Gainsborough*—indicate that the sublime and the picturesque categories of landscape art were of interest to him. The fact that a half-dozen pictures of English Lake District scenery (dates of execution unknown; unlocated) were among his works shown in 1820 and 1821–22 further suggests that Guy had discovered belatedly at Lake George a North American equivalent to the poetic environment in which he had grown up and that he claimed to have sketched as a nine-year-old boy. In this respect, the six-by-ten-foot *Lake and Mountains of Keswick* (New York 1820, no. 7; New York 1821, no. 11), which depicted the vicinity of Guy's birthplace, and the *Lake George* of the same dimensions were probably conceived as complementary compositions.

The Detroit picture and the larger canvas of the same subject must have been painted in 1817 or 1818, since the artist himself referred to them prominently (immediately after mentioning "a large and accurate view of the vale of Keswick, in the North of England") in an advertisement published on January 1, 1819, for the exhibition of "above an hundred" of his paintings in Baltimore (reprinted in Baltimore 1981, 37). Both works were probably shown again in New York in July 1819. They were displayed once more by Guy himself in New York in 1820 and by his heirs in the winter of 1821/22. Candor's review of the Detroit work in the latter exhibition termed it "upon the whole . . . an admirable performance" (*New York Evening Post,* April 17, 1822, 2).
G. C.

Provenance The artist's heirs, 1822. William McNeil, Tappan, New York. Kennedy Galleries, New York, 1967. Acquired in 1968.

Exhibitions Baltimore 1819. New York 1819 (probably this work). New York 1820, no. 12. New York 1821, no. 74. Philadelphia 1838, no. 132 (possibly this work). Philadelphia 1839, no. 38 (possibly this work). Philadelphia 1840, no. 210 (possibly this work). Hartford and Washington 1986.

References *New York Evening Post,* April 17, 1822, 2. *Kennedy Quarterly* 1967, 21–22. Hood et al. 1977, 76–78. Baltimore 1981, 73. Hartford and Washington 1986, 215, pl. 156.

Chester Harding was an American original, "a self-made man," as he called himself (Harding 1866, 169), who willed his ascent from impoverished backwoodsman to cultured portraitist. His realization of the American dream was a signal achievement, perhaps overshadowing his art. Harding appreciated the mythic potential of his fantastic rise and in his self-effacing manner exploited it to the fullest. He became one of the most prominent antebellum painters, especially in his native New England.

A bear of a man, Harding was skilled at wielding the ax, but he played the clarinet as well. He tried his hand at cabinet-making and tavern keeping in western New York before debt drove him in 1816 to Pittsburgh, where he painted signs and portraits. Ambition impelled him to study at the Pennsylvania Academy of the Fine Arts in Philadelphia (in the winter of 1819/20) and to travel through Kentucky to St. Louis, where he lived until 1821 and discovered his talent for portraiture. Harding then painted portraits in Washington, D.C., and Northampton, Massachusetts, before moving to Boston in 1823. There, for reasons that are not fully explained by his art, he was immensely popular. "I can account for this public freak," he wrote, "only in the circumstance of my being a back-woodsman, newly caught [and] self-taught" (Dunlap 1834, 2: 292). He eclipsed Gilbert Stuart (q.v.), whose inactivity helped make Harding's reputation, as, ironically, Harding mimicked Stuart's style.

Harding achieved the same bewildering popularity in Great Britain between 1823 and 1826 that he had found in Boston. From London to Glasgow many aristocrats, businessmen, and liberal intellectuals were captivated by the giant frontiersman, his exotic background, his unpretentious, republican manner, and his bent for self-improvement. Describing himself as of "the Stuart School" (Harding 1866, 62), Harding emulated the styles of Sir Thomas Lawrence and Sir Henry Raeburn, combining his dedication to detail with their broad effects and handling.

Upon Stuart's death in 1828, Harding was in fact the leading portraitist in Boston, finding ample patronage within his own Federalist and Whig society. After 1830 he lived in Springfield, Massachusetts, but he maintained a studio in Boston as well as a gallery for the exhibition of contemporary art. He traveled widely and often to complete commissions as far afield as New Orleans and Cincinnati, and he returned to Europe in 1846 and 1847. He also dabbled in landscape architecture, designing the waterworks and the cemetery in Springfield. An inveterate outdoorsman, he spent many of his later years hunting and fishing in the backwoods.
W. T. O.

Bibliography Dunlap 1834, 2: 289–294. Harding 1866.

44
Solomon Sibley, 1822

Oil on canvas
74 × 61 cm (29⅛ × 24 in.)
Gift of the Sibley Estate (58.170)

In 1821 Harding planned a trip to study in Europe, but his mother persuaded him to provide first for his family's security. He bought a farm, had a house built, and headed straight to Washington, D.C. There he painted about forty portraits during his visit of six months in the winter of 1821–22 (Dunlap 1834, 2: 291–292).

One might fairly assume that the more illustrious or wealthy patrons in Washington would have turned not to the unknown Harding but to Charles Bird King (1785–1862), the capital's artist-in-residence, or to such a visiting celebrity as Thomas Sully (q.v.). Demand was high, however, and Harding's prices were low, so he was "full of business" (Harding 1866, 43). Among his sitters was Solomon Sibley (1769–1846), a man whose pioneer nature and background paralleled Harding's. Born in Massachusetts, Sibley became a lawyer and in 1797 settled in Detroit, then little more than a fort in the wilderness. He was appointed mayor in 1806, then served as auditor of the territory of Michigan, United States district attorney, representative to Congress from the territory (1821–23), and justice of its supreme court (1823–37). He paid forty dollars for his portrait, which he had commissioned by request of his wife, Sally (née Sarah Whipple). The circumstances are recounted in a letter to her on March 3, 1822:

My dear, to gratify your wishes, often expressed, I have employed an artist, who has placed my resemblance on Canvas, in the form of a Portrait, in full size, but not full length. It is pronounced a good likeness by Gentlemen of my acquaintance. It may be so, but I cannot reconcile myself to the belief that it is. It appears harsh and morose, and in other respects different from what I had fancied for myself. How you should ever have made choice of a man so unpropitious in features, is a riddle not easily solved" (Burton Historical Collection, Detroit Public Library).

"Harsh" is an apt adjective for the portrait, which seems perfunctorily descriptive and typifies Harding's early style. The eyes do have life, foretelling the facility with faces that Harding would later develop, and the image projects an innate dignity. The background appears to be a landscape of hills at sunset, a generalized frontier setting appropriate for Congressman Sibley.
W. T. O.

Provenance Descended in the Sibley family, Detroit. Acquired in 1958.

Exhibitions Detroit 1853, no. 280. Detroit 1921, 6, no. 13.

References Washington and Louisville 1985, 15, 19, 180.

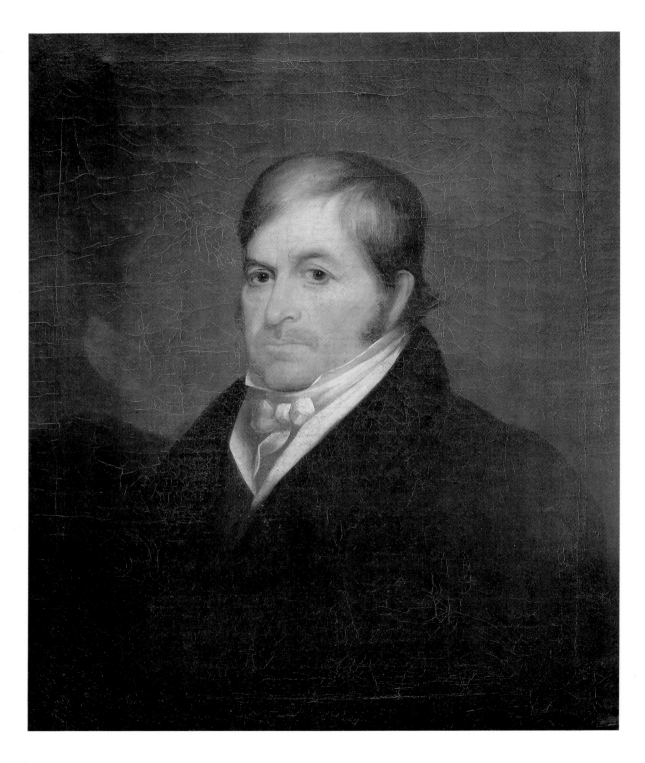

Solomon Sibley

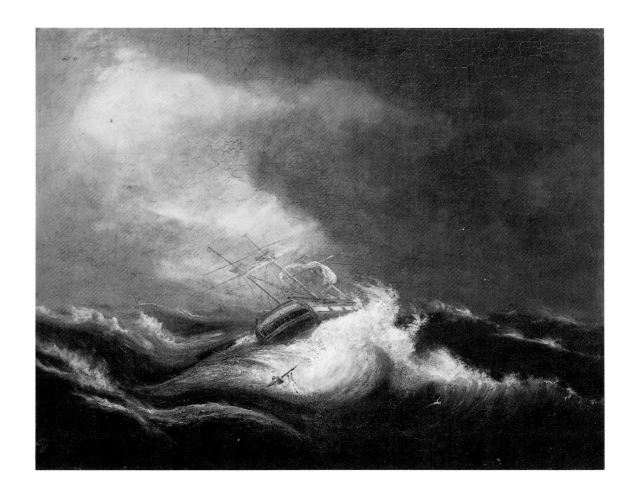

45

Ship in a Storm, ca. 1823/26

Oil on wood panel
73 × 91.4 cm (28¾ × 36 in.)
Gift of Mr. and Mrs. A. D. Wilkinson (66.236)

According to family tradition Harding
painted this scene of a ship in a storm
while he was in Europe. Although the
work is unsigned and only one other
seascape is attributed to him (see Wash-
ington and Louisville 1985, 180), there
would seem to be little reason to doubt its
assignment to Harding.

While he had no great love for the sea,
Harding was impressed by his few ocean
experiences and recounted them at length
in his autobiography. When he first
planned to visit England he had intended
to sail on the *Albion,* which went down in
the Irish Channel; the event aroused in
him "not a little emotion." His own pas-
sage on the ship *Canada* was an ordeal of
gale winds, rain, and "mountain-high"
waves. On arriving in Liverpool he "felt
so ridiculously happy in putting my foot
on shore again that I laughed heartily,
without knowing why" (White 1890,

65–67). While in Dublin he viewed the
effects of "a most dreadful storm." "It
was a horrible sight," he wrote, "wrecks in
every quarter" (ibid., 135–137). Such
events may well have induced Harding to
paint the seascape, probably for his own
interest; certainly they would have pro-
vided the experiential basis for it.

In its romantic sublimity the painting is
not associated with the sedate harbor
scenes typical of American marine paint-
ing in the second quarter of the nine-
teenth century, but relates instead to sea
pieces such as those of J. M. W. Turner
(which Harding no doubt encountered

Ship in a Storm

while in England) and *Rising of a Thunderstorm at Sea* (1804; Museum of Fine Arts, Boston) by Harding's friend Washington Allston (q.v.). *Ship in a Storm* describes the essence of the sublime: terrorizing vastness and deprivation, depicted with rough and irregular forms and abrupt contrasts of light and dark. The viewer finds no shore on which to put a foot, but is cast, like the damaged ship, into a nightmare of mountainous waves.
W. T. O.

Provenance Probably the artist's son, Frank S. Harding; one of the latter's daughters, either Elizabeth M. Harding or Annette T. Harding; a collateral descendant, Albert H. Trowbridge, 1961; his wife, Margaret M. Trowbridge [later Mrs. A. D. Wilkinson], Grosse Pointe, Michigan, 1966. Acquired in 1966.

References Washington and Louisville 1985, 180.

46
Dr. Samuel A. Bemis, 1842

Oil on canvas
92.1 × 71.8 cm (36¼ × 28¼ in.)
Gift of Dexter M. Ferry, Jr. (27.538)

Dr. Samuel A. Bemis (1793–1881) was one of Harding's good friends. In his boyhood Bemis had walked from Vermont to Boston, where he apprenticed himself to a watchmaker, but he plied that trade for only a short time; by 1815 he had bought out the business of a Boston dentist and become a dentist himself (he also made dental tools and false teeth that did not rattle). Bemis made a fortune and was a pioneering photographer as well; early in 1840 he bought one of the first of Louis Daguerre's cameras to be sold in the United States.

Like Harding, Bemis had emerged from the woods and, on the strength of his native talents and industry, assumed a position of prominence in society. Harding painted him in Boston, at the height of his career, seated in his office. (The precise date of 1842 was assigned to the work by the former owner, Florence Morey.) In this unusual *portrait d'apparat* of a dentist, we cannot mistake the sitter's profession —a mandible, a forceps, and an instrument box rest on the table. Nor can we mistake the importance of books to Bemis's profession, given the one in his hand and the shelves of others behind his head. The green of the table covering and the reds of the chair, instrument box, and drapery enrich the sober color scheme. Typical of Harding's style is the contrast between the fully modeled, closely painted head and the rest of the composition, which is handled cursorily. The treatment of the eyes and mouth discloses the "suggestiveness" and "changing play of the countenance" that contemporaries praised in his paintings: "They seem to give us, not only the prominent expression of the countenance at the moment, but the possibilities of its expression in other moods" (*Atlantic Monthly* 1867, 487).

After Dr. Bemis quit dentistry in about 1845, he and Harding maintained their friendship. Bemis retired to a stone country manor he had built near the Saco River in Crawford Notch, New Hampshire. He eventually owned a huge tract of woodland in the Notch, which he bequeathed, along with his possessions, to his caretaker, George W. Morey.
W. T. O.

Provenance The sitter, Dr. Samuel A. Bemis, Boston, and Hart's Location, New Hampshire. Probably George W. Morey, Hart's Location, New Hampshire; Florence Morey, Bemis, New Hampshire, 1927. Acquired in 1927.

References C. Burroughs 1927, 19–21. C. Burroughs 1929a, 271, 273. Washington and Louisville 1985, 137.

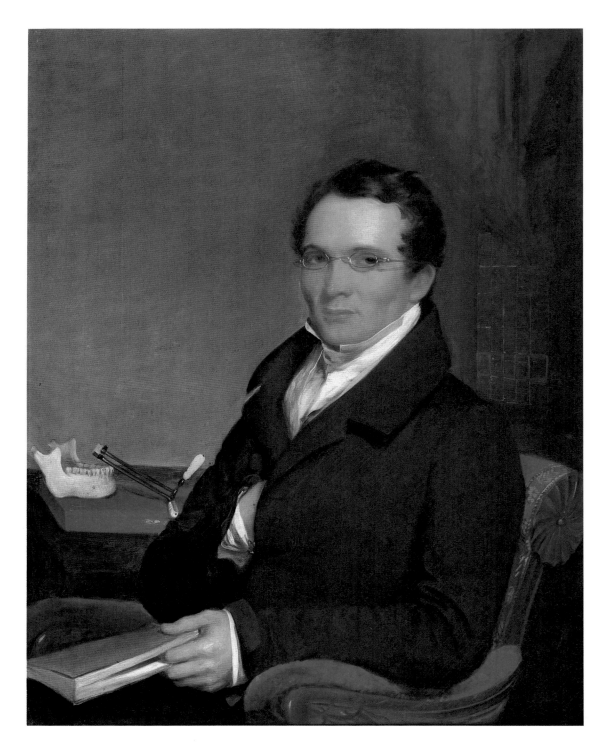

Dr. Samuel A. Bemis

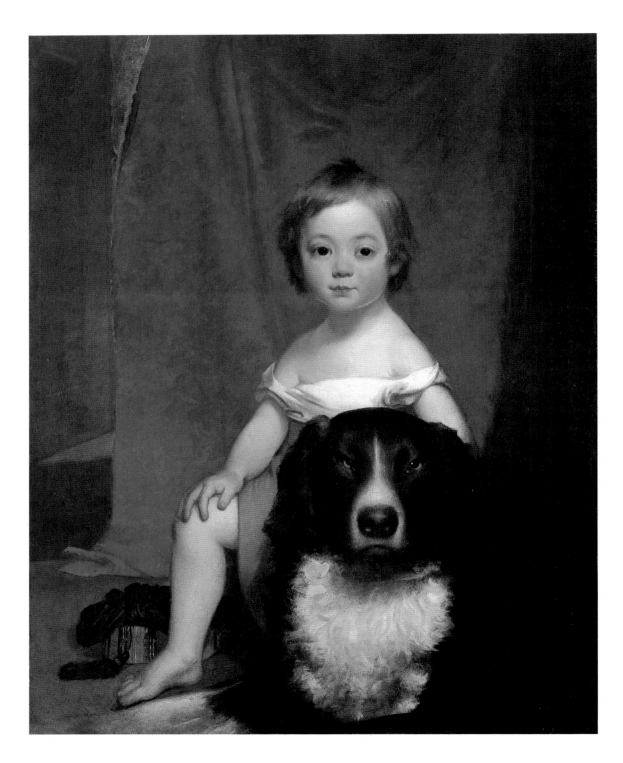

Frank S. Harding

47
Frank S. Harding, ca. 1843/46

Oil on canvas
90.2 × 71.1 cm (35½ × 28 in.)
Gift of Mr. and Mrs. A. D. Wilkinson (66.235)

The sitter in this portrait of a child with a dog was unidentified when the picture came to Detroit from descendants of the Harding family. The provenance suggests, however, that the subject may be one of the artist's ten children. The likely candidate is Frank (1839–?), the youngest child, who later lived in Detroit. In its informality, liveliness, and wit, the painting relates to the large body of family portraits by Harding, and in style—particularly the direct delineation of the features—it compares with those of the mid-1840s, such as *Mary Ophelia Harding Krum* (private collection) and *Chester Harding Krum* (Indianapolis Museum of Art).

Despite the evident misapprehensions of composition, drawing, and anatomy that plagued the unschooled Harding, the portrait of his son is bold and endearing, reflecting both the artist's nature and the instinctive "heartiness and kindliness" that he felt for young people (White 1890, 12). He delighted in the "exploits" of Frank and his grandson Chester, "a grand team," who enlisted frogs to re-create battles of the Mexican War (Washington and Louisville 1985, 128). Harding portrayed a disheveled Frank, pausing from some such mischief, posing with his guardian, a menacing spaniel, alertly stationed between him and the viewer. They make a formidable pair. Behind is a sumptuous red curtain hanging over what appears to be a window seat; on the floor is a hat of some kind, perhaps a tam-o'-shanter.
W. T. O.

Provenance Probably the artist's son, Frank S. Harding; one of the latter's daughters, either Elizabeth M. Harding or Annette T. Harding; a collateral descendant, Albert H. Trowbridge, 1961; his wife, Margaret M. Trowbridge [later Mrs. A. D. Wilkinson], Grosse Pointe, Michigan, 1966. Acquired in 1966.

48
Attributed to Chester Harding
Edward Everett, 1846/49

Oil on canvas
75.6 × 64.8 cm (29¾ × 25½ in.)
Gift of Dexter M. Ferry, Jr. (29.193)

Nothing is known of this painting before 1929, when it surfaced on the art market as a portrait of Edward Everett by Samuel F. B. Morse. The identification of the sitter is confirmed by comparison with the certain likenesses of Everett, such as the George Parker (?–ca. 1868) engraving after Asher B. Durand's (q.v.) portrait published in *The National Portrait Gallery of Distinguished Americans* (1834–39, 4: 324). Durand's portrait (unlocated) probably dates from 1837, when he exhibited it at the National Academy of Design in New York City as *Governor Everett of Massachusetts*. Since Everett's tenure as governor was from 1836 to 1839, and he appears in the Detroit painting to be some five to ten years older than in Durand's portrait, the Detroit work probably dates from the late 1840s. Since, furthermore, Everett served as minister to the Court of Saint James from 1841 to 1845, the painting likely pertains to his presidency at Harvard College (1846 to 1849). If the identification of the sitter in the Detroit portrait is sound, however, the ascription to Morse is not. Morse, as far as we know, stopped painting in 1837 (New York 1982, 80).

Edward Everett (1794–1865) was a clergyman, scholar, teacher, statesman, and politician, but above all he was an orator with few peers in an age of oratory. A native of Massachusetts, he graduated at the head of his class from Harvard and became, at twenty, minister of the Brattle Street (Unitarian) Church. After holding the chair of Greek literature at Harvard (at the same time he was editor of the *North American Review*), he served as a congressman, governor of Massachusetts, minister to Great Britain, president of Harvard, secretary of state, and senator. His political career ended in 1854, when, although opposed to slavery, he sought concessions to Southern interests in order to preserve the Union. For the next six years he toured the country, lecturing on George Washington and the Union for the benefit of the Mount Vernon Ladies' Association; he raised sixty-nine thousand dollars for the purchase and preservation of Washington's estate as a national shrine.

A noted connoisseur, Everett championed the cultivation of the fine arts in the United States and was familiar with the leading artists. In Boston in the mid-1840s he knew Chester Harding, whom he deemed "one of the most distinguished portrait painters" (Washington and Louisville 1985, 37). It is known that in 1846, just before making a second trip to Great Britain, Harding painted Everett's portrait (ibid., 33, 35, 150), but no subsequent history is recorded for that painting. While it cannot be said conclusively to be the Detroit canvas, a strong case can be made for it. Certainly, as an heir to Gilbert Stuart, Harding was capable of the monumentality, delicate handling, and subtle modeling that characterize the work, similar in these aspects to such portraits by Harding from the period as *Amos Lawrence* (1845; National Gallery of Art, Washington, D.C.) and *Gardner Braman Perry* (ca. 1850; Essex Institute, Salem, Massachusetts).
W. T. O.

Provenance Ehrich Galleries, New York, 1929. Acquired in 1929.

Exhibitions (All references cite the work as by S. F. B. Morse.) New York 1932, 35, fig. 45. Boston 1943. Poughkeepsie 1961, no. 21. New York 1982, 90, no. 45.

References C. Burroughs 1929, 104–106. C. Burroughs 1929a, 273–274. BDIA 1930, 70.

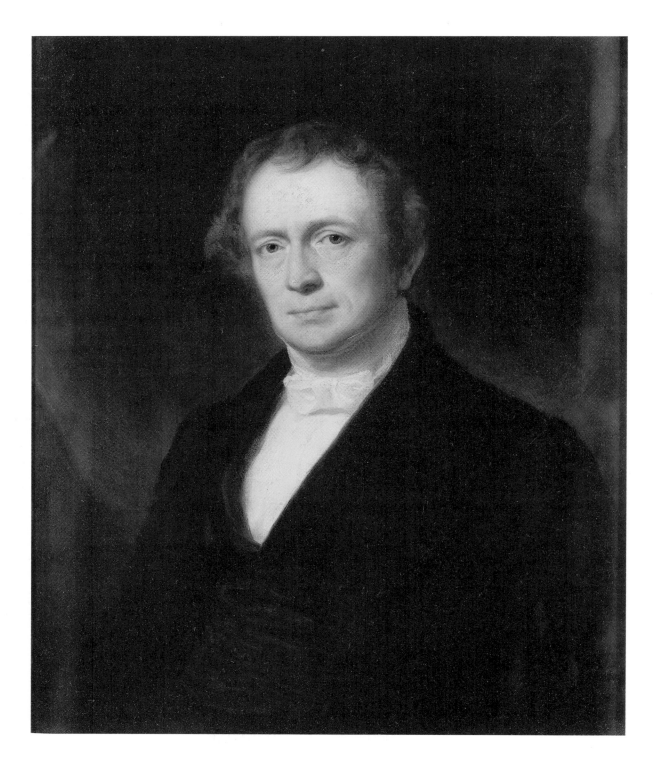

Edward Everett

George Healy rose rapidly from obscurity to become the first American portraitist of international fame. Untrained, but encouraged by Thomas Sully (q.v.), he established a studio in Boston in 1831; three years later he went to Paris to study with the venerable Baron Antoine-Jean Gros, whose art, along with that of Diego Velázquez, had an enduring effect on his style. By 1839, after traveling in Europe, he had come to the notice of King Louis Philippe of France and an array of aristocrats, with the result that he reaped choice commissions from the court, including, in 1842, an order from the king to take the likenesses of American presidents and statesmen.

Shuttling back and forth across the Atlantic in the late 1840s and 1850s with his gregarious British wife, Healy was swamped with patronage and praise. He was, in truth, a cosmopolitan phenomenon, the perfect guest, the forerunner of John Singer Sargent. Healy moved to Chicago in 1855, accepting the personal invitation of Mayor William B. Ogden and becoming the city's first top-rank artist. He continued to travel, painted a distinguished series of portraits of Civil War officers, returned to Europe in 1867, and passed the next twenty-five years in Rome and Paris, still making frequent excursions to the United States.

Healy grasped early the formula for successful portraiture: he painted faithful likenesses, he painted quickly, and he painted a great deal, producing as many as one hundred portraits in a year. His forte was the big portrait, the spacious, gilded full-length of personages of high society and state, but he could also convey grandeur in smaller formats and undertook several history paintings. Healy's earlier portraits were especially effective, by comparison with the compromised classicism of Gros and his friend Thomas Couture, combining taut draftsmanship, substantial form, and restrained brush-

work with a keen grasp of human grace and, occasionally, character. In much of the later work, particularly as Healy felt the influence of photography, such elements of technique became ends in themselves, and his art, while no less in demand, became routine and dry.

W. T. O.

Bibliography DeMare 1954.

49
Franklin Pierce, 1853

Oil on canvas
58.7 × 50.5 cm (23⅛ × 19⅞ in.)
Gift of Dexter M. Ferry, Jr. (43.74)

Healy began his series of presidential portraits for Louis Philippe, who intended to add them to the galleries at Versailles, but his royal patronage ended with the Revolution of 1848 and the death of the exiled king two years later. Healy persevered on his own, completing eleven portraits, which he sold to Thomas B. Bryan of Chicago in 1860. Bryan commissioned four more portraits to complete the collection through Lincoln (inexplicably the series lacks a portrait of William Henry Harrison) and sold them as a group to the Corcoran Gallery of Art in 1879. Healy's life portrait of Franklin Pierce (oil on canvas, 76.2 × 63.5 cm; Corcoran Gallery of Art, Washington, D.C.), painted in November 1852, was one of that group.

The Corcoran painting is ostensibly the prototype for at least five oil portraits of Pierce by Healy. Three of them date from 1853: the versions at Detroit, the New-York Historical Society (68.6 × 55.9 cm), and the National Portrait Gallery in Washington, D.C. (76.2 × 64.1 cm). The fourth, at the Museum of Fine Arts, Boston (76.2 × 63.5 cm), is not dated, but is thought to have been painted while Pierce was in office. The fifth version, at the White House in Washington, D.C., is

a full-length portrait (167.4 × 115.6 cm) painted in Chicago in 1858. All of these paintings repeat the likeness, expression, dress, and pose of the Corcoran original, but they differ in format and other particulars: the version at the National Portrait Gallery, for instance, includes Pierce's right hand; that at the New-York Historical Society, like the Detroit canvas, is an oval, but it is larger than the latter.

Healy was able to take accurate likenesses and to make subsequent copies of them partly because he always "asked permission to measure the face" of his sitter—the distance between the eyes, and so on (Healy 1894, 157). Such reliance on mechanical proofs is deeply rooted in the tradition of portraiture, but was especially prevalent in the nineteenth century, the age of the physiognotrace, the silhouette, phrenology, and the photograph. Healy's literal-mindedness certainly contributed to what the critic James Jackson Jarves (1864, 206) called "hard intellectualism," but it also contributed to success, as it fulfilled the demands of his patrons. As the Detroit portrait of Pierce demonstrates, Healy couched his naturalism in painterly terms, achieving a fluid technique that was neither bravura nor labored; he sought the particular, but not at the expense of general effect.

Pierce (1804–1869) was born in Hillsborough, New Hampshire, graduated from Bowdoin College (Brunswick, Me.), and practiced law before entering politics. A loyal Jacksonian Democrat, he served as a congressman (1833–36) and senator (1837–42). His association with Healy began no later than 1847, when he commissioned a portrait of his friend Nathaniel Hawthorne (DeMare 1954, 159–160). Pierce served in Mexico during the Mexican War, ultimately becoming a brigadier general. In 1850 he reemerged as a national political figure through his support of Southern rights, and in 1852 was nominated as a compromise candi-

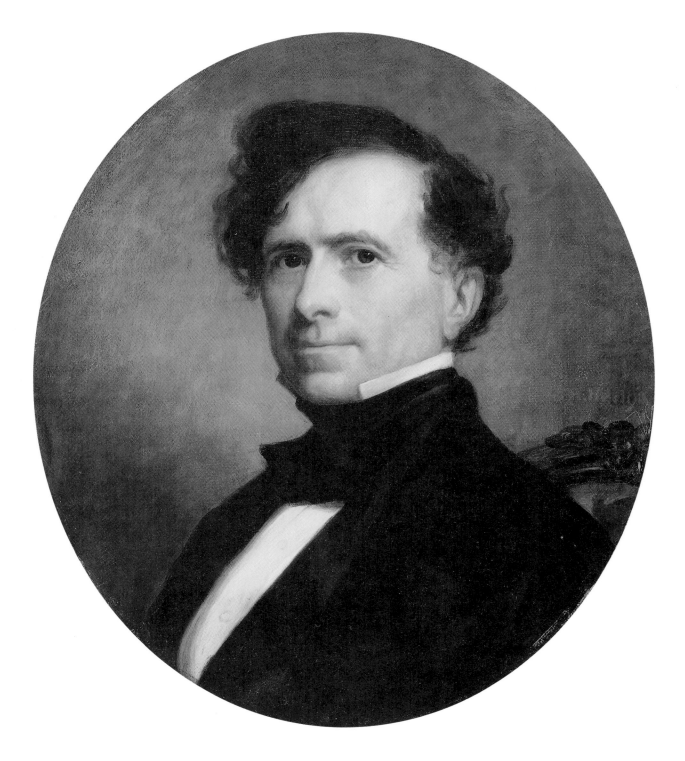

Franklin Pierce

date and elected president. His term (1853–57) was difficult. Although he was kind and honest, he was also inexperienced and indecisive. The central bill of his administration—the Kansas-Nebraska Act—was a disaster, and he continually faced issues that overwhelmed him. He retired to Concord, New Hampshire, denounced Lincoln—his most unpopular act—and faded into obscurity.
w. t. o.

Inscriptions At center right, *G. P. A. Healy 1853*

Provenance Probably Kirk D. Pierce, Hillsborough, New Hampshire, ca. 1920. The Pierce family, Boston. John Levy Gallery, New York, 1943. Acquired in 1943.

50
Sanford Robinson Gifford, ca. 1868

Oil on canvas
35.6 × 30.5 cm (14 × 12 in.)
Founders Society Purchase, Merrill Fund
(52.245)

Healy's portrait of the artist Sanford Robinson Gifford demonstrates—in contrast to his stock, full-blown productions in the grand manner—an ability to render a sensitive, incisive portrayal on a small scale. While the painting is unsigned, it bears the hallmarks of Healy's work in the clarity of drawing, the restrained brushwork, the three-dimensional realization of the head, and the fidelity of the likeness. Both the near-profile and the silhouetting of the figure against a blank, greenish blue ground derive from the classicism of Antoine-Jean Gros and Thomas Couture. The profile pose is unusual for Healy, who preferred frontal or three-quarter views, but it flatters Gifford, whose face and nose were long and narrow.

Why Healy painted Gifford's portrait is unknown. The small size and the lack of pretension in the characterization attest to a private commission. While the early provenance of the painting is lost, the "you" in the phrase "for whom you were named," which appears on a label affixed to the stretcher, refers (according to Gifford's niece, Edith Wilkinson) to Gifford Pinchot; James W. Pinchot, a wealthy New York merchant and the father of the great conservationist, was a close friend and patron of Gifford. It is likely, then, that James Pinchot commissioned Healy to paint the canvas.

When Healy painted the portrait is also unknown. His path could have crossed Gifford's a number of times from the late 1840s to the late 1860s, but the sitting most likely occurred in Rome in 1868. Healy lived in Italy from 1867 to 1873, as he waited out the Franco-Prussian War before settling in Paris. Gifford was in Rome briefly in September 1868 and then again from October to December. Both Gifford and Healy were members of an illustrious American community in Rome that included Frederic E. Church, Jervis McEntee (1828–1891), and Henry Wadsworth Longfellow.

A detail of internal evidence may also support the date of 1868. Gifford's self-portraits show him with hair parted on the right, but a photograph of 1868 (see Austin et al. 1970, 2) shows the part on the left, as it is in Healy's work. Although the Gifford portrait does not relate to Healy's large paintings of the time, such as the dark, weighty portrait of Longfellow and his daughter Edith (1869; Worcester Art Museum, Mass.), the difference probably has to do with the intimate nature of Gifford's likeness.

Gifford (1823–1880) came from a well-to-do family in Hudson, New York. He left Brown University to become a painter and studied in New York with John Rubens Smith (in 1845) and at the National Academy of Design, which awarded him full membership in 1854. An admirer of Thomas Cole (q.v.), he gave up portraiture and turned almost exclusively to landscape painting. He traveled, but his base throughout his mature career was the Studio Building on West Tenth Street in New York. Gifford was noted for the luminous color and atmospheric effects of his art, which was dominated by idyllic, poetically evocative scenes of the near-wilderness of upstate New York. He was also esteemed for his genial, gentlemanly character and for the quality of stoical reserve that is reflected in both his own art and Healy's portrait of him.
w. t. o.

Annotations On label affixed to stretcher, *Sanford R. Gifford N.A. / (for whom you were named)*

Provenance Anne Richardson, Melrose, Massachusetts. (Dealer), Melrose, Massachusetts. Robert Campbell (dealer), Boston. M. Knoedler Co., New York. William Macbeth (dealer), New York, 1952. Acquired in 1952.

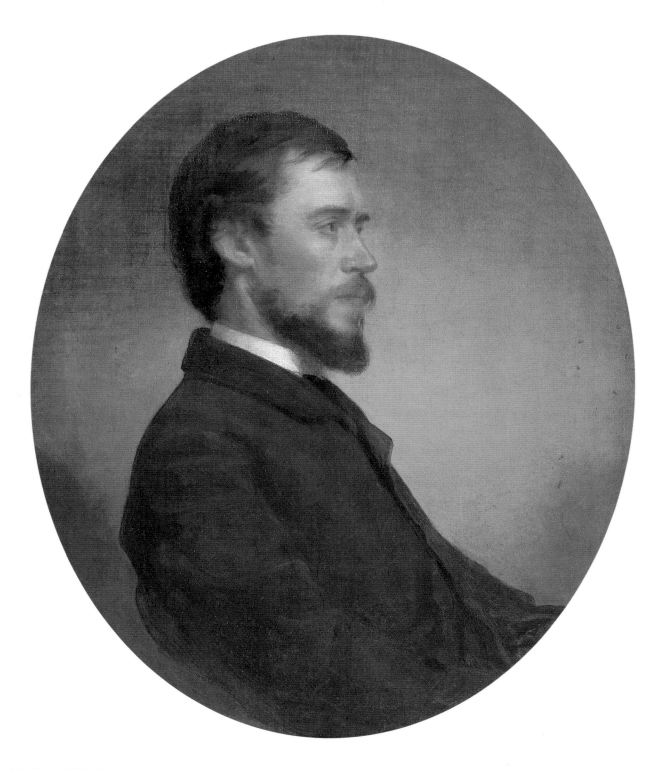

Sanford Robinson Gifford

The major painter active in the middle American colonies during the second quarter of the eighteenth century, Gustavus Hesselius was born in central Sweden to parents who were deeply involved in the Lutheran Church. As a youth he received some artistic training in his native country; in October 1711 he and his eldest brother Andreas, a Lutheran pastor, set out via England (where Gustavus surely took note of current conditions in the visual arts) for the Swedish colony in Wilmington, Delaware. Almost immediately after their arrival in May 1712, Gustavus traveled on to the Swedish colony in Philadelphia. From there, around 1720, he moved to St. George's County in Maryland for approximately a decade, afterward returning to Philadelphia, where he lived for most of the remainder of his life. He was buried in Gloria Dei (Old Swedes Church) in Philadelphia. His son John Hesselius (q.v.) was also a productive colonial portraitist.

At the time he set foot in North America, Hesselius considered himself a portraitist, but like most colonial painters, his practice on this side of the Atlantic ranged across the two-dimensional arts. In an advertisement placed in a Philadelphia newspaper in 1740, he listed first his skill as an "ornamentalist," then claimed proficiency in sign-, house-, and ship-painting, "landskips," and the repair of "old pictures," while saying nothing about portraits. Strong family involvement with religious matters and his own spiritual restlessness account in part for further accomplishments as an organ and spinet builder, and for the fact that he painted at least two compositions of religious subjects, one of them for the altarpiece of a Maryland church. These last-named works, plus two small canvases of mythological subjects owned by the Detroit Institute of Arts and the Pennsylvania Academy of the Fine Arts, two bust-length portraits of Delaware Indian chieftains (ca. 1735; Historical Society of Pennsylvania, Philadelphia), and a pair of likenesses presumed to be those of the artist and his wife (ca. 1740; Historical Society of Pennsylvania), constitute a synthesis of the lingering European taste and indigenous realism unique in early American colonial painting.

G. C.

Bibliography Philadelphia 1938. Fleischer 1971.

51

Attributed to Gustavus Hesselius

Bacchus and Ariadne, ca. 1720–30

Oil on canvas
62.2 × 82.2 cm (24½ × 32⅜ in.)
Gift of Dexter M. Ferry, Jr. (48.1)

Since this painting surfaced at the 1938 Gustavus Hesselius exhibition held at the Philadelphia Museum of Art, scholars have generally accepted the attribution to Hesselius that was put forward by Christian Brinton but have seriously debated the work's subject matter and probable date. On one matter only has there been uniform agreement: the Detroit picture should be considered one of a pair of pendant images. The other, a canvas of the same size and provenance, showing a group of mythological figures in a landscape, was also exhibited in Philadelphia in 1938 and was purchased by the Pennsylvania Academy of the Fine Arts, Philadelphia, in 1949.

The provenance of the two paintings narrows the possible authorship to two artists. Until the late 1940s, both paintings were owned by descendants of Gustavus Hesselius. The earliest known references to works of these descriptions date from 1825, nearly three-quarters of a century after Gustavus's death and almost a half-century following the demise of his son, John (q.v.). To the "Fourth Annual Exhibition" held at Rembrandt Peale's Baltimore Museum, which ran in December 1825 and January 1826, "Mrs. Hesselius" —presumably Mary Williams Hesselius, wife of John Hesselius, Jr. (1777–1804)—lent three paintings by "John Hesselius": *Venus and Adonis* (no. 55 [the current work]), *Diana and Her Nymphs* (no. 58), and *Virgin and Child* (no. 52). According to the catalogue for the showing, "a selection from the various cabinets of old masters, in this city and its vicinity" complemented a larger number of works by "American artists' in "Sculpture, Painting, Architecture, Drawing, Engraving, &c." It is likely that Peale family connections facilitated the loan of the three pictures: in the 1760s, Charles Willson Peale (q.v.) had taken painting lessons in Annapolis from the elder John Hesselius.

The three works can be identified with reasonable probability as, respectively, the Detroit and Philadelphia mythological scenes and a larger painting handed down through the Hesselius family, a *Holy Family* acquired by the Pennsylvania Academy of the Fine Arts in 1930. However, comparison of the three pictures presents a conundrum: the two pagan scenes are stylistically and inconographically similar, but the *Holy Family* appears to be the work of a second artist and, moreover, does not readily accord with present-day perceptions of the work of either Gustavus or John Hesselius.

The question of the authorship of these pictures is complicated further by the titles assigned in 1825 to the first two compositions. Assuming the mythological works to be the same as those displayed in 1825–26, neither title is farfetched, yet neither is correct. Allowing for the provincial level both of the artist's mastery of technique and of his understanding of Greco-Roman mythology, the principal figures in the Detroit painting can be identified as Bacchus and Ariadne, as Edgar P. Richardson (1949) adduced. It is true that certain components of the scene—in particular the large cupid-like figure, the spearlike staff held by the standing male at the right, the partial nudity of the three largest figures, and the drapery hung in the tree above and behind them—could conceivably suggest a "Venus and Adonis"

theme. Yet by that reckoning, Adonis's dogs are missing, while those recognizable elements that are present are intelligible as Bacchic motifs. Bacchus' identity is confirmed by the wreath of grape leaves he wears and by the fact that he grasps a *thyrsus*, a Bacchic staff often (though not always) embellished toward the top with grape leaves, as it is here. The pointed tip of the *thyrsus* is an unusual but not unprecedented variant of the more frequently depicted blunt end. In this context, then, the largest female figure is Ariadne, and the female kneeling in *profil perdu* below is surely Ariadne's handmaiden. In the left distance, a Bacchic chariot carrying Ariadne is pulled by a pair of stubby leopards and attended by a satyr and cupids (two of them very sketchily painted), all of which reinforce the primary theme.

The presentation is not without discordances. Seemingly alarmed by the satyr, the background figure of Ariadne should instead be amorously enthralled with her rescuer-deity, Bacchus, who, however, does not ride with her and is nowhere to be seen in the nearby landscape. The upside-down, oversize male infant dragging a torch on the ground is an especially anomalous component. In some contexts of classical subject matter, such a figure could allude to the death of love (i.e., Theseus' abandonment of Adriadne), yet even if that were the artist's intent, it must be admitted that the figure disrupts both the iconographic and spatial logic of the composition. The fact that the figure is wingless led Dorinda Evans (in Philadelphia 1976) to propose that he represents the infant Bacchus, "born of a burning mother," and that therefore the two large women might represent the god's foster parents, the nymphs of Nysa. But this interpretation does not take into account the mature Bacchus at the right, and it bypasses the traditional pairing of Adriadne with a handmaiden. Everything considered, the interpretation of the scene as Bacchic remains intact, as it does in the Philadelphia pendant under the currently accepted title, *Bacchanalian Revel*. Brinton's proposal (in Philadelphia 1938) that the Detroit painting depicts *Pluto and Persephone* must be discounted in light of the Bacchic attributes in both compositions, as well as a lack of characteristics appropriate to a theme of rape involving an older male deity and the underworld.

Part of the seeming iconographical inconsistency of the Detroit work may stem from the artist's use of more than one compositional model. Identification of a specific source or sources would provide a *terminus ante quem* for the picture, but this information, too, remains elusive. Numbers of nothern European baroque and late baroque compositions are stylistically and thematically related to the Detroit work. Among the closest parallels are scenes by late-seventeenth- and early-eighteenth-century Dutch masters. The Leiden painter Willem van Mieris, for example, frequently resorted to neo-mannerist figures, abrupt neomannerist changes in scale, and selective attention to floral and herbal detail in scenes that can be read as sophisticated relatives of the two paintings under consideration here. Indeed, van Mieris painted at least three variations on the theme of Bacchus and Ariadne, and in 1694 he issued a series of engravings of subjects from Ovid. Similarly, the arcadian landscape settings of the Detroit and Philadelphia pictures can be seen as provincial reflections of, for example, works by Jan van Huysum in the same vein.

Whether or not the elder Hesselius was aware of these particular artists' works cannot be determined, since no substantive information is known about his European training or the contents of his American studios. Similar lacunae in our knowledge of John Hesselius's artistic upbringing render any judgments problematical, although it can be assumed that the son's education was based on his father's instruction and studio materials. In recent years several paintings previously assumed to be by the father have been shown conclusively to be the work of the son; in general the son's figures and their accessories are sleeker and (within the limits of colonial portraiture) are more refined than those by the father. If the two classical works are by Gustavus Hesselius, they are best comprehended in terms of his early career, as Edgar P. Richardson (1949) was the first to suggest. Upon or shortly before the painter's move to America in 1712, when his European experiences were still fresh, he would have had most reason to paint in such a thoroughly Continental manner. If they were indeed executed before 1730, as Roland Fleischer (1971), Evans, and, most recently, Jessie Poesch (in Richmond et al. 1983) have speculated, the two small pictures stand as the earliest known paintings of mythological subjects in American art. On the other hand, if the paintings are by John Hesselius, the chronological situation in which they might be placed—the early training of a colonial painter by his artist-father—is equally reasonable, and the stylistic analogies are more compelling. In the delicate hands, luxuriant draperies, and uncertainties of draftsmanship and paint handling can perhaps be seen the formation of the younger artist, a successful American rococo portraitist.
G. C.

Provenance The artist's descendants; Mary Young [Hesselius] Dundas [Mrs. Francis Henry Hodgson], until 1948. Acquired in 1948.

Exhibitions Baltimore 1825–26, no. 55 (as *Venus and Adonis* by John Hesselius, possibly this work). Philadelphia 1938, 16, 27, no. 13 (as *Pluto and Persephone*). Philadelphia 1956, no. 24. Montreal 1967, no. 203. New York 1975a, 6, no. 1. Philadelphia 1976, 24, no. 20.

References H. Keyes 1938, 145. Richardson 1949, 223–224. McCoubrey 1963, 167–168. Detroit 1965, 52 (dated ca. 1725). Fleischer 1971, 139–146. Wilmerding et al. 1973, 39–40. Gerdts 1974, 19–20 (as *Bacchus and Ariadne* or *Pluto and Persephone*). Richmond et al. 1983, 10, 176.

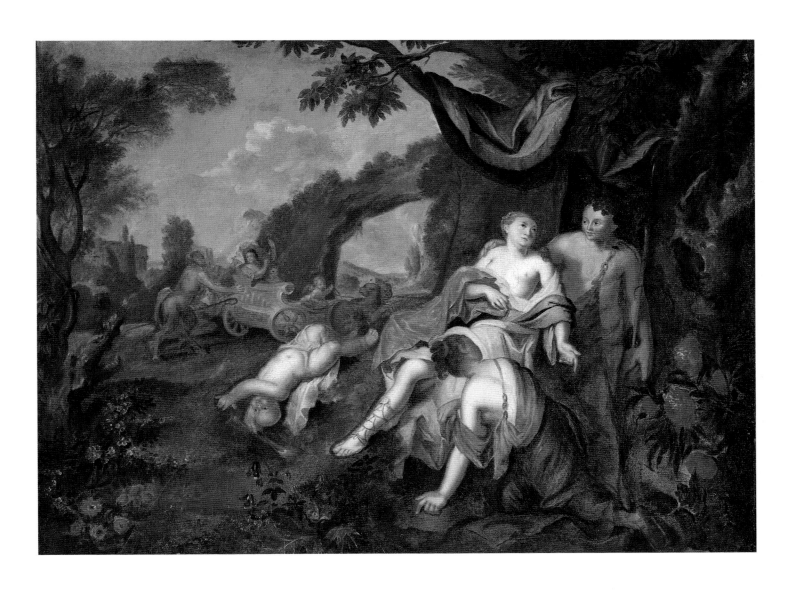

Bacchus and Ariadne

J ohn Hesselius was the son of Gustavus Hesselius (q.v.), a Swedish-born painter who came to Philadelphia in 1712. As no contemporary accounts of Hesselius's life exist, his signed and dated works provide the major clues to his development. By 1749 the younger Hesselius, then twenty-one, had begun a professional career. Unlike his better-known father, he seems to have limited himself to portrait painting, and after his father's death in 1756, be became the major painter in the middle colonies of Pennsylvania, Maryland, Delaware, and Virginia. Like other native-trained artists who did not travel outside the Colonies, Hesselius was necessarily influenced to a great degree by the work of colleagues and immediate predecessors. Consequently, his style was affected in succession by his father, Robert Feke (q.v.), and John Wollaston (q.v.). Hesselius's works after 1760, with their flickering highlights, pastel colors, and graceful poses, have much in common with those of his contemporaries, especially Wollaston, with whose work his own paintings are sometimes confused. His style is frequently marked by a taste for slightly angular heads and overly elaborate costumes.

Hesselius's best-known work is the 1761 portrait *Charles Calvert and His Servant* (Baltimore Museum of Art), and many of his surviving works date from that decade. By 1763 he had settled on an estate, Bellefield, near Annapolis, where he remained except for painting trips to other parts of Maryland and Virginia. The artist is also remembered as the first teacher of Charles Willson Peale (q.v), an Annapolis neighbor who turned to the older artist for advice in 1763.

R. S.

Bibliography Doud 1969.

52
William Allen, ca. 1770–77

Oil on canvas
91.4 × 72.4 cm (36 × 28½ in.)
Gift of Dexter M. Ferry, Jr. (27.606)

This picture, which came to the museum identified as a portrait of Joseph Allen by John Wollaston (q.v.), was reattributed to John Hesselius by George Groce in 1957 (note, curatorial files, DIA). Shortly after its acquisition, Charles K. Bolton, who had studied the pedigree of the Allen family, suggested that the portrait represented Joseph Allen's son William (ca. 1739– 1790/93). This identification was later confirmed by the genealogist Prentiss Price (letter, curatorial files, DIA). Part of the problem in sorting out Hesselius from Wollaston has been that both painted in Virginia during the 1750s, that Wollaston influenced Hesselius's style, and that until recent scholars devoted attention to their careers, neither artist's work was well known.

Allen lived at Claremont, an estate in Surry County, Virginia, which borders the James River across from Williamsburg. His family's home is now better known as Beacon's Castle, one of the oldest houses in Virginia. He was politically active and served in the House of Burgesses (1759–61), as justice of the peace (1770–?), and as colonel commandant of Surry County (1764). Allen's portrait is thickly painted and typical of Hesselius's doggedly conservative style evident in the first two decades of his career. Given the apparent age of the sitter, however, the portrait probably was done on one of the artist's painting trips from Maryland to Virginia in the early 1770s. Particularly characteristic of Hesselius during this period are the sitter's small head and pear-shaped upper body, which are made more emphatic because of the kit-cat format (between a miniature and a full-size likeness, or approximately 91.4 x 71.1

centimeters [36 × 28 inches]). This length normally also revealed the sitter's hands, which took more time to paint, and the artist charged accordingly. Hesselius, how-ever, seems to have avoided painting hands at this point in his career, which made good sense, as he was not particularly adept at them anyway. But the alteration, as here, produced less dramatic results than Sir Godfrey Kneller, a sculptor and the originator of the kit-cat format, intended.

R. S.

Provenance The sitter, William Allen, ca. 1758–90/93; his son, Colonel William Allen, 1790/93–1831; his sister, Anne Armistead Allen, 1831–33; her daughter, Martha Armistead Edloe, 1833–57; her son, William Griffin Orgain, who took the name of Allen, 1857–75; his son, William Allen; his widow, Mrs. William Allen. Robert C. Vose (dealer), Boston, 1927. Acquired in 1927.

Exhibitions (All references cite the work as by Wollaston.) Minneapolis 1939, 17, no. 45.

References C. Burroughs 1927, 20. C. Burroughs 1929a, 259. Heil and Burroughs 1930, no. 409. A. Burroughs 1936, 48, fig. 44.

53
Mrs. William Allen, ca. 1770–77

Oil on canvas
91.4 × 72.4 cm (36 × 28½ in.)
Gift of Dexter M. Ferry, Jr. (27.607)

This portrait, like its pendant, *William Allen,* was thought to be by John Wollaston (q.v.) at the time it was acquired by the museum. In 1957 it, too, was reattributed to Hesselius by George Groce (note, cura-torial files, DIA). Mrs. Allen, née Mary

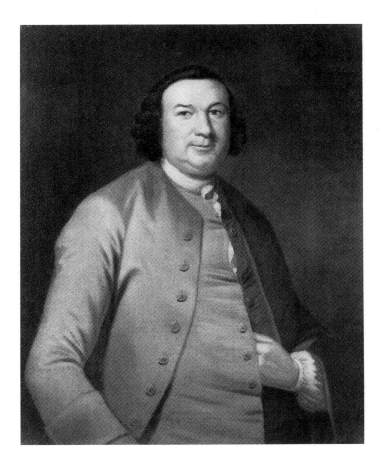
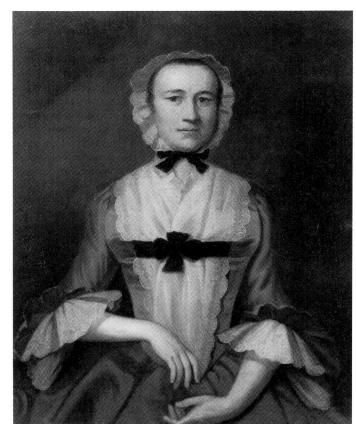

William Allen
Mrs. William Allen

Lightfoot (1750–1789), was in her twenties at the time of her portrait, although both her costume and Hesselius's technique make her appear considerably older. The frontal pose Hesselius employed is an unfortunate one, as it makes the sitter appear particularly stern and overbearing. At the time of the portrait, Hesselius had been painting for many years, but an unsuitable picture such as this suggests an inconsistent quality in his work. His awkwardness at painting hands, for example, is painfully apparent. The Detroit painting is now in a somewhat neglected state, and the removal of its darkened varnish might give a clearer impression of what Hesselius intended.

Two other portraits traditionally identified as Mrs. William Allen and attributed to Wollaston survive: one (undated; Shelburne Museum, Vt.) appears to portray the same woman as the Detroit portrait, the other (ca. 1760; Brooklyn Museum) depicts a younger woman with a different hairline that may well be another sitter.

R. S.

Provenance The sitter, Mrs. William Allen, ca. 1758–before 1764; her husband, William Allen, before 1764–90/93; his son, Colonel William Allen, 1790/93–1831; his sister, Anne Armistead Allen, 1831–33; her daughter, Martha Armistead Edloe, 1833–57; her son, William Griffin Orgain, who took the name of Allen, 1857–75; his son, William Allen; his widow, Mrs. William Allen. Robert C. Vose (dealer), Boston, 1927. Acquired in 1927.

References C. Burroughs 1927, 20 (as by Wollaston). Heil and Burroughs 1930, 410 (as by Wollaston). Sellers 1957, 432, pl. 22, 18D. Belknap 1959, 295, pl. 22, 18D.

54
Thomas Chamberlaine, ca. 1772/75

Oil on canvas
74.6 × 61.9 cm (29⅜ × 24⅜ in.)
Gift of Dexter M. Ferry, Jr. (44.140)

Although not included in Richard Doud's list (1969, 149–150) of Hesselius's Maryland subjects, this Detroit picture is quite representative of the artist's late work. The painting relates stylistically to several of the artist's signed and dated works; presumably, it was simply overlooked, since its provenance is known. The portrait is one of the more charming examples of Hesselius's skills, and it exceeds the unambitious level generally typical of his work. Also, in contrast to his early style, this portrait is thinly painted.

Hesselius had employed the format of a young man standing in an open landscape for his earlier, more elaborate *Charles Calvert and His Servant* (Baltimore Museum of Art). In the Detroit picture, the background, with a rocky, vine-covered embankment on the left and jagged coastline to the right, is virtually identical to that in his signed and dated (1761) portrait *Samuel Lloyd Chew* (Museum of Early Southern Decorative Arts, Winston-Salem, N.C.). Hesselius also chose on occasion, as here, to depict a half-length figure in a bust-length (76.1 × 63.5 centimeters [30 × 25 inches]) format, whereas other colonial artists would not have tried to squeeze this much of a figure onto a small canvas. But surprisingly, in the works in which Hesselius did this, the figure is not crowded, partly because he deftly reduced its proportions.

Although the portrait was thought to represent the Thomas Chamberlaine who lived between 1731 and 1764, it was correctly pointed out by Ethelwyn Manning (within a few months of the painting's acquisition) that the sitter was more likely his son and namesake Thomas Chamberlaine (1762–1786), who appears to be between ten and fourteen years of age (letter to Edgar P. Richardson, curatorial files, DIA). Chamberlaine, an only child, was born at his father's estate, Plaindealing, in Talbot County, Maryland, a short distance across Chesapeake Bay from Hesselius's home near Annapolis. In 1782 Chamberlaine studied law at the Middle Temple in London, then returned to America, where he entered the firm of Nicolas, Ferr, and Chamberlaine at Easton, Maryland, then called Talbot Court House. He was of delicate health, however, contracted tuberculosis, and died before his twenty-fifth birthday.

On the back of the frame is an old label that reads: *Dr. J. E. M. Chamberlaine, Easton, Maryland.* Another portrait of Chamberlaine, shown with his mother, which belonged in 1945 to W. Laird Henry, is at present unlocated.

R. S.

Provenance The sitter, Thomas Chamberlaine, to 1786; Samuel Chamberlaine; his son, Samuel Chamberlaine, Jr.; his son, Dr. James E. Muse Chamberlaine; his daughter, Elizabeth Bullock Hayward; her son, J. Chamberlaine Hayward. M. Knoedler Co., New York. Acquired in 1944.

Exhibitions New York 1944. Baltimore 1958, 11.

References C. Burroughs 1944a, 22–23 (as the elder Thomas Chamberlaine).

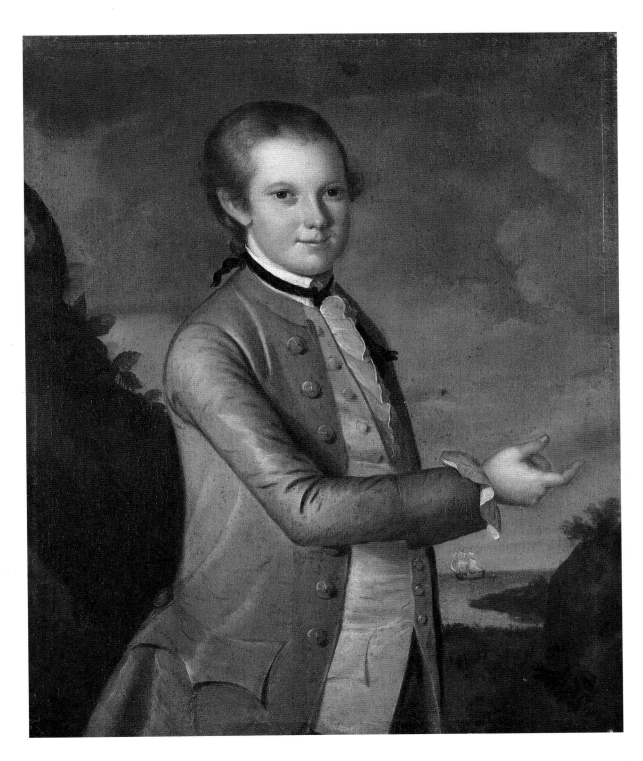

Thomas Chamberlaine

Henry Inman was the most successful portrait painter in New York City throughout much of the second quarter of the nineteenth century. He was the counterpart to Thomas Sully (q.v.) in Philadelphia, and like Sully he was called "the American Lawrence." In his art he promoted the wholesale importation of British romanticism, but he was also devoted to the promotion of national culture and the establishment of an American visual aesthetic.

Inman was the son of English immigrants, who encouraged his interest in art. In 1812 he moved to New York City and served an apprenticeship to John Wesley Jarvis (q.v.), accompanying the master on his travels and assisting in painting backgrounds and draperies. On his own by 1822, Inman began by painting miniatures but soon became known for oil portraits, particularly of men. From 1825 to 1827 he and his partner at the time, Thomas S. Cummings (1804–1894), were among the founders of the National Academy of Design (Inman became the academy's first vice-president). From 1831 to 1834 he worked in Philadelphia as a partner in a lithographic firm with Cephas G. Childs (1793–1871). The venture succeeded, since Inman's portraits were highly regarded, but the artist had financial problems and returned to New York, assuming for a time his former prominence in that city. In 1844, suffering from a decline in health as well as commissions, Inman traveled to England; soon after his return, early in 1846, he died. In an extraordinary tribute, the National Academy organized an exhibition of about one hundred twenty-five of his paintings to benefit his widow and five children.

Inman was a versatile artist. Oil portraits made up the bulk of his work, but he was probably most widely known for genre paintings. He also produced miniatures, landscapes, fancy pictures, vignettes, and literary and historical illustrations. He was a deft draftsman who considered drawings as finished works of art suited for exhibition. Many of his drawings were engraved for gift books, periodicals, bank notes, and certificates, contributing greatly to his renown.
W. T. O.

Bibliography New York 1846. Bolton 1940. Washington 1987.

55
John Church Hamilton, ca. 1830/35

Oil on canvas mounted on mahogany panel
21.1 × 17.3 cm (8⁵/₁₆ × 6¹³/₁₆ in.)
Founders Society Purchase, Dexter M. Ferry, Jr., Fund (41.5)

John C. Hamilton (1792–1882) was one of the eight children of Elizabeth Schuyler and Alexander Hamilton. After graduating from Columbia College, New York, he became a successful lawyer in New York City. In the 1830s he began to dedicate his energies to studying his famous father's life and writings. Hamilton wrote the two-volume *Memoirs and Life of Alexander Hamilton* (1834–40), edited the seven-volume *Works* (1850–51), and compiled the gargantuan six-volume *History of the Republic of the United States of America, as Traced in the Writings of Alexander Hamilton* (1857–60), which ran through several editions.

Inman's portrayal of Hamilton is formal. The boyish-looking man is seated in a red-upholstered armchair, holding a letter in his hand. His reserve is a striking feature of the painting; another is his youthfulness. His attire, particularly the black stock, is typical of the 1830s, when Hamilton was in his late thirties or early forties. Although Inman endorsed the new fashion for the black stock, he did not find it visually appealing: "I never paint a man in a black cravat if I can help it," he avowed. "On canvas, especially with a dark background, it looks as if his head was cut off" (Gerdts 1958, 78).

The portrait manifests Inman's characteristic softness of touch and tightness of drawing, as well as the gentlemanly composure and affable expression that made his likenesses popular among the urban elite. Also typical of his style is the impulse toward idealization in the features, which are smoothly modeled. Even in this small canvas Inman rendered the figure imposing by the use of the half-length format and the placement of the head high in the field. He was, in fact, a master of the small-scale portrait; he produced miniatures, portrait drawings, and many intimate cabinet pictures such as this. Among those painted between 1830 and 1835 are one of the sitter's mother, Mrs. Alexander Hamilton (ca. 1825; Cincinnati Art Museum), and one of himself (1834; Pennsylvania Academy of the Fine Arts, Philadelphia).
W. T. O.

Inscriptions On back of panel, *John C. Hamilton / Son of Alexander Hamilton / Henry Inman / Pinxit*

Provenance (Dealer), New York. John Levy Galleries, New York, 1941. Acquired in 1941.

Exhibitions East Lansing 1966, 15, no. 9.

References Bolton 1940a, 406, no. 56. C. Burroughs 1941a, 21–22.

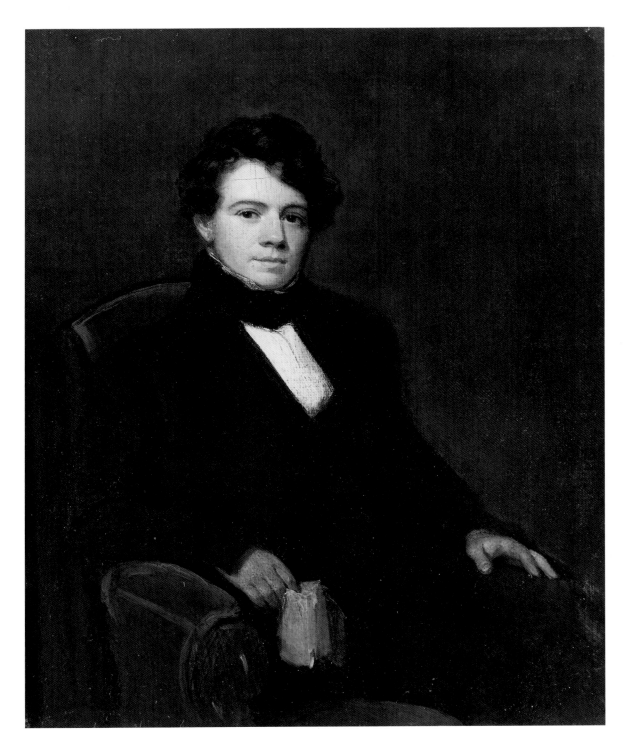

John Church Hamilton

56
Lieutenant Philip Augustus Stockton, 1833

Oil on canvas
76.2 × 63.5 cm (30 × 25 in.)
Gift of Dr. and Mrs. Coleman H. Mopper
(1988.61)

The Stocktons were an eminent family descended from Richard Stockton, one of the earliest and largest landowners in Long Island and, subsequently, Princeton, New Jersey. The family tree bears a signer of the Declaration of Independence and other lawyer-politicians, as well as influential clergymen, physicians, writers, and naval officers. In the last category the most illustrious member of the family was Commodore Robert Field Stockton, who was noted especially for his service in California during the Mexican War. The sitter of the Detroit portrait was his second cousin, Philip Augustus Stockton (1802–1876), who was the son of Lucius Witham Stockton, a lawyer, and the grandson of the Reverend Philip Stockton, a chaplain in the Continental army during the Revolutionary War. The value of military and public service must have been impressed upon young Stockton men, and Philip Augustus was no exception. He entered the Navy as midshipman on February 1, 1823, and was promoted to passed midshipman in 1829 and lieutenant in 1831; he was on furlough in 1833 before resigning on February 14, 1834. Stockton served four of his eleven years in the Navy on board the original

Constitution in the Mediterranean. His first wife, Sarah Cantey, died in 1835 after the birth of their second son, and five years later Stockton married Mary Remington, who provided him with a third son. In 1856 Stockton was appointed consul-general for Saxony, a position he held for six years at Dresden. He resided as well at Princeton, on the family property, "Woodlawn," and later at Newport, Rhode Island, where he died. According to the family genealogist, he was a Whig and an Episcopalian.

It was while he was on furlough and on the eve of his retirement from the Navy that Stockton commissioned Henry Inman to paint his portrait in his eye-catching, braid- and brass-trimmed officer's uniform. Stockton may never have engaged in battle, but Inman provided the conventional romantic setting for the bust-length representation of a military figure: a diagonal aureole, for the most part behind the head, colored to suggest swirling clouds, smoke, and flames. The vigorous brushstrokes in the background are meant to impart dash and energy to the man of action in the foreground, an effect heightened by the windblown sketchiness of the hair and the placement of the figure just off center with the arms held apart from the torso. Inman rarely portrayed men in uniform, but he certainly knew how to do so effectively, drawing on his awareness of John Wesley Jarvis's (q.v.) work in this field, and perhaps Rembrandt Peale's (q.v.) as well. The portrait of Stockton reveals the reasons why Inman offered a serious challenge to Thomas Sully (q.v.) and John Neagle (q.v.) in Philadelphia: he not only painted in a similarly idealizing, facile manner, but also surpassed their workmanship in selected passages of closely

observed detail, such as the wholly convincing rendering of the epaulet. The bluish gray lines that set the lips, nose, and hairline in high relief are characteristic of his expertise in modeling.

From 1831 to 1834 Inman was probably busier than at any other point in his career. He traveled to New York, Baltimore, and elsewhere but worked primarily at both his studio in Philadelphia and at his estate, Sterling Farms, in Mount Holly, New Jersey, where he commanded important commissions and produced a distinguished series of portraits, many of Episcopalian leaders. In 1833 alone he painted such diverse personalities as the naturalist John James Audubon (private collection) and the Right Reverend Charles Pettit McIlvaine (private collection), a Princeton graduate and well-known evangelist who had just been consecrated bishop of Ohio. In the same year Inman copied many of the portraits of Native Americans by Charles Bird King and James Otto Lewis that had been commissioned by Colonel Thomas L. McKenney, chief of the Bureau of Indian Affairs in Washington, D.C.; Inman's copies served as models for the colored lithographs illustrating the three-volume *History of the Indian Tribes of North America* (1836–44) published by McKenney and James Hall.
W. T. O.

Provenance Probably Philip Augustus Stockton, Newport, Rhode Island; probably his son, Howard Stockton, Boston; his son, Howard Stockton, Boston. Vose Galleries, Boston. Dr. and Mrs. Coleman H. Mopper, Huntington Woods, Michigan. Acquired in 1988.

Exhibitions Detroit 1968.

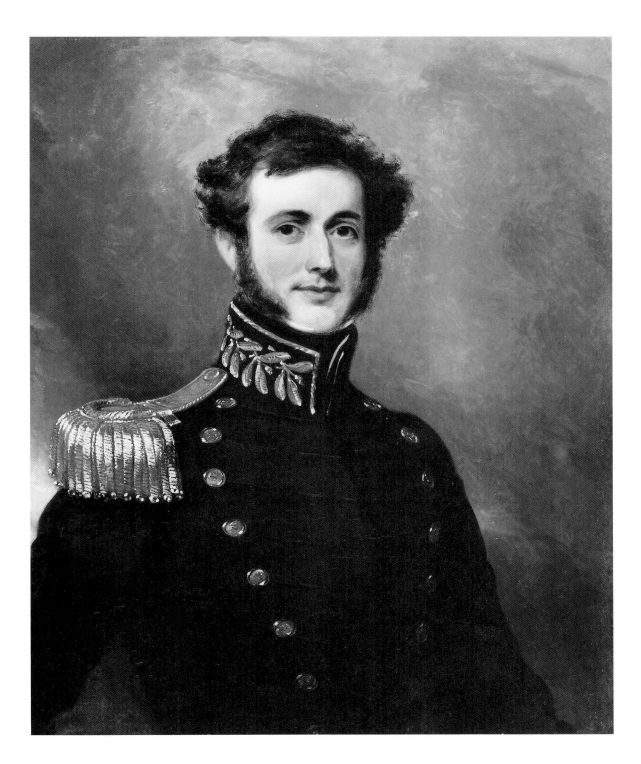

Lieutenant Philip Augustus Stockton

John Jarvis was born in England to an American father and a British mother. She was the grandniece of the Reverend John Wesley, founder of Methodism, a fact that the artist would proclaim after 1807 by adopting the theologian's name. The family immigrated to New York City when Jarvis was about five and then settled in Philadelphia.

At the close of an unhappy indenture to the painter-engraver Edward Savage, Jarvis set up shop in New York as an engraver. From 1803 to 1810 he shared a studio with the miniaturist Joseph Wood (q.v.) and found success as a portrait painter. After a three-year stint in Baltimore he returned to New York, where he maintained for nearly a decade a reputation as the city's foremost portraitist. He was the favored artist of the Knickerbocker elite. With the help of his assistant, Henry Inman (q.v.), he could spin off six portraits in a week and commanded an annual income of six thousand dollars. He was a competent, forthright painter, whose best efforts are technically coarse in contrast to those of Gilbert Stuart (q.v.), Thomas Sully (q.v.), Samuel Waldo (q.v.), John Vanderlyn (q.v.), and Rembrandt Peale (q.v.).

Apparently New York patrons valued his homespun artistry and vitality. They also appreciated his bohemian character and famous wit, puns, and endless gab. He was an unequaled storyteller, who circulated easily among the masculine circles of businessmen, writers, lawyers, actors, and artists. Never skimping on clothing or drink, he devoted his substantial income to this boisterous social life.

Jarvis's career began to unravel in 1820, following his second marriage. He escaped more and more on painting trips to the South, to Washington, Richmond, Charleston, and New Orleans. In 1824 he pleaded in court, unsuccessfully, to gain custody of his daughters. By then he was less illustrious than notorious; alcoholism undid him, and business declined until, in 1834, a stroke left him incapacitated. For his last six years he survived in poverty under the care of his sister.

W. T. O.

Bibliography Dickson 1942.

57
Jacob Houseman, 1809

Oil on wood panel
86.4 × 67.3 cm (34 × 26½ in.)
Gift of Dexter M. Ferry, Jr. (41.55)

When John Trumbull (q.v.) left New York City for England in December 1808, Jarvis found himself in the position of being the only first-rate portrait painter in the city. Although that status changed when Samuel Waldo (q.v.) arrived in January, the next few years were productive for Jarvis. He pressed the advantage, establishing a studio at the conspicuous corner of Wall Street and Broadway and advertising his business in New York and Long Island newspapers. In 1809 and 1810 he painted a number of large portraits (about 86.3 × 66 centimeters [34 × 26 inches]), many on wood panels, that evinced his newfound self-assurance and maturity. Prime among these was *Jacob Houseman.* For such a "portrait with hands" he charged sixty dollars in 1809.

Houseman was a wire manufacturer and merchant in New York City from 1801 to 1825. He also shared a partnership with Jacob Crocheron, a grocer, in operating a "flaxseed store" from 1802 to 1811. Jarvis portrayed Houseman as a busy entrepreneur, poised to leave, holding his hat, fidgeting with his watch fob. Such animation, such arrested movement in pose and expression were typical of Jarvis, who delighted in discovering the physical bearing and energy of his sitters, if not in plumbing their psychological depths.

Jarvis's early portraits reveal an incongruity in assimilating objective realism and stylish conventions. No such disjunction clouds portraits of 1809, which exhibit an internal consistency of style. How Jarvis suddenly arrived at this resolution remains a mystery, but he seems to have felt the influence of artists such as Jacques-Louis David and Robert Lefèvre. In general his style derived from Anglo-American exemplars, especially Edward Savage, Gilbert Stuart (q.v.), and Trumbull. *Jacob Houseman,* however, belongs to a small group of Jarvis's portraits that reflect the impact of French neoclassicism. New Yorkers held French fashion in high esteem; so high, in fact, that even the Anglophile Trumbull found himself adopting such elements of the modern French style as tighter outlines, a more muted palette, sparer backgrounds, and a larger, more vertical format in many of his New York portraits from 1804 to 1808. Jarvis's *Houseman* documents the same trend, the beginning of which may be traced to John Vanderlyn's (q.v.) visit to New York from Paris from 1801 to 1803; the recent arrival of Waldo may have contributed also to Jarvis's development. In its expanded vertical field, clarity of contour, and even-handed brushwork, *Houseman* compares to his other portraits of 1809, such as those of Washington Irving (Sleepy Hollow Restorations, Tarrytown, N.Y.) and a gentleman of the Gosman family (New-York Historical Society). The portrait of Houseman displays, for once, Jarvis's capability as a designer, particularly in the relationship between the figure and the measured intervals of the architecture. His color

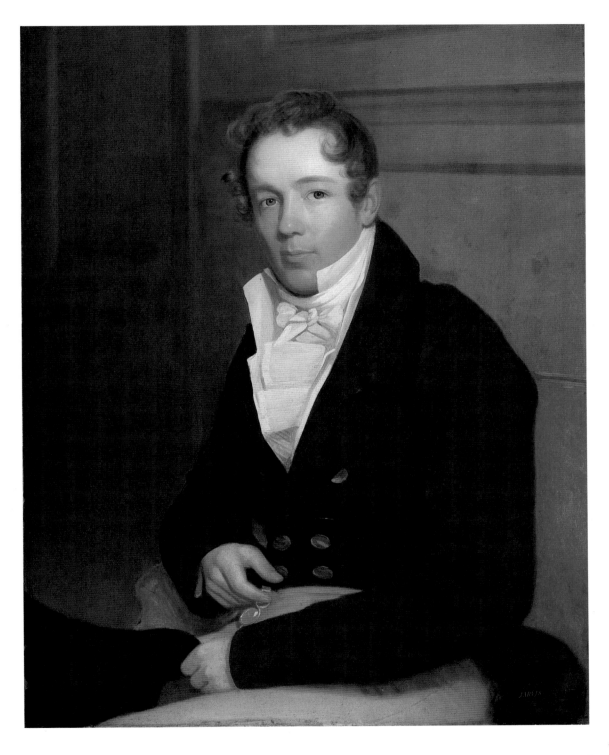

Jacob Houseman

scheme is similarly simplified and restrained.

w. t. o.

Inscriptions At lower right, *JARVIS. PINXT/ 1809 NEW YORK*

Provenance Malcolm Sands Wilson, New York, 1940. John Levy Galleries, New York, 1941. Acquired in 1941.

Exhibitions New York 1940.

References C. Burroughs 1941, 3–4. Dickson 1949, 130, 325, 329–330, 334, 338, 353, pl. 41. Pierson and Davidson 1960, 314, no. 2736. New York 1974, 1: 298, no. 760.

58

Commodore Oliver Hazard Perry, ca. 1814–20

Oil on canvas
81.9 × 66 cm (32¼ × 26 in.)
Gift of Dexter M. Ferry, Jr. (50.139)

The American naval victories over the British in the War of 1812 were pivotal events in the definition and development of the nation's character, bestowing honor and glory on the generation that had missed the Revolution. Perhaps none of the bold new heroes of this war was more celebrated than Commodore Oliver Hazard Perry (1785–1819). Born in Rhode Island, he emulated his father, a veteran of the Revolution, by entering the navy in 1799, during the undeclared war with France. In 1802 he saw action in the Tripolitan War; in 1809 he received his

first command. At the outbreak of the War of 1812, he was entrusted with no less a responsibility than to wrest the Great Lakes waterway, a vital artery to the Northwest Territory, from the control of the British fleet commanded by Robert Barclay. On September 10, 1813, sailing from his base at Put-in-Bay on Lake Erie, he engaged and captured the entire British fleet, an unprecedented achievement. His terse dispatch to General William Henry Harrison—"We have met the enemy and they are ours"—entered the history books. The British were defeated; the Northwest Territory became part of the United States. Perry served further in the war and later in the Mediterranean. In 1819, on a mission to Venezuela, he died of yellow fever.

Perry's victory on Lake Erie was the most sensational American military event since Yorktown in 1781, and it held for the public the same promise of finality. Perry was hailed as *triumphator:* President Madison promoted him to commodore; Congress rewarded him; states and cities honored him with trophies, swords, receptions, and toasts; artists beseeched him for sittings. The Common Council of the City of New York commissioned Jarvis to paint a full-length portrait of Perry (oil on canvas, 243.8 × 152.4 cm; New York City Art Commission).

Related to the full-length portrait, which depicts Perry in an active pose in the midst of the battle, are at least three busts by Jarvis. The Detroit painting portrays Perry in plainer dress than the other portraits, while still manifesting the conventional background of heroic portraits: a stormy, smoke- and cloud-filled sky that begins to clear as if in response to the hero's presence. Jarvis makes of that clearing a dynamic diagonal, whose white accents complement the stock and epaulets

of the uniform. This is the kind of facilely painted, vivid, but unrevealing portrait that made Jarvis so popular. It demonstrates clearly the contemporary accounts of Perry's strength, stature, and magnetism, but barely reveals the ambitious, impetuous, argumentative man.

Jarvis probably painted at least one of the bust-length portraits before completing the full-length canvas for City Hall in 1816, since Perry was not available for sitting in New York after 1815. The best version—the youthful, spirited likeness that descended in Perry's family (oil on canvas, 86.4 × 68.6 cm; United States Naval Academy, Annapolis, Md.)—is likely a life portrait. The Detroit painting appears to be a copy after a second version, also owned by Perry's descendants (private collection). Although both of these latter portraits lack the delicate, fluid brushstroke of Jarvis's finest work, they came from his studio. The history of the Detroit painting suggests that it was commissioned by Perry's friend, former commander, and brother-in-law, Captain John Rodgers, whose portrait Jarvis painted in 1814. Certainly the Detroit portrait dates from 1814 or later, for Perry wears a medal of the Society of the Cincinnati, awarded him in 1814.

w. t. o.

Provenance John Rodgers, Washington, D.C., 1859; descended in the Rodgers family, Washington, D.C. Victor D. Spark (dealer), New York, 1950. Acquired in 1950.

Exhibitions Washington 1968, 91.

References Richardson 1950–51, 75–77. Richardson 1951, 166, 170–171.

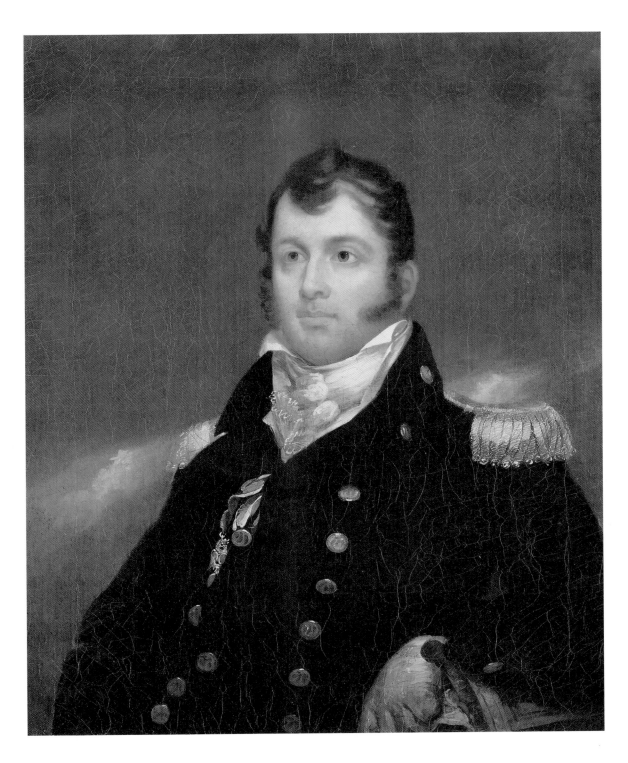

Commodore Oliver Hazard Perry

Reuben Moulthrop was the son of John and Abigail Holt Moulthrop. The first notice of his career as an artist occurred in New Haven, Connecticut, where he was mentioned in a newspaper advertisement (*Connecticut Journal*, September 4, 1793) as a modeler of portrait heads in wax. He exhibited wax work in New York City in 1794 and, by 1800, was traveling with his wax museum, showing it that year in Harrisburg, Pennsylvania (*Oracle of Dauphin County*, May 19, 1800).

Moulthrop's first dated oil portrait is a 1794 likeness of Ezra Stiles, president of Yale University. While nothing is known of Moulthrop's training as a painter, he appears, like many another little-taught provincial artist, to have been influenced by the work of his contemporaries. His paintings from the mid-1790s, for example, echo in style works of two New York painters, John Durand (active 1766–82) and Abraham Delanoy, Jr. (1742–1795). Both of these artists used strong highlighting of faces and broad planes of color in costumes and shared an especially distinctive way of painting fabric, ribbon, and flowers. One possible explanation for the appearance of such characteristics in Moulthrop's work is that he became acquainted with these artists and their work during his 1794 trip to New York (Delanoy is known to have been in the city in that year).

The work of the Woodstock, Connecticut, artist Winthrop Chandler (1747–1790) appears to have been an early influence, as was that of another Connecticut artist, Joseph Steward (1753–1822). In the latter case, there are indications of actual acquaintance between the painters, who were both active in central Connecticut at the same time. In 1796 Steward opened painting rooms in Hartford and in 1797 began a museum in the State House, which was maintained there and at a

nearby location until some years after Moulthrop's death in 1814. Other influences can be found in the work of the portrait painters William and Richard Jennys (active 1795–1806 and 1766–98, respectively).

Ralph W. Thomas (1956) thought that the unevenness in quality that characterizes Moulthrop's portraits might result from "the fact that he was actively occupied with wax modelling and his museum and may have painted portraits only as a means of 'taking up the slack' during those periods when attendance at his exhibitions fell off."

M. B.

Bibliography Gottesman 1954, 2: nos. 1281, 1287. Thomas 1956, 98.

59
The Reverend Ammi Ruhamah Robbins, 1812

Oil on canvas
79.7 × 69.9 cm (31 3/8 × 27 1/2 in.)
Gift of Mr. and Mrs. Harold R. Boyer and Mr. and Mrs. Frederick M. Alger, Jr. (61.272)

This portrait of the Reverend Ammi Ruhamah Robbins, a distinguished Congregational clergyman in Norfolk, Connecticut, is a companion to one of his wife (see cat. no. 60). Both paintings are mentioned in letters dated 1812 from Ammi Robbins to his son, the Reverend Thomas Robbins, of East Haven, Connecticut (see Thomas 1956, 100). Also noted in letters between Robbins and his son is Moulthrop's almost-six-foot-square, life-size portrait of the elder Robbins (Yale University Art Gallery, New Haven, Conn.), painted in the same period. Eleven years earlier Moulthrop had painted a portrait of the son (Connecticut Historical Society, Hartford) in the same pose on a canvas of similar size.

M. B.

Provenance The Swift family, Norfolk, Connecticut; a descendant, Mrs. Frederick

Alger [later Mrs. Fred T. Murphy], Grosse Pointe, Michigan; her daughter, Mrs. Harold R. Boyer, and her son, Frederick Alger, Jr., Grosse Pointe. Acquired in 1961.

Exhibitions Fort Worth 1975.

References Thomas 1956, 100.

60
Mrs. Ammi Ruhamah Robbins, 1812

Oil on canvas
79.7 × 69.9 cm (31 3/8 × 27 1/2 in.)
Gift of Mr. and Mrs. Harold R. Boyer and Mr. and Mrs. Frederick M. Alger, Jr. (61.273)

This portrait is a companion piece to one of Mrs. Robbins's (née Elizabeth Le Baron) husband, the Reverend Ammi Ruhamah Robbins (see cat. no. 59). In style it is reminiscent of the portraits of William Jennys, who worked in Connecticut in the early 1800s. The very realistic portrayal of the face—as well as the meticulous painting of the lace and satin ribbon of the bonnet—echoes similar passages in Jennys's canvases. The chair and the posing of Mrs. Robbins's left arm and hand are mirror images of the chair and pose in Moulthrop's 1801 likeness of her son, the Reverend Thomas Robbins (Connecticut Historical Society, Hartford).

M. B.

Provenance The Swift family, Norfolk, Connecticut; a descendant, Mrs. Frederick Alger (later Mrs. Fred T. Murphy), Grosse Pointe, Michigan; her daughter, Mrs. Harold R. Boyer, and her son, Frederick Alger, Jr., Grosse Pointe. Acquired in 1961.

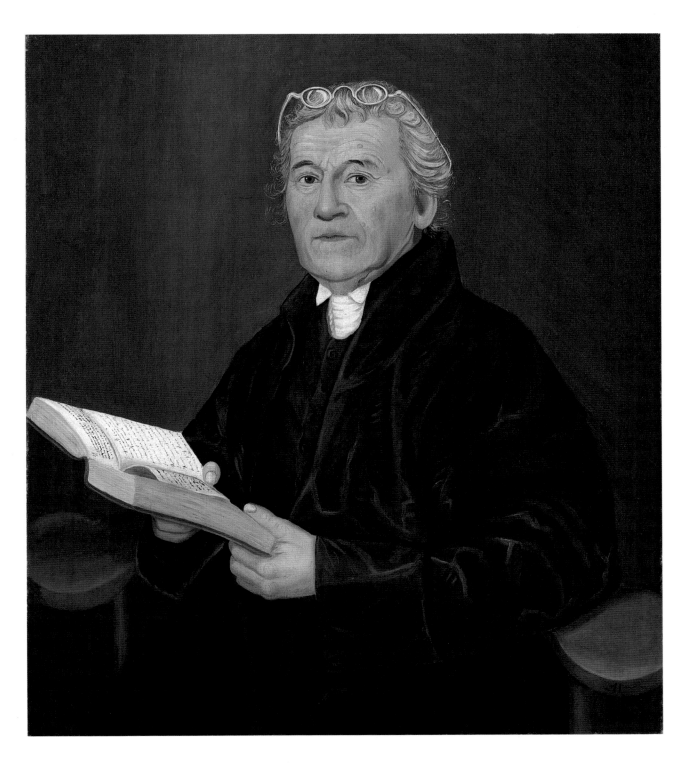

The Reverend Ammi Ruhamah Robbins

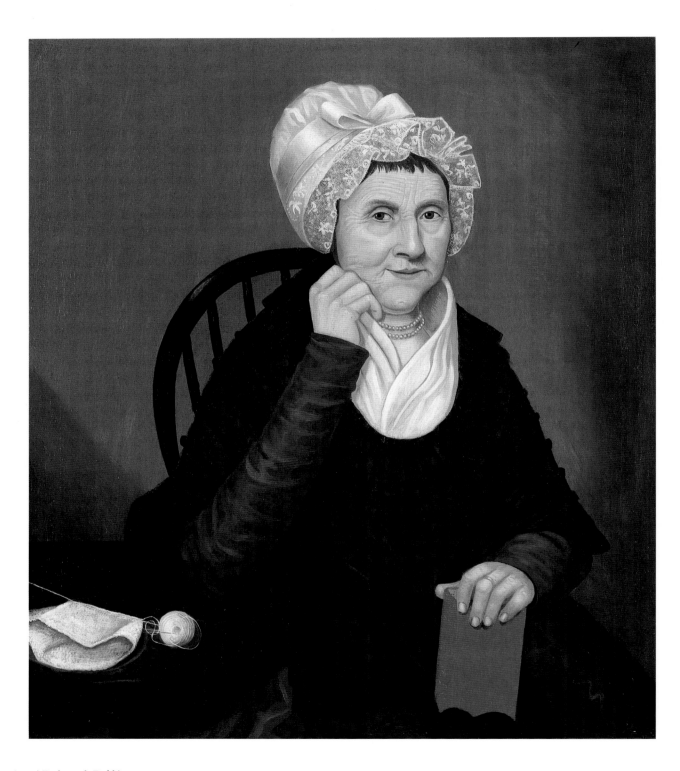

Mrs. Ammi Ruhamah Robbins

William Sidney Mount

1807 SETAUKET, NEW YORK 1868

Of the American genre painters who flourished during the second and third quarters of the nineteenth century, William Sidney Mount today ranks behind only the much younger Winslow Homer in reputation. Mount's prominence results principally from four factors: his position as the first American genre artist of real stature, the everyday rural American virtues exemplified in his compositions, the generally high quality of his work, and his truly sympathetic portrayal of the American black.

Mount was born on Long Island and, in terms of the subject matter of his work, remained a local painter. For the most part self-taught, he was apprenticed for a short time at the age of seventeen to his eldest brother, Henry Smith Mount (1802–1841); he later studied briefly at the newly organized National Academy of Design, New York, and still more briefly with Henry Inman (q.v.). He left Inman's employ after just one week because of (in Mount's words) "the fear of debt [i.e., creative dependence] and the desire to be entirely original" (Frankenstein 1975, 17). Artistic autonomy was, indeed, one of Mount's lifelong preoccupations. Years later he was still ruminating about his wish "not to be dictated to by others," and in the 1830s and 1840s he turned down at least three offers of financial assistance that would have allowed him to travel to Europe, excusing himself on the grounds of inconvenient scheduling and uneasiness about losing "my nationality" (Frankenstein 1975, 49).

In fact, Mount was neither simply a painter of comic incidents in ordinary human behavior, nor a naïve amateur, nor a willful isolationist. The modest sizes, uncluttered compositions, and readily intelligible themes of his most successful paintings belie the carefully thought-out processes by which they were conceived. Viewed closely, his genre works demonstrate a subtle, educated awareness of

both historical and contemporary art, while his voluminous extant writings reveal him as a voracious reader and a relentless inquirer into the conceptual and technical aspects of his profession. Although he functioned within narrow geographical limits, Mount was both a restless and a socially capable individual. For years he shuttled frequently between Long Island and New York City, and he numbered many of New York's premier artists and connoisseurs among his friends and patrons. Occasionally he ventured farther away, and toward the end of his life he had made for himself a studio perched atop a carriage in order to sketch *en plein air* in the countryside. Elected as associate of the National Academy of Design in 1831, and a full member in 1832, he remained one of that institution's most frequent exhibitors for more than two generations. His interest in spiritualism, temperance causes, and contemporary musical practices added further layers of depth to the studied simplicity of his art. G. C.

Bibliography Lane 1941. Cowdrey and Williams 1944. Frankenstein 1975.

61
The Banjo Player, ca. 1852–56

Oil on canvas
63.5 × 76.2 cm (25 × 30 in.)
Gift of Dexter M. Ferry, Jr. (38.60)

The Banjo Player is one of Mount's most elusive and enigmatic works. No mention of it occurs in the artist's writings, no known reference pinpoints either a public or a private showing of the painting during his lifetime, and none of his extant drawings and just one of his oil studies is apparently related to it. Although the Detroit picture is unfinished, this lack of documentation is striking, given the comparatively large size of the canvas and the similarity of the subject matter to that of several of Mount's most ambitious compositions.

Mary Bartlett Cowdrey and Hermann Warner Williams, Jr. (1944), and after them Alfred Frankenstein (in Washington et al. 1968 and Frankenstein 1975), proposed a partial remedy for the documentary deficiencies by suggesting that the Detroit picture is identical to a *Banjo Player* that was one of thirty-three works by Mount that his heirs, Robert and Thomas Mount and Ruth H. Seabury, attempted to sell at auction through Robert Somerville's gallery in New York on April 10 and 11, 1871. Listed as number nineteen in Somerville's catalogue and offered at fifty dollars, that work failed to attract a buyer and was retained by the artist's descendants for an indefinite period after 1871.

The hypothesis can be supported by bringing together several pieces of evidence. A contemporary newspaper article about the 1871 sale referred to "Banjo Player, [which] gives one finished figure, exceedingly well painted" (*New York Herald*, April 10, 1871, 7). This succinct description is useful because it implies that the Somerville *Banjo Player* was among numerous canvases in the sale that Mount's heirs regarded as "unfinished" or "barely commenced" (Frankenstein 1975, 460). Charles J. Werner, a historian from Long Island who owned the Detroit painting and quantities of Mount memorabilia early in this century, told Cowdrey and Williams that Mount's descendants had spoken of the artist's intention "to paint additional figures dancing in the barn," and Werner himself recalled that when he "first knew the painting in 1904, the outlines of two figures [in the barn] were lightly sketched in with whitish pigment" (Cowdrey and Williams 1944, 27). Recent technical examination has confirmed that sketchy outlines in faded white paint of two high-stepping figures can be discerned, with the aid of strong raking light, to the right of the instrumentalist. The nearer figure turns toward the right and away from the viewer to the other figure, who

faces his companion from a position farther into the barn. In 1871 these outlines—and therefore the incomplete condition of *Banjo Player*—would have been more apparent than they are today, which presumably accounts for the fact that it, along with about half the paintings offered at the sale, remained unpurchased. That the Detroit work is incomplete yet is signed in the artist's characteristic manner (the last name in capital letters) suggests that his heirs, rather than Mount himself, added the inscription after his death.

The approximate date by which Mount brought the picture to its present state is difficult to deduce, but several clues yield a reasonable conclusion. One indicator is the 63.5×76.1-centimeter (25×30-inch) size of the canvas, which in both upright and horizontal formats is recurrent in Mount's oeuvre, particularly in portraits and musical subjects involving single and multiple figures. He most frequently turned to canvases of those dimensions from the mid-1840s through the early 1860s, and his last major genre painting of this size, *Coming to the Point* (New-York Historical Society), was executed in 1854.

The subject matter of the Detroit work—a close-up parallel-planar view into a partially open barn, against and within which various male figures listen and dance to music provided by a single Caucasian male figure playing a stringed instrument—first appeared in Mount's 63.5×76.1-centimeter *Interior of a Barn with Figures* (1831; the Museums at Stony Brook, N.Y.), which was followed by the 50.8×76.1-centimeter (20×30-inch) *Dance of the Haymakers* (1845; the Museums at Stony Brook) and his best-known, somewhat smaller variant of the theme, *The Power of Music* (1847; Century Association, New York).

In September 1852 Mount's agent, the New York dealer-publisher William Schaus, requested that the artist paint pendant works depicting black musicians. This

he finally did in 1856 in works titled *The Banjo Player* and *The Bones Player* (both owned by the Museums at Stony Brook). As an amateur musician, composer, music lover, and inventor—in the 1850s—of a patented "hollow-back" violin, Mount evidenced a longtime artistic attachment to that instrument, but his interest in the banjo appears to have been confined to the creation of the just-mentioned black *Banjo Player* and the unfinished Detroit work. Perhaps, as Schaus's order for two paintings of black musicians percolated in Mount's mind for nearly four years, he commenced on his own a variation of the barn-dance theme centering on a white banjo player.

Taking into account the unfinished condition of the work, the slightly granular handling of the Detroit picture is more consistent with the appearance of Mount's paintings dating from the first half of the 1850s than with his firmer technique of the previous decade or his still less precise manner in the 1860s. Everything considered, the Detroit *Banjo Player* probably dates from the early to mid-1850s.

Perhaps in the end Mount did not complete the painting because problems in working out the composition proved insoluble. Possibly, without recognizing the implications, he had shifted his allegiance as he began *The Banjo Player* from the high-spirited musical gatherings of Jan Steen and Sir David Wilkie to an attentive soulfulness appropriate to the quieter sounds of a plucked stringed instrument as depicted by Gabriel Metsu, Gerard Terborch, and Antoine Watteau. Finally, there is the possibility that Mount's opinion of his work-in-progress was altered by the considerable success of another genre painting featuring a black

banjo player, Eastman Johnson's *Life in the South* (1859; New-York Historical Society). As Patricia Hills (1977, 56–60) has shown, from the time of its display at the National Academy of Design, New York, in 1859, *Life in the South* brought the younger artist a new level of public appreciation and remained one of his best-known works.

An undated oil study by Mount of a view into a barn, in which the floor and the right-hand wall and doors are arranged much as in the Detroit painting, is in the collection of the Museums at Stony Brook, New York (no. 0.5.67). Another work now in the same collection, a vertical canvas corresponding to the left side of the Detroit picture, has sometimes been regarded as a preparatory study by Mount. Mary Bartlett Cowdrey and Hermann Warner Williams (1944, 34, 37) concluded, however (in the present author's opinion, correctly), that the painting is a later replica, perhaps by Evelina Mount, the artist's niece, who is known to have copied her uncle's work.

G. C.

Inscriptions At lower left, w^m s. MOUNT

Provenance The artist's descendants. Charles Q. Archdeacon, Stony Brook, New York. Charles J. Werner, Stony Brook, until 1917. Norman Hirschl (dealer), New York, 1938. Acquired in 1938.

Exhibitions Detroit 1944, 34, no. 86. Cincinnati 1955, no. 62. New York 1957, no. 12. Hamilton 1961, no. 49. Washington et al. 1968, 55, no. 36. Buffalo et al. 1976, no. 16.

References *New York Herald*, April 10, 1871, 7. Lesley 1939, 6–7. *Magazine of Art* 1939, 108–109. Lane 1941, 137, 143 (said to have been exhibited at the National Academy of Design, New York, 1858). Cowdrey and Williams 1944, 27, 37, no. 95. Eliot 1957, 69. Detroit 1965, 78. Green 1966, 272, pl. 4-84. Cummings and Elam 1971, 140. Price 1972, 107. Frankenstein 1975, 324, 462, 477, pl. 37 (as *Banjo Player in the Barn*, dated ca. 1855). Fisher 1985, 62–63.

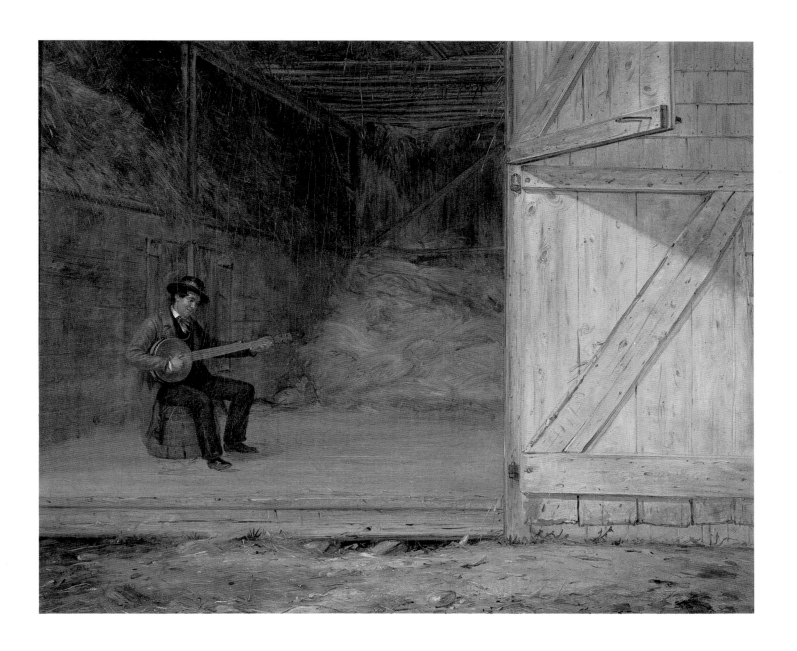

The Banjo Player

Reared in Philadelphia, John Neagle trained initially with Edward F. Peticolas (1793–ca. 1853), who encouraged him to draw; he then studied briefly in the drawing school of Pietro Ancora (active in Philadelphia ca. 1800–1805) and served an apprenticeship with Thomas Wilson, a coach painter who also did ornamental work. Before 1817, when he established himself as a portrait painter, Neagle studied with Bass Otis. After traveling to Kentucky and New Orleans during the depression of 1818, the young artist returned to Philadelphia and entered the orbit of Thomas Sully (q.v.), whose stepdaughter he later married. A pilgrimage to the Boston studio of Gilbert Stuart (q.v.) in 1825 completed Neagle's education and sealed his dedication to the business of portraiture.

Neagle ranked second only to Sully among portrait painters in Philadelphia in the 1830s and 1840s. While Sully commanded the highest prices and the choicest commissions, Neagle, his protégé, was assured of the next tier, and the two artists conspired to fix their prices accordingly. Ambitious for success, Neagle emulated Sully, Stuart, and Sir Thomas Lawrence; he also studied theory and technique assiduously, assembling an impressive collection of drawings and prints. His own work, however, is uneven technically and is often uninspired. The better paintings are graceful, colorful, and freely executed in the manner of British romantic portraiture; the best paintings are animated, trenchant characterizations in the manner of Stuart. Neagle was esteemed by both patrons and artists in Philadelphia. As director of the Pennsylvania Academy of the Fine Arts (1830–31) and a founder and first president (1835–44) of the Artists' Fund Society, both in Philadelphia, he played a significant role in promoting younger painters.

W. T. O.

Bibliography Patrick 1959.

62

The Reverend Gregory Townsend Bedell, 1830

Oil on canvas
74.9 × 64.1 cm (29½ × 25¼ in.)
Gift of Dexter M. Ferry, Jr. (29.192)

Among Neagle's many portraits of clergymen, that of the Reverend Gregory Bedell is one of the more engaging. Bedell was a popular preacher in the Episcopal church and an evangelist of broad appeal. Neagle portrayed him in that public role, as an inspiring figure in the pulpit, gesturing toward his text as he gazes directly into the eyes of the congregation. The parson's expression speaks of compassion, righteousness, and authority, as well as breeding. Bedell (1793–1834), the nephew of an Anglican bishop, was a graduate of Cheshire Academy in Connecticut and Columbia College, New York. Ordained in 1814, he held ministries in New York and North Carolina before settling in Philadelphia. There he helped to establish Saint Andrew's Church, serving as first rector. He was editor of the *Episcopal Record* and published several sermons, poems, and musical compositions.

Alan Burroughs (1936, 134) described the portrait of Bedell as "perfunctory and flat," but evidently neither Neagle nor his contemporaries viewed it in such a light. The portrait proved as popular as the subject: both James W. Steele and James B. Longacre published engravings after it, and Neagle exhibited a reduced copy, which is merely perfunctory, at the Pennsylvania Academy of the Fine Arts, Philadelphia, in 1851 (for the copy, see Wainwright 1974, 191). Actually, the Bedell portrait is typical of Neagle's style: the characterization is generous, not probing; the handling is suggestive but not yet mannered, as are some of his later works. Neagle's boldness, which enabled him to finish a likeness in only two or three sittings, is apparent in the big, often scumbled strokes, the virtual absence of line, and the use of broken, unmixed color.

W. T. O.

Inscriptions At lower left, *J. Neagle. 1830.*

Provenance The Bowen family, Philadelphia. Ehrich Galleries, New York, 1929. Acquired in 1939.

Exhibitions Philadelphia 1925, 140, no. 113.

References C. Burroughs 1929, 104–105. C. Burroughs 1929a, 267–268, 271. A. Burroughs 1936, 134.

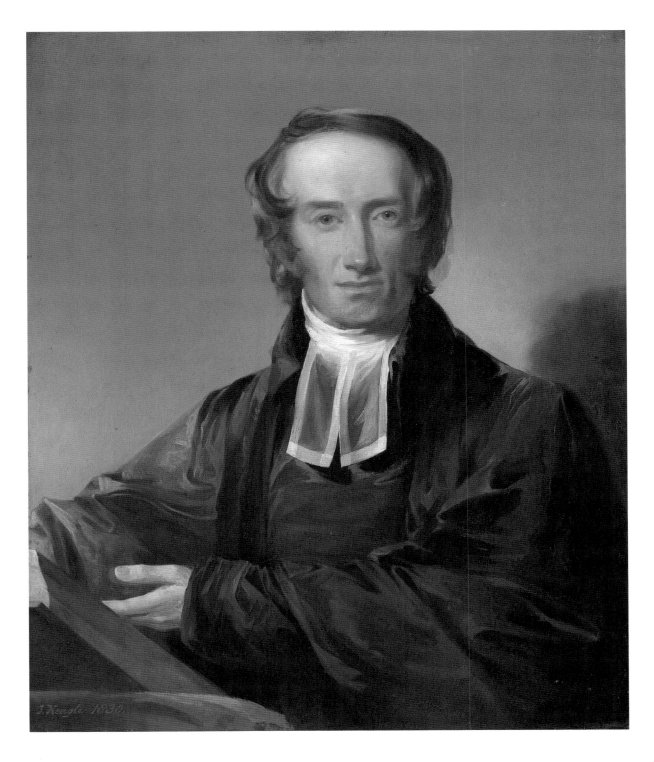

The Reverend Gregory Townsend Bedell

William Page was one of the most original, complex artists of his generation. Having moved to New York City as a child with his family, he first studied law and theology before turning to art. He worked in the studios of James Herring (1794–1867) and Samuel F. B. Morse and studied in New York at both the National Academy of Design and the American Academy of the Fine Arts, demonstrating an exceptional talent for drawing. After painting portraits in upstate New York, he returned to the city in 1833, but did not succeed; nor did he prosper in Boston from 1843 to 1847, although he was embraced by James Russell Lowell and the Transcendentalists. His portraits and history paintings attest to an anxious, independent mind, as Page avoided convention and saw each canvas as a vehicle for self-discovery, spiritual expression, and experiment in form, color, and chiaroscuro. Chiefly through Morse's tutelage, Page became the successor to Washington Allston (q.v.). They were both troubled spirits obsessed by the dream of rediscovering the principles of Titian and Veronese, of revivifying the distant past, and of transforming the grand tradition into a modern aesthetic. Page developed arcane theories about art that intertwined with his belief in the spiritualism of Emanuel Swedenborg.

He spent the 1850s in Europe, studying in Paris before settling in Italy. There he painted copies after Titian, landscapes, and a series of classical and biblical subjects. The cognoscenti applauded him. Robert and Elizabeth Barrett Browning, John Ruskin, and Hiram Powers admired his art and his charisma; but still he did not realize a market for his increasingly prodigious theories or his increasingly limited production. The pattern continued after his return to New York in 1860, despite his "private opinion" that he had "done more for art than *any man* (or woman) since Titian" (Taylor 1957a, 174). He was compared to Poe, Hawthorne, and the novelist Charles Brockden Brown,

but to little avail (Benjamin 1880, 93). In later years he painted only a few portraits, retouched old canvases, and taught at the National Academy, the ideal forum for reworking his ideas. "None of our artists," said Henry T. Tuckerman (1867, 295), "can so philosophize on his vocation; his lectures and his talk are as metaphysical as they are artistic; he has the intuition and the extravagances of genius." W. T. O.

Bibliography Richardson 1938. Taylor 1957a.

63
Self-Portrait, 1860–61

Oil on canvas
149.9 × 91.4 cm (59 × 36 in.)
Gift of Mr. and Mrs. George S. Page, Blinn S. Page, Lowell Briggs Page, and Mrs. Leslie Stockton Howell (37.60)

Page began his self-portrait in Rome and finished it upon his return to New York. Actually, even in 1867 he did not consider it finished, for he wrote then: "When . . . I get my palette redy [*sic*]—if painters ever do—we may come out right yet" (New York 1867, no. 16). His veneration for the creative process as an end in itself—a burden that he shared with the artists Washington Allston (q.v.) and Albert Pinkham Ryder (1847–1917), for instance—generated repeated revisions of his major statements in paint.

The Detroit painting testifies to an extraordinary self-absorption. The commanding stature of the nearly-full-length figure and the aloof, sideward gaze bring to mind state portraits of royalty. Page appears as a heroic type from antiquity, a *doryphoros* in modern dress (in 1843 he had painted a *Self-Portrait as a Roman Senator;* unlocated). He poses before a cast of the *Dionysus* (the *Heracles*?) from

the Parthenon, a sculpture then thought to represent Theseus. "The Theseus—jolly blade—lounges in my studio modestly in the background," he wrote (New York 1867, no. 16). The sculpture—a souvenir of ancient days and an enduring ideal form—sets the mood of the portrait. Page cast it as the shadow of his own form, which is sculptural, heroic, and, but for the clothes, of all time; it is also, like the sculpture, a fragment, cut off at the ankles. Page presented himself as the keeper and purveyor of "high art," the incarnation of Phidias and Titian, the avatar of the ideal, who, through his forceful presence, eclipses the past.

The portrait is a perfect world unto itself, deliberately measured and invested with its own logic. Page's meticulous method of preparation, which commenced and concluded with a grasp of the general character of the composition (rather than with isolated details), is reflected in an outline drawing of the figure, squared for transfer (pencil on paper; 28.9 × 18.1 cm; private collection). Just a few years earlier, in his *New Geometrical Method of Measuring the Human Figure, Verified by the Best Greek Art* (New York, 1860), Page had managed to unite phrenological principles with an ideal, geometric canon of proportions. "The order of nature is fixed in portraits as in planets," he claimed (p. 568), in language recalling seventeenth-century German mystics. Hence, we sense system in the grid of the floor (added last, in May 1861; see Taylor 1957a, 170), the plaid of the coat lining, the folds of the drapery behind the sculpture, the clearly demarcated color fields, and the precisely parallel patches of vermilion and green on the palette and brushes that the artist holds. The secondary lines in the composition—the brushes, maulstick, and palette, the watch chain, the spectacles and cord—seem to describe an orrery or some mystical machine; the orbed end of the maulstick is exactly tangential to the contour of the

sleeve, apparently describing a schematic relationship with the glasses, the row of buttons, and other elements within its "orbit." The point is that Page has created not simply his likeness but a vision of an inner world ordered by the artist as an extension of his intellect and spirit.
W. T. O.

Provenance The artist's son, William S. Page, 1893; his son, George S. Page, Pittsburgh, 1936 (owned jointly with his wife, Delilla B. Page, his sons, Blinn S. Page, Grosse Pointe Park, Michigan, and Lowell Briggs Page, and his daughter, Mrs. Leslie Stockton Howell, Philadelphia). Acquired in 1937.

Exhibitions London, International Exposition, 1862, no. 2882. New York 1867, no. 16. New York 1877, unpaginated. Chicago 1893, 59, no. 2840a. New York 1943, 140. Detroit 1944, 12, no. 13. Detroit and Toledo 1951, 55–56, no. 81. New York 1966, 50, 152, no. 206. Northfield 1967. Washington 1974, 90–91, no. 38

References Sheldon 1879, 179. Richardson 1938, 90–91, 96, 99–100. Detroit 1957, 183. Taylor 1957, 361. Taylor 1957a, 168–171, 175, 270, no. 82, fig. 42. L. Goodrich 1966, 60. McCoy 1967, 15–16. Novak 1969, 240, ill. 14-3. Flexner 1970, 435. Flexner 1970a, 142–144, 146.

64
Mrs. William Page, 1860–61

Oil on canvas

153 × 92.1 cm (60¼ × 36¼ in.)

Gift of Mr. and Mrs. George S. Page, Blinn S. Page, Lowell Briggs Page, and Mrs. Leslie Stockton Howell (37.61)

In Rome in the fall of 1857 William Page married Sophia Candace Stevens Hitchcock, a young, well-to-do widow

from Boston who had studied drawing with him. His private life, like his career, had been tempestuous and filled with unfulfilled promise. His first wife had abandoned him and their three daughters; his second wife had eloped in Rome with a Neapolitan count after a spending spree that left Page destitute. He and Sophia Hitchcock, however, were to be forever infatuated with one another.

Page painted the portrait of his wife at the same time that he painted his own, in Rome and in New York in 1860 and 1861. It, too, was preceded by a small, squared, outline drawing (pencil on paper, 32.4 × 14.9 cm, private collection). The portraits seem to have been conceived as a pair, for they show traditional formulas for companion male/female portraits: the man indoors in a professional setting, the woman outdoors at leisure. Furthermore, in keeping with traditional sexual imagery, the male portrait is characterized by angles and points, the female by curves and darkened recesses. Traditional symmetry is not upheld, however, as Page looks darkly to the side, presumably at a mirror, and his wife stares calmly at the viewer.

The portrait of his wife is Page's finest painting. It is an image of tremendous evocative power. As in the *Self-Portrait*, the figure stands before and is enframed by an ancient fragment, the Colosseum, which is enveloped by an atmosphere that is not so much physical as temporal, drained of substance. Page's rendering of the ruins is idealized rather than factual; he reordered the contours of the architecture and reduced the rubble of the Temple of Venus and Rome in the middle ground to a series of geometric forms. The blocks, fragments, and rhythms of the architecture find their counterparts in the archi-

tectonic figure, thus conveying empathy—metaphysical or in fact—between the woman and the environment in which she is portrayed (note in particular the complementary relationship between the contour of the exterior wall of the Colosseum and the contour of the woman's head within the bonnet). Again, as in Page's *Self-Portrait*, the painting is a self-contained world, recognizable as such but unfamiliar. It is the kind of parallel spiritual world envisioned by Swedenborg: still, timeless, impeccable, measured, a world of ether and the soul. "A true likeness," Page wrote, "shows one inside out" (Page 1875, 573).

Mrs. Page, like her husband, is our intermediary or medium for gaining entry to this tranquil mental space. The figure is solidly modeled, sculptural, highly detailed, and immediate, documenting Page's use of photographs in developing his portraits. Mrs. Page pauses to fasten her glove; her wedding ring is much in evidence, the counterpart of the artist's brushes. Portrayed as if she could step out of the canvas or melt back into it with equal ease and contentment, Mrs. Page stands forever in equilibrium on this plane.

Page's famed color theories are evident here. He believed that color was the key element in painting, but that it should be restrained, of medium intensity, and drawn from a palette of red, yellow, blue, white, and black. These colors form the basis of the portrait; there is no gray or dull note in the painting. Page saw red as the foundation of flesh color, underlying successive layers of "cool" skin tones. He argued that what he called the "middle tint" held the most color, being neither light nor dark, but of middle value. In these views Page believed that he was heir to the Venetian painters, especially Titian. His experiments in color and glazes, however,

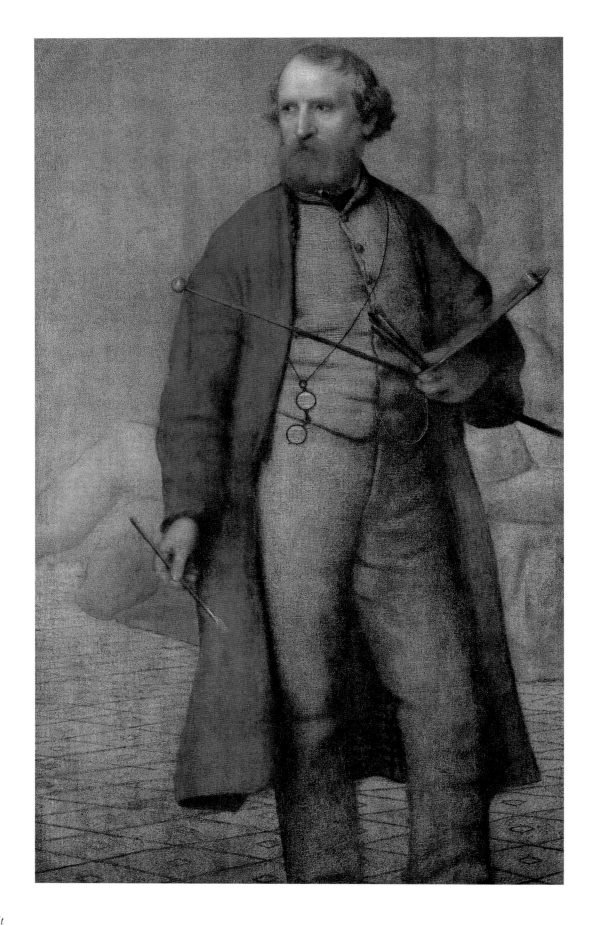

Self-Portrait

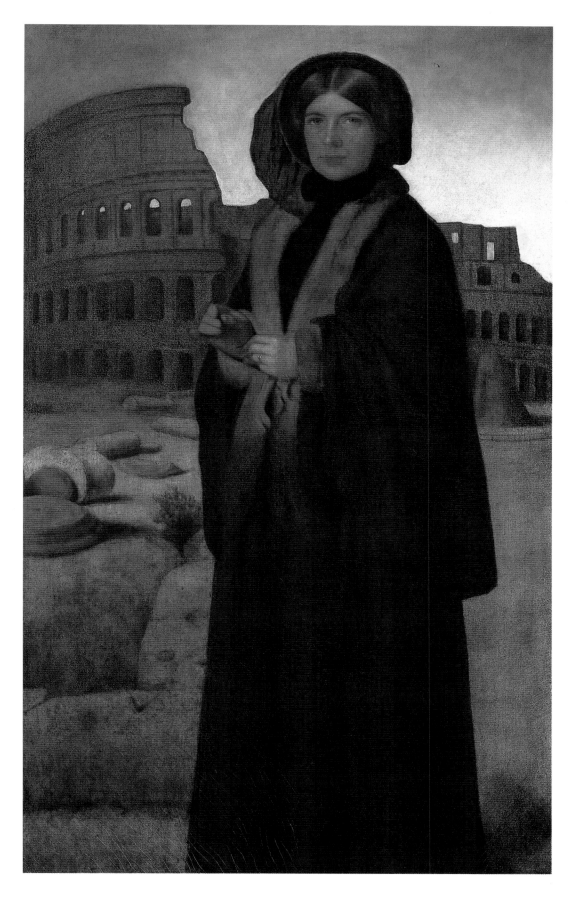

Mrs. William Page

resulted in paintings that deteriorated even in his lifetime. (The *Self-Portrait* and *Mrs. Page* have been extensively restored, each displaying a pervasive, mosaic-like crackle pattern.) Still, the deep resonance of Page's color and glazes remains to impart a nearly animate translucence to the figures. He expected viewers to look beneath the surfaces of his paintings to comprehend their complexity as original creations, and he negated almost all evidence of brushstroke that might compromise their integrity or the hermetic uniformity of the surface. As Page wrote to his wife in May 1861, when he applied the "final" touches to the two portraits, "I mean they shall 'stand out rounded and alive' before long" (Taylor 1957a, 170).

w. t. o.

Provenance The artist's son, William S. Page, 1893; his son, George S. Page, Pittsburgh, 1936 (owned jointly with his wife, Delilla B. Page, his sons, Blinn S. Page, Grosse Pointe Park, Michigan, and Lowell Briggs Page, and his daughter, Mrs. Leslie Stockton Howell, Philadelphia). Acquired in 1937.

Exhibitions London, International Exposition, 1862, no. 2883. New York 1867, no. 15. New York 1877, unpaginated. Chicago 1893, 59, no. 2840. New York 1943, 25–26, 69, 140. Detroit 1944, 12, no. 13a. Washington 1949, no. 14. Detroit and Toledo 1951, 56, no. 82. Frankfurt et al. 1953, 33, no. 71, pl. 30. New York 1954, no. 41. New York 1954a, 29, no. 161. Rome and Milan 1954, 30, no. 42, pl. 15. Brooklyn 1957, no. 52. Wilmington 1962, 49, fig. 76, 61–62, 81, no. 76. Cleveland 1963, no. 80. Minneapolis 1963, unpaginated [no. 104]. New York 1966, 50, 152, no. 207. Worcester 1973, 30–31, no. 21.

References Benjamin 1880, 91. Isham 1905, 283. Richardson 1938, 91, 96, 99–101. Swenson 1949, 27. Baur 1953, pl. 58. Detroit 1957, 183, 196, fig. 81. Taylor 1957, 347–363, fig. 1. Taylor 1957a, 168–171, 175, 213, 217, 235, 269, fig. 45. Pierson and Davidson 1960, 319, no. 2813. L. Goodrich 1966, 50. Green 1966, 246, pl. 4-45. McCoy 1967, 15, 17. Wilmerding 1967, 85, 94. Canaday 1969, 3: 1081–1083; 4: pl. 344. Mendelowitz 1970, 287, fig. 392. Wilmerding 1970, 15, 77, pl. 59. Wilmerding 1976, 162–163, fig. 199. Dinnerstein 1984, 117, fig. 5.

Charles Willson Peale received his first painting lessons in about 1762 or 1763 from John Hesselius (q.v.), a portrait painter in Annapolis, Maryland. At that time, the always-versatile Peale was not only an amateur painter and an established saddler but also an upholsterer, a metalworker, a glassworker, and a clock repairer. In 1765 he traveled to Boston and gained advice on painting from John Singleton Copley (q.v.). Still dissatisfied with his progress, he went to London in December of 1766 with the good wishes and financial support of a group of Maryland gentlemen. Once there, he became a student of Benjamin West (q.v.). After his return to the colonies over two years later, Peale painted portraits in Annapolis for a while, served in the Continental Army for three years, and then settled in Philadelphia in 1778 as an artist and inventor. Later, in 1782, he opened a picture gallery. Reflecting Peale's broad interests, the establishment expanded within a few years beyond its original purpose, developing into the first significant natural-history museum in the United States.

Peale's ideas about painting were transmitted to four of his sons and to his brother, James, all of whom became well-known artists. Even a third generation of Peales produced portraits and still lifes that manifested his preference for exactness in representation. Peale believed that accurate drawing could be learned by anyone of intelligence. No doubt it was partly for this reason that he assumed a leading role in establishing Philadelphia's first real art academy in 1794 and its successor, the Pennsylvania Academy of the Fine Arts, in 1805.

Concentrating on his expanding museum, Peale increasingly referred portrait commissions to his sons during the 1790s. He almost stopped painting completely from about 1799 to 1804. Then, on a visit to Washington in the latter year, he could not resist the temptation of adding to his museum's portrait gallery of distinguished men. With renewed enthusiasm, Peale continued to paint, chiefly portraits for the museum or of relatives or friends, until about a year before his death. His late portraits generally have stronger characterizations and show the results of experimentation with richer coloring.

D. E.

Bibliography Sellers 1969. Washington et al. 1983.

65
General William North, 1785

Oil on canvas
58.4 × 48.3 cm (23 × 19 in.)
Gift of Dexter M. Ferry, Jr. (42.117)

This bust-length portrait of General William North (1755–1836), who is shown in the uniform of the Continental Army and wearing the order of the Society of the Cincinnati, is an excellent example of Peale's early mature style. The heads in his portraits of about this date have a tendency to be ovoid and are usually modeled in dark gray with a relatively smooth paint surface. Peale's authorship is revealed also in the Detroit work's trompe l'oeil effects. The sparkle of the gold braid on North's epaulets, for example, is depicted with considerable care, and his creamy white jabot is cleverly arranged so as to project toward the viewer and thereby enhance the impression of three-dimensionality.

North, who had been an officer in a Massachusetts regiment, was appointed aide-de-camp in 1779 to the German military strategist Baron von Steuben, who had joined the American cause. Steuben, as an adviser to General Washington and inspector general of the army, played an essential role in converting the Continental Army into a disciplined military force during the Revolutionary War. He adopted North as his son and heir, and it is thought that Peale might have painted this portrait for Steuben. Support for this theory can be found in the crossed-out opening line of a recorded fragment of a letter dated between August 2 and December 18, 1785, in Peale's letter book (Peale-Sellers Papers, Letterbook, vol. 2, American Philosophical Society, Philadelphia). In total, it reads: "Sir / the Portrait of Major North," indicating perhaps that the portrait of North was commissioned by some unidentified man, such as Steuben. This possibility is strengthened by the fact that Steuben asked another favorite aide at about this time to sit to Peale, but the aide preferred another artist (Sellers 1952, 152). Steuben's own portrait (Pennsylvania Academy of the Fine Arts, Philadelphia) had been painted by Peale about five years earlier.

D. E.

Provenance The sitter's family. John Levy Galleries, New York, 1942. Acquired in 1942.

Exhibitions Oberlin 1954. Detroit and Utica 1967, no. 43. Berlin and Washington 1981, no. A-120.

References C. Burroughs 1944, 54–55. Sellers 1952, 152, no. 598.

66
Belfield Farm, ca. 1816/17

Oil on canvas
27.3 × 39.7 cm (10¾ × 15⅝ in.)
Gift of Dr. and Mrs. Irving Levitt (63.238)

Early in 1810, at the age of sixty-eight, Peale purchased about one hundred acres of plantation property near Germantown, Pennsylvania, with the intention (as he wrote to his friend Thomas Jefferson) of retiring there "to muse away the remainder of my life" (Washington et al. 1983, 224). But the name, Farm Persevere, that Peale bestowed on his new residence indicates that in fact he planned to continue the habits of physical industriousness and intellectual inquiry that he had developed

General William North

Belfield Farm

during an already long lifetime. Two years later, when he changed the name of the farm to Belfield, after the residence near Annapolis of John Hesselius (q.v.), from whom Peale had learned painting techniques in the early 1760s, his activities were becoming more relaxed yet more expansive.

During the following several years, at the same time as he engaged in serious farming, Peale delighted in laying out European-style formal gardens complete with walkways, ornamental plantings, fountains, statuary, and architectural adornments. By 1820 Belfield had acquired a series of these visual embellishments on which, with himself as well as his many visitors in mind, he affixed didactic inscriptions and the names of American historical events. The farm functioned, "in effect, [as] his outdoor museum," an open-air, living, rural complement to his indoor, inanimate, urban museum in Philadelphia (Washington et al. 1983, 228). After his third wife, Hannah, died in 1821, Peale's interest in the property slackened. He moved back to Philadelphia in 1823, rented out the farm that year, and finally sold it in January 1826, thirteen months before his own death.

In 1810 Peale had embellished a letter to his son Rembrandt Peale with detailed pen sketches of Belfield. The next year he began translating this informal interest in Belfield topography into oil studies of the gardens and nearby scenery. Further sporadic activity in the latter vein between 1815 and 1817 is recorded in several of his letters. By February 1817, as he again wrote to Rembrandt, he had completed fourteen eleven-by-sixteen-inch oil studies of the farm, all of which he hung in the back parlor of the house, presumably not far from a larger oil painting of the garden that he had executed in 1815 and 1816. Several additional scenes of the farm completed Peale's oeuvre on the subject around 1820. Five of the Belfield landscapes were shown at

the Pennsylvania Academy of the Fine Arts, Philadelphia, in 1817, and four of the fifteen that were transferred to his museum in 1822 can be seen at the near right in his and Titian Ramsay Peale's watercolor view of the museum's Long Gallery (1822; Detroit Institute of Arts, 57.261).

Although other members of the Peale family painted Belfield landscapes at various times, the Detroit picture would seem to be the work of the farm's creator. The cool colors, the studious differentiation of tree species, and the carefully worked yet generalized remaining details are consistent with firmly established examples of Charles Willson Peale's work and with discussions in his correspondence of the quandaries posed by his Belfield landscape painting; so, too, more subtly, is the subject itself. The combination of fences and pathway produces a strong sense of perspective, which in the foreground focuses the viewer's attention on the hand-hewn construction of the fences and in the background helps define geological contours and distances. In several Belfield landscapes securely associated with Charles Willson Peale, including the pen sketches on his letter of 1810, he made prominent features of the fences (usually the four-rail variety), although in none of these works nor in any of the known eleven-by-sixteen-inch canvases are they brought quite so close up, and disposed over so many distant slopes, as in the present example. The early fall coloring is commensurate with Peale's statement in a letter to his son Rembrandt (Sellers 1969, 41) that he had finished around a dozen "small landscapes" between August and late December 1816.

The Detroit picture reads as both an informal scene tinged with personal asso-

ciations and a solution to multiple pictorial problems on a modest scale. In all likelihood, Belfield's "persevering" owner himself painted it, around 1816 or 1817.

G. C.

Provenance The artist's grandson(?) Augustus Runyon Peale. Ralph L. Parkinson. Dr. and Mrs. Irving Levitt, Bloomfield Hills, Michigan. Acquired in 1963.

Exhibitions Philadelphia 1817, no. 177, 221, 223, 224, or 225 (possibly this picture). Detroit 1964, pl. 14. Detroit and Utica 1967, 20, 72, no. 66. Hartford and Washington 1986, 278–280.

References Detroit 1965, 85 (dated ca. 1812). Sellers 1969, 41–42, no. S.109, 41.

67
James Peale (The Lamplight Portrait), 1822

Oil on canvas
62.2 × 91.4 cm (24½ × 36 in.)
Gift of Dexter M. Ferry, Jr. (50.58)

In this unusually lit portrait, Peale's younger brother James, a well-known miniaturist, is shown smiling appreciatively to himself as he holds a miniature, painted by his daughter, up to the light of an Argand lamp. The painting is a tribute to the talent of the Peale family, whose members Charles Willson Peale had himself instructed in art. As in this case, he was always proud to portray them in relation to their artistic endeavors. But beyond this, the choice of such an ambitious subject suggests that the picture was intended to be a virtuoso performance, a test of skill in the depiction of artificial light.

Peale's letters at the time reveal that he was fascinated by the challenge of painting light convincingly in all of its variations. He wrote to his son Rembrandt on

August 2, 1822, in regard to a full-length self-portrait (Pennsylvania Academy of the Fine Arts, Philadelphia) that he painted just prior to the portrait of James: "I make a bold attempt by *the light behind me* [italics his], and all my features lit up by a reflected light, beautifully given by the mirror. . . . That you may understand me, place yourself between a looking glass and the window" (Peale-Sellers Papers, Letterbook, vol. 17, American Philosophical Society, Philadelphia).

Less than two months after the self-portrait that he mentions was first placed before the public in his museum, Peale was at work on the Detroit lamplight portrait of James, also meant for museum display. Perhaps because of this he deliberately posed himself a problem that was more challenging than usual. He wrote of his progress to Rembrandt on December 7, 1822:

The brightest light is on the end of his nose downward, the forehead has only the light through the shade of the lamp, a miniature pallet [*sic*] and pencil on the table, this to show that he is a painter" (Peale-Sellers Papers, Letterbook, vol. 17, American Philosophical Society, Philadelphia).

Many details of the portrait—the reflected light on the lamp and table, the subtly observed transition from half light to full light across James's face, and the attention paid to recording darker shadows within shadows— testify to Peale's painstaking care in his attempt to create a believable reality. Such verisimilitude, even to the inclusion of the two warts on James's cheek, recalls the work of Peale's compatriot John Singleton Copley (q.v.), but Copley, less inclined to experiment, never painted a night scene such as this.

The portrait is also a testament to the deep affection between two brothers who evidently did not compete but rather were artistic partners. Peale had intended to list on the lampshade the battles of the Revolutionary War in which James had fought but decided against it and, perhaps instead, included the ribbon and badge of the Society of the Cincinnati in James's lapel.

D. E.

Provenance Peale Museum, Philadelphia, 1822–54. Peale Museum sale, M. Thomas & Sons (auctioneers), Philadelphia, October 6, 1854, no. 88. Bought by the family of Augustin Runyon Peale, grandson of C. W. Peale, 1854; his son, Augustin Runyon Peale, Jr.; his son and daughter, Herbert Raphaelle Peale and Adele Peale Conway. Edward A. Newnam (dealer), Philadelphia, 1950. Acquired in 1950.

Exhibitions New York 1953 (not in catalogue). Cincinnati 1954, no. 31. University Park 1955, no. 8. Hartford 1964, no. 214. Detroit and Utica 1967, no. 7. Jacksonville 1972, no. 10. Washington et al. 1983, no. 74, 99–100, 104.

References Sellers 1947, 2: 352. Richardson 1950–51b, 8–11. Sellers 1952, 166. Flexner 1954, 104–105. Sellers 1969, 403. Cummings and Elam 1971, 134. Wilmerding et al. 1973, 94, 95. Rivard 1978, 1044. Detroit 1985, 192, 193. Miller 1986, 44, fig. 26.

Raphaelle Peale

1774 ANNAPOLIS, MARYLAND—
PHILADELPHIA 1825

Raphaelle Peale was the first surviving child of Charles Willson Peale (q.v.), the foremost painter of his day in Philadelphia. Like many of the sons and daughters of the elder Peale, Raphaelle was named after an illustrious painter of the past, and like a number of his siblings, with the active intervention and support of his father, he accepted the challenge and became an artist. At the age of twelve, Raphaelle began to assist his father in the newly founded Peale's Museum in Philadelphia and by 1791 was beginning to paint portraits. In 1794 Charles Willson Peale announced that he was giving up portraiture to devote more time to his museum, recommending that potential sitters patronize his two sons, Raphaelle and Rembrandt.

Raphaelle Peale was primarily a portrait painter until the second decade of the nineteenth century, working in the two basic portrait forms then common: life-size oil portraits and watercolor miniatures. He was obviously also trying his hand at still life, for he exhibited eight works of that genre at the Columbianum exhibition held in Philadelphia in 1795, the first public art exhibition to be organized in this country.

Peale had some success at miniature painting and, briefly, far greater success in the South (in 1803–4) with the physiognotrace, a device for creating small profile silhouettes, but his large oil portraits were not well received. Burdened with an unhappy personal life, the artist began to drink heavily—a circumstance that, coupled with increasing attacks of gout, forced him to abandon the delicate art of miniature painting. Around 1812 Peale turned instead to a concentration upon still life, the first professional artist in America to do so. He was undoubtedly inspired to move in this direction by the establishment of annual exhibitions at the Pennsylvania Academy of the Fine Arts,

Philadelphia, beginning in 1811. The existence of such exhibitions assured artists who painted on speculation a professional showplace and an outlet for their work.

Peale's ability in still-life painting was recognized in his own time: when his works were reviewed in the critical press, they were invariably well received. A number of major collectors in this country, such as Robert Gilmor and Frederick Graff, both of Philadelphia, acquired his work. His father, too, recognized Raphaelle's unique abilities, even commending his son's painting to his own former teacher, Benjamin West (q.v.). However, the traditional denigration of still-life painting, which was viewed as purely transcriptional and thus the least valuable form of painting, militated against the possibility that its specialized practitioners would achieve any great financial success. Raphaelle continued to drink heavily and his illnesses became worse; yet his talent for still-life painting remained intact, and he is recognized as one of the finest still-life artists this nation has produced.

w. g.

Bibliography Philadelphia 1795, 6. Milwaukee and New York 1959. Detroit and Utica 1967, 31–32, 36–37. Gerdts and Burke 1971, 24–31. Baltimore 1975, 49–57. Gerdts 1981, 48–60.

68

Still Life with Wine Glass, 1818

Oil on panel
26 × 34.6 cm (10¼ × 13⅝ in.)
Founders Society Purchase, Laura H. Murphy Fund (39.7)

Although it has no secure provenance, *Still Life with Wine Glass* appears to have remained in the Peale family collection beyond the artist's lifetime. The painting is typical of Raphaelle Peale's art at its most able and secure and exhibits all the characteristics that resulted from his espousal of neoclassical formal principles. A conglomeration of different objects is centered in the composition, forming a stable, pyramidal shape, but the triangular formation is scalene, thereby introducing a dynamic pull in the diagonal emphasis on the branches of berries and leaves at the right, which is repeated in the diagonal of the roll tipped up onto the shallow dish. The peak of the triangle is upheld in the wineglass, which reinforces the stability of the composition through its rigid verticality. As is typical of Peale's work, all the forms are parallel to the picture plane and picked out with clarity in intense light, originating in a source at the left. The support for these objects is a plain shelf or board, offering no distractions from the central composition. Likewise, the background is a neutral, indeterminate plane, divided into a dark left side and a well-lit right side along a diagonal axis, which itself meets and balances the diagonals of the main grouping below. The chiaroscuro of the background further dramatizes the composition without intruding on or distracting from the primary group of objects. Colors are purely local, no hue impinging upon another; the browns and tans of the roll, cakes, and wine lend a comforting warmth, while the rich reds of the berries activate the composition and attract the eye. The emphasis upon edibles is characteristic; throughout his oeuvre Peale seldom included flowers.

This work of 1818 was painted in the middle years of Peale's strong preoccupation with still life, which began in 1812 and 1813 and ended with his death in 1825. While many examples feature larger fruit, such as apples, peaches, oranges, and especially watermelons, over half a dozen from the period 1813–22 are concerned with very small objects, and their appeal, as here, is more intimate. Cakes appear in several of Peale's pictures, from

his *Still Life with Raisin Cake* of 1813 (Stralem Collection, New York) to his *Still Life with Cake* of 1822 (Brooklyn Museum). Perhaps closest in spirit and composition to the Detroit picture is the somewhat more somber *Still Life with Cake* (Metropolitan Museum of Art, New York), which the artist also painted in 1818. A number of Peale's still lifes of this year exhibit a particularly clear and dramatic emphasis upon light-and-dark contrasts, which he had begun to intensify in 1816. W. G.

Inscriptions At lower right, *Raphaelle Peale Pinx* A. D. *1818*

Provenance Thomson Gallery, 1939. Acquired in 1939.

Exhibitions Philadelphia, 1819, no. 79 (as *Still Life—Wine, Cake, &c.*, possibly this picture). Philadelphia, 1822, no. 419 (as *Cakes, Wine &c.*, possibly this picture). New York 1825–26, no. 39 (as *Still Life—Cakes and Wine*, possibly this picture). Philadelphia 1829, no. 18 (as *Cakes, Wine &c.*, possibly this picture). Detroit 1944, no. 40. Cincinnati 1954, no. 55. Vancouver 1955, no. 11. Detroit and Utica 1967, no. 134. Buffalo et al. 1976, no. 4. Washington 1988, no. 19.

References Baur 1940, fig. 8, no. 8. C. Burroughs 1944, 55. Richardson 1944, 44, fig. 49. Born 1947, 13, fig. 20. Flexner 1954, 113, fig. 46. Rivard 1978, 1044. Washington 1988, no. 19, ill. p. 31.

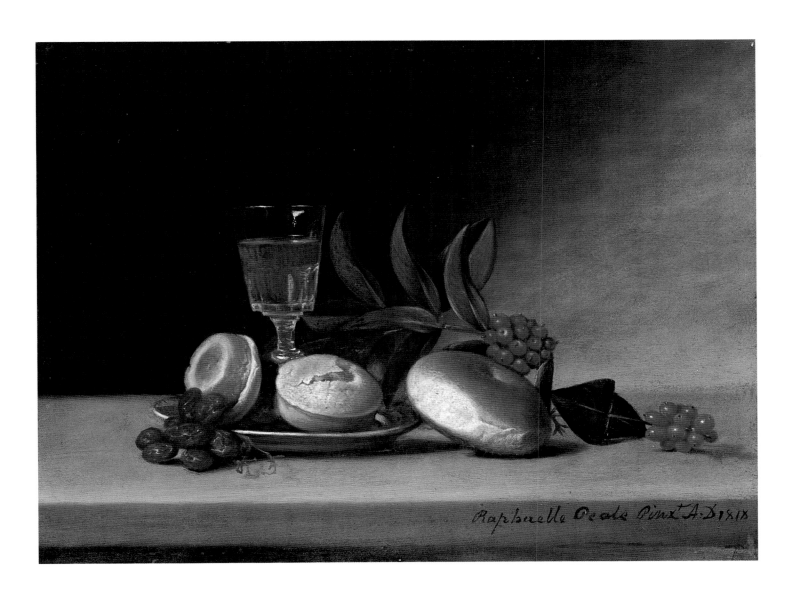

Still Life with Wine Glass

Perhaps the central fact of Rembrandt Peale's life is that he was the son of Charles Willson Peale (q.v.). His relationship to one of the architects of American culture in the Revolutionary and Federal eras was both an asset and a liability. It meant that he was well trained in his profession and had ready access to rarefied circles of patronage and knowledge. It also meant that he was condemned to impossibly high expectations and unjust comparisons. Peale felt the burden of his father's influence, sought to sustain the elder Peale's aims, and struggled to establish his own.

He learned to paint from his father, creating credible likenesses by his midteens and forceful portrayals by his early twenties. While he harbored great admiration for Gilbert Stuart (q.v.) as an artist, he was also envious of his fame, another factor that motivated his career. He and his brother Raphaelle (q.v.) were in Charleston, South Carolina, in 1795/96 and in Baltimore in 1797 attempting to found versions of their father's Philadelphia museum; the ventures failed. In London in 1802 and 1803 he and his brother Rubens (q.v.) hoped to reap a fortune by exhibiting one of their father's mastodon skeletons; again, the venture failed, although Rembrandt did profit from an association with Benjamin West (q.v.) and the Royal Academy. He settled in Philadelphia, hoping to establish himself as Stuart's successor; unsuccessful in that effort, he nevertheless produced some of the finest American portraits of the period. Most of Rembrandt's major commissions came from his father, who was eager to advance his son's career by increasing the museum's portrait gallery of illustrious men of science, philosophy, art, and war. To these ends his father funded two trips to Paris, in 1808 and 1809–10.

Beginning in 1811 Peale increasingly struck out on his own. He founded his own gallery in Philadelphia and composed big history paintings. In 1814 he moved to Baltimore and fashioned a museum of art and natural history. There he prospered sporadically and gained a reputation as one of the country's leading artists. In the 1820s he moved from city to city, to New York, Philadelphia, Washington, Baltimore, Boston, and then, between 1829 and 1831, to Rome, Florence, Paris, and London. Another journey to London in 1832 and 1833 nearly convinced him to settle there, but he decided on Philadelphia, where he became, with his friend Thomas Sully (q.v.), one of the grand old men of American art.

Peale's varied interests and achievements speak of unbounded inquisitiveness, energy, and ambition. Committed to fostering the arts in the United States, he was a founder of the Pennsylvania Academy of the Fine Arts and of the Society of Artists in Philadelphia, a member of the National Academy of Design, and president of the American Academy of the Fine Arts (1836–41), both in New York. Concerned with broadening the popular base of the arts, he was a pioneering lithographer and museologist, author of *Graphics: A Manual of Drawing and Writing* (1835), and the first drawing master at Central High School in Philadelphia (1840–44). Absorbed by scientific and technological advances, he published two studies on the mastodon (1803) and founded the Gas Light Company of Baltimore (1816); throughout his career he carried out extensive experiments concerning the chemical properties of pigments and mediums that led him to rediscover encaustic and to compile a handbook for painters titled "Notes of the Painting Room" (1860; Historical Society of Pennsylvania, Philadelphia). A republican who revered the ideals and the heroes of the Revolution, Peale devoted himself, especi-

ally in his later years, to preaching, in his art and in public lectures, on the character and accomplishments of George Washington.

W. T. O.

Bibliography Geske 1953. Mahey 1969. Philadelphia 1985.

69

George Washington (The Gadsden-Morris-Clarke Portrait), 1795/96

Oil on canvas
74.3 × 63.5 cm (29¼ × 25 in.)
Gift of Mrs. James Couzens (61.163)

The great event of Rembrandt Peale's career occurred in Philadelphia in October and November 1795, when he painted a life portrait of George Washington. It was his first important commission, painted at the request of Henry William DeSaussure of Charleston, who was retiring from the directorship of the United States Mint in Philadelphia. Peale was beside himself with excitement, for he worshiped Washington. He also felt a cosmic kinship with him, since they were born on the same day. (Washington was born on February 11 by the old-style, pre-1751 calendar and observed that date until he became president; Peale was probably born on February 11 by the new-style calendar, but later changed the date to coincide with Washington's birthday [see Miller 1983, 265, n. 70].) Having watched his father paint Washington in 1787 and having exploited every opportunity "to glance at his countenance," Peale "longed for no greater honor than to paint his portrait" (Lester 1846, 204).

Charles Willson Peale made the arrangements, procuring the commission, scheduling the sittings, and attending them. Since he and Washington were old friends, he could maintain conversation while

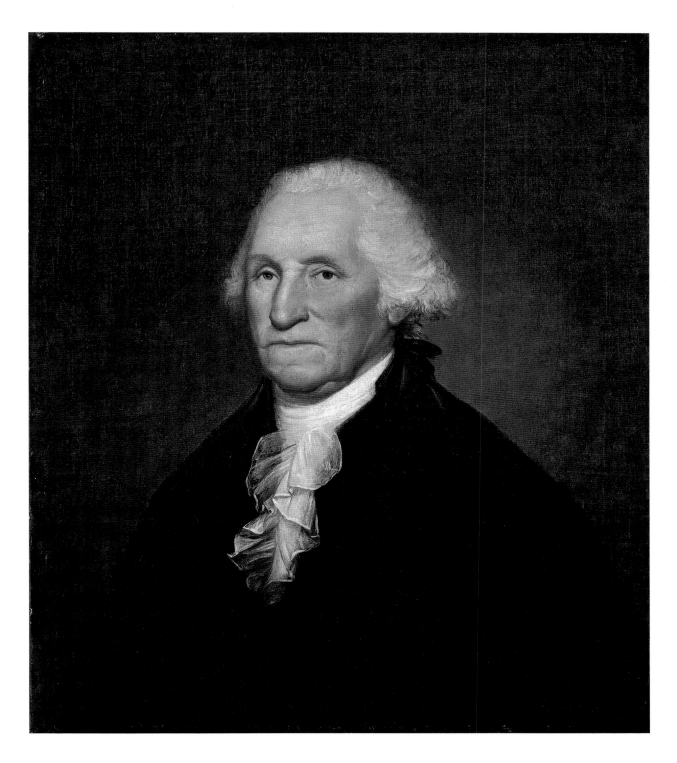

Rembrandt worked. This was a tough assignment for so young a man; already Washington was one of the great figures of history. Rembrandt Peale was a nervous wreck: he was up before dawn, but "could scarcely mix my colours" in time for the seven-o'clock appointment in his father's studio in Philosophical Hall (Peale 1857a, 16). There were three sittings, each from seven to ten. After the first, other Peales joined in: Charles Willson painted at Rembrandt's right and James at his left; Titian Ramsay and Raphaelle were there too. This was the setting for the famous pun by Gilbert Stuart, who advised Mrs. Washington to "take good care of her husband, as he was in danger of being *Peeled* all round" (ibid. 17). The early-morning appointments gave the Peales the opportunity to study Washington in his private guise, "somewhat in dishabille [sic]," before the barber made him over for public life. Rembrandt noted that the natural color of his sideburns was dark brown, but the rest of his hair was white with powder (Lester 1846, 211–212).

Rembrandt Peale's life portrait (Historical Society of Pennsylvania, Philadelphia) is of the head only and is a grim likeness, especially after its partial restoration in 1982, which revealed a wan visage with slack jaw and sagging jowls. It shows a careworn, tired old man who was having so much trouble with his false teeth that he was being fitted for a new set, which would give him even more trouble. The likeness can be assumed to be thoroughly accurate, without any attempt to idealize or ennoble Washington; in this respect it is probably unique in the Washington portraiture and thus an extremely important painting. The extent of Peale's verism can be appreciated by comparing his life portrait of Washington with his father's (New-York Historical Society). Charles Willson Peale was less concerned with a detailed, candid likeness than with conveying such republican virtues as restraint, modesty, simplicity, and a quality of detachment that implies absorption with issues beyond personal vanity.

By late November 1795, before his canvas was dry, Rembrandt had departed for Charleston, South Carolina, with Raphaelle. Their purpose was to deliver a copy of the portrait of Washington to DeSaussure and to establish themselves as independent artists in an area other than Philadelphia, which was then dominated by Stuart. In Charleston they opened a gallery that included about twenty-five of their copies after their father's portraits of Revolutionary heroes, as well as "a Portrait of the President of the United States painted the first of last month being the last which had been taken from the distinguished Patriot" (*Charleston City Gazette*, December 3, 1795). The brothers remained in Charleston until May 1796. During this stay Rembrandt painted ten copies after his life portrait (he kept the original in his own collection until his death).

Of the ten copies only two are located: the Detroit painting and the one for DeSaussure, now at the National Portrait Gallery in Washington, D.C. (oil on canvas, 75.5 × 64 cm). Peale painted the former for General Christopher Gadsden. The two copies vary only slightly: in the Detroit version the expression is less vigorous and the jabot is of lace, not linen.

Peale touted his portrait as "the most *recent* likeness" of Washington, although he fully realized that his rendering had already been supplanted by Stuart's "Vaughan" portrait (Peale 1857a, 20). He had seen Stuart's painting and modeled his Charleston copies after it, setting the bust-length figure against a blank brownish red ground (he used the same device in other portraits executed in Charleston). Lacking Stuart's knowledge of physiognomic principles, however, Peale could not ennoble his subject, so he depicted what he must have seen in Washington: small eyes, a thin nose, a drawn, downturned mouth, a short neck, and sloping shoulders. Where Stuart saw a leonine hero-statesman for all time, Peale saw a

weary sixty-four-year-old mortal as he might have appeared on any given day. If he perceived permanent values in Washington's appearance, they were austerity, gravity, and directness, not an ideal of heroic grandeur and virtuous nobility. For Peale, only seventeen years old, truth alone was sufficient virtue.

w. t. o.

Provenance General Christopher Gadsden, Charleston, South Carolina; his grandson, Christopher Gadsden Morris; his niece, Miss Hume (later Mrs. Frederick Wentworth Ford); her daughter, Mrs. Lewis S. Jervey, 1917. Charles Henry Hart, New York. Thomas B. Clarke, New York. M. Knoedler Co., New York, 1919, 1923. Senator James Couzens, Washington, D.C., and Detroit, ca. 1930; Mrs. James Couzens, Detroit. Acquired in 1961.

Exhibitions Brooklyn 1917, no. 71. Philadelphia 1923, 147, no. 157. Detroit 1964, 14. Baltimore 1965, no. 9. Detroit and Utica 1967, 19, no. 157.

References New York 1919, no. 41 (ill.). Morgan and Fielding 1931, 373, no. 3. Eisen 1932, 2: 408, 413–414. Richardson 1961, 3–4. *Antiques* 1961, 466.

70
The Court of Death, 1819–20

Oil on canvas
351 × 714 cm (138 × 281 in.)
Gift of George H. Scripps (85.3)

The Court of Death was the most sensational American painting of the early 1820s. Exhibited throughout the eastern United States from 1820 to 1823, it was a cultural phenomenon. In the first year of its tour it grossed nearly nine thousand dollars, as over thirty-two thousand people paid twenty-five cents each to see it. The painting, composed of twenty-two over-life-size figures, was sublime and spectacular.

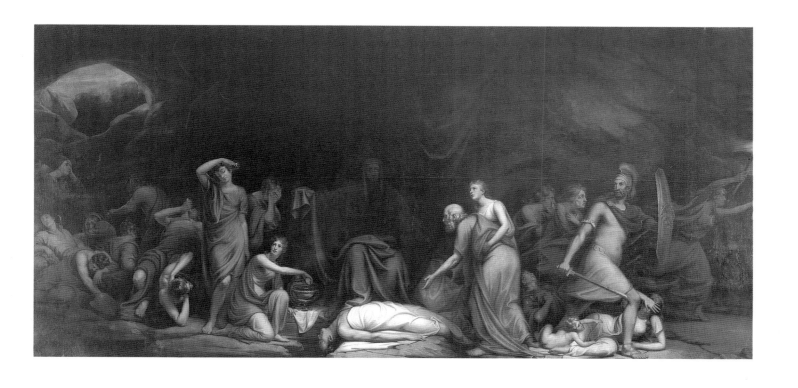

Peale was moved to undertake the subject after reading the popular poem "Death" (see *The Works of the British Poets, with Lives of the Authors*, ed. by Robert Walsh, vol. 37, Boston, 1822, pp. 371–383) by the late Anglican bishop of London, Beilby Porteus (1723–1809). In visualizing the poem, Peale composed a frieze of figures flanking the central hooded figure of Death within a dark grotto. At his feet lies the body of a man struck down in the prime of life, his head and feet touching, in Peale's own words, the "waters of oblivion." To the left are the kneeling figure of Pleasure and her entourage: Remorse, Intemperance, Frenzy, and Suicide. Beyond is "a darkened group of disease and misery, the victims of luxury and intemperate pleasure": Gout, Dropsy, and Apoplexy; Hypochondria, Fever, and Consumption. At the right are the agents and attendants of war. A warrior— "depicted with a countenance agitated by ambition and revenge"—strides past his victim and over an infant and its widowed mother; Want, Dread, and Desolation complete the scene. In the foreground stands "venerable Old Age, supported by Virtue," which Peale meant to personify also hope and religion. These figures are central to the painting's composition and moral. "Old Age . . . beholds the prospect without alarm, and submits with cheerfulness to the divine law. Virtue still supports him, and *looks* the sentiments he *feels*." Peale's point, then, is that "Death has no terror in the eyes of Virtuous Old Age, and of Innocence, Faith, and Hope" (Peale, quoted in Lester 1846, 225–227).

Peale devoted his career to the celebration of virtue, which American society at that period saw as the proper concern of the fine arts in the republic. Although *The Court of Death* treats a scene from the afterlife, it represents not a religious allegory or a scene of resurrection or divine wrath, but a "moral metaphor" not unlike Peale's later "porthole" portraits of Washington. Death, according to Peale (1857, 278), contains no mystery or miracle: it is "a fact, an incident, the natural and ordained termination of life." While death cannot be denied, its claim upon the individual can be controlled and postponed by virtue. In Peale's view, vice and excess are the agents of agonized, untimely death, just as they are abuses of the individual's innate spiritual nature; but if the individual sustains a virtuous, temperate life, he or she can, like Peale's Old Age, achieve a divine state and need not fear death (depicted by Peale as a comprehensible human form). Virtue is a democratizing force: the individual is not predestined to damnation or salvation; rather, virtue places divinity within the grasp of all. Peale's approach is humanistic: he offers a statement of faith in human dignity, reason, and self-determination.

The painting illustrates the kind of moralistic, rational religion upheld by liberal Christians, particularly the Unitarians, in the early nineteenth century. Peale was a founding member of the Unitarian congregation in Baltimore in 1817 and a friend of the Reverend Jared Sparks, the first pastor. Sparks's ordination in May 1819 was one of the great moments in Unitarian history, since William Ellery Channing, the leading spokesman of Unitarianism, then delivered his most important address. Channing maintained that every individual possesses inherent traits of divinity and could thus approach a state of salvation after life through the exercise of virtue and morality in life. That Peale began his *Court of Death* in Baltimore late in 1819 suggests a strong relationship between his conception and Unitarianism, for a similarly humanistic tone is the distinguishing feature of the painting.

Peale composed his pictorial sermon at a time of resurgent moralistic evangelism and social reformism in the United States. The message of the painting was intended to address all faiths and levels of society, for who would not agree that war and intemperance were abhorrent? A pacifist, Peale devoted a third of his canvas to an indictment of war. He was also among the first to make intemperance a public issue by expounding at length upon its evils in the left third of his canvas. As a teetotaler, he would applaud the temperance movement that gained strength in the 1830s and 1840s. Medical books of the time attest that all of the conditions personified at the left of the painting were believed to result from alcohol, excessive eating, or eating the wrong foods. Even yellow fever, which afflicted both Baltimore and Philadelphia in the summers of 1819 and 1820, and which Peale included among the "ministers" in his painting, was thought to be subject to the control of reason through diet and exercise.

Like all good theater or sermonizing, *The Court of Death* was broad in conception and emotionally stimulating. Peale conceived of it partly as a moneymaking venture, for he suffered during the economic panic of 1819. Many American artists, enduring similar hardships, produced large-scale paintings as speculative schemes for public exhibition and tour. But while the efforts of Thomas Sully (q.v.), John Vanderlyn (q.v.), and, later, Samuel F. B. Morse, for example, did not succeed, Peale's venture did.

His success stemmed no doubt from his choice of subject matter, since the American public could appreciate his "pictorial discourse on life and death" (Peale, quoted in Lester 1846, 209) simply by drawing on experience. Peale had produced the painting for an audience not educated in the grand tradition of ancient, Renaissance, and baroque art. "It was not," he asserted, "an Allegorical Picture, composed after the examples of Lebrun, or of any school" (Peale, ibid., 224). He claimed, instead, that he had rediscovered an ancient genre—"metaphorical painting" (Peale 1820a, 4)—that was explicitly suited to the democratic republic. He viewed *The Court of Death* as "the first attempt, in modern times, to produce moral impressions on the ancient Greek plan, without the aid of mythology, or conventional allegory, being as readily understood by the ignorant as the learned" (Peale, quoted in Lester 1846, 209). Peale saw himself as the first modern painter thus to popularize history painting, "to employ the language of painting . . . for the purpose of affecting the heart without doing violence to the understanding" (Peale 1820a, 4).

His interest in democratizing art, however, did not preclude a commitment to the grand manner; he based many of his figures on acknowledged masterpieces from the grand tradition. The features of Old Age were adapted from the antique bust of Homer at the Louvre; the figures of Pleasure and Intemperance were modeled on Hellenistic Venuses, Death on various Greek and Roman depictions of Zeus/Jupiter, and the warrior on the Borghese *Gladiator* at the Louvre. The artist referred to baroque lamentation scenes, to representations of the "Massacre of the Innocents," and, perhaps, to

Rubens's *Government of the Queen* from the Marie de' Medici cycle at the Louvre.

Peale drew inspiration from contemporary art, too. He stated that as he began work on *The Court of Death* the image of Benjamin West's *Death on the Pale Horse* (q.v.) was fixed in his mind (Lester 1846, 223), and he would have known as well West's drawing *Moses Striking the Rock* (1788, retouched in 1803; Royal Academy of Arts, London), which could have offered prototypes for the figures of Old Age and Virtue. Peale's experience in Paris also influenced his design; Jacques-Louis David's *Intervention of the Sabine Women* (1799; Musée du Louvre) may have provided a source for the painting's friezelike composition and for certain figural types. Furthermore, Peale approached in his painting the sculptural fullness of form, linear clarity, and high degree of surface finish that characterize the work of David, Baron François Gérard, and Anne-Louis Girodet, the French masters whom he most admired and whom he had met in 1809.

Despite the fact that Peale's visual sources were not especially relevant to the time in which he lived, he achieved his goal of painting a moral metaphor that the society could comprehend. Inspired by Unitarian beliefs and a strong social conscience, the *Court of Death*, his grand statement on the rewards of virtue, struck a responsive chord within the new republic.
W. T. O.

Provenance G. Q. Cotton, Philadelphia, 1858. S. A. Coale, St. Louis, 1885. George H. Scripps, Detroit, 1885. Acquired in 1885.

On deposit Municipal Museum of Baltimore, 1932–44.

On tour Baltimore, 1820; Philadelphia, 1820; New York, 1820–21; Boston, 1821; Albany, 1821; Charleston, 1821–22; Savannah, 1822; [Richmond, 1822;] [New York, 1822–23;] Philadelphia, 1823; Boston, 1823; New York, 1832; Philadelphia, ca. 1837; New York, 1845–46; Boston, 1846; Troy, New York, 1846; Detroit, 1847; New York, 1857; Philadelphia, 1860.

Exhibitions Baltimore 1937a, 7, no. 8. Detroit 1944, 20–21, no. 29. Detroit and Utica 1967, 23, 114–115, no. 167.

References Peale 1820. Peale 1820a, 4. Dunlap 1834, 2: 54–55. Peale 1839, 238–240. Lester 1846, 209, 221, 223–231. Peale 1846, 2, 4–16. Peale 1846/47. Arvine 1851, 505, 516–517. Peale 1857, 278–279. Tuckerman 1867, 62. Benjamin 1880, 28. Isham 1905, 125. BDMA 1910, 38–39. Mather et al. 1927, 34, no. 53. LaFollette 1929, 71. Swan 1940, 7. Dickson 1943, 18, 20–21, 28, 74–76, 78. C. Burroughs 1944, 57–58. Dickson 1945, 263, fig. 2, 266. Sellers 1947, 2: 330–332, 338, 344. Larkin 1949, 134, 189. Rutledge 1949, 132, 139. Barker 1950, 335–337, pl. 46. Flexner 1954, 166–167. Sellers 1954, 384–385, 387. Baltimore 1956, 9–10. Detroit 1957, 149–150, 153, 166, 188–189, fig. 68. Hunter 1964, 15–16. Baltimore 1965, n.p. McCoubrey 1965, 53–56. Harris 1966, 190, 303. Canaday 1969, 2: 640–641. Sellers 1969, 393–394, 401–402. Flexner 1970a, 138–139. Dickson 1973, 10–11, fig. 5. Los Angeles 1974, 11, fig. 3. Thayer 1976, 40. Craven 1979, 41–42, fig. 34. Miller 1979, 72–73. Taylor 1979, 34. Sellers 1980, 308. Washington and Philadelphia 1980, 184, fig. 147. Los Angeles and Washington 1981, 45. Philadelphia 1985, 16, 60, 82, fig. 3. Gerdts and Thistlethwaite 1988, 28, 85–86, fig. 43.

71

Self-Portrait, 1828

Oil on canvas
48.3 × 36.8 cm (19 × 14½ in.)
Founders Society Purchase, Dexter M. Ferry, Jr., Fund (45.469)

Peale's penetrating self-analysis of 1828 ranks among the best American self-portraits. Painted for his wife, Eleanor, on the eve of his long-anticipated journey to Italy, it is an intimate image, a keepsake. It is also a summary of the artist's career at the landmark age of fifty.

Peale painted his portrait in Boston, probably in the winter or early spring of 1828. It is almost certainly the portrait titled *The Artist* that he entered in the exhibition at the Boston Athenaeum in mid-May of that year. He was "a good deal occupied with Portraits" in Boston, where he had "established a reputation for valuable likenesses" (letter from Peale to Coleman Sellers, June 4, 1828; American Philosophical Society, Philadelphia). He found opportunities there, despite competition from Gilbert Stuart (q.v.), and after Stuart's death in July, he might have prospered more had he not been obsessed by the dream of studying in Italy. "The most of my work there," he noted, "was for people who would not wait the turns of his [Stuart's] caprice and for a few who preferred my style. It is probable I might have done well enough by remaining there—but no *Portrait business* is very desireable in America" (letter from Peale to Charles Mayer, September 9, 1828; Haverford College, Haverford, Pa.). In the late 1790s and early 1800s Peale had made efforts to assimilate Stuart's style,

but his penchant, unlike Stuart's, was for linear clarity, detail, and surface polish. A painterly flair reminiscent of Stuart was conveyed only occasionally, as here in the ill-defined, broadly brushed clothing.

In its frontality and sober objectivity the painting recalls Peale's neoclassical, "republican" style of the turn of the century, exemplified by his *Thomas Jefferson* of 1800 (The White House, Washington, D.C.). In its intensity and forceful lighting, however, it may be described as romantic or neobaroque, for the lighting does not so much clarify the features as it discovers them within an undefined darkness, thus inviting a subjective response. Of all of Peale's portraits, this one most closely alludes to characterizations by his namesake, Rembrandt van Rijn.

The Detroit painting is unusual in Peale's oeuvre for its limited field and small size (perhaps the canvas was a fragment). Typical of his style, however, are the high finish of the head and the sharp focus. We see Peale as he saw so many of his sitters, as if he were an exhibit in a cabinet of natural history. Thus, we are invited to scrutinize each detail of his life mask—the structure of the head, the spectacles, and their shadows.

This was Peale's first self-portrait since early in his career, but he would paint several more in the 1840s and 1850s, since, like his father before him, he delighted in studying and celebrating the family in portraiture. In the subsequent paintings also he portrayed himself wearing spectacles, which he had begun to use in 1818 (Peale 1856, 164). He revered the truth—that is one theme of the present painting—and the spectacles, which he wore constantly, were a fact of his appear-

ance and were essential to his livelihood. As Peale planned his European tour, anxious about his impaired health as well as the dangerous voyage, he took stock of himself and found both a restless dreamer and a temperate, blunt pragmatist who was devoted to his art. Most of the later self-portraits are slick public affairs; this one is a confession.

W. T. O.

Annotations On back at center right, *Rembrandt Peale | painted by himself | Boston 1828 | for his Wife Eleanor Peale* (transcribed from a card attached to the stretcher when the painting was relined prior to its acquisition by Detroit)

Provenance The artist; probably his daughter, Eleanor Peale Jacobs; probably her daughter, Mary Clare Jacobs Wirgman; her son, Grafton B. Wirgman, East Orange, New Jersey, 1923; probably his daughter, Carol Wirgman, East Orange, New Jersey. James Graham & Sons, New York, 1941. Victor Spark (dealer), New York, 1945. Acquired in 1945.

Exhibitions Boston 1828, no. 204 (see Perkins and Gavin 1980, 108). Philadelphia 1923, 209, no. 261. New York 1941, no. 6. Minneapolis 1963, unpaginated [no. 105]. Baltimore 1965, no. 27. Detroit and Utica 1967, 101–102, no. 136. Buffalo et al. 1976, no. 5.

References Dickson 1945, 264, fig. 4. Richardson 1946, 53–54. Richardson 1954, 74. Detroit 1957, 153–154. Pierson and Davidson 1960, 320, no. 2830. Andrews and McCoy 1965, 50. *Apollo* 1976, 137. Wilmerding 1976, 58, pl. 61. Miller 1979, 70. Detroit 1985, 194. Philadelphia 1985, 94, fig. 10.

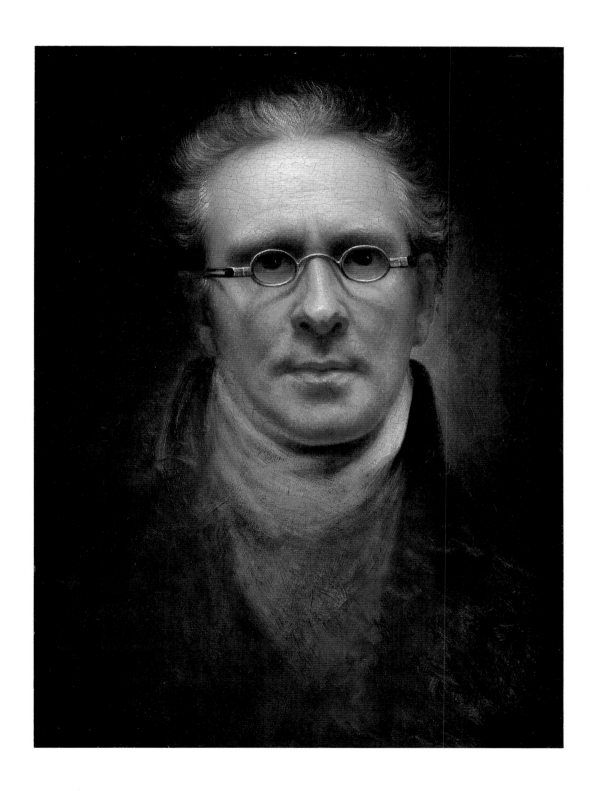

Self-Portrait

72

Attributed to Rembrandt Peale

Man Reading by Candlelight,
ca. 1805/06

Oil on canvas
139.7 × 114.3 cm (55 × 45 in.)
Founders Society Purchase, Director's
Discretionary Fund (59.187)

This painting of a middle-aged man seated, reading by candlelight, is an impressive work. Its unusually large size, its uncommon subject matter, and the technical competence that it manifests characterize it not only as a major effort by an accomplished artist but also, most likely, as a display of virtuosity intended for exhibition. Here was an artist who enjoyed a challenge, who plotted the effects of night light—the moon and the candle—on a prodigious array of surfaces and substances: flesh, hair, paper, and various fabrics, glass, water, wood, metal, and leather. Here, too, was an artist who had studied human nature, who knew the reader's attitude of simultaneous repose and concentration. Here was a master of both the broad view and the still life, of both the broad brush and the fine. Who was the artist?

The dealer from whom the painting was acquired reported that it came from a private collection in Philadelphia by way of a dealer there. This provenance was upheld, he argued, because the subject sits in a Windsor armchair of Philadelphia manufacture. He noted further that Charles Coleman Sellers, who was an authority on Philadelphia painting and the authority on the Peale family, had suggested that the painting was by Matthew Pratt (1734–1805) and may have been Pratt's *Reading, by Candlelight,* which was exhibited at the Pennsylvania Academy of the Fine Arts, Philadelphia, in 1812.

Sometime shortly after its acquisition, presumably just after the painting was restored, the initials "RP" were seen, in-

distinctly, within the blackness at the lower left. On the basis of this inscription, which is now visible only by infrared reflectography, the painting was accepted by Edgar P. Richardson as the work of Rembrandt Peale (curatorial files, DIA). Wilbur Harvey Hunter (Baltimore 1965) identified it as the self-portrait at fifteen or sixteen that Peale later described in his reminiscences (see Peale 1856, 164). Clearly, however, the subject is no teenager. Two years later Charles H. Elam (Detroit and Utica 1967) maintained that it was more likely that the candlelight self-portrait at the Wadsworth Atheneum in Hartford was the subject of Peale's reminiscence, which, in fact, it is. Still, Elam upheld the attribution to Rembrandt but cited as well the possible collaboration of both Raphaelle (q.v.) and Rubens Peale (q.v.).

If we accept the Philadelphia origin of the painting—and there is no reason not to do so—we would think first of an attribution to one of the Peales. Charles Willson Peale (q.v.) and his sons Raphaelle and Rembrandt all challenged tradition, as well as their skills, in various self-imposed studio tests undertaken for private enjoyment and public acclaim. In their more inventive works they explored both dramatic lighting effects and the line that might distinguish reality from illusion. Since similar interests and a similarly inventive spirit underlie the *Man Reading by Candlelight,* an attribution to one of the Peales is logical.

Among the Peales, Rembrandt would be the most likely candidate to whom the painting might be assigned; there is no conclusive evidence, either documentary or stylistic, to suggest the participation of Raphaelle or Rubens. It is true that the generalized treatment of hair, the sinuous, elongated limbs, and the schematic modeling of the head do not relate to Rembrandt's conventional portraits of

the early 1800s, such as *Thomas Jefferson* (1805; New-York Historical Society) and *William Short* (1806; College of William and Mary, Williamsburg, Va.); however, Rembrandt's fascination with dramatic lighting is well documented. The exhibition at Peale's Museum in Philadelphia in 1795 included the Wadsworth Atheneum portrait, Rembrandt's view of the recent conflagration of the Lutheran Church in Philadelphia, and his copy (after a mezzotint) of a blacksmith's shop from a painting by Joseph Wright of Derby. Influenced by his father and a print after Godfried Schalcken, a seventeenth-century Dutch artist who specialized in nocturnal and candlelight paintings, Peale also painted a moonlight scene in the family garden and several lamplight portraits. His interest in nocturnal and artificial lighting was rekindled in 1805 or 1806, when, endeavoring to emulate aspects of Gilbert Stuart's (q.v.) style, he followed "the advice of Sir Joshua [Reynolds], to study by lamp-light, the effects of which delight me by the precision of the lights, beauty of the shadows and richness of the reflections" (letter from Peale to Stuart, March 24, 1806; see Mason 1879, 71). This interest was sustained in later works, notably *The Court of Death* (cat. no. 70) and the 1828 *Self-Portrait* (cat. no. 71); thus the painting may be one of Rembrandt Peale's unlocated lamplight pictures of 1805–6.

W. T. O.

Inscriptions At lower left, *RP* [not visible to naked eye] / *D* [not visible to naked eye]

Provenance Private collection, Philadelphia. (Dealer), Philadelphia. Joe Kindig, Jr., & Son, York, Pennsylvania, 1958. Acquired in 1958.

Exhibitions Baltimore 1965, no. 8. Detroit and Utica 1967, 101–102, no. 135.

References Gerdts 1967, 262.

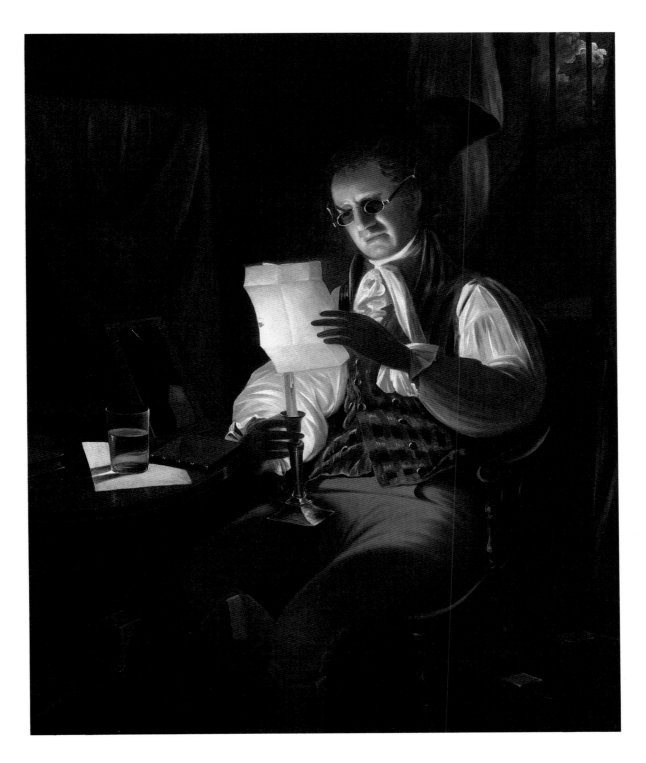

Man Reading by Candlelight

The fourth son of Charles Willson Peale (q.v.), Rubens suffered from poor eyesight from birth, and so was trained by his father primarily in natural history and museum-management techniques, rather than for a career in the fine arts. In such scientific and administrative pursuits he was successful for nearly three decades, overseeing his father's museum in Philadelphia (1810–22) and that of his brother Rembrandt (q.v.) in Baltimore (1822–25) before founding his own Peale Museum in New York in 1825. The economic crisis of 1837, however, ended that enterprise. After selling out to P. T. Barnum, Peale retired with the financial assistance of his wife's family to Woodland Farm, near Schuylkill Haven, Pennsylvania, where he immersed himself in rural work and study much as his father had done a quarter-century earlier at Belfield Farm outside Philadelphia.

Rubens Peale might never have entered the mainstream of American art had his daughter Mary Jane Peale not returned from Philadelphia to live at Woodland Farm in 1855. Trained as a portraitist by her uncle Rembrandt, Mary Jane activated her father's interest in painting and sketching and at times collaborated with him. During the last ten years of his life, despite advancing age and weak vision, Rubens Peale produced more than one hundred thirty landscapes, still lifes, animal and bird subjects, and copies after works by other family members. As the artist's own records indicate, he painted most of these pictures for personal pleasure, but he was also able to sell a proportion of them to family friends and local patrons. Only a small percentage of his oeuvre is known today.

G. C.

Bibliography Detroit and Utica 1967.

73
Two Ruffed Grouse, 1864

Oil on canvas
48.9 × 69.2 cm (19¼ × 27¼ in.)
Gift of Dexter M. Ferry, Jr. (43.41)

According to two separate listings kept by the artist (see Sellers 1960; Detroit and Utica 1967), he painted, during the first four months of 1864, three scenes representing "Pheasants or Ruffed Grouse" for three different members of his wife's family. The earliest of these pictures (unlocated) of a favorite American game bird was commissioned by James Patterson. Painted between January 22 and February 12 of that year, it depicted (as Peale noted in his diary; see R. Peale 1864a) "a very large specimen which I mounted for somebody in Pottsville." The second and third paintings portrayed a pair of birds. The first version of the latter type (unlocated), which Peale termed "a new picture [of] male and female pheasant in a grove," must have been prompted in part by favorable reception of the single-bird composition. It occupied the painter for about one month, between February 22 and March 19, 1864, and was purchased by Lydia Patterson. The second variant, "another male and female pheasant piece"— the Detroit work—was begun on the day the previous painting was completed. After finishing it in less than three weeks, Peale sold it to Robert Patterson, another of his wife's relatives. With evident satisfaction, he signed the canvas on the back: "Painted by Rubens Peale in his eightieth year, April 1864." To judge by extant works, he frequently signed pictures in this manner, but the inscription also recalls one that his aged father had affixed to a self-portrait of 1822 (private collection): "Painted in the 81st year of his age without [the aid of] spectacles."

That Rubens painted two consecutive canvases of paired ruffed grouse probably resulted in part from the substantial sum of sixty dollars he received from Lydia Patterson for the first such work (James Patterson had paid twelve dollars for the picture of a single bird), the same price Peale obtained from Robert Patterson. But the subject itself and the artist's handling of it are indicative of the Peale family's expertise in ornithology and can be linked to occurrences in Rubens Peale's own family during 1864.

Charles Willson Peale, a skilled taxidermist who passed on his abilities to his sons, had assiduously collected ornithological specimens for his museum from the time of its inception. Although a comprehensive catalogue of the Philadelphia Peale Museum was never issued, the nineteen examples of (stuffed) "pheasants and other birds" recorded in a sale inventory of the museum in 1848 (Sellers 1980, 314) doubtless included one or more ruffed grouse. One of the museum's specimens may have been the model for the elaborate hand-colored lithograph of a male grouse published in Alexander Wilson's landmark book *American Ornithology* in 1811. Certainly the elder Peale both encouraged and personally assisted in the production of Wilson's magnum opus by providing mounted specimens and perhaps the colors for some of Wilson's tinted illustrations. Furthermore, Rubens's younger brother Titian Ramsay Peale II, a collaborator with their father on the Philadelphia Peale Museum and director of that establishment between 1833 and 1843, was a professional naturalist of wide-ranging experience whose expertise included the ruffed grouse. An article on the species printed in John and Thomas Doughty's *Cabinet of Natural History and American Rural Sports* (Philadelphia, 1830–34) was embellished

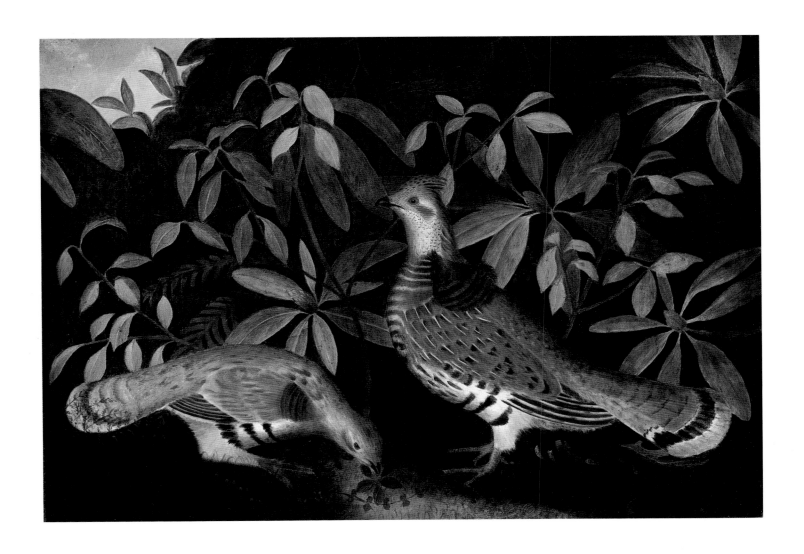

Two Ruffed Grouse

with a full-page colored print copied from an example "prepared by T. R. Peale," while the text referred to some of the latter's observations regarding the bird's behavior patterns.

Although the male depicted in the Detroit painting must have been based on the large specimen that Rubens himself had preserved, the composition of a pair of birds recalls scattered examples of early nineteenth-century ornithological illustrations in which the male and female are shown facing one another, the latter bending to the viewer's right, eating, the former standing erect. Such compositional adherence to printed precedents, and for that matter to museum displays arranged by members of the Peale family, was probably deliberate. Evidently lacking a specimen of the female, and with no existing print of ruffed grouse to which to refer for a profile pose complementing that of his male, Peale painted the unresolved, rather awkward female premised on compositional models involving other (albeit related) bird species. The stance of the male, on the other hand, does resemble, in reverse, Wilson's more elaborate lithograph. Whether or not Peale consciously took a cue from that rendering is difficult to judge, but it is true that Wilson's print was included in all the many nineteenth-century editions of his treatise and that it remained well enough known later in the century to have been reproduced, in reverse and without acknowledgment, in *Charles Knight's Pictorial Museum of Animated Nature*, a two-volume compendium published in London and New York between 1856 and 1858 (1:400). Peale's male differs from Wilson's portrayal, as well as from those of Doughty and John James Audubon (*Birds of America*, 1828, pl. 41), in that the pinions are folded under rather than over the bird's tail feathers.

Nineteenth-century commentators agreed that the ruffed grouse characteristically inhabited hillside groves of evergreen and laurel. In diagrammatic fashion, that is precisely where Peale placed them. The largest plant, *Rhododendron maximum* (laurel), is complemented by *Kalmia latifolia* (mountain laurel), a fern, an evergreen (perhaps white hemlock), white oak (at the lower right), and two varieties of "partridge berries" at the birds' feet— *Mitchella repens* and (probably) *Gaultheria procumbens;* the female pecks at one of the latter. Because these plants could conceivably occur naturally together in the northern Appalachian region, it can be assumed that Peale contrived the setting from local observation, as well as from his knowledge of earlier ornithological research.

Unfortunately, the Detroit picture cannot now be compared with the other two paintings of grouse that Peale produced at nearly the same moment, but it can be assessed with respect to the two extant examples (private collection) of five additional canvases of bird subjects that emerged from his easel between December 1863 and November 1864. All five depicted a "happy family of partridges" (Sellers 1960, 149) that his wife had sheltered in their home in July 1860. Peale had taken up this theme on two previous occasions, once in 1861 and again in 1862 (both works unlocated), but the fact that he returned to it five times within the space of a few months suggests that he was working under exceptional conditions. Indeed he was: during those months, despite the watchful care of her husband and daughter, Eliza Patterson Peale's health was rapidly declining. She eventually died on September 13, 1864. It is possible to interpret these paintings of a "happy family," and the expansion of Peale's initial one-bird composition of ruffed grouse to a scene featuring a male and female bird, in terms of his wish to commemorate bygone happiness in his own family, as well as to cling to its present-day remnants during those final hours.
G. C.

Inscriptions On the back (visible before relining), *Painted by Rubens Peale in his eightieth year, April 1864*

Provenance Joseph Patterson; the Patterson family, Pittsburgh. A. F. Mondschein (dealer), New York. Acquired in 1943.

Exhibitions Hartford 1942, 25, no. 2. Detroit 1944, 14, no. 39. Cincinnati 1954, no. 81. Wilmington 1962, no. 77. Tucson 1964, no. 149. Detroit and Utica 1967, 120–121, no. 175.

References R. Peale 1864, no. 101. R. Peale 1864a. C. Burroughs 1944, 58. Born 1947, 15, fig. 33. Sellers 1954, 11. Detroit 1957, 158, 320. Pierson and Davidson 1960, 321, fig. 2834. Sellers 1960, 148–149. Detroit 1965, 85. Detroit and Utica 1967, 120–121, no. 175, ill.

The Pepperrell Limner

ACTIVE IN COASTAL NEW ENGLAND, CA. 1705–1715

The Pepperrell Limner was one of four artists working in a limited area of New England between 1705 and 1729 whose styles and palettes are similar and whose patrons were often related to each other. The one identified painter of the four was Nehemiah Partridge, born in Portsmouth, New Hampshire, in 1683 (and the only one to leave their common territory, bounded on the north by Kittery, Maine, and on the south by Boston). Of those unidentified, the Frost Limner is named for likenesses of the Frost family of southern Maine; the Pollard Limner is named after a portrait of one-hundred-year-old Ann Pollard, painted in Boston in 1721; and the Pepperrell Limner is named for one of his patrons, Colonel William Pepperrell of Kittery Point, Maine.

Striking similarities in patronage and painting practices make it difficult to differentiate among the artists, inevitably leading to the conclusion that they were related by blood or by apprenticeship—or a little of both. Their works share various poses, almost all of them derived from widely circulated mezzotints of English royalty and aristocracy. Certain awkward hand positionings may be observed as a common trait. The same pigments are commonly found in all the works, with rich golden browns, Indian reds, and vibrant blues predominating. The Frost Limner's use of these colors is slightly less saturated and somewhat more sophisticated than the palettes of the other three, as he created dramatic contrasts between complementary hues.

The four limners were, by far, the most active painters in New England in the first quarter of the eighteenth century.

Their subjects include members of most of the families of the area's leading merchants, shipbuilders, and government officials. Together, Nehemiah Partridge and the Pepperrell, Frost, and Pollard limners probably produced several hundred New England portraits, of which approximately one hundred are known today. Those that survive are powerful representations of the early colonists, characterized by flat, shadowless figures; rich, contrasting color; and primitive ways of expressing anatomical and facial features.

M. B.

Bibliography W. Warren 1958, 97–128, no. 23.

74

Attributed to the Pepperrell Limner

Mary Hirst, ca. 1710

Oil on canvas
83.8×64.8 cm (33×25½ in.)
Gift of Dexter M. Ferry, Jr. (48.163)

Mary Hirst was the granddaughter of Samuel Sewall of Boston, the diarist, merchant, and judge at the Salem witch trials of the early 1690s—an action of which he later repented publicly. Mary was the first child born to Sewall's daughter Elizabeth and her husband, Grove Hirst, on January 31, 1704. The girl's early history and her marriage to William Pepperrell, Jr., of Kittery Point, Maine, on March 16, 1723, were matters of interest and note to Sewall, and the poignant youth of this child, motherless at twelve and an orphan at fourteen, is frequently mentioned in

his diary. (Interestingly, she is not mentioned by him after her marriage to Pepperrell, although the Sewall record continued for six more years.)

One of the households known to Mary Hirst when she was a child was that of Hannah Sewall Moody. Hannah was her cousin, the daughter of Sewall's brother John, and was married to the Reverend Samuel Moody of York, Maine, which was just west of Kittery Point, the Pepperrell home. It is most likely that this couple or other Sewall relations in nearby Newbury, Massachusetts, arranged for the Pepperrell Limner to paint the portrait of Mary when she was very young. Her dress and pose—holding a coral rattle with silver bells—are those seen in portrayals of infants of very tender years. Mary's early acquaintance with the Pepperrell family—whose son William she was to marry—may be assumed from the fact that her portrait and theirs, by the same unknown painter, were all done at about the same time.

William Pepperrell, Jr., became one of the richest and most famous merchants and landowners in the Colonies and the first American-born baronet (he was knighted by the English for his capture of Louisburg in 1745). He and his wife were the parents of six children, of whom only four lived beyond infancy. Widowed in 1759 and surviving her husband by thirty years, Lady Pepperrell died on November 25, 1789. Their house at Kittery Point still stands.

The painting is in very poor condition. Showing through the skinned surface of the painting in many areas is a red-brown

tone—the color of the ground coat—which sometimes appears on the surface as a middle tone between the dark background and the light accents of features and costume. The elaborate lace pattern edging the child's apron is a typical feature of paintings by the Pepperrell Limner, as are the faint orange-pink and green sprigs that were once an overall pattern on her robe. Her face appears to have been overpainted; nevertheless, the features and shadowing greatly resemble portraits by the Pierpont, Pepperrell, and Savage family limners (W. Warren 1958, 97–128). While her hands and arms appear to have been skinned and overpainted, their positioning—and her grip on the silver and coral rattle—is very similar to that seen in a Detroit portrait of Thomas Savage, Jr., by the Savage Limner (private collection). Recent cleaning of the Detroit portrait reveals that the position of the skirt and shoes was altered by the artist to make the figure three inches shorter than it was originally.

M. B.

Provenance Descended in the family of Mary Hirst Pepperrell. [Goodspeed Bookstore, Boston.] Childs Gallery, Boston. Old Print Shop, New York. Dexter M. Ferry, Jr., Detroit. Acquired in 1948.

Exhibitions Manchester 1956. Detroit 1967, 43, no. 119.

Mary Hirst

William Matthew Prior

1806 BATH, MAINE—
SALEM, MASSACHUSETTS 1873

The career of William Matthew Prior is typical of many artist-entrepreneurs who made a decent living as painters of portraits and fancy pictures in the second quarter of the nineteenth century. Although Nina Fletcher Little, an authority on Prior and the artists associated with him in Maine and Massachusetts, found almost no evidence to indicate how he acquired his training, the unusually wide range of Prior's efforts as a painter shows that he was not only expert at his craft but that he was blessed with excellent business sense as well. Pragmatically accepting of the wide variation in his patrons' tastes and in their ability to pay, Prior painted to order in either academic or untutored style. Evidence for this appears in an advertisement located by Little: "Persons wishing for a flat picture can have a likeness without shade or shadow at one quarter price" (Little 1950, 82). Today folk-art enthusiasts invariably prefer these flat, unshadowed likenesses to the prosaic academic works.

Prior's earliest known work, a signed portrait of a subject from Portland, Maine, was painted in 1824, when he was just eighteen. By this date he was already on the road, working as a traveling artist. As he reached his twenty-first year, he was advertising his skills—"Ornamental painting, old tea trays, waiters re-japanned and ornamented in a very tasty style"—in newspapers such as the *Maine Inquirer* (Little 1948, 44).

A little more than six months later, in the same newspaper, he inserted the first notice of the skill that was to dominate the remainder of his career: "Portrait painter, William M. Prior, offers his services to the public. Those who wish for a likeness at a reasonable price are invited to call soon" (Lyman 1934, 180).

In 1828 Prior married Rosamond Clark Hamblen in Bath, Maine, thus entering a family in which there were already three painters: Nathaniel, Joseph G., and Sturtevant J. Hamblen. Prior was to live and work with the Hamblens for most of his career, in one of the Hamblen households in Portland in the early 1830s and

in his own East Boston house in the early 1840s. The last became the headquarters from which Prior and the Hamblens worked, producing quantities of portraits to order in a wide range of prices. The less-expensive paintings by the four artists are extraordinarily similar. Most of them, usually painted on academy board and less frequently on canvas, sold for under five dollars. These portraits are characterized by unshadowed, straightforward likenesses in which broad expanses of color appear in the costumes and background. A common feature is the academic convention of wine-red draperies tied back with shaded cords that end in tassels.

Like the painter Joseph Whiting Stock (q.v.), a contemporary with a similar clientele and territory, Prior traveled in the New Bedford and Fall River areas. He also shared Stock's interest in phrenology, but his chief enthusiasm was for the teachings of the Adventist preacher William Miller, who predicted that the end of the world would occur in the early 1840s. Another parallel in the two artists' careers was the frequent requests each received for portraits of dead infants. In his manuscript journal Stock noted several portraits taken "from corpse" or from photographs, but Prior's son recalled his father declaring that the images of deceased children came to him "from the spirit world" (Lyman 1934, 180).

In 1846, as Prior's new house in East Boston was completed, he hung out a sign and advertised the third story as his "Painting Garret." For more than twenty-five years he continued to stamp the reverse side of his portraits on canvas and academy board with his name and the location of his studio and house.

Little's assessment of Prior's career sums up this prolific artist's achievements:

He neither exhibited great artistic talent, nor excelled in imaginative composition. He could, however, execute portraits with a considerable degree of competence when the occasion demanded. His flat likenesses [are] examples of a conscious effort to give the public what it wanted at a price it was willing to pay.... He was an able and varied craftsman, combining a

knowledge of general decorating with commercial, portrait, and landscape painting (Little 1950, 88–89).

M. B.

Bibliography Lyman 1934, 180. Little 1948, 44–48. Little 1950, 82, 88–89. Little 1957, 3–4, 98, 114, 352–354. Black and Lipman 1966, 84. Bishop 1979, 33–34, 40, 42.

75
Attributed to William Matthew Prior
Mr. Dudley, ca. 1850

Oil on canvas
89.2 × 76.8 cm (35⅛ × 30¼ in.)
Gift of the Estates of Edgar William and Bernice Chrysler Garbisch (81.835)

The subject of this portrait was identified by a previous owner simply as Mr. Dudley, and no further information on the sitter exists (although the family name is well known in Boston and southern New Hampshire, the first Dudleys having arrived in New England in the late seventeenth century). Since the painting verges on the academic, its cost was probably at the high end of the range advertised by the painter. While a flat, unshadowed likeness with a plain frame might be had for under three dollars, Prior's top price was about twenty dollars, a figure that included a gilded frame.

A date of around 1850 is suggested by the subject's long, full sideburns, narrow turned-down collar, and flowing bow tie. The swagged red curtain held with a gold cord ending in tassels is a motif used frequently by Prior, both in a fully developed work and in a less expensive two-dimensional face and figure. Typical of Prior and the painters who worked with him is the small view through the window of sailboat, lake, mountain, and clouds.

M. B.

Provenance David Hollander, 1949. Edgar William and Bernice Chrysler Garbisch, New York. Acquired in 1981.

Mr. Dudley

76

Attributed to the Prior-Hamblen School

John Sherburne, ca. 1840

Oil on canvas
78.1×65.7 cm (30¾×25⅞ in.)
Gift of the Estates of Edgar William and
Bernice Chrysler Garbisch (81.833)

This portrait of a bright-eyed, alert little
boy is in the manner of William Matthew
Prior and the painters Nathaniel, Joseph
G., and Sturtevant J. Hamblen, who
worked with him in East Boston, Massa-
chusetts, from the second to the sixth
decade of the nineteenth century. The
Detroit work is typical of the flat, unshad-
owed likenesses that Prior advertised as
available for only a few dollars. The col-
ors of the boy's dress, the small rabbit at
his feet, and the apples and cherries that
he holds are bright accents to the seated
figure, which is set against a very dark
brown background. In the dealer rec-
ords accompanying the painting, John
Sherburne is listed as having been a resi-
dent of Farmington, New Hampshire.

 Although the date 1810 is inscribed on
the reverse of the canvas, it is likely to be
a later addition, since the child's costume
is from the 1840s.
M. B.

Inscriptions On the back (visible before
relining), *Painted November 17, 1810*

Provenance Isabel Carleton Wilde
(dealer), Cambridge, Massachusetts.
Downtown Gallery, New York. Edgar
William and Bernice Chrysler Garbisch,
New York. Acquired in 1981.

Exhibitions Washington 1954, no. 13.

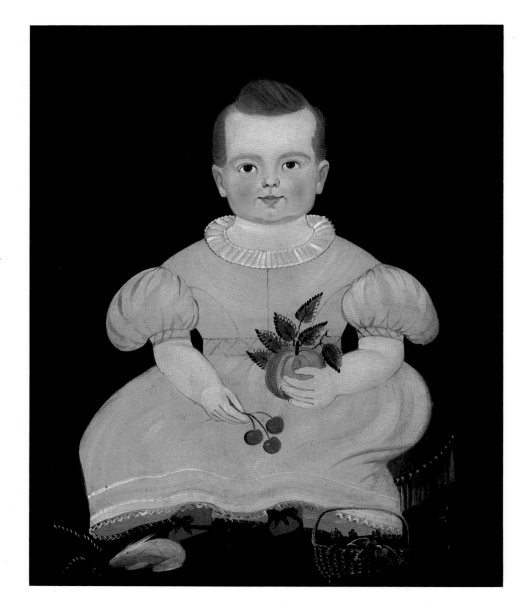

John Sherburne

In retrospect, John Quidor's life seems to mirror the picturesqueness of his art. Quarrelsome in temperament and personally mysterious, affiliated to some degree with political causes and politicians, living for years on the fringes of American artistic activity, and associated (through tantalizingly vague references) with Albert Pinkham Ryder in a supposed teacher-student relationship, Quidor invites categorization as an iconoclast. The reality was probably somewhat different, however. His personal and professional circumstances alike were deeply colored by difficulty and frustration, which in turn deflected his creativity and blunted his aspiration of becoming a nationally significant artist.

Trained in New York City between 1818 and 1822 by the portraitist John Wesley Jarvis (q.v.)—with whom he later had a dramatic falling-out—Quidor thereafter embarked on a checkered career in farming, land speculation, and sign, fire-engine, and political-banner painting, with occasional forays into the fields of portraiture and genre painting. Most of his works in the last-named category were drawn from subjects in recent American literature related to the colonial history of the United States. In 1844, following the examples of the late Benjamin West (q.v.) and other artists whose works had toured the United States in the 1830s, and doubtless inspired in part by the widespread attention accorded three huge national-history paintings completed in the 1840s for the United States Capitol, Quidor began a series of eight giant canvases of religious subjects, which he intended to present in moneymaking special exhibitions in several American cities. Three of the pictures were in fact shown in New York in 1847, by which time Quidor had been living in central Illinois for ten years. During the early 1850s, after he returned to New York, his productivity as a genre artist increased and,

except for some interruption during the Civil War, he continued to paint through most of the 1860s. Quidor lived in retirement in Jersey City for about the last fourteen years of his life.

Although little is conclusively known about his training, his level of knowledge, or his career ambitions, the fact that Quidor exhibited work fairly frequently in New York during the late 1820s and 1830s and ventured into the mainstream field of "great picture" displays in the 1840s attests to his interest in achieving national artistic standing. The subject matter and technical handling of his most famous paintings are evidence of another kind of sophistication. One of a few painters of the day who pegged their creativity to the writings of Washington Irving and James Fenimore Cooper, Quidor was certainly the sole American artist who attempted a full-fledged stylistic and thematic emulation of exemplars of seventeenth-century northern European genre art such as Adriaen and Isaac van Ostade, Jan Steen, Rembrandt, and the followers of Rembrandt. To these precedents Quidor added a salty dash of caricature probably traceable to eighteenth-century English precedents and a neomannerist flavor probably derived from late-eighteenth- and early-nineteenth-century art from the same country. In light of the strong connections between English and Dutch genre and landscape painting in the generation previous to his own, Quidor's depictions of mythological events from Dutch colonial American history can be viewed as being among the most apposite manifestations of historicism in nineteenth-century art.

G. C.

Bibliography New York et al. 1965. Sokol 1970.

77
Embarkation from Communipaw, 1861

Oil on canvas
68.6 × 87 cm (27 × 34¼ in.)
Founders Society Purchase, General Membership Fund (62.176)

The subject of this painting is taken from Washington Irving's satiric *History of New York*, written under the pseudonym Diedrich Knickerbocker, which was first published in 1809 and reprinted in numerous editions throughout the nineteenth century. According to Irving's fictionalized narrative, New Amsterdam, predecessor of the bustling New World commercial and cultural capital of which the author himself was a leading light, was founded in the seventeenth century by Dutch colonists who initially had settled on the coast of New Jersey. But after their contented life at the village of Communipaw was shattered by a near-disastrous encounter with English forces, the Dutch decided to seek safer habitation elsewhere. Under the leadership of Olaffe Van Kortlandt, they mounted an exploratory expedition, the findings of which would determine their future. On the appointed day,

no sooner did the first rays of cheerful Phoebus dart into the windows of Communipaw, than the little settlement was all in motion. Forth issued from his castle the sage Van Kortlandt, and seizing a conch shell, blew a far resounding blast, that soon summoned all his lusty followers. Then did they trudge resolutely down to the water side, escorted by a multitude of relatives and friends, who all went down, as the common phrase expresses it, "to see them off." . . . The good Olaffe bestowed his forces in a squadron of three canoes, and hoisted his flag on board a little round Dutch boat. . . . And now, all being embarked, they bade farewell to the gazing throng upon the beach (New York: G. P. Putnam, 1848, 102).

Eventually, after having endured inclement weather and stormy seas, the voyagers

accidentally "discovered" Manhattan Island, on which they established their New Amsterdam settlement.

Quidor combined in one scene the various pre-departure activities recounted by Irving. As the portly Van Kortlandt (right center) blows on a conch, his followers, some of whom are already on board the three ships, ready the sails and hoist the flags, while others march in ragtag style toward their vessels. In the distance at the right, nearer the village, two figures wave farewell. The expansive gestures of several figures and the wobbly strides of the two men stepping onto the gangplank, plus an assemblage of one embracing couple, one yapping dog, and numerous canes, knapsacks, baskets, long-stemmed pipes, flopping hats, one rifle, and one pick, added to the commotion. The vibrancy of the scene is enhanced by the trees that surround all four sides of the figure group with a splintery, electrified halo of leaves and branches. Catching the early morning light, the vegetation at the right is especially highly charged, while the more sedate, silhouetted trees and boulders at the left shelter a pipe-smoking observer of the proceedings.

John I. H. Baur (in New York et al. 1965, 61–66), David Sokol (1970), and others have aptly characterized Quidor's late works as diaphanous and dreamlike in comparison with his own earlier productions, as well as with those of most of his contemporaries. But Sokol's evaluation of the figures in the Detroit work as impotent beings "seemingly quite powerless to affect their own destinies," and the painting as a whole as symptomatic of the artist's declining abilities, states the matter too strongly. While it is true that Quidor's very last paintings invite such an assessment, *Embarkation from Communipaw,* in this author's opinion, as yet betrays no incapacitation from either a conceptual or a technical standpoint. Rather, by placing his figures within a larger setting, Quidor became, in effect, as much a landscape as a genre painter, while by reducing his palette to sepia tones and his paint handling to thin glazes punctuated by ridges of impasto, he imparted to the composition both a sense of urgency and an appropriate flavor of historicism.

Because of the corpulent yet nimble figure of Van Kortlandt in particular, the procession exudes a boisterousness akin to a bacchanal or, more specifically, to a *kermesse,* which is reminiscent of northern European pictorial precedents ranging from Pieter Bruegel to Peter Paul Rubens and Jan Steen. The jovial atmosphere is combined with sketchy handling and a murky color balance so close to certain Dutch and Flemish baroque works by Rembrandt, Jan van Goyen, Salomon van Ruysdael, and Adriaen and Isaac van Ostade that the parallel must have been intentional. When and under what circumstances Quidor might have encountered seventeenth-century (or purported seventeenth-century) northern European landscape and genre paintings is difficult to guess, but such works, and works of similar content by nineteenth-century European artists, were increasingly of interest to American collectors of the day. More accessible to Quidor would have been numerous nineteenth-century writings on Dutch art, especially those in which Rembrandt was characterized (by Washington Allston [q.v.] and Daniel Huntington [1816–1906], among others) as a vivid personality who painted pictures combining remarkable realism, inexplicable fantasy, and jewellike glitter. This analogy presents a key by which to unlock the mystery of the final phase of Quidor's art: without plagiarizing from his models, Quidor may well have been depicting early-nineteenth-century fictionalized episodes from seventeenth-century Dutch colonial history as he believed seventeenth-century Dutch or Flemish artists might have done.

Quidor's formal and technical vocabularies were not without parallel in his own century. The trees at the left recall *repoussoir* elements in many compositions by Asher B. Durand (q.v.), as well as those by Meindert Hobbema and the Ruisdaels; the foreground tree trunk and distant clouds echo components of the work of Thomas Cole (q.v.) and Jasper Cropsey (1823–1900) as much as that of Jacob van Ruisdael; and the figures' angular jocularity, verging on caricature, is about as close to creations by David G. Blythe (1815–1865), James Henry Beard (1812–1893), William Holbrook Beard (1824–1900), and at times Felix Octavius Carr Darley (famed as an illustrator of Irving's writings) as to those of seventeenth-century Dutch and Flemish genre specialists. In addition, as Bryan Wolf has pointed out (1982, 144), Quidor's treatment of human characters is in some respects analogous to that in contemporary writings by Nathaniel Hawthorne, as well as, of course, by Washington Irving.

Nothing is known for certain about the circumstances that inspired Quidor to paint *Embarkation from Communipaw,* or about the work's provenance. Christopher Wilson (1982) intimates that the outbreak of the American Civil War was a factor in the artist's thinking. The idea of a link between Unionist rallies and Quidor's painted imagery is indeed promising at first glance, in view of the artist's demonstrable interest at an earlier period in political matters, as well as the fact that at least two of Quidor's sons fought with the Northern army. But the comical overtone of the picture, and the fact that Quidor's earlier, ambitious *Battle Scene from Knickerbocker's History of New York* (1838; Museum of Fine Arts, Boston) can be

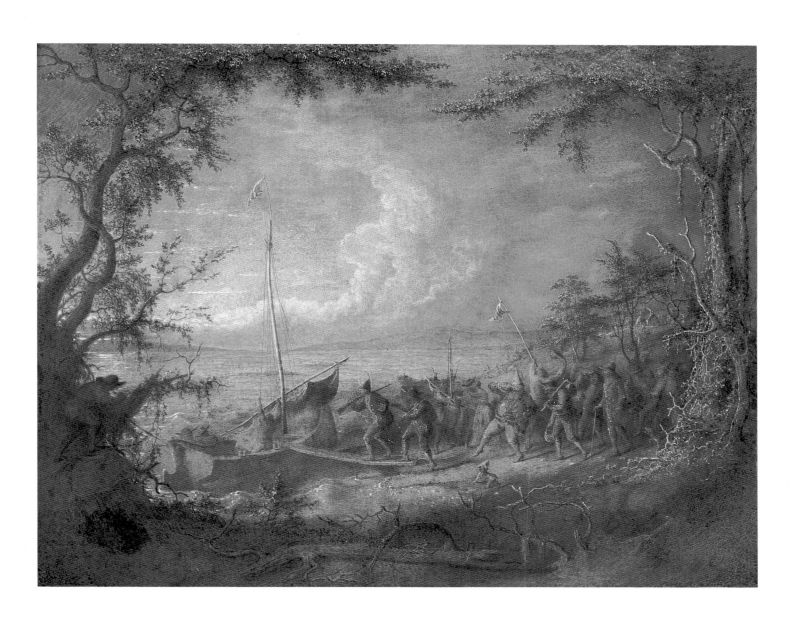

Embarkation from Communipaw

linked only by inference to political events of the 1830s, calls for caution on this point. In the spring of 1861, Quidor displayed in New York a much larger painting of a subject from Irving's work, *Peter Stuyvesant Watching the Festivities on the Battery* (private collection), in which the aspect of a *kermesse* is even more pronounced, but he must have completed that work before the Civil War began in April.

More important, sometime during the 1860s Quidor painted a second episode in the founding of New Amsterdam as recounted by Irving, *Voyage to Hell Gate from Communipaw* (Wichita Art Museum). Baur (in Wichita and Milwaukee 1973, 64), Sokol (1970, 69), and Wilson (1982, 204) have reasonably proposed, first, that the date inscribed on that work (the last two digits are illegible) should read "1861" (although Sokol [in Wichita and Milwaukee 1973, 70] later opted for a date of ca. 1866–67) and, second, that Quidor painted the picture as a companion to the Detroit canvas. Seen in the context of the stormy *Voyage to Hell Gate*, the gathering clouds and choppy sea depicted in the Detroit painting would indeed hint at the expedition's tempestuous times ahead.
G. C.

Inscriptions At lower center, *John Quidor N. York 1861*; on the back, *John Quidor, painter / New York 1861*

Provenance Kennedy Galleries, New York, 1962. Acquired in 1962.

Exhibitions New York 1964, no. 23. Detroit 1964, 14. New York et al. 1965, 50–51, no. 17. Wichita and Milwaukee 1973, 62–63, no. 12.

References Kennedy Quarterly 1960, 13–14. Detroit 1965, 89. Sokol 1970, 71–72. Sokol 1971, 97–100. Rivard 1978, 1046, no. 2. Wilson 1982, 198–204, 294.

In 1728 John Smibert, a forty-year-old artist, took steps to abandon a safe but predictable career as a London portrait painter for life as a college professor in Bermuda. A native of Scotland, he had trained at Sir Godfrey Kneller's Great Queen Street Academy before traveling to Italy and then opening his London studio. Smibert traveled to New England with Dean George Berkeley to await Parliament's appropriation of funds for the college. He commemorated this venture with his influential portrait *The Bermuda Group* (Yale University Art Gallery, New Haven, Conn.). When funds for the college were not forthcoming, Smibert stayed in Boston, where, for almost twenty years, he was the portrait painter of record. There he painted portraits of Boston's leading citizens and in the process created a clear impression of the pomp and pageantry associated with the late baroque world of the early eighteenth century.

Throughout Smibert's career, he kept an account of his activities. That record, which was not discovered and published until 1969, documents over four hundred commissions by the artist in Italy, England, and America between 1719 and 1746. No comparable chronology exists for any other colonial artist. Smibert's *Notebook* (Massachusetts 1969) has assisted in the dating of many of the pictures assigned to him in the only monograph to date on the artist (Foote 1950). It also documents the eventual decline of patronage for his work in the late 1730s and stresses the difficult conditions that confronted the talented artist in America.

In 1734, to supplement his income, Smibert opened a "color shop," where he sold artist's supplies and prints as well as house paint. His studio was above the shop, and in it he exhibited a collection of casts and copies after European works of art that attracted the attention of aspiring artists and casual visitors alike. Even after Smibert's death, the studio, which re-mained nearly intact until the 1770s, was recognized as the one place in America where those who were interested might have some suggestion of the richness of European art.

Contrary to earlier assessments, Smibert's American period can now be seen as the continuation of an already well-established professional career. His style was that of the late baroque painter and placed a premium on a rich, dark palette, absolute decorum, and a methodical modeling of features. Smibert's American portraits, rather than showing a radical departure from those painted in London, indicate a slow but persistent transformation of his technique. Since Smibert felt unthreatened by colonial competition, modest as it was prior to the emergence of Robert Feke (q.v.), he had minimal concern for the brighter, lighter, rococo palette or the increasingly varied compositions of some younger artists. Like native-trained colonial artists, he suffered from a lack of constant exposure to European traditions and knowledgeable criticism. Nevertheless, by the time of its conclusion, Smibert's American career had spawned the most impressive body of colonial portraits prior to John Singleton Copley (q.v.), and his achievement provided inspiration to the subsequent generation of native American artists.

R. S.

Bibliography Foote 1950. Saunders 1979.

78
Mrs. James Pitts, 1735

Oil on canvas
92.7 × 71.4 cm (36½ × 28⅛ in.)
Founders Society Purchase, Gibbs-Williams Fund (58.352)

Smibert had been in Boston about six years when he was commissioned to paint two members of the Pitts family. This portrait, which is one of approximately one hundred American portraits by Smibert that survive, has been identified in this century as Mrs. John Pitts. But the sitter, as noted prior to 1900 by Goodwin, was actually Mrs. James Pitts; in his *Notebook* (Massachusetts 1969, 93) Smibert identified her as "young Mrs. Pitts" to distinguish her from her mother-in-law, Mrs. John Pitts, of whom he also did a portrait (see cat. no. 79). The young Mrs. Pitts was Elizabeth Bowdoin (1716–1771), the daughter of James Bowdoin (see cat. no. 5). At the time of her portrait, she was only nineteen and a bride of less than three years.

Smibert, as is evident here, had some difficulty painting women. In an age when flattery and idealization were essential ingredients in the success of a lady's likeness, Smibert found it difficult to give women the air of gentility they coveted. *Mrs. James Pitts* follows the predictable format of many of his female portraits of the 1730s, the sitter's right hand grasping the folds of the gown. The pose is derived from a mezzotint after a portrait by Sir Godfrey Kneller, the *Countess of Ranelagh*. Although the original is quite graceful, Smibert's modifications make Mrs. Pitts less so. Despite the uneasiness of the pose, he repeated it in his much-repainted portrait *Mrs. William Pepperell* (private collection), done the same year. The repetition suggests that Smibert either considered the awkwardness of the pose acceptable or had not yet managed to resolve this particular difficulty.

Smibert found that many of his Boston patrons, such as the Pittses, favored kit-cat portraits (between a miniature and a full-size likeness, or approximately 91.4 × 71.1 centimeters [36 × 28 inches]), so named after an English club whose members were all painted by Kneller in this format. The kit-cat satisfied the desire of sitters who wished to have portraits larger than a bust-length, but who chose to avoid the expense of the larger knee-length composition.

R. S.

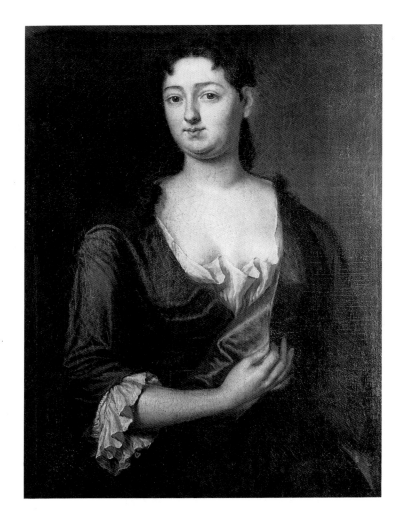

17). Smibert entered a record of a portrait of her in his *Notebook* (Massachusetts 1969, 93) as "Mrs. Pitts HP KK 9 Ginnes." The notation indicates that the portrait was commissioned, that the size was a kit-cat, and that the total fee was nine guineas, his standard price for a portrait of this size. A previous identification as Mrs. James Lindall (1660–1733; Foote 1950, 166–167), the mother of Mrs. John Pitts, seems unlikely, as Smibert made no *Notebook* entry for a portrait of Mrs. Lindall.

While the fifty-four-year-old sitter was far from beautiful, Smibert's portrait of her is much more memorable than that of her daughter-in-law, Mrs. James Pitts (see cat. no. 78). This stern, masculine-looking woman with piercing eyes was painted with a force seldom found in Smibert's female portraits. The artist did not mask her lack of ease or her ill-fitting gown. His handling of paint is firm and confident; the details are clear and precise. With her gray-flecked hair, sagging cheeks, double chin, and ruddy complexion, Mrs. Pitts was painted as she undoubtedly looked rather than in an idealized manner. It is in portraits such as this that Smibert presented a much less refined, but probably much more precise, image of the inhabitants of Boston.

R. S.

Provenance S. Lendall Pitts, Paris; Mrs. S. Lendall Pitts, Norfolk, Virginia, by 1949. On loan to Mrs. Arthur Maxwell Parker, Grosse Pointe Farms, Michigan. Acquired in 1958.

Exhibitions Detroit 1930, no. 80. Detroit 1957, no. 15. Detroit 1959, 16–17.

References Goodwin 1886, 7, 14. Foote 1950, 160, 166–167, 184. Payne 1960, 87–89. Massachusetts Historical Society 1969, 93. Saunders 1979, 184–185.

Provenance The sitter's great-great-grandson, Thomas Pitts, 1883; his son, S. Lendall Pitts, Paris; Mrs. S. Lendall Pitts, Norfolk, Virginia, by 1949. On loan to Mrs. Arthur Maxwell Parker, Grosse Pointe Farms, Michigan. Acquired in 1958.

Exhibitions Detroit 1883, no. 650. Detroit 1959, 16–17.

References Goodwin 1886, 14–15. Foote 1950, 160, 184 (as *Mrs. John Pitts*). Payne 1960, 87, 89. Massachusetts Historical Society 1969, 93. Saunders 1979, 184–185.

79
Mrs. John Pitts, 1735

Oil on canvas
91.8 × 73 cm (36⅛ × 28¾ in.)
Founders Society Purchase, Gibbs-Williams Fund (58.353)

Mrs. John Pitts [Elizabeth Lindall] was born to James and Susannah Lindall on July 16, 1680; married on September 10, 1697; and died in 1763 (Detroit 1959,

Mrs. James Pitts

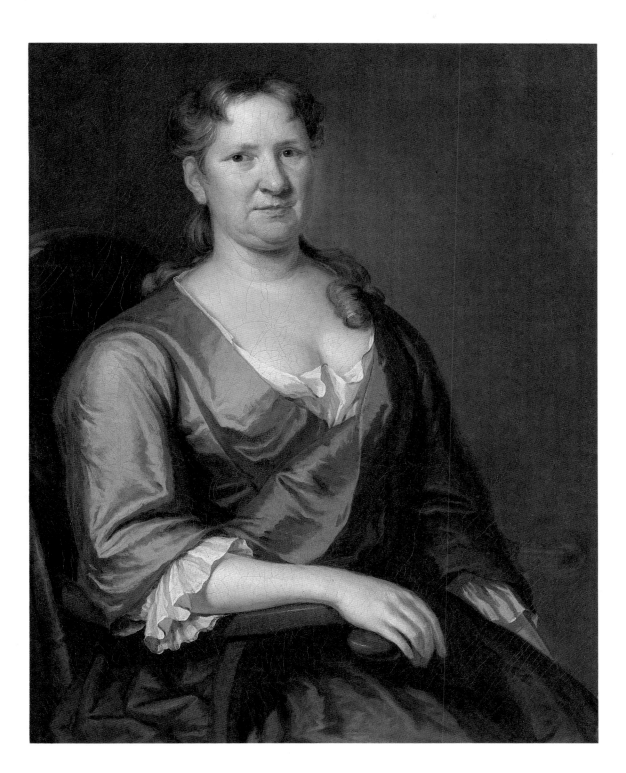

Mrs. John Pitts

John Mix Stanley, like his contemporaries George Catlin and Paul Kane, is best known today for vivid documentations of American Indian life in the West, before it was swept away by advancing settlement. Stanley spent his youth in upstate New York and, at the age of fourteen, was apprenticed to a coach maker. In 1834 he moved to Detroit, where he made his living in house- and sign-painting. It was in Detroit that he received his first training in the fine arts under James Bowman (q.v.), with whom he began a partnership painting portraits. Stanley and Bowman moved to Chicago in 1838 and then traveled to Galena, Illinois; Green Bay, Wisconsin; and Fort Snelling, Minnesota. It was in Fort Snelling that Stanley first began to paint Indian subjects—a genre that was to preoccupy him for the remainder of his life. He returned to the East briefly (1840–42), painting portraits in Troy, New York; New York City; Philadelphia; Baltimore; and Washington, D.C.

There is little doubt that Stanley's desire to paint the Indians of the West was influenced by the precedent of Catlin, who had achieved fame in the late 1830s with his Indian Gallery. Beginning in the summer of 1842 Stanley and a partner, Sumner Dickerman, traveled to Fort Gibson, Arkansas; New Mexico; and Oklahoma. On January 19, 1846, Stanley and Dickerman opened their North American Indian Gallery in Cincinnati. Later the same year Stanley journeyed again to New Mexico along the Santa Fe Trail. From there he accompanied Major Stephen W. Kearney on a military expedition to San Diego as a topographical draftsman with the corps of engineers.

During the spring of 1847 Stanley traveled overland to San Francisco, Oregon, and the area that is now the state of Washington, where he collected Indian artifacts among the tribes around Fort Walla Walla. In the summer of 1848 he left San Francisco and traveled to Hawaii to paint portraits of the Hawaiian royal family. By 1850 he had returned to New York, where he completed paintings from the sketches made in the West. These were added to his Indian collection, which was enthusiastically received in New York City and later sent on tour to Troy and Albany, New York; New Haven and Hartford, Connecticut; and Washington, D.C.

In 1852 Stanley settled in the capital, placing his Indian Gallery, which included over one hundred fifty items, on deposit at the Smithsonian Institution. The following year, from July to December, he returned to the West as an official artist on a government expedition led by General Isaac I. Stevens to explore a railroad route from St. Paul, Minnesota, to Puget Sound. During that trip he made many sketches and used a daguerreotype camera to photograph the Indians and the landscape.

From 1854 to 1862 Stanley again lived in Washington, D.C. Much of his time was consumed by a huge panorama of the West based on the sketches and photographs he had made on the Stevens expedition. The panorama, comprising forty-two separate scenes, took two hours to view and was shown in Washington and Baltimore. Like Catlin, Stanley tried in vain to persuade the government to purchase his Indian Gallery. Tragically, all but five of the paintings from it were destroyed in 1865 by a fire at the Smithsonian; a later fire destroyed another group of paintings deposited at P. T. Barnum's American Museum.

In 1863 Stanley moved to Buffalo, New York, where he remained for a year and completed another large panorama, this time of the Civil War. He exhibited the work successfully in 1864 in Detroit, to which city he moved and where he remained for the rest of his life. One of his last major works was *The Trial of Red Jacket* (1868; Buffalo and Erie County Historical Society, Buffalo, N.Y.).
J. G. S.

Bibliography Muskegon and Detroit 1987, 39–54.

80

Tin-Tin Malikin (Strong Breast), ca. 1847

Oil on board
27 × 19.7 cm (10⅝ × 7¾ in.)
Gift of Dexter M. Ferry, Jr. (38.103)

Tin-Tin Malikin, or "Strong Breast," the subject of this field sketch by Stanley, was a Spokane Indian. A life-size portrait with the same title is listed as number 144 in Stanley's *Portraits of North American Indians* (Stanley 1852). Unfortunately, the larger version was destroyed in the fire at the Smithsonian Institution in 1865.
J. G. S.

Inscriptions At lower left, *J. M. Stanley.*; at lower center, *Tin-Tin Malikin, or strong Breast / Leggins* [illegible] *deer skin*

Provenance Dexter M. Ferry, Detroit; Dexter M. Ferry, Jr., Detroit, 1938. Acquired in 1938.

Exhibitions Washington 1944, no. 11. Omaha 1954. Cedar Rapids 1956. New York 1961–62. Ann Arbor 1969, 3, no. 5.

References Detroit 1909, no. 46. Pipes 1932, 25–27. Kinietz 1942, 32, pl. 5. Detroit 1944a, no. 749.

81

Western Landscape, ca. late 1840s

Oil on canvas, mounted on Masonite
47 × 76.2 cm (18½ × 30 in.)
Gift of Dexter M. Ferry, Jr. (15.14)

Representative of Stanley's early landscapes, a mood of stillness, an unbroken horizontal axis, and the presence of clarifying light create in this painting an image of inviting, unspoiled wilderness. The artist's sharp-focused vision and his treatment of the reflecting surface of the water link Detroit's *Western Landscape* to the work of luminist painters such as John F. Kensett and Fitz Hugh Lane, who were

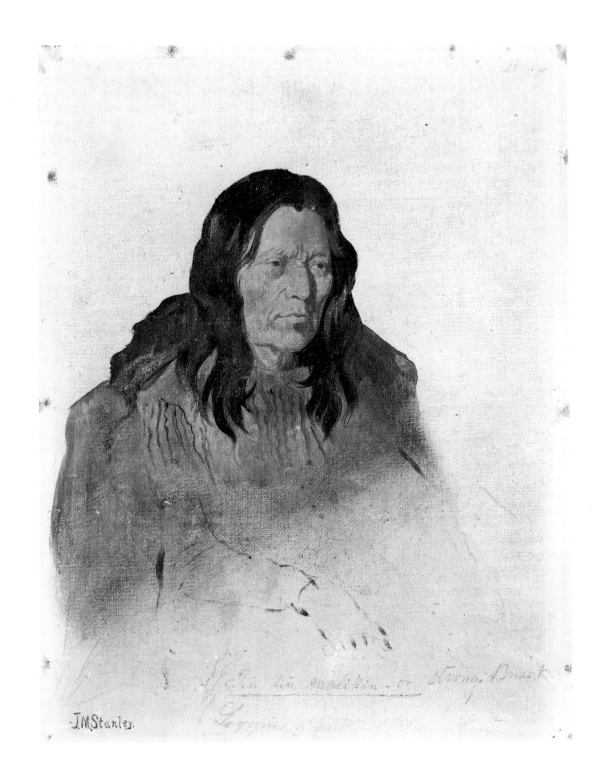

J.M.Stanley.

Tin-Tin Malikin (Strong Breast)

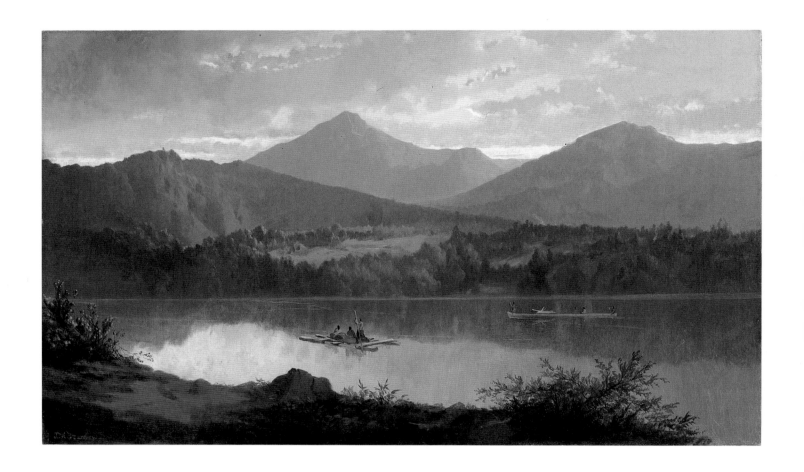

greatly influenced by the daguerreotype photographic process (see Kilgo 1982.). It is known that Stanley used the daguerreotype camera in some of his western travels during the 1840s. Because of the long exposure required by the early photographic process, water in a daguerreotype view shows no movement but is smoothed into a transparent, reflective surface much like that seen in Stanley's painting.

The presence of an elongated wooden canoe, or dugout, a long raft, and a mountainous landscape in the distance have been taken to indicate that the work depicts the Pacific Northwest, although there is no documentation to support such a speculation. It appears more likely that the work represents Stanley's conception of the ideal western landscape—a mountain-locked lake forbidding access to a pristine, virgin wilderness.
J. G. S.

Inscriptions At lower left, *J. M. Stanley*

Provenance Dexter M. Ferry, Jr., Detroit. Acquired in 1915.

Exhibitions Chicago and New York 1945, 76–77, 122. Saint Louis and Minneapolis 1954, 50, cat. no. 19. Denver 1955, 31, no. 91. Philadelphia 1958, no. 65. Denver 1959. Indianapolis 1961, no. 34. Norfolk 1961, no. 30. Geneseo 1968, 178. Bloomington 1970, no. 71. Seattle 1976, 71, no. 83. Muskegon and Detroit 1987, no. 5.

References Detroit 1920, no. 246. Detroit 1944a, no. 747. Larkin 1949, 209. Kenny 1965, 19. A. Gibson 1975, 220. Sweeney 1975, 117, fig. 17. Kilgo 1982, 179, fig. 57.

82
Indian Telegraph, 1860

Oil on canvas
50.8 × 39.4 cm (20 × 15½ in.)
Detroit Museum of Art Purchase, Popular Subscription Fund (01.2)

Indian Telegraph is one of five paintings that Stanley considered significant enough to have engraved by the celebrated house of Storch and Kramer in Berlin in 1869. The event depicted is said to be based on actual incidents that occurred in 1846 during the march of Major Stephen W. Kearney through the territory of the Apache Indians, an effort in which Stanley was a participant. The events of Kearney's march to the Pacific left an indelible impression on Stanley, and in 1860, some fourteen years later, the artist committed the events he had experienced to canvas. On the back of the painting is an inscription, written by Stanley, describing the scene depicted.

Although the work is apparently based on actual experience, the figure of the Indian waving the smoking faggot suggests a classical prototype, while the golden light of the setting sun accentuates the romantic character of the image. It is understandable why Stanley selected *Indian Telegraph* for reproduction in 1869: its idealized image of the noble savages of the Far West would have assured its success with European and American audiences, both of whom were keenly aware of the recent completion of the transcontinental railroad. It seems fair to speculate that the artist hoped to capitalize on the nostalgic awareness that such scenes of Indian life were rapidly disappearing.
J. G. S.

Inscriptions At lower left, *J. M. Stanley / 1860*; on back of canvas beneath lining, *The scene is laid amidst the rugged ground of the Gila river country and represents a party of Apaches advising their friends of the advance of General Kearney's expedition. In the foreground stands a high rock, illuminated by the rays of the declining sun. A party of Apaches are approaching while two have already scaled the rocks and one of them is waving a smoking faggot on high and the other is shading his eyes from the sun's rays with his hand. In the distance, across the valley to the left, a faint streak of smoke rises from behind a hill, which appears to be the answer to the signal. A mountain range dimly looming up on the horizon completes the picture.*

Provenance The artist's student, Mrs. M. Noble Brainard, 1868–1901. Acquired in 1901.

Exhibitions Chicago 1893. Washington 1944. Brooklyn 1949, no. 80. Saginaw 1952. St. Louis and Minneapolis 1954, no. 80. Kansas City 1957, no. 64. Philadelphia 1958, no. 67. Denver 1959. New York 1961–62. Denver 1966. Kalamazoo 1967. Ann Arbor 1969, 22, no. 7. Muskegon and Detroit 1987, no. 3.

References Farmer 1889, 358. Detroit 1920, no. 245. Draper 1942, 182. Kinietz 1942, 27, 33, pl. 13. Detroit 1944a, 746. Larkin 1949, 209. Kenny 1965, 18.

83
Indians Playing Cards, 1866

Oil on canvas
41.3 × 66 cm (16¼ × 26 in.)
Gift of Mr. and Mrs. Frederick K. Stearns (43.60)

The image of Indians gathered near a watering hole is one that Stanley employed often, and this work is his most elaborate depiction of the theme. In the right foreground a group of Indians play a friendly game of cards while awaiting their approaching companions. Their red blankets and picturesque accoutrements create

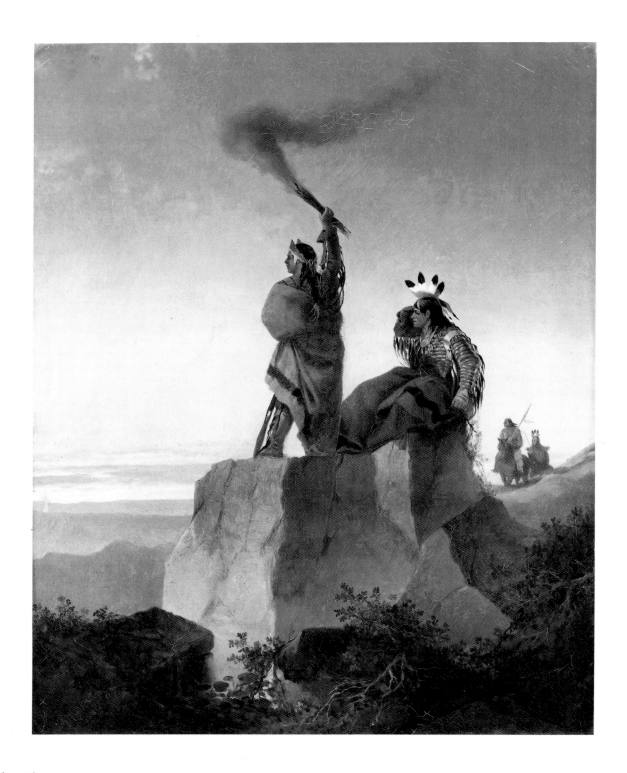

Indian Telegraph

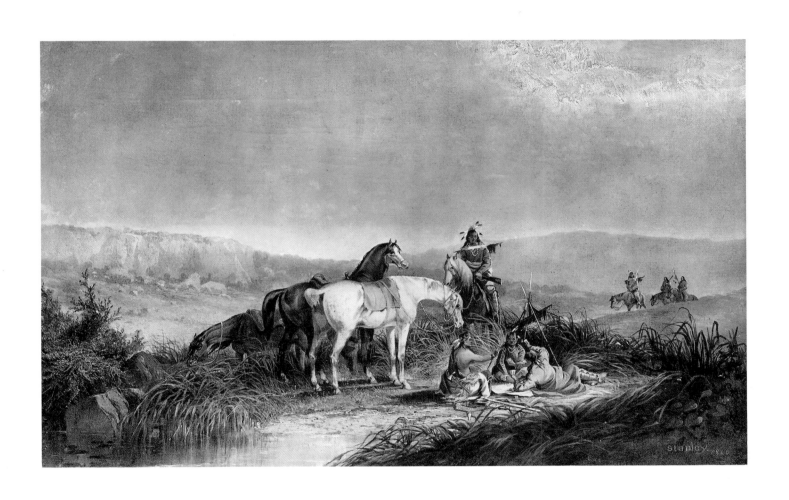

Indians Playing Cards

an interesting genre passage in the expansive western landscape. Characteristically, Stanley enlarged the eyes of the horses, so that with their anthropomorphically expressive faces they function as a mute audience for the card game. Surrounding the water hole is low, grassy vegetation that suggests a locale at the extreme western edge of the prairie. Like most of Stanley's works completed in the 1860s, the scene probably derives from field sketches or recollections of similar events that the artist witnessed during his travels in the West in the 1840s and early 1850s. The appeal of this idealized, nostalgic image of the Indians' fast-disappearing way of life is apparent in the fact that Stanley produced numerous variants on the subject, including four smaller oval paintings in the Detroit Institute's collection (see cat. nos. 88–91).

J. G. S.

Inscriptions At lower right, *Stanley 1866*

Provenance Mr. and Mrs. Frederick K. Stearns, Detroit. Acquired in 1943.

Exhibitions Detroit 1883, no. 680. Detroit 1944, no. 91. Washington 1944. Detroit 1949, 2. Saginaw 1952. Omaha 1954, 6. Cedar Rapids 1956. Philadelphia 1958, no. 66 (date given as ca. 1848). Denver 1966. Ann Arbor 1969, no. 6.

References Detroit 1944a, no. 756.

84
Samuel Mountfort Pitts, 1869

Oil on canvas
122.2 × 91.4 cm (48⅛ × 36 in.)
Founders Society Purchase, Gibbs-Williams Fund (58.364)

Stanley's portrait of Samuel Mountfort Pitts—a representative example of his mature style—shows Pitts as the epitome of financial success and social prominence (for a portrait of Pitts in his twenties see cat. no. A10). The degree of realism and detail present in the handling of the head

provides a clue that the work may have been painted from a daguerreotype, a practice for which Stanley was noted and which he first employed as early as 1853. The hypothesis is further borne out by the posthumous date of the work (the subject died on April 28, 1868).

Samuel Mountfort Pitts was born April 17, 1810, at Fort Preble, Portland Harbor, Maine, the first son of Thomas and Elizabeth Mountfort Pitts, of a distinguished New England family. After studying law at Harvard University (a graduate of the class of 1830), he moved to Detroit and entered the law office of General Charles Larned, succeeding to his practice upon Larned's death. A hardworking pioneer entrepreneur, Pitts branched out into salt manufacturing and lumbering; he astutely acquired vast areas of pine forest and made a substantial fortune. In 1836 he married Sarah Merrill, by whom he had five children.

J. G. S.

Inscriptions At lower right, *Stanley / 1869*

Provenance Descended in the Pitts family; Mrs. Lendall Pitts, Detroit, 1958. Acquired in 1958.

Exhibitions Detroit 1959, 39.

85
Chinook Burial Grounds, ca. 1870

Oil on canvas
23.2 × 35.9 cm (9⅛ × 14⅛ in.)
Gift of Mrs. Blanche Ferry Hooker (41.64)

After two disastrous fires in 1865, first in January at the Smithsonian Institution, and later in July at P. T. Barnum's American Museum in New York City, which destroyed much of his work from the preceding two decades, Stanley conceived an ambitious scheme to render his works anew in a different medium. He planned an album of from fifty to one hundred chromolithographic reproduc-

tions of paintings representing various phases of Indian life and customs. In preparation for this large undertaking, and in order to secure financial backing, Stanley drafted several lengthy descriptions of three of the works proposed for inclusion in the album.

Detroit's *Chinook Burial Grounds* was one of the works described in the letterpress prospectus that Stanley submitted to various publishers in hopes of raising the funds necessary to carry out this major work. A description of Chinook burial customs, as well as an account of the rendering, is evidence of his close attention to ethnographic detail in the manner of George Catlin:

Another curious custom peculiar to the Chinook was their mode of burial, which consisted in the exposure instead of the interment of their dead. When one of the tribe died he was wrapped in his mantle of skins, laid in his canoe, with his paddle, fishing spear, apparel and other property, beside him, so that he might be supplied with everything he needed on reaching those placid streams and sunny lakes well stored with fish, which await the brave in the happy hunting-ground. Having been thus equipped and prepared for the journey to spirit land, the canoe was filled with rush mats and boughs, and lifted on four posts, or poles, where the corpse was supposed to be beyond the reach of wild animals and dogs. In the vacant space beneath were sacrificed the animals, horses, cattle, and even the favorite dogs of the deceased; and there the bones remained to bleach on the ground.... In the accompanying sketch, the artist has represented one of these Chinook burial-grounds on the banks of the Columbia. In the foreground ... a dead tree, fit emblem of decay and ruin, whose leafless arms rise to the sky. Above the massive trunk, just where the limbs shoot out, is a scaffold, on which rests an Indian corpse. The deceased, it is evident, must have been poor and of no note, for he has no canoe, and his remains are only covered with rushes and boughs.... The mourner, an Indian woman, who stands on the scaffold with a basket in her hand, has brought him the food which is still thought necessary for his support beyond the grave. On the left hand, a little further back, are seen four canoes. The one nearest to the spectator rests on the ground, the props having perhaps rotted away, and it now lies half

190

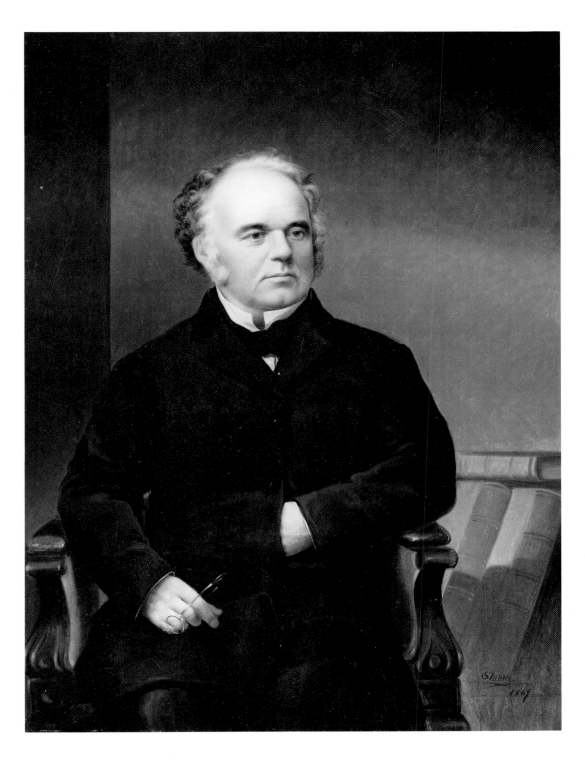

Samuel Mountfort Pitts

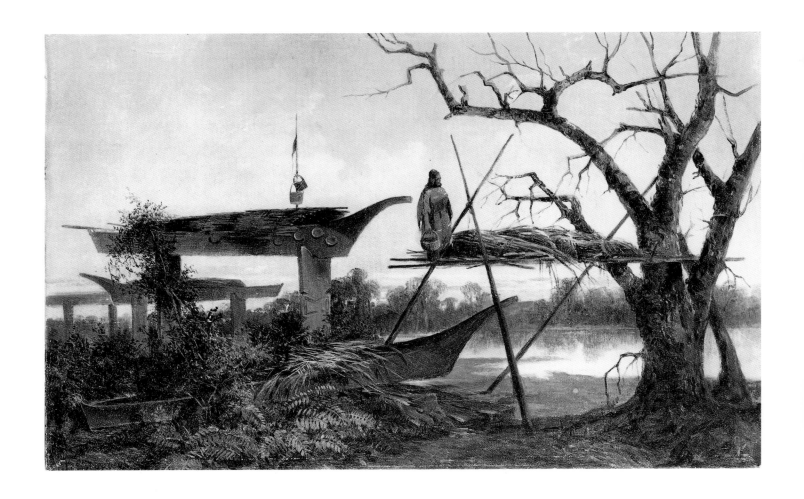

Chinook Burial Grounds

hidden amidst a luxuriant undergrowth of vines, flowering shrubs, and tangled weed, which have entwined themselves partly over and partly round its sides. . . . The composition is highly poetical and suggestive. The canoes with the corpses, the blazing sky, the naked branches, the setting sun, all speak in mute eloquence of the doom which has overtaken not only the tribe itself but its sepulchres, for both have now equally passed away. The Chinooks are extinct, and even their dead, whom they hoped to save from destruction, by placing them beyond the reach of wild animals, have not been able to escape the still more destructive propensities of the race that has supplanted the tribe in the land of its fathers (quoted in Kinietz 1942, 22–24).

Stanley was unsuccessful in interesting any publisher in his venture. The letterpress prospectus is now in the collection of the Museum of the American Indian, Heye Foundation, New York.

J. G. S.

Inscriptions At lower left, *J. M. Stanley*

Provenance Blanche Ferry Hooker, Detroit, 1941. Acquired in 1941.

Exhibitions Detroit 1883, no. 698. Washington 1944. Brooklyn 1949. St. Louis and Minneapolis 1954, 112, no. 79. Ann Arbor 1969, 3, 24, no. 8. Olympia 1971.

References Pipes 1932, 256. *DFP* 1941. Kinietz 1942, 21–24, 34, pl. 2. Detroit 1944a, no. 751. Green 1966, 276, pl. 4-65.

86

Prairie Indian Encampment, ca. 1870

Oil on canvas
23.2 × 35.9 cm (9⅛ × 14⅛ in.)
Gift of Mrs. Blanche Ferry Hooker (41.63)

Prairie Indian Encampment is one of the works intended for inclusion in Stanley's proposed portfolio of chromolithographic reproductions of Indian life and customs.

The work is related in subject to another composition, *Assiniboin Encampment on the Upper Missouri* (cat. no. 88); it is identical in size to *Chinook Burial Grounds* (cat. no. 85). Stanley's lengthy description provides a close reading of the scene depicted:

In this sketch the artist has given us the section of an encampment of Prairie Indians, a name bestowed indiscriminately on the Crows, Assiniboins, Blackfeet, Sioux, and other nomads, who possess no fixed habitations, but who follow the immense herds of Buffalo which roam over the plains from north to south, and east to west, and depend for subsistence entirely on the spoils of the chase. The scene here depicted is laid in a treeless prairie, for these tribes never like to take up their transient abode in the neighborhood of timber, where they are always in more or less danger of being surprised by some of their numerous enemies. . . . In front of the spectator is a cluster of wigwams, or lodges, some of which are inhabited by braves, because in addition to the strips of red flannel that flutter from the lodge poles, we notice a number of scalp-locks and other trophies of savage warfare.

The lodge which occupies the most conspicuous and central position in the picture evidently belongs to the chief. . . . On both sides of the chief's lodge and nearly on a line with it, are two groups of figures. The one on the left hand is composed of five braves, who sit on the ground in various attitudes, while a squaw, with a papoose strapped on behind, stands in the rear of them. . . . The second group, to the right of the lodge, represents two Indian girls in a recumbent attitude, and a third extended at full length on the grass. . . . We are also afforded a glimpse into the domestic economy of the tribe. Two Indian women are engaged in drying large pieces of buffalo meat, which hang in two parallel rows from a large scaffolding. . . . Two horses are picketed in front of a lodge. It is the custom of the Prairie tribes to corral their horses inside of the encampment, and to mount guard over them by day and by night (quoted in Kinietz 1942, 24–25).

J. G. S.

Inscriptions At lower left, *J. M. Stanley*

Provenance Dexter M. Ferry, Detroit; Mrs. Blanche Ferry Hooker, Detroit, 1941. Acquired in 1941.

Exhibitions Detroit 1883, no. 692a. Washington 1944. Brooklyn 1949, no. 78. St. Louis and Minneapolis 1954, no. 78. Cedar Rapids 1956. Denver 1959. Ann Arbor 1969, no. 9. Johnson City 1970, no. 29. Los Angeles et al. 1972, no. 4, 23, 187.

References Detroit 1909, no. 47 (as *Indian Encampment*). Pipes 1932, 25–27. Kinietz 1942, 21, 24–26, pl. 1. Detroit 1944a, no. 750. Omaha 1954, 6. *Antiques* 1965, 305.

87

Mountain Landscape with Indians, early 1870s

Oil on canvas
45.7 × 76.8 cm (18 × 30¼ in.)
Gift of the Wayne County Medical Society (59.312)

This landscape is a smaller version of a work in the collection of the University of Michigan Museum of Art known as *Mount Hood*, which measures 144.8 × 99.1 centimeters (57 × 39 inches). Except for a few minor details in the handling of the rock formations, the shape of the mountain, and the placement of the figures, the two works are virtually identical. Considering that the larger version is signed and dated 1871, there is reason to believe that the present work is a preliminary sketch and probably dates from about the same period. Given Stanley's interest in photography, it is possible that the work was derived from a daguerreotype taken by Stanley during one of his explorations of Oregon in 1847 or 1853. No photographs by Stanley of the subject are known to exist, however.

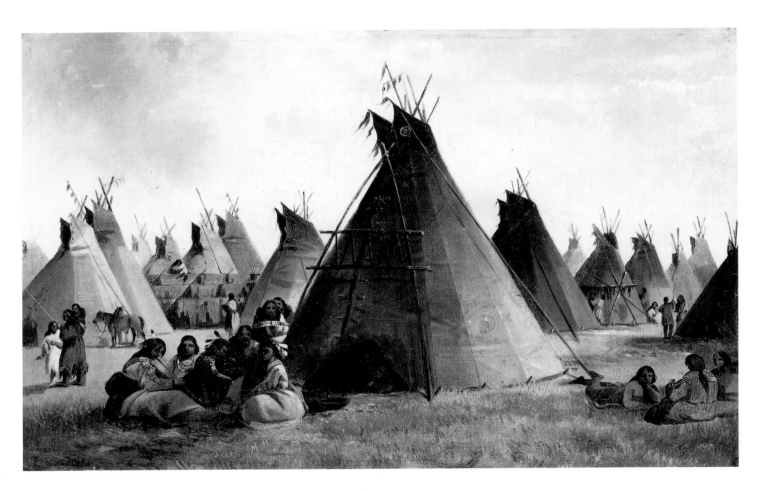

The hypothesis of daguerreotype photography as a potential influence on Stanley is argued in a recent study by Delores A. Kilgo (1982), who observes of the present work:

From the foreground to the distant cliffs . . . the painter has rendered "part by part" to preserve the visual autonomy of every object. . . . He gives the most minute attention to the gradation of tones, yet still presents a sharply delineated work frozen in time and space by the precision of technique. Stanley's strangely stilled and delicate scenes are further removed from the real world, as are all luminist paintings, by tints of lyrical color which do not describe but rather serve to amplify the private, poetic experience.

Despite similarities in composition, handling, and luminist sentiment, *Mountain Landscape with Indians* is a more complex and detailed work than the earlier *Western Landscape* (cat. no. 81), and provides a gauge of Stanley's artistic development over two decades from the late 1840s to the early 1870s. In *Mountain Landscape with Indians* a dark foreground genre passage consisting of several Indians seated in front of a wigwam leads the eye toward an Indian village situated on a peninsula of land jutting out into a lake. Instead of the placid, tree-filled plateau in the earlier work, the middle ground here is filled with ranks of fantastically eroded rock

formations. At the right, a group of wooden dugout canoes provides visual balance for the composition. The rocks and mountains in the background are clearly reflected on the mirror-smooth surface of the water. Through a valley in the center, cascading down to the lake, is a river on either side of which are flanking mountains much like those in *Western Landscape*. Interestingly, in the larger final version, *Mount Hood*, these rugged mountains appear less steep and wild, and the conical form of Mount Hood is less craggy and foreboding than in the sketch. In addition, there are introduced accessory

Prairie Indian Encampment

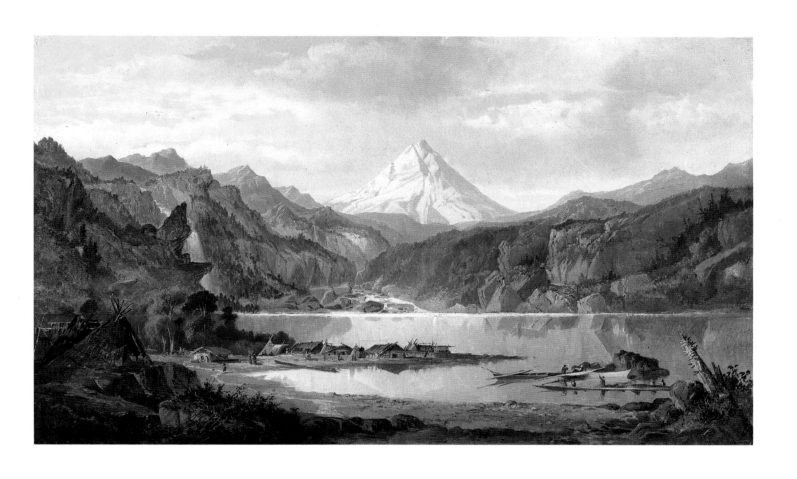

Mountain Landscape with Indians

elements (such as a grouping of three trees) that are absent in the sketch, and the vegetation in the foreground is considerably more elaborate.

J. G. S.

Provenance David Whitney, Detroit. Wayne County Medical Society, Detroit. Acquired in 1959.

Exhibitions Bloomfield Hills 1964. Ann Arbor 1969, 18, no. 1. Los Angeles et al. 1972, 187, no. 40, pl. 53. San Francisco 1972.

References Kilgo 1982, 180, fig. 58.

88
Assiniboin Encampment on the Upper Missouri

Oil on canvas
20 × 27.6 cm (7⅞ × 10⅞ in.)
Gift of Mrs. William Fitzhugh Edwards (01.6)

Inscriptions At lower left, *J. M. Stanley*

Provenance Mrs. William Fitzhugh Edwards, 1901. Acquired in 1901.

Exhibitions Washington 1944, no. 7. St. Louis and Minneapolis 1954, no. 81, 114. Kansas City 1957, no. 63. New York 1959–60. Santa Fe 1961. St. Petersburg 1968. Ann Arbor 1969, 24, no. 10. Johnson City 1970, no. 30. Los Angeles et al. 1972, 3, no. 44. New York 1973, 7, no. 66. Seattle 1976, 45, no. 10.

References DFP 1865. Kinietz 1942, 26, 34, pl. 10. Detroit 1944a, no. 754.

89
The Challenge

Oil on canvas
20 × 25.1 cm (7⅞ × 9⅞ in.)
Gift of Mrs. Blanche Ferry Hooker (41.65)

Inscriptions At lower left, *J. M. Stanley*

Provenance Mrs. Blanche Ferry Hooker, Detroit, 1941. Acquired in 1941.

Exhibitions Washington 1944, no. 3. Ann Arbor 1969, 26, no. 13.

References DFP 1865. Detroit 1909, no. 43. Kinietz 1942, 34, pl. 9. Detroit 1944a, no. 752.

90
A Halt on the Prairie for a Smoke

Oil on canvas
22.5 × 28.6 cm (8⅞ × 11¼ in.)
Gift of Mrs. William Fitzhugh Edwards (01.7)

Inscriptions At lower left, *J. M. Stanley*

Provenance Mrs. William Fitzhugh Edwards, 1901. Acquired in 1901.

Exhibitions Washington 1944, no. 5. Minneapolis 1949. New York 1961–62. Ann Arbor 1969, no. 12. Los Angeles et al. 1972, no. 58. New York 1973, 7, no. 68.

References DFP 1865. Kinietz 1942, 26, 34, pl. 6. Detroit 1944a, no. 755. Katonah 1981.

91
A Morning in the Milk River Valley

Oil on canvas
20 × 25.4 cm (7⅞ × 10 in.)
Gift of Mrs. Blanche Ferry Hooker (41.66)

Inscriptions At lower left, *J. M. Stanley*

Provenance Mrs. Blanche Ferry Hooker, Detroit, 1941. Acquired in 1941.

Exhibitions Washington 1944. Minneapolis 1949. New York 1961–62. Ann Arbor 1969, 26, no. 11.

References DFP 1865. Kinietz 1942, 34, pl. 11. Detroit 1944a, no. 753. A. Gibson 1975, 220.

These four similarly sized oval paintings may have been intended as vignettes for Stanley's proposed portfolio of chromolithographs (see cat. no. 85 above). However, their small size and the fact that they are sketchily done could also indicate that they were preparatory sketches for larger works. The four paintings share a common theme: a gathering of American Indians at a watering place.

Assiniboin Encampment on the Upper Missouri bears a resemblance, in the placement of the Indian lodges and the group of figures in front of them, to the larger work *Prairie Indian Encampment* (cat. no. 86). However, the presence of trees, shrubbery, and water in the foreground indicates a different locale.

In *The Challenge* two groups of Indians, perhaps rivals, meet at a watering hole on the prairie. Members of each group wear feathered war bonnets, but the scene betrays no sense of any imminent exchange of hostilities. The impression given is of two equally matched groups raising their weapons in mutual salute.

A Halt on the Prairie for a Smoke presents a colorful, yet quiet view of a sunset on the prairie. The small drawing of two horses in the lower right corner supports the premise that these works are sketches in which the artist experimented with compositions and subjects for larger works.

In *A Morning in the Milk River Valley*, yet another idyllic image of Indian life, one of the figures has dismounted and appears to be surveying the distant trees, while his companion remains on horseback.

J. G. S.

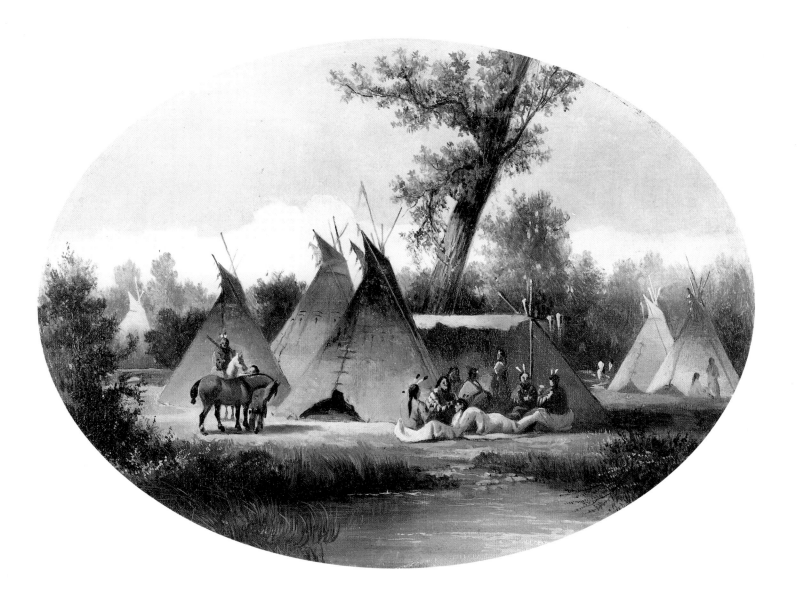

Assiniboin Encampment on the Upper Missouri

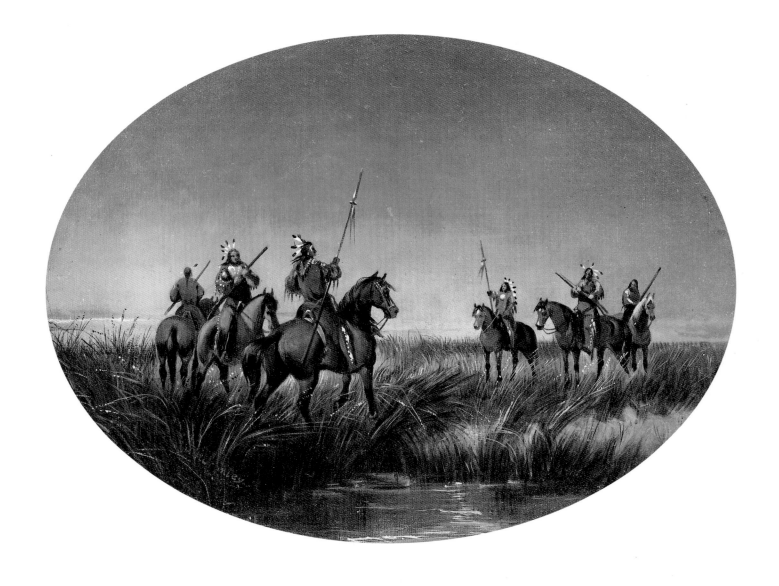

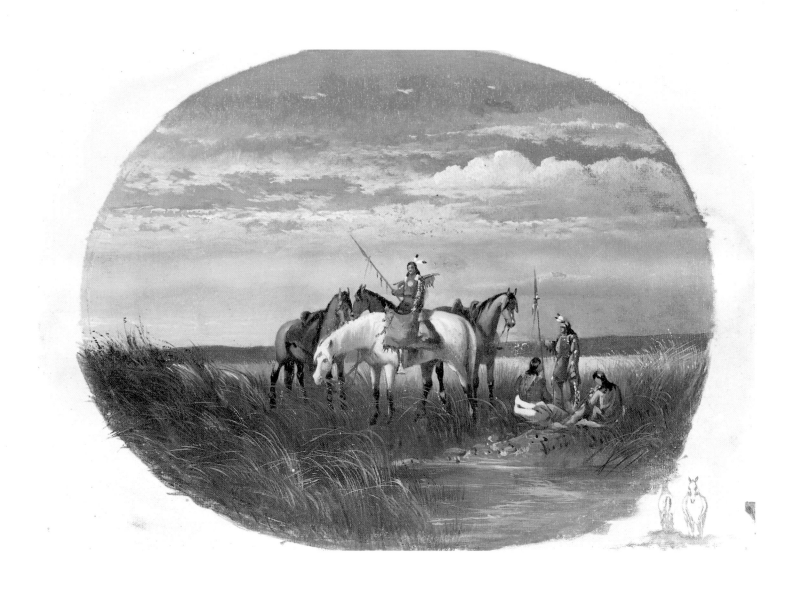

A Halt on the Prairie for a Smoke

A Morning in the Milk River Valley

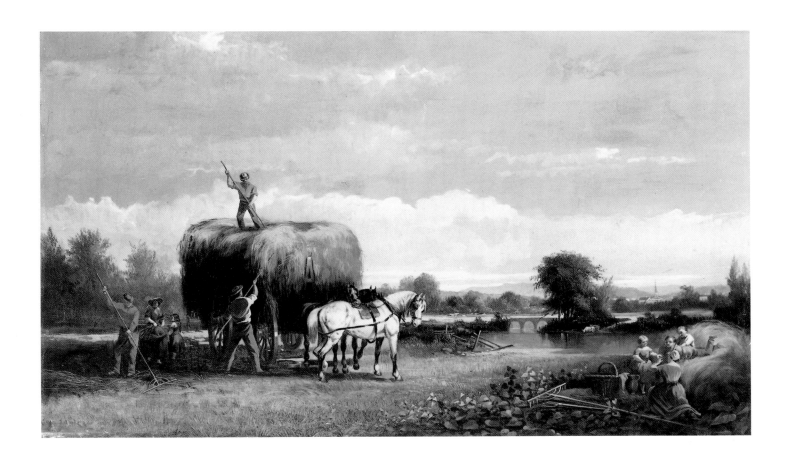

92

Attributed to John Mix Stanley

Haying (The Last Load of Hay),
1865

Oil on canvas
47 × 77.5 cm (18½ × 30½ in.)
Gift of Mrs. Wilfred C. Leland (66.25)

While certain aspects of this painting, for example, the expressive handling of the horses' faces, are typical of Stanley's work, the distinctly European flavor of the scene, the somewhat awkward handling of the figures at right, and the signature have raised questions about this work as autograph. Stanley's signature is characteristically bold and definite, and it cannot be ruled out that he may have painted such a pastoral scene. The provenance of this picture would argue that this may, indeed, be a work by this artist even though it is atypical of his usual subjects.
J. G. S.

Inscriptions At lower left, *[S]tanley 1865*

Provenance The artist's granddaughter, Alice Stanley Acheson [Mrs. Dean Acheson]. Mr. and Mrs. Wilfred C. Leland. Acquired in 1966.

Exhibitions Detroit 1883, no. 684.

References Kinietz 1942, 9.

Haying (The Last Load of Hay)

Joseph Whiting Stock was a prolific painter of anatomical illustrations, portraits, miniatures, landscapes, and genre scenes. At the age of eleven, he was maimed when a heavy oxcart accidentally fell on him. The injury left Stock paralyzed from the waist down, and he was confined to the house—often to his bed—for the eight years that followed. In the fall of 1832, at the suggestion of his doctor, he began to take painting lessons from Franklin White, himself a pupil of the painter Chester Harding (q.v.). Two years later, another doctor, James Swan, became interested in Stock's case and in his work. Dr. Swan constructed a wheelchair that allowed the young artist to sit up for long periods of time and permitted him to move in a limited fashion.

In the spring of 1836, Stock began his career as an itinerant artist, traveling to the nearby towns of North Wilbraham and what is now Chicopee, Massachusetts, and the following spring to Stafford, Connecticut. During this period he began to copy portraits of famous figures, landscapes, and genre scenes from prints.

On New Year's Day in 1839, Stock suffered severe burns from a fire that began as he was preparing varnish. This accident, and an infection in his hip from the earlier injury, kept him at home for six months, but by September he had resumed traveling. His itineracy in the Springfield area continued until the middle of 1842, when he journeyed to coastal New England. He remained there for almost a year and a half, working in Warren and Bristol, Rhode Island, and in New Bedford and East Randolph, Massachusetts.

It was in New Bedford that Stock began a journal (Connecticut Valley Historical Society, Springfield, Mass.), an account of his life and travels, including precise details concerning his patronage. Its seventy-three manuscript pages outline the painting and prices of the more than nine hundred works he completed between 1832 and 1846. In 1845 he began an on-again, off-again partnership with his brother-in-law, Otis H. Cooley (1820–1860), a daguerreotypist, in a succession of studios in the Springfield business district.

Stock moved from Springfield to Orange County, New York, in the spring of 1852, and for the next two and a half years his career may be traced in Goshen, Middletown, and Port Jervis, where he continued to do portraits of local people as well as historical figures. He copied daguerreotypes and advertised gilt frames and painter's supplies along with shellwork boxes and clocks. During his New York sojourn, Stock taught Salmon W. Corwin, a young Goshen resident, to paint. He later went into partnership with Corwin, and together they created and published a hand-colored print of Port Jervis. The inventory of Stock's estate indicates that he did some work for Fowler & Wells, publishers of books, including the first edition of Walt Whitman's *Leaves of Grass*, pamphlets, and a periodical on the pseudoscience of phrenology.

In October 1854 Stock became ill and returned to Springfield, where he made his will. At the beginning of the new year he was back in Port Jervis, but his stay in New York was brief. He became ill once more and returned to Springfield for the last time. On June 28, 1855, he died of tuberculosis at the age of forty.

M. B.

Bibliography Black 1984, 44–53. Tomlinson 1976. Northampton 1977.

93

Attributed to Joseph Whiting Stock
Joseph Rubin Berthelet, ca. 1845

Oil on canvas
76.2 × 61 cm (30 × 24 in.)
Gift of William T. Berthelet (52.205)

This portrait of Joseph Rubin Berthelet (1808–1883) may be compared, stylistically, with Stock's self-portrait (Connecticut Valley Historical Society, Springfield, Mass.), which was painted in New Bedford, Massachusetts, in 1843, and with two other portraits of New Bedford residents, Elihu Mott Mosher (1845?; private collection) and Captain Stephen Christian (1847; Old Dartmouth Historical Society, New Bedford). The pre-primed canvas is of a commercially available size regularly used by Stock in this period. While Berthelet's portrait lacks the details that Stock was fond of using, the shaded background is typical of his small portraits and miniatures of his own family. The shading and the form of the head and facial features follow the artist's usual practice in his portraits of the mid-1840s.

Berthelet lived in various cities throughout his life, although never in any of the New England cities in which Stock also worked. During his years in Detroit, where he died, he owned several parcels of land as well as an establishment called the Market House on the corner of Margaret and Randolph streets.

M. B.

Provenance The sitter's grandson, William T. Berthelet, Milwaukee, 1952. Acquired in 1952.

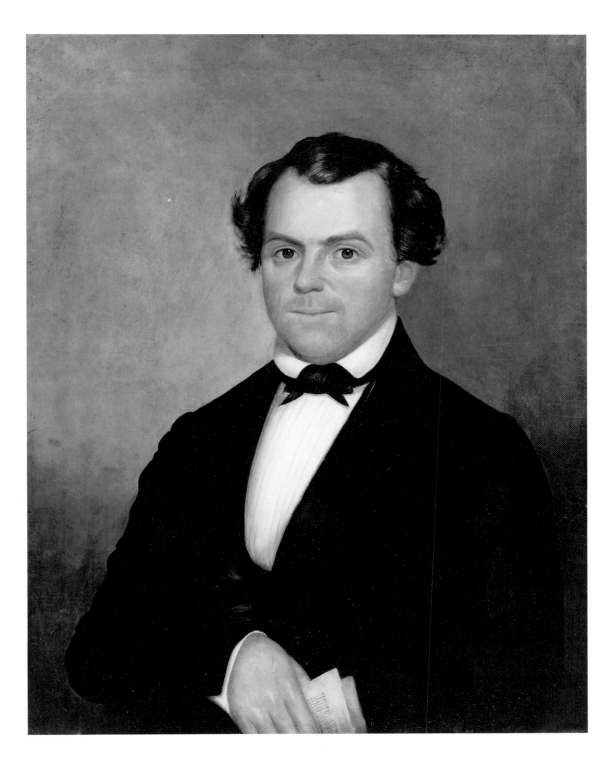

Joseph Rubin Berthelet

94

Attributed to Joseph Whiting Stock

Mrs. Joseph Rubin Berthelet and Her Son, ca. 1845

Oil on canvas
97.2 × 72.4 cm (38¼ × 28½ in.)
Gift of William T. Berthelet (52.206)

The painting of Mrs. Berthelet and her son is a companion to one of her husband (cat. no. 91). Slightly larger dimensions were necessary to accommodate a second figure. The shading and rendition of Mrs. Berthelet's face recall those of the sitters in several other works by Stock of the period, notably an 1844 portrait of James Eugene Judd of Springfield, Massachusetts (private collection), and a small likeness of a young woman (ca. 1845; Connecticut Valley Historical Society). Similar to the infants and their toys encountered in Stock's delightful miniatures of children are the sweet-faced child and his domino "house."

M. B.

Provenance The sitter's grandson, William T. Berthelet, Milwaukee, 1952. Acquired in 1952.

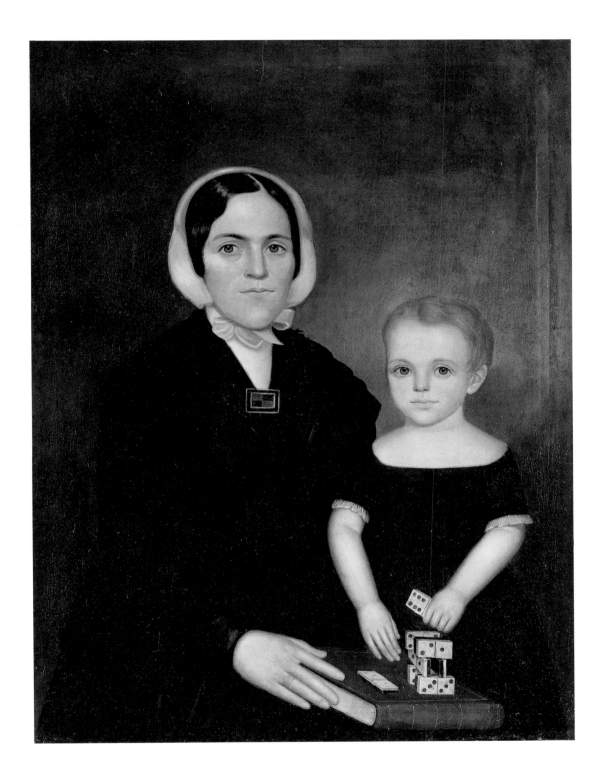

Mrs. Joseph Rubin Berthelet and Her Son

Gilbert Stuart's father, a Scotsman, operated a snuff mill in North Kingstown, Rhode Island. The mill failed in 1761, and the family moved to Newport, where Stuart, who had already shown some artistic talent, received lessons, sometime between 1769 and 1770, from the Scottish artist Cosmo Alexander (ca. 1724–1772). When Alexander left Newport, probably in 1771, Stuart went with him, as an apprentice, to South Carolina and on to Edinburgh, Scotland. Apparently by 1773, after Alexander's death, Stuart had returned to Newport and was executing portraits with the simple compositions and the smooth, linear style of his teacher.

In 1775 Stuart, who was then living in Boston, crossed the ocean again, this time via Newport to England. Evidently he realized that his prospects would be diminished by remaining in the colonies with war becoming inevitable. After about two years of financial failure as a portraitist and organ player in London, Stuart appealed to Benjamin West (q.v.) for help; West, with characteristic generosity, provided space in his studio until the younger artist was able to set out on his own. Stuart's success in London began in 1782 with the exhibition of a full-length portrait called *The Skater* (National Gallery of Art, Washington, D.C.) at the Royal Academy. By this time his portraits had acquired the decorative elegance and facile brushwork typical of the work of his better-known English contemporaries. Stuart's fresh, luminous coloring and his ability to capture a strong likeness eventually even won the admiration of fellow artists.

Despite the improvement in financial status, Stuart habitually lived beyond his means and was rarely solvent. To escape his creditors, he fled to Dublin in the fall of 1787 and painted there until late in 1792, when he decided that it would be financially advantageous to return to the United States.

After almost two years in New York City, during which time he furthered his reputation with portraits that were unusually diverse for him compositionally, Stuart moved in 1794 to Philadelphia. There he fulfilled his goal of painting America's most famous citizens, including George Washington and Thomas Jefferson. Stuart never lacked commissions in Philadelphia, but after the seat of government moved in 1803 from there to Washington, D.C., he followed. Between bursts of activity and bouts of exhaustion, he painted in the new capital for two years. Then in 1805, encouraged by a Massachusetts senator, he traveled to Boston, where he produced some of his finest portraits and remained for the rest of his life. After his return to the United States, he was generally acknowledged by American artists and art patrons alike to be at the head of his profession.
D. E.

Bibliography Whitley 1932. Mount 1964.

95
Mrs. Aaron Lopez and Her Son Joshua, ca. 1773/74

Oil on canvas
66 × 54.6 cm (26 × 21½ in.)
Gift of Dexter M. Ferry, Jr. (48.146)

This portrait of a woman and a boy was formerly attributed to Stuart's master, Cosmo Alexander. It was first assigned to Stuart by William Sawitzky in a letter of January 27, 1937, to Francis P. Garvan (quoted in a letter from Robert G. McIntyre to Edgar P. Richardson, February 12, 1948, curatorial files, DIA), at which time the identities of the subjects were still unknown. In 1941 Lawrence Tower located an old photograph of the painting at the American Jewish Historical Society, which was then in New York City. On the back of the photograph, a respected historian, the Reverend Jacques

Judah Lyons (1813–1877) had written "Sarah Lopez, wife of Aaron Lopez, and her son Joshuah [*sic*]" (Tower 1941, 185). The photograph has been lost, but there appears to be no reason to doubt the identification. Only the sitters, not the artist, were identified by Lyons, but Tower recognized the painting as the portrait by Stuart. (The knowledge that Stuart painted members of the Lopez family actually goes back to George Mason's 1879 biography of Stuart, in which Mason stated, without giving a source, that these early portraits—more than one—were missing.)

Both Sarah Rivera Lopez and her husband, Aaron, were members of wealthy Jewish families who had immigrated to Newport, Rhode Island, from Portugal. In addition to being a prominent merchant, Aaron Lopez contributed to the founding of both the Redwood Library and the synagogue in Newport. The couple's son Joshua would later marry the only daughter of Isaac Touro, the eminent first rabbi of the synagogue. Since the boy in the painting appears to be about six or seven years of age and Joshua Lopez was born in 1767, a date for the work of about 1773 or 1774 is plausible.

In pose and subject the picture is related to Stuart's early portrait *Mrs. John Bannister and Her Son* (Redwood Library and Athenaeum, Newport, R.I.), which has a very approximate date of 1773, based on the apparent age of the younger sitter, the style of the portrait, and the probable date of Stuart's return to Newport. Of these two paintings, which are among the artist's earliest extant works, the Detroit portrait is less easily recognized as by Stuart because at some time before 1937 it was overcleaned, removing some of the detail along the hairlines and perhaps some of the modeling of the faces. It remains, however, a rare document of his early style.
D. E.

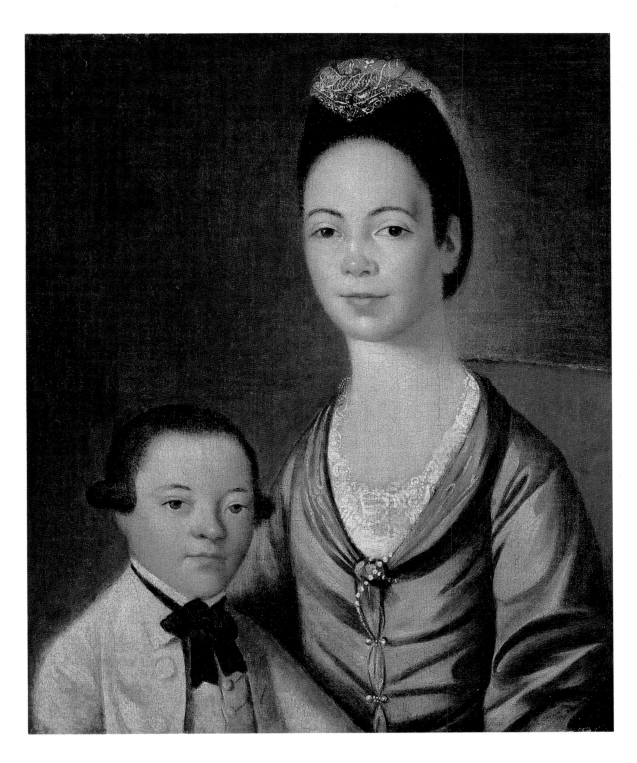

Mrs. Aaron Lopez and Her Son Joshua

Provenance Albert Rosenthal, Philadelphia. Feragil Galleries, New York, 1936. William Macbeth, Inc., New York, 1936–37. Francis P. Garvan, New York, 1937; (Mrs. Francis P. Garvan, 1948?). William Macbeth, Inc., 1948. Acquired in 1948.

Exhibitions Albany 1936, no. 6 (as *Portrait of a Woman and Boy* by an unknown artist). Newport 1963, no. 6.

References Mason 1879, 216. Park 1926, 1: 22, 488–489, no. 505. H. London 1927, 47, 77 (as by an unknown artist). *Art Digest* 1936, 21 (as *Woman and Boy* by Cosmo Alexander). Tower 1941, 185. Payne 1948, 19–24. Flexner 1955, 21, 23–24. Mount 1964, 371.

96
General Amasa Davis, ca. 1820

Oil on panel
83.2 × 66.7 cm (32¾ × 26¼ in.)
Gift of Mrs. J. Bell Moran (45.17)

Typically, as in this portrait of Amasa Davis, Stuart's flesh tones are remarkably fresh and transparent. The face and hair are enlivened with delicate, visible brushwork that is best described as "penciling," the term used in Stuart's day. Such penciling or hatching is done in a short, dabbing manner so that the colors, rather than blending, remain in a purer state and can be appreciated for themselves; furthermore, the sketchy technique conveys the impression of a portrait created spontaneously. In fact, Stuart did work quickly as a rule, frequently completing a head in three sittings, while he conversed with the sitter. As he aged, his stroke became more tremulous, as seen here, so that in 1824 an observer could write: "it was interesting to see how Stuart, with shaking hand, would poise the brush above his work, and then, stabbing it suddenly, get the touch he desired" (Whitley 1932, 177).

But this portrait is not just aesthetically appealing. Undoubtedly, given the artist's reputation for obtaining an accurate resemblance, it is also a strong likeness. One of Stuart's acquaintances, the art critic John Neal, compared him in 1823 with other contemporary painters, concluding that Stuart "developes [*sic*] character like a magician" (Dickson 1943, xxiv).

The sitter, Amasa Davis (1744–1825), was a Boston merchant and a close friend of the governor of Massachusetts, John Hancock. In 1786, at the time of Shays's Rebellion, Davis was recruited as an officer by the Ancient and Honorable Artillery Company of Massachusetts. He remained active in the state militia and from 1787 until his death served as quartermaster general of the commonwealth. An obituary praised his "distinguished integrity" and patriotism (*Columbian Centinel* [*sic*], February 2, 1825).
D. E.

Provenance The sitter; his eldest daughter, Lucinda Dorr, Dorchester, Massachusetts, 1825; her daughter, Sarah Whitney Davis Dorr Lemist, Roxbury, Massachusetts, 1843; her daughter, Frances Ann Lemist Wheelock, Roxbury, 1915. Bought by another of the sitter's great-granddaughters, Ann Lothrop Motley Winthrop, Boston, 1915; her niece, Maria Davis Motley Park, Groton, Massachusetts, 1923. Bought by William H. Murphy, the sitter's great-great-grandson, Detroit, 1927; his daughter, Mrs. J. Bell Moran, Detroit, 1945. Acquired in 1945.

Exhibitions Boston 1828, no. 106. Boston 1911, no. 54. Richardson 1934.

References Mason 1879, 168. Park 1926, 1: 257, no. 212. Richardson 1934, 11, 13. C. Burroughs 1946, 52–53. Mount 1964, 366.

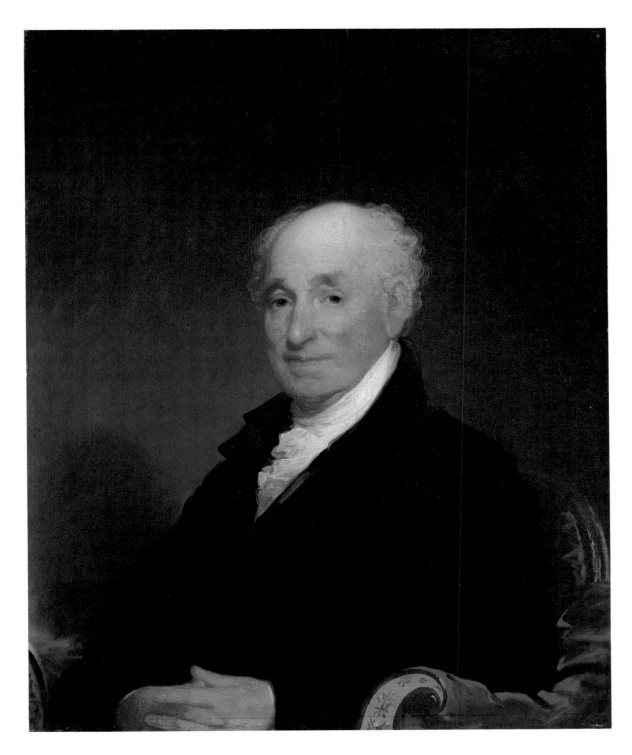

General Amasa Davis

Thomas Sully was brought to Charleston, South Carolina, at age nine by his parents, both of whom were British actors. The first person who taught him to draw, according to Sully, was Charles Fraser (1782–1860), a schoolmate who later led a successful career as a miniaturist. He received further instruction in miniature painting with watercolor on ivory from his brother-in-law Jean Belzons and his oldest brother, Lawrence, whom he followed to Richmond, Virginia, in 1799. About two years later, the Sully brothers, now both miniature painters, moved from Richmond to Norfolk. It was there that Henry Benbridge (q.v.) gave Thomas lessons in the use of oils, which he demonstrated by painting the younger artist's portrait. This method of learning by observing other artists at work became a practice with Sully. After Lawrence's death, Thomas married his brother's widow in 1806 and transferred his studio to New York City, where he hired John Trumbull (q.v.) to paint his bride's portrait. In 1807 Sully journeyed to Boston and spent about three weeks absorbing free instruction from Gilbert Stuart (q.v.). In the same year, he left New York in hopes of improving his financial situation and settled permanently in Philadelphia.

The next phase of Sully's education— a year in London—was probably undertaken at the encouragement of Stuart. In any case, Sully proposed a scheme for financing the trip to several wealthy Philadelphians, who responded favorably and provided the necessary funds. Sully agreed to supply them with pictures in return. In London, he carried introductory letters to Benjamin West (q.v.), who wisely suggested that he study bone structure and seek further guidance from a portrait painter. With this in mind, Sully sought advice from Sir Thomas Lawrence, and after about a year in London, returned in 1810 to become Philadelphia's leading portrait painter.

One of the artist's greatest honors was to paint the recently crowned Queen Victoria in London in 1838, a portrait commissioned by the Society of the Sons of Saint George in Philadelphia. This commission brought about Sully's second and last trip to the country of his birth.

Aside from portraits, which constitute so much of his work, Sully produced landscapes, imaginary scenes, and historical compositions such as the large *Washington at the Passage of the Delaware* (1819; Museum of Fine Arts, Boston), commissioned by the state of North Carolina. Active in other areas as well, he wrote *Hints to Young Painters and the Process of Portrait Painting,* which was revised in 1871 and published two years later. It is a short, informal compendium of practical advice and painting recipes.

A master in the fluid style of the English school, Sully spent his mature years creating flattering, decorative portraits that often show an unusual concern for their overall effect, particularly in terms of harmonious color.

D. E.

Bibliography Biddle and Fielding 1921. Washington 1983.

97
Dr. Edward Hudson, 1810

Oil on canvas
73.7 × 60.3 cm (29 × 23¾ in.)
City of Detroit Purchase (26.89)

The sitter, Dr. Edward Hudson (1772–1833), was one of the best-educated and most talented dentists of his generation. He arrived in Philadelphia in 1803 as an Irish refugee, having been exiled, after a term of imprisonment, for agitating against the legislative union of Ireland with Great Britain. Versatile and possessed of a magnetic personality, Hudson, like Sully, was a flutist; both men belonged to

the same Philadelphia musical society, and this mutual interest may have been the basis for their friendship (information from Margaret M. Harm in a conversation with the author, July 11, 1984).

Sully's handwritten "Account of Pictures Register, 1801–1871" (Dreer Collection, Historical Society of Pennsylvania, Philadelphia) indicates that he painted four portraits of Hudson, for which he recorded dates of 1810, 1824, 1828, and 1841 (painted posthumously), and two portraits of Hudson's third wife, Maria Mackie Hudson, one in 1814 and another in 1824.

The Detroit portrait of Mrs. Edward Hudson (cat. no. 98) is inscribed with the date 1814, but there has been some question as to the date of Dr. Hudson's portrait. Since Sully described two of the recorded portraits of Hudson as heads— those of 1828 and 1841—the Detroit bust-length work must date from either 1810 or 1824 (both called "busts"). The difficulty of pinpointing which date is correct is compounded by the fact that when Edward Biddle and Mantle Fielding published an annotated version of Sully's register in 1921, they added a description to the citation of the 1810 work that reads "bust, head to right, wearing a brown cape coat with fur collar," and this does not fit the Detroit picture. Apparently, the portrait that Biddle and Fielding saw, or had described to them, was not signed or dated, since, whenever possible, these authors included such information along with their description.

It seems that Biddle and Fielding were mistaken in believing the likeness with a fur-collared coat to be the portrait from 1810. Although the present location of the fur-collared coat portrait is unknown, a work fitting its description was reproduced in 1910 in *The History of Dental Surgery* by Charles R. E. Koch (vol. 3, p. 29), where it is simply identified as a painting of Dr. Hudson by Sully. The

reproduction provides convincing evidence that the picture it illustrates was not painted in 1810: both the sitter's hairstyle and the shawl collar of his inner jacket date from about the mid-1820s. Therefore, the portrait is probably the 1824 likeness that Biddle and Fielding describe as unlocated. This conclusion is supported by the fact that, stylistically, the Detroit picture bears a close resemblance to Sully's other works of 1810 and it has the fresh quality of an original.

The Detroit portraits of the Hudsons appear to be companion pieces since they are of the same size and the sitters face each other. It would be logical to suppose that Sully, having painted Dr. Hudson in 1810, was commissioned in 1814 to paint a complementary portrait of Hudson's wife, whom Hudson had married in 1813. Given Biddle and Fielding's description of the 1824 portrait of Mrs. Hudson (unlocated) as showing her in a fur-collared coat and Sully's own notations—he cites the 1824 portrait of Dr. Hudson as having been painted "for Strainer" and the 1824 portrait of Mrs. Hudson as "for Mr. Trainer of N.Y." (the slight difference in the names could be the result of an error in transcription)—it would appear that the two pictures with the Hudsons in similar attire were also intended as companion pieces. These suppositions are borne out by what we know of the provenance of the four works—the two Detroit pictures having descended together in the family of the Hudsons' youngest daughter, Johanna, and the two 1824 portraits apparently having been handed down in the family of Johanna's sister Elizabeth.
D. E.

Provenance The sitter's grandson, Thomas A. Sutherland, San Diego; an unidentified descendant, 1926. Gump's Gallery, San Francisco, 1926. William Macbeth, Inc., New York, 1926. Acquired in 1926.

Exhibitions East Lansing 1966, no. 3.

References Hart 1908, 85, no. 810. Biddle and Fielding 1921, 21–22, 181, no. 836. C. Burroughs 1926, 9–11. C. Burroughs 1929a, 267.

98
Mrs. Edward Hudson, 1814

Oil on canvas
73.7 × 60.3 cm (29 × 23¾ in.)
City of Detroit Purchase (26.90)

Sully was at the height of his powers when he completed the Detroit portrait of Dr. Edward Hudson and the companion piece of Hudson's wife, Maria Mackie (1797–1862). Characteristically, the sitters are shown gracefully posed in easy, relaxed postures, assumed seemingly without an awareness of the artist's presence. While Hudson twists back over his chair—creating the feeling of only momentary pause—his wife looks beyond the artist and expresses perhaps a youthful uncertainty in her lowered gaze. Painted at age nineteen, she was twenty-three years younger than her husband.

Sully took obvious delight in depicting her stand-up collar, which provides a flattering frame for her head and an excuse for demonstrating the artist's skill. Unlike Gilbert Stuart (q.v.), who hated painting accessories, Sully considered them important enough to include in the preliminary drawing made during the first

sitting. Where possible, he elaborated the sitter's costume to luxurious effect. Only in the third sitting out of six did he concentrate on likeness and correct any inaccuracies that might have been introduced while he was laying in the picture as a whole (Sully 1873, 13). Color is carefully considered throughout. Usually, as seen here in the use of a medium rust, different shades of gray, and a warm pink, he created a poetic repetition of a limited color scheme.

Sully's contemporary, the art critic John Neal, described the artist's pictures with some justification as "beautiful, and tranquil; or romantick [*sic*], and spirited. His characteristics are elegance, and taste. He is not remarkable for strength, or fidelity... but... a surpassing gracefulness, and a careless unstudied richness" (Dickson 1943, 5).
D. E.

Inscriptions At lower right, *TS 1814*

Provenance The sitter's grandson, Thomas A. Sutherland, San Diego; an unidentified descendant, 1926. Gump's Gallery, San Francisco, 1926. William Macbeth, Inc., New York, 1926. Acquired in 1926.

Exhibitions Philadelphia 1955, no. 29.

References Hart 1908, 85, no. 812. Biddle and Fielding 1921, 181, no. 841. C. Burroughs 1926, 9–11. C. Burroughs 1929a, 267.

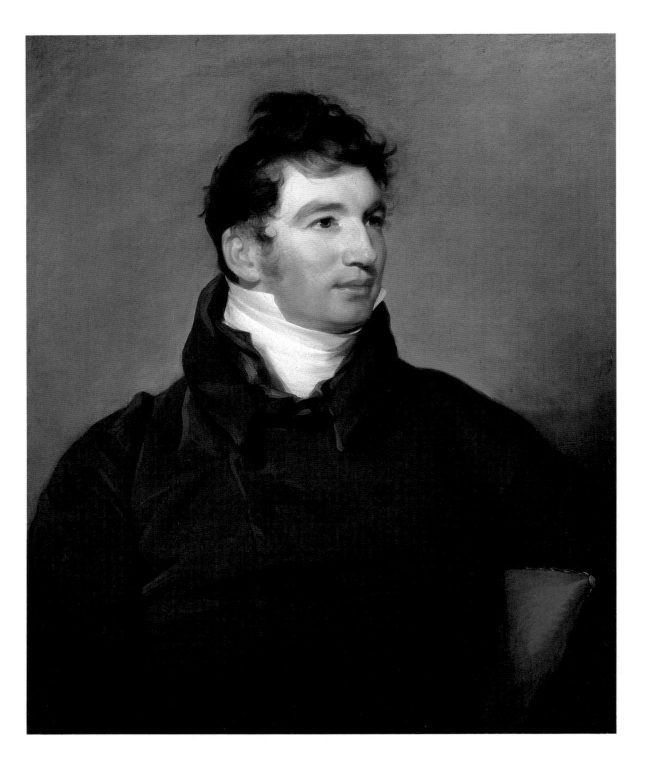

Dr. Edward Hudson

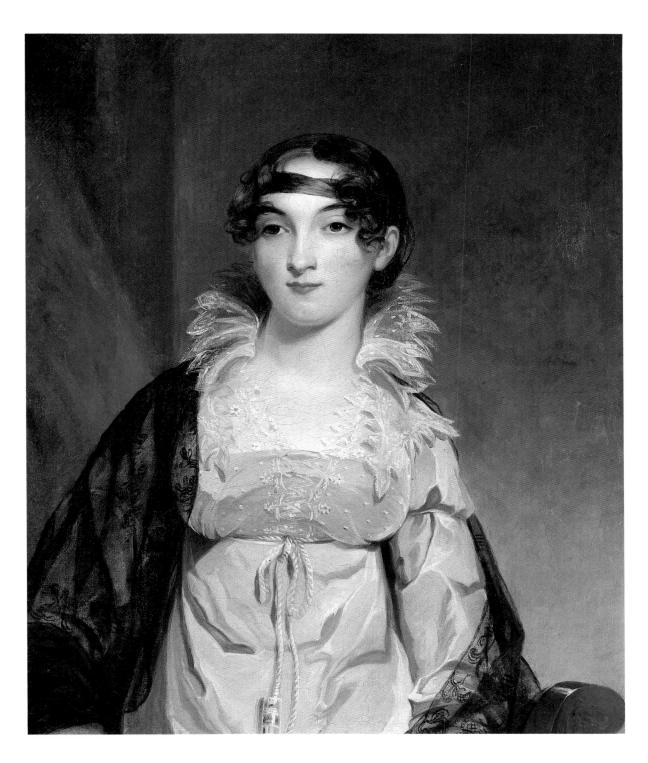

Mrs. Edward Hudson

Jeremiah Theüs's primary claim to fame is as the principal painter in Charleston, South Carolina, for thirty-five years. His family came to Charleston in 1735, and four years later he advertised:

Notice is hereby given, that Jeremiah Theus Limner is remov'd into the Market Square near Mr. John Laurans Sadler where all Gentlemen and Ladies may have their Pictures drawn, likewise Landskips [sic] of all sizes, crests and Coats of Arms for Coaches or Chaises. Likewise for the Conveniency of those . . . in the Country, he is willing to wait on them at their respective Plantations (Middleton 1953, 33).

Had Theüs settled in another colonial city with one or more competent painters, it is unlikely he would have received the considerable patronage that fell to him by default. William Dunlap's description of his work (1834, 1:33), expressed a century and a half ago, claiming that his portraits were "as stiff and formal as the originals, when dressed for the purpose and sitting for them," still has the ring of truth. Quite simply, Theüs was a follower, not an innovator; the repetitive late-baroque style of portrait painting that found favor in Charleston in 1740 was the same style he pursued thirty years later. One indication that, by the 1760s, some Charlestonians were beginning to weary of his predictability is the fact that John Wollaston (q.v.) generated a number of commissions during his stay there (1765–67). Nevertheless, Theüs seems to have secured steady patronage and, aside from a trip to Savannah, did not have to contemplate the peripatetic wanderings required of so many other colonial painters. At his death, Theüs had celebrated two marriages, fathered a number of children, and amassed a sizable estate. Approximately one hundred eighty of his paintings are known. Theüs occasionally signed his works, but discovery of his oeuvre has been hindered by the modest level of scholarship his work has stimulated.

R. S.

Bibliography Middleton 1953.

99
William Wragg, ca. 1750/60

Oil on canvas
39.7 × 34.4 cm (15⅝ × 13½ in.)
Gift of Dexter M. Ferry, Jr. (53.144)

William Wragg (1714–1777) was a prominent Charleston merchant who owned Ashley Barony, an estate situated at the head of the Ashley River. His portrait contains features that are characteristic of Theüs: the stiff pose; the vague, almost incidental background; and the porthole effect created by black, spandrel-shaped areas. The artist's strengths lay in his delicate color sense and attention to details of dress, such as the gray jacket accented by the yellow vest. While his style remained quite consistent during his lengthy career, Theüs did make allowances for changes in fashion. Consequently, based on the sitter's short, bobbed wig and elaborately patterned waistcoat, the painting can be dated to the 1750s.

Theüs portraits are frequently in the standard bust-size format (76.1 × 63.5 centimeters [30 × 25 inches]) that was prevalent throughout the Colonies. But on occasion, as here, or in his signed and dated portraits *Dr. Lionel Chalmers* and *Mrs. Lionel Chalmers* (1756; Museum of Fine Arts, Boston), Theüs chose to work on a conversation-piece scale, which is roughly one-third the standard bust size. Why he did so is unclear, but it may reflect a desire to accommodate patron tastes or to establish a more reasonable price scale.

R. S.

Provenance The artist's daughter, Charlotte [later Mrs. William Loughton Smith]; her son, William Wragg Smith; his daughter, Elizabeth Adda [later Mrs. Charles Mayhew Phinney]. Purchased by H. A. Schindler, Charleston, S.C. Acquired in 1953.

Exhibitions Washington 1960, no. 12.

References Middleton 1953, 174–175. Richardson 1953, 50, 52. Detroit 1957, 39, fig. 13.

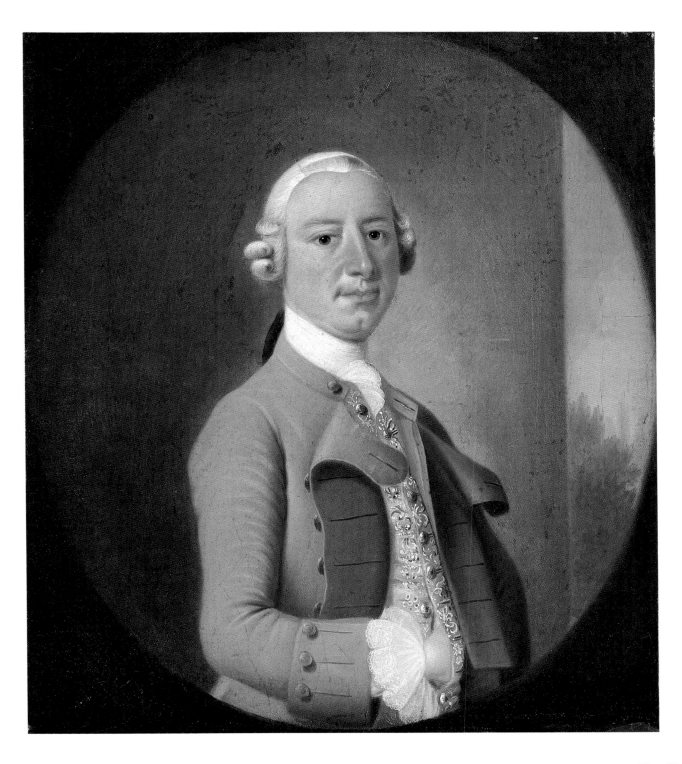

William Wragg

The son of a governor of Connecticut, John Trumbull graduated from Harvard in 1773 and decided, against his father's wishes, to pursue an artistic career in Boston. His plans were postponed, however, during the War of Independence. On the strength of his connections and his ability to draw maps, he served as second aide-de-camp to General Washington and later as a colonel, with chiefly bureaucratic duties, under General Horatio Gates. In 1777 Trumbull resigned from the army, over a disagreement with Congress on the terms of his commission, and once again sought to improve his abilities as an artist. This attempt, as well as a family financial project, led to a trip in 1780 to London, where Trumbull was arrested as a spy and eventually deported.

After the war, Trumbull returned to London in 1784 to resume his training under Benjamin West (q.v.). With West's encouragement, he began in 1785 to paint on speculation a series of small historical scenes from the Revolutionary War, which could be engraved for profit. Up to this point Trumbull had specialized as a painter of portrait miniatures, and the experience stood him in good stead as he traveled through England, France, and the United States, executing miniature oil portraits of the various participants in the war; they were to be incorporated into his historical scenes to give them greater authenticity. The project became his life's work and, in its earliest stages, inspired some of his best painting.

When the war between Great Britain and France threatened to endanger financial support of his project, Trumbull accepted an offer in 1794 from Chief Justice John Jay to serve as his secretary on the Jay Treaty Commission in London. Thus, he embarked briefly upon a diplomatic career.

In 1804 Trumbull re-established himself as an artist in the United States, opening a studio in New York City. Four years later, with portrait commissions declining, he journeyed back to London and found the same economic depression there; the War of 1812 prevented his return to New York until 1815. Trumbull's hopes for government patronage were finally fulfilled in 1817, when Congress employed him to decorate the rotunda of the United States Capitol with four large scenes from the Revolution. Although he completed the commission, his artistic ability had gone into a noticeable decline.

In the same year that he was awarded the rotunda commission, Trumbull was elected president of the American Academy of the Fine Arts in New York. Unfortunately, however, Trumbull's dictatorial rule over the next nineteen years, the result perhaps of his own bitter disillusionment, brought about such dissension among students at the academy that they formed an effective body to found the National Academy of Design.

Trumbull's 1841 autobiography was the first such work by an artist published in the United States, preceding his death by only two years. He is buried at Yale University, having helped to establish there the first college-affiliated art gallery in this country.

D. E.

Bibliography Trumbull 1841. Cooper 1982.

100

Study for *Surrender of Cornwallis at Yorktown,* 1787

Oil on canvas
35.2 × 53.3 cm (13⅞ × 21 in.)
Gift of Dexter M. Ferry, Jr. (48.217)

As Trumbull reported in his autobiography, he struggled over different compositional sketches for the figural arrangement in his *Surrender of Cornwallis at Yorktown* (1787–ca. 1828; Yale University Art Gallery). The present study is per-haps the earliest known sketch in oil. Although the artist discarded this idea for the composition, it has been praised as potentially the most successful of all the versions (Jaffe 1975). In its informality and its enlargement of key figures, it is much more immediate and dramatically impressive than the final symmetrical composition. Major General Benjamin Lincoln, Washington's second-in-command, shown mounted (from the rear), accepts the British surrender at Yorktown on October 19, 1781—an event that, in effect, ended the Revolutionary War.

There are three known preliminary oil sketches for the composition of *Surrender of Cornwallis,* two in the Detroit Institute and a third—more developed and closer to the final version—in a private collection. The arrangement suggested in the second Detroit study (see cat. no. 101) falls chronologically between the other two and is the first intimation of the final composition, which puts the central figures in the middle ground with Lincoln seen from the front, balanced by lines of French and American soldiers on either side.

Despite the title of the picture, Cornwallis was not actually present at the event. He feigned illness to avoid the occasion, sending in his place an assistant, General Charles O'Hara, who offered to surrender not to Washington, but to the Comte de Rochambeau, who had led the supporting French forces. The count referred O'Hara to Washington, who, in recognition of the affront, arranged for the surrender to be accepted by his second-in-command, Major General Lincoln.

The Detroit sketch is gratifying not only as a composition but also as an expression of Trumbull's love of painterly effect. The application of oil paint varies from a thin wash, diluted with turpentine until it merely stains the canvas, to creamy highlights on small details of clothing and

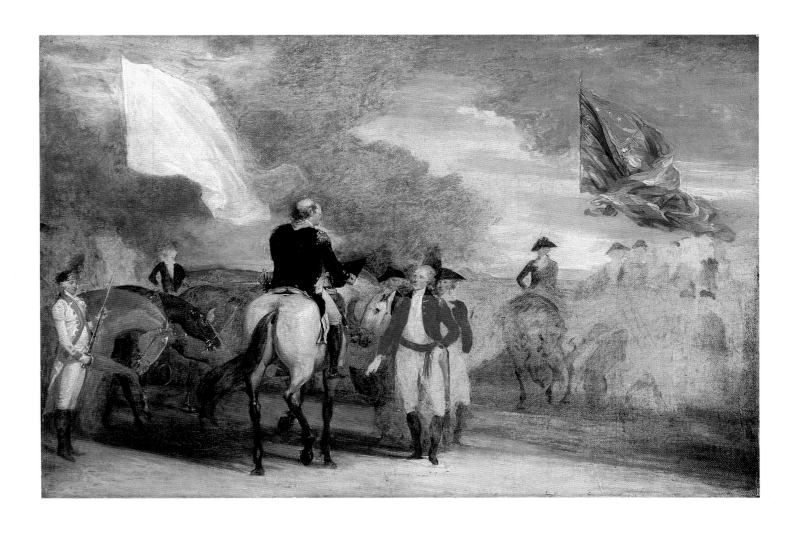

Study for *Surrender of Cornwallis at Yorktown*

anatomy, to the carefree brushstrokes on the whirling American flag, loaded with viscous paint but still too liquid to be a true impasto. Perhaps because, as an early stage in the compositional process, this sketch is little more than the blocking out of an inspiration, it has a vibrancy lacking in the finished version.

D. E.

Provenance The Trumbull family, until 1867. Descended in an English aristocratic family, 1867–1948. Harry Shaw Newman (dealer), New York, 1948. Acquired in 1948.

Exhibitions Washington 1959, no. 114. Buffalo et al. 1976, no. 2.

References Trumbull 1841, 147. Sizer 1948, 357–359. Gnau 1949, 43–46. Sizer 1950, 75. Jaffe 1975, 126–129, figs. 102–103, 319. Cooper 1982, 82–84, figs. 40–41.

101

Study for *Surrender of Cornwallis at Yorktown*, 1787

Oil on canvas
35.2 × 53.3 cm (13⅞ × 21 in.)
Gift of Dexter M. Ferry, Jr. (48.216)

This small study for Trumbull's *Surrender of Cornwallis at Yorktown* is not as finished as the sketch discussed above, but the disposition of the figures is the same as in the final version (Yale University Art Gallery). Here, Major General Benjamin Lincoln, on horseback, addresses two English officers in the center, while at the left the French supporting forces are lined up opposite their American counterparts, vaguely suggested at the right.

Trumbull's correspondence and autobiography provide evidence that both Detroit studies were done in London in 1787. The autobiography mentions that

he "made various studies" for *Surrender of Cornwallis* during the summer (Trumbull 1841, 147). Trumbull then wrote to his friend Thomas Jefferson on September 17, 1787, postponing a visit to him in Paris during which Trumbull planned to paint portraits of the French officers involved at Yorktown. As he explained, "I am not quite prepared to make my Journey to Paris. . . . I wish to have decided exactly in my own mind and even in a Sketch, the composition for the Surrender at York; that I may have no embarrassment and lose no time when I do come to you" (Boyd 1955, 12: 139). Since Trumbull visited Jefferson in December, the later Detroit sketch, showing the final composition but not containing portraits, was apparently produced that fall. On February 6, 1788, the artist wrote that he had been in Paris "near six weeks," which would mean that the composition was established by Christmastime (letter to Jonathan Trumbull, Jr., New-York Historical Society).

The final version, which Trumbull worked on periodically from 1787 to about 1828, is less than ten inches longer in either direction than this study. Unlike many historical pictures of the period, it was evidently not intended to be exhibited alone and therefore did not need to be of an impressive size. Trumbull abandoned his scheme for engraving the scene as part of his Revolutionary War series, originally planned to contain twelve pictures, because, in the end, subscriptions for the first two engravings—*Death of General Warren at the Battle of Bunker's Hill* and *Death of General Montgomery in the Attack on Quebec*— did not cover his expenses. Nevertheless, it was on the basis of the quality of his small finished oils that Trumbull received the commission in 1817 to paint life-size episodes from the war for the rotunda of the United States Capitol. One of the compositions selected by President Madison and Trumbull to be

enlarged for this project was the completed version of Lord Cornwallis's surrender.

D. E.

Provenance The Trumbull family, until 1867. Descended in an English aristocratic family, 1867–1948. Harry Shaw Newman (dealer), New York, 1948. Acquired in 1948.

References Trumbull 1841, 147. Sizer 1948, 357–359. Gnau 1949, 43–46. Sizer 1950, 75. Boyd 1955, 12: 139. Jaffe 1975, 126–128, 319, fig. 103. Cooper 1982, 82–84.

102

John Trumbull, 1793

Oil on canvas
76.2 × 61 cm (30 × 24 in.)
Founders Society Purchase, Dexter M. Ferry, Jr., Fund (38.13)

Trumbull's portrait of his second cousin, who shared the same name, was completed, probably on commission, in 1793 and was then copied by the artist a year later as a miniature (Yale University Art Gallery). He apparently intended to add the replica to his collection of miniature portraits of members of his family. Not long after Trumbull finished the portrait, he gave up painting in favor of a diplomatic career, and when he again took up his brush in 1800, he had lost, with rare exceptions, the ability to match the quality of the portraits he had produced from about 1784 to 1794.

This portrait of Trumbull's cousin, in which the narrow outlines of the forms are faintly visible, conveys the impression of having been drawn and then tinted with color. Details such as the illusionistic highlights on the fingernails, book, and

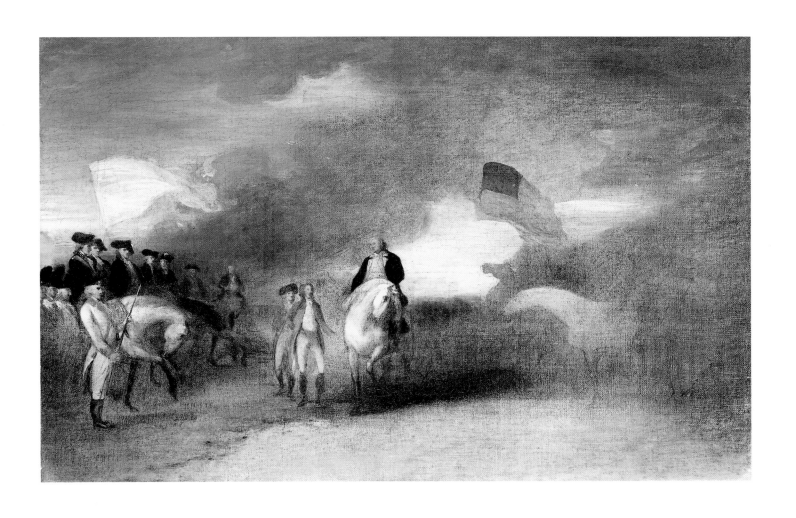

Study for *Surrender of Cornwallis at Yorktown*

shirt cuff, as well as the very subtle transitions in the modeling of the face, are all characteristic of the care that a miniature painter might take.

The sitter, John Trumbull (1750–1831), a well-known lawyer and poet who had graduated from Yale at age seventeen, established his reputation with a 1782 political poem, *M'Fingal*. Partially written as early as 1775, the poem satirizes the life of an American Tory, Squire M'Fingal, and pokes fun at the British. While it was the most popular poem of its length in America prior to Longfellow's 1847 *Evangeline*, the author is not known to have written other such commentaries; after a long career in law and politics in Connecticut, Trumbull joined his married daughter in Detroit, where he spent the last six years of his life.

D. E.

Inscriptions At lower left, *J. Trumbull / 1793*

Provenance The sitter's great-granddaughter, Mrs. Charles H. Metcalf, Detroit. Acquired in 1938.

References Richardson 1938a, 212–213. Sizer 1950, 55, no. 25. Sizer 1952, 170. Cooper 1982, 125n. Gerdts 1983, 63.

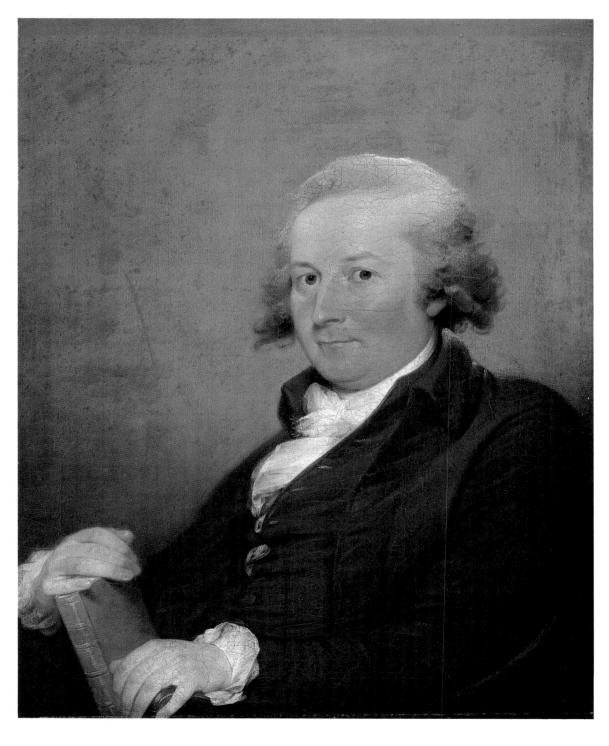

John Trumbull

Samuel Lovett Waldo

1783 WINDHAM, CONNECTICUT—
NEW YORK 1861

Samuel Lovett Waldo's desire to paint was indulged by his father, a Connecticut farmer, who paid tuition for Waldo, at age sixteen, to study with Joseph Steward (1753–1822), a retired minister who painted in Hartford. Four years later, in 1803, Waldo opened his own portrait studio not far from that of Steward. Finding little employment, he soon became an itinerant, traveling from Connecticut to South Carolina. Finally, dissatisfied with his own professional ignorance, he visited London in 1806 and studied at the Royal Academy. Upon his return in 1809, he established himself in New York as one of the city's leading portrait painters. William Jewett (1789/90–1874) became his apprentice in about 1812 and proved so invaluable that the two formed a partnership. From about 1818 to Jewett's retirement in 1854, they worked in close collaboration, painting portraits both together and separately. On rare occasions, they produced subject pictures as well. Waldo repeatedly exhibited his own and their jointly painted work, as a means of advertising, at the American Academy of the Fine Arts and its successor, the National Academy of Design. Because of such efforts and the consistent quality of their productions, the firm of Waldo and Jewett was so successful financially that Waldo lived out his life in relative prosperity.

Unfortunately, no one has yet determined the precise working relationship between the two artists. The few portraits by Jewett known today show that, by at least about 1840, he could rival Waldo in ability and with a style closely fashioned after the older master. It would appear that they were equal partners and that Jewett's work was not limited to backgrounds and accessories.

D. E.

Bibliography Dunlap 1834.

103
Mrs. Margaret Snelling,
probably 1830s

Oil on canvas
75.6 × 63.5 cm (29¾ × 25 in.)
Gift of Julius Weitzner (30.407)

Unlike Thomas Sully (q.v.), who constantly varied the positions, accessories, and backgrounds in his portraits, Samuel Lovett Waldo, and later the firm of Waldo and Jewett, developed a successful formula and adhered to it. The format—an interior scene with a chair, sometimes a curtain, and the sitter shown facing three-quarters to the right or left, looking directly at the viewer— evidently derives from Gilbert Stuart's (q.v.) precedent. The present portrait, about which little is known, is consistent with its basic details.

Waldo's assistant, William Jewett, could have contributed to this portrait by painting the accessories or even working on the head but, if he was involved, we are not now able to determine the fact or extent of his participation. When Waldo and Jewett painted together, they habitually signed the reverse with the stenciled name of their firm, but the Detroit portrait has an old relining that would cover any such stencil if it existed. In joint works, the styles of Waldo and Jewett merged to such an extent that no one has yet been able, or has even systematically tried, to separate the two hands. When more research is done, the present attribution may change to include Jewett.

Regardless of its authorship, the characterization in this portrait is arresting: the sitter—wide-eyed and smiling—comes across as alert and vivacious. According to Elizabeth Ann Coleman, curator of costumes and textiles at the Brooklyn Museum, the lady, about whom we know nothing beyond her name, is not fashionably dressed. Her collar was high style in 1816, her cap popular during the 1820s and 1830s, the position of her waistline

correct for the late 1830s, and her gathered bodice preferred by middle-aged ladies from the 1830s to the 1870s. This mélange of different fashions makes it difficult to date the picture with any degree of accuracy.

D. E.

Provenance Julius H. Weitzner (dealer), New York and London, 1930. Acquired in 1930.

104
Attributed to Samuel Lovett Waldo
Portrait of a Man, ca. 1815

Oil on canvas
66 × 54.9 cm (26 × 21⅝ in.)
Gift of Mr. and Mrs. Lawrence A. Fleischman (58.189)

This painting has long been called a self-portrait by Waldo, but the likeness does not agree with other portraits of him— most especially the *Self-Portrait* that descended in Waldo's family (Metropolitan Museum of Art, New York), which shows him to have had dark brown eyes rather than the grayish blue eyes seen in the Detroit portrait. Not only the eyes but also the eyelids, eye sockets, bottom lip, and ears in the two pictures are quite different. The superficial resemblance between these sitters, however, may well have been the original cause of the Detroit picture's having been assigned to Waldo. The attribution dates back to at least 1931, when the portrait was on loan to the Museum of the City of New York and when Waldo's *Self-Portrait,* which had been at the nearby Metropolitan Museum since 1922, was his best-known work.

The discovery that the painting is not a self-portrait by Waldo may be reason to cast doubt on the attribution. There is general confusion about the development of Waldo's early style before he joined

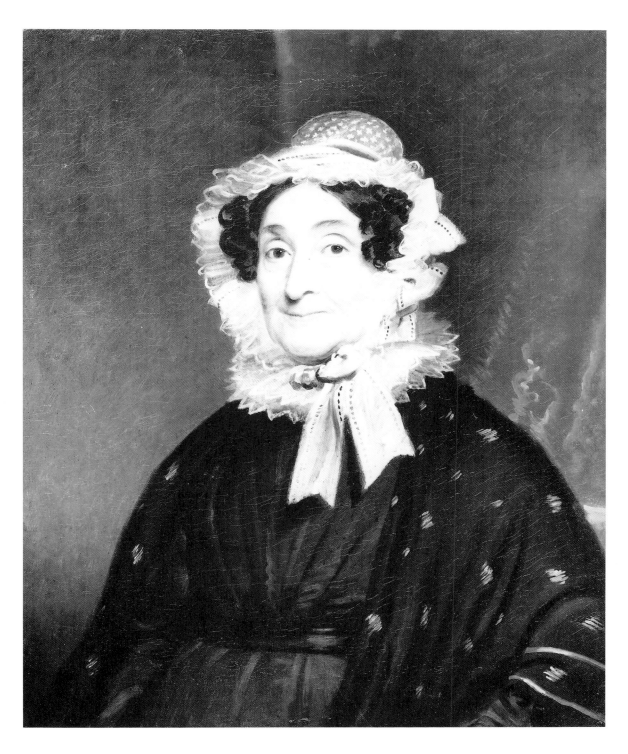

Mrs. Margaret Snelling

William Jewett around 1818 to form a painting partnership. Some historians say that his early work, after a period of study in England, was freely painted in the manner of Sir Thomas Lawrence (Gardner and Feld 1965, 171). Others characterize Waldo's painting as probably hard-edged "before public pressure and his association with William Jewett softened his style" (Worcester 1973, 19). The truth is that we know little about his style before at least 1815.

The first firmly dated portrait by Waldo is the 1815 full-length *General Alexander Macomb* (City Hall, New York); next is an 1819 portrait titled *Old Pat, The Independent Beggar* (Boston Athenaeum). Compared with the portraits of Macomb and Old Pat, the Detroit painting—which can be dated by the sitter's black coat and hairstyle to about 1815—is less broadly painted, less facile, and more experimental. This last characteristic is especially evident in the artist's somewhat hesitant but ambitious use of light and shade as well as in the uneven treatment of the more sculptural near eye. What complicates matters is that the Detroit portrait is not stylistically very like either of these dated works or even the rest of Waldo's oeuvre. But, because of the gap in our knowledge of his development just before 1815, there is insufficient evidence, at this point, to discard the attribution to Waldo altogether. The portrait has the searching quality often associated with a self-portrait (which would give it a different attribution), and yet it could conceivably be a work from what is virtually Waldo's lost period.

D. E.

Provenance The family of Captain William Booth, Stratford, Connecticut. Robert Friedenberg, New York, 1920. Erskine Hewitt, New York, 1931–38. Sale, Parke-Bernet Galleries, New York, October 20, 1938, no. 770. Norvin H. Green, Tuxedo Park, New York, 1938–50. Sale, Parke-Bernet Galleries, New York, December 2, 1950, no. 594. Lawrence A. Fleischman, New York, 1958. Acquired in 1958.

On deposit The Museum of the City of New York, 1931–38.

Exhibitions Minneapolis 1963, unpaginated [no. 133].

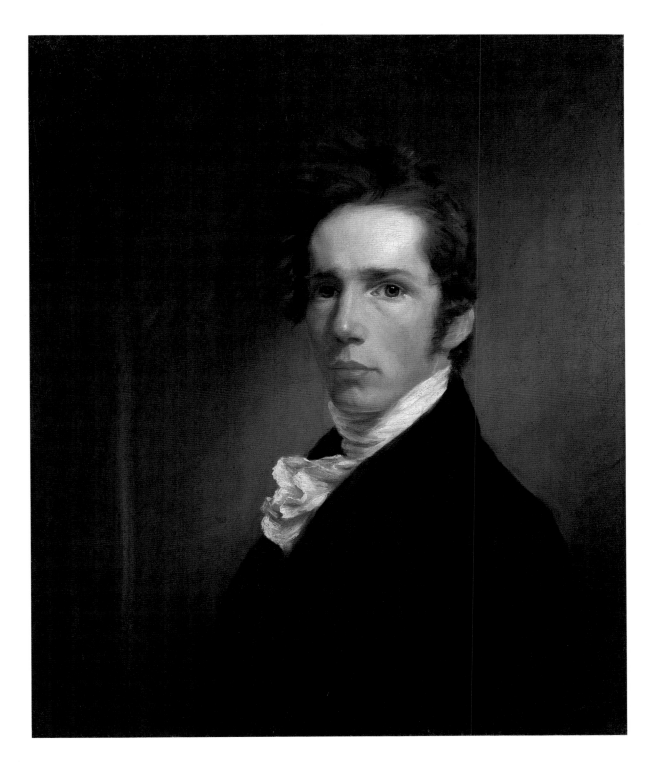

Portrait of a Man

A painter whose diversified repertoire was his forte, Robert Weir was trained in New York City by masters from two distinct sectors of the profession: the portraitist John Wesley Jarvis (q.v.) and a heraldic artist of English birth, Robert Cox. From the former, Weir obtained an appreciation for traditional occupational goals, which culminated in a three-year residency in Italy between 1824 and 1827, while from the latter he derived the fastidious interest in historical details that became a hallmark of his art. In 1834 Weir was appointed instructor of drawing at the United States Military Academy at West Point, succeeding Charles Robert Leslie (1794–1859), who had occupied the post less than a year. Weir, by contrast, remained in this disciplined academic environment for more than four decades, rising to the rank of professor in 1846 and earning the respect of fellow artists and the friendship of generations of cadets. The duties of the position allowed him considerable time for his own work, which he used to shape a sizable oeuvre of history, genre, landscape, and portrait paintings, as well as book illustrations.

Weir's most famous works were painted at West Point. Of the four giant canvases commissioned in 1836 for the United States Capitol to complement the Revolutionary War compositions of John Trumbull (q.v.), Weir's contribution, *The Embarkation of the Pilgrims at Delft Haven, Holland, July 22nd, 1660* (1843), was the second to be completed (after John Gadsby Chapman's *Baptism of Pocahontas at Jamestown, Virginia, 1613* [1840]) and was the most successful (the other artists involved were Henry Inman [q.v.] and John Vanderlyn [q.v.]). Exhibitions of the picture in New York and Boston prior to its installation in the rotunda of the Capitol helped to stimulate an interest in American history painting that lasted a quarter of a century, and—aided by a reduced-size replica (Brooklyn Museum) that was painted by Weir in 1857 for the New York dealers Williams, Stevens, and Williams—

established an enduring reputation for the composition itself. Twenty years later, Weir's smaller *Taking of the Veil* (1863; Yale University Art Gallery), a scene based upon the ceremonial consecration of a young Roman nun that the painter had witnessed as a young man, was completed and shown at Goupil's Gallery in New York. In the interim the artistic environment had been transformed: history painting had declined in importance, having been superseded by an emphasis on nature and the New World landscape. Significantly, the display of Weir's work overlapped with that of *Cotopaxi* (1862; the Detroit Institute of Arts, 76.89) by Frederic E. Church.

Weir retired from West Point in 1876 but continued to paint into the 1880s. Two of his sons, John Ferguson Weir (1841–1926) and Julian Alden Weir (1852–1919), were noted artists in their own right. The former followed his father into the profession of teaching, becoming director of the Yale School of Fine Arts in 1869.

G. C.

Bibliography Weir 1947.

105

The Hudson River from Hoboken, 1878

Oil on panel

76.2 × 63.5 cm (30 × 25 in.)

Founders Society Purchase, Activities Committee Fund (69.7)

During the national centennial year, after a long career as America's foremost teacher-painter, Weir retired from West Point. For the next three years he occupied a waterfront studio at Castle Point in Hoboken, New Jersey, before moving to New York City. Remaining active in retirement, he gave newspaper interviews befitting his position as a dean of American art, embarked on an ambitious sequence of history paintings, and at least once—in the present work—turned his attention to the daily proceedings outside his New Jersey residence. Speaking of this work, he explained the scene to a writer for the *New York Times*:

Here is a view I took from my window in Hoboken a year ago. It is just evening, and you see the gleam of lamps on the opposite side of the North River. It is a dim light and a sombre picture, but those coal barges are typical of that particular wharf (March 28, 1880).

Considering Weir's lingering preoccupation with the momentous events of human history, this picture offers an unusually direct characterization of modern urban industry. As Graham Hood observed (Hood et al. 1977), the frank modernity, nocturnal lighting, strong silhouettes, heavy atmosphere, and carefully scattered genre and rustic details bring to mind James McNeill Whistler's work from the 1860s as well as two heroic paintings of industrial subjects by Weir's son John, *The Gun Foundry* (1866; Putnam County Historical Society, Cold Spring, N.Y.) and *Forging the Shaft* (1867; destroyed). We know that the elder Weir was well aware of Whistler's art and reputation. As an army cadet between 1851 and 1854, Whistler had been Weir's prize pupil in drawing and, in the same newspaper article (quoted above) in which he described the Detroit picture, Weir praised his former student as "the gentleman of the Nocturnes in blue and silver." Furthermore, Weir would have been well aware of the grander conceptions of his son as well as their European antecedents. In 1876 John Ferguson Weir exhibited a composition titled *Tapping the Furnace* (unlocated) at the National Academy of Design and the following year painted a replica of the destroyed *Forging the Shaft* (Metropolitan Museum of Art, New York). The new version was shown in the American section of the International Exposition of 1878 in Paris and at the National Academy

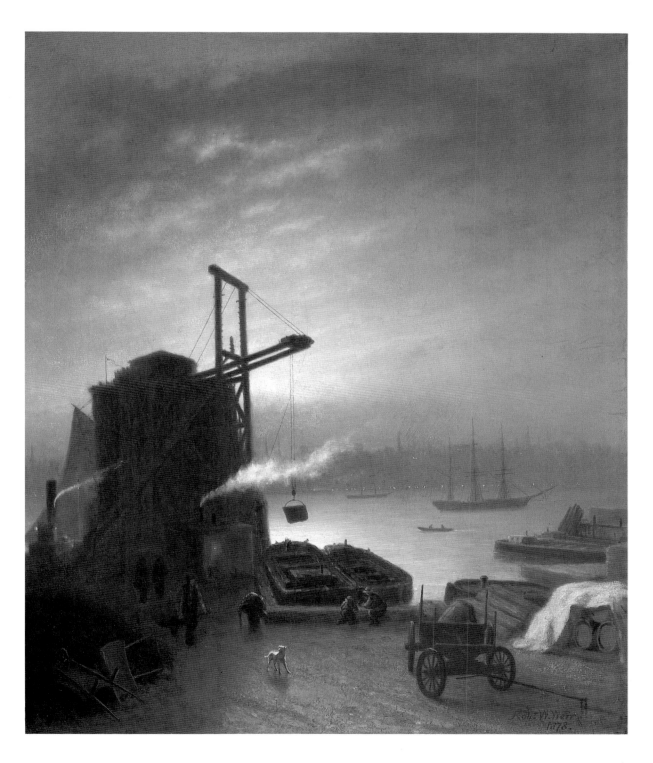

The Hudson River from Hoboken

of Design in 1879. Some reverberations of his son's recent activities can be measured in the fire and smoke in the present Hoboken harbor scene. As a painter whose works were notable for their "Flemish vein" (to use Henry Tuckerman's words [1867, 22]), Robert Weir must have been familiar with baroque and eighteenth-century figural and landscape compositions combining moonlight with pockets of the manmade firelight produced by campfires, farriers' forges, and industrial furnaces.

Nearly as close at hand were the many nineteenth-century depictions of local industry along the length of the Hudson River and views of Manhattan itself. The most spectacular of the latter, George Loring Brown's *Bay and City of New York at Sunrise* (Royal Collection, England), had been exhibited in New York in 1860 to large audiences and wide acclaim before it was acquired by the Prince of Wales and was reproduced in an engraving. Probably the most pertinent precedents, however, were Weir's own paintings of the Hudson, that artery of history, natural scenery, and commerce with which he had been closely associated for most of his life. His *Landing of Henry Hudson* (ca. 1838; Joslyn Art Museum, Omaha, Nebr.), *View on the Hudson River from West Point* (1864; United States Military Academy, West Point), and the present picture constitute an actual rather than mythical "Course of Empire." In these paintings, following but also diverging from paths taken by William Guy Wall (1792–after 1864) and Francis Guy (q.v.), Weir depicted the evolution of the river from discovery-colonization through militarization-domestication and urbanization-industrialization.

G. C.

Inscriptions At lower center, *Robert W. Weir / 1878*

Provenance Private collection, Boston. Kennedy Galleries, New York, 1969. Acquired in 1969.

Exhibitions West Point 1976, 39, no. 76. Annandale-on-Hudson et al. 1983, 83–86, 104, no. 67.

References Weir 1947, 141. Hood et al. 1977, 82–83.

Benjamin West

1738 SPRINGFIELD, PENNSYLVANIA—
LONDON 1820

Benjamin West was born and raised in a rural Quaker community in colonial Pennsylvania, although he was not himself a Quaker, and he commenced his career as an artist in Philadelphia. He spent three years, from 1760 to 1763, in Italy, then proceeded to London, where he remained for the rest of his life. In 1768 he was one of the founding members of the English Royal Academy. In the same year, he received his first commission from King George III, the academy's ardent and active patron, for whom West painted some sixty pictures between 1768 and 1801. In 1772 he was named historical painter to the king; beginning in 1780 he received a royal stipend of one thousand pounds per annum; and in 1792 he succeeded Sir Joshua Reynolds as president of the Royal Academy.

In America, West worked primarily as a portraitist, and he continued to paint numerous portraits during his early years in England. He had begun also to paint pictures of historical subjects before leaving America. Having come into contact with the nascent neoclassical movement in Rome, he achieved recognition in the later 1760s as the chief proponent in England of neoclassical historical painting. In 1771 he first exhibited a painting of a recent British historical event, *The Death of General Wolfe* (National Gallery of Canada, Ottawa), which instantly became one of the most celebrated and influential paintings of the eighteenth century. He subsequently produced many paintings of subjects from British history and literature, in an increasingly neobaroque or protoromantic, rather than neoclassical, manner. After 1780 the largest part of his output consisted of paintings of biblical subjects, most prominently two series of works commissioned by George III for chapels at Windsor Castle. In 1801 West's royal commissions came to an end, but in 1811 the British Institution purchased his large *Christ Healing the Sick* for the unprecedented sum of three thousand guin-

eas. The popular, as well as pecuniary, success of that work led him to paint two still-larger sequels—*Christ Rejected*, completed in 1814, and *Death on the Pale Horse*, completed in 1817—both of which he exhibited to enormous audiences in specially rented premises (both paintings are now in the collection of the Pennsylvania Academy of the Fine Arts, Philadelphia).

During the first twenty years of the nineteenth century, the venerable president of the Royal Academy was the best-known artist in England. After his death, West's sons turned his home and studio into a public gallery of his paintings, but his reputation soon began to slip, and it has not yet significantly recovered. He produced an immense quantity of work over a period of more than sixty years, the quality of which is variable. Nevertheless, his historical importance is indisputable. Although he never returned to his native shores after his twenty-second year, West played a central role in the history of American art as the teacher of three generations of American painters who traveled to England to work under his tutelage.

A. S.

Bibliography Von Erffa and Staley 1986.

106

The Last Supper, 1786

Oil on canvas
250 × 360 cm (98 × 140½ in.)
Founders Society Purchase, Robert H. Tannahill Foundation Fund and Gibbs-Williams Fund (80.101)

The Last Supper is described in all four Gospels (Matthew 26:17–29; Mark 14:12–25; Luke 22:7–38; and John 13:21–30), and the subject has been depicted so frequently in Western art that most paintings showing it owe their inspiration more to general pictorial tradition than to specific lines in the Bible. Nevertheless, West's *Last Supper* in Detroit

does illustrate John 13:30, which describes the departure of Judas following his being singled out as the future betrayer of Christ. The bag that Judas holds in his left hand is mentioned in the preceding verse; it contains the thirty pieces of silver that Judas has been paid by the priests, but the apostles believe that Judas is carrying it because Christ has instructed him either to buy things for the feast or to give money to the poor. Peter sits on Christ's right and John on his left. John's head is lowered in accordance with descriptions of his leaning on Jesus and lying on his breast in John 13:23 and 25.

West painted this large work to serve as the altarpiece of Saint George's Chapel at Windsor. *The Last Supper* was installed in December 1786 in a neo-Gothic reredos designed by Thomas Sandby (1721–1798) and carved by Henry Emlyn (1725–1815). It was situated over the communion table and under a huge stained-glass window showing the Resurrection, executed after designs by West and also installed in 1786. Several late-eighteenth- and early-nineteenth-century views of the interior of the chapel show it in situ (see Von Erffa and Staley 1986, 90).

West's work in Saint George's Chapel constituted only part of his activities at Windsor Castle between 1779 and 1801; two other paintings in the Detroit collection, *The Burghers of Calais* and *Death on the Pale Horse* (cat. nos. 107 and 109), likewise owe their inception to ambitious programs for the castle undertaken by West at the behest of George III. A project to restore the medieval physical fabric of Saint George's Chapel was commenced in 1776. According to contemporary sources, it was George III who initially conceived the idea of decorating the east end of the choir with a stained-glass window, and the window was paid for via a subscription organized by the canon of the chapel and approved by the king in 1782. George III himself then commissioned the painting of *The Last Supper* by West and presented it to the chapel. There it replaced a seven-

teenth-century painting of the same subject, which was reinstalled in the Windsor parish church. The price of the picture, recorded in accounts drawn up by the artist for the king in 1797 and 1801, was seven hundred guineas.

West subsequently designed several more windows for the chapel. In the middle of the nineteenth century, when the eighteenth-century improvements were considered out of harmony with the late-Gothic structure they embellished, West's windows were removed and destroyed, and in 1863 the altarpiece was relegated to an ambulatory behind the altar. It was later removed from public view entirely and stored in the Chapter Library.

The altarpiece for Saint George's Chapel was the second painting of the Last Supper commissioned by George III for chapels at Windsor Castle and painted by West within a span of two years. The other *Last Supper*, which is now in the Tate Gallery in London, was part of a series of paintings of biblical subjects intended for the royal chapel in the state apartments. That work is not dated, but it appeared at the Royal Academy in 1785. The Detroit *Last Supper*, which is signed and dated 1786, was not exhibited during West's lifetime. The Tate painting is somewhat smaller (184 × 277 cm), and there are numerous differences between the two works (most conspicuously in the earlier picture: Judas is in the background; the positions of Peter and John are reversed; the architectural settings differ; the vantage point is higher; and the figural scale in relation to the size of the canvas is smaller). Nevertheless, the compositions and many details are sufficiently similar to allow us to think of the Detroit painting as a development and refinement of West's earlier treatment of the subject.

A drawing in the Royal Library at Windsor, which West must have made about 1779 or 1780 as a study for the altar wall of the royal chapel in the state apartments, shows a *Last Supper* over the communion table in the position that the Tate Gallery picture was later painted to fill (see Von Erffa and Staley 1986, 579). The composition of the painting in that drawing is not particularly close to either of the two *Last Supper*s that West subsequently painted, but a large arched opening in the center of the background does prefigure a similar round arch in the background of the Detroit work. A drawing that has elements in common with both the Tate and Detroit pictures, which West evidently made while reshaping the composition of the former before starting to paint the latter, is in the Pierpont Morgan Library (see Kraemer 1975, pl. 27). This may be the *Design for the Altar Piece, in Saint George's Chapel, Windsor* sold by Benjamin West, Jr., in 1839 (described as in black chalk, washed with bister [S. Leigh Sotheby, London, June 1, 1839, lot 88]).

A monochromatic oil sketch (49.5 × 69.9 cm) showing essentially the same composition as the Detroit work, but with numerous slight differences in details, is in the University of Virginia Art Museum, Charlottesville (Von Erffa and Staley 1986, 355). It is signed and dated 1787, so if West painted it as a preliminary sketch for the Detroit painting, as the changes in details seem to suggest, he may have continued to work on it after completing the large picture. This sketch may have been *The Last Supper, the original sketch for the great picture over the communion table in the Collegiate Church, Windsor*, which was exhibited by West at the Royal Academy in 1804 (no. 28). Another smaller, painted study (unlocated) for the Detroit painting is recorded as having been sold by West's sons (Robins, London, May 22–25, 1829, lot 21: *The study for the admired picture, placed over the table of the Altar of the choir of Saint George's chapel, Windsor*, 26.7 × 35.6 cm).

John Thomas Smith (1766–1833), the future keeper of prints at the British Museum, claimed to have sat for the head of Saint John in the *Last Supper* that was painted for Saint George's Chapel (Smith 1845). But in her memoirs, Charlotte Papendiek, who had been a member of the court at Windsor, wrote that West's elder son, Raphael (1766–1850), posed for Saint John (Papendiek 1887).

In 1791 Horace Walpole visited Windsor and sent an account of what he saw to his friend Mary Berry. After describing the east window of Saint George's Chapel, he continued: "and there is a Judas below so gigantic, that he seems more likely to burst by his bulk than through guilt" (Walpole 1944). Similar criticisms of the towering figure of Judas in the *Last Supper* were evidently widespread, leading the author of *The Windsor Guide*, a local guidebook first published in 1792, to come to the work's defense: "those who affect to be critics pretend that the figure of Judas is too predominant, 'though real judges esteem the whole a masterly composition."

A. S.

Inscriptions At lower left, *B. West 1786*

Provenance Commissioned by George III and presented by him in 1786 to Saint George's Chapel, Windsor. Sale, Dean and Canons of Windsor, Sotheby's, London, June 2, 1978, lot 132. Somerville and Simpson (dealer), London, and P. and D. Colnaghi (dealer), London. Acquired in 1980.

Exhibitions Washington and Philadelphia 1980, 19, fig. 4.

References Windsor Guide 1792, 63. *Academic Annals* 1805, 68. *Public Characters* 1805, 562. *Universal Magazine* 1805, 528. Barlow 1807, 433. *Belle Assemblée* 1808, 15. Pyne 1819, 2: 182. Galt 1820, 220. Smith 1845, 77. Papendiek 1887, 2: 278. Hope 1913, 2: 388–389, 426–427. Walpole 1944, 11; 363. Von Erffa 1969, 22, 29. Kraemer 1975, 28–29. Dillenberger 1977, 96–97, 147, 153, 212. Farington 1978–84, 6: 2412. Meyer 1979, 56, 58. San Antonio 1983, 51, 53. Von Erffa and Staley 1986, 354–355, no. 346.

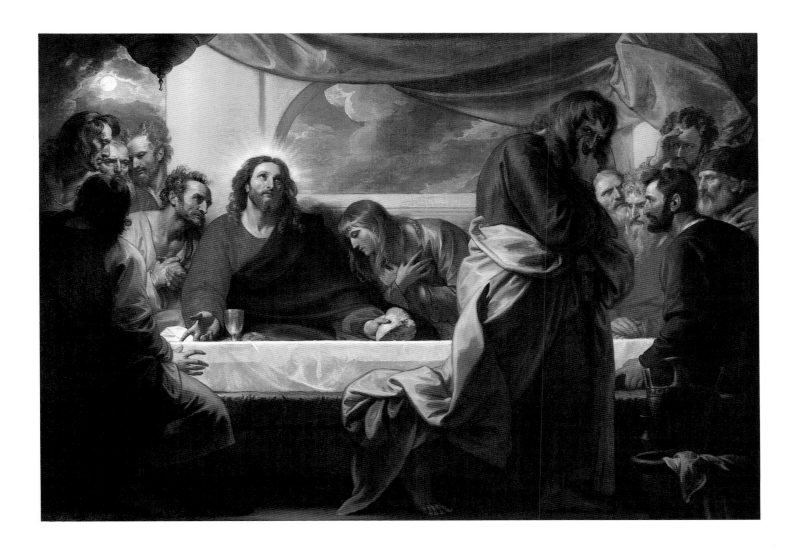

107
The Burghers of Calais, 1788

Oil on canvas
100.3 × 132.7 cm (39½ × 52¼ in.)
Gift of James E. Scripps (89.73)

On August 3, 1347, the French port of Calais surrendered to an English army led by King Edward III, following a siege that had lasted almost a year with great suffering on both sides. Edward agreed to spare the inhabitants on the condition that six of the town's most considerable citizens be sent to him, bareheaded and barefooted, with ropes around their necks, carrying the keys of the city. When they appeared, Edward ordered their execution but subsequently yielded to a plea from his queen, Philippa, that he spare their lives. The chief source for the story is the contemporary French chronicler Jean Froissart (ca. 1337–1410), whose descriptions of historical events were translated into English in the sixteenth century. When West painted this picture, the most up-to-date account would have been David Hume's *History of England*, published between 1754 and 1762. For costume and other details, West probably used *The Regal and Ecclesiastical Antiquities of England* (1773), and *Honda Angel-cynnan or, A compleat View of the Manners, Customs, Arms, Habits, etc. of the Inhabitants of England* (1774–76) by the antiquarian Joseph Strutt (for which, see Strong 1978, 50–52, 80–85).

In West's painting, Edward's intended victims stand on the left, led by Eustace de Saint Pierre, the wealthiest citizen of the town and the first to volunteer to sacrifice himself for the sake of his neighbors. The keys to the city, a French flag, and a sword lie on the ground in the center of the picture between Saint Pierre and the English king. On the right behind Edward are the Prince of Wales, the Earl of Warwick, and Lord Stafford, who had previously attempted in vain to persuade him to be merciful. If West had illustrated

Froissart exactly, Queen Philippa, large with child, would be on her knees before the king, and the six burghers would also be shown on the ground, pleading with upraised hands for their lives. His transformation of the subject into a dignified confrontation between proud adversaries is probably attributable to eighteenth-century distaste for the cruelly authoritarian behavior that Edward was said to have displayed on this occasion. (In discussing the incident, Hume questioned Froissart's reliability and whether in fact Edward had determined to execute his prisoners, since such a barbarous decision seems radically inconsistent with his usual generosity and humanity.)

West undertook the subject as part of a commission from George III to decorate the Audience Chamber in Windsor Castle. Between 1786 and 1789, he painted for that room one picture of Saint George and the dragon and seven scenes from the reign of Edward III (1327–77) (for the series as a whole see Millar 1969, 1:132–135; 2: pls. 125–128; Strong 1978, 78–85, pls. 85–95; Von Erffa and Staley 1986, 192–203). Edward had been closely associated with Windsor Castle and in 1348 founded the Order of the Knights of the Garter, whose spiritual home was Saint George's Chapel at Windsor, and whose patron saint was Saint George. In the late 1770s George III commenced a program of restoration of Windsor Castle after a long period of neglect in order to be able to use it as a royal residence; he was also deeply concerned with the reform and rejuvenation of the Order of the Garter. These royal activities both reflected and stimulated the widespread growth of interest in the Middle Ages during the last quarter of the eighteenth century.

The series of paintings for the Audience Chamber was one of three major groups of works for Windsor upon which West was engaged during the 1780s. The other two consisted of biblical paintings for the royal chapel in the state apartments (for which, see *Death on the Pale*

Horse, cat. no. 109) and designs for stained-glass windows plus an altarpiece (*The Last Supper,* discussed in cat. no. 104) for Saint George's Chapel. Unlike these two groups of works, the scenes from the reign of Edward III are scenes of secular events from British history.

According to West's biographer, John Galt, the project was conceived in a conversation between the artist and the king:

Mr. West happened to remark, that he had been much disgusted in Italy at seeing the base use to which the talents of the painters in that country had been too often employed; many of their noblest efforts being devoted to illustrate monkish legends, in which no one took any interest, while the great events in the history of their country were but seldom touched. This led to some further reflections; and the King, recollecting that Windsor-Castle had, in its present form, been erected by Edward the Third, said, that he thought the achievements of his splendid reign were well calculated for pictures, and would prove very suitable ornaments to the halls and chambers of that venerable edifice (Galt 1820, 51–52).

Thus we see in West's series an appeal to national pride mingled with a distinctly monarchical view of history. West was not the first artist in England to paint such subjects: Robert Edge Pine had won a premium from the Society of Arts in 1760 with his painting *The Surrender of Calais to Edward III* (unlocated; see Strong 1978, pl. 6; for two other eighteenth-century treatments of the subject, see Strong, pls. 15 and 16). West himself had painted subjects from British history as early as 1770 (in *The Death of General Wolfe;* National Gallery of Canada, Ottawa) and from the Middle Ages as early as 1772 (in *The Death of the Chevalier Bayard;* royal collection, England). Nevertheless, the paintings for the Audience Chamber constitute the most ambitious sequence of paintings from British history or from medieval history to have been produced in the eighteenth century, and their importance for the efflorescence of this type

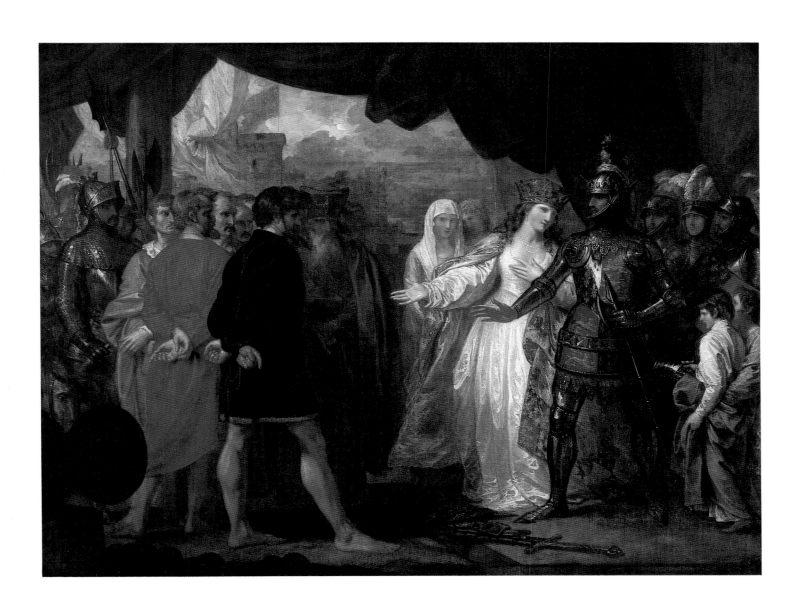

of subject matter in the nineteenth century was immense.

The scene at Calais that West painted for the Audience Chamber is in the English royal collection and, although not in the Audience Chamber, it is still at Windsor, hanging in the Chapter Library of Saint George's Chapel. The work is signed and dated 1789 and is approximately the same height but some eight inches wider than the Detroit painting (see Von Erffa and Staley 1986, 197–198). It shows basically the same composition, but in reverse— Saint Pierre and his companions are on the right—and there are numerous differences in lesser details. Furthermore, the added eight inches of width allows space on the right edge of the composition for a group of distressed women and children who have no counterparts in the Detroit picture.

The painting in Detroit is signed and dated 1788, and West exhibited it at the Royal Academy in that year (he never exhibited the Windsor version). It is not a sketch but a finished work in its own right. Comparable full-size variants of the other paintings in the Audience Chamber do not exist, and no documentation is known that explains why West painted two versions of this subject. Since he painted it before the picture he ultimately created for the Audience Chamber, he may have intended it originally for the chamber, only to replace it subsequently, for reasons unknown.

An oil sketch for the composition, dated 1787, is in a private collection (see Von Erffa and Staley 1986, 199). Like the painting in the royal collection, it shows the king and queen on the left, and in most respects it is closer to the painting at Windsor than to the one in Detroit, but it does not include the group of women and children who stand on the right side of the final version of the composition. A rather faint drawing of the subject, which

is not very close to either of the finished pictures, but which does show the king and queen on the right, is in the Delaware Art Museum, Wilmington (unpublished). A drawing of details from a fourteenth-century manuscript in the King's Library in the British Museum, which West may have used for the bearded man at the center of the composition wearing a long robe and high headdress, is in the Pierpont Morgan Library, New York (see Kraemer 1975, 29–30, no. 44, pl. 28).

A. S.

Inscriptions At lower left, *B. West/1788*

Provenance Thomas Hankey sale, Christie's, London, June 7–8, 1799, lot 20. John Willett sale, Peter Coxe, London, June 1, 1813, lot 79. James E. Scripps, Detroit. Acquired in 1889.

Exhibitions London, Royal Academy, 1788, no. 89. Detroit 1921, no. 31. Des Moines 1960. Allentown 1962, no. 17.

References *Public Characters* 1805, 563. *Universal Magazine* 1805, 529. Barlow 1807, 433. *Belle Assemblée* 1808, 16. Galt 1820, 224. Scripps 1889, no. 85. G. Evans 1959, 69, pl. 50. Millar 1969, 1: 133. Dillenberger 1977, 162. Rosenblum and Janson 1984, 19, fig. 7. Von Erffa and Staley 1986, 198–199, no. 65.

108

King Lear, ca. 1788

Oil on canvas
52.1 × 69.9 cm (20½ × 27½ in.)
Founders Society Purchase, Gibbs-Williams Fund (77.58)

This oil sketch illustrates the fourth scene of the third act of Shakespeare's tragedy *King Lear*. An engraving published in 1793 after West's large final version of the composition (discussed below) is inscribed with Lear's words, "Off, off, you lendings! Come, unbutton here" (lines

107–108), accompanied by the stage direction "Tearing off his clothes." The scene takes place before a hovel on the heath during a raging storm. The main characters shown by West are, from left to right: Gloucester, the Fool, Lear, Kent, and Edgar, disguised as a madman. In addition, Cordelia and her maid Arante are discernible as tiny figures in the distance in the lower left corner, although, according to Shakespeare's text, they do not belong in this scene. Their inclusion is based on eighteenth-century modifications in productions of *Lear*, which followed the adaptation by Nahum Tate first performed in 1681. Tate introduced a romance between Edgar and Cordelia into the play, and in the third act of Tate's version, instead of going to France, where Shakespeare sends her, Cordelia wanders onto the heath. There, two ruffians attack her, and Edgar saves her. Gloucester, who enters the scene at the moment Lear begins to tear off his clothes, is described in the stage directions as carrying a torch, which prompts the Fool's declaration in the following lines, "Look, here comes a walking fire." Edgar's bare limbs are also of central importance in the scene, as his state of undress provokes Lear to remove his clothes in emulation.

The Detroit picture is a preparatory sketch for a large work (Museum of Fine Arts, Boston, oil on canvas, 271.8 × 365.7 cm; see Von Erffa and Staley 1986, 100, 272) completed in 1788 for the gallery of paintings of Shakespearean subjects sponsored by the London print publishers John Boydell and his nephew Josiah Boydell. The larger work was one of three paintings of scenes from *Lear*, all approximately the same size, that appeared together in the opening exhibition of the Boydell Shakespeare Gallery in May 1789. The other two were *Lear Cursing Cordelia* by Henry Fuseli, illustrating the opening

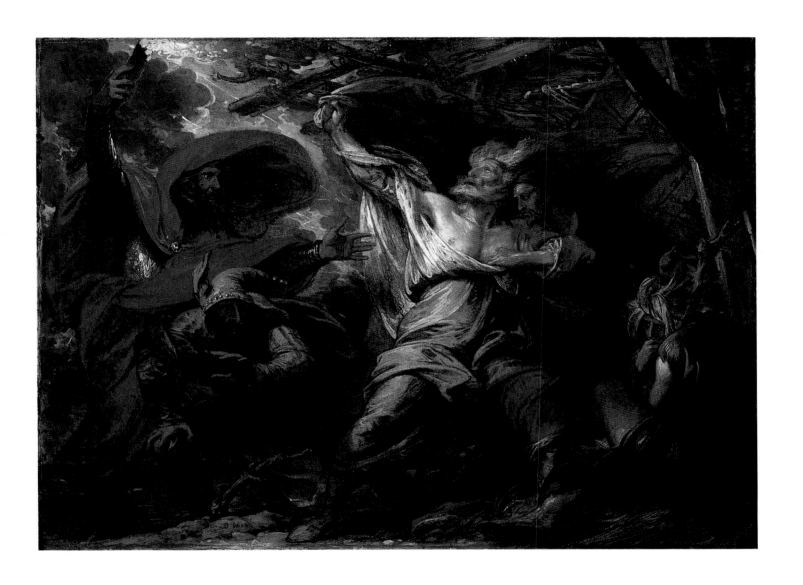

scene of the play (Art Gallery of Ontario, Toronto), and *Lear Weeping over the Dead Body of Cordelia* by James Barry (Tate Gallery, London). West subsequently also painted for the gallery a scene from the fourth act of *Hamlet* (1792; Cincinnati Art Museum).

The Boydell Shakespeare Gallery was the most ambitious venture in private patronage in eighteenth-century England. One of its purposes, which West certainly had a hand in formulating, was to encourage an English school of history painting devoted to native subject matter. The gallery was to be paid for by the sale of engravings after the pictures, and the Boydells did publish two series of prints, some two hundred in all, after the paintings they had commissioned from virtually all of the leading artists of the period (for a full discussion, see Friedman 1976; the prints are all reproduced in *The Boydell Shakespeare Prints*, New York: Benjamin Blom, 1968). Upon the dispersal of the Boydell collection in 1805, West's two paintings were bought by Robert Fulton, who sent them to America to be placed on exhibition in the newly founded Pennsylvania Academy of the Fine Arts in Philadelphia. There they were the first important works by West to be visible to the public in his native land.

At the same time that West's large *Lear* was hanging in the opening display of the Boydell Shakespeare Gallery in Pall Mall, an oil sketch appeared in the Royal Academy exhibition of 1789, the only work West exhibited there that year. It was identified in the catalogue as *King Lear, a finished sketch for the Gallery of Shakespear,* and it was mentioned in a review of the Boydell Gallery in *The Public Advertiser* for June 5, 1789, which declared about the large work: "the figure of Edgar and some other parts of the picture are varied from the sketch, and they are improved." Prior to 1977, it was generally

assumed that a small version of the subject belonging to the Museum of Art of the Rhode Island School of Design in Providence (see Sund 1980, fig. 3) was the sketch in question, but that picture shows no differences from the Boston painting of a sort that would have elicited comment in a contemporary review. It is not sketchlike in handling, and in the opinion of the present writer, it is a copy of the large painting rather than a study for it—possibly one of two recorded copies of the painting by Rembrandt Peale (q.v.) and James Ward (1769–1859), the latter painted over a print.

The Detroit picture, which came to light in 1977 after being long lost, does show Edgar's head in a markedly different position from the one in the final painting. Kent's head and expression also differ considerably in the two works. While the Detroit painting bears a signature that does not appear to be in West's hand, the manner of painting is completely consistent with the relatively free use of paint in West's sketches, and the work's provenance can be traced back to William Beckford, one of West's chief patrons.

The Detroit work is truly a sketch in handling, yet it is sufficiently complete as a picture to be described as a "finished sketch," and there can be little doubt about identifying it as the sketch exhibited at the Royal Academy in 1789. Since the large painting was undertaken on commission and left West's possession as soon as it was completed, the Detroit sketch is almost certainly the *King Lear in the Storm at the Hovel* recorded as being in the gallery in West's home in a catalogue of his works first published in *Public Characters of 1805* and frequently reprinted.

We do not know when the sketch left West's possession. It was not included in any of the sales of his estate in 1829.

William Beckford, who subsequently owned it, bought most of his works by West in the years 1797 to 1799, while he was building Fonthill Abbey, but the sketch is not mentioned in any descriptions of the abbey's contents. It is first recorded as belonging to Beckford in an anonymous account (Lansdown 1893) of an 1838 visit to his later home in Lansdown Crescent in Bath, and a plausible theory is that Beckford acquired it from West's sons sometime between 1822, when he sold Fonthill Abbey, and 1829, when they would have put it up for auction if it had still been in their possession.

Writing about the small version of the subject in Rhode Island, Helmut Von Erffa (1956, 7) pointed out the dependence of the composition upon West's earlier *Cave of Despair* of 1772 (Yale Center for British Art, New Haven), and he noted how West's Raphaelesque manner had evolved into a Rubensian baroque style by 1788. Von Erffa also suggested that West ultimately based his Lear on the *Laocoön.* More recently, in an article about the Detroit sketch, Judy Sund (1980) argued that the *Dioscuri,* or horse tamers, on Monte Cavallo in Rome, which West had seen and admired (see Galt 1816, 107–109), provide closer parallels. She has also pointed out the similarities in Edgar's pose to that of Michelangelo's figure of Day in the Medici Chapel in Florence.

In 1839 William Beckford's visitor wrote the following glowing account of the sketch, which was then hanging in the dining room in Lansdown Crescent:

A most wonderful performance. The expression of the face of the poor mad king is astonishing; the colouring rich and mellow—nothing of West's usually hard outline. The whole picture is full of energy and fire, and seems to have been struck off with the greatest ease and rapidity. "Do observe the face of Edgar," said Mr. Beckford. "Under his assumed madness you trace a sentiment of respect and anxiety

for the monarch; he could not forget that it was his sovereign." "I have seen," I said, "most of West's greatest pictures, but there is more genius in that sketch than in anything I ever saw of his. I think he took too much pain with his sketches. The consequence was that the original spirit evaporated long before the completion of the great tame painting, where his men and women too often look like wooden lay figures covered with drapery."

The two men then went on to discuss West's sketch of *Death on the Pale Horse*, which is now also in Detroit and is the subject of the following entry.

A. S.

Inscriptions At lower left, *B. West*

Annotations On a label formerly affixed to the back of the painting, *Hamilton Palace, no. 1068*

Provenance William Beckford, Bath, by 1838; his daughter Euphemia, wife of the tenth Duke of Hamilton; the twelfth Duke of Hamilton. Hamilton Palace sale, Christie's, London, June 17–July 20, 1882, lot 1068. H. Graves and Co. (dealers), London. Thomas B. Walker, Minneapolis, 1909. Harry W. Peterson, 1937. Frank Gunter, Champaign, Illinois, 1977. Acquired in 1977.

Exhibitions London, Royal Academy, 1789, no. 88. London, British Institution, 1862, no. 183. Minneapolis 1909, no. 91. San Jose 1978, 28–29, no. 2.

References Public Advertiser 1789. *Public Characters* 1805, 566. *Universal Magazine* 1805, 530. *Belle Assemblée* 1808, 17. Galt 1820, 229. Lansdown 1893, 13. Adams 1927, 170, no. 317. Friedman 1976, 150. Dillenberger 1977, 174. Sund 1980, 127–136. Von Erffa and Staley 1986, 273, no. 211.

109

Death on the Pale Horse, 1796

Oil on canvas
59.7 × 128.3 cm (23½ × 50½ in.)
Founders Society Purchase, Robert H. Tannahill Foundation Fund (79.33)

The final book of the Bible, the Revelation of Saint John the Divine, often referred to as the Apocalypse, describes visions that prophesy events leading to the millennium: the second coming of Christ and the Last Judgment. In the sixth and seventh chapters, the Lamb of God opens a book closed with seven seals. The pale horse of the picture's title appears following the opening of the fourth seal:

And when he had opened the fourth seal, I heard the voice of the fourth beast say, Come and see. And I looked, and behold a pale horse: and his name that sat on him was Death, and Hell followed with him. And Power was given unto them over the fourth part of the earth, to kill with sword, and with hunger, and with death, and with the beasts of the earth (Revelation 6:7–8).

The rider on the pale horse is at the center of the composition; creatures from Hell trail behind him at the upper right; and scenes of killing by the sword, by hunger, by plague (the usual interpretation of "to kill . . . with death"), and by animals, both wild and domestic, fill the bottom and left side of the canvas. On the right are the apparitions revealed by the opening of the first three seals: a white horse whose rider wears a crown and carries a bow; a red horse whose rider wields a sword; and behind them, a black horse whose rider carries a pair of scales.

West used the title *The opening of the four seals (vide Revelation)* when he first exhibited the Detroit picture at the Royal Academy in 1796. He re-exhibited it six

years later in the Paris Salon of 1802 as *Esquisse représentant la Mort sur le cheval pâle, ou l'ouverture des Sceaux, 6ᵉ c. des Révél., v. 7 et 8.* When he had exhibited an earlier version of the composition in 1784, he had called it *The Triumph of Death from the Revelation.* A third and final treatment of the subject completed in 1817 was first exhibited and has always been known as *Death on the Pale Horse.*

The entries in the Royal Academy catalogues of 1784 and 1796 also bore subtitles identifying the exhibited works, respectively, as a design and as a sketch for His Majesty's Chapel in Windsor Castle. (The chapel referred to is not Saint George's Chapel at Windsor, for which West painted *The Last Supper* discussed in a preceding entry [cat. no. 104], but the royal chapel in the state apartments, which was never completed.) From 1779 to 1801, the preparation of a series of huge pictures of biblical subjects for this chapel was the dominant activity of West's life. He intended to paint possibly as many as thirty-five or thirty-six works for the project and had completed some eighteen before it was called off in 1801. Several drawings that West probably made in 1779 or 1780 in conjunction with Sir William Chambers, the court architect, presumably show what the artist, the architect, and their royal patron intended at the inception of the project. One of these (Royal Library, Windsor Castle; see Von Erffa and Staley 1986, 578) shows a wall of five windows with five horizontal pictures illustrating subjects from Revelation above them. The four horsemen are recognizable in the second of the five (in left-to-right sequence), but in a composition that does not show any significant similarity to that of the picture in Detroit. West did work out his eventual composition in a large and highly finished

drawing, signed and dated 1783, which now belongs to the Royal Academy (see Von Erffa and Staley 1986, 390). This was *The Triumph of Death*, the design for the chapel that he exhibited in 1784. He then seems to have done nothing further with the subject until 1796, when he exhibited the Detroit picture, identifying it as a sketch for the chapel. He never painted a full-size version, which would have measured approximately six by nine feet, for Windsor, but he returned to the subject once again in 1815 to commence a huge painting, which he completed and exhibited in 1817 as the final great achievement of his long career (oil on canvas, 447×765 cm, Pennsylvania Academy of the Fine Arts, Philadelphia; Von Erffa and Staley 1986, 148, 388–390).

For the Windsor chapel, West painted one other sketch of a subject from Revelation, *The Destruction of the Beast and False Prophet*, which he completed and exhibited in 1804 (Minneapolis Institute of Arts; Von Erffa and Staley 1986, 397). In 1796 or the following year, he also received a commission from William Beckford to execute a series of paintings for a "Revelation Chamber," which Beckford intended to incorporate into Fonthill Abbey, the vast neo-Gothic edifice he began to build in 1796. The Revelation Chamber, the idea of which may well have been prompted by Beckford's viewing of *Death on the Pale Horse* at the Royal Academy in 1796, was, like the royal chapel, never realized, but several of West's oil sketches for it do exist, and their visionary subject matter makes them the thematic sequels of *Death on the Pale Horse* (see San Antonio 1983, 56–73).

West's three treatments of *Death on the Pale Horse,* from 1783, 1796, and 1815–17, reveal only relatively slight modifications in composition during the thirty-four-year period of the theme's gestation, but they do show numerous and significant changes in detail. A kneeling figure with arms outstretched in the lower left corner

of the drawing of 1783 has been replaced in the Detroit painting by a man holding a spear, and this figure has been integrated into a much more cohesive group with others near him. A youth being struck by lightning, at the extreme left edge of the Detroit canvas, replaces a fleeing family in the earlier work. The scene of distant battle on the extreme right of the Detroit work, below the hooves of the white horse, replaces a group of much larger fleeing figures. And so on.

In 1815 West began the large, final version of *Death on the Pale Horse* by having his son Raphael copy the outlines of the composition from the Detroit sketch onto the larger canvas (Dunlap 1834, 2: 147). Hence the final picture repeats the Detroit painting even more closely than the Detroit painting repeats the drawing of 1783. In proportion the Pennsylvania Academy's painting is somewhat more vertical and less horizontal than the Detroit version, and consequently the lateral spacing is contracted throughout. There is also one major iconographic change: the fierce warrior on the white horse in both earlier versions has become a figure of Christ, who gazes beatifically toward a visionary group of white-robed figures in the sky at the upper right. These are "the souls of them that were slain for the word of God," revealed to John after the opening of the fifth seal (Revelation 6:9–11), and their presence accounts for a subtitle, *The Opening of the First Five Seals,* used in the catalogue published to accompany this work in 1817 (London 1817). An eagle attacks a heron in the sky in the upper left of the final version, while in the drawing of 1783 two eagles assault a heron. Two eagles attacking a heron can also be seen in a similar position in an outline engraving after the Detroit picture, first published in 1807 (see *Belle Assemblée* 1808, opp. p. 55). Nevertheless, this group does not appear in the Detroit picture itself, and an examination of the canvas (by Barbara Heller in the Conservation Services Laboratory

of the Detroit Institute of Arts in September 1980) did not reveal any evidence to suggest that the birds had once been there and had subsequently been painted out. This odd discrepancy between the print and the picture, which the engraving otherwise reproduces faithfully, could hardly have resulted from the anonymous engraver's attempt to improve the work on his own initiative, but must have been dictated by West, anticipating his reintroduction of a scene of fighting birds in the final, large painting begun eight years later.

Two copies of the Detroit composition belong to the Philadelphia Museum of Art (see Dillenberger 1977, pls. 63 and 65). Both have been exhibited and reproduced as works by West, but neither is signed, neither has any recorded history prior to 1928, and, in the opinion of the present writer, neither shows any sign of having been painted by West himself. Fiske Kimball, a former director of the Philadelphia Museum, who was responsible for the acquisition of both pictures, asserted on several occasions that the larger of the two was the painting of the subject exhibited by West in Paris in 1802 (see below), but there is no evidence to sustain his claim. In 1820, in an obituary article about West, William Carey, who had published a book-length treatise about the final version of the *Pale Horse* of 1815–17, stated explicitly that it was the Detroit picture (then in the collection of Lord Egremont) that West had exhibited in Paris (Carey 1820, 696–697).

The Detroit *Pale Horse*, magnified to the scale of the painting in the Pennsylvania Academy, appeared in the background of a portrait of West by James Green (1771–1834) that was exhibited at the Royal Academy in 1817. Green's painting was acquired by the Metropolitan Museum of Art in 1923 as a self-portrait by West. At some later time, it was cut down to a bust-length portrait, and the part of the

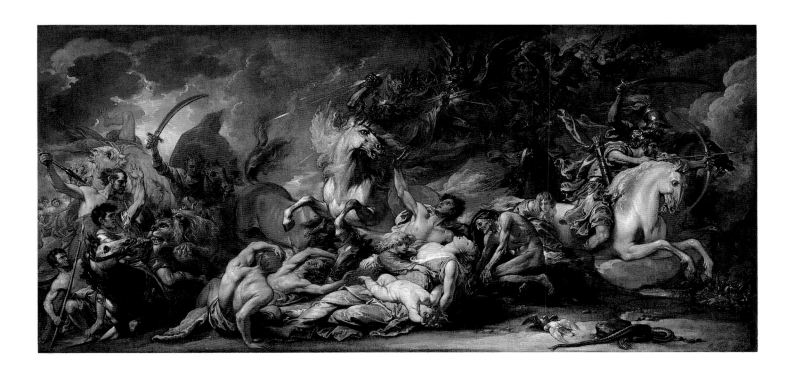

background showing the pale horse became a separate painting, which the museum lent to a West exhibition at the Graham Gallery in New York in 1962 under the title *Death on a Pale Horse*. Green's composition—before dismemberment—is recorded in an engraving by William Say (see Holme 1904, pl. A2).

When exhibited in 1796 the Detroit *Pale Horse* attracted widespread praise, and several critics pointed out the superiority of West's sketches, as exemplified in this work, to his large finished paintings, thus anticipating much subsequent comment about West's art. During the brief period of peace between France and England in 1802, he visited Paris and took the painting with him to exhibit in that year's Salon. Among the many English artists who flocked to Paris at the same time, West was the only one to show his work there. Perhaps for that reason, the painting seems to have attracted considerable comment from the French, some of which West's fellow artist Joseph Farington (1747–1821) recorded in his diary. On September 2, 1802, he reported, "Many French Artists were viewing Mr. West's picture and said, 'the attempt was hardy and the only one of such a subject of difficulty that had succeeded since the time of Rubens.'" On September 12, he wrote that Jacques-Louis David had been seen in front of West's picture and had been heard to call it "a caricature of Rubens." Back in England, however, at a dinner that Farington attended on November 19, the portrait painter Martin Archer Shee (1769–1850), who had also been in Paris, told West "that David had spoken very well of his picture and admired the execution of it." On September 24, Napoleon Bonaparte visited the Salon, stopped before West's picture, and asked who painted it. When West was then introduced to him, Napoleon spoke to him in Italian and "expressed his approbation of the merit of his picture" (Farington

1978–84). According to William Carey (1820), Napoleon tried to buy the painting, but West declined to let him have it, expressing his sense of duty and respect to George III, on whose behalf he had originally undertaken the subject. In 1802 the artist probably still nurtured hopes of utilizing the sketch as the basis for a large picture for the royal chapel.

According to William Beckford, West also refused to sell the sketch to the Prince Regent, the future George IV:

The President [West] himself considered it his best and refused £100 offered for it by the Prince Regent; yet afterwards, being distressed for money, he parted with it, I believe, to Mr. Thompson, the artist for £50 (Lansdown 1893).

"Mr. Thompson" was the painter Henry Thomson (1773–1843), who was West's near neighbor in Newman Street in London. Exactly when West sold the painting is not recorded, and Beckford's "I believe" raises a question about whether Thomson was in fact the purchaser. We do know that both the Detroit painting and the drawing from 1783 were in West's possession in 1804, when the catalogue of his works published in *Public Characters of 1805* was drawn up, and that one or the other, more probably the painting, appeared in a small supplementary group of works that accompanied the exhibition of the great *Christ Rejected* (1814; Pennsylvania Academy of the Fine Arts, Philadelphia) in 1814. We also know from Farington that the Earl of Egremont called on West in July of 1819 and, when he asked about purchasing works from the artist, West evidently offered them at prices that Farington considered too low (Farington 1978–84, 15: 5384, 5403). Lord Egremont's agent in negotiating with West was Thomas Phillips (1770–1845), a painter and former studio assistant of West's; it seems possible, therefore, that when Beckford said he believed that the artist Henry Thomson had purchased the painting for half the price that West had previously declined, he really meant

the artist Thomas Phillips. In any case, within a year of Lord Egremont's visit, by June 1, 1820, when William Carey published the second installment of his two-part obituary of West, the painting was "at once the glory of Lord Egremont's collection, and the triumph of modern art."

Iconographically, the most obvious source for West's composition is Dürer's engraving *The Four Horsemen of the Apocalypse*, and William Carey (1817, 122) did compare West's visualization of the subject with that of Dürer. Nearer at hand, the English artist John Hamilton Mortimer (1740–1779) had drawn a *Death on a Pale Horse* around 1775, but his composition, which was engraved in 1784, shows a single skeletal horseman, rather than the four depicted by both Dürer and West (see Staley 1980, fig. 11). Stylistically, West's turbulent composition recalls seventeenth-century hunting scenes by Peter Paul Rubens, and the central pale horse appears to derive from the horse in the upper left of Rubens's *Wolf and Fox Hunt* of about 1615 (versions in the Metropolitan Museum of Art, New York, and in the Methuen Collection at Corsham Court, Wiltshire). West included a similar horse in a large painting of a hunting incident, *Alexander III of Scotland Saved from a Stag*, of 1786 (National Gallery of Scotland, Edinburgh; Von Erffa and Staley 1986, 190–191), which displays even more obvious affinities with Rubens. He began work on that subject and the subject of *Death on the Pale Horse* at approximately the same time and exhibited sketches of both together at the Royal Academy in 1784. Lord Egremont eventually also acquired the sketch (which is still at Petworth House) of West's hunting subject.

In 1802 the scenes of suffering in West's foreground reminded the French critic for the *Journal des Arts* of *The Plague of Asdod* by Poussin (1630/31; Musée du Louvre; cited in *Public Characters* 1805),

and in 1817 the English critic William Hazlitt suggested that the child falling from its dying mother's breast in the center foreground was based on the child being dropped by its drunken mother in Hogarth's well-known print *Gin Lane* (Hazlitt 1930–34, 18: 135–140). For further consideration of the picture's affinities with works by other artists, its place within West's oeuvre, and its possible influence on later painting, see Staley 1980. For a more general discussion of West's painting of apocalyptic subject matter, see the catalogue of an exhibition of West's religious paintings organized by Nancy Pressly (San Antonio 1983). Her concluding essay, although not specifically about *Death on the Pale Horse*, points out the currency of millennarian ideas, prompted by the French Revolution, at the time West painted the Detroit picture. The book of Revelation has always been interpreted as a symbolic description of warfare, and the four horsemen of the Apocalypse have become a virtual cliché, standing for the destructive horrors of war. In 1796, England was at war with revolutionary France, and so it would remain, apart from the brief interlude of the Peace of Amiens, until the downfall of Napoleon almost twenty years later. Since West had conceived the composition of *Death on the Pale Horse* by 1783, his imagery was not inspired initially by hostilities that commenced in 1793. Nevertheless, contemporary events may have encouraged West to return to the subject in 1796, and his depiction of it was adopted by at least one observer as a metaphor for what was happening, or what he expected to happen in the contemporary world. In 1810, William Beckford predicted the future that an inept and corrupt government would bring upon England: "Over deserted smoking plains pale Napoleon will be galloping. It will be West's Apocalypse, his Triumph of Death, painted in the same terrible colors, a mingling of mire and blood" (Alexander 1957, 96).

A. S.

Inscriptions At lower right, *B. West 1796*

Provenance Possibly Henry Thomson, R. A., London. George Wyndham, third Earl of Egremont, Petworth House, Sussex, by 1820; John Wyndham, seventh Baron Leconfield and second Baron Egremont. Wyndham sale, Sotheby's, London, July 19, 1978, lot 18. P. and D. Colnaghi (dealer), London. Acquired in 1979.

Exhibitions London, Royal Academy, 1796, no. 247. Paris, Salon, 1802, no. 756. London, British Institution, 1806, North Room, no. 18 (possibly this work). London 1814, no. 7 (possibly this work). London, British Institution, 1833, no. 13. London, Royal Academy, 1871, 39. Washington and Philadelphia 1980, no. 101.

References Public Characters 1805, 555–557, 566. *Universal Magazine* 1805, 530. Barlow 1807, 434. *Belle Assemblée* 1808, 17, 55. Carey 1817, 47–48, 96, 102–103, 115, 122. Carey 1820, 696–697. Galt 1820, 228. Flagg 1892, 43–44. Lansdown 1893, 13. Baker 1920, 133. Kimball 1932. D. Keyes 1973. Kraemer 1975, 27. Meyer 1975, 265. Dillenberger 1977, 90–93, 173, 213, pl. 64. Alberts 1978, 261–263, 270. Farington 1978–84, 2: 528; 5: 1820, 1823, 1851, 1875, 1935. Staley 1980, 137–149. San Antonio 1983, 19, 58, 61–64. Rosenblum and Janson 1984, 59–60, pl. 6. Detroit 1985, 190. Von Erffa and Staley 1986, 391–392, no. 403.

110
Paddington Canal, 1801

Oil on panel
99.1 × 143.5 cm (39 × 56½ in.)
Gift of Dexter M. Ferry, Jr. (57.247)

When this painting was acquired by the Detroit Institute of Arts in 1957, it was known as *Paddington Passage*. That title, however, is based on a misreading of the entry for the painting in the Royal Academy exhibition catalogue of 1802: *The Paddington passage-boats returning from Uxbridge in the evening.* During the artist's lifetime, the painting also bore variant descriptive titles: *The Paddington boats returning from Uxbridge* and *Uxbridge Passage-boats on the Canal.* Following West's death, his sons exhibited it as *The Paddington Canal Boats*, and they sold it in 1829 simply as *Paddington Canal.*

When West painted it, the canal began at Paddington, an area of London north of Hyde Park, and ran to Uxbridge in Middlesex, thirteen and one-half miles to the west. It was subsequently extended both on the east (through the Regent's Park, to allow access to the Thames) and on the west (to join the Grand Union Canal, the main waterway between London and the north). Passage boats, or barges, on the canal provided nineteenth-century Londoners with an inexpensive and pleasant way to visit the countryside, and West's painting shows two such barges moving through a bucolic landscape. Each is pulled by two horses. Those drawing the nearer barge are at the extreme left of the painting, and the tow rope can be distinguished running across the center of the picture. The boy in the foreground is opening a swing bridge to allow the barges to pass.

The canal was constructed between 1795 and 1801 and opened on July 10, 1801. Since the picture shows the scene during the summer and, since it is signed and dated 1801 and was exhibited in the spring of 1802, West must have painted it soon after the canal's opening. In his biography of the sculptor Joseph Nollekens, published in 1828, John Thomas Smith (for whom, see also the entry for West's *Last Supper*, cat. no. 106) described an excursion to Uxbridge via the canal made by Mr. and Mrs. Nollekens, and he appended a footnote mentioning West's painting:

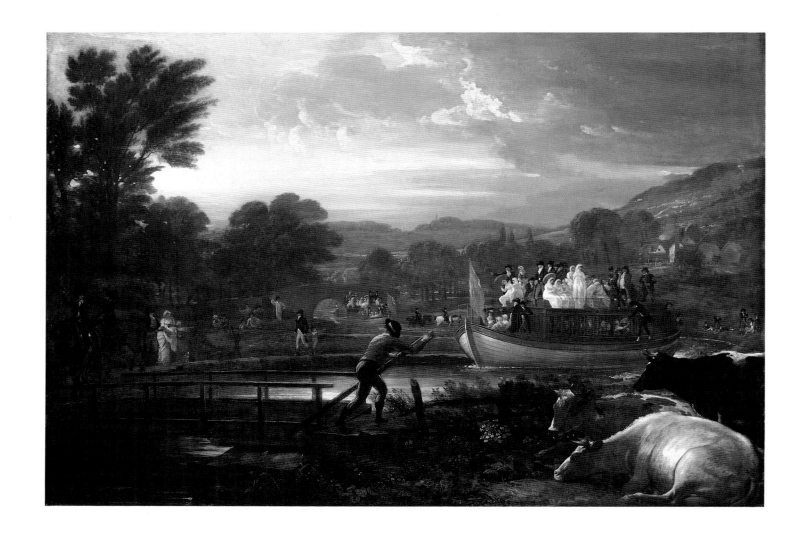

Paddington Canal

The pleasure of a similar excursion induced the late venerable President West to paint a picture of the barge he went by, on the crowded deck of which he has introduced his own portrait, and also those of several of his friends who were that day on board.

In 1828 the painting was on public view as part of the collection of their father's works that was inherited by West's sons and exhibited by them in a gallery constructed in the garden of his former home and studio. When they sold the collection the following year, the sale catalogue declared that the painting also included a portrait of the artist's wife. West is presumably the man leaning on a cane who stands prominently at the front of the upper deck of the nearer barge. Mrs. West may be the older woman with a shawl over her head who is seated between two younger women to his left.

An unfinished picture of St. James's Park, generally known as *The Milk-woman in Saint James's Park* (private collection; see Von Erffa and Staley 1986, 418), was probably meant by West as a companion to his view of the canal; the two works are on wooden panels of the same size. West painted landscapes occasionally throughout his career and with increasing frequency after 1790. They include both classically composed scenes of historical, mythological, and biblical subjects, in the tradition of Claude and Poussin, as well as more informal views of actual places populated by contemporary figures, such as the present work, recalling seventeenth-century Dutch paintings. The prominent cattle in the foreground and the effect of the light of the setting sun on the clouds suggest the strong influence of Aelbert Cuyp, whose paintings had a considerable vogue among English collectors in the years around 1800.

A. S.

Inscriptions At lower center, *B. West. 1801*

Provenance West sale, George Robins, London, May 22–25, 1829, lot 59. Henry Pierce Bone, London, 1829. Daniel H.

Farr (dealer), New York, 1921. Victor Spark (dealer), New York, 1954. Hirschl and Adler Galleries, New York. Acquired in 1957.

Exhibitions London, Royal Academy, 1802, no. 191. London, British Institution, 1806, South Room, no. 17. London 1822–28, no. 134. Philadelphia 1921, 17.

References *Public Characters* 1805, 566. *Universal Magazine* 1805, 530. Barlow 1807, 435. *Belle Assemblée* 1808, 17. Galt 1820, 228. West 1826, 5, no. 29. Smith 1828, 1: 383–384. Dillenberger 1977, 173. Rivard 1978, 1046, pl. 2. Von Erffa and Staley 1986, 426–427, no. 466.

111

Belisarius and the Boy, 1802

Oil on canvas
67.3 × 47.6 cm (26½ × 18¾ in.)
Gift of A. Leonard Nicholson (13.11)

At the end of his life, Belisarius (ca. 505–563), the great Roman general, was accused of conspiring against the Emperor Justinian and was briefly imprisoned. In subsequent legend, but not in historical fact, he was blinded and reduced to beggary, as portrayed by West in several paintings. For a version of the subject that he exhibited at the Royal Academy in 1805, West included as part of the title the words *Vide Marmontel*—a reference to the short novel *Bélisaire* published in 1767 by the French writer François Marmontel. None of West's paintings of Belisarius seems to illustrate a specific passage in the novel, but they all represent Belisarius as a blind beggar accompanied by a boy, as described by the novelist.

The inscription on the placard held by the boy, DATE OBOLUM BELISARIO (Give a penny to Belisarius), is traditional and appears in many depictions of the subject. The inscription on the wall behind

Belisarius, MOENIA URBIS REPARATA SUB IUSTINIANO A BELISARIO (The fortifications of the city restored under Justinian by Belisarius), refers to Belisarius's reconstruction of the walls of Rome in 537. The block of stone on which he sits is carved with a relief showing a figure of Victory holding a wreath over the head of a triumphant general, in all too obvious contrast to the present condition of West's protagonist.

Although the version in Detroit is a small work, it is nevertheless the largest of West's known paintings of the subject. It is signed and dated 1802, which makes it also the earliest, and it should probably be equated with the *Bellisarius and the boy: Date Obolum Bellisario* exhibited by West at the Royal Academy in 1802. It is probably also the painting of the subject included under the heading "In various Collections" in the catalogue of West's works that was published as a footnote to Joel Barlow's epic poem *The Columbiad*. (Although the poem was first published in 1807, West supplied Barlow with the list of his works while in Paris in 1802.) In Barlow's catalogue, *Belisarius and the Boy* immediately precedes a portrait titled *Sir Francis Baring and Family*. This sequence is repeated in slightly later catalogues of West's works, such as that in *Public Characters of 1805*, where the names of collectors are given, and where the owner of both paintings is recorded as Sir Francis Baring.

Other versions of the subject by West are dated 1804 (oil on canvas, 55.9 × 40.6 cm; see Von Erffa and Staley 1986, 184–185) and 1805 (oil on canvas, 61.6 × 45.7 cm; collection of Anthony Burton Capel Philips, see Von Erffa and Staley 1986, 185). One of the paintings must have been the *Bellisarius and the boy. Vide Marmontel* exhibited at the Royal Academy in 1805. A copy of the 1805 picture is also known (oil on canvas, 59.7 × 44.5 cm; sold anonymously, Christie's, London, January 29,

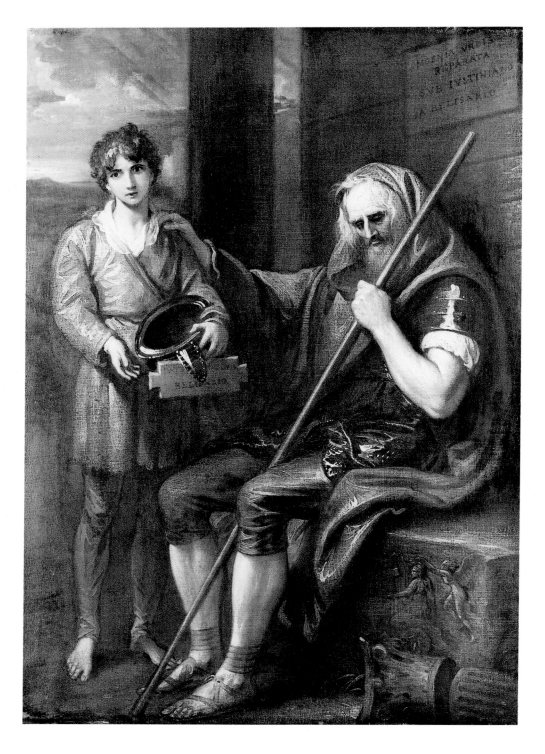

Belisarius and the Boy

1982, lot 69). These paintings all show a composition fundamentally similar to that of the Detroit painting, but with Belisarius on the left, the boy on the right, and many differences in detail. Most notably, Belisarius's head is uncovered, rather than hooded. West also, while still in America in 1758 or 1759, painted a copy after an engraving of the famous painting of Belisarius by Salvator Rosa (unlocated). The Rosa showed Belisarius as a blind beggar, but standing rather than seated, and its composition is not echoed in West's later paintings. The catalogue of West's oeuvre published in *La Belle Assemblée* in 1808 records, in addition, a drawing called *Belisarius brought to his family*, made for a Mr. Mier in Hamburg, and a duplicate noted as in the artist's possession. Mier's drawing has disappeared, but the duplicate may be a drawing, signed and dated 1784, that shows a blind old man being led by a boy (Philadelphia Museum of Art; see Von Erffa and Staley 1986, 185–186).

Following the publication of Marmontel's *Bélisaire*, the subject had a considerable vogue in France. The best-known French *Belisarius* is that by Jacques-Louis David of 1781 (Musée des Beaux-Arts, Lille); another much admired and discussed *Belisarius*, that by François Gérard, appeared at the Salon in 1795 (unlocated). In 1802, the year in which he executed the Detroit painting, West visited Paris, where he could have seen the above-mentioned and other paintings; however, if we have properly identified the Detroit picture as the one he exhibited at the Royal Academy in that year, he painted it before seeing them, since the Royal Academy exhibition opened in May, and he went to Paris only in August.

A. S.

Inscriptions At lower right, *B. West / 1802*

Provenance Sir Francis Baring, Bt., London, 1802; his son, Sir Thomas Baring, Bt., 1848. Baring sale, Christie's,

London, June 2–3, 1848, lot 26.
A. Leonard Nicholson, London. Acquired in 1913.

Exhibitions London, Royal Academy, 1802, no. 139. London, British Institution, 1824, no. 15. London, British Institution, 1833, no. 21. London, British Institution, 1845, no. 99. Detroit 1921, no. 310. Baltimore 1968, no. 48.

References *Public Characters* 1805, 563. *Universal Magazine* 1805, 529. Barlow 1807, 434. *Belle Assemblée* 1808, 16. Galt 1820, 224. BDMA 1913, 21, 45–47. G. Evans 1959, 90–91, pl. 68. Detroit and Philadelphia 1968, 99–100. Kraemer 1975, 40–42. Dillenberger 1977, 161. Von Erffa and Staley 1986, 183–184, no. 42.

112
Lot Fleeing from Sodom, 1810

Oil on panel
119.7 × 198.4 cm (47⅛ × 78⅛ in.)
Founders Society Purchase, Robert H. Tannahill Foundation Fund (70.831)

This painting, which is signed and dated 1810, appeared at the Royal Academy in the following year under the title *Lot and his daughters conducted by two Angels*. It depicts the flight of Lot and his family from Sodom, which is seen being destroyed by fire and brimstone in the background. The listing of the work was accompanied in the catalogue of the Royal Academy exhibition by a quotation from chapter nineteen of Genesis in which that act of divine punishment is described. The figure behind the main group is Lot's wife, being turned into a pillar of salt. A preparatory drawing for the figures, in a much less extensive landscape setting, is in the Vassar College Art Gallery in Poughkeepsie, New York.

The rain of fire and brimstone over Sodom in the distance, the sun rising

over the horizon on the left side of the canvas, and the mountains to the right are integral to the biblical narrative and function as prominently in the composition as the relatively small band of hurrying figures. The artist did not refer to the painting as a landscape, but in 1812, when he exhibited another painting of an Old Testament subject in which the figures have a similar diminutive scale in relation to their setting, he titled it *Historical Landscape: Saul before Samuel and the Prophets* (Huntington Library and Art Gallery, San Marino, Calif.).

West painted comparable works—biblical, mythological, or actual historical subjects set in extensive and imaginative landscape settings—on occasion throughout his career. Prior to 1800, in examples such as *The First Interview of Telemachus with Calypso* of 1773 (unlocated) and *Cicero Discovering the Tomb of Archimedes* of 1797 (Kennedy Galleries, New York), they showed chiefly classical subjects, painted in a style reminiscent of the historical landscapes of Claude and Poussin, but perhaps more immediately inspired by the British painter Richard Wilson. In the first decade of the nineteenth century, J. M. W. Turner revolutionized the genre by painting and exhibiting a series of scenes of Old Testament disasters executed in an expressively vigorous manner that provided pictorial equivalents for the divinely unleashed forces of destruction. In choosing to paint *Lot Fleeing from Sodom*, West must have had in the forefront of his mind Turner's *Fifth Plague of Egypt* of 1800 (Herron Museum of Art, Indianapolis), *The Tenth Plague of Egypt* of 1802 (Tate Gallery), and other works, including a *Destruction of Sodom* of about 1805 (also Tate Gallery). Yet West was seventy-two years of age in 1810, and his *Lot Fleeing from Sodom* is a much more conservative work than the pictures by the younger artist to which it owed at

245

least part of its inspiration. Compared with any of Turner's Old Testament subjects, it is more traditionally composed, and the conflagration is presented as a theatrical spectacle, complete with audience in the form of Lot's wife. In this respect it has more in common with the work of older artists such as Philip James de Loutherbourg than with that of Turner; Lot's wife in West's picture might be compared with the spectator in Loutherbourg's *Avalanche in the Alps* of 1803 (Tate Gallery). Although in 1801 West had spoken to Joseph Farington "in the highest manner" about Turner, his admiration soon waned, and in 1805 he announced that Turner was "tending to imbecility" (Farington 1978–84, 4: 1539, and 7: 2555). So, in rendering a subject that Turner had previously painted, West may have been attempting to demonstrate how Turner should have done it.

Farington saw *Lot Fleeing from Sodom* in West's studio on March 15, 1811, and was "much struck by it" (Farington 1978–84). It seems to have attracted little attention when it appeared at the Royal Academy in the following May, but it drew several notices when West re-exhibited it at the British Institution in 1814. A friendly review praised it for "the same majesty and force in the outline, the same taste in the drapery, and the same richness and fullness of colouring, by which all his productions are distinguished" ("Press Cuttings," vol. 3, Victoria and Albert Museum Library). The most memorable

comment, however, came from William Hazlitt, a younger critic who almost never had a good word to say about West:

Mr. West's picture of *Lot and his Family* is one of those highly finished specimens of *metallurgy* which too often proceed from the President's hardware manufactory. As to the subject, we conceive it has been often enough treated in a country famed for "pure religion breathing household laws." We do not mean to lay it down as a rule, that the sublimity of the execution may not redeem the deformity of the subject of a composition, as there is a great and acknowledged difference between Shakespeare and the Newgate Calendar; but this of Mr. West's is a mere furniture picture, and offers no palliation from the genius displayed by the artist (Hazlitt 1930–34).

In January 1819 Sir John Fleming Leicester acquired the painting from the European Museum, a commercial gallery begun by a displaced Loyalist from South Carolina named John Wilson (1748–1835), to whom West had probably sent the picture to be sold on commission. Wilson was paid one hundred guineas and also received another painting by West in exchange, *The Destruction of the Beast and False Prophet* (1804; Minneapolis Institute of Arts), which Leicester had bought in 1818 for three hundred pounds; hence, the total cost of Leicester's acquisition came to four hundred five pounds. Leicester was forming a representative collection of contemporary British painting, which he opened to the public shortly after buying West's *Lot*. In the same year, William Carey published a lavish catalogue of the collection, in which he devoted four pages to describing and praising West's painting, and in which the engraved frontispiece shows the picture installed prominently

in Leicester's recently constructed gallery. A second catalogue of the collection—by John Young, published two years later—included an etched reproduction of the composition and a briefer discussion. Neither catalogue says anything of real interest apart from stressing West's advanced age when he painted the picture. In Carey's words: "The date of 1810 upon this picture shows that time had not impaired the powers of the venerable founder of the British school of historical painting, in his seventy-second year" (Carey 1819).

A. S.

Inscriptions At lower right, *B. West / 1810*

Provenance John Wilson, European Museum (dealer), London, 1819. Sir John Fleming Leicester, Bt. [later the first Lord de Tabley], London, 1819. Leicester sale, Christie's, London, July 7, 1827, lot 45, bought by Jackson. Given by Mrs. Newton Jackson to Radley College, Oxfordshire, 1906. Sale, Phillip, Son, and Neale, London, April 6, 1970, lot P90. Leger Galleries, London. Acquired in 1970.

Exhibitions London, Royal Academy, 1811, no. 188. London, British Institution, 1814, 146. London, Sir John Leicester's Gallery, 1819 (see Carey 1819 below).

References Carey 1819, 77–80, no. 26. Young 1821, 14, no. 30. Hazlitt 1930–34, 18: 13–14. Hall 1962, 102, 122. Dillenberger 1977, 121, 214. Farington 1978–84, 11: 3894. Von Erffa and Staley 1986, 288, no. 238.

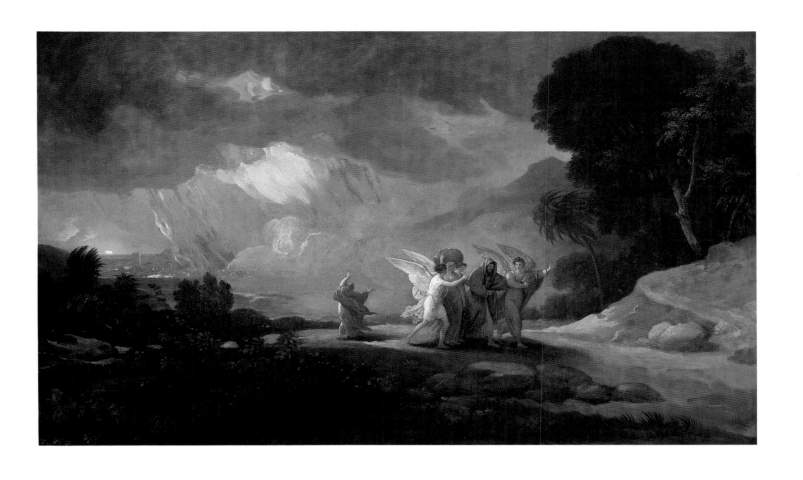

Lot Fleeing from Sodom

Almost nothing is known of the painter John Wilkie beyond the evidence supplied by the artist in the places and dates inscribed on four of his five known paintings, all done between 1837 and 1839. The earliest is a portrait of DeWitt Clinton (Union College, Schenectady, N.Y.) painted in Schenectady in early May 1837. The others are the Detroit Institute of Arts' portraits of Julia A. M. Peck and Mary P. Fiske, painted in New Woodstock, New York (just south of Cazenovia, in Madison County), in 1838, and those of Polly and John M. Fonda (unlocated), painted in Livingston, New York, in 1839. The dates and places indicate that Wilkie worked as an itinerant. It is tempting to associate him with two Albany painters with the same last name: William Wilkie, who painted an enchanting watercolor of the Albany jailer Nathan Hawley and his family in 1802, and Thomas Wilkie, a portrait painter in Albany in the late 1850s and early 1860s.
M. B.

Bibliography Schenectady 1972, 117–119.

113
Mary P. [Peck?] Fiske, 1838

Oil on canvas
76.2 × 63.2 cm (30 × 24⅞ in.)
Gift of Betsey Mast Reid in memory of her aunt, Jane Betsey Welling (1987.34)

Mary P. [Peck?] Fiske

114

Julia A. M. Peck, 1838

Oil on canvas, 76.2 × 63.2 cm (30 × 24⅞ in.)
Gift of Betsey Mast Reid in memory of her
aunt, Jane Betsey Welling (1987.33)

The portraits of these two western New
York women are among the five known
paintings by John Wilkie. Given that the
women greatly resemble each other, and
the inscriptions state that Mary P. Fiske
is thirty-four, while the younger sitter is
twenty-two, the pair may be sisters. Simi-
larities are seen also in the costumes of
the figures: each wears an onyx pin with a
gold lyre decoration and a fringed shawl
embroidered with flowers, leaves, and
tendrils. The elder woman's frilly bonnet
and pearls add graceful notes to her
strict, rather plain visage, while a rose-
wood or mahogany fancy chairback ap-
pears in the background in the younger
woman's portrait.
M. B.

Inscriptions (1987.34) On the back, at
center right, *painted by John Wilkie/New
Woodstock Sept. 17th 1838.;* at lower left,
Mary P. Fiske./Aged 34 years.

Inscriptions (1987.33) On the back,
at center right, *painted by John Wilkie/
New Woodstock Sept. 10th 1838;* at lower left,
Julia A. M. Peck/Aged 22 years.

Provenance Jane Betsey Welling, Detroit;
her niece, Betsey Mast Reid [Mrs.
Gordon V. K. Reid]. Acquired in 1980.

Julia A. M. Peck

The son and namesake of a London portrait painter, John Wollaston, Jr. (he changed the spelling of his name from Woolaston), was painting in London at least by 1733 (Craven 1975, 22). Charles Willson Peale (q.v.), who later knew him in England, stated in an 1812 letter to his son Rembrandt (q.v.) that Wollaston had trained under a noted London drapery painter (quoted in John Sartain, *The Renaissance of a Very Old Man, 1808–1897*, New York, 1899, p. 147). More recently, it has been shown that Wollaston had a fairly active portrait practice in London (Craven 1975, 19–25). He made his way to America in 1749, painting first in New York and Philadelphia (1749–52), then moving south to Maryland (1753–54), Virginia (1755–57), and back to Philadelphia (1758). After ten years in America, Wollaston departed, and where he went is subject to dispute. Some scholars believe that he abandoned his painting career to travel to India as an agent for the East India Company in Bengal. He is said to have served as a court magistrate in Calcutta, among other duties, and to have remained in India for six years. An alternative view is that he may have been in the West Indies during the early 1760s, as there is evidence of his presence on St. Christopher's Island (St. Kitts), before resurfacing in Charleston, South Carolina, in 1765 (Weekley in Richmond et al. 1983, 26). He remained in Charleston until late 1767, after which he returned to England.

Wollaston's style is among the most easily recognizable of any painter's in colonial America. No author who has discussed him at length has failed to mention his propensity for painting almond-shaped eyes. This mannerism may actually have increased his popularity with sitters; he painted approximately three hundred portraits during his ten-year American career, a rate that exceeded those of his contemporaries and all colonial artists who preceded him. One authority has suggested that the mannerism was not limited to Wollaston but was an affectation used by other artists as well to enhance their sitters' appearance (Craven 1971, 258). Wollaston influenced both Robert Feke (q.v.) and John Hesselius (q.v.), and, although his pictures are never enchanting, as portraits by these contemporaries sometimes are, his work is occasionally confused with theirs. Wollaston's impact can also be seen in the early works of Benjamin West (q.v.) and Matthew Pratt (1734–1805).

R. S.

Bibliography Craven 1975.

115

Mrs. Charles Carroll, ca. 1753/54

Oil on canvas
127 × 101.6 cm (50 × 40 in.)
Founders Society Purchase, Mr. and Mrs. Walter Buhl Ford II Fund (66.397)

This portrait of a sumptuously dressed, middle-aged woman, her brown hair flecked with gray, is representative of Wollaston's best work in America. Mrs. Carroll (1709–1761) was the wife of Charles Carroll (1702–1782) of Annapolis and the mother of Charles Carroll of Carrollton, one of the signers of the Declaration of Independence. Her portrait was originally painted to hang with a pendant work by Wollaston depicting her husband (private collection). Two versions of Mrs. Carroll's portrait exist: the Detroit work and a second version that is still in private hands. Without seeing the two pictures together, it is difficult to determine which was painted first; the only obvious differences between them are minor dress folds and a few background details.

The Detroit portrait can be dated quite precisely to Wollaston's 1753–54 trip to Maryland. The earliest evidence of his presence in the colony is an encomium in *The Maryland Gazette* for March 25, 1753; the last firm date for his presence is August 1754 (Groce 1952, 140). During the time he lived in Maryland Wollaston painted approximately fifty-five portraits that included representatives of practically all the leading families—Calverts, Bordleys, Diggeses, and Galloways.

While Wollaston's thrifty Scottish and Dutch patrons in New York preferred the smaller bust-length format, his more lavish, freewheeling southern patrons invariably selected the more imposing knee-length—the size typical of his work in Maryland and Virginia. Like Joseph Blackburn (q.v.), Wollaston was an exceptional painter of textiles, and his women's gowns have a distinctive pneumatic quality. Wollaston differs from Blackburn, however, in that he favored a more intense palette composed of dark, rich colors, such as the deep blue of the gown seen in the Detroit portrait. Given the large number of patrons who turned to him, they may be presumed to have been less bothered than we are by his somewhat awkward placement of the arms and his penchant for plump, boneless hands.

R. S.

Provenance The sitter, Mrs. Charles Carroll, Annapolis, Maryland, 1753/54–61; her son, Charles Carroll, 1761–1832; his great-grandson, Charles Carroll McTavish, 1832–68; his daughter, Virginia Scott McTavish, 1868–1917; her brother, Charles Carroll McTavish, 1917–47; Charles Bancroft Carrollton, 1947–64. Kennedy Galleries, New York, 1964–66. Acquired in 1966.

Exhibitions Detroit 1967, 43, no. 120.

References W. Peck 1967, 29–33. Weekley 1977, 347.

Mrs. Charles Carroll

Refusing to follow in his father's footsteps as a farmer, Joseph Wood left home at age fifteen in hopes of becoming a successful painter in New York City. He earned his living as a silversmith's apprentice, playing the violin on the side and teaching himself to draw portrait miniatures. By June of 1803 he had joined the artist John Wesley Jarvis (q.v.) in a commercial partnership devoted to the painting of likenesses and the use of a physiognotrace to take profile portraits. In about 1805 Wood befriended the well-known miniaturist Edward G. Malbone (1777–1807) and received instruction from him that helped to form Wood's miniature style. After his partnership with Jarvis dissolved in about 1810, Wood moved to Philadelphia (in 1813) and from there to Washington, D. C. (in 1816), where, at the height of his popularity, his most prominent sitters included President James Madison and his wife. In Washington he supplemented his income by providing drawings and specifications of models for patent applications. Toward the end of his life, however, he lacked commissions both for these drawings and for portraits, and his reputation increasingly became that of a genial alcoholic.
D. E.

Bibliography Groce and Willet 1940.

116
Portrait of a Man, ca. 1820

Oil on panel
39.4 × 31.8 cm (15½ × 12½ in.)
Founders Society Purchase, General Membership Fund (60.39)

The sitter in this portrait was once identified as George Washington's private secretary, Tobias Lear (1762–1816), but likenesses of Lear that have descended in his family bear no resemblance to this man; considering this, and the fact that the painting's provenance is incomplete, there is no supporting evidence for such an identification.

The portrait, precise in its drawing and smoothly painted with little color in the pale tan flesh, is typical of Wood's cabinet-size likenesses of about 1820, a date that would agree with the costume and hairstyle. The silhouetting of the image and the transition in the background coloring from pale gray at the top to a muted pink at the bottom, suggesting a sunset, are found in other Wood paintings of that time, such as his portrait of Thomas Say (1820; National Portrait Gallery, Washington, D.C.). Also characteristic of Wood's work is the fact that the sitter's hands are not visible. Although known for his strong likenesses, Wood could not draw hands well and avoided including them.
D. E.

Provenance The Honorable and Mrs. Breckinridge Long, Laurel, Maryland, by 1933; Mrs. Breckinridge Long, 1958–59. Kennedy Galleries, New York, 1959–60. Acquired in 1960.

On deposit Baltimore Museum of Art, 1933–37.

References *Kennedy Quarterly* 1959, no. 24.

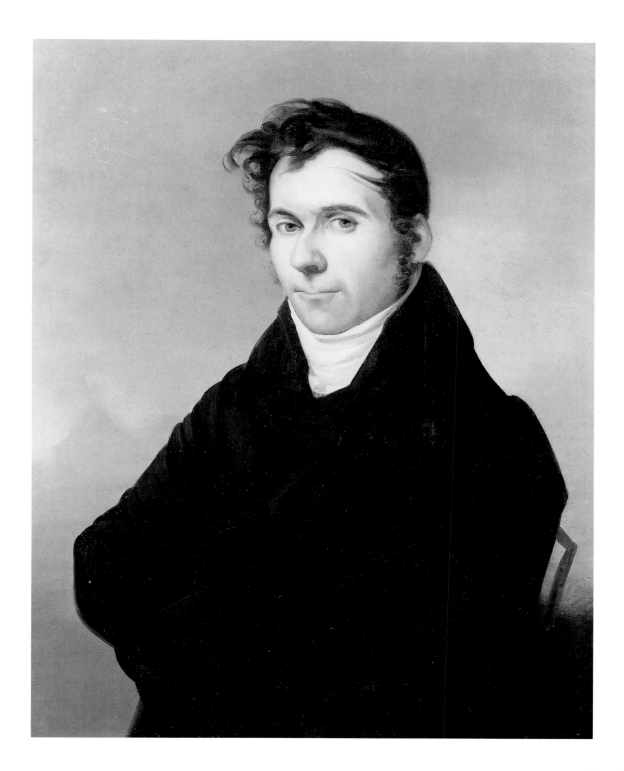

Portrait of a Man

117

Unknown Artist

Elderly Woman, ca. 1720

Oil on canvas
65.4 × 55.9 cm (25¾ × 22 in.)
Founders Society Purchase, Gibbs-Williams
Fund (55.80)

In 1935 this near-ruin of an early New
England painting was examined by a com-
mittee of scholars and conservators headed
by Louisa Dresser, former curator of the
Worcester Art Museum, in preparation
for the exhibition "Seventeenth-Century
Painting in New England." Then owned
by Charles K. Bolton, an art historian and
dealer in colonial paintings, the portrait
was tentatively identified as "Sally
Manning." However, the former owner,
Mrs. Edwin A. Waldo, the great-great-
granddaughter of William Heath of
Roxbury, Massachusetts, a Manning de-
scendant, doubted that the sitter was a
Manning family member. As a result, the
subject is now identified only as a portrait
of an elderly woman. As far as it is possi-
ble to tell from the condition of the paint-
ing, which was already badly abraded,
skinned, and overpainted fifty years ago,
it appears to be the work of one of a
group of painters who flourished in
Boston from the late seventeenth cen-
tury to about the late 1720s. The painting
of hands and lace places it in this group,
and the costume is of about that period.
M. B.

Provenance William Heath, Roxbury,
Massachusetts; his great-great-grand-
daughter, Mrs. Edwin A. Waldo, 1927.
Charles K. Bolton (dealer), Shirley,
Massachusetts, 1935. M. Knoedler Co.,
New York, 1947. Goodspeed's Book Shop
(dealer), Boston, 1955. Acquired in 1955.

Exhibitions Worcester 1935, 95–97.

Elderly Woman

118

Unknown Artist

Henry Dobinson, 1761–65

Oil on canvas
75.3 × 62.9 cm (29⅝ × 24¾ in.)
Gift of the American Institute of Interior
Designers, Michigan Chapter (69.292)

The provenance of this portrait of a young
boy is unknown, but if his mother's name
was Curwin (as suggested by an inscrip-
tion on an old stretcher since replaced),
the picture may have been painted in
New England. The Curwin (or Corwin)
family appears in the records of Salem,
Massachusetts, dating from the late
seventeenth century on.

Certain aspects of the work—the boy's
almost flattened head, the style of his
robe, and the bird he holds—are similar
to features found in the portraits of
Joseph Badger (q.v.), who worked in
Massachusetts, but the painting does not
display the incisive detailing that is char-
acteristic of Badger's work in the 1760s.
M. B.

Inscriptions On an old stretcher now re-
placed, *Born 1758 / Henry Dobinson died
1795 aged 37. Married Mary Feddon / Son of
N. Dobinson & Julia Dobinson (née Curwin [?]).
Father of William Dobinson who was born
1785 / Nephew of Thomas Dobinson whose
picture appears as a small blond boy with a
dog.*

Provenance Estate of Paul L. Grigaut.
Acquired in 1969.

Henry Dobinson

119

Unknown Artist

The Lady from Hornell, ca. 1810

Oil on wood panel
73 × 65.4 cm (28¾ × 25¾ in.)
Founders Society Purchase, Gibbs-Williams
Fund (36.91)

Detroit's *Lady from Hornell* is one of the
best-known and most striking American
folk portraits of women. The subject of
this comparatively small work is identified
only as a resident of Hornell, a town on
the Canisteo River in Steuben County in
southwestern New York. The skill of the
painter, who remains unknown, is obvi-
ous in the delicately delineated features,
costume, bonnet, jewels, and decorated
chair.

There are tantalizing traces of the styles
of at least three other painters in the work,
which was done on a fairly unusual wood-
panel support. The pose, the positioning
of the hand, and the fine details high-
lighting the face are reminders of the
folk artist Micah Williams, who worked in
New Jersey, Connecticut, and the New
York City area in this period. The same
elements forecast the similar styles of
Milton Hopkins (1789–1844) and Noah
North (1809–1880), artists who spent most
of their careers in western New York.
M. B.

Provenance American Folk Art Gallery,
New York. Acquired in 1936.

Exhibitions New York 1942. New York
1945. Cooperstown et al. 1958, no. 11.

120

Unknown Artist

Boy with Flute, ca. 1820

Oil on wood panel
74.9 × 64.1 cm (29½ × 25¼ in.)
Gift of the Estates of Edgar William and
Bernice Chrysler Garbisch (81.838)

Although there are some resemblances
between this painting and those by A.
Ellis, whose works have been located in
the vicinity of Exeter, New Hampshire,
and in nearby Maine, it is executed with
less precision and style.
M. B.

Provenance Edwin D. Hewitt (dealer),
1948. Edgar William and Bernice Chrysler
Garbisch, New York. Acquired in 1981.

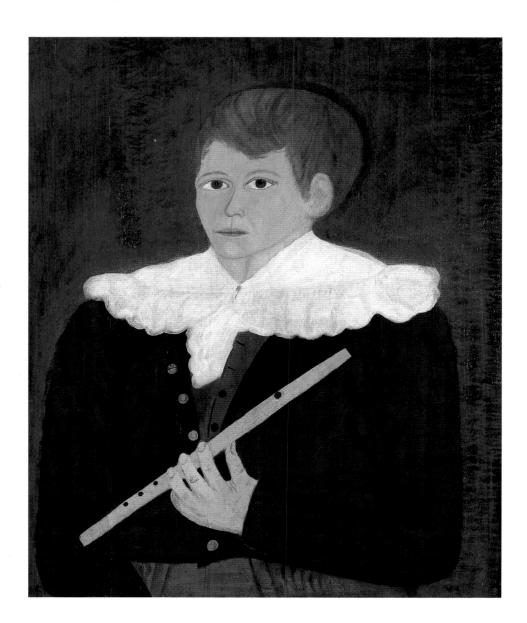

121

Unknown Artist

Man with a Folding Rule, ca. 1820

Oil on wood panel
82.2 × 73.7 cm (32⅜ × 29 in.)
Gift of the Estates of Edgar William and
Bernice Chrysler Garbisch (81.828)

The painter of this work, in which a
folding two-foot rule and a decorated
chair provide a graceful note to a hand-
some likeness, has not been identified.
The painting is unusual both in its wood-
panel support and in the use of shades of
blue for the background, which is remi-
niscent of watercolor and tempera pas-
sages in portraits by Ruth Whittier Shute
and her husband, Dr. Samuel Archer
Shute, who were working in New
Hampshire at about the time this
painting was created.
M. B.

Provenance M. Knoedler Co., New York,
1947. Edgar William and Bernice Chrysler
Garbisch, New York. Acquired in 1981.

Man with a Folding Rule

122

Unknown Artist

C. Blair, ca. 1830

Oil on canvas

71.1 × 61 cm (28 × 24 in.)

Gift of the Estates of Edgar William and
Bernice Chrysler Garbisch (81.839)

Little is known concerning the subject
or painter of this portrait of a boy with a
small accordion. The child's spiderlike
hands, in curious contrast to the rest of
the composition, illustrate an untutored
painter's difficulties with anatomy. The
collection record (curatorial files, DIA) for
the painting indicates that "C. Blair," an
otherwise unidentified subject, was a resi-
dent of Fitzwilliam, New Hampshire.
M. B.

Provenance George Abraham and Gilbert
May Antiques, 1961. Edgar William and
Bernice Chrysler Garbisch, New York.
Acquired in 1981.

123

Unknown Artist

Seated Woman, ca. 1830–40

Oil on canvas
77.5 × 78.7 cm (30½ × 31 in.)
Gift of the Estates of Edgar William and
Bernice Chrysler Garbisch (81.830)

This winsome portrait, an unidentified
subject by an anonymous painter, demon-
strates some of the most appealing as-
pects, along with some of the most typical
distortions, of American folk art. The
strange joining of neck to torso and of
the right arm to the upper figure are
trouble spots glossed over in the painter's
attention to the subject's deep-sunk eyes
and almost heart-shaped face. The three-
quarter view makes the body seem bulky
in contrast to the face, and the artist's
understanding of dressmaking was as frag-
mentary as his knowledge of anatomy.
These problems do not detract greatly
from the charm of the portrait, however.
Cat's-eye earrings, a full-blown rose, gold
chains for locket and watch, and a ribbon
belt in gold and brown enhance the at-
tractive portrait. Possibly because of the
way the large hands and the details and
folds of the white dress are painted, the
portrait was once attributed to Ammi
Phillips (1788–1865) (curatorial files, DIA).
M. B.

Provenance Reveille Antiques, Houston.
Edgar William and Bernice Chrysler
Garbisch, New York. Acquired in 1981.

Seated Woman

124

Unknown Artist

The Dennison Sisters, ca. 1845

Oil on canvas
107 × 91.4 cm (42⅛ × 36 in.)
Gift of the Estates of Edgar William and
Bernice Chrysler Garbisch (81.832)

The two girls dressed in identical white
linen dresses in this double portrait are
identified only as the Dennison sisters.
One of the girls holds a book open to a
scene showing Pharaoh's daughter discov-
ering the infant Moses in the bulrushes.
The mahogany-framed sofa with red up-
holstery is of about the same period as
the girls' costumes, suggesting a date of
about 1845 for the composition.
M. B.

Inscriptions On cover of book, *B.*[?] *E.*[?]
O.[?]

Provenance George Arons and Brother
(dealer), 1963. Edgar William and
Bernice Chrysler Garbisch, New York.
Acquired in 1981.

The Dennison Sisters

125

Unknown Artist

Whaling Fleet, Icebound, ca. 1860

Oil on canvas
45.1×80.7 cm (17¾×31¾ in.)
Gift of the Estates of Edgar William and
Bernice Chrysler Garbisch (81.836)

This small painting portrays a scene typi-
cal of early- to late-nineteenth-century sea-
faring life. The size of the factory complex
(perhaps a tryworks for extracting oil
from whale blubber) and the number of
whaling vessels indicate that the view dates
to about the 1860s.
M. B.

Provenance Clifton Blake, 1949. Edgar
William and Bernice Chrysler Garbisch,
New York. Acquired in 1981.

Whaling Fleet, Icebound

Appendix

William James Bennett

1787 LONDON—NEW YORK 1844

William James Bennett was born and trained in London, but his reputation and career were largely made in the United States. Bennett studied watercolor landscape painting and aquatint at the Royal Academy where he was a student of the noted history painter Richard Westall. At the age of eighteen, as part of the medical staff of the British army, he traveled to Egypt and Malta, where he sketched the antiquities and landscapes. A few years later, while still in military service, he visited several parts of Italy, traveling to Florence, Rome, and Naples during his leaves of absence.

Over the next several years, Bennett established a solid reputation in London. He was elected a member of the Society of Aquatint Artists in 1808 and actively exhibited his works beginning in that year. In 1816 Bennett emigrated to America, but continued for a time (until at least 1825) to send works back to his native country for exhibition, and in 1820 he was made an associate of the Water Color Society of London. After 1826 his career flourished; he produced engraved views in aquatint of at least twenty-seven American cities and landscapes.

Bennett was elected a member of the newly established National Academy of Design in 1827 and for some years served as the academy's curator.

J. G. S.

Bibliography Dunlap 1834, 2: 274–275. A. Gibson 1975, 49.

View of Detroit in 1836

A1

Copy after William James Bennett
View of Detroit in 1836, ca. 1836–37

Oil on canvas
44.5 × 63.5 cm (17 ½ × 25 in.)
Gift of the Fred Sanders Company in memory of its founder, Fred Sanders (34.24)

Although this painting bears no signature, it was ascribed to William James Bennett by Edgar P. Richardson in 1935 because it is virtually identical to an aquatint titled *A View of Detroit in 1836* (Library of Congress) that is inscribed as follows: *Painted by W. J. Bennett from a sketch by Fredk. Grain. Engd. by W. J. Bennett. [published by] Henry J. Megarey, New York. Entered . . . 1837 by Henry J. Megarey.* Richardson reasonably assumed that the painting under discussion here is the original from which the print was made.

In a letter dated April 1, 1942, however, Harry Shaw Newman of the Old Print Shop in New York called into question the attribution of the painting to Bennett (curatorial files, DIA). Newman observed that the artist was trained in watercolor and aquatint and, although there do exist rare original works by Bennett, no record shows his ever having worked in the medium of oil. (Indeed, William Dunlap, author of the only known contemporary comments on Bennett, stated that his annual submissions to the exhibitions at the National Academy of Design were in watercolor.) Newman stated also that in order to meet the popular demand for such views at least one artist, the Frenchman Victor de Grailly, is known to have created copies in oil of prints by a contemporary of Bennett's, William Henry Bartlett (1809–1854); he went on to speculate that perhaps the present painting could be a copy after the engraving rather than vice versa, but offered no suggestion as to the copyist's identity. In light of these considerations and the lack of any definitive evidence arguing for Bennett's au-

thorship of the oil painting, the work should be considered a copy after the aquatint of 1837, possibly by the same Victor de Grailly, who is said to have made copies in oil of other prints by Bennett (see William Nathaniel Banks, *Victor de Grailly: Views of America* [New York: Washburn Gallery, 1975]). There is no documentary evidence to support this surmise, but such an attribution may help to explain the European provenance of the Detroit painting.

The scene depicted—a view of the city from the Canadian shore—is carefully composed within the picturesque landscape tradition of the harbor view. The painting shows Detroit when it was still the capital of Michigan, and the dome farthest to the left is that of the state capitol. To its right is the spire of the First Baptist Church, while the square tower with pinnacles is that of Saint Paul's Episcopal Church, and the twin pointed cupolas in the center of the view are those of Saint Anne's Roman Catholic Church.
J. G. S.

Provenance Theodor Lagerquist (dealer), Berlin, Germany. Acquired in 1934.

Exhibitions Detroit 1942, no. 82. Detroit 1949. Detroit 1951, no. 527. Dearborn 1964. New York 1975b, no. 58. Muskegon 1983, no. 13. East Lansing 1986, 15, 47–48.

References Richardson 1935, 81. Sweeney 1983, 25.

John Beale Bordley

1727 ANNAPOLIS—PHILADELPHIA 1804

Trained as a lawyer, John Beale Bordley was an amateur artist who was deeply interested in the fine arts and their cultivation in America. In 1770, after holding several important judgeships, he inherited Wye Island in Queen Anne's

Still Life with Fruit

County, Maryland, and turned his attention to farming. He was a member of the American Philosophical Society and the founder of the Philadelphia Society for Promoting Agriculture.

Bordley and Charles Willson Peale (q.v.) were close friends from an early age (Peale's father was Bordley's first schoolmaster), and it was Bordley who initiated the subscription that enabled Peale to travel to London to study with Benjamin West (q.v.) in 1766. After Peale's return to the colonies in 1769, Bordley and Peale painted together during the years just prior to the Revolution.
W. G.

Bibliography E. Gibson 1865.

A2

Attributed to John Beale Bordley
Still Life with Fruit, 1769/70 (?)

Oil on cardboard
27.3 × 33.3 cm (10¾ × 13⅛ in.)
Gift of Dexter M. Ferry, Jr. (52.162)

A3

Attributed to John Beale Bordley
Still Life with Flowers and Fruit, 1769/70 (?)

Oil on panel
27.3 × 33.3 cm (10¾ × 13⅛ in.)
Gift of Dexter M. Ferry, Jr. (52.163)

These paintings have long been considered early works by Charles Willson Peale (q.v.) because of three notes affixed to

Still Life with Flowers and Fruit

their backs that read: a) *The first pic-
tures painted by C. W. Peale when a youth
of fruit at Mr. Beal Bordly's place in
Maryland, given me by his daughter when
an old lady, Mrs. James Gibson—who
lived at the corner of 8th or 9th & Spruce
St., Philadelphia.* (On back of 52.163.)
b) *Fruit pieces painted by C. W. Peale
when a youth. Fruit raised at Mr. Beal
Boardley's place in Maryland. Given to
me by Mrs. James Gibson who was Miss
Boardley. She afterwards married Mr.
James Gibson & was a friend of mine. Her
photograph in a picture by Sully I have.
One was done by Stuart.* (On back of
52.162.) c) *These two pictures are some of
the very first paintings by Chas. W. Peale.
Fruit on Mr. Beal Boardley's place, Wye
Island, Maryland. given me by his
daughter Mrs. James Gibson of Phila.
M. J. P.* (On back of 52.162.)

The initials on the last note were said,
at the time the paintings were acquired,
to be those of Maria Peale, Charles Willson
Peale's niece (letter from Edgar P.
Richardson to Charles Coleman Sellers,
October 26, 1951, curatorial files, DIA).
Another possibility is that the initials are
those of Mary Jane Peale, his granddaugh-
ter. Both paintings were purchased from
a Rubens H. Peale of Philadelphia in
1925. The notes, in combination with the
provenance of the paintings, thus lend
some credence to the theory that these
could be early works by Charles Willson
Peale, painted before he went to London
to study with Benjamin West (q.v.).

The problem with the attribution is
that beginning very early in his career
Peale thought of still life as an exercise
for students and amateurs and not wor-
thy of treatment as an independent com-
position. Although still-life accessories
figure importantly in his portraiture, he is
known to have painted only one discrete
still life, in 1811. Peale's letters relate,
however, that after his return from London

in 1769, he and John Beale Bordley
painted together on Bordley's Maryland
estate and that Bordley was at that time
doing still lifes and landscapes. The pic-
tures' history would also support the
supposition that these two works were
actually painted by Bordley himself. In-
deed, Charles Coleman Sellers, the Peale
family descendant and scholar, certainly
leaned toward that conclusion in a letter
to Richardson (October 29, 1951, curato-
rial files, DIA).

It should be mentioned that Edward H.
Dwight (archival notes, Barra Foundation,
Philadelphia) suggests the possibility that
the *Still Life with Flowers and Fruit* might
be by Peale, although he believes the *Still
Life with Fruit* is most probably *not* by
Peale.

W. G.

Provenance The artist's daughter, Mrs.
James Gibson. Maria J. Peale [niece of
Charles Willson Peale] or Mary Jane Peale
[his granddaughter]; Rubens H. Peale, to
1925. Mary H. Sully [Mrs. Albert W.],
1925–41. William Macbeth, Inc., New York.
Acquired in 1952.

On deposit Brooklyn Museum, 1930–31,
lent by Mary H. Sully.

Exhibitions New York 1941a, no. 2.
Cincinnati 1954, nos. 42–43. Detroit and
Utica 1967, nos. 69–70.

References Sellers 1969a, 11–12.

James Bowman

**1793 ALLEGHENY COUNTY, PENNSYLVANIA—
ROCHESTER, NEW YORK 1842**

James Bowman's career was typical
of many itinerant portrait limners whose
modest contributions enriched the cultural
life of this nation during the early dec-
ades of the nineteenth century. Bowman
first worked as a carpenter, and although

he learned the rudiments of painting from another itinerant portrait painter, J. T. Turner (active 1811–?) of New York, there is little doubt that he was mainly self-taught. Like most portraitists of the period, he traveled widely and seldom lived for long in any location. He is known to have worked in Pittsburgh (in 1811) and Cincinnati (in 1814) and to have made brief visits to Philadelphia, Washington, D.C., and several small towns in the mid-Atlantic states during the early phase of his career. Around 1822 he traveled to Europe for further study, returning in 1829. Little is known of his years of study in Europe, except that he visited London, Paris, and Rome.

In 1829 he opened a studio in Pittsburgh, but soon after left the city for Charlestown, South Carolina, where he is known to have lived during the winters of 1829–30 and 1830–31. It was probably around this time that he met his first serious student, George Flagg (1816–1897), a nephew of Washington Allston (q.v.). Bowman then spent time in Boston and in Montreal before arriving in Detroit in 1835 and opening a studio, advertising himself as a portrait painter and teacher. His most notable student was John Mix Stanley (q.v.), who had moved to Detroit the previous year and was working as a sign painter, Bowman and Stanley worked as partners for several years, traveling to Chicago and Galena, Illinois, and to Fort Snelling, Minnesota. While in Detroit, Bowman had married Julia M. Chew; they moved after about a year to Green Bay, Wisconsin, and finally to Rochester, New York, where he continued (along with Stanley) to practice portraiture but also branched out into the increasingly popular genre of landscape painting.

Among the notables Bowman is said to have painted were the Marquis de Lafayette, the author James Fenimore Cooper, the sculptor Albert Thorwaldsen, and Supreme Court Justice Henry Baldwin. (None of these works has been located.)

J. G. S.

Bibliography Dunlap 1834, 2: 471. Groce and Wallace 1964. A. Gibson 1975, 57–58.

A4

Attributed to James Bowman

Mrs. Solomon Sibley, ca. 1835

Oil on canvas
76.2 × 63.2 cm (30 × 24⅞ in.)
Gift of the Sibley Estate (58.171)

When given to the museum in 1958, this painting was said by the donors to be the work of Charles V. Bond (active 1846–64);

the attribution was later changed to James Bowman (curatorial files, DIA). The subject of the portrait—born Sarah Whipple Sproat (1782–1851)—is presented before a red drapery in the frontal view typical of itinerant painters. Her expression suggests an individual of some self-possession, as would befit the wife of Solomon Sibley, a well-known politician in early-nineteenth-century Detroit (see cat. no. 44). The artist was careful to record every detail of Mrs. Sibley's clothing with its associations of respectability and prominence.

J. G. S.

Provenance Frances Sibley, Detroit; her estate, 1958. Acquired in 1958.

Exhibitions Detroit 1921, no. 14 (as *Sarah Whipple Sibley* by Chester Harding). Detroit 1949.

Mrs. Solomon Sibley

Alvah Bradish

1806 SHERBURNE, NEW YORK—DETROIT 1901

Alvah Bradish was one of the most noted portrait painters of nineteenth-century Detroit. He established his reputation in Rochester, New York, working there intermittently from 1837 to 1847 before moving to Michigan. There is no record of Bradish receiving professional training, and it is assumed that he was self-taught. Like many artists of this period, Bradish was an itinerant portrait painter. He visited Detroit in 1834, 1837, and 1839, and he may have been in the city sometime in 1840, when he is known to have worked briefly in Cleveland. He also did portraits in St. Paul, Minnesota, and in the West Indies before settling permanently in Detroit in 1851.

From 1852 to 1865 Bradish served as the first professor of fine art at the University of Michigan. He was also the author of several books, including, in 1889, a memoir of his close friend Douglass Houghton, who was Michigan's first state geologist and the founder of Houghton, Michigan, in the Upper Peninsula.

It is believed that Bradish executed at least five hundred portraits during the course of his long career. Among his more notable subjects were Daniel Webster (painted from memory); Washington Irving; Millard Fillmore; Lewis Cass, governor of Michigan; and Henry Philip Tappan (ca. 1804–1881), president of the University of Michigan. He also painted numerous governors, mayors, judges, military officers, ecclesi-astics, and other illustrious national and regional citizens. His works were exhibited at the National Academy of Design in New York in 1846, 1847, 1851, and 1867.
J. G. S.

Bibliography Dunlap 1834, 2: 456. A. Gibson 1975, 59–60.

A5
Shubael Conant, 1854

Oil on canvas
92.1 × 76.5 cm (36¼ × 30⅛ in.)
Bequest of William Shubael Conant (51.297)

Bradish's portrait of Shubael Conant is typical of the work of this self-taught painter. The inscription "BUNYAN" on the large book to Conant's right is no doubt a reference to the author John Bunyan, whose *Pilgrim's Progress* (1678) was one of the most popular books in mid-nineteenth-century America, and was probably intended as an allusion to the struggles and the success of Conant; it may also refer to his religious convictions.

Shubael Conant (1783–1867), born in Vermont, came to Michigan in 1807 as a fur trader. He served in the state militia during the War of 1812 and subsequently settled in Detroit, where he became an important figure in the city's early development. A shrewd businessman and financier, he was the builder and owner of the Michigan Exchange Hotel and the first president of the Detroit Water Board. Conant also served, among other things, as commissioner of the public schools, director of the Detroit and St. Joseph Railroad, and fire warden. He was a bachelor and lived simply during most of his life in a few rooms in an old log house.
J. G. S.

Inscriptions At lower left, on edge of table, *A. Bradish 1854*

Provenance Descended in the family of Shubael Conant; William Shubael Conant, Washington, D.C. Acquired in 1951.

A6
Henry N. Walker, 1854

Oil on canvas
91.4 × 76.2 cm (36 × 30 in.)
Bequest of Henry Lyster Walker and Elizabeth Gray Walker (56.262)

Although painted in the same year and in virtually the same format as *Shubael Conant*, Bradish's portrait of Henry Nelson Walker (1811–1886) is quite different in character. More imposing than Conant's likeness, Walker's statesman-like figure is positioned before a large column, against a view opening toward what may be trees and a sky filled with pink and blue clouds. While both figures are shown half length, Walker is standing rather than sitting, underscoring his image as a successful businessman and civic leader.

According to notes prepared by his widow (curatorial files, DIA), Walker befriended the young artist Robert S. Duncanson (1817/22–1872) in 1849, when Duncanson was living in Detroit, and gave him fifty dollars. Later Duncanson traveled to Italy to study, and when he returned to Detroit he insisted on presenting Walker with a painting now known as *Fruit Piece* (Detroit Institute of Arts, 57.84).
J. G. S.

Inscriptions At center right, on base of column, *A. Bradish / 1854*

Provenance The sitter, Henry N. Walker; his son, Henry Lyster Walker, and his daughter, Elizabeth Gray Walker. Acquired in 1956.

Shubael Conant

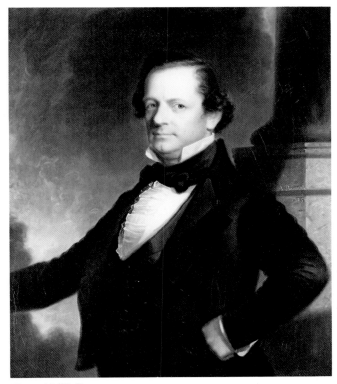

Henry N. Walker

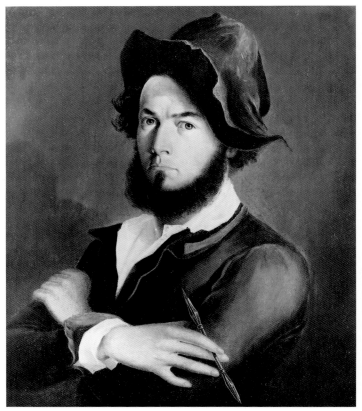

Self-Portrait _Warren Hill_

Frederick E. Cohen

CA. 1818 ENGLAND (?)—MT. VERNON, OHIO 1858

Frederick E. [Elmour?] Cohen is
said to have been English by birth, but
that has not been firmly documented. He
came to Detroit from Woodstock, Ontario,
about 1837. Where Cohen received his
schooling is not known, but the quality of
his surviving works suggests that he may
have obtained professional training at
some point early in his career. He was a
well-known bohemian figure in Detroit
for almost two decades, during which
time he is known to have painted else-
where occasionally. In 1850 he married

Maria Louisa Roberts of Mt. Vernon,
Ohio, and five years later moved to that
city.

Cohen was a versatile artist who special-
ized in portraits and miniatures, painting
many notable Michigan citizens; he also
produced landscape and history paintings
ranging from scenes of contemporary life
such as _The Meeting of the Michigan State
Agricultural Society: Reading the Premiums at
the First State Fair, Detroit, 1849_ (Burton
Historical Collection, Detroit Public
Library) to biblical events such as _Salome
with the Head of John the Baptist_ (ca. 1849;
the Detroit Institute of Arts, 44.91). He
exhibited at the American Art-Union in
1848, at the "Fine Arts Exhibition" of

1852 in Detroit, and at several Michigan
state fairs.

J. G. S.

Bibliography A. Gibson 1975, 75.
Muskegon and Detroit 1987, 56–61.

A7
Self-Portrait, 1845

Oil on canvas
71.1×60.3 cm (28×23¾ in.)
Gift of Mrs. Robert Hopkin (10.9)

Frederick E. Cohen's _Self-Portrait_ was a
gift from the widow of the Michigan
artist Robert Hopkin (1832–1909). Cohen,
it is believed, was one of Hopkin's teachers,
and Hopkin may have received the por-

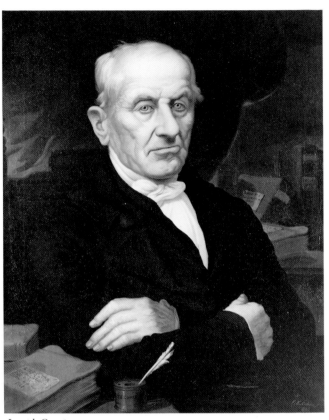

Joseph Campau

Warren Hill (ca. 1780–1854) was one of Detroit's leading citizens in the mid-nineteenth century. A land speculator, he came to Michigan by way of Connecticut and Vermont. Hill was married twice, first to Kziah Dewey and second to Margaret A. Pierce Hazard.

Hill is portrayed here as a man of respectability and social prominence. Seated in a red-upholstered chair in black formal attire, with a cane in his right hand and wearing a pair of octagonal glasses, he epitomizes the prosperous businessman. Cohen's treatment of the subject possesses a strength of characterization and modeling that is clearly superior to the typical portrait by a naïve or self-taught artist.

J. G. S.

Inscriptions On the back, *Cohen pinxt Nov. 1847*

Provenance The sitter, Warren Hill; his son, Rodney Dewey Hill; his daughter, Sarah Beacon Hill. Detroit Public Library, the Burton Historical Collection, 1950. Acquired in 1950.

Exhibitions Detroit 1949.

A9
Joseph Campau, 1853

Oil on canvas
86.4 × 68.6 cm (34 × 27 in.)
Founders Society Purchase, Elizabeth and Allan Shelden Fund (56.101)

This portrait helps to explain Cohen's reputation as one of Detroit's outstanding artists in the mid-nineteenth century. It captures vividly the businesslike manner and idiosyncratic personality of Campau, at the time the richest man in Michigan and one of Detroit's most famous citizens. Cohen's handling of Campau's wrinkled face, twinkling eyes, and determined mouth are particularly impressive, conveying a clear impression of the personality of this shrewd businessman and noted practical joker.

trait as a memento of their professional relationship. The *Self-Portrait* reveals an impressive ability at characterization and the handling of chiaroscuro effects, its red background creating a dramatic foil against which the artist's half-length figure is poised. Cohen's bearded face, his floppy-brimmed hat, and his shirt and jacket open at the neck suggest something of the eccentric, bohemian personality for which he was famous. The penetrating expression of the eyes and slightly downturned cast of the mouth in conjunction with the crossed arms reveal a reserved yet self-confident personality. The curious double-ended brush he holds completes the image of a dedicated pioneer artist.

J. G. S.

Inscriptions On back of canvas, *FE Cohen Pxt Buffalo Feb^y 1845*

Provenance Robert Hopkin, Detroit; his wife. Acquired in 1910.

Exhibitions Detroit 1876, no. 98. BDIA 1938. Detroit 1949. Flint 1963, no. 6. Bloomfield Hills 1964.

References Detroit 1910, no. 99. C. Burroughs 1936a, 397.

A8
Warren Hill, 1847

Oil on canvas
74.9 × 66 cm (29½ × 26 in.)
Gift of the Detroit Historical Commission (50.196)

Joseph Campau (1769–1863) was born in Detroit, but he was educated in Montreal and never lost his French accent. He was a fur trader and landowner at the age of seventeen and during later life occupied numerous official positions: he was one of the founding trustees of the City of Detroit and later the city's treasurer. (For a portrait of Mrs. Campau see cat. no. A42.)
J. G. S.

Inscriptions At lower right, *F. E. Cohen, Pinx / 1853*; at lower left, on inkwell, *F. E. COHEN, pinx*; on cover of book at lower left, *LIVRE Nº 16 / Des Maison et lots de / Cette Ville / Detroit de 11 mars / 1847*; on cover of book at upper right, *LIVRE Nº 11 / Des Fermes a / louer*

Provenance Springle Estate, Oka, Quebec, Canada. John L. Russell (dealer), Montreal, 1956. Acquired in 1956.

Exhibitions Detroit 1969.

References Muskegon and Detroit 1987, 56.

Charles Octavius Cole

1814 NEWBURYPORT, MASSACHUSETTS— PORTLAND, MAINE (?), AFTER 1856

Charles O. Cole was the son of Moses Dupré Cole (1783–1849), a sign painter and portraitist in Newburyport, Massachusetts. He and his two brothers, Joseph G. (1803–1858) and Lyman E. (1812– ca. 1878), were all artists and all presumably studied with their father. As a group, they found patronage in an area ranging from Boston, through northeastern Massachusetts, to Bath, Maine. Itinerant early in his career, Cole had by 1850 settled in Portland, Maine, where he remained until at least 1856.
W. T. O.

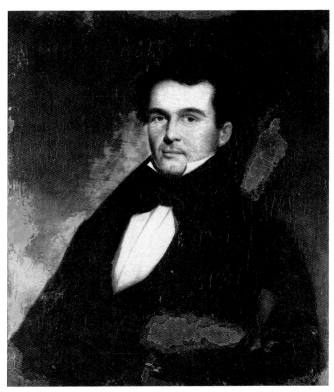

Samuel Mountfort Pitts

A10

Attributed to Charles Octavius Cole

Samuel Mountfort Pitts, ca. 1836

Oil on canvas
81.6×65.4 cm (32⅛×25¾ in.)
Founders Society Purchase, Gibbs-Williams Fund (58.365)

Samuel M. Pitts (1810–1868) was born at Fort Preble in Portland Harbor, Maine, where his father was stationed. After studying law at Harvard, he moved to Detroit in 1832; according to family tradition, he walked there from Boston, swapping French lessons for room and board along the way. Michigan, which the Erie Canal had lately opened to mass settlement, was ripe for development. Pitts worked in the law offices of Charles Larned, helped manage a lumber company, and invested in salt and the Saginaw pinelands. Eventually he assumed Larned's practice, but left it to administer his booming lumber business. In 1836 he married Sarah Merrill of Maine, thus joining two old, wealthy families of New England and extending their influence to Michigan.

The portrait of Pitts probably dates from the occasion of his marriage. His wife, as noted in her obituary in 1896, "was painted as a bride sixty years ago by Cole of Portland" (Detroit 1959; 37 unlocated), and her husband's portrait is likely to have been painted at the same time. His dress and apparent age (mid-twenties) would support such a date, as would his evident confidence and affluence.

"Cole of Portland" was undoubtedly one of the three Cole brothers; in the present case the painter was probably

Charles Octavius Cole. Although the portrait of Pitts is in poor condition, it is similar—in size, pose, placement of the figure in the field, expression, lighting, modeling, and handling—to his portrait of James Gallier of about 1838 (oil on canvas, 83.8 × 68.6 cm; Louisiana State Museum, New Orleans). Cole painted the distinguished architect in New Orleans, where he worked in 1838 and 1841. For some time the Gallier portrait was attributed to Jacob Eichholtz (q.v.), a measure of Cole's capabilities. Like Eichholtz, he worked successfully in the orbit of larger talents—particularly that of Chester Harding (q.v.)—creating staid, individualized likenesses in a linear manner, but, unlike Eichholtz, he did not develop a consistent grasp of pattern-making. (For a later likeness of Pitts, painted by J. M. Stanley in 1869, see cat. no. 84.)

W. T. O.

Provenance The sitter, Samuel Mountfort Pitts, Detroit; his son, Thomas Pitts; his daughter, Mrs. Helen Pitts Parker, Detroit. Acquired in 1958.

Exhibitions Detroit 1959, 36–37.

Thomas Cole

The following eighteen oil studies were purchased by the Detroit Institute of Arts in 1939 from Florence Cole Vincent, Thomas Cole's (for biography, see p. 48) granddaughter, as part of a collection of almost six hundred separate objects—pencil and pen drawings on loose sheets of paper, a few watercolor sketches, several complete sketchbooks, and the present oils—left in Cole's studio at the time of his death. The drawings, watercolors, and sketchbooks span Cole's career and artistic ambitions; so, too, on a much-reduced scale, do the oils. The earliest of these, a study of trees, can be assigned tentatively to about 1825–26, while the latest is dated "July 8ᵗʰ 1846" in the painter's own

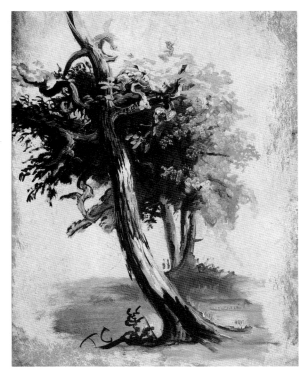

Study of Trees

handwriting. Between these termini are some vignettes of urban and rural Italian scenery, four figure studies (two of them connected with Cole's largest historical painting), two sketches of farm animals, one close-up view of a small stream in a forest, and two glimpses of more expansive topography not far from Cole's home in Catskill, New York. Two or three of the oils are so freely painted that their subject matter is difficult to discern, while another (the view across Roman rooftops) is executed in the exacting style of an architectural drawing. Several of the sketches were evidently painted outdoors, four others were painted indoors from human models, and at least one, *Wooded Landscape with Figures*, evidently was conceived wholly as a studio composition.

G. C.

A11
Study of Trees, ca. 1825–26

Oil on paper, mounted on canvas
40.6 × 31.4 cm (16 × 12 3/8 in.)
Founders Society Purchase, William H. Murphy Fund (39.578)

When Cole began to draw from nature in the early 1820s, he turned (perhaps instinctively) to individual trees and groups of trees of an unusually vigorous and expressive character. The fact that some of the drawings, those dated 1823, are highly finished and are carefully inscribed "from Nature" suggests that they are among his earliest works of this kind. Other, more freely handled, undated drawings of such subjects can probably be assigned to subsequent years, say 1824 to 1826; a proportion of those same drawings were no doubt musings created within the confines of the artist's studio rather than outdoors.

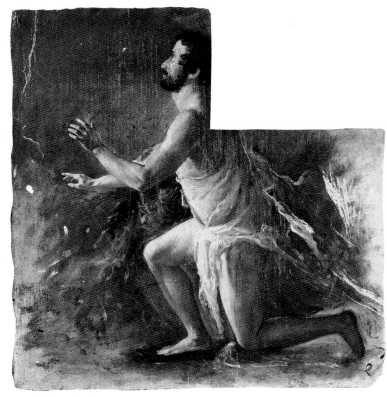

Man with a Staff

Kneeling Male Figure

The present oil study of contorted trees is the painted equivalent of the 1824–26 drawings. The writhing form of the nearest tree as well as the broad brushwork and strong highlights on the trunk and branches are consistent with trees prominently featured in several Cole studio paintings from the period 1825–27—e.g., *The Woodchopper, Lake Featherstonhaugh* (1826; private colletion), *Daniel Boone and His Cabin at Great Osage Lake* (1826; Mead Gallery of Art, Amherst College, Mass.), *Kaaterskill Falls from Below* (1826; Warner Collection of the Gulf States Paper Corporation, Tuscaloosa, Ala.), and *Near Catskill Village* (1827; private collection). G. C.

Inscriptions At lower left, *TC*

References Parry 1988, 23.

A12

Man with a Staff, 1831

Oil on paper, mounted on canvas
57.2 × 43.2 cm (22½ × 17 in.)
Founders Society Purchase, William H. Murphy Fund (39.576)

A13

Kneeling Male Figure, 1831

Oil on canvas
44.8 × 42.1 cm (17⅝ × 16⁹⁄₁₆ in.)
Founders Society Purchase, William H. Murphy Fund (39.577)

As Ellwood Parry (1972) has explained, these two vertical figure studies and an-other oil of horizontal format showing a nearly prostrate kneeling young man (private collection, White Plains, N.Y.) were among the preparations for the largest painting of Cole's career, *The Angel Appearing to the Shepherds* (1833–34; Chrysler Museum, Norfolk, Va.). Cole painted at least two studies for the entire composition and a series of sketches for individual figures within the scene. The studies were executed during his extended stay in Florence in 1831 and 1832, when the artistic ambience and the opportunity to attend life classes at the Accademia di San Luca stimulated his ambitions as a figure painter.

The two Detroit oils, as well as that of the kneeling man in New York, demonstrate the salutary effects of Cole's "study of the Nude" (as he wrote to a friend in January 1832) in Florence. Clearly all

three are taken from life and, despite Cole's recurrent uncertainties with figures in earlier easel paintings, all three are accomplished. The standing shepherd in particular captures well the expressive effect at which Cole aimed, betraying no reticence or haste in its execution.

It was probably after he returned to New York that Cole adjusted the grouping of the figures in a careful pencil drawing (the Detroit Institute of Arts, 39.428). There the standing male shepherd was transformed into a patriarchal figure leaning more heavily on his staff. In the finished painting, Cole shifted the kneeling young shepherd from the primary group to a secondary location on a distant hill and substituted a bearded shepherd reclining in the opposite direction, based on the so-called Ilysses from the west pediment of the Parthenon.
G. C.

Exhibitions (39.576) Detroit and Toledo 1951, no. 31a.

References Parry 1972, 79–86. Parry 1988, 119.

A Goat

A14
A Goat, ca. 1831–32

Oil on canvas
29.9 × 39.4 cm (11¾ × 15½ in.)
Founders Society Purchase, William H. Murphy Fund (39.583)

A15
Studies of Animal Heads, after 1836

Oil on canvas
29.9 × 39.4 cm (11¾ × 15½ in.)
Founders Society Purchase, William H. Murphy Fund (39.582)

Indigenous pastoral animals populate almost all of Cole's paintings of Italian scenery and many of his North American landscapes. Although unidentified and undated, the first of these two oils seems

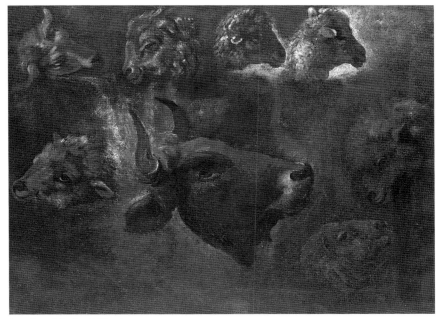

Studies of Animal Heads

The Colosseum

Man Pouring Water

related to the goats depicted (in reverse) in such early Italian compositions by Cole as *Cascatelli at Tivoli* (1832; private collection) and *Landscape Composition, Italian Scenery* (1832; Memorial Art Gallery of the University of Rochester, N.Y.), as well as to later ones in which most of the animals face to the viewer's left as shown here—for example, *View of Florence from San Miniato* (1837; Cleveland Museum of Art). The animals are more North American in character, as though culled from the artist's experience of individual specimens in a barnyard. As such, the latter work might well be dated after 1836, the year Cole married and established permanent residency in Catskill, New York.

G. C.

A16

The Colosseum (front) and *Man Pouring Water* (back), ca. 1832

Oil (front) and ink (back) on paper
39.4 × 27 cm (15½ × 10⅝ in.)
Founders Society Purchase, William H. Murphy Fund (39.584)

Among the "great multitude of wondrous things" to be found in Rome, as Cole wrote in his journal just after his departure from the Eternal City in 1832, "the Colosseum [was] the object that affected me most." In this small vertical sketch from the arena floor, he concentrated on one of the monument's primary aspects—its height. "From the broad arena within," he continued in his journal,

it rises around you, arch upon arch, broken and desolate, and mantled in many parts with the laurustinus, the acanthus, and numerous other plants and flowers, exquisite both for their colour and fragrance. It looks more like a work of nature than of man; for the regularity of art is lost, in a great measure, in dilapidation, and the luxuriant herbage, clinging to its ruins as if to "mouth its distress," completes the illusion. Crag rises over crag, green and breezy summits mount to the sky (quoted in Noble 1853, 159).

Arch of Nero, Tivoli

Stormy Landscape

Another, fully finished study of the Colosseum showing the horizontal expanse of the monument from the arena floor (Albany Institute of History and Art, N.Y.) is comparable to two drawings in Cole's 1832 sketchbooks. The present work was probably painted at about the same time.

G. C.

Inscriptions On front at lower center, *Colloseum*

A17
Arch of Nero, Tivoli (front) and *Stormy Landscape* (back), ca. 1832

Oil on paper
25.1 × 33 cm (9⅞ × 13 in.)
Founders Society Purchase, William H. Murphy Fund (39.586)

During his first visit to Italy in 1832, Cole was strongly attracted to the landscape and the monuments of the Roman campagna, in particular the crumbling Claudian aqueducts near the Via Appia and the cascades and ruins at Tivoli. On the recto of this sheet is a rough depiction of the so-called Arco di Nerone at Tivoli, a towerlike combination of aqueduct remnants and medieval fortifications, viewed from approximately the opposite direction from which it is shown at the near right of Cole's painting *View near Tivoli (Morning)* (1832; Metropolitan Museum of Art, New York). In 1846 he painted a much larger, more tranquil, vertical composition (Newark Museum, N.J.) based on the horizontal canvas of 1832, in which the arch reappears prominently at the right of the scene.

Given the unfinished informality of the study on the front, the stormy landscape on the back may—or may not—represent Italian topography. Cole could have reused the sheet at a later date in America.

G. C.

Inscriptions On back, *Thunder Storm* [crossed out by artist] *the Campania di Roma / seen near Tivoli*

Study for *The Fountain of Egeria*

A18

Study for *The Fountain of Egeria,*
ca. 1832

Oil on paper, mounted on canvas
18.4 × 28.9 cm (7¼ × 11⅜ in.)
Founders Society Purchase, William H.
Murphy Fund (39.587)

Although it could represent a later devel-
opment of the subject by Cole, this study
was probably produced in Italy in 1832,
after a compatriot, H. W. Field, asked the
artist to paint a picture of the Fountain of
Egeria. Located not far from the Via
Appia south of Rome, the ruined grotto
of that title was famed for the spring of
pure water that issued from within and
for its association with an episode re-
counted in Ovid's *Metamorphoses*. Accord-
ing to Ovid's tale, when the Roman king
Numa Pompilius died, a nymph named
Egeria wept so uncontrollably that the
goddess Diana transformed her into a
fountain to commemorate as well as to
relieve the girl's sorrow.

Before his temporary departure from
Rome for Florence in 1832, as Ellwood
Parry (1978) has discussed, Cole visited
the ruin and sketched it in pencil. Pre-
sumably working from that drawing, he
subsequently produced the present study.
By late 1832 he had completed the studio
picture (unlocated) for Field. The follow-
ing spring, the full-size *Fountain of Egeria*
was exhibited (at the National Academy
of Design; no. 97), accompanied by a
quotation from Byron's *Childe Harold*.
Parry perceptively proposed that Cole
intended *The Fountain of Egeria* to be
understood as a thematic complement to
another of his pictures shown that year,
Scene from Manfred (1833; Yale University
Art Gallery, New Haven, Conn.), a depic-
tion of Manfred and the Witch of the
Alps. The pairing coupled Byron-like
and actual Byronic imagery with a subtle
volte-face of subject: in *The Fountain of*

Egeria a woman is transformed into water, whereas in *Manfred*, water is changed into a woman.

G. C.

References Parry 1978, 18–21. Parry 1988, 122–123.

A19

Head of an Old Man, ca. 1832

Oil on canvas
61.9 × 48.3 cm (24³/₈ × 19 in.)
Founders Society Purchase, William H. Murphy Fund (39.574)

A20

Man in a High Hat, ca. 1842

Oil on paper
27 × 19.4 cm (10⁵/₈ × 7⁵/₈ in.)
Founders Society Purchase, William H. Murphy Fund (39.588)

During his trip to Italy in 1831 and 1832, Cole was much interested in the people he encountered as well as, of course, the scenery. In Genoa, for example, he was scandalized yet fascinated by remarkably "wild" and "savage" porters and beggars; in Rome he was diverted by lazy laborers and the hordes of dressed-up characters who roamed the streets at carnival time. Some of these encounters inspired him to paint figure studies that he felt were worthy of public attention. In 1833, after he had returned to New York, he sent to the National Academy of Design exhibition a *Head of a Roman Called Cristo, from Nature,* a *Head of a Roman Woman, from Nature,* and a *Bandit of Itry,* all painted in Rome, along with three landscape compositions emphasizing the human figure and five canvases of Italian scenery.

The first of the two undated Detroit portrait studies was probably a product of Cole's Roman portrait-painting activities in 1831 and 1832. *Head of an Old Man,*

Head of an Old Man

in which the subject displays an appropriately Homeric countenance, is technically proficient and stylistically similar to Cole's two full-length figure studies executed in Florence in 1831 (see cat. nos. A12 and A13). The smaller profile portrait resists chronological or thematic categorization; however, the verso inscription indicating that the work was a gift to the painter's daughter Emily (born in Catskill, New York, on August 27, 1843) suggests that it dates from a subsequent period, perhaps the artist's second journey to Italy in 1841 and 1842. Although Cole was not as occupied with the human figure in his work during the later sojourn, his extensive involvement with Roman society, as well as a six-week trip to Sicily in April and May 1842, offered ample opportunities to revive, on a less formal level, his previous interests in that vein.

G. C.

Man in a High Hat

Inscriptions (39.588) On the back, in pencil, *T Cole / for Emily Cole.*

A21

Wooded Landscape with Figures, ca. 1837–38

Oil on paper, mounted on canvas
12.7 × 21 cm (5 × 8¼ in.)
Founders Society Purchase, William H. Murphy Fund (39.590)

This small, broadly brushed study of two figures seated in a wood in front of a low Gothic arch may be related to a project on which Cole reported he was working at the end of 1837. During the latter part of that year, he had been approached by Thomas Henry Faile (who also patronized Asher B. Durand [q.v.] to paint a picture of Medora, the pale, unfortunate heroine of *The Corsair* by Byron. When Cole was in Florence in 1832, his friend Horatio Greenough was working on a

Wooded Landscape with Figures

Landscape

sculpture of the subject that Cole believed "would touch every heart that is capable of feeling" (Noble 1853, 169), but in New York five years later, the painter persuaded Faile to accept a change of theme to that of Genevieve and her lover, from Coleridge's poem "Love." In the end neither composition was carried out and the artist painted instead a scene of "a Ruined & Solitary Tower" standing above a calm sea, *Landscape, the Vesper Hymn: An Italian Twilight* (1841; Toledo Museum of Art; Strickler 1979, 35).

G. C.

A22
Landscape, ca. 1844/46

Oil on paper, mounted on canvas
29.9 × 40 cm (11¾ × 15¾ in.)
Founders Society Purchase, William H. Murphy Fund (39.580)

A23
Landscape, ca. 1844/46

Oil on paper, mounted on canvas
29.9 × 40 cm (11¾ × 15¾ in.)
Founders Society Purchase, William H. Murphy Fund (39.581)

A24
Landscape, ca. 1844/46

Oil on paper, mounted on canvas
14.6 × 15.2 cm (5¾ × 6 in.)
Founders Society Purchase, William H. Murphy Fund (39.589)

A25
Landscape, 1846

Oil on paper, mounted on canvas
29.2 × 41 cm (11½ × 16⅛ in.)
Founders Society Purchase, William H. Murphy Fund (39.579)

Cole did not often sketch outdoors in oil. That he did so at all and with the variety

demonstrated here, is primarily attribut-
able to two factors. The first is that he was
a friend of Asher B. Durand (q.v.). Until
Durand began to do so during the early
1830s, no American landscape painter
practiced the art with any frequency (or
perhaps at all). Before Durand, American
landscapists drew but did not paint out-
doors from nature; after him, plein-air oil
sketching became an increasingly famil-
iar facet of American artists' approach to
the landscape repertoire. Cole's study of
a tiny waterfall amid boulders and trees,
the first work in the present group, is
particularly Durand-like, although the
paint handling is noticeably looser than
was typical of Durand.

The second factor concerns the adjust-
ment to Cole's professional practice that
occurred when his first pupil, Frederic E.
Church, arrived in Catskill in June 1844
to begin a two-year course of study. Little
documentation exists about the artistic
chemistry that developed between the two
men, but clearly Cole was obliged to re-
think his own bearings to some extent as
he took on a teacher's duties. Within a
few weeks, Church was painting as well as
drawing (in much larger quantities) na-
ture studies ranging from individual plants
to full landscapes. Doubtless the didactic
procedures Cole formulated for Church
were continued when Cole's second pupil,
Benjamin McConkey (active 1840s–50s),
arrived in mid-1845.

The second work in this group, a view
of an avenue of trees in autumn, is nei-
ther dated nor identified. It was probably
painted near Catskill, although another
locale cannot be ruled out. The briskly
painted small scene of mountains and a
foreground flowering tree appears to show
the northern ridge of the Catskill
Mountains, looking west toward Blackhead
Mountain. The last work in the present
group, and the lone dated oil in the col-
lection, was painted just after Church
had departed and McConkey was entering
his second year. It is possible that the
picture reflects McConkey's presence in
some way; it is likely that the full inscrip-
tion derives from Church's conscientious

Landscape

Landscape

Landscape

View of the Quirinal from the Pincian Gardens

practice of dating most of his student drawings and some (though not all) of his early oils. With the exception of his initial efforts to draw "from Nature," Cole usually neglected to date outdoor sketches, but Church's more analytical approach to data-gathering may well have induced his teacher to reconsider the practice.

G. C.

Inscriptions (39.579) At lower left, *Barley July 8ᵗʰ 1846*

Exhibitions (39.580) Mansfield 1981, no. 3.

A26
View of the Quirinal from the Pincian Gardens, ca. 1841–42

Oil on canvas

38.7 × 71.1 cm (15¼ × 28 in.)

Founders Society Purchase, William H. Murphy Fund (39.575)

This precisely drawn, unfinished topographical study probably dates from Cole's second trip to Italy in 1841–42. Seen over the rooftops of the city, the view of Rome is dominated by the Quirinal Palace (at the left) atop the Quirinal Hill, with Borromini's dome and tower for the church of Sant' Andrea delle Fratte lower down (at the right). Such a prospect would have been readily available to Cole in 1832, when he lived on the Pincian Hill and used a nearby studio. But the draftsmanlike character of the Detroit work suggests that it was painted after, rather than before, Cole ventured seriously into architectural practice. In 1838 he submitted designs to the Ohio State Capitol competition and the next year undertook *The Architect's Dream* (completed 1840; Toledo Museum of Art), a picture that, while it failed to satisfy the architect for whom it was conceived, is premised on the exacting architectural perspectives of *Culmination* and *Destruction,* from Cole's series "The Course of Empire" (1836; New-York Historical Society).

According to George Washington Greene, the American consul in Rome who later wrote about Cole's second visit to the Eternal City, the artist passed many hours surveying major art collections and preparing "careful studies of Rome from Sant' Onofrio [on the opposite side of town] and the Pincian," among other views and monuments (*Biographical Studies*, New York, 1860, 105). The present sketch bears out Greene's report. Interestingly enough, more than a quarter-century later, Cole's former pupil Frederic E. Church also sketched the dome and tower of Sant' Andrea delle Fratte from his apartment on the Via Gregoriana (ca. 1868/69; Cooper-Hewitt Museum, New York). G. C.

Exhibitions Detroit and Toledo 1951, no. 31b. St. Petersburg 1968.

References Ourusoff 1962, 17–18.

A27
Italian Landscape, ca. 1841–42

Oil on paper, mounted on canvas
23.5 × 29.2 cm (9¼ × 11½ in.)
Founders Society Purchase, William H. Murphy Fund (39.585)

Both the topography and the free handling of paint in this sketch suggest that it dates from Cole's second trip to Italy. The scene bears some resemblance to the setting of Cole's *Landscape—The Fountain of the Vaucluse* (1841; formerly in the collection of the Metropolitan Museum of Art, New York; recently with Hirschl and Adler Galleries, New York.)
G. C.

A28
Copy after John Singleton Copley
Samuel Pitts

Oil on panel
59.7 × 49.5 cm (23½ × 19½ in.)
Founders Society Purchase, Gibbs-Williams Fund (58.358)

Italian Landscape

Samuel Pitts

This portrait, a copy after a lost pastel by John Singleton Copley (q.v.), was probably painted during the early nineteenth century. The fact that Copley painted with oil only on canvas, never on panel, is a compelling reason to place it outside his oeuvre. Although it was accepted by Parker and Wheeler (1938) as by Copley, they probably never saw the work, since they list it as a pastel. Edgar P. Richardson was the first to question the attribution; Jules Prown later pointed out that, although the Detroit picture is painted in oil, it has a pastellike palette. Judging from the identity of the sitter, the original was probably painted in Boston, between about 1767 and 1769, when Copley did several pastels of a similar nature.

Samuel Pitts (1745–1805) was one of the six sons of James and Elizabeth Bowdoin Pitts (see cat. nos. 5, 6, 12, 13, 78, and 79). After reaching his majority, he entered a partnership with his father and brothers, sending merchant ships to Bermuda. The present portrait shows him in the uniform of the Hancock Cadets, a unit well trained in military procedure and led by John Hancock. Pitts later joined the Sons of Liberty and stood watch while this cohort dumped tea into Boston Harbor. He married Johanna Davis on June 18, 1776, fought during the Revolution, and afterward retired to Chelmsford, Massachusetts, where he remained until his death.

R. S.

Provenance S. Lendall Pitts, Detroit; Mrs. S. Lendall Pitts, Norfolk, Virginia. Acquired in 1958.

Exhibitions Detroit 1883, 73 (as by an unknown artist). Detroit 1959, 32–33.

References Goodwin 1886, 34, 35, 39. Bayley 1929, 255. Parker and Wheeler 1938, 227 (as a pastel). Payne 1960, 87–89. Prown 1966, 241.

Mary Jane Derby

1807 SALEM, MASSACHUSETTS 1892

Mary Jane Derby was the grand-daughter of Elias Hasket Derby, a leading merchant-shipowner in Salem who was called "King Derby" and who is mentioned in the works of Nathaniel Hawthorne. While she may have had some lessons in drawing, her work appears to be that of a gifted amateur and is limited to views of her Massachusetts environment. Miss Derby married the Reverend Ephraim Peabody in 1831 (he later served as minister of King's Chapel, Boston). John Rogers, the sculptor of hundreds of genre figures in the mid-nineteenth century, was her nephew.

M. B.

Bibliography Information from conversations with Anne Farnum, Director, Essex Institute, Salem, Massachusetts.

A29

Attributed to Mary Jane Derby

The Pickman-Derby House, Salem, Massachusetts, ca. 1825

Oil on canvas
32.7 × 40.5 cm (12⅞ × 15¹⁵⁄₁₆ in.)
Founders Society Purchase, Gibbs-Williams Fund (44.84)

The Pickman-Derby House still stands on Washington Street in Salem, Massachusetts. A drawing and a lithograph of the same scene known to be by Mary Jane Derby are in the collection of the Essex Institute in Salem. Anne Farnum, director of the institute, has pointed out the stylistic resemblances between these two works and the present oil painting, particularly as regards the feathery trees and the appearance of the horse and rider; thus its current attribution.

The old colonial house at the far right in the Detroit work is not fully realized in

The Pickman-Derby House, Salem, Massachusetts

the lithograph, eliminating the print as a source for this composition and introducing the likelihood that the painting was done on site by the artist.

M. B.

Provenance J. L. Hudson Company, Detroit. Acquired in 1944.

James Van Dyck

ACTIVE IN NEW YORK CITY 1834–36 AND 1843

An obscure painter of miniatures, James Van Dyck is mentioned by Theodore Bolton (p. 167) as having flourished from 1806 to 1835. The artist is listed in the New York City Directory for the years 1834 to 1836, however, and the exhibition record of the National Academy of Design places Van Dyck in New York also in 1843, when he exhibited the only full-size work that he is known to have painted (see below).

W. T. O.

Bibliography Bolton 1921. Cowdrey 1953. New York 1974.

A30

Copy after James Van Dyck

Aaron Burr, ca. 1834/82

Oil on canvas
86.4 × 63.5 cm (34 × 25 in.)
Gift of Mr. and Mrs. Arthur Fleischman (58.390)

This portrait of Aaron Burr came to Detroit as the work of James Van Dyck. Van Dyck did finish a portrait of Burr in 1834, and exhibited it at the National Academy of Design nine years later as for sale. He did not, however, paint the Detroit canvas.

In 1919 John E. Stillwell, a collector of Burr material, acquired what he assumed to be the Van Dyck portrait (oil on wood

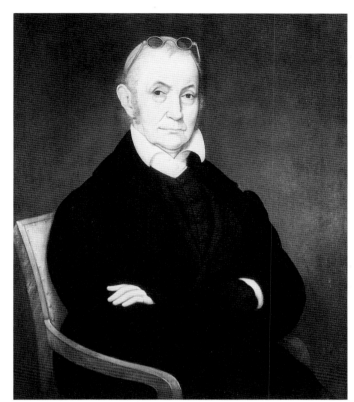

Aaron Burr

panel, 24.5 × 19.7 cm; New-York Historical Society). A label pasted on the back of the panel bore an inscription that supported his contention: *For Sale. Aaron Burr, painted in 1834, in six sittings by James Van Dyck. If not satisfactory, return to 18 Centre St. Room No. 3.* Stillwell theorized that Van Dyck painted the portrait on speculation, since Burr was impoverished at the time and did not buy the painting. Evidently, however, Burr did endorse the likeness, for soon after his death in 1836 a lithograph after the portrait was published with a testimonial purported to be his: "I certify that the Portrait by Vandyke is the best likeness ever Painted of me since 1809. N. York 1st Jany 1834. A. Burr." Stillwell also owned "a large facsimile of this painting in oil, 26 inches by 31 inches" (Stillwell 1928, 31), which he had found in 1882 in

the cellar of Burr's alleged grandson, Hippolyte Burr. He attributed the copy to Hippolyte, who was active then as a portrait painter in New York, calling it "a mediocre work, though perhaps a good likeness" (ibid., 32).

It may be argued that the panel at the New-York Historical Society is Van Dyck's original painting, since its cabinet size is appropriate for the miniaturist and its attached inscription has an authentic ring. The Detroit portrait is probably the "large facsimile" that Stillwell owned, since its dimensions and the dimensions of the copy as cited by Stillwell are nearly the same. (The inscription on the back of the Detroit canvas, however, was most likely adapted from the legend on the lithograph.) The panel, then, was the proto-

type for the Detroit painting: they are virtually identical in pose, expression, dress, and color scheme, although the larger version has a more expansive field, and the chair is more prominent and of a plainer style. The paintings are different stylistically, however, and are clearly by different hands. Whether Stillwell was correct in attributing the copy to Hippolyte Burr is unclear; that artist's copy of John Vanderlyn's (q.v.) 1803 cabinet portrait of Burr reveals the hand of a more sensitive copyist and exhibits more painterly handling (Vanderlyn's original belongs to the New-York Historical Society, the copy to Princeton University in New Jersey).
W. T. O.

Annotations On canvas lining in black paint, *Painted 1st January 1834 / by J. Van Dyck*; on cardboard backing, in black wax crayon, *Van Dyck / BURR*

Provenance Probably the sitter's alleged son, Aaron Columbus Burr, New York, 1882; probably his son, Hippolyte Burr, New York, 1882. Probably John E. Stillwell, New York, 1882–1928. Mr. and Mrs. Authur Fleischman, Detroit, 1958. Acquired in 1958.

References Stillwell 1928, 30–33. New York 1974, 1: 117, no. 275.

Louis-Chrétien de Heer

CA. 1750 GUEBWILLER, ALSACE, FRANCE— MONTREAL (?) BEFORE 1808

It is thought that Louis-Chrétien de Heer came to North America with the French forces sent to assist in the American Revolution, but this has not been firmly documented. Evidence does exist to show that de Heer was in Montreal by the end of 1783, and by July 25, 1784, he had married Marie-Angélique Badel. Where or when he trained as an artist is unknown, and, although his marriage contract designates him as a "maître-peintre," no works from before 1788 have been discovered.

De Heer painted portraits in oil and in pastel, gave lessons in painting, and even produced a few landscapes. He seldom signed his works, and as many of them are in a poor state of conservation, owing in part to inadequacies in his craftsmanship, it has been difficult to attribute works precisely to his hand. Furthermore, his style is similar to those of two other contemporary Quebec artists, Louis Joseph Dulongpré (1754–1843) and François Baillairgé (1759–1830).

The sketchy documentation of de Heer's movements indicate that he was something of an itinerant, traveling often between the cities of Quebec and Montreal in search of commissions. His last known work, a portrait of a Captain François Mailhot (Musée de la Province, Quebec), is dated 1796. After about 1800 de Heer seems to have ceased working entirely.
J. G. S.

Bibliography Morisset 1960, 63–66. Harper 1966, 75, 78.

A31
Attributed to Louis-Chrétien de Heer
Madame Gabriele Cotte, ca. 1790

Oil on canvas
63.8 × 50.2 cm (25⅛ × 19¾ in.)
Founders Society Purchase, Director's Discretionary Fund (59.116)

Madame Gabriele Cotte was attributed to Louis-Chrétien de Heer around 1959 by the Canadian art historian Gérard Morisset

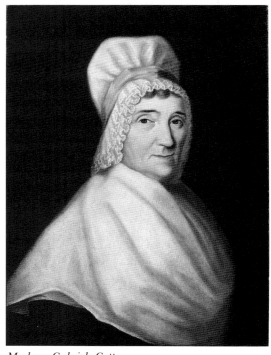

Madame Gabriele Cotte

(Registrar's files, DIA). According to members of the LaRocque family, who once owned the portrait, Madame Cotte was the second wife of a well-to-do merchant, whom she married on December 29, 1783. She is said to be the founder of a Catholic orphanage. One of her daughters, Elizabeth, married François Antoine LaRocque.

J. G. S.

Provenance LaRocque family, Montreal. John L. Russell (dealer), Montreal. Acquired in 1959.

References Harper 1966, 73.

Cornelius David Krieghoff

1815 AMSTERDAM—CHICAGO 1872

An Indian Encampment

Cornelius David Krieghoff moved to Germany from Amsterdam with his parents in about 1824. His artistic talents were probably developed at the Düsseldorf Academy, where genre painting was then being advocated strongly as suitable subject matter for serious artists. For a time after that Krieghoff may have traveled on foot throughout Europe as an itinerant musician and sketch artist.

Krieghoff sailed to New York around 1836, where he enlisted in the United States Army. He then met and presumably married Emilie Gautier, a young French-Canadian woman visiting the city from her home in the rural community of Boucherville, near Montreal. In 1840, after having served as a soldier and as a pictorial historian sketching the events of the army's campaign against the Seminole Indians in Florida, Krieghoff was discharged. He returned to Emilie and an infant daughter, who were then living in Boucherville.

Krieghoff became a keen observer of French-Canadian life, the social customs of which he portrayed with a generous sense of humor in paintings of the local farms and inns and their inhabitants. Some insight into the plight of North American Indians is evinced also in Krieghoff's scenes of them camping, hunting, or trading with the *habitants*.

In 1845, after a few months of studying at the Louvre, for the most part copying Dutch and Flemish landscapes and paintings of peasant life, Krieghoff returned to Canada. Seeking wider patronage, he moved his family to Longeuil, to Montreal, and finally to Quebec in 1853. For the next ten years he enjoyed tremendous popularity, producing his largest and best body of work.

Between 1863 and 1867 Krieghoff and his family traveled in Europe. There is little information about them after that; apparently their daughter married and moved to Chicago, taking her parents with her. Krieghoff visited Quebec once more, in 1870, before his death in Chicago in 1872.

J. G. S.

Bibliography Barbeau 1934. Harper 1979.

A32

Imitator of Cornelius David Krieghoff

An Indian Encampment,
20th century

Oil on canvas, mounted on Masonite
27.9 × 22.9 cm (11 × 9 in.)
Gift of Mrs. Albert de Salle in memory of her husband (69.219)

Cornelius David Krieghoff, an avid outdoorsman and artist *en plein air,* painted numerous scenes of the Caughnawaga Iroquois around Montreal and the Lorette Hurons in the Quebec region—works

that were as well liked and widely collected as his lively paintings of the French-Canadian *habitants*. It is because of Krieghoff's continuing popularity, particularly among Canadian collectors, that his paintings began to be forged—during his lifetime as well as more recently in the 1950s and again in the late 1970s.

The Detroit painting is not signed. Although the subject matter is typical of Krieghoff, a number of points are uncharacteristic of his work: the painting is lacking in the meticulous detail for which the artist is known—there are no miscellaneous utensils or articles of belonging discarded casually in the encampment, the sky is devoid of cloud banks and the dramatic coloration brought on by the severe Canadian weather, and the highlighting of vegetation on the rocks is an odd, incongruous color. Also, the arrangement of the various elements in the Detroit painting is more self-consciously decorative (and, in that sense, modern) than is usual in Krieghoff's compositions, which derive much of their appeal from the sense of immediacy imparted by being executed from life. (Many thanks to Jeremy Adamson and to Laurier Lacroix for their observations concerning the authenticity of this painting.)
J. G. S.

Provenance Albert de Salle, Detroit; Mrs. Albert de Salle, Detroit. Acquired in 1969.

John Lee Douglas Mathies

1780 WASHINGTON COUNTY, NEW YORK (?)—ROCHESTER, NEW YORK 1834

It is thought that John Lee Douglas Mathies was born in Washington County, New York, in 1780. The first mention of him occurs in 1815, when he advertised a drawing school in Canandaigua, New York.

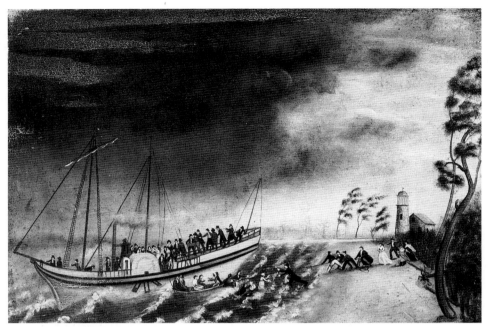

The Wreck of the Steamer "Walk-in-the-Water"

Mathies, like many regional artists of his period, had a second career as a prominent restaurateur and hotel owner in Canandaigua until 1823 and subsequently in Rochester, catering to travelers along the busy Erie Canal.

Mathies painted portraits of the famed Indian leader and orator Red Jacket (1820; private collection) and of Jemima Wilkinson (1816; private collection), who was a leader of one of frontier New York's utopian religious communities, as well as a group portrait of Seneca Indian veterans of the War of 1812 (ca. 1820; private collection). With his nephew, William Page (q.v.), who came to Rochester about 1825, Mathies opened the first gallery in that city. It is thought that Page may have worked briefly with Mathies before moving to New York City to enter the studio of Samuel F. B. Morse.
J. G. S.

Bibliography Cooperstown et al. 1958, 61–64. Wisbey 1958, 133.

A33
The Wreck of the Steamer "Walk-in-the-Water," 1821

Oil on panel
43.5 × 59.7 cm (17⅛ × 23½ in.)
Bequest of the Honorable Thomas Witherell Palmer (13.25)

This work is the first known painting by an American artist to depict a shipwreck on the Great Lakes; it is also a historically important image of a pioneering steam vessel. The documentary value of Mathies's painting is increased by the eyewitness account of the shipwreck by Mary A. Witherell Palmer of Detroit, who was a passenger on board and whose family probably commissioned Mathies's work.

The first steamship on the upper Great Lakes, "Walk-in-the-Water" was launched near Buffalo, New York, in 1818 and regularly plied between Buffalo and Detroit, with stops in Erie and Cleveland and an occasional trip as far as Mackinac

Island. The career of the vessel was cut short, however, on October 31, 1821, when she foundered in a gale. According to Mary Palmer, at four o'clock on the morning of November 1, after a terrifying night, the captain summoned the passengers on deck and indicated that he was going to allow the steamer to run aground in hopes of safely landing her passengers and crew. He did so, and after a great ordeal a hawser was gotten ashore and tied to a tree. By this means all the passengers were safely taken off the stranded ship. At dawn they found themselves only a mile from the Buffalo lighthouse.

Palmer's account then states, "A young gentleman of Buffalo, named J. D. Mathies, went down to the beach where the wreck lay, and being an amateur artist, took sketches of it in two different positions, painted them and sent them to me at Detroit" (Palmer 1902, 319).
J. G. S.

Provenance Mary A. Witherell Palmer; her son, Thomas Witherell Palmer, Detroit, 1913. Acquired in 1913.

Exhibitions Detroit 1883, no. 1786. Cooperstown et al. 1958. Muskegon 1983, no. 12.

References Palmer 1902, 319–323. Newman 1932, 11–14. Wisbey 1958, 133.

Shepard Alonzo Mount

**1804 SETAUKET, NEW YORK—
STONY BROOK, NEW YORK 1868**

Three of the four sons of Thomas and Julia Mount pursued careers as artists. The eldest, Henry Smith, painted signs and then still lifes, landscapes, and game pieces, but died a young man without having attained recognition. The youngest, William Sidney (q.v.), was recognized

as a genius almost from his first efforts in painting, and he held a dominant, if detached, position in the artistic life of New York from the 1830s to the Civil War, gaining an international reputation. Shepard Alonzo was a professional, polished artist in his own right, but he worked in the long shadow of his brother's fame.

He served an apprenticeship to James Brewster, who carried on a trade in coach and harness making in New Haven, and moved to New York City about 1827 as Brewster's agent. By 1828 he had enrolled as a student in the National Academy of Design and from 1829 to 1860 he exhibited regularly at the academy; he became an associate in 1833 and a full member in 1842. Mount painted still lifes, landscapes, and animals, a few figural and genre compositions, and many pictures of fish and anglers, his favorite subjects. He was primarily a portraitist, however, and he found considerable success among genteel society figures outside New York. Unlike many painters of the day, he was skilled at portraying women. Until 1841 he resided in the city, but then, having inherited a share of the family homestead, he moved to Stony Brook. He was a retiring, introspective individual, one who wrote poetry and invested his portraits with a melancholic, wistful note.
W. T. O.

Bibliography Stony Brook 1988.

A34
William Sidney Mount, ca. 1829–37

Oil on wood panel
22.9 × 15.2 cm (9 × 6 in.)
Founders Society Purchase, Merrill Fund (55.181)

It is not certain that the young man represented in this cabinet portrait is William Sidney Mount, but the likeness does compare with Mount's self-portraits of 1828 and 1832 (particularly the latter), in

which he appears wide-eyed and clean-shaven (the Museums at Stony Brook, N.Y.). It also bears a resemblance to later portraits of Mount wearing a mustache and beard, including two by Shepard Mount, one from 1846 (National Academy of Design, New York) and another from about 1857 (the Museums at Stony Brook, N.Y.). All of these paintings reveal the same engaging face characterized by large, dark eyes; a long, pointed nose; and a broad, high forehead. Since it shows him clean-shaven, the Detroit panel must date from before 1846, when Mount first grew his mustache and beard.

It is possible that Shepard Mount painted the portrait in 1829, when the two young artists shared a room on Cherry Street in New York. Shepard began at that time to study in the evening at the National Academy, and he and his brother "set up our easels for chance customers" (quoted in Frankenstein 1975, 18). This cabinet portrait may have been one of the early essays; its intimate characterization, the sitter's bemused expression, and the sketchy handling suggest an informal sitting. Or it may have commemorated William Sidney Mount's election as an associate of the National Academy in 1831 or as an academician in 1832. He was then twenty-five, about the age of the man represented in the panel, and, as the ascot and fur-collared coat would suggest, at the outset of a successful career.

The cabinet size and the use of a wood panel are rare in Shepard Mount's portrait work, for he preferred the standard canvas of 76.2 by 63.5 centimeters (30 by 25 inches). In style and technique the portrait is similar to the small panel painting of a black woman named Tamer that Mount completed in 1830 (private collection). One other cabinet picture that may relate to the Detroit portrait is *Louisa Adelia Nichols* of 1837 (Estate of Edith Louisa Hubbard, Poughkeepsie, N.Y.). That figure is depicted full length, seated on a porch overlooking a groomed landscape, but the paintings share the stress on large eyes and grainy, sketchy brushwork.

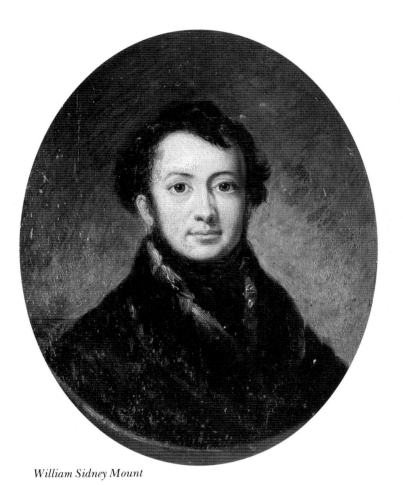

William Sidney Mount

Boy with Cat and Whip

William Sidney Mount praised his brother's "good eye for color," noting that Shepard often "mixes his tints mostly with his brush, feels out what he wants from the heap" (quoted in Frankenstein 1975, 184). Such twiddling is evident in this little porthole portrait of his brother. In its glowing light and the sitter's fixed gaze and directness, this family icon conveys a greater sense of inner life than the portraits of many of Mount's contemporaries. Such intensity and quietude characterized both Shepard Mount's personality and his portraits. Theodorus Bailey, who owned portraits by each of the brothers, noted the distinction in a letter to William Sidney Mount: "*yours* has spirited action, and *his* calm repose" (quoted in Frankenstein 1975, 454).
W. T. O.

Inscriptions On the back at lower right, *By S. A. Mount*; incised on the back at upper center, *May first* [indecipherable]

Provenance Descended in the Mount family. Frederic Frazier, Inc., New York, 1938. Harry Stone, New York. Argosy Gallery, New York, 1955. Acquired in 1955.

References Payne 1954–55, 82–84.

A35

Style of the Prior-Hamblen School
Boy with Cat and Whip, ca. 1845

Oil on academy board
43.8 × 34.3 cm (17¼ × 13½ in.)
Gift of the Estates of Edgar William and Bernice Chrysler Garbisch (81.841)

This hastily painted small portrait is typical of the least expensive portraits produced by the Prior-Hamblen School and other artists in the Boston area from the 1840s through the 1860s (see biography for William Matthew Prior, p. 174).
M. B.

Provenance Mrs. Lawrence J. Ullman (dealer), 1949. Edgar William and Bernice Chrysler Garbisch, New York. Acquired in 1981.

A36

Copy after Gilbert Stuart

General Henry Knox, after 1805

Oil on academy board
31 × 25.6 cm (12³⁄₁₆ × 10¹⁄₁₆ in.)
Founders Society Purchase, Gibbs-Williams Fund (40.51)

This small portrait has long been considered a preliminary study by Gilbert Stuart (for biography, see p. 206) for his life-size portrayal of General Henry Knox (Museum of Fine Arts, Boston). Actually it is a fairly amateurish copy by another artist. Compared with Stuart's original, the head is misshapen, the eyes enlarged, the ear placed on a strange angle, and the right arm out of proportion to the rest of the figure. Since the colors are relatively close to those in the original, and the brushwork is imitative of Stuart's, the Detroit picture is probably after Stuart's oil rather than after the 1834 engraved copy of it "by E. Prud'homme." The composition of the original differs, however, from the Detroit copy in that it shows Knox resting his left arm on a cannon.

The Detroit version is one of at least seven extant copies, all dating from sometime after about 1805, when the original was completed and presented to the city of Boston. No doubt it is because of Knox's prominence that so many copies of his portrait exist. He participated in nearly every important battle of the Revolution and, after Independence, served as secretary of war for the United States. Since the Detroit copy is said to have descended directly from Knox, it was apparently either commissioned by him or given to him, perhaps by an admirer.
D. E.

General Henry Knox

Provenance The sitter, General Henry Knox, Thomaston, Maine; his daughter, Mrs. Lucy Knox Thatcher, Thomaston, 1854. Lawyer Keith, Thomaston, 1854–80. Captain Charles W. Stimpson, Thomaston, 1880; his son, Charles W. Stimpson, Arlington, Massachusetts, 1903. Vose Galleries, Boston, 1903–5. Charles H. Paine, Boston and Paris, 1905–9; the estate of Mrs. Charles H. Paine, 1940. Vose Galleries, Boston, 1940. Acquired in 1940.

Exhibitions Indianapolis 1942, no. 23.

References BDIA 1941, 43, 46. Washington 1969, 47.

John Vanderlyn

1775 KINGSTON, NEW YORK 1852

Grandson of the patroon painter Pieter Vanderlyn, John Vanderlyn showed an early interest in art. During a trip to New York City with his older brother in 1792, he found employment with a print-seller, which enabled him to attend Archibald Robertson's drawing school. It was probably in 1794 that Gilbert Stuart (q.v.) gave Vanderlyn permission to copy some of his portraits, and the young artist copied one of Aaron Burr with such fidelity that he won Burr's admiration. Consequently Burr became a friend and a fi-

Portrait of a Man

in 1837 to paint *The Landing of Columbus* for the rotunda of the Capitol, he died a frustrated and impoverished man.

D. E.

Bibliography Lindsay 1970.

A37

Attributed to John Vanderlyn
(formerly attributed to Rembrandt Peale)
Portrait of a Man, ca. 1820

Oil on canvas
69.2 × 57.8 cm (27¼ × 22¾ in.)
Gift of the Ford Foundation (47.118)

When this portrait arrived at the museum in 1947, it was identified as *Robert Fulton* painted by Rembrandt Peale (q.v.). Stylistically the painting is much closer to the work of John Vanderlyn—under whose name information on the picture in the Frick Art Reference Library, New York, was refiled in about 1960—but whether it is actually by Vanderlyn has remained for some time a difficult question.

The identification of the sitter as Robert Fulton also came into dispute in the 1960s (letter from Charles H. Elam, April 27, 1966, curatorial files, DIA) because none of the better-documented likenesses of Fulton, such as Vanderlyn's 1798 drawing (private collection) or Benjamin West's (q.v.) 1806 oil portrait (The New York State Historical Association, Cooperstown), resembles the man in the Detroit painting.

The first real test of the second attribution came in 1970, when Graham Hood at the Detroit Institute of Arts offered to lend the picture, for comparative purposes, to an exhibition of Vanderlyn's work. The author of the exhibition catalogue, Kenneth C. Lindsay, remained uncommitted, reproducing the portrait as "*Robert Fulton* (?) by Rembrandt Peale (?)" in a section of the catalogue called "problem pictures." His conclusion, expressed

nancial contributor to Vanderlyn's career. He subsidized his period of apprenticeship of about ten months with Stuart and then, in 1796, sent him to study in Paris, where he was trained under François André Vincent in the neoclassical style of Jacques-Louis David.

Except for a return visit to America from 1801 to 1804, and trips to England, Switzerland, and Italy (where he spent over two years in Rome), Vanderlyn remained chiefly in Paris until 1815. He was warmly encouraged by the French, who awarded him a gold medal in 1808 for his historical painting *Marius amid the Ruins of Carthage* (1807; M. H. de Young Mem-

orial Museum, San Francisco). Before embarking for the United States, Vanderlyn sketched panoramic views of Versailles and painted a large female nude, *Ariadne Asleep on the Island of Naxos* (1812–14; Pennsylvania Academy of the Fine Arts, Philadelphia), with the intention of adding them to a group of pictures that he would exhibit for profit.

The exhibition of these pictures in New York, with an admission charge, proved a financial failure, and in 1829 Vanderlyn retired to Kingston in deep disillusionment. Although he eventually won a commission from the United States Congress

later in a conversation of July 20, 1984, with this author, was that, compared with Vanderlyn's portraits of about 1803—the date then assigned to the painting—it did not look like the work of that artist. He maintained that the paint was too thick and the flesh tones appeared too red or "liverish" when placed next to those of documented portraits by Vanderlyn of this date.

The thicker paint and more colorful flesh are closer to Vanderlyn's later work after about 1815. On the basis of costume, the Detroit portrait should be given a later date of about 1820, but, even then, an attribution to Vanderlyn is not altogether convincing. Central to the problem is that our knowledge of the chronological development of Vanderlyn's style is based on too few well-documented works and our sense of his overall oeuvre is obscured by misattributions or possible misattributions. In general, the head in the Detroit picture does not appear to be as delicately modeled or as sophisticated in anatomical drawing as is usual in accepted portraits by Vanderlyn.
D. E.

Provenance The family of Robert Livingston, state of New York. Miss Cruger, great-grandniece of Robert Fulton, Cruger's Island on the Hudson, New York. Louis Van Bergen, Coxsackie, New York. M. Knoedler Co., New York, 1926. Edsel B. Ford, Detroit, 1926–43. The Ford Foundation. Acquired in 1947.

Exhibitions Richardson 1934. Detroit 1944, 11, no. 9. Binghamton 1970, 110, 148–149, no. 85.

References Richardson 1934, 13 (as *Robert Fulton* by Rembrandt Peale). Richardson 1948, 161–167 (as *Robert Fulton* by Rembrandt Peale). Sellers 1948, 273 (as *Robert Fulton* by Rembrandt Peale). Lindsay 1970, 80 (as *Robert Fulton* [?] by Rembrandt Peale [?]).

William Heatley Wilder

1813 BEAUFORT, SOUTH CAROLINA— NEW ORLEANS, LOUISIANA 1896

William Heatley Wilder is one of the early painters of Michigan whose life and career are virtually undocumented. He was active as a portrait painter in Detroit from 1833 to 1841.
J. G. S.

Bibliography A. Gibson 1975, 245.

A38

Attributed to William Heatley Wilder

Marie Françoise Vindevogel, 1st Abbess, Saint Claire Sisters of Detroit, after 1833

Oil on academy board
29.9 × 25.4 cm (11¾ × 10 in.)
Gift of Mrs. A. Campau Thompson (02.32)

The birth and death dates of Sister Vindevogel are unknown. She arrived in Detroit in May or June of 1833 from Pittsburgh and established a seminary for young women. She was accompanied by several sisters of the order of Saint Claire who were originally from Bruges. By 1837

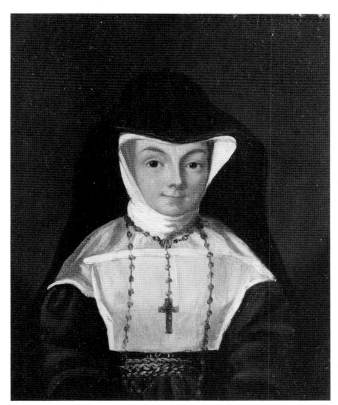

Marie Françoise Vindevogel, 1st Abbess, Saint Claire Sisters of Detroit

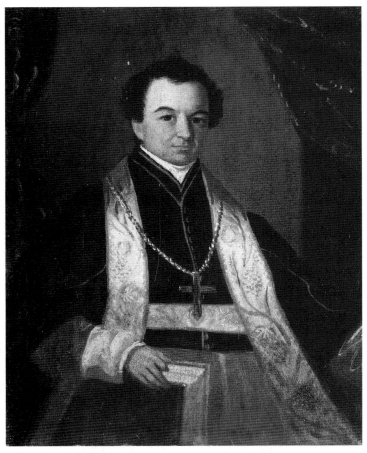

Bishop Résé

they were conducting a German and English free school with forty-five students. The school ceased operation in 1871.
J. G. S.

Provenance Mrs. Daniel J. Campau, Detroit; her daughter, Mrs. A. Campau Thompson, Detroit, 1902. Acquired in 1902.

Exhibitions Detroit 1949.

A39
Attributed to William Heatley Wilder
Bishop Résé, after 1837

Oil on academy board
45.1 × 35.6 cm (17¾ × 14 in.)
Gift of Mrs. A. Campau Thompson (02.33)

Like the portrait of Marie Françoise Vindevogel, which it resembles in both style and size, the portrait of Bishop Résé has been attributed to William Heatley Wilder since its donation to the Detroit

Institute of Arts in 1902. The first bishop of the Detroit diocese, Bishop Résé was consecrated at Cincinnati in 1837.
J. G. S.

Provenance Mrs. Daniel J. Campau, Detroit; her daughter, Mrs. A. Campau Thompson, Detroit, 1902. Acquired in 1902.

Exhibitions Detroit 1949.

Henry Benbridge

1743 PHILADELPHIA 1812

Henry Benbridge's early interest in art was encouraged and supported by his stepfather, a prosperous merchant. John Wollaston (q.v.), who visited Philadelphia in 1758, may have provided the young artist's first valuable instruction, as Benbridge's earliest style seems to show Wollaston's influence. The seventeen-year-old Benbridge is said to have painted the walls of his house with scenes from European prints (Charles Willson Peale Papers, MSS, American Philosophical Society), and judging from two of his surviving paintings that are dependent upon prints after Rubens—*Achilles among the Daughters of Lycomedes* (before 1765; private collection) and *The Three Graces* (after 1765; private collection)—the story is likely to be true.

In 1764 an inheritance enabled Benbridge to travel to Italy to study painting. There, like Benjamin West (q.v.), who had preceded him in 1760, he was much affected by the portrait style of Pompeo Batoni. His first real opportunity to prove

himself came when the English author James Boswell commissioned him to go to Corsica to paint a likeness of the popular general Pascal Paoli (1768; private collection). When finished, the ambitious, full-length portrait was shipped to England, with Benbridge following in 1769. The painting was widely praised, and the artist was well received by West in London, but Benbridge decided to return to his native Philadelphia in 1770. He moved to Charleston, South Carolina, in 1772 and was imprisoned there eight years later when the British took the city. Upon being freed in 1782, Benbridge traveled to Philadelphia and then south again, painting portraits in his strongly modeled, sharply outlined, neoclassical manner. He apparently retired in about 1790 because of failing health and returned to Philadelphia just before his death in 1812.
D. E.

Bibliography Washington 1971.

A40

Unknown Artist (formerly attributed to Henry Benbridge)

Portrait of an Artist, ca. 1765

Oil on canvas
76.2 × 63.5 cm (30 × 25 in.)
Founders Society Purchase, Dexter M. Ferry, Jr., Fund (38.14)

The identity of the artist who painted this portrait has long been in doubt. In 1938 William Sawitzky, the author of a book on Matthew Pratt, attributed the portrait to Pratt. Later, in 1959, Edgar P. Richardson re-attributed the painting to Henry Benbridge (notation in curatorial files, DIA). At that time it was thought to be a self-portrait, but as Robert Stewart pointed out in his 1971 catalogue for an exhibition on Benbridge, the sitter has brown eyes and Benbridge's eyes were blue. While Stewart reproduced the portrait in the section of the catalogue on questionable attributions, he gave his own conclusion

in a remark that seems to contradict this decision: "Certainly it is by Benbridge" (Washington 1971, 78).

What makes this attribution problem so difficult is that it depends upon visual comparison with documented examples of Benbridge's work, and there are very few secure pictures. For instance, there are only two known portraits that are actually signed, *Justice Charles Pinckney* (ca. 1773–74; Museum of Early Southern Decorative Arts, Winston-Salem, N.C.)

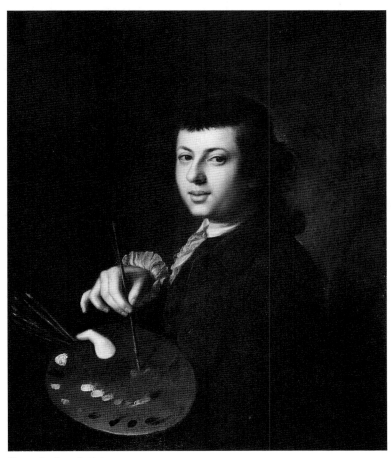

Portrait of an Artist

and *Unknown Gentleman* (1771; National Gallery of Art, Washington, D.C.). While the Detroit painting is much closer stylistically to Benbridge's portraits than to Pratt's, and while the hands and modeling of the face, particularly around the eyes, especially resemble Benbridge's work, there are still reasons to doubt an attribution to Benbridge. First, compared with the unquestioned works—even Benbridge's early family portraits painted just prior to his trip abroad in 1764—the facial fea-

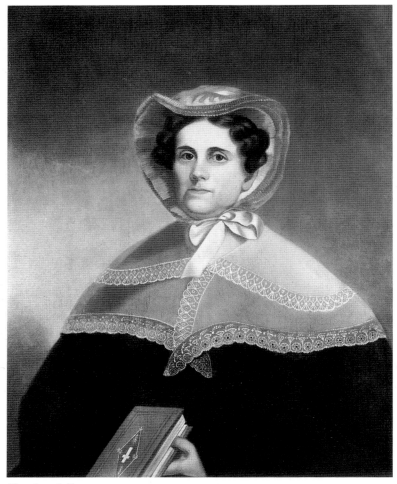

Mrs. Joseph Campau

Unknown Artist (formerly attributed to
Alvah Bradish)

Mrs. Joseph Campau, mid-nineteenth century

Oil on canvas
86×67.9 cm (33⅞×26¾ in.)
Founders Society Purchase, Elizabeth and Allan
Shelden Fund (56.102)

Attributed to Alvah Bradish when acquired
for the museum's collection in 1956, this
portrait of Mrs. Joseph Campau (1793–
1862) is unlike the artist's documented
works. Although Bradish was self-taught,
his paintings are technically quite compe-
tent and generally do not display the
flattened look and poorly rendered anat-
omy, typical of folk art, seen in this work.
Further evidence that the work is by an-
other hand can be found in a comparison
of the decidedly linear, sharply focused
treatment of Mrs. Campau's face and
shawl with the looser handling of fea-
tures and fabrics in the Bradish portraits
Shubael Conant and *Henry N. Walker* (cat.
nos. A5 and A6). The present portrait
and one of Joseph Campau by Frederick
E. Cohen (cat. no. A9) share a provenance,
both having been once in the collection of
the Springle Estate in Oka, Quebec. The
two works are almost identical in size,
raising the possibility that they were in-
tended as companion pieces. It is unlikely,
however, that the female portrait is by
Cohen, whose expertise is evident in his
insightful rendering of Mr. Campau.
J. G. S.

Inscriptions On the back of canvas,
*Adelaide fille de Antoine Lapieanniere
Dequindre et Catherine Desriviere Laminodiere,
l'espouse de Major Joseph Campau*

Provenance Springle Estate, Oka,
Quebec, Canada. John L. Russell (dealer),
Montreal. Acquired in 1956.

Exhibitions Detroit 1969.

tures are not as well integrated with the
head. Second, the head is placed unchar-
acteristically low on the canvas for a half-
length portrait by Benbridge. The third
and perhaps the strongest argument
against Benbridge, the subject appears in
a typical self-portrait pose; this, combined
with the work's provenance, supports the
opposing theory that it is by a provincial
English artist and dates, on the basis of
costume, from about 1765.
D. E.

Provenance Bought in England by Norton
Galleries, New York, 1938. Acquired in
1938.

References Letter in curatorial files, DIA,
from William Sawitzky, March 8, 1938 (as
by Matthew Pratt). C. Burroughs 1939, 2
(as by Pratt). Sawitzky 1942, 75. Washington
1971, 78.

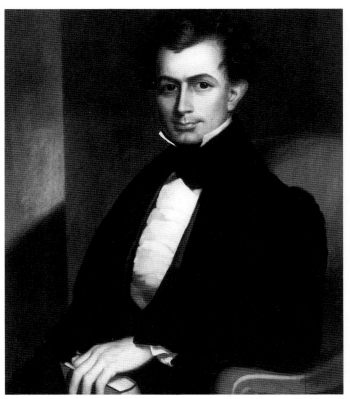

Henry Seymour Cole

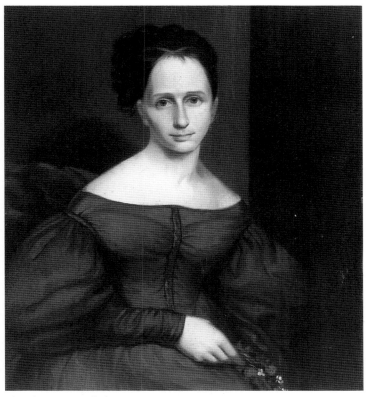

Victoria Desnoyer Cole

A42

Unknown Artist (formerly attributed to Alvah Bradish)

Henry Seymour Cole

Oil on panel
76.2 × 62.2 cm (30 × 24½ in.)
Bequest of Marion North Wilcox (66.2)

A43

Unknown Artist (formerly attributed to Alvah Bradish)

Victoria Desnoyer Cole

Oil on panel
76.2 × 63.5 cm (30 × 25 in.)
Bequest of Marion North Wilcox (66.3)

The style and the poses of the sitters in these companion paintings resemble innumerable works by itinerant folk artists who traveled throughout the Midwest in the mid-nineteenth century. The portraits' former attribution to Alvah Bradish may be based upon a faint resemblance between the likenesses of *Henry Seymour Cole* and a similar work in the Ontario County Court House, Canandaigua, New York, that is tentatively attributed to Bradish. As there is no firm evidence linking the Detroit paintings to Bradish, and as their handling is not distinctive enough to identify a particular hand, they are here attributed to an unknown artist.
J. G. S.

Provenance Marion North Wilcox, Marshall, Michigan. Acquired in 1966.

A44

Unknown Artist (probably Joseph Mansfeld, Austrian; formerly attributed to John F. Francis)

With the Daily Telegraph, 1880s(?)

Oil on panel
26.7 × 21 cm (10½ × 8¼ in.)
Bequest of Robert H. Tannahill (70.149)

This work bears the signature of William Michael Harnett, the well-known late-nineteenth-century master of trompe l'oeil, but in 1953 Alfred Frankenstein, an authority on Harnett, identified the signature as a forgery and re-attributed the painting to John F. Francis (q.v.).

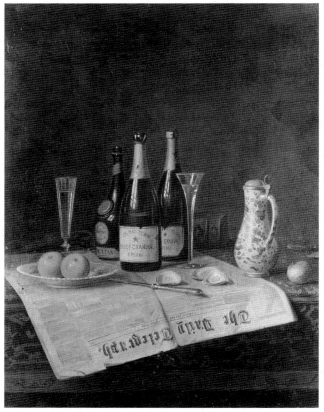

With the Daily Telegraph

identical to the one that appears in the present work. The Vienna painting is dated 1885. Three years later, Mansfeld painted a pair of still lifes (now in the Metropolitan Museum, Fresno, Calif.); in one of them, *Still Life with "Wiener Allgemeine Zeitung,"* is a ceramic jug with a pewter lid identical to the one in the Detroit picture, while the companion painting, *Still Life with "The Daily,"* features an English-language newspaper, as do both the Vienna picture and the present example. The reason for the appearance of this motif is unknown, but its inclusion suggests that Mansfeld was attempting to attract English or American patronage.
W. G.

Inscriptions At lower right, *W. M. Harnett*

Provenance Downtown Gallery, New York. Robert A. Tannahill, Detroit, by 1953. Acquired in 1970.

References Frankenstein 1953, 175.

Francis Matté

1808 ECUREUILS, QUEBEC, CANADA 1839

While Frankenstein may have been led to this conclusion by the work's bright palette and particularly by its emphasis on wine and liqueur bottles—both of which are characteristic of Francis's work—no other formal or stylistic traits displayed in the painting are remotely related to that artist's now extensively known oeuvre.

Another conjecture as to the work's attribution can, however, be made. Tabletop still lifes displaying the miniaturization of forms seen here are seldom found in American painting in the nineteenth century (except in the work of Harnett), but quite a number of such works were produced in the last quarter of the nineteenth century by a group of South German and Austrian painters, well known

in their own day, that included Camilla Friedländer (1856–1928) and Joseph Mansfeld (1819–1894).

The present work is very similar to Mansfeld's known still lifes, not only in the miniaturization of the forms but also in the dimensions of the painting, in the vertical composition, and in the combination of newspaper, edibles, crockery, and glassware. Heinrich Fuchs (*Die Osterreichischen Maler das 19. Jahrhunderts* [Vienna, 1973], 3: K37, 93) reproduces a similar still life, in which one of the champagne bottles is almost identical to the one in the Detroit picture. Even more important, the heavy, carpet-like table covering in the picture reproduced by Fuchs (private collection, Vienna) has a very similar pattern and a border almost

Only the bare outlines of Francis Matté's life have been discovered. His training as an artist was with the Quebec painter Antoine-Sébastien Plamondon (1804–1895) from 1834 to 1838. From the few works by Matté that survive it is evident that he followed closely the neoclassical style of Plamondon, who had been a student in Paris of Guérin, a follower of Jacques-Louis David. Among the artist's extant works are a series of portraits of bishops, which are preserved in the convent of the Ursulines in Quebec City.
J. G. S.

Bibliography Morisset 1960, 124.

298

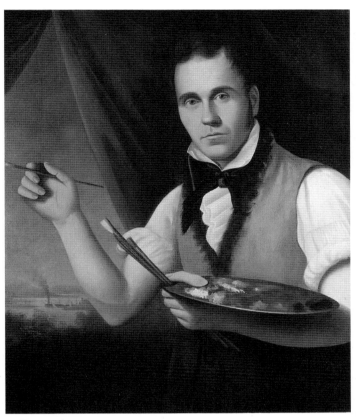

Self-Portrait

A45

Unknown Artist (formerly attributed
to Francis Matté)

Self-Portrait

Oil on canvas, 79.4 × 64.8 cm (31¼ × 25½ in.)
Founders Society Purchase, Director's
Discretionary Fund (57.262)

The identification of this work as a self-
portrait by the Canadian artist Francis
Matté was first proposed in 1960 by the
Canadian art historian Gérard Morisset.
In 1990, however, Paul Bourassa, Assis-
tant Curator of Early Quebec Art at the
Musée du Québec, in conjunction with a
committee of other scholars, rejected the
attribution to Matté. No alternative attri-
bution has been offered; thus the work
remains unattributed despite the fact that

it is a fine and even compelling self-portrait
of an early American or Canadian artist.

The artist portrayed himself looking
directly at the viewer, with the tools of his
craft in his hands. A calm sense of self-
assurance is communicated by his facial
expression. The sitter's red, fur-trimmed
vest and black bow tie create a lively
contrast to the more subdued brown and
green tones of the curtain behind him
and the distant landscape seen through
the window at the left. The modeling of
the face and figure is solid and the draw-
ing clear and precise.
J. G. S.

Provenance John Michael (dealer),
Detroit, 1957. Acquired in 1957.

Exhibitions Ottawa and Toronto 1967,
no. 89.

References Morisset 1960, 124.

A46

Unknown Artist (formerly attributed to
William Page)

Unidentified Figure, ca. 1835/75

Oil on canvas
94.6 × 73.7 cm (37¼ × 29 in.)
Founders Society Purchase, Merrill Fund
(46.314)

In 1946 the Henry Shaw Newman Gallery
identified this painting as *Man in Arabian
Costume*, but later in the year the Detroit
Institute of Arts purchased it from the
Old Print Shop as a *Shakespearean Figure*
by William Page (for biography, see
p. 144). The attribution was credible be-
cause of the layered paint film and the
alleged subject matter. Page was intensely
interested in Shakespeare; in the 1870s
he modeled several busts of Shakespeare,
painted two ideal characterizations, and
published "A Study of Shakespeare's
Portraits" in *Scribner's Magazine*.

The painting may be a Shakespearean
portrait, but little recommends it as by
Page. Joshua Taylor (1957a) listed the
painting among "attributed portraits,"
noting that it was not mentioned in the
Page literature and maintaining that if it
were by Page, it would date from the late
1830s. (Edgar P. Richardson then with-
drew his attribution to Page advanced a
few years earlier [1949a].) Although the
moody expression and shadowy atmos-
phere are characteristic of Page's early
work, the high-keyed palette, the frontal-
ity of the head, and the lax draftsman-
ship of the drapery and hand are not.
W. T. O.

Provenance Henry Shaw Newman
Gallery, New York, 1946. Old Print Shop,
New York, 1946. Acquired in 1946.

References Richardson 1949a, fig. 6, 9,
15. Taylor 1957a, 276, no. 125.

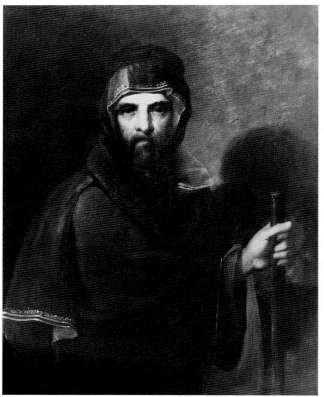

Unidentified Figure

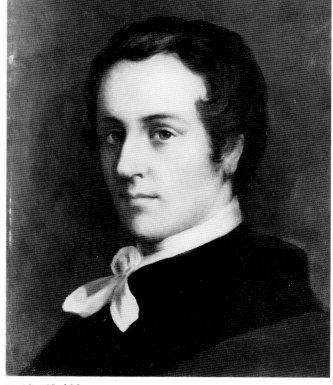

Unidentified Man

A47

Unknown Artist (formerly attributed to Rembrandt Peale)

Unidentified Man, ca. 1845/50

Oil on academy board
46.4 × 37.5 cm (18¼ × 14¾ in.)
Founders Society Purchase, *Detroit News'* Nancy Brown Experience Column Picture Fund (35.104)

This painting came to Detroit as a portrait by Rembrandt Peale (for biography, see p. 158) of Henry Wadsworth Longfellow at the age of twenty-seven. It had no history of ownership except for an inscription on the back documenting its presentation in 1855 to Daniel Edgar Sickles, secretary of the American Legation in London. The identification of the subject went unquestioned until 1955, when Henry Wadsworth Longfellow Dana, Longfellow's grandson, advised Edgar P. Richardson that the sitter was definitely not his grandfather.

The attribution to Peale, however, is also unlikely. The previously ascribed date of 1834 (when Longfellow was twenty-seven) could not apply, since Peale's portraits of that year, immediately after his third trip to London, are especially distinguished. As exemplified by *William Rankin* (Newark Museum, N.J.), they are characterized by vigorous modeling, stressing the softness of flesh, and by an emphasis on salient details, particularly the hair and the area around the eyes. A more likely date for the Detroit painting is in the mid- to late 1840s, when Peale and others responded to prevailing romantic taste by painting idealized, sentimentalized, often flaccid portraits in a broad manner. Despite Peale's remarkable stylistic flexibility, however, the Detroit portrait is anomalous for him in its support (Peale seldom painted on board) and its sketchiness (the ear and mouth are unusually ill-defined for Peale, and the sitter's right eye is misconceived).
W. T. O.

Annotations On the back, *Presented to / Secretary / Daniel Edgar Sickles / London 1855*

Provenance Daniel Edgar Sickles, London, 1855. Gabriel Wells (dealer), New York, 1935. Acquired in 1935.

References C. Burroughs 1935, 39–41. C. Burroughs 1944, 56. Jensen 1955, 44.

A48

Unknown Artist (formerly attributed to John Mix Stanley)

Wild Horses

Oil on wood panel
19.1 × 21.6 cm (7½ × 8½ in.)
Gift of Dexter M. Ferry, Jr. (15.15)

The reasons for the former attribution of this painting to John Mix Stanley (for biography, see p. 184) are not known. The work bears no signature or inscription to link it to Stanley. Neither is the style typical of that artist's oeuvre: the depiction of the horses is lacking in definition of detail and in expressiveness, and the handling of the medium in general is too weak. The absence of any distinctive characteristics in the execution of this work makes it impossible to suggest an alternative attribution.

J. G. S.

Provenance Dexter M. Ferry, Jr., Detroit. Acquired in 1915.

References Kinietz 1942, 9.

A49

Unknown Artist(s) (formerly attributed to Gilbert Stuart)

Portrait of a Woman, ca. 1785

Oil on canvas
76.2 × 63.5 cm (30 × 25 in.)
Gift of Dr. and Mrs. Coleman H. Mopper (75.112)

In the past, this oval, half-length portrait has been attributed to Gilbert Stuart (for biography, see p. 206). An x-radiograph of the work taken in an attempt to help verify the artist reveals, however, that much of the present surface is repainting. A somewhat faint but very different image appears underneath. The unidentified sitter was portrayed originally with a more protruding nose and perhaps more sharply arched eyebrows. Although these minor changes may have been made by

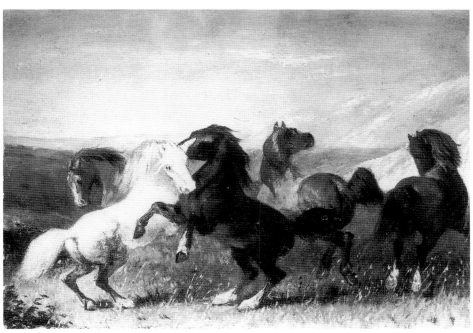

Wild Horses

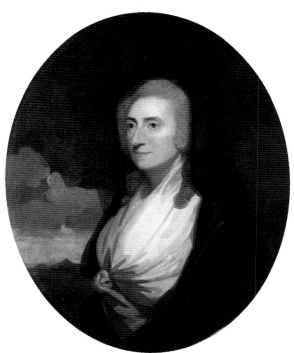

Portrait of a Woman

the first artist, a different and more clumsy hand altered the hairstyle, added a black veil, and (it would appear) completed most of the rest of the picture. Initially, the sitter's frizzled, bouffant hair, worn in the "hedgehog" style so popular around 1785, was defined with a free play of brushstrokes that are now hidden—making the present surface a kind of palimpsest.

When the picture was cleaned in 1976, the conservator, James L. Greaves, discovered that it had once been partially overcleaned after having been repainted. The restorer who had used the harsh cleaning agent covered his error by reinforcing the repainting. What is curious, when the picture is closely examined, is that it is so thinly painted, as if the original had been an unfinished sketch. Since Stuart was notorious for leaving his portraits unfinished after receiving at least half payment, it is possible that he did paint the face; but with so much incongruous repainting and the face partly overcleaned, the present portrait is too much of a distortion to be considered a work by any one artist.

D. E.

Provenance Sale, W. & F. C. Bonham & Sons, London, March 21, 1966, lot 112 (as *Portrait of a Lady* by "West"). Leger Galleries, London, 1966–68 (as by Gilbert Stuart). Dr. and Mrs. Coleman H. Mopper, Detroit, 1968–75. Acquired in 1975.

References BDIA 1976, 8 (as by Gilbert Stuart).

A50

Unknown Artist(s) (formerly attributed to Gilbert Stuart)

The Todd Family, ca. 1785

Oil on canvas
122.6 × 169.6 cm (48¼ × 66¾ in.)
Gift of Dexter M. Ferry, Jr. (27.187)

This group portrait, said to be of an English family named Todd, was attrib-

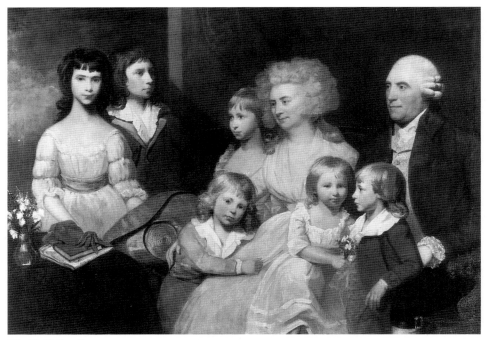

The Todd Family

uted to Gilbert Stuart (for biography, see p. 206) at the time of its acquisition in 1927. If it were by Stuart, it would be highly unusual; Stuart avoided painting such complex, multiple-figure compositions. Perhaps Charles M. Mount was the first to doubt the attribution, since, although he knew of the picture's existence (letter from Mount to Miss Monroe, August 21, 1962, curatorial files, DIA), he did not include it in the checklist of Stuart's works published in his 1964 book *Gilbert Stuart, a Biography.* Earlier, in a monograph of 1926, Lawrence Park had accepted the Stuart attribution but qualified his acceptance by saying that he had not seen the actual painting.

At first sight, the Detroit picture appears to be the work of possibly four different hands, which can be separated on stylistic grounds. The mother, wraithlike in her paleness, is sketchily painted with very light, rather weak modeling, in contrast to the strongly modeled younger children who have impastoed highlights

and red cheeks. These figures are quite unlike the more flatly painted father, with his overall opaque pink flesh color. The fourth group, the two older children, have highlights similar to the younger children but much darker shadows than all of the others. The shading of the flesh around the elder girl's nose and under her chin is actually black.

These discrepancies are explained by a recent x-radiograph, which shows that the picture has been repainted extensively. The original likenesses were more individualized and more expressive, particularly in the case of the father, the mother, and the two smaller children to her right. All of the heads were initially modeled more consistently so that there was less difference among them. In another major change, the mother and her two eldest daughters once wore day caps that were painted out, possibly by a restorer who meant to improve the figures' appearance. Other artists and/or restorers may have been involved in repainting the canvas

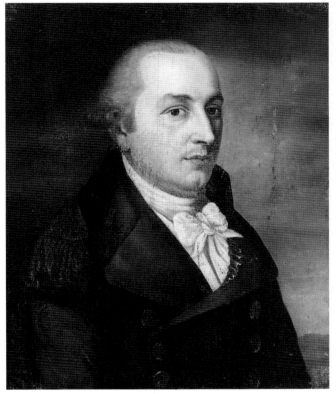

An Officer

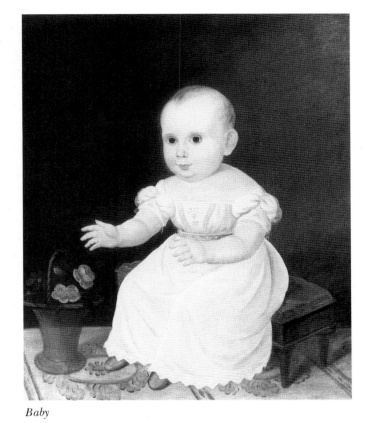

Baby

as well, producing the present stylistic incoherence.

It may be assumed that the original artist was English. The picture came from Southampton (albeit with a provenance that dates back no further than 1922), and the painting style and costuming are consistent with English taste in the late eighteenth century. On the basis of the costumes and hairstyles, this composition is datable to about 1785.

D. E.

Provenance William Burrough Hill (C. Burroughs [1927b] calls Hill "a member of the Todd family"), Southampton, England, 1922. Eugene Bolton, London. Frank T. Sabin (dealer), London, 1927. Acquired in 1927.

References Park 1926, 2: no. 843 (as by Gilbert Stuart). C. Burroughs 1927b, 96–97. C. Burroughs 1929a, 263, ill.

A51

Unknown Artist

An Officer, ca. 1795

Oil on canvas
35.6 × 27.9 cm (14 × 11 in.)
Bequest of John S. Newberry (65.216)

Little is known about this portrait, which was rendered in the popular kit-cat size (between a miniature and a full-size likeness, or approximately 91.4 × 71.1 centimeters [36 × 28 inches]) by a fairly competent but anonymous hand.

M. B.

Provenance John S. Newberry, New York. Acquired in 1965.

A52

Unknown Artist

Baby, ca. 1830

Oil on canvas
88.3 × 74.9 cm (34¾ × 29½ in.)
Gift of the Estates of Edgar William and Bernice Chrysler Garbisch (81.834)

The reasonable accuracy of the child's anatomy and the pleasing contrasts of color in this portrait verge on the academic. Unfortunately, nothing has yet come to light to help identify either the sitter or the artist.

M. B.

Provenance Herbert Schiffer (dealer), 1960. Edgar William and Bernice Chrysler Garbisch, New York. Acquired in 1981.

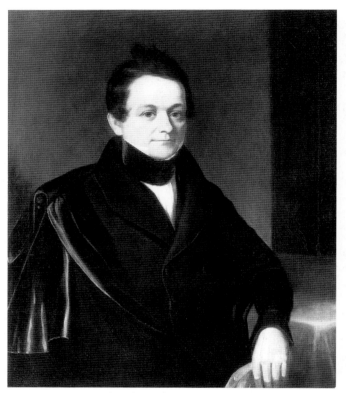

Benjamin Berry Kercheval

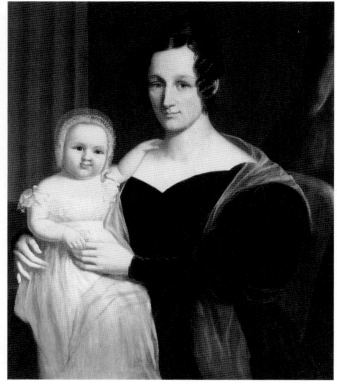

Mrs. Benjamin Kercheval and Her Daughter Mary

A53

Unknown Artist

Benjamin Berry Kercheval, ca. 1835

Oil on canvas
76.8 × 81.3 cm (38¼ × 32 in.)
Gift of Mrs. Jane Grasselli (60.163)

A54

Unknown Artist

*Mrs. Benjamin Kercheval and Her
Daughter Mary,* ca. 1835

Oil on canvas
97.2 × 81.3 cm (38¼ × 32 in.)
Gift of Mrs. Jane Grasselli (60.164)

Benjamin Berry Kercheval (1793–1855)
was a prominent Detroit businessman
with interests in real estate and land de-
velopment. He also served in the Michigan
state senate.

The double portrait of Maria Forsyth
Kercheval (1801–1882) and her infant
daughter Mary (1833–1910) is a compan-
ion in all but size to the portrait of
Benjamin. The canvas used for the por-
trait of his wife and daughter was proba-
bly larger so that the scale of their figures
would be proportionate to his.
M. B.

Provenance Benjamin Berry Kercheval,
Detroit; his daughter, Mary Kercheval
Field; her husband, Judge Moses W. Field;
their granddaughter, Jane [Mrs. Eugene]
Grasselli. Acquired in 1960.

Exhibitions (60.163) Flint 1963, no. 27.

A55

Unknown Artist

The Artist and His Subject, ca. 1845

Oil on canvas
74.9 × 64.5 cm (29½ × 25⅜ in.)
Gift of the Estates of Edgar William and
Bernice Chrysler Garbisch (81.840)

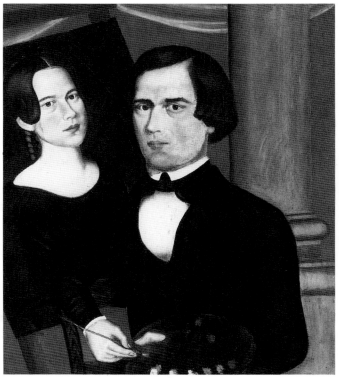

The Artist and His Subject

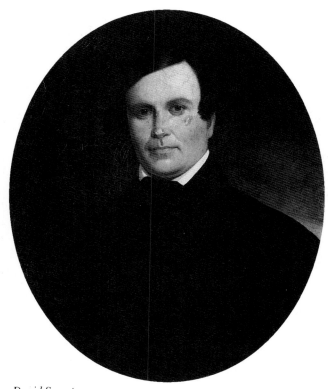

David Smart

The faces of the artist and "his subject"—the easel painting at the left—seem to be almost mirror images, both having similar features. The resemblance may indicate that the pair are siblings or perhaps man and wife. The subject of a portrait from eastern Massachusetts owned by the Childs Gallery in Boston, also unidentified, greatly resembles the girl in this painting-within-a-painting.
M. B.

Provenance Louis Lyons (dealer), 1949. Edgar William and Bernice Chrysler Garbisch, New York. Acquired in 1981.

References Bishop 1979, 43.

A56

Unknown Artist

David Smart, ca. 1845

Oil on canvas
74.9 × 62.2 cm (29½ × 24½ in.)
Gift of the Honorable Sol White (10.13)

The somber, monochromatic quality of the color in this work leads to the conjecture that the source may be a photograph, copied in oil on canvas. The practice was followed by a number of painters as cheap, quick mechanical images began to rob them of their clientele.

David Smart (1808–1874) immigrated from Scotland in 1826. From his uncle,

Robert Smart, he inherited a cartage business and the Merrill block in Detroit (currently the site of the City-County Building). He was also involved in the lumber business in Canada and served as president of the Detroit Fire Department.
M. B.

Provenance The Honorable Sol. White. Acquired in 1910.

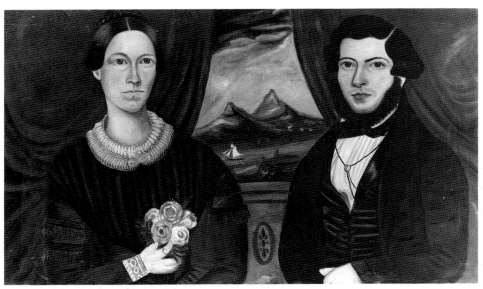

Mr. and Mrs. Gilbert Ide

A57

Unknown Artist

Mr. and Mrs. Gilbert Ide, ca. 1845

Oil on canvas
84.1 × 131.1 cm (33⅛ × 51⅝ in.)
Gift of the Estates of Edgar William and
Bernice Chrysler Garbisch (81.829)

Mr. and Mrs. Gilbert Ide, the otherwise
unidentified subjects of this painting, are
believed to have been residents of Westerly,
Rhode Island. Although the awkward
poses, the odd handling of the two visible
hands, the bunching of the drapery, and
the arresting landscape seen through the
window link the pair, their faces are ex-
traordinarily disparate in shading and
form. Many of the characteristics that
define American folk painting are in this
primitive work: difficulties with anatomy
and form, compositions crowded with
design with no real center of interest, and
indications of the meager training avail-

able to self-taught or little-tutored paint-
ers. Judging from costumes and hairstyles,
the painting can be dated to about 1845.
M. B.

Provenance Sara H. Andrews (dealer),
Rhode Island, 1961. Edgar William and
Bernice Chrysler Garbisch, New York.
Acquired in 1981.

A58

Unknown Artist

Ralph C. Smith, ca. 1855

Oil on canvas
76.2 × 59.7 cm (30 × 23½ in.)
Bequest of Abigail Smith (51.14)

A59

Unknown Artist

Mrs. Ralph C. Smith, ca. 1855

Oil on canvas
76.2 × 61 cm (30 × 24 in.)
Bequest of Abigail Smith (51.15)

Ralph C. Smith (1816–1874) was presi-
dent of Ralph C. Smith and Company, a
land office in Detroit. He married his
wife, Jane (1825–1915), in 1845.
M. B.

Provenance The sitters' daughter,
Abigail Smith. Acquired in 1951.

A60

Unknown Artist

Old Woman Reading the Detroit Morning Post, ca. 1875

Oil on canvas
53.3 × 43.2 cm (21 × 17 in.)
Founders Society Purchase, Merrill Fund
(55.293)

This caricature of an old woman, dressed
in a costume from the 1790s and reading
the *Detroit Morning Post*, was shown in the
"Art Loan" exhibition in Detroit in 1883
as *Reminiscence of the Patriot War*. The
appearance of the words "upper Canada"
on the first page of the paper and on one
of the maps held by the woman makes it
likely that the conflict referred to is the
War of 1812. The work does not appear
to be from the period depicted; it proba-
bly dates from the late nineteenth century.
M. B.

Annotations On a handwritten label on
center of back board, "*Old Lady Reading /
the First Copy of the Detroit / Morning Post."
(1824) / Artist unknown. / Family Heirloom
from Original Home of Mrs. Fisher.* [The
date for initial publication of the *Post* is
incorrect; it was first published in July
1837.]

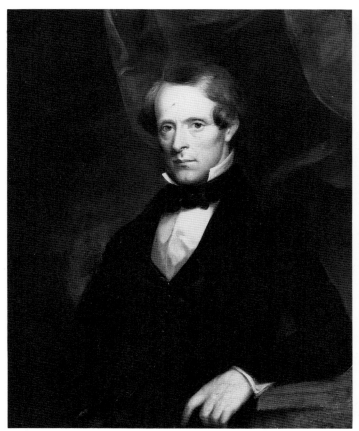

Ralph C. Smith

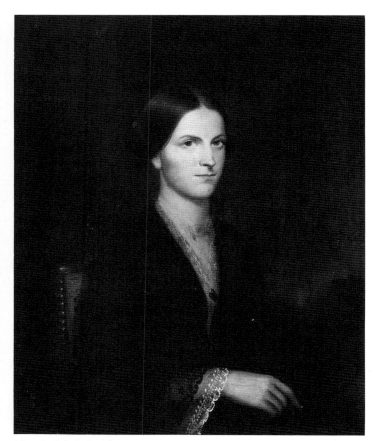

Mrs. Ralph C. Smith

Provenance Mrs. Robert Stead, Detroit, 1883; her daughter, Mrs. George Fisher, 1908. May Eubanks. Marian Fortune (dealer), 1955. Acquired in 1955.

Exhibitions Detroit 1883, no. 769 (as *Reminiscence of the Patriot War*). Flint 1963, no. 26.

A61

Unknown Artist

A Street in Brooklyn, ca. 1880–90

Oil on canvas
76.2 × 113 cm (30 × 44 ½ in.)
Founders Society Purchase, *Detroit News'* Nancy Brown Experience Column Picture Fund (34.21)

This scene depicts pristine streets and houses at the corner of Johnson and Adams streets in Brooklyn Heights, New York, in the last quarter of the nineteenth century. The gaslights, iron fences and stair rails, and shutters (closed on the upper levels to block out light and heat) are all typical of this upper-middle-class section of the borough of Brooklyn in the 1880s and 1890s.
M. B.

Provenance Newhouse Galleries, New York. Acquired in 1934.

Exhibitions New York 1955, no. 73. Salt Lake City 1976, no. 38.

References Richardson 1935, 83. *Antiques* 1954, 134.

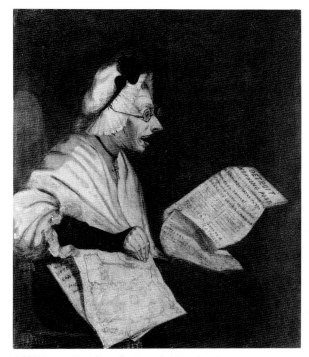

Old Woman Reading the Detroit Morning Post

A Street in Brooklyn

Abrams 1979
Abrams, Ann Uhry. "Politics, Prints, and John Singleton Copley's *Watson and the Shark.*" *Art Bulletin* 61 (June 1979): 265–276.

Academic Annals 1805
"An Account, Delivered at the Desire of the Council of the Royal Academy, of the Great Historical Works painted for His Majesty by Benjamin West, Esq. President." *Academic Annals, Published by Authority of the Royal Academy of Arts, 1804–1805. Collected and Arranged by Prince Hoare, Secretary for Foreign Correspondence to the Royal Academy.* London, 1805.

Ackroyd 1975
Ackroyd, Elizabeth. "Joseph Blackburn, Limner in Portsmouth." *Historical New Hampshire* 30 (Winter 1975): 231–243.

Adams 1927
Adams, R. H. *The Walker Art Galleries, Minneapolis, Minnesota.* Minneapolis, 1927.

Adler 1976
Adler, M. J., ed. *The Revolutionary Years: Britannica's Book of the American Revolution.* Chicago, 1976.

Akron 1951
Akron Art Institute, Ohio. [Exhibition; no cat.]. January 1951.

Albany 1936
Albany, N. Y., Albany Institute of History and Art. *Exhibition of American Portraits and Landscapes.* Exh. cat. 1936.

Albany 1946
Albany, N. Y., Albany Institute of History and Art. *A Selective Historical Survey.* 1946.

Alberts 1978
Alberts, Robert C. *Benjamin West: A Biography.* Boston, 1978.

Alexander 1957
Alexander, Boyd, trans. and ed. *Life at Fonthill 1807–1822; with Interludes in Paris and London: From the Correspondence of William Beckford.* London, 1957.

Allentown 1962
Allentown, Pa., Allentown Art Museum. *The World of Benjamin West.* Exh. cat. by Richard Hirsch. 1962.

American Art-Union 1851
American Art-Union, New York. "Committee of Management Minutes, February 20, 1851." MS. in collection of the New-York Historical Society.

American Art-Union 1851a
American Art-Union, New York. "Committee of Management Minutes, May 15, 1851." MS. in collection of the New-York Historical Society.

American Art-Union n.d.
American Art-Union, New York. "Register of Works of Art." MS. in collection of the New-York Historical Society.

Amory 1882
Amory, Martha Babcock. *The Domestic and Artistic Life of John Singleton Copley, R. A.* Boston, 1882.

Andover 1939
Andover, Mass., Phillips Academy, Addison Gallery of American Art. *William Dunlap, Painter and Critic: Reflections on American Painting of a Century Ago.* 1939.

Andrews and McCoy 1965
Andrews, Wayne, and Garnett McCoy. "The Artist Speaks. Part III: Romantic America and the Discovery of Nature." *Art in America* 53 (August–September 1965): 38–53.

Ann Arbor 1969
Ann Arbor, Mich., University of Michigan Museum of Art. *John Mix Stanley: A Traveler in the West.* Exh. cat. 1969.

Ann Arbor 1972
Ann Arbor, Mich., University of Michigan Museum of Art. *Art and the Excited Spirit.* Exh. cat. by David C. Huntington. 1972.

Annandale-on-Hudson et al. 1983
Annandale-on-Hudson, N.Y., Edith Blum Art Institute, Bard College; Yonkers, N.Y., Hudson River Museum; Albany, N.Y., Albany Institute of History and Art. *In Search of the Picturesque: Nineteenth Century Images of Industry along the Hudson River Valley.* Exh. cat. by Kenneth W. Maddox. 1983.

Antiques 1946
"The Martins of Rock Hall." *Antiques* 50 (December 1946): 398.

Antiques 1953
"Bingham Portrait at Detroit." *Antiques* 64 (October 1953): 310.

Antiques 1954
"Special Events: Primitives Abroad." *Antiques* 66 (August 1954): 134.

Antiques 1961
"In the Museums." *Antiques* 80 (November 1961): 466.

Antiques 1965
"The People and Places of the Old Northwest Territory." *Antiques* 87 (March 1965): 302–331.

Apollo 1976
"Art across North America." *Apollo* 104, n.s. 174 (August 1976): 136–137.

Apollo 1980
"The Sale-Room." *Apollo* 111, n.s. 217 (March 1980): 268.

Art Digest 1930
"Early America." *Art Digest* 4 (February 15, 1930): 8.

Art Digest 1936
"Albany Shows Historic Art at Celebration of Her Sesqui-Centennial." *Art Digest* 10 (August 1, 1936): 21.

Art Digest 1945
"Parted by Fame." *Art Digest* 19 (July 1, 1945): 12.

Art Digest 1952
"Recent Additions to America's Public Collections." *Art Digest* 26 (July 1952): 7–8.

Art News 1965
"American Milestone Comes to Washington." *Art News* 64 (March 1965): 35, 65–66, fig. 1.

Arvine 1851
Arvine, Kazlitt. *The Cyclopaedia of Anecdotes of Literature and the Fine Arts.* Boston, 1851. Reprint, Detroit, 1967.

Athens 1954
Athens, Ohio University. *American Painting 1804–1854.* Exh. cat. 1954.

Atlantic Monthly 1867
"Chester Harding." *Atlantic Monthly* 19 (April 1867): 484–488.

Austin et al. 1970
Austin, Tex., University of Texas Art Museum; Albany, N.Y., Albany Institute of History and Art; and New York, Hirschl and Adler Galleries. *Sanford Robinson Gifford (1823–1880).* Exh. cat. by Nicolai Cikovsky, Jr. 1970.

Baigell 1971
Baigell, Matthew. *A History of American Painting.* New York, 1971.

Baker 1920
Baker, C. H. Collins. *Catalogue of the Petworth Collection of Pictures in the Possession of Lord Leconfield.* London, 1920.

Baker 1945
Baker, C. H. Collins. "Notes on Joseph Blackburn and Nathaniel Dance." *Huntington Library Quarterly* 9 (November 1945–August 1946): 33–47.

Baltimore 1819
Baltimore, Auction Room at Corner of Second and Frederick Streets. "Landscape Paintings by Francis Guy." 1819.

Baltimore 1825–26
Baltimore, Peale Museum. *Fourth Annual Exhibition of Peale's Baltimore Museum.* Exh. cat. [1825–26].

Baltimore 1937
Baltimore Museum of Art. *Charles Carroll of Carrollton and His Family.* Exh. cat. 1937.

Baltimore 1937a
Municipal Museum of Baltimore. *An Exhibition of Paintings by Rembrandt Peale.* Exh. cat. with essay by Macgill James. 1937.

Baltimore 1956
Municipal Museum of Baltimore. *Rendezvous for Taste: Peale's Baltimore Museum, 1814 to 1830.* Exh. cat. by Wilbur Harvey Hunter, Jr. 1956.

Baltimore 1958
Baltimore Museum of Art. *J. Hall Pleasants Memorial Exhibition.* Exh. cat. 1958.

Baltimore 1965
Baltimore, Peale Museum. *The Peale Family and Peale's Baltimore Museum 1814–1830.* Exh. cat. by Wilbur Harvey Hunter, Jr. 1965.

Baltimore 1968
Baltimore Museum of Art. *From El Greco to Pollock: Early and Late Works by European and American Artists.* Exh. cat. by Gertrude Rosenthal et al. 1968.

Baltimore 1975
Baltimore, Maryland Historical Society. *Four Generations of Commissions: The Peale Collection of the Maryland Historical Society.* Exh. cat. with essay on Raphaelle Peale by Edward H. Dwight. 1975.

Baltimore 1975a
Baltimore Museum of Art. *"Anywhere, So Long as There Be Freedom": Charles Carroll of Carrollton, His Family and His Maryland.* Exh. cat. by Ann C. Van Devanter. 1975.

Baltimore 1981
Baltimore, Maryland Historical Society. *Francis Guy 1760–1820.* Exh. cat. by Stiles Tuttle Colwill. 1981.

Banister 1746–49
Banister, John. "Waste Book 1746–1749." MS. in the collection of the Rhode Island Historical Society, Providence.

Barbeau 1934
Barbeau, Marius. *Cornelius Krieghoff: Pioneer Painter of North America.* Toronto, 1934.

Barker 1950
Barker, Virgil. *American Painting: History and Interpretation.* New York, 1950.

Barlow 1807
Barlow, Joel. *The Columbiad. A Poem.* Philadelphia, 1807.

Baur 1940
Baur, John I. H. "The Peales and the Development of American Still Life." *Art Quarterly* 3 (Winter 1940): 81–92.

Baur 1953
Baur, John I. H. *American Painting in the Nineteenth Century.* New York, 1953.

Bayley 1910
Bayley, Frank W. *Sketch of the Life of and a List of Some of the Works of John Singleton Copley.* Boston, 1910.

Bayley 1915
Bayley, Frank W. *The Life and Works of John Singleton Copley.* Boston, 1915.

Bayley 1929
Bayley, Frank W. *Five Colonial Artists of New England.* Boston, 1929.

BDIA 1930
"Gifts, January 1, 1929, to December 31, 1929." *Bulletin of the Detroit Institute of Arts* (Annual Report) 11, no. 5 (February 1930): 69–71.

BDIA 1938
"Alger House Exhibition of Portraits of Prominent Detroiters." *Bulletin of the Detroit Institute of Arts* 17, no. 6 (March 1938): 55.

BDIA 1941
"Annual Report of the Trustees for the Year 1940" and "Accessions." *Bulletin of the Detroit Institute of Arts* 20, no. 5 (February 1941): 43–45, 46–50.

BDIA 1953–54
"Director's Report" and "Accessions." *Bulletin of the Detroit Institute of Arts* (Annual Report) 33, no. 2 (1953–54): 50, 51–59.

BDIA 1954–55
"Recent Acquisitions: An Album." *Bulletin of the Detroit Institute of Arts* 34, no. 1 (1954–55): 9–19.

BDIA 1976
"Curatorial Reports: American Art." *Bulletin of the Detroit Institute of Arts* (Annual Report) 55, no. 1 (1976): 7–8.

BDMA 1910
"The Court of Death. By Rembrandt Peale." *Bulletin of the Detroit Museum of Art* 4 (July 1910): 38–39.

BDMA 1913
"*Belisarius and the Boy* by Benjamin West." *Bulletin of the Detroit Museum of Art* 7 (1913): 21, 45–47.

Beal 1969
Beal, Rebecca J. *Jacob Eichholtz 1776–1842: Portrait Painter of Pennsylvania.* Philadelphia, 1969.

Belknap 1959
Belknap, Waldron Phoenix, Jr. *American Colonial Painting.* Cambridge, Mass., 1959.

Belle Assemblée 1808
"A Correct Catalogue of the Works of Benjamin West, Esq." *La Belle Assemblée or Bell's Court and Fashionable Magazine* (London) 4 (1808): Supplement, 13–20.

Benjamin 1880
Benjamin, S. G. W. *Art in America.* New York, 1880.

Berlin and Washington 1981
Berlin, Foundation for Prussian Cultural Property, and Washington, D.C., National Museum of American History. *Steuben, Secret Aid for the Americans.* Exh. cat. 1981.

Biddle and Fielding 1921
Biddle, Edward, and Mantle Fielding. *The Life and Works of Thomas Sully (1783–1872).* Philadelphia, 1921.

Binghamton 1970
Binghamton, N.Y., State University of New York, University Art Gallery. *The Works of John Vanderlyn from Tammany to the Capitol.* Exh. cat. by Kenneth C. Lindsay. 1970.

Bishop 1979
Bishop, Robert. *Folk Painters of America.* New York, 1979.

Black 1980
Black, Mary. "Contributions Toward a History of Early Eighteenth-Century New York Portraiture: The Identification of the Aetatis Suae and Wendell Limners." *American Art Journal* 12 (Autumn 1980): 4–31.

Black 1984
Black, Mary. "Phrenological Associations: Footnotes to the Biographies of Two Artists." *Clarion* (Museum of American Folk Art, New York) (Fall 1984): 44–53.

Black and Lipman 1966
Black, Mary, and Jean Lipman. *American Folk Painting.* New York, 1966.

Bloch 1967
Bloch, E. Maurice. *George Caleb Bingham: The Evolution of an Artist.* Berkeley and Los Angeles, 1967.

Bloch 1967a
Bloch, E. Maurice. *George Caleb Bingham: A Catalogue Raisonné.* Los Angeles, 1967.

Bloch 1975
Bloch, E. Maurice. *The Drawings of George Caleb Bingham; with a Catalogue Raisonné.* Columbia, Mo., 1975.

Bloch 1986
Bloch, E. Maurice. *The Paintings of George Caleb Bingham. A Catalogue Raisonné.* Columbia, Mo., 1986.

Bloomfield Hills 1964
Bloomfield Hills, Mich., Bloomfield Art Association. "Exhibition of Works of Early Michigan Artists." 1964.

Bloomington 1970
Bloomington, Indiana University Art Museum. *The American Scene 1820–1900.* Exh. cat. by Louis Hawes. 1970.

Bolton 1921
Bolton, Theodore. *Early American Portrait Painters in Miniature.* New York, 1921.

Bolton 1940
Bolton, Theodore. "Henry Inman, An Account of His Life and Work." *Art Quarterly* 3 (Autumn 1940): 353–375.

Bolton 1940a
Bolton, Theodore. "A Catalogue of the Paintings of Henry Inman." *Art Quarterly* 3 (Autumn 1940): Supplement, 401–418.

Bolton 1942
Bolton, Theodore. "Charles Loring Elliott, An Account of His Life and Work." *Art Quarterly* 5 (Winter 1942): 58–96.

Bolton and Binsse 1930
Bolton, Theodore, and Harry Lorin Binsse. "An American Artist of Formula: Joseph Blackburn." *Antiquarian* 15 (November 1930): 50–53, 88, 90, 92.

Bolton and Binsse 1930a
Bolton, Theodore, and Harry Lorin Binsse. "John Singleton Copley." *Antiquarian* 15 (December 1930): 76–88, 116, 118.

Bolton and Binsse 1930b
Bolton, Theodore, and Harry Lorin Binsse. "Robert Feke, First Painter to the Colonial Aristocracy; Biography with a Check-list of His Works." *Antiquarian* 15 (October 1930): 32–37ff.

Born 1945
Born, Wolfgang. "Sources of American Romanticism." *Antiques* 48 (November 1945): 274–277.

Born 1947
Born, Wolfgang. *Still-Life Painting in America.* New York, 1947.

Boston 1827
Boston, Athenaeum. *First Exhibition of Paintings in the Athenaeum Gallery Consisting of Specimens by American Artists and a Selection of the Works of the Old Masters.* 1827.

Boston 1828
Boston, Athenaeum. *Exhibition of Portraits Painted by the Late Gilbert Stuart, Esq.* Exh. cat. 1828.

Boston 1830
Boston, Athenaeum. *Fourth Exhibition.* 1830.

Boston 1831
Boston, Athenaeum. *Fifth Exhibition of Paintings.* 1831.

Boston 1839
Boston, Harding's Gallery. *Exhibition of Pictures Painted by Washington Allston.* Exh. cat. 1839.

Boston 1844
Boston, Corinthian Gallery. [Exhibition; no cat.] 1844.

Boston 1857
Boston, Athenaeum. *Thirtieth Exhibition of Paintings and Statuary.* 1857.

Boston 1863
Boston, Athenaeum. *Catalogue of Pictures Lent to the Sanitary Fair for Exhibition, Together with Catalogue of Paintings and Statuary of the Athenaeum Gallery.* 1863.

Boston 1871
Boston, Athenaeum. *Exhibition of Paintings for the Benefit of the French.* 1871.

Boston 1876
Boston, Museum of Fine Arts. *Second Catalogue of the Collection of Ancient and Modern Works of Art Given or Loaned to the Trustees.* 1876.

Boston 1881
Boston, Museum of Fine Arts. *Exhibition of the Works of Washington Allston.* Exh. cat. with essay by Thomas Gold Appleton. 1881.

Boston 1908
Boston, Museum of Fine Arts. [Exhibition; no cat.] 1908.

Boston 1911
Boston Art Club. *Loan Exhibition of Early American Portraits.* Exh. cat. 1911.

Boston 1930
Boston, Museum of Fine Arts. *One Hundred Colonial Portraits.* Exh. cat. 1930.

Boston 1938
Boston, Museum of Fine Arts. *John Singleton Copley, 1738–1815.* Exh. cat. 1938.

Boston 1943
Boston, Museum of Fine Arts. "Boston: Its Life and Its People, 1630–1872." 1943.

Boston 1969
Boston, Museum of Fine Arts. *American Paintings in the Museum of Fine Arts, Boston.* 2 vols. Perm. coll. cat. 1969.

Boston 1975
Boston, Museum of Fine Arts. *Paul Revere's Boston.* Exh. cat. 1975.

Boston and Philadelphia 1979
Boston, Museum of Fine Arts, and Philadelphia, Pennsylvania Academy of the Fine Arts. *"A Man of Genius": The Art of Washington Allston (1779–1843).* Exh. cat. by William H. Gerdts and Theodore E. Stebbins, Jr. 1979.

C. Bowen 1892
Bowen, Clarence Winthrop, ed. *The History of the Centennial Celebration of the Inauguration of George Washington as First President of the United States.* New York, 1892.

D. Bowen 1940
Bowen, Dana Thomas. *Lore of the Lakes.* 1940.

Boyd 1955
Boyd, Julian P., ed. *The Papers of Thomas Jefferson.* Vol. 12. Princeton, 1955.

Bridenbaugh 1948
Bridenbaugh, Carl, ed. *Gentleman's Progress: The Itinerarium of Dr. Alexander Hamilton.* Chapel Hill, N.C., 1948.

Brooklyn 1863
Brooklyn Art Association. *Fifth Exhibition.* Exh. cat. 1863.

Brooklyn 1917
Brooklyn Museum. *Early American Paintings.* Exh. cat. 1917.

Brooklyn 1949
Brooklyn Museum. "Westward Ho!" [No cat.] 1949.

Brooklyn 1949a
Brooklyn Museum. *The Coast and the Sea: A Survey of American Marine Paintings.* Exh. cat. 1949.

Brooklyn 1957
Brooklyn Museum. *Face of America. The History of Portraiture in the United States.* Exh. cat. with introduction by John Gordon. 1957.

Brooklyn 1960
Brooklyn Museum. *Victoriana: An Exhibition of the Arts of the Victorian Era in America.* Exh. cat. 1960.

***Brooklyn Museum Quarterly* 1915**
S. A. H. "Old Letters. The Avery Collection of Artists' Letters in the Brooklyn Museum." *Brooklyn Museum Quarterly* 2 (July 1915): 269–292.

Brown et al. 1979
Brown, Milton, Sam Hunter, John Jacobus, Naomi Rosenblum, and David M. Sokol. *American Art: Painting, Sculpture, Architecture, Decorative Arts, Photography.* New York, 1979.

Buffalo et al. 1976
Buffalo, Albright-Knox Art Gallery; Detroit Institute of Arts; Toledo Museum of Art; Cleveland Museum of Art. *Heritage and Horizon: American Painting, 1776–1976.* Exh. cat. 1976.

Buffet 1923
Buffet, Edward P. "William Sidney Mount and His Environment." *Quarterly Bulletin of the New-York Historical Society* 7, no. 3 (October 1923): 75–78.

***Bulletin of the AAU* 1851**
"The Chronicle: Art and Artists in America." *Bulletin of the American Art-Union* (December 1, 1851): 151.

A. Burroughs 1936
Burroughs, Alan. *Limners and Likenesses: Three Centuries of American Painting.* Cambridge, Mass., 1936.

A. Burroughs 1943
Burroughs, Alan. *John Greenwood in America, 1745–1752.* Andover, Mass., 1943.

A. Burroughs 1943a
Burroughs, Alan. "Young Copley." *Art in America* 31 (October 1943): 161–171.

C. Burroughs 1926
C. H. B. (Clyde H. Burroughs). "Portraits by Thomas Sully." *Bulletin of the Detroit Institute of Arts* 8, no. 1 (October 1926): 9–11.

C. Burroughs 1927
Burroughs, Clyde H. "Portraits by Wollaston and Harding." *Bulletin of the Detroit Institute of Arts* 9, no. 2 (November 1927): 20–21.

C. Burroughs 1927a
Burroughs, Clyde H. "A Portrait by Joseph Badger." *Bulletin of the Detroit Institute of Arts* 8, no. 7 (April 1927): 74.

C. Burroughs 1927b
C. H. B. (Clyde H. Burroughs). "The Todd Family by Gilbert Stuart." *Bulletin of the Detroit Institute of Arts* 8, no. 8 (May 1927): 96–97.

C. Burroughs 1928
Burroughs, Clyde H. "A Portrait by Copley." *Bulletin of the Detroit Institute of Arts* 9, no. 6 (March 1928): 69–70.

C. Burroughs 1929
Burroughs, Clyde H. "Portraits by John Neagle and Samuel F. B. Morse." *Bulletin of the Detroit Institute of Arts* 10 (May 1929): 104–106.

C. Burroughs 1929a
Burroughs, Clyde H. "Early American Portraits at the Detroit Institute of Arts." *Art in America* 17 (October 1929): 258–274.

C. Burroughs 1935
Burroughs, Clyde H. "Portrait of Henry Wadsworth Longfellow by Rembrandt Peale." *Bulletin of the Detroit Institute of Arts* 15, no. 3 (December 1935): 39–41.

C. Burroughs 1936
Burroughs, Clyde H. "Early American Landscape Paintings." *Bulletin of the Detroit Institute of Arts* 15, no. 6 (March 1936): 86–89.

C. Burroughs 1936a
Burroughs, Clyde H. "Paintings and Sculpture in Michigan." *Michigan Historical Magazine* (Autumn 1936): 395–409.

C. Burroughs 1939
Burroughs, Clyde H. "A Portrait by Matthew Pratt." *Bulletin of the Detroit Institute of Arts* 18, no. 7 (April 1939): 2.

C. Burroughs 1940
Burroughs, Clyde H. "*Monument Mountain, Berkshires,* by Asher B. Durand." *Bulletin of the Detroit Institute of Arts* 20, no. 1 (October 1940): 5–7.

C. Burroughs 1941
Burroughs, Clyde H. "Two American Portraits." *Bulletin of the Detroit Institute of Arts* 21, no. 1 (October 1941): 2–4.

C. Burroughs 1941a
Burroughs, Clyde H. "*John C. Hamilton* by Henry Inman." *Bulletin of the Detroit Institute of Arts* 21, no. 3 (December 1941): 21–22.

C. Burroughs 1944
Burroughs, Clyde H. "Paintings by the Peales." *Bulletin of the Detroit Institute of Arts* 23, no. 7 (April 1944): 54–58.

C. Burroughs 1944a
Burroughs, Clyde H. "Thomas Chamberlaine by John Hesselius." *Bulletin of the Detroit Institute of Arts* 24, no. 2 (1944): 22–23.

C. Burroughs 1945
Burroughs, Clyde H. "*Mrs. Josiah Martin* by Robert Feke, American (1705–1750)." *Bulletin of the Detroit Institute of Arts* 24, no. 5 (1945): 64–65.

C. Burroughs 1946
Burroughs, Clyde H. "*General Amasa Davis* by Gilbert Stuart." *Bulletin of the Detroit Institute of Arts* 25, no. 3 (1946): 52–53.

Bush 1977
Bush, Clive. *The Dream of Reason: American Consciousness and Cultural Achievement from Independence to the Civil War.* London, 1977.

Butler 1971
Butler, J. T. "Copley Portrait for Detroit." *Connoisseur* 176 (April 1921): 289.

Callow 1967
Callow, James T. *Kindred Spirits: Knickerbocker Writers and American Artists, 1807–1855.* Chapel Hill, N. C., 1967.

Canaday 1958
Canaday, John. "Metropolitan Seminars in Art." *Art in America* 46 (Fall 1958): 72–75.

Canaday 1969
Canaday, John. *The Lives of the Painters.* 4 vols. New York, 1969.

Carey 1817
Carey, William. *Critical Description and Analytical Review of "Death on the Pale Horse" Painted by Benjamin West, P. R. A.* London, 1817.

Carey 1819
Carey, William. *A Descriptive Catalogue of a Collection of Paintings by British Artists in the Possession of Sir John Fleming Leicester, Bart.* London, 1819.

Carey 1820
Carey, William. "Memoirs of Benjamin West, Esq., Late President of the Royal Academy of Painting, Sculpture, and Architecture, in London," *New Monthly Magazine* 13 (1820): 513–520, 688–697.

Cedar Rapids 1956
Cedar Rapids, Iowa, Coe College Auditorium. "Paintings Assembled for the Midwest Heritage Conference." 1956.

Chapel Hill 1968
Chapel Hill, N. C., William Hayes Ackland Memorial Art Center. *Arts of the Young Republic: The Age of Dunlap*. Exh. cat. by Harold E. Dickson. 1968.

Chicago 1893
Chicago, World's Columbian Exposition. *Official Catalogue. Part X. Department K. Fine Arts*. Exh. cat. 1893.

Chicago and New York 1945
Art Institute of Chicago and New York, Whitney Museum of American Art. *The Hudson River School and the Early American Landscape Tradition*. Exh. cat. with essay by Frederick A. Sweet. 1945.

Christ-Janer 1940
Christ-Janer, Albert. *George Caleb Bingham of Missouri: The Story of an Artist*. New York, 1940.

Christ-Janer 1975
Christ-Janer, Albert. *George Caleb Bingham*. New York, 1975.

CHSB 1961
"Exhibition of Portraits by Fitch, Moulthrop, Trumbull, and Richard and William Jennys." *Connecticut Historical Society Bulletin* 24, no. 4 (October 1961): 11.

Cincinnati 1954
Cincinnati Art Museum. *Paintings by the Peale Family*. Exh. cat. with introduction by Edward H. Dwight. 1954.

Cincinnati 1955
Cincinnati Art Museum. *Rediscoveries in American Painting*. Exh. cat. 1955.

J. Clarke 1840
Clarke, James Freeman. "Nature and Art, or The Three Landscapes." *Dial* 1 (October 1840): 173–175.

S. Clarke 1865
Clarke, Sarah. "Our First Great Painter and His Works." *Atlantic Monthly* (February 15, 1865): 130, 136.

Cleveland 1963
Cleveland Museum of Art. *Style, Truth and the Portrait*. Exh. cat. by Rémy G. Saisselin. 1963.

Coad 1917
Coad, Oral Sumner. *William Dunlap: A Study of His Life and Works and of His Place in Contemporary Culture*. New York, 1917.

Cody et al. 1987
Cody, Wyo., Buffalo Bill Historical Center; Fort Worth, Tex., Amon Carter Museum of Western Art; Philadelphia, Pa., Pennsylvania Academy of the Fine Arts. *American Frontier Life: Early Western Paintings and Prints*. Exh. cat. by Ron Tyler et al. 1987.

Colorado Springs 1949
Colorado Springs, Fine Arts Center. *Likeness of America 1680–1820*. Exh. cat. by Louisa Dresser. 1949.

Columbus 1952
Columbus, Ohio, Gallery of Fine Arts. *A Tour of Famous Cities*. Exh. cat. 1952.

Comstock 1958
Comstock, Helen. "The Connoisseur in America. 19th-Century Painting." *Connoisseur* 141 (March 1958): 63–66.

Constant 1974
Constant, Alberta Wilson. *Paintbox on the Frontier: The Life and Times of George Caleb Bingham*. New York, 1974.

Cooper 1982
Cooper, Helen A. *John Trumbull: The Hand and Spirit of a Painter*. New Haven, 1982.

Cooperstown et al. 1958
Cooperstown, N.Y., State Historical Society; Rochester, N.Y., Memorial Art Gallery; Albany, N.Y., Albany Institute of History and Art; Utica, N.Y., Munson-Williams-Proctor Institute; Syracuse, N.Y., Everson Museum of Art; New-York Historical Society. *Rediscovered Folk Painters of Upstate New York*. Exh. cat. by Agnes Halsey Jones. 1958.

Coral Gables 1975
Coral Gables, Fla., University of Miami, Lowe Art Museum. *The Paintings of Washington Allston*. Exh. cat. with essay by Kenyon C. Bolton III. 1975.

Cornell 1983
Cornell, Sara. *Art: A History of Changing Style*. Oxford, 1983.

Cowdrey 1953
Cowdrey, [Mary] Bartlett. *American Academy of Fine Arts and American Art-Union Exhibition Record, 1816–1852*. New York, 1953.

Cowdrey and Williams 1944
Cowdrey, [Mary] Bartlett, and Hermann Warner Williams, Jr. *William Sidney Mount 1807–1868: An American Painter*. New York, 1944.

Craven 1971
Craven, Wayne. "Painting in New York City, 1750–1775." In *American Painting to 1776: A Reappraisal*. Edited by Ian M. G. Quimby. Charlottesville, Va., 1971.

Craven 1975
Craven, Wayne. "John Wollaston: His Career in England and New York City." *American Art Journal* 7 (November 1975): 19–31.

Craven 1979
Craven, Wayne. "The Grand Manner in Early Nineteenth-Century American Painting: Borrowing from Antiquity, the Renaissance, and the Baroque." *American Art Journal* 11 (April 1979): 4–43.

Crean 1983
Crean, Hugh R. "The Influence of William Wordsworth's Concept of Memory on Washington Allston's Later Works." *Arts Magazine* 57 (June 1983): 58–63.

Cummings and Elam 1971
Cummings, Frederick J., and Charles H. Elam, eds. *The Detroit Institute of Arts Illustrated Handbook*. Detroit, 1971.

Custer 1952
Custer, General George A. *My Life on the Plains*. Edited by Milo M. Quaife. Chicago, 1952.

Dame 1947
Dame, Lawrence. "Boston Museum Evaluates Washington Allston." *Art Digest* 21 (August 1947): 13, 30.

Dana 1889
Dana, Richard Henry. "Allston and His Unfinished Picture. Passages from the Journals of R. H. Dana." *Atlantic Monthly* 64 (November 1889): 637–642.

A. Davidson 1978
Davidson, Abraham. *The Eccentrics and Other American Visionary Painters.* New York, 1978.

R. Davidson 1957
Davidson, Ruth. "Paintings in America: Seminar and Exhibition." *Antiques* 71 (April 1957): 364.

A. Dearborn 1844
Dearborn, A. H. S. "Allston's Feast of Belshazzar." *Knickerbocker* 24 (September 1844): 205–217.

Dearborn 1964
Dearborn, Mich., Henry Ford Museum. "Arts and Crafts of the Old Northwest." [No cat.] 1964.

DeMare 1954
DeMare, Marie. *G. P. A. Healy, American Artist: An Intimate Chronicle of the Nineteenth Century.* New York, 1954.

Denver 1948
Denver Art Museum. *Our American Heritage.* Exh. cat. 1948.

Denver 1955
Denver Art Museum. *Building the West.* Exh. cat. 1955.

Denver 1956
Denver Art Museum. "Clothes Make the Man." *Denver Art Museum Quarterly* (Spring 1956).

Denver 1959
Denver Art Museum. "Western Heritage." [No cat.] 1959.

Denver 1966
Denver Art Museum. *The Western Frontier.* Exh. cat. 1966.

Des Moines 1960
Des Moines Art Center. "Ways to Look." [No cat.] 1960.

Detroit 1853
Detroit, Gallery of Fine Arts, Fireman's Hall. *Catalogue of Articles on Exhibition at the Gallery of Fine Arts.* Exh. cat. 1853.

Detroit 1876
Detroit Art Association. *First Exhibition.* Exh. cat. 1876.

Detroit 1883
Detroit. *Art Loan Exhibition.* Exh. cat. 1883.

Detroit 1909
Detroit Museum of Art. *Catalogue of the D. M. Ferry Collection of Paintings.* 1909.

Detroit 1910
Detroit Museum of Art. *Handbook of Modern Paintings Belonging to the Detroit Museum of Art.* 1910.

Detroit 1920
Detroit Institute of Arts. *Catalogue of Paintings, Sculpture, and Contemporary Arts and Crafts.* 1920.

Detroit 1921
Detroit Institute of Arts. *Pilgrim Tercentenary Exhibition.* Exh. cat. with foreword by C. H. B. (Clyde H. Burroughs). 1921.

Detroit 1930
Detroit Institute of Arts. *A Loan Exhibition of American Colonial and Early Federal Art.* Exh. cat. 1930.

Detroit 1942
Detroit Institute of Arts. *Five Centuries of Marine Painting.* Exh. cat. 1942.

Detroit 1944
Detroit Institute of Arts. *The World of the Romantic Artist: A Survey of American Culture from 1800 to 1875.* Exh. cat. by E. P. Richardson. 1944.

Detroit 1944a
Detroit Institute of Arts. *Catalogue of Paintings.* 2nd ed. Detroit, 1944.

Detroit 1949
Detroit Institute of Arts. "An Exhibition of the Work of Painters in Detroit before 1900." Typewritten list. 1949.

Detroit 1951
Detroit Institute of Arts. *The French in America, 1820–1880.* Exh. cat. 1951.

Detroit 1957
Detroit Institute of Arts. *Painting in America: The Story of 450 Years.* Exh. cat. by E. P. Richardson. 1957.

Detroit 1959
Detroit Institute of Arts. *Portraits of Eight Generations of the Pitts Family.* Exh. cat. by Elizabeth H. Payne. 1959.

Detroit 1963
Detroit Historical Museum. *Pontiac Uprising 1763–1963.* Exh. cat. 1963.

Detroit 1964
Detroit Institute of Arts. *The Institute Collects: A Selective Survey of Additions to the Collections, 1959–1964.* Exh. cat. 1964.

Detroit 1965
Detroit Institute of Arts. *Paintings in the Detroit Institute of Arts: A Check List of the Paintings Acquired before June 1965.* 1965.

Detroit 1967
Detroit Institute of Arts. *American Decorative Arts from the Pilgrims to the Revolution.* Exh. cat. 1967.

Detroit 1968
Detroit Institute of Arts. "American Paintings from Detroit Collections." [No cat.] 1968.

Detroit 1969
Detroit Bank and Trust. "120th Anniversary Exhibition." 1969.

Detroit 1985
Detroit Institute of Arts. *One Hundred Masterworks from the Detroit Institute of Arts.* New York, 1985.

Detroit and Boston 1947
Detroit Institute of Arts and Boston, Museum of Fine Arts. *Washington Allston, 1779–1843: A Loan Exhibition of Paintings, Drawings, and Memorabilia.* Exh. cat. with essay by Edgar P. Richardson. 1947.

Detroit and Philadelphia 1968
Detroit Institute of Arts and Philadelphia Museum of Art. *Romantic Art in Britain: Paintings and Drawings 1760–1860.* Exh. cat. by Frederick Cummings, Robert Rosenblum, and Allen Staley. 1968.

Detroit and Toledo 1951
Detroit Institute of Arts and Toledo Museum of Art. *Travelers in Arcadia.* Exh. cat. by E. P. Richardson and Otto Wittmann, Jr. 1951.

Detroit and Utica 1967
Detroit Institute of Arts and Utica, N.Y., Munson-Williams-Proctor Institute. *The Peale Family: Three Generations of American Artists.* Exh. cat. edited by Charles H. Elam, with essays by Charles Coleman Sellers, E. Grosvenor Paine, and Edward H. Dwight. 1967.

DFP 1865
"A Visit to Stanley's Studio." *Detroit Free Press,* May 21, 1865.

DFP 1935
Detroit Free Press, [article on Copley], September 29, 1935.

DFP 1941
"Institute Announces New Gift." *Detroit Free Press,* November 30, 1941.

DFP 1941a
"Indian Folkways Recorded." *Detroit Free Press*, November 9, 1941.

Dickson 1942
Dickson, Harold E. "John Wesley Jarvis (1780–1840): A Painter of the Early Republic." Ph.D. diss., Harvard University, 1942.

Dickson 1943
Dickson, Harold E., ed. *Observations on American Art: Selections from the Writing of John Neal (1793–1876)*. Pennsylvania State College Studies, no. 12. 1943.

Dickson 1945
Dickson, Harold E. "The Artist's Profession in the Early Republic." *Art Quarterly* 8 (Autumn 1945): 261–280.

Dickson 1949
Dickson, Harold E. *John Wesley Jarvis: American Painter, 1780–1840*. New York, 1949.

Dickson 1973
Dickson, Harold E. "Artists as Showmen." *American Art Journal* 5 (May 1973): 4–17.

Dillenberger 1977
Dillenberger, John. *Benjamin West: The Context of His Life's Work with Particular Attention to Paintings with Religious Subject Matter*. San Antonio, Tex., 1977.

Dillenberger 1984
Dillenberger, John. *The Visual Arts and Christianity in America*. Decatur, Ga., 1984.

Dinnerstein 1984
Dinnerstein, Lois. "The Significance of the Colosseum in the First Century of American Art." *Arts Magazine* 58 (June 1984): 116–120.

DN 1941
"Indian Folkways Recorded." *Detroit News*, November 9, 1941.

Dorra 1960
Dorra, Henri. "Ryder and Romantic Painting." *Art in America* 48, no. 4 (1960): 22–33.

Doud 1969
Doud, Richard K. "John Hesselius, Maryland Limner." *Winterthur Portfolio* 5 (1969): 129–154.

Downes 1888
Downes, William Howe. "Boston Painters and Paintings II. Allston and His Contemporaries." *Atlantic Monthly* 62 (August 1888): 260.

Draper 1942
Draper, Benjamin Poff. "John Mix Stanley, Pioneer Painter." *Antiques* 14 (March 1942): 182.

Dresser 1958
Dresser, Louisa. "Jeremiah Theüs: Notes on the Date and Place of His Birth and Two Problem Portraits Signed by Him." *Worcester Art Museum Annual* 6 (1958): 43–44.

Dunlap 1834
Dunlap, William. *A History of the Rise and Progress of the Arts of Design in the United States*. 2 vols. New York, 1834. Reprint (2 vols. bound as 3). New York, 1969.

Dunlap 1931
Dunlap, William. *Diary of William Dunlap: The Memoirs of a Dramatist, Theatrical Manager, Painter, Critic, Novelist, and Historian*. 3 vols. New-York Historical Society, 1931.

East Lansing 1966
East Lansing, Michigan State University, Kresge Art Center Gallery. *American Nineteenth-Century Painting*. Exh. cat. 1966.

East Lansing 1986
East Lansing, Michigan State University, Kresge Art Center Gallery. *The Michigan Experience*. Exh. cat. 1986.

Eisen 1932
Eisen, Gustavus A. *Portraits of Washington*. 3 vols. New York, 1932.

Eliot 1957
Eliot, Alexander. *Three Hundred Years of American Painting*. New York, 1957.

Ellis 1986
Ellis, Elizabeth. "The 'intellectual and moral made visible': The 1830 Washington Allston Exhibition and Unitarian Taste in Boston." *Prospects* 10 (1986): 39–75.

Ellis forthcoming
Ellis, Elizabeth. "Washington Allston's Later Career and Art and Taste in Boston." Ph.D. diss., New York, Columbia University, forthcoming.

Elwood 1979
Elwood, Marie. "Two Portraits Attributed to Robert Feke." *Antiques* 116 (November 1979): 1150–1152.

D. Evans 1982
Evans, Dorinda. *Mather Brown: Early American Artists in England*. Middletown, Conn., 1982.

G. Evans 1959
Evans, Grose. *Benjamin West and the Taste of His Times*. Carbondale, Ill., 1959.

Evanston 1981
Evanston, Ill., Terra Museum of American Art. *Life in Nineteenth-Century America*. Exh. cat. 1981.

Fairbrother 1981
Fairbrother, Trevor J. "John Singleton Copley's Use of British Mezzotints for His American Portraits: A Reappraisal Prompted by New Discoveries." *Arts Magazine* 55 (March 1981): 122–130.

Farington 1978–84
Farington, Joseph. *The Diary of Joseph Farington*. Vols. 1–6. Edited by Kenneth Garlick and Angus Macintyre. Vols. 7–16. Edited by Kathryn Cave. New Haven and London, 1978–84.

Farmer 1889
Farmer, Silas. *The History of Detroit and Michigan. . . .* 2nd ed., rev. 2 vols. Detroit, 1889.

Fisher 1985
Fisher, L. E. *Masterpieces of American Painting*. New York, 1985.

Flagg 1892
Flagg, Jared B. *The Life and Letters of Washington Allston*. New York, 1892.

Fleischer 1971
Fleischer, Roland E. "Gustavus Hesselius: A Study of His Style." In *American Painting to 1776: A Reappraisal*. Edited by Ian M. G. Quimby. Charlottesville, Va., 1971.

Flexner 1947
Flexner, James Thomas. *American Painting: First Flowers of Our Wilderness*. Boston, 1947.

Flexner 1947a
Flexner, James Thomas. "Aristocratic Visions: The Art of Feke; with a Chronological List of His Works." *Magazine of Art* 40 (January 1947): 2–7, 35–36.

Flexner 1954
Flexner, James Thomas. *The Light of Distant Skies: American Painting, 1760–1835*. New York, 1954. Reprint. New York, 1969.

Flexner 1955
Flexner, James Thomas. *Gilbert Stuart: A Great Life in Brief*. New York, 1955.

Flexner 1970
Flexner, James Thomas. "Nineteenth-Century American Painting." *Antiques* 98 (September 1970): 432–435.

Flexner 1970a
Flexner, James Thomas. *Nineteenth-Century American Painting.* New York, 1970.

Flint 1963
Flint, Mich., Flint Institute of Arts. *Michigan Art: Yesterday and Today.* Exh. cat. 1963.

Foote 1930
Foote, Henry Wilder. *Robert Feke: Colonial Portrait Painter.* Cambridge, Mass., 1930.

Foote 1950
Foote, Henry Wilder. *John Smibert, Painter.* Cambridge, Mass., 1950.

Ford 1949
Ford, Alice. *Pictorial Folk Art from New England to California.* New York and London, 1949.

Fort Worth 1975
Forth Worth, Tex., Amon Carter Museum of Western Art. "1776." [No cat.] 1975.

Frankenstein 1951
Frankenstein, Alfred. "J. F. Francis." *Antiques* 59 (May 1951): 374–377, 390.

Frankenstein 1953
Frankenstein, Alfred. *After the Hunt: William Harnett and Other American Still-Life Painters, 1870–1900.* Berkeley, 1953. Rev. ed. Berkeley, 1969.

Frankenstein 1970
Frankenstein, Alfred. *The World of Copley 1738–1815.* New York, 1970.

Frankenstein 1975
Frankenstein, Alfred. *William Sidney Mount.* New York, 1975.

Frankfurt et al. 1953
Frankfurt, Städelsches Kunstinstitut; Munich, Bayerische Staatsgemäldesammlungen; Hamburg, Kunsthalle; Berlin, Charlottenburger Schloss; Düsseldorf, Kunstsammlungen der Stadt. *Hundert Jahre amerikanische Malerei, 1800–1900.* Exh. cat. by John I. H. Baur, H. K. Röthel, and A. Schädler. 1953. (See also Rome and Milan 1954, New York 1954.)

Friedman 1976
Friedman, Winifred H. *Boydell's Shakespeare Gallery.* New York and London, 1976.

Fuller 1840
Fuller, Margaret. "A Record of Impressions Produced by the Exhibition of Mr. Allston's Pictures in the Summer of 1839." *Dial* 1 (July 1840): 79.

Galt 1816
Galt, John. *The Life and Studies of Benjamin West, Esq., President of the Royal Academy of London, Prior to His Arrival in England, Compiled from Materials Furnished by Himself.* London, 1816.

Galt 1820
Galt, John. *The Life and Works of Benjamin West, Esq., President of the Royal Academy of London, Subsequent to His Arrival in This Country.* London, 1820.

Gardner and Feld 1965
Gardner, Albert Ten Eyck, and Stuart P. Feld. *American Paintings: A Catalogue of the Collection of the Metropolitan Museum of Art.* Vol. 1. Perm. coll. cat. 1965.

Geneseo 1968
Geneseo, N. Y., State University College. *The Hudson River School.* Exh. cat. 1968.

Gerdts 1958
Gerdts, William H. "'Heads or Tails': The Seward Portrait in City Hall." *Art Quarterly* 21 (Spring 1958): 68–81.

Gerdts 1967
Gerdts, William H. "The Peale Family at Detroit and Utica." *Burlington Magazine* 109 (April 1967): 258, 260–262.

Gerdts 1973
Gerdts, William H. "Allston's Belshazzar's Feast I." *Art in America* 61 (March–April 1973): 59–66.

Gerdts 1973a
Gerdts, William H. "Belshazzar's Feast II: 'That Is His Shroud.'" *Art in America* 61 (May–June 1973): 58–65.

Gerdts 1974
Gerdts, William H. *The Great American Nude.* New York, 1974.

Gerdts 1981
Gerdts, William H. *Painters of the Humble Truth: Masterpieces of American Still Life 1801–1939.* New York and London, 1981.

Gerdts 1983
Gerdts, William H. "The American 'Discourses': A Survey of Lectures and Writing on American Art, 1770–1858." *American Art Journal* 15 (Summer 1983): 61–78.

Gerdts and Burke 1971
Gerdts, William H., and Russell Burke. *American Still-Life Painting.* New York, Washington, and London, 1971.

Geske 1953
Geske, Norman. "Rembrandt Peale: A Case Study in American Romanticism." Master's essay, New York University, 1953.

A. Gibson 1975
Gibson, Arthur H. *Artists of Early Michigan.* Detroit, 1975.

E. Gibson 1865
Gibson, Elizabeth Bordley. *Biographical Sketches of the Bordley Family of Maryland.* Philadelphia, 1865.

Gilbert 1973
Gilbert, Bil. *The Trailblazers.* New York, 1973.

Gnau 1949
Gnau, Joyce Black. "Trumbull's *Surrender of Lord Cornwallis at Yorktown.*" *Bulletin of the Detroit Institute of Arts* 28, no. 2 (1949): 43–46.

L. B. Goodrich 1967
Goodrich, Laurence B. *Ralph Earl, Recorder for an Era.* Albany, N.Y., 1967.

L. Goodrich 1966
Goodrich, Lloyd. *Three Centuries of American Art.* New York, 1966.

Goodwin 1886
Goodwin, D. *Provincial Pictures by Brush and Pen.* Chicago, 1886.

Gottesman 1954
Gottesman, Rita S. *The Arts and Crafts in New York, 1777–1799.* New-York Historical Society, 1954.

Grand Rapids 1943
Grand Rapids, Mich., Art Gallery. [Exhibition; no cat.] 1943.

Graves 1905
Graves, Algernon. *The Royal Academy of Arts: A Complete Dictionary of Contributors and Their Works from Its Foundation in 1769 to 1904.* 8 vols. London, 1905.

Green 1957
Green, Samuel M. "Some Afterthoughts on the Moulthrop Exhibition." *Connecticut Historical Society Bulletin* 22, no. 2 (April 1957): 33–45.

Green 1966
Green, Samuel M. *American Art: A Historical Survey.* New York, 1966.

Greene 1860
Greene, George Washington. *Bibliographical Studies*. New York, 1860.

Grigaut 1955–56
Grigaut, Paul. "An *American Lake Scene* by Thomas Cole." *Bulletin of the Detroit Institute of Arts* 35, no. 4 (1955–56): 88–90.

Groce 1952
Groce, G. C. "John Woolaston [*sic*], fl. 1736–1767: A Cosmopolitan Painter in the British Colonies." *Art Quarterly* 15 (Summer 1952): 132–149.

Groce and Wallace 1964
Groce, G. C., and D. H. Wallace. *The New-York Historical Society's Dictionary of Artists in America, 1569–1860*. New Haven, 1964.

Groce and Willet 1940
Groce, G. C., and J. T. Chase Willet. "Joseph Wood: A Brief Account of His Life and First Catalogue of His Work." *Art Quarterly* 3 (Spring 1940): 149–166 and suppl. 393–418.

Hall 1962
Hall, Douglas. "The Tabley House Papers." *Walpole Society* 38 (1962): 59–122.

Hamilton 1961
Hamilton, Ont., Canada, Art Gallery. *American Realists*. Exh. cat. 1961.

Harding 1866
Harding, Chester. *My Egotistography*. Cambridge, Mass., 1866.

Harper 1966
Harper, J. Russell. *Painting in Canada: A History*. Toronto, 1966.

Harper 1979
Harper, J. Russel. *Krieghoff*. Toronto, 1979.

Harris 1966
Harris, Neil. *The Artist in American Society: The Formative Years, 1790–1860*. New York, 1966.

Hart 1908
Hart, Charles Henry, ed. *A Register of Portraits Painted by Thomas Sully*. Philadelphia, 1908.

Hartford 1942
Hartford, Conn., Wadsworth Atheneum. *In Memoriam*. Exh. cat. 1942.

Hartford 1964
Hartford, Conn., Wadsworth Atheneum. *Let There Be Light*. Exh. cat. 1964.

Hartford and Washington 1986
Hartford, Conn., Wadsworth Atheneum, and Washington, D.C., Corcoran Gallery of Art. *Views and Visions: American Landscape before 1830*. Exh. cat. by Edward J. Nygren et al. 1986.

Harwood 1969
Harwood, B. R. "Copley Copyist at Princeton." *Princeton Museum Record* 28, no. 2 (1969): 15–21.

Hazlitt 1930–34
Hazlitt, William. *Complete Works*. Edited by P. P. Howe after the edition of A. K. Waller and Arnold Glover. 21 vols. London and Toronto, 1930–34.

Healy 1894
Healy, George P. A. *Reminiscences of a Portrait Painter*. Chicago, 1894.

Heil and Burroughs 1930
Heil, Walter, and Clyde H. Burroughs. *Catalogue of Paintings in the Permanent Collection of the Detroit Institute of Arts of the City of Detroit*. Detroit, 1930.

Hills 1977
Hills, Patricia. *The Genre Painting of Eastman Johnson: The Sources and Development of His Style and Themes*. New York, 1977.

Hinsdale 1906
Hinsdale, Burke A. *History of the University of Michigan*. Ann Arbor, 1906.

Holme 1904
Holme, Charles, ed. "The Royal Academy from Reynolds to Millais." *The International Studio* (Special Summer Number, 1904).

Hood et al. 1977
Hood, Graham, Kathleen Pyne, and Nancy Rivard. "American Paintings Acquired during the Last Decade." *Bulletin of the Detroit Institute of Arts* 55, no. 2 (1977): 69–108.

Hope 1913
Hope, W. H. St. John. *Windsor Castle: An Architectural History*. 2 vols. London, 1913.

Hunt 1844
Hunt, William Parsons. "Belshazzar's Feast." *Christian Examiner* 37 (July 1844): 49–57.

Hunter 1964
Hunter, Wilbur Harvey. *The Peale Museum, 1814–1964: The Story of America's Oldest Museum Building*. Baltimore, 1964.

Huntington 1966
Huntington, David C. *The Landscapes of Frederic Edwin Church*. New York, 1966.

Indianapolis 1942
Indianapolis, John Herron Art Institute. *Retrospective Exhibition of Portraits by Gilbert Stuart*. Exh. cat. 1942.

Indianapolis 1961
Indianapolis, John Herron Art Institute. *Romantic America*. Exh. cat. 1961.

Isham 1905
Isham, Samuel. *The History of American Painting*. New York, 1905.

Jacksonville 1972
Jacksonville, Fla., Cummer Gallery. *1822 Sesquicentennial Exhibition, Part I*. Exh. cat. 1972.

Jaffe 1975
Jaffe, Irma B. *John Trumbull: Patriot-Artist of the American Revolution*. Boston, 1975.

Jaffe 1977
Jaffe, Irma B. "John Singleton Copley's *Watson and the Shark*." *American Art Journal* 9 (May 1977): 15–25.

Jameson 1844
Jameson, Anna Brownell. "Washington Allston." *Athenaeum* (London) 845 and 846 (January 6 and 13, 1844): 39–40.

Jarves 1864
Jarves, James Jackson. *The Art-Idea*. New York, 1864. Reprint edited by Benjamin Rowland, Jr. Cambridge, Mass., 1960.

Jensen 1955
Jensen, Oliver. "The Peales." *American Heritage* 6 (April 1955): 40–51, 97–101.

Johns 1977
Johns, Elizabeth. "Washington Allston: Method, Imagination, and Reality." *Winterthur Portfolio* 12 (1977): 1–18.

Johns 1979
Johns, Elizabeth. "Washington Allston and Samuel Taylor Coleridge: A Remarkable Relationship." *Journal of the Archives of American Art* 19, no. 3 (1979): 2–7.

Johns 1979a
Johns, Elizabeth. "Washington Allston's Later Career: Art about the Making of Art." *Arts Magazine* 54 (December 1979): 122–129.

Johnson City 1970
Johnson City, East Tennessee State University, Carroll Reece Museum. *The Painter Goes West*. Exh. cat. 1970.

Jones 1914
Jones, Guernsey, ed. *Letters and Papers of John Singleton Copley and Henry Pelham, 1739–1776.* Boston, 1914.

Kalamazoo 1967
Kalamazoo, Mich., Kalamazoo Institute of Arts. *Western Art: Paintings and Sculptures of the West.* Exh. cat. 1967.

Kansas City 1957
Kansas City, Mo., Nelson Gallery of Art. *The Last Frontier.* Exh. cat. 1957.

Kansas City 1977
Kansas City, Mo., Nelson Gallery and Atkins Museum. *Kaleidoscope of American Painting: Eighteenth and Nineteenth Centuries.* Exh. cat. 1977.

Kasson 1982
Kasson, Joy S. *Artistic Voyagers: Europe and the American Imagination in the Works of Irving, Allston, Cole, Cooper, and Hawthorne.* Westport, Conn., 1982.

Katonah 1981
New York, Katonah Gallery. "Opening the Way West." [No cat.] 1981.

Kellogg and Heslip 1984
Kellogg, Helen, and Colleen Heslip. "The Beardsley Limner Identified as Sarah Perkins." *Antiques* 3 (October 1984): 548–565.

Kennedy Quarterly **1959**
"Selections of American Nineteenth-Century Paintings from Our Current Stock." *Kennedy Quarterly* 1 (December 1959): n.p.

Kennedy Quarterly **1960**
"American Genre, Still Life and Landscape Paintings: Important Recent Acquisitions." *Kennedy Quarterly* 2 (October 1960): 13–14.

Kennedy Quarterly **1965**
"Charles Loring Elliott." *Kennedy Quarterly* 5 (January 1965): 100–101, no. 96.

Kennedy Quarterly **1967**
"An American Survey: Paintings from Two Centuries." *Kennedy Quarterly* 7 (March 1967): 3–75.

Kenny 1965
Kenny, Sister M. Kilian. "A History of Painting in Michigan, 1850 to World War II." Master's essay, Wayne State University, Detroit, 1965.

D. Keyes 1973
Keyes, Donald D. "Benjamin West's *Death on the Pale Horse*: A Tradition's End." *Ohio State University College of the Arts: The Arts* 7 (September 1973): 3–6.

H. Keyes 1938
Keyes, Homer Eaton. "Doubts Concerning Hesselius." *Antiques* 34 (September 1938): 144–146.

Kilgo 1982
Kilgo, Delores Ann. "The Sharp-Focus Vision: The Daguerreotype and the American Painter." Ph.D. diss., University of Illinois at Urbana-Champaign, 1982.

Kimball 1932
Kimball, Fiske. "Benjamin West au Salon de 1802: *La Mort sur le cheval pâle.*" *Gazette des Beaux-Arts* 7 (1932): 403–410.

King and Ross 1956
King, Edward S., and Marvin C. Ross. *The Walters Art Gallery: Catalogue of the American Works of Art.* Baltimore, 1956.

Kinietz 1942
Kinietz, W. Vernon. *John Mix Stanley and His Indian Paintings.* Ann Arbor, Mich., 1942.

Kraemer 1975
Kraemer, Ruth S. *Drawings by Benjamin West and His Son Raphael Lamar West.* New York, 1975.

LaFollette 1929
LaFollette, Suzanne. *Art in America from Colonial Times to the Present Day.* New York, 1929.

Lane 1941
Lane, James W. "William S. Mount, the Long Islander." *Art Quarterly* 4 (Spring 1941): 134–143.

Lansdown 1893
Lansdown, Charlotte, ed. *Recollections of the Late William Beckford, of Fonthill, Wilts, and Lansdown, Bath.* Privately printed, 1893.

Larkin 1949
Larkin, Oliver W. *Art and Life in America.* New York, 1949.

Lawall 1977
Lawall, David. *Asher Brown Durand: His Art and Art Theory in Relation to His Times.* New York, 1977.

Lawall 1978
Lawall, David. *Asher Brown Durand: A Documentary Catalogue of the Narrative and Landscape Paintings.* New York, 1978.

Lee 1929
Lee, Cuthbert. *Early American Portrait Painters.* New Haven, 1929.

Leningrad 1976
Leningrad, The Hermitage. *Exhibition of Pictures from Museums of the United States of America.* Exh. cat. 1976 (see also Paris 1976).

Lesley 1939
Lesley, Parker. "*The Banjo Player* by William S. Mount." *Bulletin of the Detroit Institute of Arts* 18, no. 4 (January 1939): 6–7.

Lester 1846
Lester, C. Edwards. *The Artists of America.* New York, 1846.

Lester 1868
L[ester], C. E[dwards]. "Charles Loring Elliott." *Harper's New Monthly Magazine* 38 (December 1868): 42–50.

Lewisburg 1958
Lewisburg, Pa., Bucknell University. *A Catalogue of Paintings by John F. Francis.* Exh. cat. with essay by George L. Hersey. 1958.

Lewisburg 1986
Lewisburg, Pa., Packwood House Museum. *A Suitable Likeness: The Paintings of John F. Francis 1832–1879.* Exh. cat. with essay by David W. Dunn. 1986.

Lindsay 1975
Lindsay, Kenneth C. "John Vanderlyn in Retrospect." *American Art Journal* 7 (November 1975): 79–90.

Lipton 1984
Lipton, Leah. "Chester Harding in Great Britain." *Antiques* 125 (June 1984): 1382–1390.

Lister 1973
Lister, Raymond. *British Romantic Art.* London, 1973.

Little 1948
Little, Nina Fletcher. "William Matthew Prior, the Traveling Artist, and His In-Laws, the Painting Hamblens." *Antiques* 26 (January 1948): 44–48.

Little 1950
Little, Nina Fletcher. "William Matthew Prior." In *Primitive Painters in America, 1750–1950: An Anthology.* Edited by Jean Lipman and Alice Winchester. New York, 1950.

Little 1957
Little, Nina Fletcher. *The Abby Aldrich Rockefeller Folk Art Collection.* Boston, 1957.

Little 1957a
Little, Nina Fletcher. "Little-Known Connecticut Artists, 1790–1810." *Connecticut Historical Society Bulletin* 22, no. 4 (October 1957): 97–128.

Lloyd 1984
Lloyd, Phebe. "Washington Allston, American Martyr." *Art in America* 72 (March 1984): 144–155, 177–179.

H. London 1927
London, Hannah R. *Portraits of Jews by Gilbert Stuart and Other Early American Artists*. New York, 1927.

London 1814
London, 125 Pall Mall. *Christ Rejected: Catalogue of the Pictures Representing the Above Subject Together with Sketches of Other Scriptural Subjects: Painted by Benjamin West, Esq.* 1814.

London 1817
London, 125 Pall Mall. *A Description of Mr. West's Picture of Death on the Pale Horse; or the Opening of the First Five Seals*. Exh. cat. by J. G. [John Galt]. 1817.

London 1822–28
London, West's Gallery. *Pictures and Drawings by the Late Benjamin West, Esq., President of the Royal Academy*. (Several catalogues all virtually identical.) 1822–28.

Los Angeles 1974
Los Angeles County Museum of Art. *American Narrative Painting*. Exh. cat. with essay by Donelson F. Hoopes, notes by Nancy Wall Moure. 1974.

Los Angeles and Washington 1981
Los Angeles County Museum of Art and Washington, D.C., National Portrait Gallery. *American Portraiture in the Grand Manner, 1720–1920*. Exh. cat. by Michael Quick with essays by Michael Quick, Marvin Sadik, and William H. Gerdts. 1981.

Los Angeles et al. 1972
Los Angeles County Museum of Art; San Francisco, M. H. de Young Memorial Museum; and St. Louis, City Art Museum. *The American West*. Exh. cat. by Lawrence Curry. 1972.

Los Angeles et al. 1974
Los Angeles, University of Southern California; Seattle Art Museum; Honolulu Academy of Art; and Santa Barbara Museum of Art. *Reality and Deception*. Exh. cat. with essays by Donald J. Brewer and Alfred Frankenstein. 1974.

Lyman 1934
Lyman, Grace A. "William Matthew Prior, the Painting Garrett Artist." *Antiques* 26 (November 1934): 180.

McCoubrey 1963
McCoubrey, John W. *The American Tradition in Painting*. New York, 1963.

McCoubrey 1965
McCoubrey, John W. *American Art 1700–1960: Sources and Documents*. Englewood Cliffs, N. J., 1965.

McCoy 1967
McC[oy], G[arnett]. "William Page and Henry Stevens: An Incident of Reluctant Art Patronage." *Journal of the Archives of American Art* 7 (July–October 1967): 15–23.

McDermott 1956
McDermott, John Francis. "Bingham's Portrait of John Quincy Adams Dated." *Art Quarterly* 19 (Winter 1956): 412–414.

McDermott 1959
McDermott, John Francis. *George Caleb Bingham, River Portraitist*. Norman, Okla., 1959.

Madison 1952
Madison, Wisconsin Historical Society. "Exhibition of American Painting." 1952.

Magazine of Art 1939
"News and Comment: Donations for Detroit." *Magazine of Art* 32 (February 1939): 108–109.

Mahey 1969
Mahey, John A. "Studio of Rembrandt Peale." *American Art Journal* 1, 2 (Fall 1969): 20–40.

Manchester 1956
Manchester, N. H., Currier Gallery of Art. "Seventeenth- and Eighteenth-Century American and English Decorative Arts." Exh. cat. 1956.

Mankin 1976
Mankin [Kornhauser], Elizabeth R. "Zedekiah Belknap." *Antiques* 110 (November 1976): 1056–1070.

Mansfield 1981
Mansfield, Ohio, Mansfield Art Center. *The American Landscape*. 1981.

Mason 1879
Mason, George C. *The Life and Works of Gilbert Stuart*. New York, 1879.

Massachusetts 1969
Massachusetts Historical Society. *The Notebook of John Smibert*. Essays by Sir David Evans, John Kirslake, and Andrew Oliver and notes relating to Smibert's American portraits by Andrew Oliver. Boston, 1969.

Mastai 1965
Mastai, M. L. D. "Watson and the Shark Acquired by the National Gallery, Washington." *Connoisseur* 159 (May 1965): 66–67.

Mather et al. 1927
Mather, Frank Jewett, Jr., Charles Rufus Morey, and William James Henderson. *The American Spirit in Art*. New Haven, 1927.

Mendelowitz 1970
Mendelowitz, Daniel M. *A History of American Art*. New York, 1970.

Meservey 1978
Meservey, Anne Farmer. "The Role of Art in American Life: Critics' Views on Native Art and Literature, 1830–1865." *American Art Journal* 10 (May 1978): 72–89.

Meyer 1975
Meyer, Jerry D. "Benjamin West's Chapel of Revealed Religion: A Study in Eighteenth-Century Protestant Religious Art." *Art Bulletin* 57 (June 1975): 247–265.

Meyer 1979
Meyer, Jerry D. "Benjamin West's Window Designs for St. George's Chapel, Windsor." *American Art Journal* 9 (1979): 53–65.

Middleton 1953
Middleton, Margaret Simons. *Jeremiah Theüs: Colonial Artist of Charlestown*. Columbia, S. C., 1953.

Millar 1969
Millar, Oliver. *The Later Georgian Pictures in the Collection of Her Majesty the Queen*. 2 vols. London, 1969.

Miller 1979
Miller, Lillian B. "The Peale Family: A Lively Mixture of Art and Science." *Smithsonian* 10 (April 1979): 66–74, 76–77.

Miller 1983
Miller, Lillian B., ed. *Charles Willson Peale: Artist in Revolutionary America, 1735–1791*. Vol. 1 of *The Selected Papers of Charles Willson Peale and His Family*. New Haven, 1983.

Miller 1986
Miller, Lillian B. "In the Shadow of His Father: Rembrandt Peale, Charles Willson Peale, and the American Portrait Tradition." *Pennsylvania Magazine of History and Biography* 110, no. 1 (January 1986): 33–47 (pertinent illus. appear on pp. 13–31 and 48–70).

Milwaukee and New York 1959
Milwaukee Art Center and New York, M. Knoedler Co. *Raphaelle Peale, 1774–1825: Still Life and Portraits*. Exh. cat. with essay by Charles Coleman Sellers, 1959.

Minneapolis 1909
Minneapolis Public Library. *Catalogue of Paintings & Sculpture Placed in the Minneapolis Public Library by Thomas B. Walker, with an Appendix Giving a List and Description of Paintings and Sculpture Presented by Others.* 1909.

Minneapolis 1939
Minneapolis, University of Minnesota, University Gallery. *Survey of Colonial and Provincial Painting.* Exh. cat. 1939.

Minneapolis 1949
Minneapolis Institute of Arts. *Historic Minnesota.* Exh. cat. 1949.

Minneapolis 1963
Minneapolis Institute of Arts. *Four Centuries of American Art.* Exh. cat. with essay by Marshall B. Davidson. 1963.

Minneapolis 1976
Minneapolis, Walker Art Center. *The River: Images of the Mississippi.* Exh. cat. 1976.

Montclair 1971
Montclair, N.J., Montclair Art Museum. *A. B. Durand 1796–1886.* Exh. cat. by David Lawall. 1971.

Montreal 1967
Montreal Museum of Fine Arts. *The Painter and the New World.* Exh. cat. 1967.

Mooz 1970
Mooz, R. Peter. "The Art of Robert Feke." Ph.D. diss., University of Pennsylvania, 1970.

Mooz 1971
Mooz, R. Peter. "Robert Feke: The Philadelphia Story." In *American Painting to 1776: A Reappraisal.* Edited by Ian M. G. Quimby. Charlottesville, Va., 1971.

Morgan 1939
Morgan, John Hill. *Gilbert Stuart and His Pupils.* New York, 1939.

Morgan and Fielding 1931
Morgan, John Hill, and Mantle Fielding. *The Life Portraits of Washington and Their Replicas.* Philadelphia, 1931.

Morgan and Foote 1936
Morgan, John Hill, and Henry Wilder Foote. "An Extension of Lawrence Park's Descriptive List of the Work of Joseph Blackburn." *American Antiquarian Society Proceedings* n.s. 46 (April 1936): 15–81.

Morisset 1960
Morisset, Gérard. *La Peinture traditionnelle au Canada français.* Ottawa, 1960.

Mount 1964
Mount, Charles Merrill. *Gilbert Stuart, A Biography.* New York, 1964.

Muskegon 1983
Muskegon, Mich., Muskegon Museum of Art. *Great Lakes Marine Painting of the Nineteenth Century.* Exh. cat. by J. Gray Sweeney. 1983.

Muskegon and Detroit 1987
Muskegon, Mich., Muskegon Museum of Art, and Detroit Historical Museum. *Artists of Michigan from the Nineteenth Century.* Exh. cat. by J. Gray Sweeney et al. 1987.

NEHGR 1853
New England Historic Genealogical Society Register 7 (1853): 17.

NEHGR 1928
New England Historic Genealogical Society Register 82 (1928): 15.

New Haven 1935
New Haven, Yale University Art Gallery. *Connecticut Portraits by Ralph Earl, 1751–1801.* Exh. cat. by William Sawitzky. 1935.

New Haven and London 1976
New Haven, Yale University Art Gallery, and London, Victoria and Albert Museum. *American Art 1750–1800: Towards Independence.* Exh. cat. edited by Charles F. Montgomery and Patricia E. Kane with essays by J. H. Plumb, Neil Harris, Jules David Prown, Frank H. Sommer, and Charles F. Montgomery. 1976.

New Orleans 1984
New Orleans, Historic New Orleans Collection. *The Waters of America: Nineteenth-Century American Paintings of Rivers, Streams, Lakes, and Waterfalls.* Exh. cat. with essay by John Wilmerding. 1984.

New York 1819
New York, Number Sixty-eight William Street. "120 Landscapes, Sea and Harbor Paintings by Francis Guy." 1819.

New York 1820
New York, Shakspeare [sic] Gallery. *Landscape Paintings by the Late [Francis] Guy.* Exh. cat. 1820.

New York 1821
New York, Number Two Fifty-three Broadway. *Paintings by the Late [Francis] Guy of Baltimore.* Exh. cat. 1821.

New York 1825–26
New York, Peale's New York Museum. *Catalogue of the Paintings.* [1825–26].

New York 1827
New York, American Academy of the Fine Arts. *Thirteenth Annual Exhibition.* Exh. cat. 1827.

New York 1846
New York, American Art-Union. *Catalogue of Works by the Late Henry Inman, with a Biographical Sketch: Exhibition for the Benefit of His Widow and Family.* Exh. cat. 1846.

New York 1867
New York, Studio Building. *Some Descriptions of a Few Pictures Painted by William Page.* Exh. cat. by William Page. 1867.

New York 1877
New York, National Academy of Design. *Exhibition of William Page's Pictures.* Exh. cat. 1877.

New York 1919
New York, American Art Association. *Early American Portraits Collected by Thomas B. Clarke.* Sale cat. with introduction by Dana H. Carroll. 1919.

New York 1921
New York, M. Knoedler Co. *Early American Portraits.* Exh. cat. 1921.

New York 1922
New York, Keeler Art Galleries. *August F. DeForest Collection.* Exh. cat. 1922.

New York 1932
New York, Metropolitan Museum of Art. *Samuel F. B. Morse: American Painter.* Exh. cat. by Harry B. Wehle. 1932.

New York 1936
New York, Metropolitan Museum of Art. *The Paintings of John Singleton Copley.* Exh. cat. 1936.

New York 1940
New-York Historical Society. "Jarvis Centennial Exhibition." 1940.

New York 1941
New York, James Graham and Sons. *An Exhibition of American Paintings by Charles Willson Peale, Rembrandt Peale, Raphaelle Peale, Mrs. Rembrandt Peale, James Peale.* Exh. cat. 1941.

New York 1941a
New York, John Levy Galleries. *The Mary H. Sully Collection of American Paintings.* Exh. cat. 1941.

New York 1941b
New York, Downtown Gallery. [Exhibition; no cat.]. April 1941.

New York 1942
New York, Harry Stone Gallery. "American Folk Art." [No cat.] May 1942.

New York 1943
New York, Museum of Modern Art. *Romantic Painting in America*. Exh. cat. with essays by James Thrall Soby and Dorothy C. Miller. 1943.

New York 1944
New York, M. Knoedler Co. "American Portraits by American Painters." 1944.

New York 1945
New York, Downtown Gallery. [Exhibition of American folk art; no cat.]. October–November 1945.

New York 1949
New York, Macbeth Gallery. [Exhibition; no cat.]. 1949.

New York 1953
New York, Century Association. *Exhibition of the Work of the Peale Family*. Exh. cat. 1953.

New York 1954
New York, Whitney Museum of American Art. *American Painting: The Nineteenth Century*. Exh. cat. 1954.

New York 1954a
New York, American Academy of Arts and Letters. *The Great Decade in American Writing, 1850–1860*. Exh. cat. 1954.

New York 1955
New York, American Federation of Arts. "American Primitive Painting." [Traveling exhibition; no cat.]. 1955.

New York 1957
New York, Wildenstein Gallery. *The American Vision*. Exh. cat. 1957.

New York 1959–60
New York, American Federation of Arts. "Major Works in Minor Scale." [Traveling exhibition; no cat.]. 1959–60.

New York 1961–62
New York, American Federation of Arts. "Artists of the Western Frontier." [Traveling exhibition; no cat.]. 1961–62.

New York 1964
New York, World's Fair, Gallery at the Better Living Center. *Four Centuries of American Masterpieces*. Exh. cat. 1964.

New York 1966
New York, Whitney Museum of American Art. *Art of the United States: 1670–1966*. Exh. cat. with essay by Lloyd Goodrich. 1966.

New York 1967
New York, Museum of American Folk Art. "Domestic Manners of the Americans." [No cat.] December 1967–February 1968.

New York 1967a
New York, Museum of American Folk Art. "Folk Artists in the City." [No cat.] October–December 1967.

New York 1970
New York, Hirschl and Adler Galleries. *Forty Master Works of American Art*. Exh. cat. 1970.

New York 1970a
New York, Hirschl and Adler Galleries. *Plain and Fancy: A Survey of American Folk Art*. Exh. cat. 1970.

New York 1973
New York, Whitney Museum of American Art. *The American Frontier: Images and Myths*. Exh. cat. by Patricia Hills. 1973.

New York 1974
New-York Historical Society. *Catalogue of American Portraits in the New-York Historical Society*. 2 vols. New Haven, 1974.

New York 1975
New York, Hirschl and Adler Galleries. *American Portraits by John Singleton Copley*. Exh. cat. 1975.

New York 1975a
New York Cultural Center. *Three Centuries of the American Nude*. Exh. cat. 1975.

New York 1975b
New York, Whitney Museum of American Art. *Seascape and the American Imagination*. Exh. cat. compiled by Roger B. Stein. 1975.

New York 1982
New York University, Grey Art Gallery and Study Center. *Samuel F. B. Morse*. Exh. cat. with essays by Paul J. Staiti and Gary A. Reynolds. 1982.

New York 1990
New York, Berry-Hill Galleries, Inc. *John F. Francis: Not Just Desserts*. Exh. cat. with essay by Bruce Weber. 1990.

New York et al. 1946
New York, Whitney Museum of American Art; Huntington, N. Y., Heckscher Art Museum; and Boston, Museum of Fine Arts. *Robert Feke*. Exh. cat. 1946.

New York et al. 1965
New York, Whitney Museum of American Art; Utica, Munson-Williams-Proctor Institute; Rochester, N.Y., Memorial Art Gallery; and Albany, N.Y., Albany Institute of History and Art. *John Quidor*. Exh. cat. by John I. H. Baur. 1965.

Newark 1963
Newark, N.J., Newark Museum. *Classical America*. Exh. cat. with essays by Berry B. Tracy and William H. Gerdts. 1963.

Newberry 1949
Newberry, John S. "Four Drawings by Copley." *Bulletin of the Detroit Institute of Arts* 28, no. 2 (1949): 32–35.

Newman 1932
Newman, G. N. "On Some Pictorial Representations of the *Walk-in-the-Water*." *Grosvenor Library Bulletin* (Buffalo, N.Y.) 15, no. 1 (1932): 11–14.

Newport 1963
Newport, R.I., Art Association of Newport. *Touro Synagogue Ancestors and Memorabilia, 1763–1963*. Exh. cat. 1963.

Noble 1853
Noble, Louis Legrand. *The Life and Works of Thomas Cole*. New York, 1853. Reprint. Cambridge, Mass., 1964.

Norfolk 1961
Norfolk, Va., Norfolk Museum of Arts and Sciences. *American Landscape Painters 1800–1900*. Exh. cat. 1961.

Northampton 1977
Northampton, Mass., Smith College Museum of Art. *Joseph Whiting Stock, 1815–1855*. Exh. cat. by Juliette Tomlinson and Betsy B. Jones. 1977.

Northfield 1967
Northfield, Minn., Carleton College. "Centennial Anniversary Celebration." [No cat.] 1967.

Novak 1969
Novak, Barbara. *American Painting of the Nineteenth Century*. New York, 1969.

Nylander 1972
Nylander, Richard C. "Joseph Badger, American Portrait Painter." Master's essay, State University of New York at Oneonta, 1972.

Oberlin 1954
Oberlin, Ohio, Oberlin College, Allen Memorial Art Museum. "American Painting." [No cat.] 1954.

Oliver 1970
Oliver, Andrew. "Portraits of John Quincy Adams and His Wife." *Antiques* 98 (November 1970): 748–753.

Oliver 1970a
Oliver, Andrew. *Portraits of John Quincy Adams and His Wife.* Cambridge, Mass., 1970.

Oliver 1982
Oliver, Andrew. "The Elusive Mr. Blackburn." *Colonial Society of Massachusetts* 59 (1982): 379–392.

Olympia 1971
Olympia, Wash., State Capitol Museum. "A Pacific Northwest Art Heritage." [No cat.] 1971.

Omaha 1954
Omaha, Joslyn Art Museum. *Life on the Prairie: The Artist's Record.* Exh. cat. 1954.

Ottawa and Toronto 1967
Ottawa, National Gallery of Canada, and Art Gallery of Toronto. *300 Years of Canadian Art.* Exh. cat. 1967.

Ourusoff 1962
Ourusoff, Elizabeth. "Thomas Cole: View of Florence from San Miniato." *Bulletin of the Cleveland Museum of Art* 49 (January 1962): 12–18.

Page 1875
Page, William. "A Study of Shakespeare's Portraits." *Scribner's Monthly* 10, no. 5 (September 1875): 558–574.

Palmer 1902
Palmer, Mary A. Witherell. "The Wreck of the *Walk-in-the-Water*: Pioneer Steamboat on the Western Lakes." *Buffalo Historical Society* 5 (1902): 319–323.

Papendiek 1887
Papendiek, Charlotte Louise Henrietta. *Court and Private Life in the Time of Queen Charlotte.* 2 vols. London, 1887.

Paris 1976
Paris, Musée Marmottan. *Chefs d'oeuvre des musées des états-unis de Giorgione à Picasso.* Exh. cat. 1976 (see also Leningrad 1976).

Park 1917
Park, Lawrence. "An Account of Joseph Badger and a Descriptive List of His Work." *Massachusetts Historical Proceedings* 51 (December 1917): 158–201.

Park 1918
Park, Lawrence. *Joseph Badger.* Boston, 1918.

Park 1922
Park, Lawrence. "Joseph Blackburn: A Colonial Portrait Painter. With a Descriptive List of His Works." *American Antiquarian Society Proceedings* n.s. 32 (October 1922): 270–329. Reprint in book form. Worcester, Mass., 1923.

Park 1926
Park, Lawrence. *Gilbert Stuart: An Illustrated Descriptive List of His Works Compiled by Lawrence Park with an Account of His Life by John Hill Morgan and an Appreciation by Royal Cortissoz.* 4 vols. New York, 1926.

Parker 1946
Parker, Barbara N. "Self-Taught American: Robert Feke." *American Collector* 15 (October 1946): 6–7.

Parker and Wheeler 1938
Parker, Barbara N., and A. B. Wheeler. *John Singleton Copley: American Portraits in Oil, Pastel, and Miniature, with Biographical Sketches.* Boston, 1938.

Parry 1972
Parry, Ellwood C. "Thomas Cole and the Problem of Figure Painting." *American Art Journal* 4 (Spring 1972): 66–86.

Parry 1978
Parry, Ellwood C. "Thomas Cole and the Practical Application of Landscape Painting." *New Mexico Studies in the Fine Arts* 3 (1978): 13–22.

Parry 1988
Parry, Ellwood C. *The Art of Thomas Cole: Ambition and Imagination.* Newark, Del. 1988.

Patrick 1959
Patrick, Ransom R. "The Early Life of John Neagle, Philadelphia Portrait Painter." Ph.D. diss., Princeton University, 1959.

Payne 1948
Payne, Elizabeth H. "An Early Portrait by Gilbert Stuart." *Bulletin of the Detroit Institute of Arts* 28, no. 1 (1948): 19–24.

Payne 1954–55
Payne, Elizabeth H. "Two Nineteenth-Century Portraits." *Bulletin of the Detroit Institute of Arts* 34, no. 4 (1954–55): 82–84.

Payne 1960
Payne, Elizabeth H. "Pitts Family Portraits of the Eighteenth Century." *Antiques* 77 (January 1960): 87–89.

Peabody 1839
[Peabody, Elizabeth Palmer]. *Remarks on Allston's Paintings.* Boston, 1839.

Peale 1820
[Peale, Rembrandt]. "Description of the Court of Death, An Original Painting by Rembrandt Peale." Baltimore [1820]. MS. in the collection of the Henry Francis du Pont Winterthur Museum, Winterthur, Del.

Peale 1820a
Peale, Rembrandt. "Original Thoughts on Allegorical Painting." *National Gazette*, October 28, 1820.

Peale 1839
Peale, Rembrandt. *Portrait of an Artist.* Philadelphia, 1839.

Peale 1846
[Peale, Rembrandt]. "Biographical Sketch of the Artist." [1846]. MS. in the collection of the Henry Francis du Pont Winterthur Museum, Winterthur, Del.

Peale 1846/47
[Peale, Rembrandt]. "*The Court of Death*, Painted by Rembrandt Peale, Is Now Open for Exhibition, for a Short Time Only." [1846/47]. MS. in the Gratz Collection, Historical Society of Pennsylvania, Philadelphia.

Peale 1856
Peale, Rembrandt. "The Painter's Eyes." *Crayon* 3 (June 1856): 163–165.

Peale 1857
Peale, Rembrandt. "The Court of Death." *Crayon* 4 (September 1857): 278–279.

Peale 1857a
Peale, Rembrandt. "Washington and His Portraits." 1857. MS. in the collection of Haverford College, Haverford, Pa.

R. Peale 1864
Peale, Rubens. "List." 1864. MS. in the collection of the American Philosophical Society, Philadelphia.

R. Peale 1864a
Peale, Rubens. "Diary, March–April 1864." Microfilm roll D10, Archives of American Art, Smithsonian Institution, Washington, D.C.

T. Peck 1898
Peck, Thomas Bellows. *The Bellows Genealogy.* Keene, N.H., 1898.

W. Peck 1967
Peck, William H. "A Portrait of Mrs. Charles Carroll of Annapolis by John Wollaston." *Bulletin of the Detroit Institute of Arts* 46, no. 2 (1967): 31–33.

Perkins 1873
Perkins, Augustus Thorndike. *A Sketch of the Life and a List of Some of the Works of John Singleton Copley.* Boston, 1873.

Perkins and Gavin 1980
Perkins, Robert F., Jr., and William J. Gavin III, comps. and eds. *The Boston Athenaeum Art Exhibition Index 1827–1874.* Boston, 1980.

Philadelphia 1795
Philadelphia, American Academy of the Fine Arts. *The Exhibition of the Columbianum, or American Academy of Painting, Sculpture, Architecture, & etc. Established at Philadelphia.* Exh. cat. 1795.

Philadelphia 1817
Philadelphia, Pennsylvania Academy of the Fine Arts. *Annual Exhibition.* Exh. cat. 1817.

Philadelphia 1819
Philadelphia, Pennsylvania Academy of the Fine Arts. *Annual Exhibition.* Exh. cat. 1819.

Philadelphia 1822
Philadelphia, Pennsylvania Academy of the Fine Arts. *Annual Exhibition.* Exh. cat. 1822.

Philadelphia 1826
Philadelphia, Pennsylvania Academy of the Fine Arts. *Annual Exhibition.* 1826.

Philadelphia 1829
Philadelphia, Pennsylvania Academy of the Fine Arts. *Annual Exhibition.* 1829.

Philadelphia 1838
Philadelphia, School of Painting and Design, Number One Forty-two Chestnut Street. *First Exhibition of Philadelphia Artists and of the School of Painting and Design.* Exh. cat. 1838.

Philadelphia 1839
Philadelphia, School of Painting and Design. *Second Exhibition of Philadelphia Artists and of the School of Painting and Design.* Exh. cat. 1839.

Philadelphia 1840
Philadelphia. *First Exhibition of the Artists' and Amateurs' Association of Philadelphia, for the Promotion of the Fine Arts.* Exh. cat. 1840.

Philadelphia 1876
Philadelphia, United States Centennial Commission, Art Gallery and Annexes. *International Exhibition.* 1876.

Philadelphia 1921
Philadelphia, Art Alliance. *Benjamin West Memorial Exhibition.* Exh. cat. 1921.

Philadelphia 1923
Philadelphia, Pennsylvania Academy of the Fine Arts. *Catalogue of an Exhibition of Portraits by Charles Willson Peale and James Peale and Rembrandt Peale.* Exh. cat. 1923.

Philadelphia 1925
Philadelphia, Pennsylvania Academy of the Fine Arts. *Catalogue of an Exhibition of Portraits by John Neagle.* Exh. cat. with essay by Mantle Fielding. 1925.

Philadelphia 1938
Philadelphia Museum of Art. *Gustavus Hesselius, 1682–1755.* Exh. cat. by Christian Brinton. 1938.

Philadelphia 1955
Philadelphia, Pennsylvania Academy of the Fine Arts. *150th Anniversary Exhibition.* Exh. cat. 1955.

Philadelphia 1956
Philadelphia, Peale Museum. *Rendezvous for Taste.* Exh. cat. 1956.

Philadelphia 1958
Philadelphia, University of Pennsylvania, University Museum. *The Noble Savage: The American Indian in Art.* Exh. cat. 1958.

Philadelphia 1976
Philadelphia Museum of Art. *Philadelphia: Three Centuries of American Art.* Exh. cat. 1976.

Philadelphia 1985
Philadelphia, Historical Society of Pennsylvania. *Rembrandt Peale 1778–1860: A Life in the Arts.* Exh. cat. with essays by Lillian B. Miller and Carol Eaton Hevner. 1985.

Philadelphia et al. 1973
Philadelphia, Pennsylvania Academy of the Fine Arts; Washington, D.C., Corcoran Gallery of Art; and Albany, N.Y., Albany Institute of History and Art. *Thomas Doughty 1793–1856: An American Pioneer in Landscape Painting.* Exh. cat. by Frank H. Goodyear, Jr. 1973.

Pierson and Davidson 1960
Pierson, William, and Martha Davidson, eds. *Arts of the United States: A Pictorial Survey.* New York, 1960.

Pike 1975
Pike, Donald G. "Images of an Era: The Mountain Man." *American West* 12 (September 1976): 36–45.

Pipes 1932
Pipes, Nellie B. "John Mix Stanley, Indian Painter." *Oregon Historical Quarterly* 33, no. 3 (September 1932): 25–27.

Pittsburgh 1940
Pittsburgh, Carnegie Institute. *Survey of American Paintings.* Exh. cat. 1940.

Pittsburgh et al. 1957
Pittsburgh, Carnegie Institute; Utica, N.Y., Munson-Williams-Proctor Institute; Richmond, Virginia Museum of Fine Arts; Baltimore Museum of Art; Manchester, N.H., Currier Gallery of Art. *American Classics of the Nineteenth Century.* Exh. cat. with essay by Gordon Bailey Washburn. 1957.

Plate 1969
Plate, Robert. *John Singleton Copley.* New York, 1969.

Pleasants 1942
Pleasants, J. Hall. *Four Late Eighteenth Century Anglo-American Landscape Painters.* Reprinted from *Proceedings of American Antiquarian Society.* Worcester, Mass., 1942.

Poughkeepsie 1961
Poughkeepsie, N.Y., Vassar College Art Gallery. *An Exhibition of the Works of Samuel F. B. Morse, Trustee of Vassar College, 1861–1872.* Exh. cat. with essay by Thomas J. McCormick. 1961.

Price 1972
Price, Vincent. *Treasury of American Art.* Waukesha, Wis., 1972.

Prown 1966
Prown, Jules D. *John Singleton Copley.* Cambridge, Mass., 1966.

Public Advertiser 1789
Public Advertiser (London), June 5, 1789.

Public Characters 1805
"A Correct Catalogue of the Works of Mr. West." *Public Characters of 1805* (London): 559–569.

Pyne 1819
Pyne, W. H. *The History of the Royal Residences.* 3 vols. London, 1819.

Richardson 1934
Richardson, E. P. "American Portrait Painting." *Bulletin of the Detroit Institute of Arts* 14, no. 1 (October 1934): 11–14.

Richardson 1935
Richardson, E. P. "Two Early American Landscapes." *Bulletin of the Detroit Institute of Arts* 14, no. 6 (March 1935): 81–83.

Richardson 1937
Richardson, E. P. "A Portrait of Historical Interest." *Bulletin of the Detroit Institute of Arts* 17, no. 3 (December 1937): 16–18.

Richardson 1938
Richardson, E. P. "Two Portraits by William Page." *Art Quarterly* 1 (Spring 1938): 90–103.

Richardson 1938a
Richardson, E. P. "A Portrait of John Trumbull, the Poet." *Art Quarterly* 1 (Summer 1938): 212–223.

Richardson 1944
Richardson, E. P. *American Romantic Painting.* New York, 1944.

Richardson 1944a
Richardson, E. P. "Allston and the Development of Romantic Color." *Art Quarterly* 7 (Winter 1944): 33–56.

Richardson 1944b
Richardson, E. P. "The Flight of Florimell and Other Paintings by Washington Allston." *Bulletin of the Detroit Institute of Arts* 24, no. 1 (1944): 2–5.

Richardson 1945
Richardson, E. P. "The World of the Romantic Artist: Detroit Review." *Art News* 43 (January 15–31, 1945): 20–21, 34.

Richardson 1946
Richardson, E. P. "Self-Portrait by Rembrandt Peale." *Bulletin of the Detroit Institute of Arts* 25, no. 3 (1946): 53–54.

Richardson 1947
Richardson, E. P. "Allston: History of a Reputation." *Art News* 46 (August 1947): 12–15, 37–38.

Richardson 1947a
Richardson, E. P. "*Watson and the Shark* by John Singleton Copley." *Art Quarterly* 10 (Summer 1947): 213–218.

Richardson 1947b
Richardson, E. P. "The America of Washington Allston." *Magazine of Art* 40 (October 1947): 218–223.

Richardson 1948
Richardson, E. P. "The Portrait of Robert Fulton." *Art Quarterly* 11 (Spring 1948): 161–167. Originally published as "*Robert Fulton by Rembrandt Peale.*" *Bulletin of the Detroit Institute of Arts* 27, no. 3 (1948): 69–72.

Richardson 1948a
Richardson, E. P. *Washington Allston: A Study of the Romantic Artist in America.* Chicago, 1948.

Richardson 1949
Richardson, E. P. "Gustavus Hesselius." *Art Quarterly* 12 (Summer 1949): 220–226.

Richardson 1949a
Richardson, E. P. "Realism and Idealism, Subjective and Objective, in American Painting." *Art Quarterly* 12 (Winter 1949): 3–15.

Richardson 1950–51
Richardson, E. P. "Portrait of Commodore Oliver Hazard Perry by John Wesley Jarvis." *Bulletin of the Detroit Institute of Arts* 30, nos. 3 and 4 (1950–51): 75–77.

Richardson 1950–51a
Richardson, E. P. "*The Trappers' Return* by George Caleb Bingham." *Bulletin of the Detroit Institute of Arts* 30, nos. 3 and 4 (1950–51): 81–84.

Richardson 1950–51b
Richardson, E. P. "A Portrait of James Peale, the Miniature Painter (*The 'Lamplight Portrait'*), by Charles Willson Peale." *Bulletin of the Detroit Institute of Arts* 30, no. 1 (1950–51): 8–11.

Richardson 1951
Richardson, E. P. "Portrait of Commodore Oliver Hazard Perry by John Wesley Jarvis." *Art Quarterly* 14 (Summer 1951): 166, 170–171.

Richardson 1952
Richardson, E. P. "*The Checker Players* by George Caleb Bingham." *Art Quarterly* 15 (Autumn 1952): 251–256. Reprinted in the *Bulletin of the Detroit Institute of Arts* 32, no. 1 (1952–53): 14–16.

Richardson 1952a
Richardson, E. P. "*Head of a Negro* by John Singleton Copley." *Art Quarterly* 15 (Winter 1952): 350–351.

Richardson 1952–53
Richardson, E. P. "*Head of a Negro* by John Singleton Copley." *Bulletin of the Detroit Institute of Arts* 32, no. 3 (1952–53): 68–70.

Richardson 1953–54
Richardson, E. P. "Director's Report." *Bulletin of the Detroit Institute of Arts* 33, no. 2 (1953–54): 50, 52.

Richardson 1954
Richardson, E. P. "The Painting Peale Dynasty." *Art News* 53 (October 1954): 28–30, 73–74.

Richardson 1961
Richardson, E. P. "A Portrait of George Washington." *Bulletin of the Detroit Institute of Arts* 41, no. 1 (Autumn 1961): 3–4.

Richmond 1961
Richmond, Virginia Museum of Fine Arts. *Treasures in America.* Exh. cat. 1961.

Richmond 1977
Richmond, Virginia Museum of Fine Arts. *American Folk Painting: Selections from the Collection of Mr. and Mrs. William E. Wiltshire III.* Exh. cat. by Richmond B. Woodward with introduction by Mary Black. 1977.

Richmond et al. 1983
Richmond, Virginia Museum of Fine Arts; Birmingham, Ala., Birmingham Museum of Art; New York, National Academy of Design; Jackson, Mississippi Museum of Art; and New Orleans Museum of Art. *Painting in the South: 1564–1960.* Exh. cat. with introduction by Ella Prince Knox and essays by Donald B. Kuspit, Jessie J. Poesch, Linda Crocker Simmons, Rick Stewart, and Carolyn J. Weekley. 1983.

Rivard 1978
Rivard, Nancy. "American Paintings at the Detroit Institute of Arts." *Antiques* 114 (November 1978): 1044–1055.

Rolde 1982
Rolde, Neil. *Sir William Pepperrell.* Brunswick, Me., 1982.

Rollins 1926
Rollins, C. B. "Some Recollections of George Caleb Bingham." *Missouri Historical Review* 20 (July 1926): 463–484.

Rollins 1937
Rollins, C. B., ed. "Letters of George Caleb Bingham to James S. Rollins." *Missouri Historical Review* 32 (October 1937): 3–34.

Rome 1980
Rome, Vatican City, Vatican Museums, Braccio di Carlo Magno. *A Mirror of Creation: 150 Years of American Nature Painting.* Exh. cat. by John I. H. Baur. 1980.

Rome and Milan 1954
Rome, Galleria Nazionale d'arte moderna, and Milan, Palazzetto Reale. *Mostra di Pittura Americana del xix secolo.* Exh. cat. 1954. (See also Frankfurt 1953 and New York 1954).

Rosenblum and Janson 1984
Rosenblum, Robert, and H. W. Janson. *Nineteenth-Century Art.* Englewood Cliffs, N.J., and New York, 1984.

Rumford 1981
Rumford, Beatrix T., ed. *American Folk Portraits, Paintings and Drawings from the Abby Aldrich Rockefeller Folk Art Center.* Boston, 1981.

Rusk 1917
Rusk, Fern Helen. *George Caleb Bingham, the Missouri Artist.* Jefferson City, Mo., 1917.

Rutledge 1949
Rutledge, Anna Wells. *Artists in the Life of Charleston: Through Colony and State, from Restoration to Reconstruction.* Transactions of the American Philosophical Society, vol. 39. Philadelphia, 1949.

Rutledge 1958
Rutledge, Anna Wells. "Portraits of American Interest in British Collections." *Connoisseur* 161 (May 1958): 269–270.

Sadik 1966
Sadik, Marvin S. *Colonial and Federal Portraits at Bowdoin College.* Brunswick, Me., 1966.

Saginaw 1952
Saginaw, Mich., Saginaw Museum of Art. "Painters of the West." [No cat.] 1952.

St. Louis 1850
St. Louis, Jones's Store. [Exhibition; no cat.]. October 1850.

St. Louis 1859
St. Louis. *Fourth Annual Fair of the St. Louis Agricultural and Mechanical Association.* Exh. cat. 1859.

St. Louis 1864
St. Louis. *Mississippi Valley Sanitary Fair.* Exh. cat. 1864.

St. Louis and Minneapolis 1954
St. Louis, City Art Museum, and Minneapolis, Walker Art Center. *Westward the Way.* Exh. cat. 1954.

St. Louis and Washington 1990
St. Louis Art Museum and Washington, D.C., National Gallery of Art. *George Caleb Bingham.* Exh. cat. by Michael Edward Shapiro et al. 1990.

St. Petersburg 1968
St. Petersburg, Fla., Museum of Fine Arts. "They Saw the West." [No cat.] 1968.

Salt Lake City 1976
Salt Lake City, Utah Museum of Fine Arts. *American Paintings around 1850.* 1976.

San Antonio 1983
San Antonio, Tex., San Antonio Museum of Art. *Revealed Religion: Benjamin West's Commissions for Windsor Castle and Fonthill Abbey.* Exh. cat. by Nancy L. Pressly. 1983.

San Francisco 1957
San Francisco, M. H. deYoung Memorial Museum. *Painting in America.* Exh. cat. 1957.

San Francisco 1972
San Francisco, M. H. deYoung Memorial Museum. "The American West." [No cat.] 1972.

San José 1978
San José, Costa Rica, Museo de Jade. *Cinco Siglos de obras maestras de la pintura en colecciones norteamericanas cedidas en prestamo a Costa Rica.* Exh. cat. by Dewey F. Mosby. 1978.

Santa Barbara 1941
Santa Barbara, Calif., Museum of Art. [Exhibition; no cat.]. 1941.

Santa Fe 1961
Santa Fe, Fine Arts Museum of New Mexico. "Art of the American West." [No cat.] 1961.

Saunders 1979
Saunders, Richard H. "John Smibert 1688–1751: Anglo-American Portrait Painter." Ph.D. diss., Yale University, 1979.

Sawitzky 1942
Sawitzky, William. *Matthew Pratt, 1734–1805.* New York, 1942.

Schenectady 1972
Schenectady, N.Y., Union College. *American Portraits 1800–1850: A Catalogue of Early Portraits in the Collections of Union College.* Perm. coll. cat. by Rita Feigenbaum. 1972.

Scripps 1889
Scripps, James E., ed. *Catalogue of the Scripps Collection of Old Masters.* Detroit Museum of Art, 1889.

Seattle 1938
Seattle Art Museum. [Exhibition; no cat.]. 1938.

Seattle 1976
Seattle Art Museum. *Lewis and Clark's America.* Exh. cat. 1976.

Sellers 1939
Sellers, Charles Coleman. *The Artist of the Revolution. The Early Life of Charles Willson Peale.* Hebron, Conn., 1939.

Sellers 1947
Sellers, Charles Coleman. *Charles Willson Peale.* 2 vols. Philadelphia, 1947.

Sellers 1948
Sellers, Charles Coleman. "Colonial and Federal Faces: A Note on Contrasts in the Portraits of Charles Willson, James and Rembrandt Peale." *Art Quarterly* 11 (Summer 1948): 269–273.

Sellers 1952
Sellers, Charles Coleman. *Portraits and Miniatures by Charles Willson Peale.* Transactions of the American Philosophical Society, vol. 42, pt. 1. Philadelphia, 1952.

Sellers 1954
Sellers, Charles Coleman. "The Pale Horse on the Road." *Antiques* 65 (May 1954): 384–387.

Sellers 1954a
Sellers, Charles Coleman. "The Peale Family." *Art Digest* 29 (October 15, 1954): 10-11, 29.

Sellers 1957
Sellers, Charles Coleman. "Mezzotint Prototypes of Colonial Portraiture: A Survey Based on the Research of Waldron Phoenix Belknap, Jr." *Art Quarterly* 20 (Winter 1957): 407–468.

Sellers 1960
Sellers, Charles Coleman. "Rubens Peale: A Painter's Decade." *Art Quarterly* 33 (Summer 1960): 139–150.

Sellers 1969
Sellers, Charles Coleman. *Charles Willson Peale: A Biography.* New York, 1969.

Sellers 1969a
Sellers, Charles Coleman. *Charles Willson Peale with Patron and Populace.* Transactions of the American Philosophical Society, vol. 59, pt. 3. Philadelphia, 1969.

Sellers 1980
Sellers, Charles Coleman. *Mr. Peale's Museum: Charles Willson Peale and the First Popular Museum of Natural Science and Art.* New York, 1980.

Severens 1985
Severens, Martha R. "Jeremiah Theüs of Charleston: Plagiarist or Pundit." *Southern Quarterly: A Journal of the Arts in the South* 24 (Fall–Winter 1985): 56–70.

Sewall 1973
Sewall, Samuel. *The Diary of Samuel Sewall.* 2 vols. Edited by M. Halsey Thomas. New York, 1973.

Sheldon 1879
Sheldon, G[eorge] W. *American Painters.* New York, 1879.

Sizer 1948
Sizer, Theodore. "Trumbull's 'Yorktown' and the Evolution of the National Flag." *Art Quarterly* 11 (Autumn 1948): 357–359.

Sizer 1950
Sizer, Theodore. *The Works of Colonel John Trumbull.* New Haven, 1950.

Sizer 1952
Sizer, Theodore. "The John Trumbulls and Mme Vigée-LeBrun." *Art Quarterly* 15 (Summer 1952): 170–178.

Smith 1828
Smith, John Thomas. *Nollekens and His Times.* 2 vols. London, 1828.

Smith 1845
Smith, John Thomas. *A Book for a Rainy Day.* London, 1845.

Sokol 1970
Sokol, David M. "John Quidor, Literary Painter." *American Art Journal* 2 (Spring 1970): 60–73.

Sokol 1971
Sokol, David M. "John Quidor: His Life and Work." Ph.D. diss., New York University, Institute of Fine Arts, 1971.

Spear 1844
Spear, Thomas T. *Description of the Grand Historical Picture of Belshazzar's Feast Painted by Washington Allston and Now Exhibiting at the Corinthian Gallery.* Boston, 1844.

Staley 1980
Staley, Allen. "West's *Death on the Pale Horse.*" *Bulletin of the Detroit Institute of Arts* 58, no. 3 (1980): 137–149.

Stanley 1852
Stanley, John Mix. *Portraits of North American Indians, with Sketches of Scenery, etc., Painted by J. M. Stanley.* Smithsonian Institution Publication, no. 53 (1852).

Stein 1976
Stein, Roger B. "Copley's *Watson and the Shark* and Aesthetics in the 1770's." In *Discoveries and Considerations: Essays on Early American Literature and Aesthetics Presented to Harold Janta.* Edited by Calvin Israel. Albany, N.Y., 1976.

Stevens 1967
Stevens, William B., Jr. "Joseph Blackburn and His Newport Sitters, 1754–1756." *Newport History* 40 (Summer 1967): 95–107.

Stewart 1988
Stewart, Robert G. "James Earl: American Painter of Loyalists and His Career in England." *American Art Journal* 20 (1988): 34–58.

Stiles 1869
Stiles, Henry R. *A History of the City of Brooklyn.* 2 vols. Brooklyn, 1869.

Stillman 1855
Stillman, William J. "Sketchings." *Crayon* 1 (March 7, 1855): 155.

Stillwell 1928
Stillwell, John E. *The History of the Burr Portraits: Their Origin, Their Dispersal and Their Reassemblage.* Unpaginated, 1928.

Stony Brook 1947
Stony Brook, N.Y., The Suffolk Museum. *The Mount Brothers.* Exh. cat. by Margaret V. Wall. 1947.

Stony Brook 1988
Stony Brook, N.Y., The Museums at Stony Brook. *Shepard Alonzo Mount: His Life and Art.* Exh. cat. by Deborah J. Johnson. 1988.

Storrs 1973
Storrs, University of Connecticut, William Benton Museum of Art. *Nineteenth-Century Folk Painting: Our Spirited National Heritage* (Works of Art from the Collection of Peter Tillou). Exh. cat. by Peter Tillou. 1973.

Strickler 1979
Strickler, Susan. *The Toledo Museum of Art: American Paintings.* Toledo, 1979.

Strong 1978
Strong, Roy. *Recreating the Past: British History and the Victorian Painter.* New York, 1978.

Sully 1873
Sully, Thomas. *Hints to Young Painters.* Philadelphia, 1873. Reprint. New York, 1965.

Sund 1980
Sund, Judy. "Benjamin West: A Scene from *King Lear.*" *Bulletin of the Detroit Institute of Arts* 58, no. 3 (1980): 127–136.

Swan 1940
Swan, Mabel Munson. *The Athenaeum Gallery 1827–1873: The Boston Athenaeum as an Early Patron of Art.* Boston, 1940.

Sweeney 1975
Sweeney, J. Gray. "The Artist-Explorers of the American West 1860–1880." Ph.D. diss., Indiana University, 1975.

Sweeney 1983
Sweeney, J. Gray. "Great Lakes Marine Painting of the Nineteenth Century: A Michigan Perspective." *Michigan History* 67 (May–June 1983): 25.

Sweetser 1879
Sweetser, Moses Foster. *Allston.* Boston, 1879.

Swenson 1949
Swenson, Eleanor B. "When the Modern Battle Was New." *Art News* 48 (March 1949): 25–27, 51.

Taft 1953
Taft, Robert. *Artists and Illustrators of the Old West, 1850–1900.* New York, 1953.

Taggart 1961
Taggart, Ross E. "George Caleb Bingham Sesquicentennial Exhibition." *Nelson Gallery and Atkins Museum Bulletin* 3 (1961): 3–26.

Taylor 1957
Taylor, Joshua C. "The Fascinating Mrs. Page." *Art Quarterly* 20 (Winter 1957): 347–362.

Taylor 1957a
Taylor, Joshua C. *William Page: The American Titian.* Chicago, 1957.

Taylor 1979
Taylor, Joshua C. *The Fine Arts in America.* Chicago, 1979.

Thayer 1976
Thayer, Donald R. "Early Anatomy Instruction at the National Academy: The Tradition behind It." *American Art Journal* 8 (May 1976): 38–51.

Thistlethwaite 1979
Thistlethwaite, Mark E. *The Image of George Washington: Studies in Mid-Nineteenth-Century American History Painting.* New York, 1979.

Thomas 1956
Thomas, Ralph W. "Reuben Moulthrop, 1763–1814." *Connecticut Historical Society Bulletin* 21, no. 4 (October 1956): 97–111.

Tillou 1976
Tillou, Peter. *Where Liberty Dwells: Nineteenth-Century Art by the American People.* Buffalo, N.Y., 1976.

Time 1947
"Unfinished Feast." *Time,* July 18, 1947.

Toledo Museum News 1945
"Our Earliest American Painting." *Toledo Museum News* 109 (September 1945): unpaginated.

Tomlinson 1976
Tomlinson, Juliette, ed. *The Paintings and the Journal of Joseph Stock.* Middletown, Conn., 1976.

Tower 1941
Tower, Lawrence Phelps. "The Lost Lopez Portrait." *Antiques* 39 (April 1941): 185.

Trumbull 1841
Trumbull, John. *Autobiography, Reminiscences and Letters of John Trumbull from 1756 to 1841.* New Haven, 1841.

Tuckerman 1867
Tuckerman, Henry T. *Book of the Artists.* New York, 1867. Reprint. New York, 1966.

Tucson 1964
Tucson, University of Arizona Art Gallery. *The Bird in Art.* Exh. cat. 1964–65.

Universal Magazine **1805**
"A Correct List of the Works of Mr. West." *Universal Magazine* 3 (1805): 527–532.

University Park 1955
University Park, Pennsylvania State University, Mineral Industries Gallery. *Pennsylvania Painters.* Exh. cat. 1955.

Van Braam 1979
Van Braam, F. A., ed. *World Collector's Annuary.* Delft, 1979.

Van Zandt 1966
Van Zandt, Roland. *The Catskill Mountain House.* New Brunswick, N.J., 1966.

Vancouver 1955
Vancouver Art Gallery. *200 Years of American Painting.* Exh. cat. 1955.

Von Erffa 1956
Von Erffa, Helmut. "*King Lear* by Benjamin West." *Bulletin of the Rhode Island School of Design: Museum Notes* 43 (1956): 6–8.

Von Erffa 1969
Von Erffa, Helmut. "Benjamin West at the Height of His Career." *American Art Journal* 1 (Spring 1969): 19–33.

Von Erffa and Staley 1986
Von Erffa, Helmut, and Allen Staley. *Benjamin West.* New Haven and London, 1986.

Wainwright 1974
Wainwright, Nicholas B. *Paintings and Miniatures at the Historical Society of Pennsylvania.* Philadelphia, 1974.

Walpole 1944
Walpole, Horace. *Horace Walpole's Correspondence* [1791]. Vol. 11. Edited by W. S. Lewis. New Haven, 1944.

Ware 1852
Ware, William. *Lectures on the Work and Genius of Washington Allston.* Boston, 1852.

P. Warren 1980
Warren, Phelps. "Badger Family Portraits." *Antiques* 118 (November 1980): 1043–1047.

W. Warren 1958
Warren, William Lawson. "The Pierpont Limner and Some of His Contemporaries." *Connecticut Historical Society Bulletin* 23, no. 4 (October 1958): 97–128.

Washington 1944
Washington, D.C., Smithsonian Institution. *Exhibition of Paintings by John Mix Stanley (1814–1872), Jane C. Stanley (1863–1940), and Alice Stanley Acheson.*" Exh. cat. 1944.

Washington 1949
Washington, D.C., Corcoran Gallery of Art. *De Gustibus: An Exhibition of American Paintings Illustrating a Century of Taste and Criticism.* Exh. cat. 1949.

Washington 1954
Washington, D.C., Smithsonian Institution. "American Primitive Painting: Traveling European Exhibition." Typewritten list. 1954.

Washington 1959
Washington, D.C., Corcoran Gallery of Art. "Parallel Trends in Literature and Art." *Art in America* 47, no. 2 (Summer 1959): 20–47. (Article by Henri Dorra served as catalogue text for the exhibition "The American Muse." Rev. exh. cat. by Henri Dorra printed in book form, Washington, 1961.)

Washington 1960
Washington, D.C., Corcoran Gallery of Art. *American Painters of the South.* Exh. cat. 1960.

Washington 1968
Washington, D.C., National Portrait Gallery. *This New Man: A Discourse in Portraits.* Exh. cat. edited by J. Benjamin Townsend. 1968.

Washington 1969
Washington, D.C., National Portrait Gallery. *A Nineteenth-Century Gallery of Distinguished Americans.* Exh. cat. by Robert G. Stewart. 1969.

Washington 1970
Washington, D.C., National Portrait Gallery. *The Life Portraits of John Quincy Adams.* Exh. cat. with essay by Marvin S. Sadik. 1970.

Washington 1971
Washington, D.C., National Portrait Gallery. *Henry Benbridge (1743–1812): American Portrait Painter.* Exh. cat. by Robert G. Stewart. 1971.

Washington 1974
Washington, D.C., International Exhibitions Foundation. *American Self-Portraits, 1670–1973.* Exh. cat. by Ann C. Van Devanter and Alfred V. Frankenstein. 1974.

Washington 1983
Washington, D.C., National Portrait Gallery. *Mr. Sully, Portrait Painter.* Exh. cat. by Monroe H. Fabian. 1983.

Washington 1987
Washington, D.C., National Portrait Gallery. *The Art of Henry Inman.* Exh. cat. by William H. Gerdts and Carrie Rebora. 1987.

Washington 1988
Washington, D.C., National Gallery of Art. *Raphaelle Peale Still Lifes.* Exh. cat. with essays by Nicolai Cikovsky, Jr., Linda Bantel, and John Wilmerding. 1988.

Washington and Louisville 1985
Washington, D.C., National Portrait Gallery, and Louisville, Ky., J. B. Speed Art Museum. *A Truthful Likeness: Chester Harding and His Portraits.* Exh. cat. by Leah Lipton. 1985.

Washington and Philadelphia 1980
Washington, D.C., National Portrait Gallery, and Philadelphia, Pennsylvania Academy of the Fine Arts. *Benjamin West and His American Students.* Exh. cat. by Dorinda Evans. 1980.

Washington et al. 1965
Washington, D.C., National Portrait Gallery; New York, Metropolitan Museum of Art; and Boston, Museum of Fine Arts. *John Singleton Copley.* Exh. cat. by Jules Prown. 1965.

Washington et al. 1967
Washington, D.C., National Collection of Fine Arts; Cleveland Museum of Art; and Los Angeles, University of California, Art Galleries. *George Caleb Bingham 1811–1879.* Exh. cat. by E. Maurice Bloch. 1967.

Washington et al. 1968
Washington, D.C., National Gallery of Art; St. Louis, City Art Museum; New York, Whitney Museum of American Art; and San Francisco, M. H. deYoung Memorial Museum. *William Sidney Mount 1807–1868.* Exh. cat. by Alfred Frankenstein. 1968.

Washington et al. 1981
Washington, D.C., National Gallery of Art; Fort Worth, Tex., Amon Carter Museum; and Los Angeles County Museum of Art. *An American Perspective: Nineteenth-Century Art from the Collection of Jo Ann and Julian Ganz, Jr.* Exh. cat. with essays by John Wilmerding, Linda Ayres, and Earl A. Powell. 1981.

Washington et al. 1983
Washington, D.C., National Portrait Gallery;
Fort Worth, Tex., Amon Carter Museum; and
New York, Metropolitan Museum of Art. *Charles
Willson Peale and His World.* Exh. cat by E. P.
Richardson, Brooke Hindle, and Lillian B.
Miller. 1983.

Weekley 1977
Weekley, Carolyn J. "Portrait Painting in 18th-
Century Annapolis." *Antiques* 111 (February
1977): 345–353.

Weir 1947
Weir, Irene. *Robert W. Weir, Artist.* New York,
1947.

Wellesley 1950
Wellesley, Mass., Wellesley College. [Exhibition;
no cat.]. February 1950.

West 1826
*Letter from the Sons of Benjamin West, Deceased,
Late President of the Royal Academy of London,
Offering to Sell to the Government of the United
States Sundry Paintings of That Artist.* (9th
Congress, 2d Session, Doc. no. 8, House of
Reps.) Washington, D.C., 1826.

R. West 1978
West, Robert Edward, ed. *Rutland in Retrospect.*
Rutland, Vt., 1978.

West Point 1976
West Point, N.Y., Cadet Fine Arts Forum.
Robert Weir: Artist and Teacher at West Point. Exh.
cat. 1976.

White 1890
White, Margaret E., ed. *A Sketch of Chester
Harding, Artist.* Boston, 1890.

Whitley 1928
Whitley, William T. *Artists and Their Friends in
England, 1700–1799.* 2 vols. London, 1928.

Whitley 1932
Whitley, William T. *Gilbert Stuart.* Cambridge,
Mass., 1932.

Wichita and Milwaukee 1973
Wichita, Kans., Wichita Art Museum, and
Milwaukee, University of Wisconsin, Art
History Galleries. *John Quidor: Painter of
American Legend.* Exh. cat. by David M. Sokol.
1973.

Wight 1976
Wight, Frederick S. *The Potent Image.*
New York, 1976.

Williams 1973
Williams, Hermann Warner, Jr. *Mirror to the
American Past: A Survey of American Genre
Painting 1750–1900.* Greenwich, Conn., 1973.

Wilmerding 1967
Wilmerding, John. *Pittura Americana dell'
Ottocento.* Milan, 1967.

Wilmerding 1970
Wilmerding, John. *Audubon, Homer, Whistler,
and Nineteenth-Century America.* New York, 1970.

Wilmerding 1976
Wilmerding, John. *American Art.* Harmonds-
worth, England, 1976.

Wilmerding et al. 1973
Wilmerding, John, ed. *The Genius of American
Painting.* London, 1973.

Wilmington 1962
Wilmington, University of Delaware, and the
Wilmington Society of Fine Arts, Delaware Art
Center. *American Painting 1857–1869.* Exh. cat.
by Wayne Craven. 1962.

Wilson 1982
Wilson, Christopher Kent. "The Life and Work
of John Quidor." Ph.D. diss., Yale University,
1982.

Winchester 1971
Winchester, Alice. Untitled article. *Antiques* 99
(May 1971): 695.

Windsor Guide 1792
*The Windsor Guide; Containing a Description of the
Town and Castle; the Present State of the Paintings
and Curiosities in the Royal Apartments; an Account
of the Monuments, Painted Windows, &c. in St.
George's Chapel* Windsor, 1792.

Wisbey 1958
Wisbey, Herbert A., Jr. "J. L. D. Mathies,
Western New York Artist." *New York History* 39,
no. 2 (1958): 133.

Wolf 1982
Wolf, Bryan Jay. *Romantic Re-Vision: Culture and
Consciousness in Nineteenth-Century American
Painting and Literature.* Chicago, 1982.

Worcester 1935
Worcester, Mass., Art Museum. *Seventeenth-
Century Painting in New England.* Exh. cat. ed-
ited by Louisa Dresser. 1935. (Exhibition held
in 1934.)

Worcester 1973
Worcester, Mass., Art Museum. *The American
Portrait: From the Death of Stuart to the Rise of
Sargent.* Exh. cat. by William J. Hennessey.
1973.

Wright 1937
Wright, Cuthbert. "The Feast of Belshazzar."
New England Quarterly 10 (December 1937):
620–634.

Yonkers et al. 1988
Yonkers, N.Y., The Hudson River Museum;
Rochester, N.Y., The Margaret Woodbury
Strong Museum; Albany, N.Y., Albany Institute
of History and Art; Syracuse, N.Y., Everson
Museum of Art. *The Catskills: Painters, Writers
and Tourists in the Mountains, 1820–1895.* Exh.
cat. by Kenneth Myers. 1988.

Young 1821
Young, John. *A Catalogue of Pictures by British
Artists, in the Possession of Sir John Fleming Leicester,
Bart.* London, 1821.